The Dada Painters and Poets

**The Documents of
Twentieth Century Art**

Robert Motherwell and
Jack D. Flam, Series Editors

The **Dada** Painters and Poets: An Anthology

Edited by Robert Motherwell

Texts by:

Arp
Ball
Breton
Buffet-Picabia
Cravan
Eluard
Huelsenbeck
Hugnet
Ribemont-Dessaignes
Richter
Satie
Schwitters
Tzara
Vaché
et al.

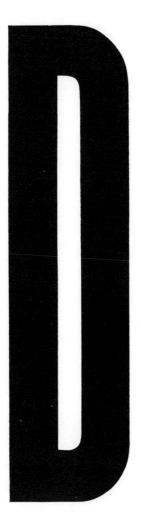

Illustrations after:

Arp
Clair
Duchamp
Eggeling
Ernst
Hausmann
Janco
Klee
Picabia
Richter
Schwitters
Stieglitz
Taeuber-Arp
et al.
and
Documents
Objects
Journals
Reviews
Manifestoes
Photographs
Catalogues
Invitations
etc.

Contents:

Acknowledgments:

The publishers gratefully acknowledge their indebtedness and thanks to all those concerned
in the compilation of this anthology, including those not specifically mentioned
by name, whose assistance made its ultimate presentation possible. Robert Motherwell, the editor, has
listed his appreciations on a separate page, but we should like to mention here, in particular, our
gratitude to Paul Rand, Bernard Karpel, Henry Aronson, Kim Swados and all the translators
mentioned in the text.

Foreword

The publication of a new edition of *The Dada Painters and Poets*, first issued in 1951 and long out of print, is a welcome event. When this book was originally published, it was the first anthology in English of Dada writings, and the most comprehensive Dada anthology in any language. Now, thirty years later, it still remains the most comprehensive and important anthology of Dada writings in any language, and a fascinating and very readable book. It is also an important historical document, in several senses. It rescued a number of important writings and an important artistic movement from obscurity, it stimulated critical and scholarly interest in Dada, and it contributed to a revival of the Dada spirit among working artists and writers.

As the first comprehensive Dada anthology, this book helped to define and contextualize—and virtually to resurrect—the Dada movement. Because Dada by its very nature had been characterized by a number of elusive and often contradictory attitudes rather than by a particular style, and its primary legacy had consisted largely of acts, stances, and (often ephemeral) printed matter rather than "art objects"—of dispersals rather than concentrations of energy—the topography of the movement had previously remained vague and obscure. Historically, Dada had been more or less cannibalized by the Surrealist movement that it sired, and, with the exception of Marcel Duchamp, the major Dadaists had either been cast aside, claimed, or absorbed by the Surrealists. (Duchamp, in his precise ambiguousness and elegantly aloof straightforwardness, was too independent to be claimed and too paradoxical to be absorbed; the Surrealists thus set him up as a sort of saintly precursor of Surrealism, a kind of St. John the Baptist to André Breton's Christ.) The first edition of *The Dada Painters and Poets* was a pioneering work that gave both general contours and much specific detail to the previously amorphous notions of the Dada past, and in so doing stimulated a great deal of interest amongst historians (as is evident in the bibliographies). Moreover, because it presented Dadaism through the eyes of the leading Dadaists themselves, it constituted a kind of composite autobiography, or family history, of the Dada movement. And as with all family histories—happy or unhappy, Tolstoy notwithstanding—each member lives and remembers and records differently. One of the great virtues of the way this book is organized is that are not only the individual members allowed to speak in their own very individual voices, but that the reader has the chance to see how these individual voices change with circumstances and over the course of time. This interplay between different voices at different moments in the history of Dada is made especially telling in Robert Motherwell's fascinating Introduction, which not only clarifies some important ideological and historical points, but gives several of the leading Dadaists the chance to comment on earlier texts, events, and personalities. As a result, the history of the

original Dadaists is given an important second phase, and the participants in that history come across with much of their complexity and humanity intact: as reflective *and* argumentative, idealistic *and* self-serving. In this way, the reader is also given some idea of the complex shadings of perception that underlie all our received notions of "history." This book then is a record of a process as well as an anthology of past events; at the same time that it presents a history, it also implicitly sets forth an attitude toward the historical process itself, which is seen to be dynamic and contradictory and full of surprising turns and reversals.

It is therefore fitting that this book has acted upon history in a dynamic as well as in a documentary sense. For in resurrecting the largely forgotten or inaccessible printed documents of a largely overlooked movement —that is, in reviving instances of past energies that had lain quiescent—this anthology brought a new force into play in the artistic and literary world of post-war America. As a result of the Dada revival, stimulated in part by this book, the Dada spirit gained a kind of second life and exerted its force on a new generation of artists and writers. What had seemed like a dead end in the history of early modernism became a vital and influential force.

This is not the place to enter into a lengthy discourse on the Dada spirit (the pages that follow, in their layout as well as in what is written in them, will provide the reader with that and more). But it does seem useful to say here that the core of Dadaism was based on what might be called an absurdist spirit, which was itself based upon a whole-hearted and unremitting attack on all the norms of industrial-age bourgeois culture: social, ethical, political, artistic, and philosophical—a kind of guerilla warfare against the Establishment. An absurdist attack on materialism, often employing the means and language of that materialism as weapons of attack. And as with any guerilla action, although there may be some disagreement about exactly what its ultimate goals are, or even about who officially belongs to it or has what rank in it, its essential unity consists in agreeing upon who the enemy is and in attacking that enemy on its own ground, no holds barred. The enduring message of Dada, in essence, was "Anything goes."

When this book appeared in 1951, the material it presented, and the "anything goes" attitude that it embodied, struck a sympathetic chord, especially among artists and writers just coming into their maturity. The younger poets, especially, seem to have been deeply affected by the liberating possibilities of Dada writing, which gave them a kind of license to free-associate, probe new subject matter, and use verbal collage and off-beat diction. Writers as diverse as Allen Ginsberg, Lawrence Ferlinghetti, Frank O'Hara, Gregory Corso, Charles Olson, and John Ashbery seem to have been deeply affected by the spirit of Dada. This is not to say that they were Dadaists in the historical sense, or even that they shared with the Dadaists or with each other a common stance in relation to either life or literature, but that they were all deeply affected by the possibilities that Dada writing suggested. In addition to the specific appeal of general principles and ideas, such as the use of chance and randomness, there was another important factor involved: the Dada spirit was becoming an increasingly inescapable part of modern existence, for artist and public alike.

By the mid 1950s, the absurdist irony and irreverence of Dada had become an integral part of more and more people's attitude toward daily life. The commercial, industrial, philistine society that Dada had been created as a reaction against in 1916 had grown so crass, so omnivorous, so omnipresent, that it was impossible either to ignore or parody it. Instead, the self-parody inherent in so many institutions offered itself as the raw material for a new kind of deadpan realism, which was not the same thing as Dada but which was clearly related to it. It is no mere coincidence that around 1960 the terms Neo-Dada and Neo-Realism were often used interchangeably. Not only certain kinds of art, but certain aspects of life in general had taken on a decidedly Dada cast.

It is one of the ironies of history that Robert Motherwell, who edited this book, belonged to an artistic generation that spiritually as well as chronologically preceded the Dada revival, and which was directly succeeded, and to a certain degree supplanted, by artists whose work was related to that revival. In fact, the Neo-Dadaists stood in relation to the high ideals and artistic seriousness of Abstract Expressionism somewhat as the Dadaists had stood in relation to Cubism. Motherwell's own interest in Dada, and the impetus for putting together this anthology, had originally grown out of his interest in Surrealist-inspired free-association and psychic automatism as sources for abstract painting—a somewhat different way from that of Dada of "letting anything happen." And indeed the art of Motherwell and his colleagues was not directly affected by the Dada revival. By 1950 the Abstract Expressionists had already achieved a self-sustaining level of artistic maturity. Also, theirs was an idealistic endeavor, in the literal sense; they were not interested in attacking or destroying the Establishment,

but in going beyond it, in looking for something outside it. One of the great *cultural* breakthroughs of American abstract painting, in fact, lay in the way that it allowed artists to ignore the American Scene, to move around the surface of both history and everyday life, and aim instead for the mythic and the cosmic. (That the Establishment at the time took this ignoration as a form of attack is another matter, and probably says as much about cultural parochialism as about the artistic conflict involved.)

The artists of the succeeding generation, on the other hand—artists such as Johns, Rauschenberg, Oldenberg, Lichtenstein, and Warhol—were very much affected by the surface of everyday life, and by the American Scene; the stance that they took in relation to the world around them was very much affected by the Dada spirit, but in a different way from earlier Dada. In 1916 the Dadaists had attacked a relatively homogeneous European culture, which—though at the time it was unwittingly about to enter its death throes—quite simply took its own view of the world for granted, and still had enough sacred cows and enough consensus behind those sacred cows, to know when it was under attack. In 1960 American society, despite its commercial homogeneity, was culturally quite pluralistic. Pop Art, Happenings, Environmental and Conceptual art—the main manifestations of the New Dada—were absorbed into the mainstream with unusual alacrity. If nothing else, they made "good press," and good press is one of the backbones of commerce. Since the most cohesive force in American society is commerce, what started out as cultural apostasy quickly became an acceptable part of American "high culture." (A similar phenomenon occurred a decade later, when the social and political dissidence of the 1960s was transformed into "boutique hippyism.") One of the most enigmatic aspects of Pop Art is that it is often very difficult to tell whether, or to what degree, the art is meant as an attack on or as an affirmation of the popular icons that it takes for its subjects.

The original Dada masters, such as Duchamp, were aware of this ambivalence and did not think much of the New Dada. "This Neo-Dada," Duchamp wrote to Hans Richter in 1962, "which they call New Realism, Pop Art, Assemblage, etc., is an easy way out, and lives on what Dada did. When I discovered ready-mades I thought to discourage aesthetics. In Neo-Dada they have taken my ready-mades and found aesthetic beauty in them. I threw the bottle-rack and the urinal into their faces as a challenge and now they admire them for their aesthetic beauty." What had happened, of course, is that Dada, which had started out as anti-art, had been incorporated into the artistic mainstream and had become, among other things, an artistic stance. Also, the world had changed. For although the New Dada may have started out as an attempt to outrage and insult, the public had in a sense become uninsultable. Just a year after Duchamp's letter to Richter, Roy Lichtenstein, one of the leading Pop artists, remarked in an interview: "It was hard to get a painting that was despicable enough so that no one would hang it—everybody was hanging everything. It was almost acceptable to hang a dripping paint rag, everyone was accustomed to this. The one thing everyone hated was commercial art; apparently they didn't hate that enough either." The Dada spirit, clearly, had not only been incorporated into the artistic mainstream, but was also becoming part of the fabric of daily existence, an attitude toward life iself. The Dada-inspired questioning of the borderline between art and non-art, and of the nature of the possible links between apparently unrelated things, had become an essential part of the modern sensibility.

This was not a phenomenon of only recent origin. The problem of absurdist reality catching up with and overtaking absurdist art on its own grounds went back virtually to the beginnings of Dada itself. In May of 1917, only a year after the founding of the Cabaret Voltaire group, Satie and Cocteau's absurdist ballet *Parade* was staged at the Théâtre du Châtelet in Paris. Just a month before that, as John Berger has pointed out, the French had opened their offensive against the Hindenburg line, only 150 miles away from Paris. An estimated 120,000 French soldiers were killed during that brief offensive (although the statistics were long kept secret), and a serious mutiny ensued. One of the most striking events of that dark time was the procession of a group of infantrymen through a town, baa-ing like sheep, to protest that they were like lambs being led to the slaughter. Here the absurdity of the theatre of life had taken the lead from absurdist art, both in terms of content and of style. The political and social history of the rest of this century has since provided countless other examples. If one of the functions of art is to create a parallel world that is somehow more vivid than the real world, then the "art-content" of raw experience, usually prepared for by previous art, is something that has to be reckoned with.

By the 1950's, Dada, originally conceived of as a non-descriptive art, as a kind of irrational nonsense, as a destruction of the conventions of language and communication, had been transformed—in spite of itself—

into something like a descriptive art, into a lucid, almost rational, and highly structured approach to the absurdity of everyday life. Compared to the haranguing double-talk of advertisements, the constant drivel that empties language of its content and credibility and destroys credence in experience itself, or to the meaninglessly euphemistic language of government agencies, the language of Dada had come to have a certain linguistic and ethical purity about it. Seen in retrospect, it had come to seem civilized, for the values that it was based on, and which made the context of its attack meaningful, were precisely those bourgeois values that had been supplanted by the increasingly aggressive indignities committed by commercially-motivated verbal and visual gush. Bourgeois values had become like Br'er Rabbit's Tar Baby: the harder you kicked it, the deeper you got stuck in it. The original audience of *Parade* had at least had the sense to realize that they were being mocked; their sense of personal dignity, philistine pigs that they may have been, was strong enough to let them know when they were under attack. By 1960 this was not something that could be counted on from any audience. This difference in the sensibility of artists and audience alike was a crucial factor in determining the shape that the New Dada would take. The New Dada had to be different, because the world that it was acting in not only looked different but was seen through very different sensibilities.

As for Dada as a "style," the very aggressions and anti-correspondences that Dada had invented have come, with the passage of time, to seem more and more related to the same ideas of Symbolist *correspondance* that Dada had set out to attack in the first place. What Dada had invented were what might be called disjunctive or negative, rather than associative or positive, correspondences. But they were correspondences nonetheless. From the Dada way of building correspondences, a new mode of symbolizing was gradually evolved, not only in objects but also in acts and concepts. Happenings and conceptual art have more than a certain historical or ideological affinity with Dada: they employ and to a certain degree systematize the symbolic and communicative modes invented by the Dadaists. Once again, art has come to imitate life which originally imitated art which imitated life, albeit in an unexpected way. Seen from a distance, what Dada had done was to create a structure through which one could make sense of, or at least recognize or pretend to gain control over, the powerful energies and inconsistencies of life itself.

That the Dada spirit has become an inescapable condition of modern life must seem self-evident. Once that spirit has been discovered, the world can never look quite the same. I would venture to say that today any city dweller who ventures past his front door, or reads a newspaper, or turns on a television set or a radio, will come across some evidence of that spirit before the day is done. After all, doesn't the location of the Dada Archive and Research Center in Iowa City have something as foreseen about it as does the cracking of *The Large Glass*?

We are, as this book implies, dealing with a process, and that process is truly ongoing. Once started, it appears to be ineluctable. Not long ago, for example, while I was walking through the Philadelphia Museum of Art, I came upon a display case in which Morton Schamberg's *God*, a 1918 Dada assemblage made of a plumbing trap set into a miter box, is supposed to rest. That this work now resides in a sealed glass museum case might in itself be seen to have something Dada about it. But the Dada spirit never stops where you expect it to. The case was empty, except for an inventory card, which read:

God—Temporarily Removed.

Jack D. Flam
May 1981

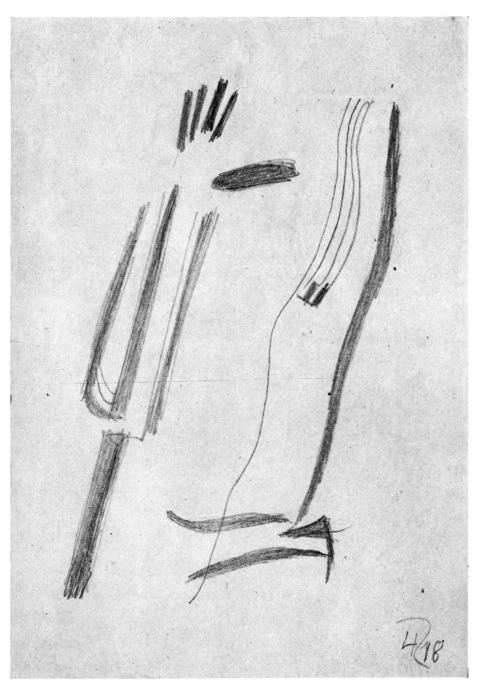

Hans Richter. *Portrait of Arp.* 1918. Coll. the artist.

Preface

The world is as you take it. John Ray: *English Proverbs,* 1670.

Hence gloom and misanthropy have become the characteristics of the age in which we live, the solace of a disappointment that unconsciously finds relief only in the exaggeration of its own despair. P. B. Shelley, c. 1820.

The world is a looking-glass, and gives back to every man the reflection of his own face. W. M. Thackeray: *Vanity Fair,* 1848.

Since the series called the Documents of Modern Art is primarily devoted to visual art, this anthology began simply with the purpose of publishing a complete translation of Georges Hugnet's *The Dada Spirit in Painting*—an abbreviated version of which appeared in Alfred H. Barr, Jr's *Fantastic Art, Dada, Surrealism*—with the addition of a few related texts. But in editing the book my conviction grew, reinforced by past experiences as a young artist among the Parisian surrealists, that, as with surrealism, without an adequate grasp of the value-judgments of dada as evidenced in its literature, the image of dada that emerges from consideration of its plastic works alone is distorted and incomplete. It was then decided to include the principal histories of dada from a literary viewpoint, the *History of Dada* by Georges Ribemont-Dessaignes, a French view, and *En Avant Dada: A History of Dadaism* by Richard Huelsenbeck, a German view. I believe the latter work to be one of the most extraordinary expressions, not only of dada, but of the avant-garde mind in the strictest and narrowest sense; and I am grateful to the

translator of many of the texts in this volume, Mr. Ralph Manheim, for having resurrected it from the small and now difficult-to-find brochure published in Germany at the end of the first world war.

From such major additions to the original project, it was a natural desire to try to make the anthology really complete. I began to ask the dadas in New York, as I would find them by chance browsing in Messrs Wittenborn and Schultz' bookstore, which is devoted to books on the fine arts, to make suggestions towards having the anthology as complete and fair as possible.

During the six years in which the anthology was in the making, in came dadas, sometimes to browse, sometimes because they knew the anthology was being prepared, champing at the bit, like old war horses—among them, Arp, André Breton, Marcel Duchamp, Max Ernst, Richard Huelsenbeck, Man Ray (whom I never met), and Hans Richter, as well as others who had known the dadas in Germany, Josef Albers, Frederick Kiesler, Moholy-Nagy, and Mies van der Rohe.

Arp, Duchamp, Ernst, Huelsenbeck and Richter examined the dummy of the book on various occasions, though its final character is my responsibility. Duchamp suggested the pre-dada section, maintaining that dada did not arrive in Zurich as a "bolt out of the blue," so to speak, but had been "in the air" a long time before. Max Ernst suggested asking Tristan Tzara in Paris to write an introduction to the anthology; and Huelsenbeck proposed that the dadas now in America sign a new (1949) dada manifesto, written by

xvi

himself, to bring the anthology to an end, with the unfortunate complications in relation to the publication of the anthology that I speak of in the Introduction. Richter kept underlining the slight done to the German-speaking side of dada by French historians. And Tzara, whose antagonism to Huelsenbeck's 1949 manifesto created an impasse, introduced by implication the question of the U.S.S.R. Indeed, I believe that present view of dada as a historical movement held by each of the dadas is in every case somewhat colored by his present sympathy for or antagonism to the U.S.S.R. It is interesting that Huelsenbeck who—to judge by his writings of the period—was one of the strongest spokesmen for the politics of the left in the dada days so long ago, who accused Tzara of trying to make a French literary movement out of dada, has been for a long time a bitter opponent of the U.S.S.R. and a practising psycho-analyst on Central Park West; and Tzara is now a Russian sympathizer living on the Left Bank of Paris.

Dada was indeed the first systematic attempt to use the means of *l'art moderne* in relation to political issues—a magazine edited by Baargeld and Max Ernst, was sold among the workers of Cologne. This tendency was one of dada's principal bequests to surrealism, which was founded by one-time dadas; and like surrealism, dada tended to be hostile towards abstract art. Yet now, a generation later, the works of dada appear more at home alongside abstract works than they do beside surrealist ones. There is even a gallery in New York now, Rose Fried's, that shows only dada and "non-objective" works. In one of his last letters, the late Piet Mondrian wrote (to James Johnson Sweeney): "I think the destructive element is too much neglected in art." Both dada and strictly non-objective art are trying to get rid of everything in the past, in the interests of a new reality.

There is another, and I believe stronger line in modern art, say, from Matisse to Picasso to Miró, that had its destructive side only in order to recover for art human values that existed in art before and will again, but to which conventional and "official" art remain insensitive. It is one thing to hold that many of humanity's values have vanished from or have been vulgarized by contemporary art, as Cézanne believed; it is another thing to believe that the history of humanity has been a collective fraud—as when Picabia nailed a stuffed monkey to a board and called it *Still Life: Portrait of Cézanne*.

A hundred years ago Leconte de Lisle wrote what could have been a dada slogan, "I hate my epoch." But the problem now, as then, is to change the epoch, not to pass through it uninvolved, like Duchamp's *Young Man on a Train*.

★

I am indebted to the following for general help:

Marcel Duchamp, for suggesting the pre-dada section; for telling me about the dada days in New York; and for supplying the reproduction of Picabia's *Udnie*. Hans Richter, for writing *Dada X Y Z . . .* for this volume; for permission to quote from various letters by and to himself; for supplying illustrations by himself, Eggeling, and Hausmann. Gabrielle Buffet-Picabia, for writing *Some Memories of Pre-Dada* for this volume. John Cage, the composer, for his note about Erik Satie. Joyce Wittenborn, for translations of Hugo Ball's *When I Founded the Cabaret Voltaire*, Francis Picabia's *La Pomme de Pins*, and a letter from Ernst Schwitters. Richard Huelsenbeck, for writing his note about Marcel Janco, and for supplying photographs. Mies van der Rohe, for information about Kurt Schwitters. Josef Albers, for the same. Justus Bier, for the same. Paul Theobald, publisher, for quotations and a plate from the late Moholy-Nagy's *Vision in Motion*. Sibyl Moholy-Nagy, for a long quotation from her recent biography, *Moholy-Nagy*. Tristan Tzara, Paris, for selecting his writings, and writing the *Introduction to Dada* (1948) that is being issued separately. Professor Marcel Raymond, for quotations from *Baudelaire to Surrealism*, the tenth volume of the Documents of Modern Art. M. Jacques-Henry Levesque, a student of dada, for his letter. Mme Dollie Pierre Chareau, for her translation of that letter, and of the poems by Pierre Albert-Birot. Max Ernst, for permission to quote from letters. Arp, for writing *Dada Was Not a Farce* for this volume, and for supplying illustrations by himself, his wife, and Max Ernst. Man Ray, for his brief note on his part in dada. Eugene Jolas, the editor of the old *Transition;* James Laughlin, the editor of *New Directions;* and the late Samuel Putnam, the editor (with others) of *European Caravan:* for quotations from the three principal sources in English of dada texts. Mr Bernard Reis, for permission to use plates from *VVV*. Joseph Cornell, for supplying the photograph of Professor Farago's dining room suite (1900). Rose Fried, for supplying photographs of Schwitters' works. Christian Zervos, the editor of *Cahiers d'art*, Paris, for texts and reproductions. Louise and Walter C. Arensberg, for reproductions.

But my chief thanks and warmest feelings go out to Bernard Karpel, librarian of the Museum of Modern Art, New York, for his remarkable bibliographical essay and bibliography at the end of this volume, as well as for innumerable occasions of help and encouragement; to Henry Aronson, of the same library, for making the list of illustra-

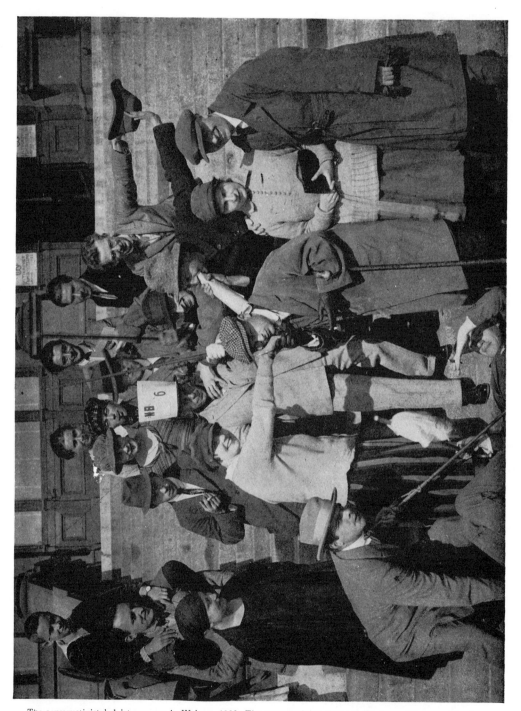

The constructivist-dadaist congress in Weimar, 1922: The constructivists living in Germany (Theo van Doesburg (1), El Lissitzki (7), Max Burchartz (6), Cornelius van Eesteren (8), Alfred Kemeny (9), Hans Richter (5) and myself (11), called a congress in October of 1922, in Weimar. Arriving there, to our great amazement we found also the dadaist, Hans Arp (4) and Tristan Tzara (3). This caused a rebellion against the host, Doesburg, because at that time we felt in dadaism a destructive and obsolete force in comparison with the new outlook of the constructivists. Doesburg, a powerful personality, quieted the storm and the guests were accepted to the dismay of the younger, purist members who slowly withdrew and let the congress turn into a dadaistic performance. At that time we did not realize that Doesburg himself was both a constructivist and dadaist writing dada poems under the pen name of I. K. Bonset. (No. (2) is Mrs. Nelly van Doesburg, No. (10) Lucia Moholy) from Vision In Motion by L. Moholy-Nagy, (*Paul Theobald Publisher*)

tions, table of contents, and the general index; and above all to the publishers, George Wittenborn and Heinz Schultz, whose devotion to publishing as a means of cultural expression and regard for modern art has led them, with modest resources and without outside help, stubbornly to carry out a program more fitted to a great institution—a museum or a university press. But none has been interested. This too is in line with the story of modern art.

★

It remains now to say what this anthology is, and what it is not. It is primarily an accumulation of raw material for students, the largest, so far as I know, under the covers of one book; there has been no effort at correlation, nor to deal with the numerous contradictions—I might add that the bibliographer and myself are not indebted, on the whole, to the dadas for accurate dates or reliable information about anyone but himself, that in every case this attitude has been justified as "being dada," with a shrug—though Duchamp alone claims still to be a dada. In the same spirit, I have been less discreet in the Introduction than normally. Secondly, though there is some effort in this anthology to indicate dada's literary ramifications, the volume is primarily concerned with visual works. Thus it must be remembered, in using the book, that dada, like surrealism, was probably more the work of poets than painters, however inspiring the cubist revolution in painting may have been to both, and that, like surrealism, dada's permanent effects have been on contemporary French literature, not on modern painting—though there is a real dada strain in the minds of the New York School of abstract painters that has emerged in the last decade; painters, many of whom were influenced by the presence of the Parisian surrealists in New York during the second world war. Thirdly, for various reasons—economic, editorial, and the limits of space—it has not been possible to make the anthology wholly complete, or always properly proportioned. But I think it would be unjust, in view of what it does present, to criticize the book seriously in regard to these details. I believe that it does succeed in its main objective, that it is not possible to read this book without a clearer image of dada forming in one's mind.

R.M.,
New York City
14 June 1951

Introduction

Once kick the world, and the world and you will live together at a reasonably good understanding. Jonathan Swift: *A Letter of Advice to a Young Poet,* 1 December 1720.

The main story of dada is self-explanatory in these pages; important histories are present, Buffet-Picabia's *Some Memories of Pre-Dada,* Huelsenbeck's *En Avant Dada,* Hugnet's *The Dada Spirit in Painting,* Schwitters' *Merz,* and Ribemont-Dessaignes' *History of Dada;* several chronologies, Aragon's *Project for a History of Contemporary Literature* and Tzara's *Zurich Chronicle (1915–19);* such memoirs as Hugo Ball's *How I Founded the Cabaret Voltaire,* Buffet-Picabia's *Arthur Cravan and America Dada,* Richter's *Dada. . . XYZ* and Schwitters' *Theo van Doesburg and Dada;* various manifestoes by Arp, Breton, Huelsenbeck, Picabia and Schwitters; satire by Arp, Cravan, Duchamp, Picabia and Satie; eulogies by Arp, Ball, Huelsenbeck and Tzara;

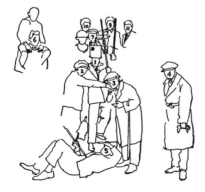

as well as poems, criticism and other material. Some of these accounts overlap, indeed one is sometimes reminded of those detective novels in which the principal event is described in turn by the various characters in the story. Still, there is less repetition than one might expect, just because different personalities, with unique emphases and often, it must be admitted, different interpretations are writing of what they themselves saw. The bibliography at the end of this book by Bernard Karpel gives a just idea of the other dada documents that are still extant. For the rest, I should like to incorporate in this preliminary note several points about this book, and some information about dada itself, that the general reader may find useful as he reads, and which has come into my hands as this anthology has slowly grown, almost by itself, far beyond its original modest plan.

The information in this introduction is for the most part what I have been able to find in reference to figures inadequately treated in the dada histories, e.g., Hausmann, Albert-Birot, Satie, Cravan, Hugo Ball, Schwitters, Vaché, Rigaut, Janco, Eggeling and Richter, among others, as well as more general subjects, such as the influence of Paul Valéry on the Parisian dadas, which has been beautifully described by Professor Raymond—and the problem raised by the *Dada Manifesto 1949.* That is to say, this introduction does not in the least represent an effort to give a balanced account of dada, but instead an effort to fill in some of the gaps—though many remain—left by existing dada texts.

Pre-dada

From the numerous proto-dada personalities, two were arbitrarily chosen to be represented in the pre-dada section, Arthur Cravan, the little known French poet and amateur boxer, and Erik Satie, the composer. Other proto-dadas, such as Duchamp and Picabia, are adequately represented in this book, as is Jacques Vaché; M. Levesque, a French student of dada, speaks further along in this introduction of Cendrars and Jarry; but there has not been room for the others, say Raymond Roussel or Max Stirner, to name two from a dozen names that come to mind,

Jack Johnson

Evidently the article on Arthur Cravan by Gabrielle Buffet-Picabia (formerly the wife of Francis Picabia) is the most complete telling of his strange story, since, so far as I know, there is no memoir by his widow, the poetess Mina Loy. That a French dada poet should have once entered the ring with Jack Johnson is unusual, and I add some further information not to be found in Mme. Buffet-Picabia's account. But first, in view of Cravan's future prize fight with Johnson (in Madrid in 1916), his sentence that begins, *"Everyone will understand that I prefer a big stupid St. Bernard to Mlle. Franfreluche,"* ending, *"a yellow man to a white man, a black man to a yellow man and a black boxer to a black student,"* ought to be cited from his review of the Independents' salon of 1914, as well as another sentence, "Arthur Cravan, *if he had not been going through a period of laziness, would have submitted a canvas entitled,* The World Champion at the Whorehouse." Cravan could not have even guessed in 1914 that one day he would have the chance to meet the negro champion in the ring.

Jack Johnson was, in 1916, European Champion, supporting himself by exhibition matches. Just as Cravan was in Spain en route to America, fleeing the European war, so Johnson was a fugitive in Spain, for violation of the Mann Act, which regulates *"interstate and foreign commerce by prohibiting the transportation therein of women and girls for immoral purposes."* Johnson had never concealed his contempt for his inferior white opponents, nor restrained himself, when the impulse took him, from consorting with white women. Consequently American society delighted in catching him on the Mann Act. Johnson apparently threw the world championship to white Jess Willard, in Havana, in 1915—the fight was meant to be held in Mexico, but everyone was afraid, despite his being promised a 'cut,' of the intervention of Pancho Villa—in the hope that, as a consequence of Johnson's defeat, the charges against him on the Mann Act would

be dropped; but ultimately he had to serve out his sentence in Leavenworth prison; in 1919 Johnson crossed over from Mexico to give himself up. Arthur Cravan had disappeared in Mexico forever the year before.

Erik Satie

Erik Satie, the great composer, earned the rent for his unheated room in an ugly Paris suburb by playing the piano in a Montmartre cabaret called *The Harvest Moon.* In 1915 he was chosen by Diaghilev to write the music for the ballet *Parade* (in collaboration with Jean Cocteau, Massine, Picasso); later he wrote the music for a ballet with *décor* by Picabia, as well as the music for the film directed by René Clair, after a scenario by Picabia, *Entr'-Acte.* Satie is the author of a dada play, *Le Piège de Meduse,* which was illustrated in book form by Braque; his musical masterpiece is *Socrates,* 1919, to the three dialogues by Plato. He was always extremely poor, which is not without interest in relation to his remark about how he *"made all his money."*

I am glad to be able to add an unpublished note written about Satie by John Cage, the young American atonal composer; it is entitled, (*unfortunate comment on our musical 'life,' that everybody's interested in*):

"Satie has long been recognized as the Maître d'Arcueil, *the leader of* Les Six. *It seems to me, however, that he has never been a leader, since no one has followed him (certainly no one among* Les Six). *It is thought now that Virgil Thomson is a Satieist; however, Thomson's work, in the most profound sense, lies in the area of form (expression, content), whereas, Satie bases everything on structure (the divisibility of a composition into parts, large and small). The two are certainly connected by dada, but one would not be giving dada proper consideration, drawing parallels by means of it. It is important with Satie not to be put off by his surface (by turns mystical, cabaretish, Kleeish, Mondrianish; full of mirth, the erotic, the wondrous, all the white emotions, even the heroic, and always tranquillity, expressed more often than not by means of cliché-juxtaposition). The basis of his music that no one bothered to imitate was its structure by means of related lengths of time. Think of Satie as interchangeable with Webern (you'll be somewhere near the truth)."*

★

I quote now from the section called *Erik Satie and his Musique d'ameublement* in Constant Lambert's *Music Ho!* (London, 1934, rev. ed., 1937):

"Satie is looked upon in this country [England] *as a farceur and an incompetent dilettante. Before examining his work, then, it is perhaps necessary to point out that in spite of his verbal wit, and his many blagues and cocasseries, no composer, not even Debussy, took a more essentially serious view of his art. As for*

his being incompetent, we have it on the eminent authority of Albert Roussel from whom he took lessons, 'Il n'avait rien à apprendre . . . Il était prodigieusement musicien,' while far from working in a careless and dilettante manner few composers have devoted such unceasing labor to the revision and remolding of phrases and the perfection of detail—for instance, the limpid opening bars of Socrate *are preceded in his notebooks by six alternative and rejected versions . . .*

"Few people know his works, but most people have heard of his remark, 'Monsieur Ravel has refused the Legion of Honor but all his music accepts it,' *or of the occasion when he went up to Debussy after a rehearsal of the first movement of* La Mer (De l'aube à midi sur la mer) *and said he liked it all, but particularly the little bit at a quarter to eleven.*
. .

"Though written in Satie's most serious vein, Socrate *has a certain affinity with his most flippant pieces, the* Musique d'ameublement, *which, though of no intrinsic importance, throw an interesting sidelight on his outlook on music. He felt that the entr'acte between two parts of a concert provided too great a break in the general atmosphere, and that music should be played in the foyer, to which music, however, people would pay no more concentrated attention than they would to the furniture or carpet. He accordingly wrote a ludicrous set of pieces for piano duet, bass trombone, and small clarinet in which themes from* Mignon *and* Danse Macabre *were mingled with his own. The players were put in different parts of the room and the short pieces were played over and over again, it being hoped that the audience would not listen but talk, move about and order drinks. Unfortunately, the moment the placard* Musique d'ameublement ['furniture-set music'] *was put up, the audience stopped talking and listened as solemnly as if at the opera until, at the thirtieth repetition of one of the furniture pieces, Satie, exasperated beyond reason by this uncalled-for respect, dashed furiously around the foyer shouting: 'Parlez! Parlez! Parlez!' "*

★

"Everyone will tell you that I am not a musician." The music Satie wrote for *Parade* (in collaboration with Cocteau, Massine and Picasso) in 1915 was severely criticized by André Breton and other dadas. (In New York, during the second world war, Breton told me that surrealism was against music, that if I asked why, he would reply, *"Because . . ."*)

Duchamp and Picabia

In regard to the illustrations in the pre-dada section, Duchamp's *Bottle Rack* is the perfect example of the new spirit. The Picabia is included on Duchamp's specific suggestion. The other works reproduced are not meant as predada, but as examples of genuinely interesting work of the period: abstract art, for the most part, which was ultimately to be charged by

dada with 'formalism,' though in the beginning what dada meant by the 'new'.

★

Hugnet describes the Picabia reproduced as follows: *"And so Picabia, from 1915 on, rejected the new forms that art was assuming, and tried to free himself, witness his pictures of the so-called Orphic period, among others, conceived to an anti-static pictorial law, by which time and memory attempt to transpose their progress into color."*

★

Duchamp's *Bottle Rack* (1914), a mass-produced utilitarian object, was his first 'readymade', that is, a manufactured commercial object from everyday life that he selected and exhibited under his own name, conferring on it the status of 'sculpture,' an anti-art and consequently dada gesture; it is evident, thirty-five years later, that the bottle rack he chose has a more beautiful form than almost anything made, in 1914, as sculpture.

It is also a subtle solution to an essential dada dilemma, how to express oneself without art when all means of expression are potentially artistic.

Dada in Zurich: Huelsenbeck

The origins of dada as a historical movement are variously attributed—to the arrival in neutral Zurich, Switzerland, of young intellectuals from all over warring Europe, to the visit to New York of Cravan, Duchamp, Picabia and others, to the meeting in Nantes of Jacques Vaché and André Breton—all events taking place in 1915 or 1916, bloody years in the first world war.

The present anthology begins with Huelsenbeck's brilliant history of the dada movement, its role in Zurich and Germany. The background of the war is sufficiently emphasized by Huelsenbeck. It might be well to add something about the locale, Zurich, substantial, old, well-to-do, a university town, perhaps not too different in felt tone from Cambridge, Massachusetts or New Haven, Connecticut:

"Zurich, the capital of the Swiss canton of the same name (Fr. Zurich; Ital. Zurigoe; Lat. Turicum). It is the most populous, the most important and on the whole the finest town in Switzerland and till 1848 was practically the capital of the Swiss Confederation. In 1920 it had 207,161 inhabitants . . . 134,580 were Protestants, 60,116 Roman Catholics, and 6,662 Jews, while 191,234 were German-speaking, 4,641 French-speaking, 7,160 Italian-speaking, and 600 Romansh-speaking.

" . . . The town is noted for numerous clubs and societies and is the intellectual capital of German-speaking Switzerland. The University of Zurich has students of many nations . . . It was opened in 1833, no doubt as a successor to the ancient chapter school at the Gross Munster, said to date back to Charlemagne's

time, and hence called the Carolinum, which was re-organized during the reformation, and suppressed in 1832. The Federal Polytechnic School, opened in 1855, is one of the best known institutions of its type and has over 1,500 students. Near it is the observatory (1,542 ft.). There are excellent primary and secondary schools, and many institutions for special branches of education, e.g., music, silk-weaving, etc.

"The position of Zurich as a meeting-point of international trade gives it a cosmopolitan character. Cotton spinning, furniture-making, the manufacture of machinery, the electrical industry and the silk industry are leading activities. The silk-weaving industry flourished in Zurich in the 12th and 13th centuries, but disappeared about 1420; it was revived by the Protestant exiles from Locarno (1555) and by the Huguenot refugees from France (1682 and 1685). Zurich is the banking centre of Switzerland" (Encyclopaedia Britannica, 14th ed.).

★

It was the sons of the Zurich bourgeoisie, the university students, who used to go to the Cabaret Voltaire, a beer parlor. Hugo Ball, the German poet who ran it, improvised entertainment to draw trade, playing the piano himself, while Huelsenbeck, a young German student of medicine, who was against the war, danced pseudo-African dances in black-face. In looking for a stage name for a singer whom they wanted to hire—a young woman who never returned—they are said to have found, in a French-German dictionary, the word 'dada', which is French baby-talk for anything to do with horses. The dictionary was at hand because Ball was writing a learned history. One cannot but wonder whether the young Zurich students had any sense of who was entertaining them along with their beers. One might say that the public history of modern art is the story of conventional people not knowing what they are dealing with.

★

The protest of dada in Zurich against the war is touching; a few sensitive and intelligent men, hardly more than boys, insisting on the sense of shame that all of Europe ought to have admitted. The dada movement was an organized insulting of European civilization by its middle-class young. A healthy feeling that gave a new vitality to European painting by everyone who felt it, dada or not.

★

Lenin was in exile in Zurich during the dada days. Oddly enough, he is rarely mentioned in this anthology, despite its rebellious texts. Marcu, a young Roumanian (as were Janco and Tzara), has left us a memoir:

"When we left the restaurant, it was late in the afternoon. I walked home with Lenin.

"'You see,' he said, 'why I take my meals here. You get to know what people are really talking about. Nadezhda Konstantinovna is sure that only the Zurich underworld frequents this place, but I think she is mistaken. To be sure, Maria is a prostitute. But she does not like her trade. She has a large family to support—and that is no easy matter. As to Frau Prellog, she is perfectly right. Did you hear what she said? Shoot all the officers! . . .'

. .

"'Do you know the real meaning of this war?'

"'What is it?' I asked.

"'It is obvious,' he replied. 'One slaveholder, Germany, who owns one hundred slaves, is fighting another slaveholder, England, who owns two hundred slaves, for a "fairer" distribution of the slaves.'

"'How can you expect to foster hatred of this war,' I asked at this point, 'if you are not, in principle, against all wars? I thought that as a Bolshevik you were really a radical thinker and refused to make any compromise with the idea of war. But by recognizing the validity of some wars, you open the doors for every opportunity. Every group can find some justification of the particular war of which it approves. I see that we young people can only count on ourselves . . .'

"Lenin listened attentively, his head bent toward me. He moved his chair closer to mine . . . Lenin must have wondered whether he should continue to talk with this boy or not. I, somewhat awkwardly, remained silent.

"'Your determination to rely upon yourselves,' Lenin finally replied, 'is very important. Every man must rely upon himself. Yet he should also listen to what informed people have to say. I don't know how radical you are or how radical I am. I am certainly not radical enough. One can never be radical enough; that is, one must always try to be as radical as reality itself . . .'"

★

Zurich was, in those days, as it is now the home of Dr. Jung and of the so-called Zurich school of psycho-analysts. Huelsenbeck himself is now a Jungian psycho-analyst, practicing in New York City, under the name of Charles R. Hulbeck.

★

"The appropriation by dada of these three principles, bruitism, simultaneity, and, in painting, the new medium [collage], is of course the 'accident' leading to psychological factors to which the real dadaist movement owed its existence."

This statement by Huelsenbeck, is one of the few attempts that have been made, and it only in passing, to formulate the nature of dada in terms of its own expressive means.

Hugo Ball, Hennings, Janco

The fragments in this anthology from Hugo Ball's Flight From Time (1927) are too brief

to give an adequate idea of the beauty of his book. In 1917, some time after he founded the Cabaret Voltaire, he went to Berne, Switzerland, where he helped to edit an anti-Kaiser weekly. By the time of Ball's death, in 1927, he had become an ardent Roman Catholic, almost a "holy man," greatly admired by the natives of the Swiss province in which he lived, and had made a pilgrimage to Rome. Yet it was he who had named his cabaret the 'Voltaire.'

A translation follows of the facsimile text by Hugo Ball on page 30 (the portraits thereon of Ball and his wife, Emmy Hennings, are by Marcel Janco):

"When I started the Cabaret Voltaire, I was sure that there must be other young men in Switzerland who, like myself, wanted not only to enjoy their independence, but also to give proof of it.

"I went to Mr. Ephraim, the owner of the Meierei, and said to him: 'I beg you, Mr. Ephraim, please let me use your place. I should like to start an artists' cabaret.' We came to terms, and Mr. Ephraim gave me the use of his place. I went to some of my acquaintances. 'Please give me a picture, a drawing, an etching. I should like to have a little exhibition in connection with my cabaret.' To the friendly Zurich press, I said: 'Help me, I want to start an international cabaret; we'll do some wonderful things.' I was given the pictures, the press releases were published. So we had a cabaret show on February 5th [1915]. Mme. Hennings and Mme. Leconte sang, in French and Danish. Mr. Tristan Tzara read some of his Roumanian poetry. A balalaika orchestra played popular tunes and Russian dances.

"I got a great deal of support and sympathy from Mr. Slodki, who made the cabaret poster, and from Mr. Arp, who loaned me some original works of art, Picasso etchings, and some pictures by his friends, O. van Rees and Artur Segal. A lot more support from Mr. Tristan Tzara, Mr. Marcel Janco and Mr. Max Oppenheimer, who all appeared many times on the stage. We organized a Russian evening, then a French one (during which works by Apollinaire, Max Jacob, André Salmon, Jarry, Laforgue and Rimbaud were read). Richard Huelsenbeck arrived from Berlin on February 26th, and on March 30th we played two admirable negro chants (always with one big drum: boom boom boom boom drabatja mo gere, drabatja mo booooooooooooo); Mr. Laban helped and was amazed. And (on the initiative of Mr. Tristan Tzara) Mr. Huelsenbeck, Mr. Janco and Mr. Tzara recited (for the first time in Zurich and in the whole world) the simultaneous verses of Mr. Henri Barzun and Mr. Fernand Divoire, and a simultaneous poem of their own composition, which is printed on pages 6 and 7 of the present booklet [cf. facsimile, p. 30]. Today, and with the help of our friends from France, Italy and Russia, we are publishing this little booklet. It is necessary to define the activity of this cabaret; its aim is to remind the world that there are independent men—beyond war and Nationalism—who live for other ideals.

"The intention of the artists here assembled is to publish an international review. The review will appear in Zurich. and will be called, DADA Dada Dada Dada Dada."

★

Of equal interest is Ball's account of his 'sound poems' read at the Cabaret Voltaire; it too appears in his *Flight From Time* and the following fragment was translated by Eugene Jolas (*Transition*, no. 25):

"I invented a new species of verse, 'verse without words,' or sound poems, in which the balancing of the vowels is gauged and distributed only to the value of the initial line. The first of these I recited tonight [1915]. I had a special costume designed for it. My legs were covered with a cothurnus of luminous blue cardboard, which reached up to my hips so that I looked like an obelisk. Above that I wore a huge cardboard collar that was scarlet inside and gold outside. This was fastened at the throat in such a manner that I was able to move it like wings by raising and dropping my elbows. In addition I wore a high top hat striped with blue and white. I recited the following:

gadji beri bimba
glandridi lauli lonni cadori
gadjama bim beri glassala
glandridi glassala tuffm i zimbrabim
blassa galassasa tuffm i zimbrabim . . .

The accents became heavier, the expression increased an intensification of the consonants. I soon noticed that my means of expression (if I wanted to remain serious, which I did at any cost), was not adequate to the pomp of my stage-setting. I feared failure and so concentrated intensely. Standing to the right of the music, I recited Labada's Chant to the Clouds, *then to the left,* The Elephant Caravan. *Now I turned again to the lectern in the center, beating industriously with my wings. The heavy vowel lines and slouching rhythm of the elephants had just permitted me to attain an ultimate climax. But how to end up? I now noticed that my voice, which seemed to have no other choice, had assumed the age-old cadence of the sacerdotal lamentation, like the chanting of the mass that wails through the Catholic churches of both the Occident and the Orient.*

"I don't know what inspired me to use this music, but I began to sing my vowel lines recitatively, in the style of the church, and I tried to remain not only serious but also to force myself to be grave. For a moment it seemed as if, in my cubist mask, there emerged a pale, disturbed youth's face, that half-frightened, half-curious face of the ten-year-old lad hanging trembling and avid on the lips of the priest in the funeral masses and high masses of his parish. At that moment the electric light went out, as I had intended, and I was carried, moist with perspiration, like a magical

bishop, into the abyss. Before the words, I had read a few programmatic words:

"With these sound poems we should renounce the language devastated and made impossible by journalism.

"We should withdraw into the innermost alchemy of the word, and even surrender the word, in this way conserving for poetry its most sacred domain. We should stop making poems second-hand; we should no longer take over words (not even to speak of sentences) which we did not invent absolutely anew, for our own use. We should no longer be content to achieve poetic effects with means which, in the final analysis, are but the echoes of inspiration, or simply surreptitiously proffered arrangements of an opulence in cerebral and imagistic values."

★

Hans Richter wrote me of the death of Hugo Ball's wife, Emmy Hennings, as follows [cf. facsimile, p. 290]:

"I wish to make a correction—a sad one—in my short essay about the dada people. Emmy Hennings died in Magliaso (Tesson) in a small room above a grocery store in August 1949 [sic]. In order to make a living (to survive) she had to work during the day in a factory.—We had not heard from her since years.—Arp told me that he saw her in Lugano 1½ years ago."

Since Richter's letter is dated January 26, 1949, the date of Emmy Hennings' death is evidently 1948.

★

Richard Huelsenbeck kindly supplied (1950) the following note on Marcel Janco, the Roumanian artist who painted the *Cabaret Voltaire:*

"When I had entered the place called Cabaret Voltaire, I saw many people sitting behind round tables, drinking beer, yelling about something that I couldn't understand. Through the cigarette smoke that hung in big clouds above the head of the audience I finally saw Hugo Ball and Emmy Hennings, the owners and founders of the Cabaret. Ball came over to me and introduced me to a little man wearing a monocle and throwing shrewd glances left and right. This was Tzara. Tzara turned around and introduced me to a man much taller than himself. 'This is my friend, Marcel Janco,' he said.

"Janco was a tall, friendly man from Roumania. He had an easy smile, and would talk to you about everything, and discuss with you any question of the universe, from morning to night, or from night to morning. We would sit in the Baserbas, a Spanish restaurant, and rant about the misery of the war. Or we would take a row-boat, sometimes with girls, sometimes without, and discuss abstract art. Janco was a young architect, deeply in love with the revolution in art that had begun with cubism and that was then throwing its lightning from the Futurists' camp in Italy.

"Janco was as good in discussion as in rowing, as in love, as in everything. He did all the

decorations of the Cabaret; he painted the pictures, made the exotic looking masks, and talked the hesitant proprietor (who had never seen anything like it) into accepting and even hanging modern posters.

"Janco danced, recited and showed his art in the Cabaret Voltaire. I see him today as one of the great pioneers of our movement, a man with many talents but without arrogance, always helpful and never interfering with other persons' ambitions. But the best of him was, and still is, his warmth, his affection for his friends, his loyalty to Dadaism, which he understood deeply and profoundly."

★

Arp has written of Janco as follows in his volume of poems and prose in the Documents of Modern Art, *On My Way* (N.Y., 1948):

"Secretly, in his little room, Janco devoted himself to a 'naturalism in zigzag.' I forgive him this secret vice because in one of his paintings he evoked and commemorated the 'Cabaret Voltaire'. On a platform in an overcrowded room, splotched with color, are seated several fantastic characters who are supposed to represent Tzara, Janco, Ball, Huelsenbeck, Madame Hennings and your humble servant. We are putting on one of our big Sabbaths. The people around us are shouting, laughing, gesticulating. We reply with sighs of love, salvos of hiccups, poems, and the bow-wows and meows of medieval bruitists. Tzara makes his bottom jump like the belly of an oriental dancer. Janco plays an invisible violin and bows down to the ground. Madame Hennings with a face like a madonna attempts a split. Huelsenbeck keeps pounding on a big drum, while Ball, pale as a plaster dummy, accompanies him on the piano. The honorific title of nihilists was bestowed on us. The directors of public cretinization conferred this name on all those who did not follow in their path.

. .

"Are you still singing that diabolical song about the mill at Hirza-Pirza, shaking your gypsy curls with wild laughter, my dear Janco? I haven't forgotten the masks you used to make for our Dada demonstrations. They were terrifying, most of them daubed with bloody red. Out of cardboard, paper, horsehair, wire and cloth, you made your languorous foetuses, your Lesbian sardines, your ecstatic mice. In 1917 Janco did some abstract works that have grown in importance ever since. He was a passionate man with faith in the evolution of art."

★

From a letter in French by Marcel Janco to Hans Richter, dated 10 March 1950, Tel Aviv (Israel):

"You are not any younger, but believe me, I am also 'a bit' changed. Having fled Europe, I hoped to find a 'Tahiti' like Gauguin for my painting, but I was mistaken, because the climate here is difficult and one works savagely in order to exist. . . . With my peregrinations and migrations during 12 years, I have lost all international contacts. On the other

hand, I believe that my painting, for which I have sacrificed everything, as for a true mistress, has kept all its force. It is true that not always have I painted abstractly, because I believe that one must also say something, but, without being deformist or expressionist, my painting is oriented towards a strong expression, like you find in folk art. I believe that at bottom I am still very close to 'dada', to the true dada which at bottom always defended the forces of creation, instinctive and fresh, colored by the popular art that one finds in all peoples. I do not like anymore the literary mystifications of the Surrealists, and Arp always pleased me with his purity and the instinctiveness of his abstractions, which are not dry outmoded mathematical complications, but on the contrary always filled with some spiritual associations. . . . A group retrospective exhibition, with Klee, Arp, Richter, Calder, Eggeling, Janco, Hulbeck, Man Ray, Ernst and others, would still be an event in Paris in 1950 or 1951. What do you think? Could we not throw a little light with such an exhibition on the development of the art to come in order to prevent a fall into the gulf of 'social realism'? I think that the problems that we posed in 1917–1919 are still not resolved. . . . Is it true that in America there is also a tendency toward that miserable 'realism'?"

Schwitters and Merz

In terms of ultimate accomplishment, the important dada painters were Arp, Marcel Duchamp, Max Ernst, Francis Picabia and Kurt Schwitters—that is, apart from George Grosz, who now prefers to forget his part in the movement. Schwitters, an eccentric, sincere, humorous man, who gathered from the débris of the streets the materials for his collages, has been commonly underestimated. "In order to achieve insight, you must work" is not a sentiment that the dadas would have found especially sympathetic. Schwitters seems to have called his version of dada 'merz' in order to preserve his independence. He was against past art, not because it was art, but because it was *past*, and we see now, so many years later, that his work of the period, like that of the best dada painters, is at home in an exhibition of 'abstract' art, that the dada painters' 'anti-structure' position in their search for the 'new' itself produced a new structure not unrelated to the new structure of the 'abstract' painters, that the dada painters were never able to reduce themselves to mere sensation or social activity, as many of the writers were able to do. It is as though the desire to shake off structure and the search for new structure had to arrive at the same place, because in both cases the means had to be the same, rejection of traditional modes of composition. The nature of Schwitters' work changed hardly at all up to the day of his death in 1947; it never lost its freshness, unpretentiousness, nor perfection of scale.

The last two plates in Mr. Barr's *Fantastic Art, Dada, Surrealism* are photographs of the *Merzbau*, representing a series of strange 'grottos' built by Schwitters in the rear of his house in Hanover.* Yet he once came to Mies van der Rohe's Berlin office and said to the renowned abstract architect, "I know you think I am insane, but let's do a book on architecture together."

★

In George Grosz's recent autobiography, *A Little Yes and a Big No* (N.Y., 1946) there is an unfriendly account of Schwitters, as well as of Johannes Baader, the latter of whom Grosz regards as mad; Grosz asserts that the meaning of 'merz' is garbage, and that consequently Schwitters' 'merz' pictures and 'merz' poems are 'garbage' pictures and 'garbage' poems; this is not out of accord with Schwitters' strange but touching habit of collecting everything he found as he walked along the street; but it must be remembered that the word 'merz' is a neologism, invented by Schwitters. Sibyl Moholy-Nagy, in her biography of her husband (N.Y., 1950), gives the following account of Schwitters' invention of the word: "*The name was accidental and came from the four central letters of the word 'komMERZiell,' which appeared on a scrap of newspaper in one of the MERZ collages.*"

★

Mies van der Rohe tells that once Schwitters was on a train, carrying great roots from trees with him. Someone asked him what the roots were, and he replied that they constituted a cathedral. "*But that is no cathedral, that is only wood!*" the stranger exclaimed. "*But don't you know that cathedrals are made out of wood?*" Schwitters replied.

★

Moholy-Nagy writes, in *Vision in Motion* (Chicago, 1947), of Schwitters' extremely popular poem, *Anna Blossom Has Wheels* ["Anna Blume"] (1919), "*At first reading the poem seems to be only double-talk. In reality, it is a penetrating satire of obsolete love poems.*" Here is the poem, which became famous in Germany, translated by Mrs. K. Klein:

Anna Blossom Has Wheels
(Merz poem No. 1)

Oh thou, beloved of my twentyseven senses, I love thine!
Thou thee thee thine. I thine, thou mine.
—We?
That belongs (on the side) not here.

* The Museum of Modern Art, New York, financed the rebuilding of them in his house in England, left unfinished at his death.

Who are thou, uncounted woman? Thou art—
art
thou?—People say, thou werst,—let them
say, they don't know, how the church tower
stands.
Thou wearest thy hat on thy feet and wanderst
on
your hands, on thy hands wanderst thou.
Hallo thy red dress, clashed in white folds.
Red I
love Anna Blossom, red I love thine! Thou thee
thee thine, I thine, thou mine.—We?—
That belongs (on the side) in the cold glow.
Red Blossom, red Anna Blossom, how say (the)
people?
Prize question:
1. Anna Blossom has wheels.
2. Anna Blossom is red.
3. What color are the wheels?
Blue is the color of thy yellow hair.
Red is the whirl of thy green wheels.
Thou simple maiden in everyday-dress, thou
dear
green animal, I love thine!—Thou thee thee
thine,
I thine, thou mine.—We?—
That belongs (on the side) in the glowbox.
Anna Blossom! Anna, A-N-N-A, I trickle thy
name. Thy name drips like soft tallow.
Dost thou know Anna, dost thou already know
it?
One can also read thee from behind, and thou,
thou
most glorious of all, thou art from the back, as
from the front: A-N-N-A.
Tallow trickles to strike over my back.
Anna Blossom, thou drippes animal, I love
thine!

★

Josef Albers, the abstract painter, tells that Schwitters used to listen to the conversations of women on street-cars and trains, and to the sentimental popular songs liked by servants and working girls, and that many of his writings were based on what he heard on these occasions, filled with parodies and puns. Albers also remembers with a smile a story Schwitters used to tell about a parrot that had a hernia; but he cannot remember the details.

★

Moholy-Nagy writes that without *"trying to define Schwitters' peculiar poetic quality, it can be said that most of his writing is emotional purgation, an outburst of subconscious pandemonium. But they are fused with external reality, with the existing social status. His verbal 'collages' are good examples of this. There the current of his thoughts is mixed with seemingly random quotations from newspapers, catalogues and advertising copy. With this technique—like Gertrude Stein—he uncovers symptoms of social decay known to all, but neglected or dodged in a kind of self-defense. The scene is Germany. Inflation after the war; corruption, waste, damage to material and man. An abortive social revolution makes the situation even more hopeless. Schwitters' writ-*

ings of that time end with a desperate and at the same time challenging cry.
"In one of his demonstrations, he showed to the audience a poem containing only one letter on a sheet [1924]:

Then he started to 'recite' it with slowly rising voice. The consonant varied from a whisper to the sound of a wailing siren till at the end he barked with a shockingly loud tone. This was his answer not alone to the social situation but also to the degrading 'cherry-mouthed'—'raven-haired'—'babbling-brook'—poetry.
"The only possible solution seemed to be a return to the elements of poetry, to noise and articulated sound, which are fundamental to all languages. Schwitters realized the prophecy of Rimbaud, inventing words 'accessible to all five senses'. His Ursonata *(1924) ['Primordial Sonata'] is a poem of thirty-five minutes duration, containing four movements, a prelude, and a cadenza in the fourth movement. The words used do not exist, rather they might exist in any language; they have no logical, only an emotional context; they affect the ear with their phonetic vibrations like music. Surprise and pleasure are derived from the structure and the inventive combination of the parts."*

★

Mies van der Rohe says that Schwitters was extremely disturbed when Mies pointed out that one of his 'sounds' was identical in sound with the Roumanian word for 'Schnapps'—Schwitters was distressed at any possibility of denotative reference to the world. Hausmann claims to have originated the idea of 'sound poems' as we shall see; we have already seen the evidence that neither he nor Schwitters, but Hugo Ball did. In any case, it is a pity that Schwitters's *Ursonata* is not brought into print again; it is beautiful to look at, and shows an extraordinarily exact and complicated structural sense. Schwitters simple sound poem called *priimiititittiii* follows (*Transition*, no. 3):

priimiititittiii	tisch
tesch	
priimiititittiii	tesch
tusch	
priimiititittiii	tischa
tescho	
priimiititittiii	tescho
tuschi	

priimiitittiii
priimiitittiii
priimiitittiii too
priimiitittiii taa
priimiitittiii too
priimiitittiii taa
priimiitittiii tootaa
priimiitittiii tootaa
priimiitittiii tuutaa
priimiitittiii tuutaa
priimiitittiii tuutaatoo
priimiitittiii tuutaatoo
priimiitittiii tuutaatoo
priimiitittiii tuutaatoo

★

The following is from a letter by the artist's only living relative, his son Ernst (Oslo, Norway, 26 August 1948):

"One thing, however, is incorrect in Mr. Huelsenbeck's statement,[1] at least as far as my father is concerned: for Kurt Schwitters political tendencies of any kind in art have always been and remained anathema.—As late as during the latter part of the war, my father resisted the so-called 'Deutscher Kulturbund', an association of refugee artists in England [where Kurt Schwitters spent the second world war], because of their definite political tendencies. He rather suffered their hatred, which, as is well enough known, in the case of political agents, may be very injurious, indeed, [rather] than yield to their view. My father remained faithful to his principle, as expressed in this very article [Merz; cf. p. 60] by the sentence: 'As a matter of principle, Merz aims only at art, because no man can serve two masters.' Consequently it would be unjust and give a wrong picture of Kurt Schwitters if any of his thoughts in this connection would be omitted."

★

Finally I add a long quotation from *Moholy-Nagy* by his wife Sibyl:

"The following night the German Press Association gave a banquet for the Italians, to which we had received a personal invitation from Marinetti. Moholy was unwilling to go. He had been shadowed by the SS; his refusal to submit his paintings to the censorship of the National Socialist Art Chamber to obtain a 'working permit' had been followed by threats of arrest. His cleaning woman had stolen his mail and had delivered it to the Blockwart (political district warden), and some of his associates had disappeared mysteriously. He was done with Germany, and on his last night in Berlin he didn't feel like sitting down with the new rulers. But Kurt Schwitters, who was our house guest at the time, insisted on going, to honor the revolutionary in Marinetti, and he finally persuaded Moholy to join him.

"Kurt was profoundly worried about the political tide. His rebellious days were over. At forty-six he wanted to be left unmolested,

[1] Asking that Schwitters' attacks on him in the article *Merz*, in this volume, be deleted.

enjoying a secure income from his real estate and his typographical work, and puttering away on his gigantic MERZ plastic, a sculpture of compound forms which extended from a corner of his studio through two stories of his house, winding in and out of doors and windows, and curling around a chimney on the roof. There was nothing he dreaded more than emigration. He died a broken man in England in 1948. [sic]

"The banquet offered a very different picture from the lecture the night before and confirmed all of Moholy's misgivings. Short of Hitler, all the Nazis were present: Goebbels and Goring, August Wilhelm of Hohenzollern, the president of the Berlin University, Gerhart Hauptmann, once the torchbearer of revolution but now a chipped plaster image of Goethe. Hess was there, and with him was fat Röhm, whose days were already numbered. These officials were sitting along a huge horseshoe table, while Nazi underlings and the artists whom Marinetti had insisted upon inviting sat at individual tables. Moholy, Schwitters, and I were sandwiched between the head of the National Socialist Organization for Folk Culture, and the leader of the 'Strength Through Joy' movement. The disharmony between the guests was accentuated by the absence of speeches and an unlimited consumption of excellent German Rhine wine. Moholy was silent. His face was shuttered, and when our eyes met I saw that he was full of resentment. The more Schwitters drank, the more fondly he regarded his neighbor.

" 'I love you, you Cultural Folk and Joy,' he said. 'Honestly, I love you. You think I'm not worthy of sharing your chamber, your art chamber for strength and folk, ha? I'm an idiot too, and I can prove it.'

"Moholy put his hand firmly on Schwitters' arm and for a few minutes he was silent, drinking rapidly and searching the blank face of his neighbor with wild blue eyes.

" 'You think I'm a Dadaist, don't you,' he suddenly started again. 'That's where you're wrong, brother. I'm MERZ.' He thumped his wrinkled dress shirt near his heart. 'I'm Aryan —the great Aryan MERZ. I can think Aryan, paint Aryan, spit Aryan.

"He held an unsteady fist before the man's nose. 'With this Aryan fist I shall destroy the mistakes of my youth'—'If you want me to,' he added in a whisper after a long sip.

"There was no reaction at all from the 'Strength Through Joy' man while the official from the Folk Culture Organization nodded droolingly, his round cheeks puffed up with wine and amazement. Schwitters took a sudden liking to him.

" 'Oh joyful babyface,' he muttered, tears running down his cheeks. 'You will not prohibit me from MERZing my MERZ art?'

"The word 'prohibit' had finally penetrated the foggy brain of the 'Strength Through Joy' man.

" 'Prohibited is prohibited [Verboten ist verboten],' he said with great firmness and a heavy tongue. 'And when the Führer says "Ja" he says "Ja" and when the Führer says "Nein" he says "Nein." Heil Hitler!'

"*Schwitters looked wildly at Moholy, at me, at Marinetti, but before he could incite anyone to action, Marinetti had risen from his chair. He swayed considerably and his face was purple.*

"*'My friends,' he said in French. 'After the many excellent speeches tonight'—the silent officials winced—'I feel the urge to thank the great, courageous, high-spirited people of Berlin. I shall recite my poem "The Raid on Adrianople."* '

"*There was polite applause. Some nice poetry would break the embarrassing dullness of the dinner.*

"Adrianople est cerné de toutes parts SSSSrrrr zitzitzitzitzi PAAAAAAAAAAgh rrrrrrrrrrrrrr

roared Marinetti.

"Ouah ouah ouah, départ des trains suicides, ouah ouah ouah.

The audience gasped; a few hus'ied giggles were audible.

"Tchip tchip tchip—féééééééééééééééééé-élez!

He grabbed a wineglass and smashed it to the floor.

"Tchip tchip tchip——des messages télégraphiques, couturières Americaines Piiiiiiiiiiiiiiing, sssssssssrrrrrrrr, zitzitzit toum toum Patrouille tapie——

Marinetti threw himself over the table.

"Vanitéeeee, viande congeléeeeeeee——veilleuse de La Madone.

expiring almost as a whisper from his lips.
"*Slowly he slid to the floor, his clenched fingers pulling the tablecloth downward, wine, food, plates, and silverware pouring into the laps of the notables.*
"*Schwitters had jumped up at the first sound of the poem. Like a horse at a familiar sound the Dadaist in him responded to the signal. His face flushed, his mouth open, he followed each of Marinetti's moves with his own body. In the momentary silence that followed the climax his eyes met Moholy's.*
" *'Oh, Anna Blume,' he whispered, and suddenly breaking out into a roar that drowned the din of protesting voices and scraping chair legs, he thundered:*
"Oh, Anna Blume
 Du bist von hinten wie von vorn
 A-n-n-a."

Jacques Vaché

"*The* Surréalistes *have their own Isadore Ducasse, or the 'Comte de Lautréamont,' while the Dadaists—and the* Surréalistes *as well, as a matter of fact—may trace their descent from the picturesque Jacques Vaché . . . The line of descent, indeed, is very clear:* Symbolism; Cubism; Futurism; poésie pure; Dadaism; Super-realism [Surrealism]. . . . *Dada really started in 1916, at a time when what is known as civilization seemed to have degenerated into a world-farce; it may be said to have started with the meeting of André Breton and that despairing dandy, Jacques*

Vaché, in a military hospital at Nantes . . ." (Putnam: op. cit.).

"*André Breton, mobilized as an interne at the neurological center, met at the hospital a very curious wounded soldier. The latter was a very large and elegant-appearing young man with red hair, a former École des Beaux-Arts pupil, who was, moreover, an utter idler, but a systematic one. His sole concern seemed to be to introduce into real life a little of that humorous fantasy which ordinarily is only to be found in Mark Twain's stories or in insane asylums . . . He never said good morning nor good evening nor good-bye and never took any notice of letters . . . He did not recognize his best friends from one day to another. He lived with a young woman whom he obliged to remain motionless and silent in a corner while he was entertaining a friend, and whose hand he merely kissed with an ineffable dignity, when she served the tea. This phenomenal being was very well informed on everything pertaining to contemporary literature; but he was long past the stage of art-for-art's-sake, and preferred to such pretentious and frivolous pastimes the satisfaction that he found in shaping his own existence to suit his fancy.*

"*Little by little, he imparted his secret to his new friends. The secret was nothing more than a definition of humor, carried to its furtherest consequences, to the point of abolishing even the feeling that life was worth while. Jacques Vaché's philosophy rested on three principles: First: 'Humor is a sense of the theatric and joyless futility of everything, when one is enlightened . . .' Second: 'It is of the essence of symbols to be symbolic . . .' Finally, Vaché held that there entered into humor a good deal of a 'formidable ubique,' that is to say, of an element of stupid surprise that is comical and, at the same time, disconcerting by reason of its destructive potentialities, an element which Jarry had illustrated in* Ubu Roi.

"*The essential thing was to put into practice this singular philosophy; as we have seen, Vaché himself succeeded very well. But the latter's triumph was his death at Nantes, some time before the Armistice. He not only committed suicide in a formidable and humorous fashion, by taking, and forcing two of his comrades to take, a large over-dose of opium, although he knew very well what the proper method of employing the drug was . . ."* (Bouvier: in Putman: op. cit.).

Tristan Tzara

Tzara's *Memoirs of Dadaism* appears as Appendix II of Edmund Wilson's *Axel's Castle* (N.Y., 1931), a book that is continuously in print, so that it has not been thought necessary to reprint Tzara's piece here. It picks up from Tzara's *Zurich Chronicle (1915–1919)*, with his arrival in Paris, in 1920. The events recounted there are described in the present anthology by Ribemont-Dessaignes and by Hugnet. In Tzara's *Memoirs*, he speaks of Huelsenbeck as "*a vigorous and intelligent man and a poet of talent,*" which is interesting

in view of the latter's consistent personal attacks, over a period of thirty years, on Tzara. His *Memoirs* end: *"At Constantinople, I talked with a Greek doctor who had lived at Paris, and who didn't know who I was. He told me that he knew Tristan Tzara very well. Calmly, in spite of my amazement, I asked him what Tzara looked like. 'He is tall and blond,' he replied. I couldn't keep from laughing, because I am small and dark."*

Tzara was editor of the various numbers of *Dada*, by far the most important of the dada reviews in French. Two of his dada books of poems were illustrated by Arp (who went to Paris, but from Cologne, in the same year as Tzara). The next year Picabia, impudent and iconoclastic, and André Breton seceded from dada, and in 1922 Tzara and Breton became opponents, at the time of the Congress of Paris. Breton succeeded in gathering most of the dadas around himself, and in 1924 they took the name 'surrealist', Tzara remaining outside the movement, save for a brief moment of adherence in 1929. Tzara is a sympathizer with the C.P., as were the surrealists for a time, though most of them (but not Naville, Aragon, or Eluard) became opponents of Stalinism.

The *Manifesto of Mr. Fire-Extinguisher* was read during the first organized dada performance, Waag Hall, Zurich, on the French national holiday, 14 July, 1916. It is clearly a protest against the war. ['Mr. Fire-Extinguisher' is a mistranslation of 'Monsieur Antipyrine', Anti-pyrine being a trade name of a well-known medicine against headaches in France.] The *Dada Manifesto 1918* was read in Meise Hall, Zurich, 23 March, 1918. Its content has perhaps been influenced by the ideas Huelsenbeck formulated so well. André Breton, at the time of a break with Tzara over the Congress of Paris, claimed to have evidence that Dr. Serner (who unfortunately is a shadowy figure in this anthology), not Tzara, wrote this manifesto; but the style seems to be Tzara's (*Je m'enfoutisme* might be roughly rendered as "I don't give a damnism.") The *Proclamation without Pretension* was read during the eighth dada public performance in Zurich, at Kaufleuten Hall, 8 April, 1919. Evidently part of the *Manifesto of Mr. AA the anti-philosopher* was read at the Peoples University (a kind of revolutionary group), Paris, 18 February, 1920; the remainder at Gaveau Hall, Paris, 22 May, 1920. The tone of this Manifesto is markedly more personal; it is less the state of the world than the personal anguish of Tzara that is evident; and there are traces of the conflicts among the dadas. The *Manifesto on Feeble Love and Bitter Love* was read at the Povolotzky Gallery, Paris, 12 December, 1920. The *Supplement* was read at the same Gallery a week later.

Tzara's *25 poèmes* (1918) was illustrated with woodcuts by Arp, as was his *Cinema calendrier* (1920); when the *Seven Manifestoes* were published in book form in 1924, the drawings were by Picabia.

★

Tzara's variations on the refrain, *"I consider myself very charming,"* make one remember the entry in André Gide's *Journal*, 30 August, 1930: *"Yesterday I had tea at Tristan Tzara's, who is charming; his young wife is even more charming."*

Ribemont-Dessaignes, Rigaut

"At the beginning of 1920 the dadaists were forming a resolute and bellicose cohort, with their headquarters established at the 'Cafe Certa.' In the first rank were Tristan Tzara, Francis Picabia, André Breton, Philippe Soupault, Louis Aragon, Paul Eluard, Georges Ribemont-Dessaignes, and, among the musicians, Erik Satie and Darius Milhaud. They had the moral sympathy and support of André Lhote, Pablo Picasso, Max Jacob, André Salmon, Pierre Reverdy, Jean Cocteau, Blaise Cendrars, Paul Morand, and the continued approval of Paul Valéry and André Gide" (Lemaitre: From Cubism to Surrealism in French Literature. Cambridge (Mass.), 1941).

"Georges Ribemont-Dessaignes best known as the author of Ugolin, 1926, was born in 1884. He began life as a painter but abandoned the brush for the pen; he has been writing now [1931] for the past ten years, and is looked upon by some as the most revolté of modern French prosateurs. His prose is marked by an everpresent sense of mystery, by a certain gift of clairvoyance, and by an extraordinary degree of energy. He lives in the country, near Paris, and commutes back and forth; he is a tremendous worker, much of his work is done on the train, and his fellow-commuters provide him with no little of his material. He says of himself and his work: 'Je ne parle autrement dans la réalité qu'en rêve' " (Putnam: op. cit.).

★

The late Samuel Putnam, the translator, dates the dada epoch from the suicide of Jacques Vaché in 1919 to the suicide of Jacques Rigaut in 1929; these dates actually refer to dada activities in Paris. Rigaut was the secretary for many years of Jacques-Emile Blanche, the well-known French academic painter and writer on art. Rigaut, another dim figure in the histories of dada, destroyed his writings as they were finished; a few have survived. In one article, printed in *La Revolution Surréaliste* (1929), Rigaut remarked that *"suicide is a vocation."*

In Putnam's anthology is a translation of Blanche's memoir of Rigaut, from which I quote a few sentences:

"There was little of the metaphysician in this youth. He took himself for a disciple of M. Teste, but he impressed me as being just the opposite. When he would bring his Dadaistic comrades to my house, and when I

would compare Rigaut's Latin face and American get-up with theirs, I became conscious of the fact that the path he had chosen to follow was not his by instinct. Which would get *him*, Dada or the Ritz? In the meanwhile, I was grateful to him for making me acquainted with some equally remarkable young writers, in whose company it seemed to me that I was once more meeting philosophers, bespectacled professors and neurologists of the sort among whom I had grown up in my grandfather's house. Amid such an areopagus —the Council of Ten or the Public Health Commission—Jacques' charming dandysme was out of place; nevertheless, he was something more than a listener.

"Theoretic suicide which was already the mode, and which was to become one of the leitmotifs of Surréalisme, had left its funereal mark on him, even to his affectation of 'accepting' life of the most conventional and futile sort. He did not align himself with any group. Indeed, he was never more than a spectator at the public performances and public team-play of the Dadaists. But his fantasticality, his attractive sigularity should have led them to claim him as one of their own. 'He who had humorously conceived the idea of suggesting to rich American families that they have the wooden crosses on the battlefields transformed into marble crosses,—he who killed himself on the 5th of November, 1929, in an absolutely methodical fashion,—he does not expect of us, his friends, those phrases which he himself would have been little disposed to utter over a grave.' Such is the chronological notice that appeared in the review conducted by his former comrades."

Rigaut's principal writing is *Lord Patchogue* (I have found no trace of this American Indian name except for the township on Long Island near New York), passages of which were translated in Putnam's anthology after its original publication in *La Nouvelle Revue Française*, August, 1930.

"... the author of that strange fragmentary confession entitled *Lord Patchogue* ... was probably the original of what Drieu la Rochelle called 'empty suitcases', i.e., those over-conscious and cynical youths who travelled the world with no faith left in their baggage. Patchogue was introduced as 'the man on the other side of the mirror.' How could a man live when he had made himself only 'the eye that looks at the eye that looks at the eye that looks'?" *(Michaud:* Modern Thought and Literature in France, *N.Y., 1934.)*

When Rigaut applied to Blanche for his job, he said, "Sir, I may impress you as being too gigolo, but I beg you to give me a trial anyway."

Hugnet

Hugnet was born in Paris in 1906, and consequently was too young to have participated in the dada movement, though he has always shown extreme sympathy for it, as well as for surrealism, a movement of which he has been an ardent supporter. Mr. Barr remarks that

Hugnet is, "among all the surrealist writers, the one most interested in an historical approach." He has written various volumes of poetry and drama, and is the editor of the important *Petite Anthologie poétique du Surréalisme* (Paris, 1934), for which he wrote a long introduction. His account of *The Dada Spirit in Painting* is obviously based on close study of the dada reviews, exhibition catalogues, and so on, and is inevitably somewhat slanted, i.e., dada as seen in the light of surrealism. Hugnet translated Gertrude Stein's *The Making of Americans* into French as well as (with Virgil Thomson) her *Ten Portraits;* Gertrude Stein in turn translated Hugnet's *Enfances* into English *(Pagany,* winter, 1931).

Breton

It is difficult to convey the force of André Breton's personality, whose domineering is perhaps welcomed by his followers because of his insistence on 'moral' and 'serious' goals. One might say, knowing it to be an oversimplification, but perhaps not misleading in view of the events of the past thirty years, that surrealism was what Breton did to dada. Not only that, after the collapse of the Congress of Paris ("to establish new directives for the modern mind") in 1922, the majority of the dadas went with him, rather than with Tzara, or that publication of the *First Manifesto of Surrealism* by Breton in 1924 is often taken to mark not only the birth of that movement, but the official end of dada as a movement; but that, in proposing that surrealism undertake psychic researches, investigate automatism, etc., and, ultimately, embrace the politics of the left (this last in turn brought about dichotomies when later surrealism became hostile to the U.S.S.R., Aragon, Eluard, Naville and others being Russian sympathizers), Breton turned 'the gay blasphemy' of Duchamp and other 'natural' dadas into a world of serious, organized aims. Yet Breton has always had the deepest respect for Duchamp, the arch-dada, who has been a kind of mediator, because of his detachment and fairness, in some of the conflicts among the surrealists. One of the important surrealist painters says of the various ideological quarrels that are part of the surrealist story that, although Breton does not always seem to have been right (even from a surrealist point of view), somehow he always *was* surrealism, and no one wrested the leadership from him. The painter remarked, in passing, that it was Breton who was the one who would have 'died' for surrealism—not merely the idea, for many artists and poets were committed to that—but for the *word*.

In 1932, nearly a decade after the dada movement, Breton wrote a preface, *Surrealism: Yesterday, Today, and Tomorrow* for the sur-

realist number of *This Quarter* (vol. V, no. 1, September, 1932), edited by Edward W. Titus, and published in English in Paris. Breton in an aside wrote:

> "There is no doubt that before the surrealist movement properly so-called, there existed among the promoters of the movement, and others who later rallied around it, very active, not merely dissenting, but unfortunately, antagonistic dispositions which, between 1915 and 1920, were to align themselves under the sign-board of Dada. Post-war disorder, a state of mind essentially anarchic that guided that cycle's many manifestations, a deliberate refusal to judge—for lack, it was said, of criteria —the actual qualifications of individuals, and perhaps, in the last analysis, a certain spirit of negation which was making itself conspicuous, had brought about the dissolution of a group as yet inchoate, one might say, by reason of its dispersed and heterogeneous character, a group whose germinating force has nevertheless been decisive and, by general consent of present-day critics, has greatly influenced the course of ideas. It may be proper before passing rapidly—as I must—over this period, to apportion the, by far, handsomest share to Marcel Duchamp (canvasses and glass objects still to be seen in New York), to Francis Picabia (reviews 291 and 391), Jacques Vaché (Lettres de Guerre: "War Letters") and Tristan Tzara (25 Poems, Dada Manifesto 1918)" [trans. by Mr. Titus].

It is Breton who wrote, "*A monstrous aberration makes people believe that language was born to facilitate their mutual relations.*"

Dada in New York: Duchamp

During the years 1915–16 various European artists came to New York, Marcel Duchamp, his brother-in-law Jean Crotti, Albert Gleizes, Edgard Varèse, Francis Picabia, and a writer, H. P. Roché. During 1916 there were meetings in the apartment of Mr. and Mrs. Walter C. Arensberg to organize the Independents' exhibition. Walter Pach, Glackens, and later on George Bellows, among other American artists, participated. When the jury-free exhibition was finally held in 1917 at the Grand Central Gallery, Duchamp's notorious *Fountain* was hidden behind a partition: "*We could not find it for a week.*" Duchamp resigned from the committee of organization. Then came Cravan's equally notorious lecture, described by Mme. Buffet-Picabia in this book; Duchamp believes that the Cravan lecture was published by one Cody, who ran one of the few modern galleries in New York, in a magazine that Cody edited, whose title Duchamp does not remember, and which I have never seen. A friend of the Arensbergs from Boston, a well-known doctor, gave a friendly lecture on the relations between the insane and modern art.

In 1917–18, Man Ray began making his "rayograms", and in 1921 collaborated with Duchamp in assembling the single number of *New York Dada*. Picabia was very much liked by the late Alfred Stieglitz, who was distant to Man Ray, and only mildly friendly in those days to Duchamp, though in after years Stieglitz repeatedly expressed regret to Duchamp for never having exhibited him. Marius de Zayas who worked for Stieglitz, drew many of the covers for *291*; around 1915, de Zayas opened a gallery of his own devoted to modern French art. In 1917 the United States entered the war and the dada activities in New York for the most part ceased: "*It was no longer much fun.*"

★

Duchamp says that the *Mona Lisa* with a moustache on the cover of *391* [reproduced on p. 173] is a copy by Picabia of the original moustache Duchamp had first penciled, as an anti-art gesture, on a reproduction of the *Mona Lisa,* but apparently Duchamp's version wasn't available for the cover (nor perhaps Duchamp himself to make another), so Picabia instead made the one that was reproduced.

The name of it is *L.H.O.O.Q.*, letters which, when pronounced in French fashion, make an obscene pun, "*Elle a chaud au cul.*" "*But make no mistake, these are no innocent games, the humor of Duchamp is gay blasphemy; this usurping of the masterpiece's privileges by the pun is aimed at destroying its prestige more effectively than any thesis could do*" (Buffet-Picabia 1945).

★

I have always wanted to publish in the Documents of Modern Art the notes Marcel Duchamp made for his *Bride Stripped Bare By Her Bachelors, Even,* and which were reproduced in facsimile in his famous green boxes in a very limited edition. The surrealist number of *This Quarter* published a translation (by J. Bronowski) of a few of them, with a note (1932) by André Breton: "*The following is an extract from a large, unpublished collection of notes by Marcel Duchamp which were intended to accompany and explain (as might an ideal exhibition-catalogue) the* verre *(painting on clear glass) known as* The Bride Stripped Bare by Her Own Bachelors *(1915–1918) and now in the collection of K. S. Dreier. . . .*

"*The unique historical position of this work of art gives the following extract, by reason of the entirely new light it throws on the author's interests considerable documentary value to surrealists.*"—A.B.

★

The extract from Duchamp follows:
"*to separate the ready-made in quantity from the already found. The separating is an operation.*

PREFACE
"*Given
(1) the waterfall*

(2) the lighting gas
we shall determine the conditions for an in-
stantaneous position of Rest (or allegorical ap-
pearance) of a sequence [of a set] of small hap-
penings appearing to necessitate one another
under causal laws, in order to extract the
sign of relationship between, *on the one hand,
this* position of Rest *(capable of all eccentrici-*
ties), on the other, a choice of Possibilities
*available under these laws and at the same
time determining them.*
"Or:
we shall determine the conditions under which
may best be demonstrated [the] super-rapid
position of Rest [the snapshot exposure]
(= allegorical appearance) of a set. . . . *&c.*
"Or:
Given, in the dark,
(1) the waterfall
(2) the lighting gas,
we shall determine (the conditions for) the
super-rapid exposure (=allegorical appearance
of several collisions [acts of violence] appear-
ing strictly to succeed one another—in accord-
*ance with certain causal laws—*in order *to*
extract the sign *of* relationship *between this*
snapshot exposure *(capable of all eccentrici-*
ties) on the one hand *and the choice of the*
possibilities available under these laws on the
other.
"*Algebraic Comparison:*
a a *being the demonstration*
b b *being the possibilities*

$$\text{the ratio } \frac{a}{b} \text{ is in no way given by a number c}$$

$$\frac{a}{b} = c, \text{ but by the sign written between}$$

a and b. "*As soon as* a *and* b *are 'knowns,'*
they become new units and lose (their rela-
tive numerical or extensive) values; there re-
maining only the sign '——' written between
them (sign of relationship *or better of* . . ?
think this out).
"Given the lighting gas

"PROGRESS (IMPROVEMENT)
OF THE LIGHTING GAS
UP TO THE LEVELS OF FLOW

"*Malic castings*
 "*By Eros matrix we understand the set of*
hollow uniforms or liveries designed [to con-
tain the] for the lighting gas *which takes 8*
malic forms (constable, dragoon, &c.).
 "*The gas castings so obtained would hear*
the litanies sung by the trolley, the refrain of
the whole celibate machine, but they *will*
never be able to pass beyond the Mask.—They
would have been as if enveloped all along
their regrets by a mirror reflecting back to
them their own complexity to the point of
their being hallucinated rather onanistically
(Graveyard of the uniforms or liveries).
 "*Each of the 8 malic forms is built above*
and below a common horizontal plane, the
plane of sex cutting them at the point of sex
"Or:
 "*Each of the 8 malic forms is cut by an*
imaginary horizontal plane in a point called
the point of sex.

★

obtained with air currents acting as pistons
(explain briefly how these pistons are 'pre-
pared')
 "*Then 'put them into position' for a*
certain length of time (2 or 3 months), and
allow them to leave their imprint in the char-
acter of [3] nets through which pass the hanged
female's commands (commands having their
alphabet and terms governed by the mutual
positions of the 3 nets [a sort of triple 'grill'
across which the milky way brings—and is the
conductor of—the command].
 "*Next, remove them so that nothing remains*
but their firm imprint, i.e. the form permit-
ting any combination of letters sent across
the above triple form, commands, orders,
authorizations, &c., which are supposed to join
the hits and the splash."

Dada in Paris: Breton, Aragon, Soupault, Eluard

For the Parisian dadas, I can do no better
than cite the relevant passages from Marcel
Raymond's *From Baudelaire to Surrealism,*
published as vol. 10 of the Documents of Mod-
ern Art series:

 "*The contributors to* Littérature—*at least*
the younger ones. . . .—*were on average*
twenty years of age in 1917, which in France
was perhaps the grimmest of the war years.
.
 "*One of the essential preoccupations of the*
dadaists was to draw up an indictment of
literature. According to them, the best litera-
ure is always imitation; the most sincere
writers have always been dependent on others,
have been prisoners of tyrannical traditions
and, above all, of reason. It is impossible to
know oneself, and the most clearsighted man
imagines himself, composes and betrays him-
self before his mirror. Some of Paul Valéry's
aphorisms seemed to justify the attitude of
these young people who had admired the
author of La Jeune Parque *at a time of in-*
tellectual impurity and scarcity, and had been
even his friends for a few seasons. 'A work of
art is always a forgery (i.e. it is a fabrication
without any relation to an author acting un-
der the influence of a single impulse). It is
the product of a collaboration of very different
states of mind.' Or: 'the slightest erasure is a
violation of spontaneity.' To this the ungrate-
ful disciples soon retorted: 'Let us then choose
spontaneity, authenticity, let us act on one
impulse, and renounce writing "works." ' For
the time being, dada contented itself with
acquiescing in such declarations of Valéry as
the following: 'The striving for a rhythmical,
measured, rhymed, alliterated language comes
up against conditions entirely alien to the pat-
tern of thought (Entretiens avec Fr. Lefèvre).'
 "*If every work of art is a forgery it is not*
only because the man who composes it cannot
possibly be sincere. In addition to the con-
straints of art, ordinary language is 'the worst
of conventions' because it imposes upon us
the use of formulas and verbal associations

which do not belong to us, which embody next to nothing of our true natures; the very meanings of words are fixed and unchangeable only because of an abuse of power by the collectivity: 'one may very well know the word 'hello' and yet say 'good-bye' to the woman one meets again after a year's absence' (André Breton, Les Pas perdus). . . . And why write at all? The editors of Littérature asked modern writers this question. Solemn or pathetic answers were ridiculed; those approved were the modest or ironical answers, like that of Valéry, 'I write out of weakness,' or Knut Hamsun, 'I write to kill time.'

". . . 'Absolutely incapable of resigning myself to my lot, wounded in my highest conscience by the denial of justice which in my eyes original sin does not excuse at all, I shall not adapt my existence to the absurd conditions of all existence in this world. . . .' This haughty profession of faith opens André Breton's Confession dédaigneuse. Whatever use literature after 1919 may have made of these themes and this rhetoric—and fashion and snobbery often debased them—we must not ignore the tragic anguish they reflect. Even if all dadaist poetry were to sink into oblivion, a few sentences would still deserve to be rescued—sentences which are among the most striking ever written to express the precariousness of man's fate and the sorrow of him who is lost and cannot resign himself to his destiny.

"Occasionally the writers of the group around Littérature use simple language, even in their poems. For instance, Louis Aragon whispers this Air du Temps to himself:

'Have you not had your fill of commonplaces
'People look at you without laughing
'They have glass eyes
'You pass, you waste your time, you pass,
'You count to a hundred and you cheat to kill ten more seconds
'Abruptly you stretch out your hand to die
'Don't be afraid
'One day or another
'There will be only one day to go and one day more
'And then that's it
'No more need to see men or the dear little beasts
'They fondle from time to time
'No need to talk to yourself at night to keep from hearing
'The wail of the chimney
'No need to raise my eyelids
'Nor to hurl my blood like a discus
'Nor to breathe in spite of myself
'Yet I do not want to die
'Softly the bell of my heart sings an ancient hope
'I know the music well. But the words
'Now what exactly were the words saying
'Idiot.' ('Le Mouvement perpetuel')

"Is this a summons to silence, a summons to renounce all literature? Such was the teaching of Rimbaud. The idea of such a sacrifice is tempting, but it is difficult to carry out, to cease protesting, to break one's pen. And then there was something else, something different from an absolute negation, which gradually came to light in the dada movement. After everything had been swept clean, a reality remained. To be sure, it was not reason or intelligence or feeling, but the obscure source of the unconscious which feeds our being and which governs even our loftiest actions, the spirit. The first slogans were soon enriched by the formula: dictatorship of the spirit. Zurich, the birthplace of dada, is the city of Bleuler and Jung, psychologists related to Freud; Louis Aragon and Breton had occasion to experiment with the methods of psychoanalysis. Here the essential is not the thesis of pansexualism, but the theory (that had been advocated by scientists such as Pierre Janet) according to which our conscious activities are only surface manifestations, most often determined by unconscious forces which constitute the substance of the self. And as Jacques Rivière said, Freud emphasized 'the hypocrisy inherent in consciousness,' the general tendency that 'drives us to camouflage ourselves,' to seek justifications of our words and acts, to cheat at all times in order to make ourselves look more beautiful or at least to 'adjust' ourselves. His theory justified an attitude of systematic distrust which curiously confirmed Valéry's statements on 'forgery' in literature and on the impossibility of being sincere. The influence of Freud on the dada movement has sometimes been contested; possibly it amounts to little, but the meeting of the Viennese philosopher and the poets on this common ground is nevertheless a significant symptom.

"We are now in a position to formulate the problem of art, more accurately the problem of expression, as it appeared to the writers of the Littérature group: only the unconscious does not lie, it alone is worth bringing to light. All deliberate and conscious efforts, composition, logic are futile. The celebrated French lucidity is nothing but a cheap lantern. At best the 'poet' can prepare traps (as a physician might do in treating a patient), with which to catch the unconscious by surprise and to prevent it from cheating. . . .

"As for the 'absolute' dadaist poem, needless to say, it gives the reader a most striking impression of incoherence—'words at liberty,' shreds of sentences, disintegrated syntax, and occasionally phrases borrowed from contemporary advertisements. Is this the voice of the unconscious? Or an application of the method advocated by Tzara: 'Take a newspaper, take scissors, choose an article, cut it out, then cut out each word put them all in a bag, shake . . .?' One wonders. No doubt the dadaists, too, hesitated between these two paths, that of mystery and that of mystification, between the 'everything is at stake' and a taste for the feigned jest, between docile submission to the injunctions of the unconscious and a call for external accidents and verbal coincidences. It is true that most often these two paths merge, to produce a procession of unreadable litanies which would interest only a psychoanalyst.

"But there are short poems bearing the dadaist label, which sum up a whole atmosphere:

'The airplane weaves telegraphic wires
'And the fountain sings the same song
'At the coachmen's rendezvous the aperitif is
 orange-colored
'But the locomotive mechanics have white eyes
'The lady has lost her smile in the woods.'

"In these lines by Philippe Soupault we feel
something like a gust of fresh air on a spring
morning in the Paris suburbs. . . .

". . . Paul Eluard used language in an un-
wonted way from the very beginning. Without
forcing anything, naturally and simply, he
diverted words from the things they usually
signify; the most familiar of them seem to be
reborn before one's eyes, to have regained
their innocence, to be prepared for any adven-
ture; the varied possibilities they suggest and
the new uncertainty concerning the scope of
their connection with their surroundings
cleanse them of all sin of utilitarianism. The
following verbal drawing is entitled Salon: . . .

'Love of permissible fantasies
'Of the sun
'Of lemons
'Of the light mimosa

'Clarity of means employed
'Clear glass
'Patience
'And vase to be pierced.

'From the sun, from the lemons, from the light
 mimosa
'To the extreme fragility
'Of the glass that contains
'This gold in balls
'This gold that rolls.'

"It is possible to be sure, to discern the
equivalent of a subject matter; but the sub-
ject matter is an intruder, and any reference
to an external reality casts a shadow on this
sun, breaks this vase, this glass, this light gold.
An exchange takes place between a careful
and purified language and the reader's sensi-
bility. On this point, Paul Eluard explains
himself in a few words appealing for their
brevity which at the same time inspires a
certain regret: 'Beauty or ugliness does not
seem necessary to us. We have always been
much more concerned with power or grace,
with sweetness or brutality, with simplicity or
balance.' We must also emphasize the follow-
ing profession of faith: 'Let us try, though it
is difficult, to remain absolutely pure. We shall
then perceive everything that binds us. And as
for the unpleasant language which suffices the
garrulous . . . let us reduce it, let us trans-
form it into a charming, true language. . . .' "

The Dada Manifesto 1949

In 1948, on the suggestion of Max Ernst, I
asked Tristan Tzara to write an introduction
for this anthology; he accepted, and sent one
to me; the alternation in tone was so marked
from his writings of the dada period, that I
thought it belonged more properly to the
end of this book, along with Huelsenbeck's
Dada Lives! (1936), and the piece by Arp,

Dada Was Not a Farce (1949). Arp had written
his piece for this book during a visit to New
York early in 1949; while he was here, there
were friendly meetings among some of the
old time dadas, and it was decided that they
would issue a joint Dada Manifesto 1949, to be
published in this book, the text to be written
by Huelsenbeck, and to be signed by Arp,
Duchamp, Ernst, Hausmann, Huelsenbeck
and Richter. The manifesto was set in type
and proofs were sent to the individuals in-
volved. Ernst refused to sign it and later on
Duchamp and Richter withdrew their signa-
tures. Tzara, who saw a copy of the proofs in
Paris, wrote me that if it were published in the
anthology, he would withdraw the whole of
his considerable contribution to it, though
permission for the publication of his writings
had already been granted. When Huelsenbeck
heard of this, he in turn said that the whole
of his considerable contribution would be
withdrawn if the manifesto were not printed,
though permission for the publication of his
writings had already been granted. Conse-
quently the anthology, which had been eagerly
awaited by the people interested in the subject
who knew of its existence, lay dormant for
some months while I was trying to resolve
the dilemma; I asked Ernst to intercede with
Tzara in Paris, and Duchamp with Huelsen-
beck here in New York; but neither Tzara nor
Huelsenbeck would give way. Rather than de-
lay the publication of this anthology, many
of whose texts are out of print, and/or appear-
ing in English for the first time, I decided to
accept the suggestion of one of the dadas and
to print Tzara's 1948 Introduction and Huel-
senbeck's Dada Manifesto 1949 as separate
pamphlets; hence they are both published, but
not in the anthology, and consequently the
presence of one cannot lead to the other's
withdrawal. This is far from a satisfactory
solution, but I can find no other.

★

Huelsenbeck's Dada Manifesto 1949 is a
more or less direct attack on the communists
(with whom Tzara is associated); but the
former's real interest seems to be in the foot-
note to it, if I can judge by the emphasis in
various conversations with his envoys concern-
ing whether it should be published or not.
The footnote reads, "For reasons of historical
accuracy, the undersigned consider it neces-
sary to state that Dadaism was not founded by
Tristan Tzara at the Cabaret Voltaire in
Zurich. It is self-evident that Dadaism could
not be invented by one man, and that all
assertions to this effect are therefore false. The
undersigned hereby state that the 'discovery'
of Dadaism was truthfully, and correctly de-
scribed by Richard Huelsenbeck. . . ."

★

I had written to Tzara previously remark-

ing, among other things, that Huelsenbeck claimed to have found the word 'dada' with Hugo Ball, despite the fact that the discovery was commonly attributed to Tzara in France, and that, in his *History of Dada* (translated in this miscellany), Ribemont-Dessaignes quotes Arp's famous comic account of Tzara finding the word. Tzara replied (26 September 1949): *"For the rest, except for Arp, how can the other signatories testify that description given by Huelsenbeck of the 'discovery of dada' is correct, since they were not in Zurich in 1916? Just as Arp has forgotten his contradictory declaration, I am sure that Duchamp, Richter and the others have not reflected enough."*

Arp had told me, in the early spring of 1949, that of course his account of Tzara finding the word was a dada joke, that he would have supposed it sufficiently evident from its fantastic tone.

Picabia

At the time of the struggle that revolved around the Congress of Paris, Picabia went off to the Riviera in disgust; there he produced the single number of the *Pine Cone*, which is reproduced in this anthology in facsimile, because of its rarity; translations of some of the texts, all by Picabia, follow:

"DEATH
doesn't exist
there is only dissolution.
"The beautiful is relative to the state
of interest it creates.
"LOVE is adhesion to
all the modalities in perfect relationships.
"Passion is only a desire for
power without outside influence
or objective.
"We are not responsible for what we do,
for we do not see our deed until it is
accomplished.
"Men have more imagination for killing
than for saving.
"Only heredity is objective.

"Erik Satie turns Dada,
he hopes to write an opera with
his friend Tzara,
Georges Dessaignes will arrange the music,
in this way we shall have an extremely modern
work.

"To appear in 1922, 'TABU,' the New
Religion
by Jean Crotti.
"Jean Cocteau became Dada the way he be-
came cubist,
the way he was the friend of Sacha Guitry,
the way he was the friend of Rostand,
the way he was nationalist.

"Ozenfant likes the new spirit.
Christian likes life.
Tzara likes glory.
Georges Ribemont-Dessaignes likes his wife.
Jean Cocteau likes—

Crotti likes Tabu.
Francis Picabia likes a car.
André Breton likes Picabia.
Aragon likes his sister.
Philippe Soupault likes brothels.
Gleizes likes dung.
Vauxcelles likes money.
Suzanne Duchamp likes Crotti.
Eluard likes Tzara.
Metzinger likes women.

"My very dear friends, Tzara, Ribemont and
consorts
Your modesty is so great that your works and
inventions will only attract flies.

"André Breton
Congress of
Paris

"Louis Aragon
Congress of
Paris

"OUR HEAD IS ROUND TO ALLOW
THOUGHT TO CHANGE ITS DIRECTION
"The Cubists who want to prolong cubism
at any price resemble Sarah Bernhardt.

"Tristan Tzara the faithless has left Paris
for La Connerie des Lilas,
He has decided to put his top hat
on a locomotive.
This is obviously easier than putting it
on the Victory of Samothrace.

"Cubism is a cathedral of s——."

★

Early in 1950, Picabia showed in New York recent works which had lately been shown in Paris; the piece by Arp on Picabia in this book served as the preface to the New York show (which also had a small piece by Michel Seuphor); Picabia's works, of relatively small size, had surfaces heavily reworked in white, with here and there an occasional disc of color, about the size of a silver dollar; these oils have more affinity in their 'purity' with the work of Mondrian than with that of Duchamp or the early Picabia, and one might think dada as a character trait was wholly gone. But an American abstract painter who went to visit Picabia, a year or two ago, in Paris, found him sitting in the superintendent's sitting-room when he inquired for Picabia's apartment. Picabia gave the American careful directions for finding his apartment, and when the American returned, saying no one answered, Picabia said, *"Oh, were you looking for me?"*

★

The meeting between Picabia and the Zurich dadas—who were unknown to each other—evidently came about through the publication in Lausanne, Switzerland, in 1918, of Picabia's book, *Poems and Drawings of the Daughter Born Without a Mother*, which is Picabia's image for the Machine. *"I dedicate*

this work to all neurologists in general and especially to Doctors Collins (New York), Dupré (Paris), Brunnschweiller (Lausanne).— F. Picabia." A characteristic poem, *Happiness*, follows:

I wish that the object
Like pagan alcohol
Would scramble the stomach of reason
And that the cock's crow would
Curse the sun
Past-time of the devil
Whims what happiness
I am well
By chance.

Eggeling and Richter

After a European modern architect had told me that he thought (though he was not sure) that Richter alone had attended Eggeling's funeral, Richter kindly wrote (16 March 1950):

"I was not the only one at E.'s funeral. We were about 30 people—all the artists who knew him, his girl friend, etc. It was quite a mess because his brother-in-law and sister (from Essen) had paid a high-pressure preacher, who said in his sermon about everything Eggeling would not have agreed with. We—his friends— were left finally, alone at the open grave, where I spoke first, then Hausmann (I think) and 2 or 3 others (whom I was too much disturbed to recall even now)."

Richter added in this same note:

"I feel that the misinterpretation that dada was a French 'invention' or movement ought to be corrected—by showing how much it came out of the general European situation, and that every country made something different of it."

★

Richter added some details about himself and Eggeling in a further letter (23 March 1950):

"About that time [1916–18] I met him through Tzara at the Hotel Louisatquai, Zurich, where Tzara and I lived. Eggeling—introduced to me as 'one who also experiments with abstract forms'—showed me a drawing and we immediately became friends (till his death in 1925). E. became a member, rather inactive, of dada. He (and later his wife) came with me (beginning of 1919) to Germany to the estate of my parents . . . and we worked there together until we settled in Berlin, December, (1921). We were experimenting on small paper sheets with variations of simple forms—started also studying Chinese old and new writing (as pictorial writing becoming abstract). Working there in the country fanatically—taking time off only for hunting (fanatically). Later in 1919 we decided one day to put our experiments into a definite continuity and form—on 'scrolls' (as the Chinese had). After two scrolls were finished (one by each of us), we found that the implications of 'Dynamism' were so strong that we decided to follow it up and realize it on film. That's when Doesburg sud-

denly visited us (completely unknown to us) . . . Decided as a first 'test' (with the help of UFA the producers) to put one drawing of my scroll Prelude *in motion—took more than 10 days (30 feet). Were utterly discouraged by technical difficulties (animation).*

"Here our ways split. E. worked (stubbornly) to make a film of his second scroll (in 4 parts), Diagonal Symphony. *Was 3 times re-shot—because E. was never satisfied—by his girl friend under the most incredible difficulties (1921). First public showing in 1922 at the V.D.I. (Berlin). Succes d'estime.—We split for a short time —violent disagreements about my dropping definitely purely graphical problems (of our scrolls) and occupying myself exclusively (in* Rhythm 21) *with the orchestration of time and space. Eggeling never touched again brush or pencil. Died May 19, 1925. His portraits (in ink) which I made on his deathbed were lost by his girl friend.*

"Eggeling's relationship with dada consisted mainly in the radicalism of his approach toward the fundamentals of expression in painting. There was nevertheless some resistance against him (by some dadaists!) at the beginning because of his 'classical' solutions. He disliked utterly 'improvisations' . . . something like an opposite (counterweight) against the 'automatism' in dada.

★

"Hans Richter, born 1888, Berlin. Cubist-expressionist influenced painter. One man show, Munich, 1916. Hans Richter number of Die Aktion, *1916. Joined dada, 1916, Zurich (as wounded soldier). Exhibited in various dada shows, Switzerland, 1916–18. Abstract paintings and line blocks, 1917–19.* Rhythm 21 (*original title,* Film is Rhythm), *1921. Surrealist movies, 1926–29. Stopped painting, 1926; started again in 1940, after Hitler overran France (was in Switzerland at this time); expected him to take all Europe; decided to settle in a hidden corner and take up the medium (painting) again that would still allow for free expression and creation. Came to U.S. 1941. New film,* The Hunt of the Minotaure (*the story of the labyrinth of oneself): to be shot this summer [1950]."*

★

From a letter (2 December 1949): *"My friend Huelsenbeck and I have agreed to take my name out—as a signer of the* Manifesto 1949— *as I cannot agree with all the points in this manifesto."*

Cendrars

More than a decade after the death of dada, and fifteen years after the publication in German of *En Avant Dada*, in 1936, Huelsenbeck bore witness in *Transition* magazine that *Dada Lives!* This position was also maintained by M. Levesque in Paris; a translation by Mme. Dollie Pierre Chareau, of a letter from him to me about the post-dada period follows (New York City, 30 March 1950):

"As you asked of me when we met recently, here you have, clearly stated in black and

white the essentials of what I said to you about dada.

"In my opinion (and this is one of the points that I made in the lecture I gave at the Sorbonne in Paris, May 4, 1936, entitled Twenty Years of the Dada Spirit, and in the one I gave in New York at Studio 35, March 10 1950, entitled Picabia and Dada) it is necessary to distinguish, in speaking of dada, of two different things even though they were identified at a certain moment: the dada spirit and the dada movement.

"The dada spirit is indefinable, like life, with which, in the end, it can be identified; but in any case it is plain that the dada spirit condemns, because of their inefficacy, literature, art, philosophy, ethics—not only theoretically, but also in regard to the pretentiousness of the men who are their high priests.

"The dada spirit existed before and after the historical dada movement which, although it gave the spirit a name, was simply its conscious expression (due in great part to the war of 1914) and very quickly its crystallization, then its negation. This was to be expected. Had not Tristan Tzara written in the famous and very important Dada Manifesto 1918: 'I am against systems, the most acceptable system is on principle to have none.'

"Before the dada movement—even if we take into consideration only what took place in the French domain, certainly similar examples can be found in other countries—Rimbaud ceased to write in order to travel and do business; Jarry, the creator of King Ubu, and later Arthur Cravan, 'the poet with the shortest hair in the world'—whose eccentricities stigmatized pontifical stupidity; Blaise Cendrars, 'Homer of the Trans-Siberian,' as John dos Passos, who devoted under this title the twelfth chapter of his book, Orient Express, called him, ran away from home when he was sixteen and led the hardest and freest life imaginable, first in Russia, then in China, then after extraordinary adventures in New York (1912) where he wrote his famous poem, Easter in New York, which was first to influence Guillaume Apollinaire and the entire modern mind and its poetry (on this point, see Jules Romains, the Poetic Spirit of the New Times, in La Lanterne Sourde, Brussels, 1923; Robert Goffin, Entrer en poesie; Louis Parrot, Blaise Cendrars; Henry Poulaille, preface to L'Homme Foudroyé, 1949), which was then groping, unable up to that time to express something other than literature and an artistic vision of life and finding the life and poems of this man who was free, not merely theoretically, but in reality, who in 1914 had already written these pre-dada lines in his poem, Bombay Express: 'I have never liked Mascagni/ Neither art nor artists/ Art criticism is as stupid as esperant,' just as thirty-five years later, January 7, 1950 true to himself, and showing, as Henry Miller has said of him, in the study Miller devoted to him called Tribute To Blaise Cendrars (in his book, The Wisdom Of The Heart); 'if sometimes he seems like a charge of dynamite it is because his sincerity, his integrity, is incorruptible.' Cendrars said in a broadcast over the French radio: 'The painters with whom I have lived have profoundly deceived me, since both their painting and their genius is in the hands of dealers, because of an unbridled ambition to see themselves in museums during their life time;' Raymond Roussel, a mysterious personality and an author impossible to classify, who, with his play, Impressions of Africa, which was produced in Paris before the war of 1914, incited the anger of the same public who, some years later, was to be enraged at the dada performances; Erik Satie, whose musical non-conformism, after having influenced Debussy and Maurice Ravel, led him to be 'the greatest French musician, the most modern, the only modern whose Musique d'ameublement ['furniture set music'] it is possible to listen to without covering one's ears with one's hands', (B. Cendrars, The Paris Suburbs, 1949) and who was to write on one occasion: "There's no need to call ourselves artists, let us leave that name to artists and chiropodists"; finally, Francis Picabia and Marcel Duchamp, two minds astoundingly free, audacious, and antidogmatic, with an acute lucidity that irretrievably put everything in question and with their unexpected handling of a totally destructive humor played the decisive role that the whole world knows in the genesis of the dada movement and in the dada movement itself—all these men demonstrate in their own ways the essence of the dada spirit.

"Since the dada movement, the purest dada spirit is demonstrated, to this very day, by Jean van Heeckeren, one of the freest men whom it's possible to know who parades his freedom and his astonishing and silent manner of living, founded on an absolute simplicity, in the four corners of the world, Europe, Africa, Asia, America, who proclaims himself to be the spiritual son of Picabia ('it is to Picabia, whom I have never seen, that I owe my birth to life,' Where Drawings Come From, 1929, in, The Lifeline) and of Dada ('The dada movement has an enormous importance. We live in it.' id.) acknowledges his admiration for Cendrars ('Cendrars has not put in question, in his sophisticated books, conventions, art, influences: he completely suppresses them. For him, to free oneself is to recover one's natural self.' Truth-Force, in Orbes, no. 4) and for Marcel Duchamp ('Blaise Cendrars, Francis Picabia and Marcel Duchamp have constantly shown us and show us more and more, every day, that there is only one thing that counts: invention.' The Inventive Spirit, 1935, Preface to the Collected Poems of Blaise Cendrars) and, as he has said, he probably would never have published a line of the books (a mixture of texts, drawings, photographs, collages, and poems) that he wrote for himself, without any idea of publication, if he had not found the atmosphere of complete freedom that his own freedom required in the magazine Orbes, a title suggested by Cendrars, whose first number appeared in Paris in the spring of 1928, with, for its motto, only 'Life,' and, as contributors, Cendrars, Picabia, Duchamp, Erik Satie, Pierre Reverdy, le douanier Rousseau, Gertrude Stein (Four Saints in Three Acts, the first French translation published in a magazine and which appeared in the spring number, 1929, accompa-

nied by the first article published in France on her, The Life of Gertrude Stein, *by Georges Hugnet), Pierre de Massot, Camille Bryen, Fernand Léger, Georges Hugnet, the former dadaists, Tristan Tzara, Arp, Ribemont-Dessaignes, Philippe Soupault, whose names were then indicative of one of the essential tendencies of that publication, maintaining the position taken by the dada movement—then abandoned by all the other reviews—against art, literature, dogmas, schools and systems.*

"Dogmas, schools, systems, the mode of conventional living and thinking, that was never tolerated by the two men who always demonstrated the purest dada spirit: in his period, that of the début of the dada movement which he ignored—he never had need of it—the astounding Jacques Vaché (of whom, happily, his friend André Breton wrote, revealing his fascinating personality, and editing his letters) and, all his life, up to his suicide in 1930, a suicide which he had minutely described ten years before in one of the few texts that he ever published during his lifetime and which appeared in Littérature, *the unforgettable Jacques Rigaut."*

Monsieur Levesque is too modest to have noted that it is he who was the editor of *Orbes.* When I met him for the only time a few months ago and asked him what his profession is, he replied, *"To be dada."*

Arp and Ernst

I have edited the writings of Arp *(On My Way,* 1948) and Max Ernst *(Beyond Painting,* 1948) in the Documents of Modern Art; both volumes have many illustrations; it has not been thought necessary to represent either Arp or Ernst very heavily in this book, in which their painting is discussed in detail by Hugnet. Both are still extremely active and productive artists, with their work constantly being exhibited in France (where Arp, an Alsatian by birth, lives) and in the United States (where Ernst, who was born near Cologne, in the Catholic Rhineland, now lives). *Notes from a Dada Diary* by Arp in this volume was originally published in *Transition* in 1932; the revised version is to be found in *On My Way.*

★

Max Ernst is not represented by his writings in this book, but I should like to quote from his ironic letter (Paris, 2 Sept., 1949) refusing to sign the *Dada Manifesto 1949:*

"The trembling of the earth in San Francisco is generally considered as a terrible and destructive movement, and one must admit that it brought about considerable damage. Unhappily the public knows only the destructive side of the event and completely forgets its highly constructive aspect; it forgets that it was necessary to create the ruins of old San Francisco in order to build a completely new city, the San Francisco that we admire today. It rid the world of a mass of 'slums' and of the criminals who lived there; it created

at the same time the possibilities for work for millions of workmen who otherwise were condemned to unemployment. It gave to the movie industry innumerable subjects . . . (it brought Mr. Clark Gable to his knees) . . . etc., etc., etc., etc.

"I have seen here and read—without pleasure—the manifesto [1949] of Mr. Huelsenbeck that you told me about some time ago . . . it goes without saying that I refuse to sign it and that I deplore its use in the book. It is absurd.
.
"Paris is very beautiful and pleasant. I suppose that you agree with this 'statement'!"

★

An earlier letter from Sedona, Arizona (2 May 1949) *re* his original interest:

"Enjoyed the way they pronounced my name on Wall Street and added it to my collection. Here it is: Mac, Maxt, Mex, Mask Oinest, Oinst, etc.

"Marcel Duchamp, who spent a few days here, told me about the manifesto [1949] which he signs (without having read it). I am ready to follow his example but I would be glad to see it afterwards."

★

Arp was profoundly saddened by the tragic accidental death of his wife, Sophie Taeuber, during the second world war; he is now more sombre and interested in religion, though his charm remains: his wit and good-spirits are legendary among those who knew him when he was younger. In 1948, the year before he wrote *Dada Was Not a Farce* for this miscellany, he wrote in *On My Way:*

"Some old friends from the days of the Dada campaign, who always fought for dreams and freedom, are now disgustingly preoccupied with class aims and busy making over the Hegelian dialectic into a hurdy-gurdy tune. Conscientiously they mix poetry and the Five Year Plan in one pot; but this attempt to lie down while standing up will not succeed. Man will not allow himself to be turned into a scrubbed, hygienic numeral, which, in its enthusiasm over a certain portrait, shouts yes like a hypnotized monkey. Man will not permit himself to be standardized. It is hard to explain how the greatest individualists can come out for a termite State. I cannot imagine my old friends in a collective Russian ballet."

Hausmann, Albert-Birot, Man Ray, Gleizes, Duchamp

The following is a translation of the main portion of a letter in German (to Hans Richter) from Raoul Hausmann (Limoges, France, 18 February 1950):

"Naturally I am a little disappointed to find that it is always the same things that get reprinted—dadaco appeared in Cahiers d'art *(1931),* D'Aci y Dala *(1935),* Art contemporain *(1937) and in* Modern Plastic Art *(1937) by Mme. Giedion, and now again: it is really a*

bit too often. Concerning the two poems, that's not very much either; I am putting down here what I have just read in Vision In Motion *by Moholy-Nagy: 'In 1935 Raoul Hausmann, the dadaist writer, gave a recital of excerpts from his novel. It was a text overloaded with details precisely described; lengthy revelations; a baroque richness in every sentence. For a while the excessive details seemed to be somewhat out-of-date, if compared to the telegraphic brevity one is used to today. But slowly I was captured by the novel. The acoustical emphasis, the foaming waterfall of words, anticipated a literature of phonograph records and of the radio—not yet accepted, but in the making. The ears are slower, less exact than the eyes. They have to be overloaded with a great variety as well as a quantity of sensations before they can compete—as to reception —with the lightning quickness of the eye.' That was the beginning of my book* Hyle *and was written in 1926. But I am now writing things far better than that.*

". . . through Mrs. Moholy I have just received a copy of Vision In Motion. *If Mr. Motherwell, who apparently knew Moholy well, had read this book with care, he would have been bound to discover that I after all was somebody. Furthermore, I am also mentioned in it under the heading of 'optophonetics,' but my poem has been falsely attributed to Schwitters, with whom I was on the best of terms until his death, and who never denied that he had based his* Ursonate *['Primordial Sonata'] on my poem."*

★

On p. 212 of Moholy's book is reproduced a photomontage by Hausmann of *Tatlin At Home, 1920,* and the caption underneath reads, *"Hausmann, the dadaist, was with John Hartfield [sic]. Hannah Hoech and George Grosz, one of the first 'photo monteurs.' The photomontage, an assemblage of single photographic illustrations into a new unity was derived from the 'collage' of the cubists. The collage itself was long known at the end of the 18th century as a kind of greeting card and it had a revival in the 1850's."*

Moholy adds on another page,

"One of Huelsenbeck's best friends, Raoul Hausman [sic], had not been in Zurich when Dada began its work. Neither were Kurt Schwitters nor Max Ernst. But all of them opposed the obsolete set up which had been preserved from the Imperial Reich and was carried into the compromising German Republic. 'In the dismal grey of a protestant despair we will open all the vents and let the electric fans furiously revolve in order to create an atmosphere for our contemporary ideas . . . What is art? It is a nonsense when it gives us only esthetic rules to move with security between the geography of the metropolis and agriculture, the apple pie and the women's bosom . . . The new man should have the courage to be new,' said Raoul Hausman [sic] in his Presentism *(February, 1921)."*

Mies van der Rohe vividly remembers Hausmann's clothes, beautifully tailored to his own designs. He remembers, too, Hausmann entering one day and proclaiming, *"God is a Hungarian!"*

★

Two poems follow by Pierre Albert-Birot, the editor of *Sic,* a dada review hand-printed by himself, and sent during the first world war gratis to the soldiers on, the western front; the translation is by Mme Dollie Pierre Chareau.

(The first poem speaks of a musical afternoon in 1917 during the war at Paul Guillaume's avant-garde gallery; the second poem of the opening day in 1918 of an exhibition by the non-objective painter, Herbin, at Rosenberg's gallery on the rue de la Beaume, and then of the opening of a van Dongen exhibition at Paul Guillaume's. *Cornet à Dés* is one of the major books by Max Jacob, the great 'cubist' poet, and there is a verbal play, in the mention of Satie on the fact that he had created the music for the ballet *Parade*.)

AT THE PAUL GUILLAUME GALLERY

The 13th day of November this year of 1917
We were at Paul Guillaume the negrophile's place
108 Faubourg Saint-Honoré at 8 o'clock
A short time after we were there
Along came Apollinaire
He sat down on a leather chair
And spoke first of a new art that one day he had implied
To be a sort of "technepheism"
To use a very simple term
Which an American had made
A photo had been taken
Between May and October
Of the very first plâtre à toucher
Apollinaire descanted afterwards
On poetry not the poets
And the new passionate man
He revealed to us the secrets of the gods
Who thee and thoued him
So that—now—none of us who were there listening
Have the right anymore to say
What's the poem all about I didn't understand a thing
And then we had some Debussy
You see
The poets X Y and Z
And the Profond Aujourd'hui
By Monsieur Blaise Cendrars
What the author of Henriette Sauret *was thinking*
I'll tell you when I find out
And then we heard three interludes set to music
Comic
By Auric
And sung by Bertin
These three little pieces were very much liked
And they ran along nicely right to the end
And then and then we had Satie Erik
Who Paraded and disappeared
And Lara who had appeared

Reappeared
And scanned however
Just as she had wished to do
In silence as for prayer
Il pleut by Apollinaire
And we left behind us the light
For the darkness of the night

OPENINGS

The 1st of March 1918 I was
At Rosenberg's where Herbin the painter
Was showing his pictures
Rue de la Beaume
It's a street
Where one sees nothing but stone
And you ask yourself as you go in
Are there people here
You push the little half open door
And you find some
Here's Cendrars Hello
And Soupault *(you arrive)*
How are you *(I depart)*
Fine Hello Severini
Good day my friend
Good day Max Jacob
Canudissimo Canudissimo
It's pretty isn't it
It's Cocteau who discovered it
He really is smart and witty
I've just read a wonderful book
It's neither of our time nor of
Any other time
Nor on this subject nor on that
To my mind it is simply wonderful
It's the Journal *of a convert*
Gazing on a flower the author
Says I am moved
Why am I moved
Because there is a God
Why have I a notion of God
Because I have faith
And one fine morning
He met Leon Blois
And the next morning
He went to confession
It's a wonderful book
Yes yes oh my dear friend
Let us beat on our breasts
With a Pickaxe
Examine our hearts know ourselves
And we will do immortal works
Be human my brothers
Thus spoke the saint
That I like to see
Still there were some pictures on the walls
 that were there
On purpose to be looked at
And therefore I looked at them
Leaving in other hands
The author of the Cornet à Dés
And said to myself
Oil painting
Is a difficult thing
Above all cubism
For there is nothing to be seen
That can take us in
The painter alone is there in each frame
And if he has nothing in him
There is nothing in the frame
Be great cubism
Or do not exist
This painter seems a very charming man

And his pictures are pretty
But not one at least while I was there
Came down from the wall on which it was
 hanging
And our feet never left the floor
I mean there was no magic
And as my report
Must be true if short
I am forced to state
That Madame André Lhote
Felt sick after clams that she ate

And the 17th
One Sunday of a bloody war week
I took off my slippers
And sauntered down quietly
To the van Dongen show
The Faubourg St. Honoré
Where Paul Guillaume the Eclectic
Keeps shop
Is quite sad on Sunday
Nobody lives in it
Only the houses
Sunday has its reasons
That love does not know . . .

★

Man Ray now lives in Hollywood, California. I wrote him in 1948, saying that I would be glad to publish anything by him about dada that he liked, and described the contents of the book. He replied (6 February 1948):

"Of course, if you are using the article of Georges Hugnet, my participation in the Dada movement is pretty well covered. I do not remember whether he mentioned my first exhibition in Paris under the auspices of the Dadaists. The enclosed photograph [reproduced, p. 100] is a reconstitution of the first dada object that I made for that show, and was considered one of the purest expressions of that activity. It does, however, overlap on the Surrealist development, as I continued to make objects of a similar nature, besides those I had already made in New York prior to my removal to Paris. Duchamp and I did publish one issue of Dada—New York [cf. pp. 214–18] around 1919 . . . I regret that I haven't my files here—they are in Paris, and I cannot give you any other documents."

★

Gleizes, a minor cubist painter, and a writer on the subject (one of the artists doubtless referred to by Picabia when he wrote, *"The cubists who want to prolong cubism at any price resemble Sarah Bernhardt"*), published an attack on dada in 1920, which I have placed as a second appendix to this volume partly to show the type of opposition dada encountered from a respectable artist at the time, and partly because an attack nowadays over dada's grave would probably take the same line. Evidently Gleizes knew the dadas in exile in Spain and in New York, as well as in Paris, where he still lives.

★

Harriet and Sidney Janis have written (1945)

one of the clearest accounts, based on conversations with the artist, of Marcel Duchamp's work, and I am glad to have their permission to reprint it as an appendix to this book; it has already appeared in the Duchamp number of *View,* a defunct little magazine, and in the more recently defunct *Horizon* (England). The third paragraph of the section called *Machine Concept and Techniques of Application* in the Janis article, describing Duchamp's relation to the machine—"*Duchamp animates the machine, mechanizes the soul*"—is also of importance in understanding Picabia's work, as well as that of many non-dadaists of the period, e.g., Fernand Léger.

★

A beautiful passage in the essay, *In Praise of Hands,* by the late Henri Focillon, in the second edition in English of his *The Life of Forms in Art* (N.Y., 1948) brings accident, or chance (which has played so large a rôle in the conceptions of Duchamp and of Arp, and Picabia as well), into relation with the machine:

"*The old story of the Greek artist who threw a sponge loaded with color at the head of a painted horse whose lather he despaired of rendering, is full of meaning. It not only teaches us that in spite of ourselves everything can be saved at the very moment when it seems to be lost, but it also makes us reflect upon the resources of pure chance. Here we are at the antipodes of automatism and mechanism, and no less distant from the cunning ways of reason. In the action of a machine, in which everything is repeated and predetermined, accident is an abrupt negation . . . [The artist]*

is a prestidigitator (I like this long, old word) who takes advantage of his own errors and of his faulty strokes to perform tricks with them; he never has more grace than when he makes a virtue of his own clumsiness. This excess of ink flowing capriciously in thin black rivulets, this insects' promenade across a brand-new sketch, this line deflected by a sudden jar, this drop of water diluting a contour—all these are the sudden invasion of the unexpected in a world where it has a right to its proper place, and where everything seems to be busy welcoming it."

Everywhere in the literature about Duchamp one finds reference to his delight at the chance additions when his great glass picture was cracked (while being moved for an exhibition in Brooklyn), and sometimes to the fact that, because of the way in which the picture was made, he predicted the directions that the cracks would follow. One of the sentences I omitted in the above quotation from Focillon is relevant:

"*In the hand of Hokusai, accident is an unknown form of life, the meeting of obscure forces and clairvoyant design. Sometimes one might say that he has provoked accident with an impatient finger in order to see what it would do. That is because Hokusai belongs to a country where, far from concealing the cracks in a broken pot by deceptive restoration, artisans underline this elegant tracery with a network of gold. Thus does the artist gratefully receive what chance gives him and places it respectfully in evidence.*"

<div align="right">

Robert Motherwell,
East Islip, Long Island,
New York,
Winter, 1951.

</div>

List of Illustrations:

I. Pre-Dada

1. *Exhibition at the Independents* (1914). By Arthur Cravan.
Translated complete from the French by Ralph Manheim. Probably
comprised a number of *Maintenànt,* written and published by
Cravan in Paris, 1913–15.

2. *Arthur Cravan and American Dada.* 1938. By Gabrielle
Buffet-Picabia. Translated complete from the French by Maria Jolas.
First published in *Transition,* Paris, no. 27, April–May,
1938. By permission of Eugene Jolas.

3. *Memories of An Amnesic (Fragments).* 1912–13. By Erik
Satie. Translated from the French by Robert Motherwell.
First published in *S.I.M.* (Journal of the Société Musicale
Indépendent), Paris, 15 April 1912, and 15 February 1913.

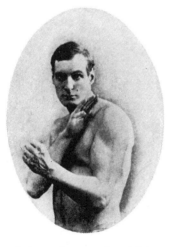

Arthur Cravan. (*In fighting stance.*) 1916(?). (Courtsey VVV).

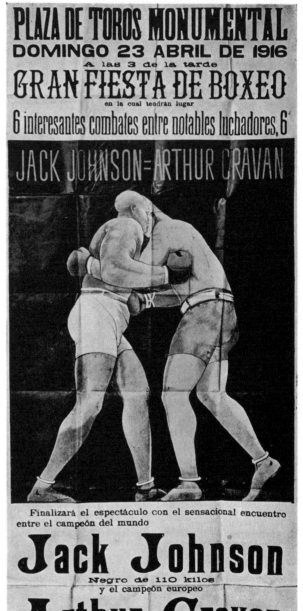

Poster. (*Announcing fight between Jack Johnson and Arthur Cravan.*) Madrid, 23 April, 1916. (Courtesy VVV).

Arthur Cravan: *Exhibition at the Independents (1914)*

Painters—there are two or three in France—really have few opportunities to show, and I can easily imagine the death-like state they are in when for months on end they can't appear in public. That is one of the reasons why I decided to swell the attendance at the Salon des Indépendants; though my best reason for so doing is the profound disgust with painting that I shall carry away from the show, a sentiment which in most cases can not be developed enough. Lord, how the times have changed. As true as I like to laugh, I just simply prefer photography to pictorial art and I would rather read newspapers than Racine. From your standpoint this requires a little explanation, which I shall hasten to give you. There are, for example, three categories of newspaper readers: first, the illiterate, who could not possibly enjoy reading a masterpiece, then the superior man, the educated man, the distinguished unimaginative monsieur who seldom reads the newspaper because he needs others to make his fiction for him, finally the man, or brute, with a temperament that feels the newspaper and cares nothing for the sensibility of the masters. Similarly there are three types of lovers of photographs. You must absolutely get it through your head that art is for the bourgeois, and by bourgeois I mean: a monsieur without imagination. Very well, but if that's the case, will you permit me to ask you why, since you despise painting, you take the trouble to write criticism about it?

It's quite simple: if I write, it is to infuriate my colleagues; to get myself talked about and to make a name for myself. A name helps you succeed with women and in business. If I were as famous as Paul Bourget, I'd show myself in the Follies every night in a fig leaf and I assure you that I'd have a good box-office. Moreover, my pen may give me the advantage of passing for a connoisseur, which in the eyes of the crowd is something enviable, for it is almost certain that no more than two intelligent people will attend the Salon.

With such intellectual readers as mine, I am obliged to give one more explanation and to say that I consider a man intelligent only when his intelligence has a temperament, since a *really intelligent* man resembles millions of *really intelligent*

men. Therefore, as far as I am concerned, a man of subtlety or refinement is almost always nothing but an idiot.

The Salon, seen from the outside, appeals to me, with its tents that give it the air of a circus set up by some Barnum; but what ugly mugs of artists are going to fill it: hordes of them: painters with long hair, writers with long hair; painters with short hair, writers with short hair; ragged painters, ragged writers; well-dressed painters, well-dressed writers; painters with ugly mugs; painters with handsome . . . there's no such thing; but Lord have mercy, there are artists a-plenty! Soon you won't see anyone but artists in the street and the one thing you'll have no end of trouble in finding is a man. They are everywhere: the cafés are full of them, new art schools open up every single day. I've always wondered how a teacher of painting, unless he teaches a locksmith how to copy keys, has ever been able to find a single pupil since the beginning of the world. People make fun of those who frequent palm-readers and other fortune tellers and never indulge in any irony about the simple souls who go to art school. Can anyone learn to draw or paint, to have talent or genius? And yet we find in these studios big dadoes of thirty or even forty and God forgive me, ninnies of fifty, yes, sweet Jesus! poor old fogies of fifty. There are even young Americans over six feet tall with fine shoulders, who know how to box and come from the lands watered by the Mississippi, where swim Negroes with snouts like hippopotamuses; lands where beautiful girls with hard buttocks ride horseback; who come from New York with its skyscrapers, New York on the banks of the Hudson where sleep torpedo boats charged like clouds. There are also fresh young American girls, oh poor *Gratteciella!!*

It may be argued that art schools provide painters with heat in winter and a model. And for a true painter a model is life itself. At any rate you can judge for yourself whether a professional model is more alive than the plaster statues people copy in the Ecole des Beaux-Arts; but the frequenters of the Academie Matisse are full of contempt for the pompous deadheads at the Beaux-Arts; why, just imagine: *they* are turning out advanced art. It is true that some among them believe that art is superior to nature. Yes, my dear!

I am astonished that some crook has not had the idea of opening a writing school.

But now let us proceed to the exhibition, as a good-natured critic would say. (As for me, I am a nasty one.)

Nine hundred and ninety-nine canvases out of 1000 might honorably appear at the Salon des Artistes Français, at the Galerie Nationale or the Salon d'Automne. Cézanne himself with his still-lives, and van Gogh, with his canvas representing books would do quite as well at the Salon d'Automne. So much fun has been made of the painters who use pomade, vaseline and soap, etc. to paint pictures that I shall say no more on this subject, and if I mention a number of names, it is solely for reasons of guile, as the only way of selling my magazine, for even if I say, for instance, that Tavernier is the worst sort of desiccated prune, or mention a little ass like Zac in the middle of an interminable list of nonentities, the two of them, along with the others, will buy the issue, just for the pleasure of seeing their names in print. And if I were mentioned, I'd do the same.

There are fake Roybets, fake Chabats, fake primitives, fake Cézannes, fake Gauguins, fake Maurice Denis', and fake Charles Guérins. Oh those dear fellows, Maurice Denis and Charles Guérin. What a kick in the ass I'd like to give them! Oh jumping Jesus Christ Almighty! How phony is the ideal of Maurice Denis. He paints women and children all naked amid nature, a thing that you simply do not see nowadays. To look at his paintings, as a friend of mine, Edouard Archinard put it, you'd think that children brought themselves up and that shoes could be resoled for nothing. How far we are from railway accidents: Maurice Denis ought to paint in heaven for he never heard of dinner-jackets and smelly feet. Not that I find it very

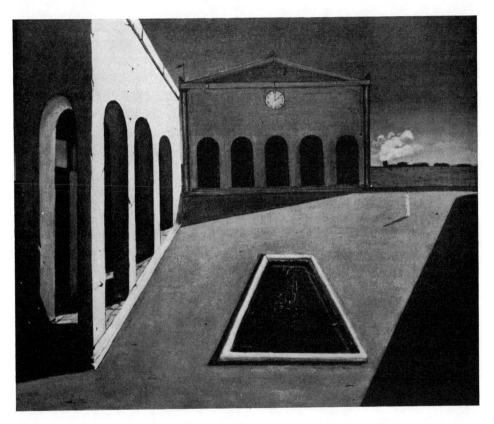

Giorgio de Chirico. *Delights of the Poet.* c. 1913. (Coll. Museum of Modern Art, N.Y.).

bold to paint an acrobat or a man shitting; on the contrary, a rose executed with novelty seems much more demoniacal. Pursuant to this line of thought, I feel the same contempt for an imitator of Carolus Duran as for an imitator of van Gogh. The first has more naiveté, the second more cultivation and good will: two mighty pitiful things.

What I have said of Maurice Denis applies more or less to Charles Guérin. There is no need to say more.

The chief thing that will be noted at the Salon is the place that has been assumed

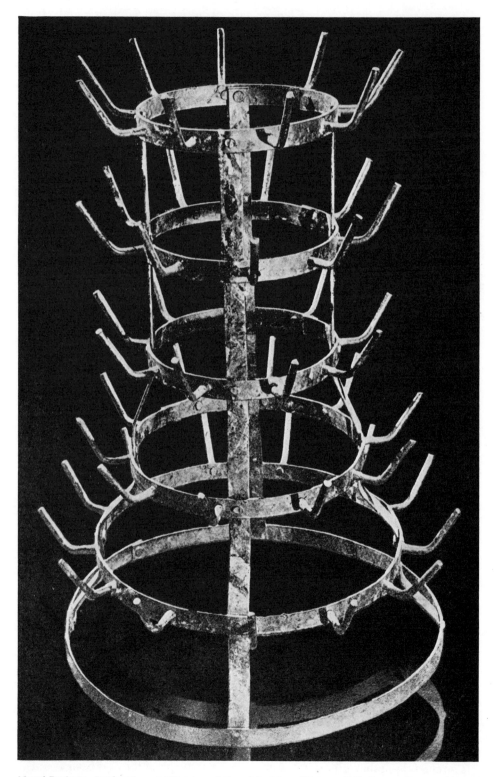

Marcel Duchamp. *Bottlerack*. 1914 (Miniature of the original from "Boîte-en-Valise". 1943. Courtesy Museum of Modern Art, N.Y.)

by intelligence among so-called artists. Let me say right at the start that in my opinion the first requirement for an artist is to know how to swim. I also feel that art, in the mysterious state corresponding to form in a wrestler, is situated more in the guts than in the brain, and that is why it exasperates me when, in the presence of a painting, I evoke the man and all I see is a head. Where are the legs, the spleen and the liver?

That is why I feel nothing but disgust for a painting by a Chagall or Jackal, that shows you a man pouring kerosene into a cow's ass-hole, when even real madness does not appeal to me because it manifests only a brain, while genius is nothing but an extraordinary manifestation of the body.

Henri Hayden. If I speak first of this painter, it is because Madame Cravan's hat went into the manufacture of his paintings. And manufactured it is indeed. Everything in it is out of place, muddy, crushed by the cerebral. I'd rather stay under water for two minutes than face to face with this painting: I should feel less suffocated. Values are arranged in it, *to make a good impression,* whereas in a work that issues from a vision the values are merely the colors of a luminous globe. The artist who sees the globe has no need to manipulate his values, which will always be false. *Hayden* has not seen the globe, for he has at least ten paintings on his canvas.

A bit of good advice: take a few pills and purge your spirit; do a lot of fucking or better still go into rigorous training: when the girth of your arm measures nineteen inches, you'll at least be a brute, if you're gifted.

Loeb. His contribution gives the impression of work, not of painting.

Morgan Russell tries to mask his impotence behind the techniques of synchronism. I had already seen his conventional paintings with their repulsively muddy color, at his show at the Bernheim Jeune gallery. I find no distinction in his work. *Chagall,* after all, has a certain naiveté and a certain color. Perhaps he is an innocent, but too small an innocent. *Chamier,* a nothing. *Frost,* nothing. *Per Krohg* is an old sinner who wants to be taken for an old lamb. *Aléxandre Exler* is one of those unfortunate artists who would do a hundred times better to show at the Artistes Français, for a cubist Bouguereau is still a Bouguereau. *Laboureur,* his paintings, though still quite muddy, have a certain life in them, especially the one of a café with billiard players; but one's pleasure in looking at it is not immense, because it is not sufficiently different. *Boussingault,* I've seen that stuff all over. *Kesmarky,* rotten, yes marquis! *Einhorn, Lucien, Laforge, Szobotka, Valmier* are cubists without talent. *Suzanne Valadon* knows her little recipes by heart, but to simplify is not to make simple, old slob! *Tobeen.* Ah, ah! Hum . . . hum!! Poor old *Tobeen!* (I don't know you but that doesn't matter), if *Dingbat* makes any more appointments with you at the *Rotonde,* stand him up. There is something in your painting (that's nice), but one has a feeling that it still owes a good deal to little discussions on aesthetics in the cafés. All your friends are little simpletons (that's nasty, isn't it). Do me a favor and get rid of that dignity of yours! Go and run in the fields, gallop across the plains like a horse; jump rope, and when you're six years old, you won't know anything any more, and you'll see mad things. *André Ritter*

contributes a black mess. Now there's a man who's obscene without suspecting it. *Ermein,* another dullard. *Schmalzigang* inclines us to think that futurism (I don't know if the canvas is exactly futurist) will have the same weakness as the impressionist school: sensibility exclusively of the eye. You'd think it was a fly looking at nature, and a frivolous fly at that, not a fly that gets drunk on shit, because the slightest sign of smell or sound is always missing, along with everything that it seems impossible to put into painting and that is precisely *everything.*

That I've spoken at such length of *Schmalzigang* does not mean that I consider his canvas a masterpiece. Far from it. Mlle. *Hanna Koschinski,* very kochonski. That poor Russian lady! *Marval* has contributed a charming picture. I know that many people would prefer to have it said that their work was diabolical. But have you any idea of all the substance contained in such words as adorable or charming? Perhaps I shall be better understood if I say that I do not consider the flowers of the national *Madeleine Lemaire* charming. *Flandrin* has a certain talent. Obviously genius doesn't blow a gale in his paintings, sweeping away trees and wheatfields. His painting smacks of the general rule and not of his personal rule, but even so we should be glad to see the *Gleizes* and *Metzingers* give the equivalent in their cubist paintings. *Marya Rubezac,* a little something in one of her canvases. *Kulbin,* his work is phony.

Hassenberg, how filthy. *Alice Bailly,* there is a certain gaiety in her *Skating in the Bois* and that's a good deal. I was expecting something horrible, because *Mlle. Bailly* has never been married. *Arthur Cravan,* if he had not been going through a period of laziness, would have submitted a canvas entitled: *The World Champion at the Whorehouse. De la Fresnaye,* I had previously noticed his contribution at the Salon d'Automne, for his painting was fresh. I am prepared to give a hundred francs to anyone who will show me twenty fresh paintings at any show. On the present occasion his prodigious quality has largely disappeared. (I am obliged to notify my readers that I have seen only two of the three canvases he is supposed to submit, since the third had not yet arrived.) I do not know if the criticism of the Jew Apollinaire—I have no prejudice against Jews, usually preferring a Jew to a Protestant—gave him a feeling of uncertainty when this replica of *Catulle Mendès* referred to him in one of his pieces as a disciple of *Delaunay.* Will he be taken in by such a low swindle?

His two still-lives have a little of that dryness of aspect which is seen in the typography of the covers of M. *Gide's* books. Knowing absolutely nothing about M. *de la Fresnaye,* I have no idea what milieu he frequents, but I am convinced that it is bad. His name tells me that he is noble and his paintings that he is distinguished. Distinction is bounded on one side by the toughocracy, and on the other by the nobility. Hence it is in the middle, and like all things of the middle, it is mediocre. Every noble has something of the tough in him and every tough has something of the noble in him, because they are the two extremes. Since distinction is enclosed by limits, it is never anything by itself and is characteristic of talent. Thus M. *de la Fresnaye* lacks the ultimate play of color and the highest freedom. It is not likely that this artist is one of those who think, on completing a masterpiece: I'm

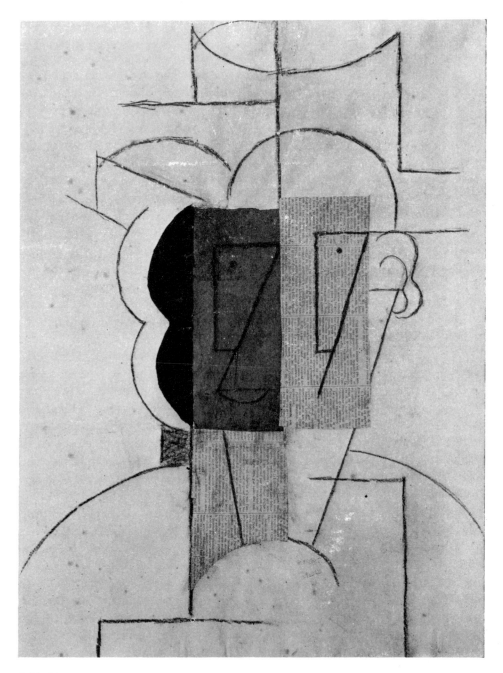

Pablo Picasso. *Man with a Hat*. 1913. (Coll. Museum of Modern Art, N.Y.).

not done laughing yet. *Metzinger*, a failure who has snatched at the coat-tails of cubism. His color has a German accent. He disgusts me. *K. Malévitch*, phony. *Alfred Hagin*, sad, sad. *Peské*, you're rotten! *Luce* has no talent. *Signac*, I shall say nothing of him because so much has been written of his work. I only want him to

9

know that I think very well of him. *Deltombe,* what a prick! *Aurora Folquer,* and your grandmother? *Puech, the pink Rose:* be still, venomous woman! *Marcoussis,* insincerity, but the cubist canvases make you feel that there ought to be something in them, but what. Beauty, stupid idiot. *Robert Lotiron,* maybe. *Gleizes* is no savior either; what the cubists need is a genius who can paint without tricks and systems. I don't even think *Gleizes* has any talent. It's too bad for him, but that's how it is. Perhaps people will think I'm prejudiced against cubism. Not at all: I prefer all the eccentricities even of a commonplace artist to the platitudinous works of a bourgeois imbecile. *A. Kristians* is an imitator, not a disciple of *Van Dongen.*

A. Kistein, my poor friend, that's not it at all. *Van Dongen,* following a habit of several years, has sent his worst work to the Salon. *Van Dongen* has done admirable things. He has painting in his skin. When I talk to him and look at him, I always imagine that his cells are full of color, that his very beard and hair carry green, yellow, red or blue down along their canals. My love will make me write a whole article about him later, and that is why I say so little today.

De Segonzac, I haven't seen his contribution. To judge by his latest canvases, this painter who gave a certain promise at first, is today doing nothing but little messes. *Kisling,* I haven't seen his contribution and I don't even know the right spelling of his name. I have heard that he has talent but I reserve judgments. Everyone will understand that it is impossible for me to see everything on one visit. In my next issue I shall not fail to draw attention to the unknown whom I shall have discovered. It is very hard to find your way in the tents when the paintings are not yet hung: some of the canvases are being moved about and since one sees nothing but horrors, one imagines, wrongly perhaps, that the nine day wonder isn't there, when the chances are a thousand to one that it is anywhere at all and not in the hall of honor, for the Exhibition of the Independents does have such a disgusting thing as a hall of honor. *Szaman Mondszain,* it seems that I once got drunk with this artist; but I don't remember him—people will say that I was dead drunk—. At any rate this forgotten companion has asked my wife to speak of him and since he paid her a few sticky compliments, I am doing my share. I couldn't find his canvas: he's lucky. *Robert Delaunay,* I am obliged to take certain precautions before speaking of him. We have had a fight, and I don't want either him or anyone else to think that my criticism has been influenced by this fact. I do not concern myself with personal hatreds or friendships. This is a great virtue which at the present time, when sincere criticism is pretty much non-existent, constitutes an excellent and perhaps quite profitable investment. If I speak a good deal of the man and certain details shock you, I assure you that this is all perfectly natural, because it is my way of looking at things.

Once more I must admit that I have not seen his paintings. It seems that *Delaunay* has a habit of sending in his canvases on the last day in order to annoy the critics, and in this I think he is perfectly justified. Anyone who seriously writes a line about painting is what I think.

I believe that this painter has turned out badly. I say "turned out badly," although I feel that this is an unrealizable feat. M. *Delaunay* has a face like an in-

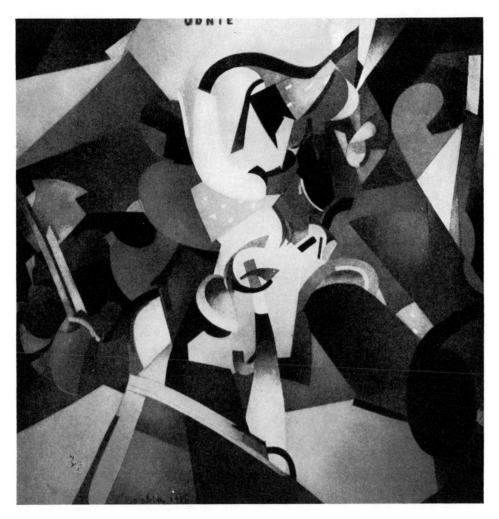

Francis Picabia. *Udnie (jeune fille américaine)*. 1913. (Reproduction courtesy Marcel Duchamp).

flamed pig or a high-class coachman; with a mug like that he might have aspired to
paint like a brute. The exterior was promising, the interior didn't amount to much.
Probably I exaggerate when I say that there was something admirable about *De-
launay's* extraordinary appearance. Physically he's a flabby cheese: he runs with
difficulty, and *Robert* has some trouble throwing a pebble thirty yards. You will
agree this isn't so hot. In spite of everything, as I have said above, he had his phiz
in his favor: that face of a vulgarity so provocative that it gives you the impression
of a red fart. Unfortunately for him—you must realize that it is a matter of total
indifference to me whether this one or that one has any talent or not—he married a
Russian, yes, Virgin Mother! a Russian woman, but a Russian woman to whom he's
afraid to be unfaithful. For my part, I should rather practise indecency with a pro-
fessor of philosophy at the Collège de France—*Monsieur Bergson* for instance—than
to go to bed with most Russian women. I do not say that I shall not fornicate some

day with *Madame Delaunay,* because, like the vast majority of men, I am a born collector and consequently it would give me a cruel satisfaction to debauch a kindergarten teacher, especially as at the moment of breaking her, I should have the impression that I was smashing an eye glass.

Before he met his wife, Robert was an ass; he had perhaps all the qualities of an ass: he brayed, he liked thistles, he liked to roll in the grass, and he looked with great stupefied eyes upon the world that is so beautiful, without giving any thought to whether it was modern or ancient, taking a telegraph pole for a tree and believing a flower to be an invention. Since he has been with his Russian, he knows that the Eiffel Tower, the telephone, automobiles, airplanes are modern things. Well, it did this big fathead no end of harm to learn so much, not that knowledge can be injurious to an artist, but an ass is an ass and to have temperament is to imitate oneself. What I see in *Delaunay* is therefore a lack of temperament. If you have the good fortune to be a brute, you've got to keep on being one. Everyone will understand that I prefer a big stupid Saint Bernard to Mademoiselle Fanfreluche who knows how to dance the gavotte and, at any rate, a yellow man to a white man, a black man to a yellow man and a black boxer to a black student. *Madame Delaunay,* who is an in-tel-lec-tu-al, although she knows even less than I do, which is saying a good deal, has crammed his head full of principles which are not even extravagant but simply eccentric. *Robert* has taken a lesson in geometry, one in physics, and another in astronomy, and he has looked at the moon through a telescope; he has become a phony scholar. His futurism—I don't say this to annoy him for I believe that nearly all painting from now on will derive from futurism which also lacks a genius, since the *Carràs* or *Boccionis* are nonentities—has a great quality of effrontery[1]—like his phiz—although his painting suffers from haste to be first at any cost.

I forgot to tell you that in his private life he does his best to imitate the frugality of the *douanier Rousseau.*

I do not know if he will come to this show as he did to the Salon d'Automne, rigged out in a red overcoat, which is not the mannerism of a living man but of a dead one, since today all men wear black and fashion is the expression of life.

Marie Laurencin (I haven't seen her contribution). Now there's one who needs to have her skirts lifted up and to get a sound . . . some place, to teach her that art isn't a little pose in front of the mirror. Oh! My dear! (keep your trap shut!) Painting is walking, running, drinking, eating and fulfilling your natural functions. You can say I'm disgusting, but that's just what it is.

It's an outrage to art to say that in order to be an artist you've got to start by eating and drinking. I am not a realist and Art is fortunately beyond all these contingencies (and your grandmother?).

Art, with a capital A, is on the contrary, dear Mademoiselle, literally speaking a flower (oh, my dear child!) which blooms only in the midst of contingencies, and there is no doubt that a turd is just as necessary to the formation of a masterpiece as your door-knob, or, to use a figure that will really strike your imagination, is

[1] *Toupet;* also means a forelock. (Tr.)

just as necessary, I say, as the deliciously languorous rose which adorably casts the perfume of its languidly pink petals over the virginally pallid surface of your delicate, tender and artistic mantelpiece (baby hair!).

P.S. Unable to defend myself in the press against the critics who have hypocritically insinuated that I was related either to Apollinaire or Marinetti, I hereby warn them that if they repeat this I shall twist their private parts.

One of them said to my wife: "What do you expect, Monsieur Cravan doesn't spend enough of his time with us." I wish to state once and for all: I do not want to be civilized.

On the other hand, I should like to inform my readers that I shall accept with pleasure anything they see fit to send me: jars of jam, money orders, liqueurs, postage stamps of all countries, etc., etc. If nothing else, each gift will make me laugh.

Gabrielle Buffet-Picabia: *Arthur Cravan and American Dada (1938)*

The atmosphere of New York during the years 1915–1918 was heavily charged as a result of the unusual gathering together of individuals of all nationalities, each of whom had his own reticences and mysteries.

It also turned out to be an exceptionally favorable climate for the development of a certain revolutionary spirit in the domain of the arts and letters which, later on, became crystallized in Europe under the name of *Dada*.

This spirit, the germs of which were perceptible quite some time before the war, appeared, at first, to be the natural reaction of one generation to the preceding one, (in this case, to the rubbish and vanity of the romantic and symbolist epochs), through a return to simpler, more natural values.

It was destined to go beyond the limits of esthetics, to grow venomous, and charged with blasphemy and harshness under the pressure of events. At a time when society refused the right of existence to every being whom it had not incorporated within its warring exigencies, this spirit became, in an indirect form, a protest, the only possible protest of persecuted individualism.

It was to manifest itself with unforeseen violence, thanks to the presence in the United States at that time, of Marcel Duchamp and Picabia, who possess, each in his own way, a veritable genius for perturbation and polemics. Looking at it from a vantage-point of twenty years, their systemic plan of disturbance and demoralisation went definitely beyond mere artistic discussions and, in a more general way, assailed the security of all commonplaces, all collective and official hypocrisies.

13

Scandal and malicious humour were the usual formulae of their manifestations and publications. And so it happened that the Exhibition of Independent Painters, which took place in New York in 1917, became known as a result of several vexatiously sensational incidents. First of all, Marcel Duchamp sent a urinal, signed by him, to be exhibited. The jury hesitated a few minutes whether to consider it as one of those "ready-made master-pieces" which he classifies and catalogues as "master-pieces" through his choice and signature alone.

The second incident, and not the least, was the lecture given during the exhibition itself by Arthur Cravan, a man who personified, within himself and without premeditation, all the elements of surprise to be wished for by a demonstration that was not yet called "Dada."

His appearance alone created a kind of awe. This Cravan, whose real name was Fabian Lloyd, boxer and poet interchangeably, was over six feet tall; his extremely heavy body, that was admirably proportioned, according to its own exceptional measures, bore an olympian head of striking regularity, although somewhat indescribable. Through his mother, he was the nephew of Oscar Wilde, a fact about which he liked to boast, even under circumstances where such a revelation could only be a shock: as for instance, when he enumerated his titles and qualifications before a boxing match. Speaking perfect English, French and German, he possessed a British culture of the best type, as well as being familiar with the spirit of Montparnasse, of Montmartre and even of the exterior boulevards. In Paris, he lived in a circle of poets and painters, and he published poems which reveal an undeniable poetic vein, in which he frees himself in a rhythmic argot that is often very moving, of his immoderate and, especially, very juvenile aspirations. But he was also on intimate terms with the boxing world, whose society, according to him, he preferred, and he was prouder of his athletic performances than of his literary works.

Above all, however, he proclaimed his incapacity to live according to the social order and its accepted exigences and he boasted loudly that he had successfully accomplished "the perfect burglary"—an exploit that had taken place in a Swiss jewelry-store.

From 1912 to 1915 he published, in Paris, under the name of *"Maintenant"* a little polemical magazine which was definitely the forerunner of "391" and other aggressive post-war publications. It served as a loud-speaker to make known to the artists (lest any should be unaware) what he thought of them. His conclusions were often surprising. Van Dongen, alone, found grace in his eyes. But he was not always wrong, and his account of a visit to André Gide, for example, is an extraordinary bit of ironically clever criticism. The article devoted to the Independent Exhibition in Paris in 1914 made him famous, and unleashed a tempest of protests. He attacked the most outstanding names. The women painters, no less than the men, were the object of his insolent commentaries, which were all the more irritating as they were characterized by an irresistible verve and drollery. And although everybody said it was outrageous, they could hardly control their chuckles. But he did go too far, nonetheless. It was too evident that he was sure of the

impunity which his six feet in height and his athletic shoulders conferred upon him. Those who were insulted, it must be said, did not cut a very brilliant figure, either, when they made a little group of ten or twelve—union makes strength—and waited for him before the Independent Gallery, where he had come to sell copies of his review, like a news-vender. The encounter ended at the police station, not to Cravan's advantage. Apollinaire, who loved duels, could not let this opportunity go by to send his seconds to the brazen offender of Marie Laurencin. Cravan made obviously hypocritical excuses and everything was all right again.

The declaration of war in 1914 found him in France. He was, of course, quite determined not to answer the call of his native land, and there began an extraordinary series of adventures around his chameleon-like nationalities. No longer is it "little intellectuals with big heads and muscleless legs" with whom he has to match his strength, but with the pitiless police of the warring nations. At last here is a game cut to his measure. In 1914 he is a "Swiss subject." We find him in Barcelona in 1916 where he arrived finally, after a long roundabout trip through Central Europe. How had he succeeded in eluding the vigilance of several frontiers? In crossing three or four belligerent countries without being either found out or arrested? And all this without any clear or normal source of income? Unheard of adventures that one would have liked to make him tell, but which he kept to himself, for he talked little, as a rule. His manners were extremely reserved and courteous, when he was not drunk. Now the woman who had shared his Paris days came to join him. He proved to be a faithful lover and revealed almost bourgeois virtues. I must add, through having experienced it later on, that he could be a devoted friend, anxious to help and to be counted on. But alcohol liberated alarmingly terrifying properties in him. He engaged in a sensational boxing match with the then world's champion, Jack Johnson, a magnificent black athlete against whose technique Cravan's performance was but amateur's play. He was knocked out all the more swiftly as, in anticipation of the inevitable result, he had arrived in the ring reeling drunk. But this bitter experience left him some money. We saw him often, as well as his brother and charming sister-in-law, Olga Sakharoff, a painter of great talent. Marie Laurencin, now exiled in Barcelona, and formerly one of his most notorious victims, was too intelligent to hold anything against him, so he became one of our little nostalgic, uprooted group. Every day we met at the Café on the Rambla, we dined at each other's lodgings and, for distraction, went in for Spanish cooking. Picabia published the first number of "391." Then, one day, we learned that Cravan had left for the United States. We met him again in New York in the beginning of 1917. He was in very bad straits, without money, and was trailing along after more fortunate friends, especially the painter, Frost. He seemed worried and restless, for America had also entered the war. He came to see us often in the little apartment in 82nd street, where chess reigned night and day, where the assaults and calumnies of "391" were planned, where the eccentricities of Marcel Duchamp were admiringly discussed. In March 1917, at the Grand Central Gallery, the American Independents Exhibition took place. It was there that Picabia and Duchamp had the

idea of having him deliver a lecture, counting on a repetition of the Paris scandal of 1914. As it happened, things took a rather different turn, one that went beyond all their expectations. Cravan arrived very late, pushing his way through the large crowd of very smart listeners. Obviously drunk, he had difficulty in reaching the lecture platform, his expression and gait showing the decided effects of alcohol. He gesticulated wildly and began to take off his waistcoat. A canvas by the American painter, Sterner, was hanging directly behind him, and the incoherence of his movements made us fear that he would damage it. After having taken off his waistcoat, he began to undo his suspenders. The first surprise of the public at his extravagant entrance was soon replaced by murmurs of indignation. Doubtless the authorities had already been notified, for, at that moment, as he leaned over the table and started hurling one of the most insulting epithets in the English language at his audience, several policemen attacked him suddenly from behind, and handcuffed him with professional skill. He was manhandled, dragged out, and would have been thrown into jail, but for the intervention of Walter Arensberg, who bailed him out and took him to his house, while the protesting crowd made a tumultuous exit. If we add that it was a very smart audience, that the most beautiful Fifth Avenue hostesses had been urged to be present—all those who professed interest in painting and had come to be initiated into the new formulae of "futurist" art—it will be seen that the scandal was complete. What a wonderful lecture, said Marcel Duchamp, beaming, when we all met that evening at the home of Arensberg. Cravan, who was still suffering from the effects of his alcoholic orgy, was gloomy and distant, and never spoke of this exploit, which did not make his existence in the United States any easier. I had the luck to find a position for him as translator in the very correct, puritan family of an old professor of philosophy, who wanted to supervise in person the translation of his works. It meant spending several weeks in the country. I hesitated to speak to Cravan about this situation, which would assure him a comfortable existence in exchange for easy work, but which demanded a certain type of conduct I did not dare guarantee. Finally I tackled the problem frankly. "Cravan," I said, "if you will swear to me that you will not carry off the silverware, that you will behave properly with the ladies, that you will not get drunk, etc. etc." He promised everything I asked of him, in such touching, serious terms that I no longer doubted his sincerity, and he was happy as a child at the idea of running around in the woods and living, for a time, far from scandals and alcohol. He kept his promise, perhaps because the test did not last long, but I give this anecdote as a striking feature of his character, with its multiple sides, of which he himself speaks so movingly in one of his poems.

At that time it became evident that America would have recourse to conscription. The recruiting bureaus for volunteers, which looked like French fair-booths, were stationed in the busiest parts of the city, and did not seem to be very popular, despite the fact that pretty, alluring girls, flanked by a few non-commissioned officers in brand new uniforms, were used as decoys. It was their duty to be eloquent through their sex appeal as well as through their patriotism; glory and a

kiss were promised to all the poor devils who stopped imprudently to listen. The suggestive haranguing, which was publicly encouraged by prudish America, was to me a daily subject of surprise and amusement; but the lack of enthusiasm on the part of the passers-by made it obvious that more efficacious measures would soon be necessary. Cravan succeeded in escaping again, thanks, perhaps, to the identity papers of his friend Frost, who had died tragically of a tubercular hemor-rhage, during a night of orgy and alcohol, in his presence. He went to Canada, was given a lift by passing motorists, who took him for a soldier on furlough, and thus he reached the Far North. A final postal card dated from Newfoundland is the last word I received from him. Then I returned to France, which forced me, for the end of this extraordinary story, to accept what others told me. Cravan, it seems, returned to New York, and succeeded in reaching Mexico, accompanied by the British poetess Mina Loy, whom he had met in our circle of friends, and whom he married in Mexico. They had a daughter who is, apparently, the image of her father. In 1918, he was still in Mexico, where he founded a boxing club. He suffered a bad defeat in a match against a native adversary, which compromised the success of this enterprise. Once more he was without resources and considered the idea of living in other, more favorable countries. Mina Loy had preceded him to Buenos Ayres, where he was to join her by sea, on a little yacht that he was equipping little by little for the long journey. Every day he left the town to carry provisions to the yacht, which was anchored farther down the bay. One day he did not come back from his customary visit to the yacht, and since that time nobody has heard of him. It seemed possible for a long time that he might be on some island, or in the prisons of one of the numerous countries at war; and his wife looked for him after the Armistice in every possible place of this kind. But no jail had heard of him, and it has finally become more and more evident that the mystery surrounding the end of this amazing figure will never be cleared up.

Erik Satie: *Memories of an Amnesic (fragments) (1912-13)*

1. *What I Am*

Everyone will tell you that I am not a musician.[1] It's true.

From the beginning of my career I classed myself among phonometrographers. My works are pure phonometry. If one takes the "Son of the Stars" or the "Pieces in the Form of a Pear," the "In Riding Habit"[2] or the "Sarabands," one can see that

[1] Cf. Séré's "Musiciens francais d'aujourd'hui."

[2] (Satie is referring to the horse, not the rider. trans.)

no musical idea presided at the creation of these works. They are dominated by scientific thought.

Besides, I get more pleasure from measuring a sound than I do from hearing it. With phonometer in hand, I work surely and joyfully.

What haven't I weighed or measured? All of Beethoven, all of Verdi, etc. It's very curious.

The first time I used a phonoscope, I examined a B flat of average size. I have, I assure you, never seen anything more disgusting. I had to call my servant in to show it to him.

On my phono-weigher an ordinary F sharp, of a very common type, registered 93 kilograms. It came out of a very fat tenor whose weight I also took.

Do you know how to clean sounds? It's a dirty business. Cataloguing them is neater; to know how to classify them is a meticulous affair and demands good eye-sight. Here, we are in phonotechnics.

In regard to sonorous explosions, often so disagreeable, cotton placed in the ears attenuates them quite comfortably. Here, we are in pyrophonics.

For writing my "Gold Pieces," I employed a caleidophone register. This took seven minutes. I had to call my servant in to listen to it.

I believe that I can say that phonology is superior to music. It is more varied. You get paid more for it. That's how I made all my money.

In any case, with a metodynamophone, a phonometry expert with practically no experience can easily note down more sounds than the most skilled musician, in the same time, with the same effort. It is thanks to it that I have been able to write so much.

The future therefore belongs to philophonics.

2. *The Day of a Musician*

An artist ought to regulate his life.

Here is the exact time-table of my daily life:

Get up: at 7:18 a.m.; inspired: from 10:23 to 11.47. I lunch at 12:11 p.m. and leave the table at 12:14.

A healthy turn on the horse to the end of my grounds: from 1:19 to 2:53. More inspiration: from 3:12 to 4:07.

Various occupations (fencing, reflections, napping, visits, contemplation, dexterity, swimming, etc. . . .): from 4:21 to 6:47.

Dinner is served at 7:16 and ends at 7:20. Then symphonic readings (out loud): from 8:09 to 9:59.

Going to bed to takes place regularly at 10:37. Once a week I awake with a start at 3:19 a.m. (Tuesdays).

I eat only white foods: eggs, sugar, minced bones; the fat from dead animals; veal, salt, coconuts, chicken cooked in white water, the mould from fruit, rice, turnips, camphor sausages, pâtes, cheese (white), cotton salad and certain fishes (without the skin).

18

I boil my wine, which I drink cold with fuchsia juice. I have a good appetite, but I never talk while eating, for fear of choking to death.

I breathe with care (a little at a time). I dance very rarely. While walking I hold my sides and stare fixedly straight ahead.

Having a very serious expression, if I laugh it is without meaning to. I apologize afterwards, affably.

I sleep with only one eye closed; my sleep is deep. My bed is round, with a hole to put my head through. Hourly a servant takes my temperature and gives me another.

For a long time I have subscribed to a fashion magazine. I wear a white cap, white socks, and a white vest.

My doctor has always told me to smoke. To this advice he adds, "Smoke, my friend: if it weren't for that, another would be smoking in your place."

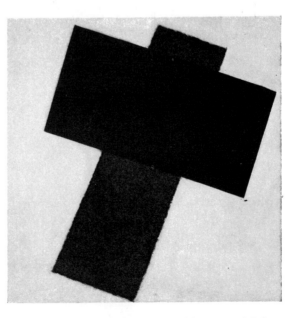

Kasimir Malevich. *Suprematist Composition.* (Extended loan, Museum of Modern Art, N.Y.)

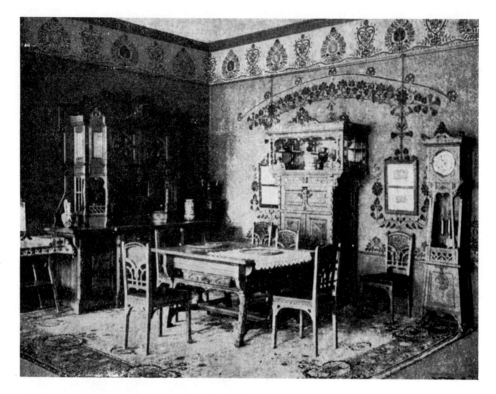

Professor E. Faragó. *Dining Room*. For Paris World Fair, 1900.

II. *En Avant Dada: A History of Dadaism*

By Richard Huelsenbeck. Translated complete from the German by
Ralph Manheim. First published as *En Avant Dada: Eine
Geschichte des Dadaismus,* Hannover, Leipzig, Wien, Zurich,
Paul Steegemann Verlag, 1920. By permission of the author.

Expressionismus. Kubismus.
Futurismus. Bruitismus.

Was ist dadaismus??? ist dada heilbar????

Sensationelle Enthüllungen:
Die Praktiken der
Engelmacherinnen!

Die abstrakte Kunst.

Das simultane Gedicht.

Alfred Kerr †.

Ist dada eine Geisteskrankheit?

Der Kaiser Hindenburg & Co.

Die Lues des Herrn Picabia.

Der Ober-dada.

Der Geheim-dadaismus.

Dada in aller Welt.

Die Speisung der Geistigen auf dem Potsdamer Platz.

Die Prügelszenen in Dresden, Prag, London, Paris, New York.

Wie wäre es mit einem Schnaps?

Dadaist kann jeder werden.

DÄUBLER.
EDSCHMID.
HILLER.

500000 Silbergäule sind aufgelegt.

Eine halbe Million Silbergäule!

Retten Sie Ihre Haare!!!!!!

Lernen Sie Beten!

En avant dada

DIE GESCHICHTE DES DADAISMUS

von

Richard Huelsenbeck

Geheimrat

Verlegt bei Paul Steegemann
Hannover / Leipzig

Das Cabaret Voltaire.
DIE TÄNZERIN.
Hans Arp. Hugo Ball. Tristan Tzara.
die wolkenpumpe.
ANNA BLUME. Letzte Lockerung.
DER MIXER DER MANHATTAN-BAR.
DADA das Holzpferdchen.
Die Kathedrale. Sekunde durch Hirn.
DER MARSTALL. DER MARSTALL.

Das witzigste Buch über ernsthafte Dinge

Cover. For *En Avant Dada* by Richard Huelsenbeck. Hanover, 1920.

Richard Huelsenbeck: *En Avant Dada: A History of Dadaism (1920)*

Dada was founded in Zurich in the spring of 1916 by Hugo Ball, Tristan Tzara, Hans Arp, Marcel Janco and Richard Huelsenbeck at the Cabaret Voltaire, a little bar where Hugo Ball and his friend Emmy Hennings had set up a miniature variety show, in which all of us were very active.

We had all left our countries as a result of the war. Ball and I came from Germany, Tzara and Janco from Rumania, Hans Arp from France. We were agreed that the war had been contrived by the various governments for the most autocratic, sordid and materialistic reasons; we Germans were familiar with the book *"J'accuse,"* and even without it we would have had little confidence in the decency of the German Kaiser and his generals. Ball was a conscientious objector, and I had escaped by the skin of my teeth from the pursuit of the police myrmidons who, for their so-called patriotic purposes, were massing men in the trenches of Northern France and giving them shells to eat. None of us had much appreciation for the kind of courage it takes to get shot for the idea of a nation which is at best a cartel of pelt merchants and profiteers in leather, at worst a cultural association of psychopaths who, like the Germans, marched off with a volume of Goethe in their knapsacks, to skewer Frenchmen and Russians on their bayonets.

Arp was an Alsatian; he had lived through the beginning of the war and the whole nationalistic frenzy in Paris, and was pretty well disgusted with all the petty chicanery there, and in general with the sickening changes that had taken place in the city and the people on which we had all squandered our love before the war. Politicians are the same everywhere, flatheaded and vile. Soldiers behave everywhere with the same brisk brutality that is the mortal enemy of every intellectual impulse. The energies and ambitions of those who participated in the Cabaret Voltaire in Zürich were from the start purely artistic. We wanted to make the Cabaret Voltaire a focal point of the "newest art," although we did not neglect from time to time to tell the fat and utterly uncomprehending Zurich philistines that we regarded them as pigs and the German Kaiser as the initiator

of the war. Then there was always a big fuss, and the students, who in Switzerland as elsewhere are the stupidest and most reactionary rabble—if in view of the compulsory national stultification in that country any group of citizens can claim a right to the superlative in that respect—at any rate the students gave a preview of the public resistance which Dada was later to encounter on its triumphant march through the world.

The word Dada was accidentally discovered by Hugo Ball and myself in a German-French dictionary, as we were looking for a name for Madame le Roy, the chanteuse at our cabaret. Dada is French for a wooden horse. It is impressive in its brevity and suggestiveness. Soon Dada became the signboard for all the art that we launched in the Cabaret Voltaire. By "newest art," we then meant by and large, abstract art. Later the idea behind the word Dada was to undergo a considerable change. While the Dadaists of the Allied countries, under the leadership of Tristan Tzara, still make no great distinction between Dadaism and *"l'art abstrait,"* in Germany, where the psychological background of our type of activity is entirely different from that in Switzerland, France and Italy, Dada assumed a very definite political character, which we shall discuss at length later.

The Cabaret Voltaire group were all artists in the sense that they were keenly sensitive to newly developed artistic possibilities. Ball and I had been extremely active in helping to spread expressionism in Germany; Ball was an intimate friend of Kandinsky, in collaboration with whom he had attempted to found an expressionistic theatre in Munich. Arp in Paris had been in close contact with Picasso and Braque, the leaders of the cubist movement, and was thoroughly convinced of the necessity of combatting naturalist conception in any form. Tristan Tzara, the romantic internationalist whose propagandistic zeal we have to thank for the enormous growth of Dada, brought with him from Rumania an unlimited literary facility. In that period, as we danced, sang and recited night after night in the Cabaret Voltaire, abstract art was for us tantamount to absolute honor. Naturalism was a psychological penetration of the motives of the bourgeois, in whom we saw our mortal enemy, and psychological penetration, despite all efforts at resistance, brings an identification with the various precepts of bourgeois morality. Archipenko, whom we honored as an unequalled model in the field of plastic art, maintained that art must be neither realistic nor idealistic, it must be true; and by this he meant above all that any imitation of nature, however concealed, is a lie. In this sense, Dada was to give the truth a new impetus. Dada was to be a rallying point for abstract energies and a lasting slingshot for the great international artistic movements.

Through Tzara we were also in relation with the futurist movement and carried on a correspondence with Marinetti. By that time Boccioni had been killed, but all of us knew his thick book, *Pittura e scultura futuriste.* We regarded Marinetti's position as realistic, and were opposed to it, although we were glad to take over the concept of simultaneity, of which he made so much use. Tzara for the first time had poems recited simultaneously on the stage, and these performances were a great success, although the *poème simultané* had already been introduced

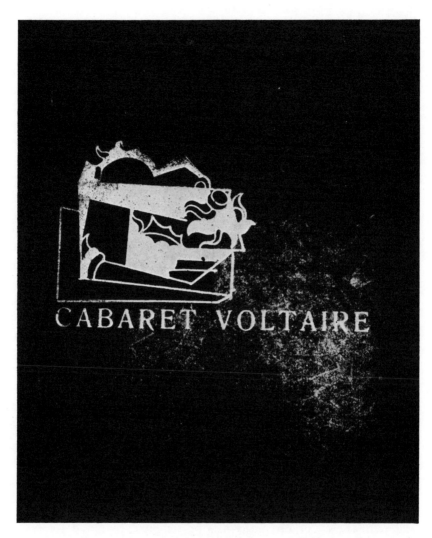

Cover. (For first number of *Cabaret Voltaire,* dada review, edited by Hugo Ball). Design by Arp. Zurich, 1916.

in France by Derème and others. From Marinetti we also borrowed "bruitism," or noise music, *le concert bruitiste,* which, of blessed memory, had created such a stir at the first appearance of the futurists in Milan, where they had regaled the audience with *le reveil de la capitale.* I spoke on the significance of bruitism at a number of open Dada gatherings.

"*Le bruit,*" noise with imitative effects, was introduced into art (in this connection we can hardly speak of individual arts, music or literature) by Marinetti, who used a chorus of typewriters, kettledrums, rattles and pot-covers to suggest the "awakening of the capital"; at first it was intended as nothing more than a rather violent reminder of the colorfulness of life. In contrast to the cubists or for that matter the German expressionists, the futurists regarded themselves as pure

activists. While all "abstract artists" maintained the position that a table is not the wood and nails it is made of but the idea of all tables, and forgot that a table could be used to put things on, the futurists wanted to immerse themselves in the "angularity" of things—for them the table signified a utensil for living, and so did everything else. Along with tables there were houses, frying-pans, urinals, women, etc. Consequently Marinetti and his group love war as the highest expression of the conflict of things, as a spontaneous eruption of possibilities, as movement, as a simultaneous poem, as a symphony of cries, shots, commands, embodying an attempted solution of the problem of life in motion. The problem of the soul is volcanic in nature. Every movement naturally produces noise. While number, and consequently melody, are symbols presupposing a faculty for abstraction, noise is a direct call to action. Music of whatever nature is harmonious, artistic, an activity of reason—but bruitism is life itself, it cannot be judged like a book, but rather it is a part of our personality, which attacks us, pursues us and tears us to pieces. Bruitism is a view of life, which, strange as it may seem at first, compels men to make an ultimate decision. There are only bruitists, and others. While we are speaking of music, Wagner had shown all the hypocrisy inherent in a pathetic faculty for abstraction—the screeching of a brake, on the other hand, could at least give you a toothache. In modern Europe, the same initiative which in America made ragtime a national music, led to the convulsion of bruitism.

Bruitism is a kind of return to nature. It is the music produced by circuits of atoms; death ceases to be an escape of the soul from earthly misery and becomes a vomiting, screaming and choking. The Dadaists of the Cabaret Voltaire took over bruitism without suspecting its philosophy—basically they desired the opposite: calming of the soul, an endless lullaby, art, abstract art. The Dadaists of the Cabaret Voltaire actually had no idea what they wanted—the wisps of "modern art" that at some time or other had clung to the minds of these individuals were gathered together and called "Dada." Tristan Tzara was devoured by ambition to move in international artistic circles as an equal or even a "leader." He was all ambition and restlessness. For his restlessness he sought a pole and for his ambition a ribbon. And what an extraordinary, never-to-be-repeated opportunity now arose to found an artistic movement and play the part of a literary mime! The passion of an aesthete is absolutely inaccessible to the man of ordinary concepts, who calls a dog a dog and a spoon a spoon. What a source of satisfaction it is to be denounced as a wit in a few cafés in Paris, Berlin, Rome! The history of literature is a grotesque imitation of world events, and a Napoleon among men of letters is the most tragi-comic character conceivable. Tristan Tzara had been one of the first to grasp the suggestive power of the word Dada. From here on he worked indefatigably as the prophet of a word, which only later was to be filled with a concept. He wrapped, pasted, addressed, he bombarded the French and Italians with letters; slowly he made himself the "focal point." We do not wish to belittle the fame of the *fondateur du Dadaisme* any more than that of *Oberdada* (Chief Dada) Baader, a Swabian pietist, who at the brink of old age, discovered Dadaism and journeyed through the countryside as a Dadaist prophet, to the delight of all

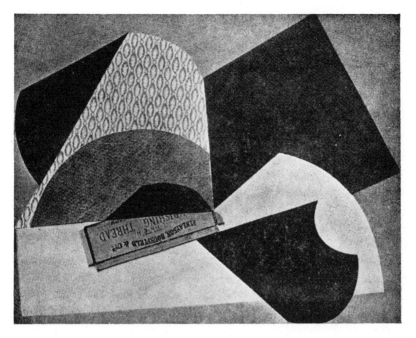

Arp. *Collage.* 1915. (Reproduced in Cabaret Voltaire). (Courtesy Cahiers d'Art, Paris).

fools. In the Cabaret Voltaire period, we wanted to "document"—we brought out the publication *Cabaret Voltaire,* a catch-all for the most diverse directions in art, which at that time seemed to us to constitute "Dada." None of us suspected what Dada might really become, for none of us understood enough about the times to free ourselves from traditional views and form a conception of art as a moral and social phenomenon. Art just was—there were artists and bourgeois. You had to love one and hate the other.

Yet despite everything, the artist as Tzara conceived him was something other than the German *dichter.* Guillaume Apollinaire jokingly claimed that his father had been a doorman in the Vatican; I suspect that Apollinaire was born in a Galician ghetto and became a Frenchman because he saw that Paris was the best place to make literature. The literary jobber is not the most deplorable figure created by the International of the mind. How much liberating honesty and decent shamelessness it takes to construe literature as a business. The litterati have their thieves' honor and their high-signs—in international trade, in the corners of hotel lobbies, in the *Mitropa* dining cars, the mask of the spirit is quickly dropped, there is too little time to dress up in an ideology that might appeal to other people. Manolescu, the great hotel thief, has written memoirs which, in point of diction and *esprit,* stand higher than all the German memoirs that have been brought forth by the war. Elasticity is everything. Marinetti has a good deal of the great literary magician of the future, who plays golf as well as he chats about Mallarmé, or, when necessary, makes remarks about ancient philology, yet at the same time is perfectly well aware which lady present it is safe to make a pass at.

The German *dichter* is the typical dope, who carries around with him an academic concept of "spirit," writes poems about communism, Zionism, socialism, as the need arises, and is positively amazed at the powers the Muse has given him. The German *dichter* has taken out a mortgage on literature. He thinks everything has to be as it is. He does not understand what a gigantic humbug the world has made of the "spirit" and that this is a good thing. In his head there is a hierarchy, with the inartistic man, which amounts to more or less the same as the uneducated, at the bottom and the man of the spirit, the Schillerian Hasenclever, yearning for the ethereal, at the top. That's how it is and that's how it's got to be. Just listen to old Schopenhauer in his *Parerga* telling us how stuck-up the German is about his culture, and, if you are anything of a psychologist you will see how comic and utterly hopeless is the situation of the German *dichter*. The German *dichter* who means violet even when he says bloodhound, the philistine over all philistines, the born abstractionist, the expressionist—surely that wasn't what Tzara wanted when he made Dadaism an abstract direction in art, but he never really understood what it meant to make literature with a gun in hand.

To make literature with a gun in hand, had for a time, been my dream. To be something like a robber-baron of the pen, a modern Ulrich von Hutten—that was my picture of a Dadaist. The Dadaist should have nothing but contempt for those who have made a Tusculum of the "spirit," a refuge for their own weaknesses. The philosopher in the garret was thoroughly obsolete—but so was the professional artist, the café litterateur, the society "wit," in general the man who could be moved in any way by intellectual accomplishment, who in intellectual matters found a welcome limitation which in his opinion gave him a special value before other men—the Dadaist as far as possible was to be the opposite of these. These men of the spirit sat in the cities, painted their little pictures, ground out their verses, and in their whole human structure they were hopelessly deformed, with weak muscles, without interest in the things of the day, enemies of the advertisement, enemies of the street, of bluff, of the big transactions which every day menaced the lives of thousands. Of life itself. But the Dadaist loves life, because he can throw it away every day; for him death is a Dadaist affair. The Dadaist looks forward to the day, fully aware that a flowerpot may fall on his head, he is naive, he loves the noises of the Métro, he likes to hang around Cook's travel bureau, and knows the practices of the angelmakers who behind closely drawn curtains dry out foetuses on blotting paper, in order to grind them up and sell them as ersatz coffee.

Everyone can be a Dadaist. Dada is not limited to any art. The bartender in the Manhattan Bar, who pours out Curaçao with one hand and gathers up his gonorrhea with the other, is a Dadaist. The gentleman in the raincoat, who is about to start his seventh trip around the world, is a Dadaist. The Dadaist should be a man who has fully understood that one is entitled to have ideas only if one can transform them into life—the completely active type, who lives only through action, because it holds the possibility of his achieving knowledge. A Dadaist is the man who rents a whole floor at the Hotel Bristol without knowing where the

money is coming from to tip the chambermaid. A Dadaist is the man of chance with the good eye and the rabbit punch. He can fling away his individuality like a lasso, he judges each case for itself, he is resigned to the realization that the world at one and the same time includes Mohammedans, Zwinglians, fifth formers, Anabaptists, pacifists, etc., etc. The motley character of the world is welcome to him but no source of surprise. In the evening the band plays by the lakeshore, and the whores tripping along on their high heels laugh into your face. It's a fucked-up foolish world. You walk aimlessly along, fixing up a philosophy for supper. But before you have it ready, the mailman brings you the first telegram, announcing that all your pigs have died of rabies, your dinner jacket has been thrown off the Eiffel Tower, your housekeeper has come down with the epizootic. You give a startled look at the moon, which seems to you like a good investment, and the same postman brings you a telegram announcing that all your chickens have died of hoof and mouth disease, your father has fallen on a pitchfork and frozen to death, your mother has burst with sorrow on the occasion of her silver wedding (maybe the frying pan stuck to her ears, how do I know?). That's life, my dear fellow. The days progress in the rhythm of your bowels and you, who have so often been in peril of choking on a fishbone, are still alive. You pull the covers up over your head and whistle the "Hohenfriedberger." And who knows, don't gloat too soon, perhaps the next day will see you at your desk, your pen ready for the thrust, bent over your new novel, *Rabble*. Who knows? That is pure Dadaism, ladies and gentlemen.

If Tristan Tzara had barely suspected the meaning of this famous existence we drag along between apes and bedbugs, he would have seen the fraud of all art and all artistic movements and he would have become a Dadaist. Where have these gentlemen who are so eager to appear in the history of literature left their irony? Where is the eye that weeps and laughs at the gigantic rump and carnival of this world? Buried in books, they have lost their independence, the ambition to be as famous as Rabelais or Flaubert has robbed them of the courage to laugh— there is so much marching, writing, living to be done. Rimbaud jumped in the ocean and started to swim to St. Helena, Rimbaud was a hell of a guy, they sit in the cafés and rack their brains over the quickest way of getting to be a hell of a guy. They have an academic conception of life—all litterati are Germans; and for that very reason they will never get close to life. Rimbaud very well understood that literature and art are mighty suspicious things—and how well a man can live as a pasha or a brothel-owner, as the creaking of the beds sings a song of mounting profits.

In Tzara's hands Dadaism achieved great triumphs. The Dadaists wrote books that were bought all over Europe; they put on shows to which thousands flocked. The world press adopted the Dada movement in art. A new sensation, ladies and gentlemen. In the hands of men who were no Dadaists, Dada became an immense sensation in Europe; it touched the soul of the true European who is at home between the pistons and boilers of machines, who hardly looks up from the *Daily News* when you meet him in Charing Cross Station, whom you find in fashionable tweeds on the decks of Red Star liners, with a pipeful of shag dangling noncha-

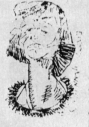

Hugo Ball. *"Lorsque je fondis le Cabaret Voltaire . . ."* (facsimile from Cabaret Voltaire). Zurich, 1916.

lantly from between his gold fillings.

Dada knew how to set the big rotary presses in motion, it was discussed in the Ecole de France and in the books of the psycho-analysts; in Madrid they tried to understand it, in Chile they tore each other's hair out over it, even in Chicago, with the grain exchange made famous by Frank Norris, there appeared for a moment as on a great eerie screen, the word Dada.

During the past decades in Europe, no word, no concept, no philosophy, no slogan of party or sect can be said to have burst upon the imagination of a civilized society with such catastrophic force. Do not forget the profound psychological significance of this fact. In the minds of all these people at the cafés, theatres, race tracks, brothels, who were interested in Dadaism because they regarded it as a

"ridiculous product of modern artistic madness," Dada had long since ceased to be a movement in art. You need to be a professor of philosophy with a catheter[1] at Berlin University not to see that ninety-nine out of a hundred people care as much about movements, individual techniques, perspectives in art, as the legendary cow about Easter Sunday. It did not interest them and was not even known to them that Dada, which did have an effect, however imponderable, upon them, had something to do with art and originated in art. A word which affects the masses so profoundly must embody an idea that touches the most vital interests of these masses, shaming, frightening or encouraging them in their innermost soul. That is why it is so incomprehensible that this Tristan Tzara, who out of childish ambition passes himself off as the inventor of Dada, should try to bind Dada to abstract art; such an attempt represents a total failure to understand things both near and far; he fails to see the possibilities of the birth, life and death of an idea, or to understand the significance that an *ens spirituale,* a *fluidum* (whether expressed in a word, concept or idea) can assume for a little circle of art-jobbers and a startled continent looking up from its work.

What Dada was in the beginning and how it developed is utterly unimportant in comparison with what it has come to mean in the mind of Europe. Dada has operated—not as mild suasion but like a thunderbolt, not like a system set down in a book, which through the channel of superior minds, after years of chewing and rechewing, becomes the universal possession of the nations, but like a watchword passed on by heralds on horseback. The immense effect of Dadaism on the great mass of the artistically indifferent lay in the senseless and comic character of the word Dada, and it would seem that this effect, in turn, must derive from some profound psychological cause, connected with the whole structure of "humanity" today and its present social organization. The average man, Smith, Schulze, Dupin, nature's famous mass-production ware, who disarms all intellectual evaluation, but with which nevertheless all psychological insight begins, heard that Dada was babies' prattle, that there were men who "made a business" of this prattle—that apparently some lunatics "wanted to start a party" based on the whimperings of the suckling babe. They held their sides laughing, they'd seen a good deal in their time, but this, well, all you can say is—(well, what can you say?) nix, nix, nix. Messrs. Schulzë, Smith and Dupin felt themselves strongly reminded by Dada of their milk bottle and honorably soiled diapers, now a generation behind them, and of the cry which was now to bring happiness into the world. Dada, Dada, Dada.

That is what I meant by the suggestivity of the word Dada, its ability to hypnotize, by guiding the vulgar mind to ideas and things which none of its originators had thought of. To be sure, the choice of the word Dada in the Cabaret Voltaire was selective-metaphysical, predetermined by all the idea-energies with which it was now acting upon the world—but no one had thought of Dada as babies' prattle. It is a rare gift of God to be present at the birth of a religion, or of any idea which later conquers the world. Even though Dada is not (I say this to reassure all Ger-

[1] A pun on the similarity of Katheder (professor's chair) and Katheter (catheter).

man high-school students and academic donkeys), thank God, an idea in the "progressive-cultural" sense celebrated in all historical compendia, but has a thoroughly ephemeral character, in that it has no desire to be anything more than a mirror which one quickly passes by, or a poster which in the harshest colors of the moment calls your attention to some opportunity to get rid of your money or fill your belly. Psychologically speaking! If you have had the miraculous good fortune to be present at the birth of such a "sensation," you will want to understand how it happens that an empty sound, first intended as a surname for a female singer, has developed amid grotesque adventures into a name for a rundown cabaret, then into abstract art, baby-talk and a party of babies at the breast, and finally—well, I shall not anticipate. This is exactly the history of Dadaism. Dada came over the Dadaists without their knowing it; it was an immaculate conception, and thereby its profound meaning was revealed to me.

The history of Dadaism is indeed one of the most interesting psychological events of the last twenty-five years; one need only have eyes to see and ears to hear. In the hands of the gentlemen in Zurich, Dada grew up into a creature which stood head and shoulders above all those present; and soon its existence could no longer be arranged with the precision demanded by a businesslike conduct of the Dadaist movement in art. Despite the most impassioned efforts, no one had yet found out exactly what Dada was. Tzara and Ball founded a "gallery" in which they exhibited Dadaistic art, i.e., "modern" art, which for Tzara meant non-objective, abstract art. But as I have said, abstract art was very old hat. Years before, Picasso had given up perspective as the expression of an intellectual and penetrating world conception, in favor of that archaizing, mathematical representation of space which, with Braque, he designated as cubism. There was something in the air of ageing Europe that demanded an attempt, by a last effort of the will, deriving its impulse from the knowledge of all cultures and artistic techniques, to return to the old intuitive possibilities, from which, it was realized, the various styles had emanated hundreds of years ago. It is no accident that the Latin peoples included in their program the mystic elements of Euclidean geometry, the conic sections and mathematical quantities, in so far as they were symbols of tangible bodies, while the Germans made the academic concept of intuition, in the form of expressionism, the signboard for their artistic barber shop. The Latins, with their last strength, directed their abstractionism toward something universally valid, something determined amid the indeterminate, which presupposed a personality that would treat the transcendental with inborn tact and moderation; while the Germans with their expressionism evoked the immeasurable eternalization of the subjective individual, giving free play to the *kolossal* and the grotesque, manifested in the arbitrary distortion of anatomical proportions.

The Galérie Dada capriciously exhibited cubist, expressionist and futurist pictures; it carried on its little art business at literary teas, lectures and recitation evenings, while the word Dada conquered the world. It was something touching to behold. Day after day the little group sat in its café, reading aloud the critical comments that poured in from every possible country, and which by their tone

of indignation showed that Dada had struck someone to the heart. Stricken dumb with amazement, we basked in our glory. Tristan Tzara could think of nothing else to do but write manifesto after manifesto, speaking of *"l'art nouveau, which is neither futurism nor cubism,"* but Dada. But what was Dada? *"Dada,"* came the answer, *"ne signifie rien."* With psychological astuteness, the Dadaists spoke of energy and will and assured the world that they had amazing plans. But concerning the nature of these plans, no information whatever was forthcoming.

Incommensurable values are conquering the world. If someone hurls a word into the crowd, accompanying it with a grand gesture, they make a religion of it. *Credo, quia absurdum.* Dada, as a mere word, actually conquered a large part of the world, even without association with any personality. This was an almost magical event. The true meaning of Dadaism was recognized only later in Germany by the people who were zealously propagating it, and these people, succumbing to the aggressive power and propagandistic force of the word, then became Dadaists. In Berlin they founded the Dada Club, which will be discussed below. The gentlemen of the Galérie Dada apparently noticed that their own stature was not consistent with the success of Dadaism. Things came to such a pass that they borrowed pictures from the Berlin art-dealer Herwarth Walden (who for a long time had been making money out of abstract art theories) and passed them off on the Swiss puddingheads as something extraordinary. In literature primitive tendencies were pursued. They read mediaeval prose, and Tzara ground out Negro verses which he palmed off as accidentally discovered remains of a Bantu or Winnetu culture, again to the great amazement of the Swiss. It was a dismal collection of Dadaists.

As I think back on it now, an art for art's sake mood lay over the Galérie Dada— it was a manicure salon of the fine arts, characterized by tea-drinking old ladies trying to revive their vanishing sexual powers with the help of "something mad." The Galérie Dada was an antechamber of ambition, where the beginners in the humbug of art had to accustom themselves to looking up to the leaders with the fish-eyed veneration found in Werfel's poems, when he sings of God, nature and spirit. The Galérie Dada was a small and cluttered kitchen of literary conventions, where no one experienced the slightest shame as long as he had a by-line. The gentlemen were all international, members of that League of the Spirit which at the decisive moment was such a catastrophe for Europe, two-dimensional, planimetric creatures, who had no sense of the compromise necessary to artistic activity in the restricted sense.

There might have been a way to make something of the situation. The group did nothing, and garnered success. They produced something, anything, and saw that the world was ready to pay high prices. It was a situation made to order for the racketeers of art and the spirit. But none of the gentlemen who sold abstract art in the Galérie Dada understood this, or else they did not want to understand it. Tzara did not want to give up his position as an artist within the abstract Myth, for the position of leadership he longed for had come tangibly near; and Ball, the founder of the Cabaret Voltaire (incidentally a far-sighted fellow) was too honor-

Cover. (For *Dada I*, review edited by Tristan Tzara). Zurich, July, 1917.

able, too Roman Catholic, too something. Both had insufficient insight into the possibilities of Dadaism; they lacked psychological astuteness. The Dadaist as racketeer, as Manolescu: this aspect reappeared.

The dissatisfaction ended in a battle between Tzara and Ball, a real bullfight among Dadaists, carried on, as such fights always are, with every resource of impertinence, falsification and physical brutality. Ball remembered his inward nature, withdrew definitively from Dada and from all art, and began to become a democrat in Bern, and in this, it seems to me, he has been very successful. Tzara and his supporters fell for a time into a stunned silence and then (since Dada was doing well in the world even without them) they plunged with renewed zeal into *l'art nouveau, l'art abstrait*. Tzara began to publish the magazine *Dada*, which found its way into every country in Europe and was widely purchased. We saw it in Germany, and it impressed us as commercial art and nothing else. The con-

tributors included, aside from the Zurich Dadaists, all the familiar names of the International of ultra-modern literature. Among many, I shall mention Francis Picabia, whom I deeply respect; at that time he was already contributing to Guillaume Apollinaire's famous *Soirées de Paris,* and is said to have stood to this periodical, which for a time played a leading role, in the relationship of the rich man to the lavatory attendant. Apollinaire, Marie Laurençin—the good Henry Rousseau who up to his death played the *Marseillaise* at home: old Paris came to life.

Now it has died for good. Today it is the stamping ground of Messrs. Foch and Millerand; Apollinaire died of influenza. Picabia is in New York—old Paris is done for. But very recently Dada turned up there in person. After exhausting all the Dadaistic possibilities in Zurich, after attempting in vain, by admitting Serner into his circle, to put new life into its ideas (after a good many more sensational performances and Dadaist parades), Tzara arrived in the city where Napoleon is supposed to have said that literature wasn't worth a pile of dung to him. Napoleon had stood at the foot of the Pyramids; Tzara managed immediately to turn the magazine *Littérature* into a Dadaist organ; he staged a great opening at which bruitist concerts and simultaneous poems made a terrific impression; he had himself enthroned, anointed and elected pope of the world Dada movement. Dada had conquered. Picasso and Marinetti must have felt rather strange when they heard of the success of their ideas under the name of "Dada." I fear that they were not Dadaist enough to understand Dada. But Picabia, who year after year, had watched the whole fraud pass him by, was not surprised. He had been a Dadaist before Tzara had let him in on the secret wisdom of Dadaism; his great wealth (his father was governor of Chile, Martinique or Cuba) permitted him to maintain a personal physician who was continually running after him with a loaded hypodermic. Francis Picabia is married to Gabriele Buffet, the daughter of a Paris deputy, and as my good friend Hans Arp (whom, in passing, I exempt from all my attacks on the Zurich Dadaists, and whose works, as an expression of his lovable personality, are most welcome to me) tells me, he loves violet waistcoats, smokes Chilean imports, and sometimes takes a glass of sarsaparilla for his imaginary or inherited lues. Tzara is in Paris; Picabia is back in New York. In the countries of the Allies, including the United States, Dada has been victorious. Before we leave it to its own resources and in particular take our leave of Tzara, and turn to Germany, I should like to say a few words about simultaneity, which those interested in Dada will encounter in all Dadaist performances and all Dadaist publications.

Simultaneity (first used by Marinetti in this literary sense) is an abstraction, a concept referring to the occurrence of different events at the same time. It presupposes a heightened sensitivity to the passage of things in time, it turns the sequence a=b=c=d into an a—b—c—d, and attempts to transform the problem of the ear into a problem of the face. Simultaneity is against what has become, and for what is becoming. While I, for example, become successively aware that I boxed an old woman on the ear yesterday and washed my hands an hour ago, the screeching of a streetcar brake and the crash of a brick falling off the roof next

door reach my ear simultaneously and my (outward or inward) eye rouses itself to seize, in the simultaneity of these events, a swift meaning of life. From the everyday events surrounding me (the big city, the Dada circus, crashing, screeching, steam whistles, house fronts, the smell of roast veal), I obtain an impulse which starts me toward direct action, becoming the big X. I become directly aware that I am alive, I feel the form-giving force behind the bustling of the clerks in the *Dresdner Bank* and the simple-minded erectness of the policeman.

Simultaneity is a direct reminder of life, and very closely bound up with bruitism. Just as physics distinguishes between tones (which can be expressed in mathematical formulae) and noises, which are completely baffling to its symbolism and abstractionism, because they are a direct objectivization of dark vital force, here the distinction is between a succession and a "simultaneity," which defies formulation because it is a direct symbol of action. And so ultimately a simultaneous poem means nothing but "Hurrah for life!" These problems are long chains. Simultaneity brings me, without feeling that I have taken a long leap, to "the new medium" in painting, which was enthusiastically touted by the Dadaists under Tzara as the *non plus ultra* of the "most modern" painting.

The introduction of the new medium has a certain metaphysical value, it is in a sense a transcendental revulsion against empty space, the result of the fear that is a part of the psychological foundation of all art and must be considered, in this special case, as a kind of *horror vacui*. The concept of reality is a highly variable value, and entirely dependent on the brain and the requirements of the brain which considers it. When Picasso gave up perspective, he felt that it was a set of rules that had been arbitrarily thrown over "nature": the parallels which cross on the horizon are a deplorable deception—behind them lies the infinity of space, which can never be measured. Consequently he restricted his painting to the foreground, he abandoned depth, freed himself from the morality of a plastic philosophy, recognized the conditionality of optical laws, which governed his eye in a particular country at a particular time; he sought a new, direct reality— he became, to use a vulgar term, non-objective. He wanted to paint no more men, women, donkeys and high-school students, since they partook of the whole system of deception, the theatre and the *blague* of existence—and at the same time he felt that painting with oil was a very definite symbol of a very definite culture and morality. He invented the new medium. He began to stick sand, hair, post-office forms and pieces of newspaper onto his pictures, to give them the value of a direct reality, removed from everything traditional. He well understood the ideal, slick, harmonious quality inherent in perspective and in oil painting; he sensed the Schillerian cadence that speaks out of every portrait, and the falsehood of the "landscape" produced by the sentimentality of oil painting.

Perspective and the color which, separated from its natural efficacy, can be squeezed out of tubes, are means of imitating nature; they run at the heels of things and have given up the actual struggle with life; they are shareholders in the cowardly and smug philosophy that belongs to the bourgeoisie. The new medium, on the other hand, points to the absolutely self-evident that is within

reach of our hands, to the natural and naive, to action. The new medium stands in a direct relation to simultaneity and bruitism. With the new medium the picture, which as such remains always the symbol of an unattainable reality, has literally taken a decisive step forward, that is, it has taken an enormous step from the horizon across the foreground; it participates in life itself. The sand, pieces of wood, hair that have been pasted on, give it the same kind of reality as a statue of the idol Moloch, in whose glowing arms child sacrifices are laid. The new medium is the road from yearning to the reality of little things, and this road is abstract. Abstraction (Tzara & Co. stubbornly refused to see this) is by its function a movement, not a goal. A pair of pants is after all more important than the solemn emotion that we situate in the upper regions of a Gothic cathedral "when it enfolds us."

The appropriation by Dada of these three principles, bruitism, simultaneity and, in painting, the new medium, is of course the "accident" leading to the psychological factors to which the real Dadaist movement owed its existence. As I have said, I find in the Dadaism of Tzara and his friends, who made abstract art the cornerstone of their new wisdom, no new idea deserving of very strenuous propaganda. They failed to advance along the abstract road, which ultimately leads from the painted surface to the reality of a post-office form. No sooner had they left the old, sentimental standpoint than they looked behind them, though still spurred on by ambition. They are neither fish nor flesh. In Germany Dadaism became political, it drew the ultimate consequences of its position and renounced art completely.

Yet it would be ungrateful to take leave of Tzara without tipping our hats. I have in my hand *Dadaphone*, a publication recently put out by the Paris Dadaists. It contains the photographs of the presidents of Entente Dadaism: André Breton, Louis Aragon, Francis Picabia, Céline Arnauld, Paul Eluard, G. Ribemont-Dessaignes, Philippe Soupault, Paul Dermée, Tristan Tzara. All very nice and harmless-looking gentlemen with pince-nez, horn-rimmed glasses and monocles, with flowing ties, faithful eyes and significant gestures, who can be seen from a distance to belong to literature. A Dadaist monster demonstration is announced, the program including a "Manifeste cannibale dans l'obscurité" (Cannibal manifesto in darkness) by Francis Picabia and a "Dadaphone" by Tristan Tzara. All this is exceedingly gay. Picabia addresses the public: "*Que faîtes-vous ici, parqués comme des huîtres sérieuses—car vous êtes sérieux, n'est-ce pas? Le cul, le cul représente la vie comme les pommes frites et vous tous qui êtes sérieux, vous sentirez plus mauvais que la merde de vache. Dada lui ne sent rien, il n'est rien, rien, rien. Sifflez, criez, cassez-moi la gueule, et puis, et puis? Je vous dirai encore que vous êtes tous des poires.*"[1] This was more than the Paris bourgeoisie in this moment of nationalistic fervor would stand for. The big newspapers went into the matter at length. In

[1] "What are you doing here, plunked down like serious oysters—because you are serious, aren't you? The ass, the ass represents life like fried potatoes, and all you serious people will smell worse than cow-flop. Dada smells of nothing, it is nothing, nothing, nothing. Whistle, shout, bash my face in, and then what? Then what? I'll just go on telling you that you're all fools."

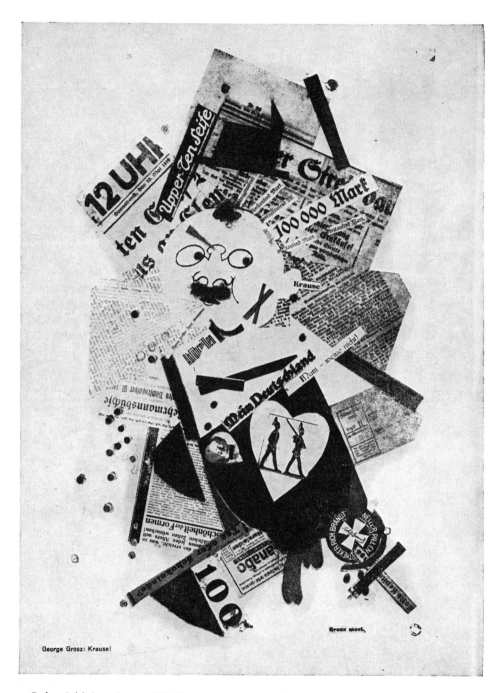

George Grosz: Krause!

Dadaco (trial sheets for unpublished anthology.) Munich, 1920. Montage by Grosz.

Le Temps, March 30, 1920, I find: *"La décadence intellectuelle est l'un des effets de la guerre. La guerre a fortifié les forts; elle a pu pervertir les pervers et abêtir les sots. Mais les vaincus eux-mêmes se protègent contre ces souffles malsains. Il est singulier de voir qu'en France des jeunes gens ('Proche-orientaux') les respirent avec satisfaction et qu'il se rencontre des gens moins jeunes pour les encourager dans cette tentative d'empoisonnement."*[1] *Dadaphone* announces a Dadaist exhibition, a Dadaist ball, a large number of Dadaist periodicals, most of which are probably a pious wish on the part of the editor of *Dadaphone;* in short, *une vie dadaïque extraordinaire* has blossomed out at Tzara's instigation.

In January 1917 I returned to Germany, the face of which had meanwhile undergone a fantastic change. I felt as though I had left a smug fat idyll for a street full of electric signs, shouting hawkers and auto horns. In Zurich the international profiteers sat in the restaurants with well-filled wallets and rosy cheeks, ate with their knives and smacked their lips in a merry hurrah for the countries that were bashing each other's skulls in. Berlin was the city of tightened stomachers, of mounting, thundering hunger, where hidden rage was transformed into a boundless money lust, and men's minds were concentrating more and more on questions of naked existence. Here we would have to proceed with entirely different methods, if we wanted to say something to the people. Here we would have to discard our patent leather pumps and tie our Byronic cravats to the doorpost. While in Zurich people lived as in a health resort, chasing after the ladies and longing for nightfall that would bring pleasure barges, magic lanterns and music by Verdi, in Berlin you never knew where the next meal was coming from. Fear was in everybody's bones, everybody had a feeling that the big deal launched by Hindenburg & Co. was going to turn out very badly. The people had an exalted and romantic attitude towards art and all cultural values. A phenomenon familiar in German history was again manifested: Germany always becomes the land of poets and thinkers when it begins to be washed up as the land of judges and butchers.

In 1917 the Germans were beginning to give a great deal of thought to their souls. This was only a natural defense on the part of a society that had been harassed, milked dry, and driven to the breaking point. This was the time when expressionism began to enjoy a vogue, since its whole attitude fell in with the retreat and the weariness of the German spirit. It was only natural that the Germans should have lost their enthusiasm for reality, to which before the war they had sung hymns of praise, through the mouths of innumerable academic thickheads, and which had now cost them over a million dead, while the blockade was strangling their children and grandchildren. Germany was seized with the mood that always precedes a so-called idealistic resurrection, an orgy à la Turnvater-Jahn, a Schenkendorf period.[2]

1 "Intellectual decadence is one of the effects of the war. The war has strengthened the strong; it has also perverted the perverts and stupefied the stupid. But even the vanquished defend themselves against these unhealthy vapors. It is strange to see that in France there are young people ('Near Easterners') who breathe them with satisfaction and that there are people less young who encourage them in this attempted poisoning."

2 "Turnvater"—"gymnastic father," refers to Ludwig Jahn, the founder of the gymnastic societies which played an important part in the liberation of Germany from Napoleon.

Now came the expressionists, like those famous medical quacks who promise to "fix everything up," looking heavenward like the gentle Muse; they pointed to "the rich treasures of our literature," pulled people gently by the sleeve and led them into the half-light of the Gothic cathedrals, where the street noises die down to a distant murmur and, in accordance with the old principle that all cats are gray at night, men without exception are fine fellows. Man, they have discovered, is good. And so expressionism, which brought the Germans so many welcome truths, became a "national achievement." In art it aimed at inwardness, abstraction, renunciation of all objectivity. When expressionism is mentioned, the first three names I think of are Däubler, Edschmid, and Hiller. Däubler is the gigantosaurus of expressionist lyric poetry. Edschmid the prose writer and prototype of the expressionist man, while Kurt Hiller, with his intentional or unintentional meliorism, is the theoretician of the expressionist age.

On the basis of all these considerations and the psychological insight that a turning-away from objective reality implied the whole complex of weariness and cowardice that is so welcome to putrescent bourgeoisie, we immediately launched a sharp attack on expressionism in Germany, under the watchword of "action," acquired through our fight for the principles of bruitism, simultaneity and the new medium. The first German Dadaist manifesto, written by myself, says among other things: "Art in its execution and direction is dependent on the time in which it lives, and artists are creatures of their epoch. The highest art will be that which in its conscious content presents the thousandfold problems of the day, the art which has been visibly shattered by the explosions of the last week, which is forever trying to collect its limbs after yesterday's crash. The best and most extraordinary artists will be those who every hour snatch the tatters of their bodies out of the frenzied cataract of life, who, with bleeding hands and hearts, hold fast to the intelligence of their time. Has expressionism fulfilled our expectations of such an art, which should be the expression of our most vital concerns? *No! No! No!* Under the pretext of turning inward, the expressionists in literature and painting have banded together into a generation which is already looking forward to honorable mention in the histories of literature and art and aspiring to the most respectable civic distinctions. On pretext of carrying on propaganda for the soul, they have, in their struggle with naturalism, found their way back to the abstract, pathetic gestures which presuppose a comfortable life free from content or strife. The stages are filling up with kings, poets and Faustian characters of all sorts; the theory of a melioristic philosophy, the psychological naïvety of which is highly significant for a critical understanding of expressionism, runs ghostlike through the minds of men who never act. Hatred of the press, hatred of advertising, hatred of sensations, are typical of people who prefer their armchair to the noise of the street, and who even make it a point of pride to be swindled by every small-time profiteer. That sentimental resistance to the times, which are neither better nor worse, neither more reactionary nor more revolutionary than other times, that weak-kneed resistance, flirting with prayers and incense when it does not prefer to load its cardboard cannon with Attic iambics—is the quality of a youth

which never knew how to be young. Expressionism, discovered abroad, and in Germany, true to style, transformed into an opulent idyll and the expectation of a good pension, has nothing in common with the efforts of active men. The signers of this manifesto have, under the battle cry Dada!, gathered together to put forward a new art, from which they expect the realization of new ideals." And so on. Here the difference between our conception and that of Tzara is clear. While Tzara was still writing: *"Dada ne signifie rien"*—in Germany Dada lost its art-for-art's-sake character with its very first move. Instead of continuing to produce art, Dada, in direct contrast to abstract art, went out and found an adversary. Emphasis was laid on the movement, on struggle. But we still needed a program of action, we had to say exactly what our Dadaism was after. This program was drawn up by Raoul Hausmann and myself. In it we consciously adopted a political position:

What is Dadaism and what does it want in Germany?

1. *Dadaism demands:*

1) The international revolutionary union of all creative and intellectual men and women on the basis of radical Communism;

2) The introduction of progressive unemployment through comprehensive mechanization of every field of activity. Only by unemployment does it become possible for the individual to achieve certainty as to the truth of life and finally become accustomed to experience;

3) The immediate expropriation of property (socialization) and the communal feeding of all; further, the erection of cities of light, and gardens which will belong to society as a whole and prepare man for a state of freedom.

2. *The Central Council demands:*

a) Daily meals at public expense for all creative and intellectual men and women on the Potsdamer Platz (Berlin);

b) Compulsory adherence of all clergymen and teachers to the Dadaist articles of faith;

c) The most brutal struggle against all directions of so-called "workers of the spirit" (Hiller, Adler), against their concealed bourgeoisism, against expressionism and post-classical education as advocated by the Sturm group;

d) The immediate erection of a state art center, elimination of concepts of property in the new art (expressionism); the concept of property is entirely excluded from the super-individual movement of Dadaism which liberates all mankind;

e) Introduction of the simultaneist poem as a Communist state prayer;

f) Requisition of churches for the performance of bruitism, simultaneist and Dadaist poems;

g) Establishment of a Dadaist advisory council for the remodelling of life in every city of over 50,000 inhabitants;

h) Immediate organization of a large scale Dadaist propaganda campaign with 150 circuses for the enlightenment of the proletariat;

i) Submission of all laws and decrees to the Dadaist central council for approval;

j) Immediate regulation of all sexual relations according to the views of international Dadaism through establishment of a Dadaist sexual center.

The Dadaist revolutionary central council.
German group: Hausmann, Huelsenbeck
Business Office: Charlottenburg, Kantstrasse 118.
Applications for membership taken at business office.

The significance of this program is that in it Dada turns decisively away from the speculative, in a sense loses its metaphysics and reveals its understanding of itself as an expression of this age which is primarily characterized by machinery and the growth of civilization. It desires to be no more than an expression of the times, it has taken into itself all their knowledge, their breathless tempo, their scepticism, but also their weariness, their despair of a meaning or a "truth." In an article on expressionism Kornfeld makes the distinction between the ethical man and the psychological man. The ethical man has the child-like piety and faith which permit him to kneel at some altar and recognize some God, who has the power to lead men from their misery to some paradise. The psychological man has journeyed vainly through the infinite, has recognized the limits of his spiritual possibilities, he knows that every "system" is a seduction with all the consequences of seduction and every God an opportunity for financiers.

The Dadaist, as the psychological man, has brought back his gaze from the distance and considers it important to have shoes that fit and a suit without holes in it. The Dadaist is an atheist by instinct. He is no longer a metaphysician in the sense of finding a rule for the conduct of life in any theoretical principles, for him there is no longer a "thou shalt"; for him the cigarette-butt and the umbrella are as exalted and as timeless as the "thing in itself." Consequently, the good is for the Dadaist no "better" than the bad—there is only a simultaneity, in values as in everything else. This simultaneity applied to the economy of facts is communism, a communism, to be sure, which has abandoned the principle of "making things better" and above all sees its goal in the destruction of everything that has gone bourgeois. Thus the Dadaist is opposed to the idea of paradise in every form, and one of the ideas farthest from his mind is that "the spirit is the sum of all means for the improvement of human existence." The word "improvement" is in every form unintelligible to the Dadaist, since behind it he sees a hammering and sawing on this life which, though useless, aimless and vile, represents as such a thoroughly spiritual phenomenon, requiring no improvement in a metaphysical sense. To mention spirit and improvement in the same breath is for the Dadaist a blasphemy. "Evil" has a profound meaning, the polarity of events finds in it a limit, and though the real political thinker (such as Lenin seems to be) creates a movement, i.e., he dissolves individualities with the help of a theory, he changes nothing. And that, as paradoxical as it may seem, is the import of the Communist movement.

42

The Dadaist exploits the psychological possibilities inherent in his faculty for flinging out his own personality as one flings a lasso or lets a cloak flutter in the wind. He is not the same man today as tomorrow, the day after tomorrow he will perhaps be "nothing at all," and then he may become everything. He is entirely devoted to the movement of life, he accepts its angularity—but he never loses his distance to phenomena, because at the same time he preserves his creative indifference, as Friedlaender-Mynona calls it. It seems scarcely credible that anyone could be at the same time active and at rest, that he should be devoted, yet maintain an attitude of rejection; and yet it is in this very anomaly that life itself consists, naive, obvious life, with its indifference toward happiness and death, joy and misery. The Dadaist is naive. The thing he is after is obvious, undifferentiated, unintellectual life. For him a table is not a mouse-trap and an umbrella is definitely not to pick your teeth with. In such a life art is no more and no less than a psychological problem. In relation to the masses, it is a phenomenon of public morality.

The Dadaist considers it necessary to come out against art, because he has seen through its fraud as a moral safety valve. Perhaps this militant attitude is a last gesture of inculcated honesty, perhaps it merely amuses the Dadaist, perhaps it means nothing at all. But in any case, art (including culture, spirit, athletic club), regarded from a serious point of view, is a large-scale swindle. And this, as I have hinted above, most especially in Germany, where the most absurd idolatry of all sorts of divinities is beaten into the child in order that the grown man and taxpayer should automatically fall on his knees when, in the interest of the state or some smaller gang of thieves, he receives the order to worship some "great spirit." I maintain again and again: the whole spirit business is a vulgar utilitarian swindle. In this war the Germans (especially in Saxony where the most infamous hypocrites reside) strove to justify themselves at home and abroad with Goethe and Schiller. Culture can be designated solemnly and with complete naivety as the national spirit become form, but also it can be characterized as a compensatory phenomenon, an obeisance to an invisible judge, as veronal for the conscience. The Germans are masters of dissembling, they are unquestionably the magicians (in the vaudeville sense) among nations, in every moment of their life they conjure up a culture, a spirit, a superiority which they can hold as a shield in front of their endangered bellies. It is this hypocrisy that has always seemed utterly foreign and incomprehensible to the French, a sign of diabolical malice. The German is un-naive, he is twofold and has a double base.

Here we have no intention of standing up for any nation. The French have the least right of anyone to be praised as a *grande nation,* now that they have brought the chauvinism of our times to its greatest possible height. The German has all the qualities and drawbacks of the idealist. You can look at it whichever way you like. You can construe the idealism that distorts things and makes them function as an absolute (the discipline of corpses) whether it be vegetarianism, the rights of man or the monarchy, as a pathological deformation, or you can call it ecstatically "the bridge to eternity," "the goal of life," or more such platitudes. The ex-

pressionists have done quite a bit in that direction. The Dadaist is instinctively opposed to all this. He is a man of reality who loves wine, women and advertising, his culture is above all of the body. *Instinctively he sees his mission in smashing the cultural ideology of the Germans.* I have no desire to justify the Dadaist. He acts instinctively, just as a man might say he was a thief out of "passion," or a stamp-collector by preference. The "ideal" has shifted: the abstract artist has become (if you insist, dear reader) a wicked materialist, with the abstruse characteristic of considering the care of his stomach and stock jobbing more honorable than philosophy. "But that's nothing new," those people will shout who can never tear themselves away from the "old." But it is something startlingly new, since for the first time in history the consequence has been drawn from the question: What is German culture? (Answer: Shit), and this culture is attacked with all the instruments of satire, bluff, irony and finally, violence. And in a great common action.

Dada is German Bolshevism. The bourgeois must be deprived of the opportunity to "buy up art for his justification." Art should altogether get a sound thrashing, and Dada stands for the thrashing with all the vehemence of its limited nature. The technical aspect of the Dadaist campaign against German culture was considered at great length. Our best instrument consisted of big demonstrations at which, in return for a suitable admission fee, everything connected with spirit, culture and inwardness was symbolically massacred. It is ridiculous and a sign of idiocy exceeding the legal limit to say that Dada (whose actual achievements and immense success cannot be denied) is "only of negative value." Today you can hardly fool first-graders with the old saw about positive and negative.

The gentlemen who demand the "constructive" are among the most suspicious types of a caste that has long been bankrupt. It has become sufficiently apparent in our time that law, order and the constructive, the "understanding for an organic development," are only symbols, curtains and pretexts for fat behinds and treachery. If the Dadaist movement is nihilism, then nihilism is a part of life, a truth which would be confirmed by any professor of zoology. Relativism, Dadaism, Nihilism, Action, Revolution, Gramophone. It makes one sick at heart to hear all that together, and as such (insofar as it becomes visible in the form of a theory), it all seems very stupid and antiquated. Dada does not take a dogmatic attitude. If Knatschke proves today that Dada is old stuff, Dada doesn't care. A tree is old stuff too, and people eat dinner day after day without experiencing any particular disgust. This whole physiological attitude toward the world, that goes so far as to make—as Nietzsche the great philologist did—all culture depend on dry or liquid nutriment, is of course to be taken with a grain of salt. It is just as true and just as silly as the opposite. But we are after all human and commit ourselves by the mere fact of drinking coffee today and tea tomorrow. Dada foresees its end and laughs. Death is a thoroughly Dadaist business, in that it signifies nothing at all. Dada has the right to dissolve itself and will exert this right when the time comes. With a businesslike gesture, freshly pressed pants, a shave and a haircut, it will go down into the grave, after having made suitable arrangements

with the Thanatos Funeral Home. The time is not far distant. We have very sensitive fingertips and a larynx of glazed paper. The mediocrities and the gentry in search of "something mad" are beginning to conquer Dada. At every corner of our dear German fatherland, literary cliques, with Dada as a background, are endeavoring to assume a heroic pose. A movement must have sufficient talent to make its decline interesting and pleasant. In the end it is immaterial whether the Germans keep on with their cultural humbug or not. Let them achieve immortality with it. But if Dada dies here, it will some day appear on another planet with rattles and kettledrums, pot covers and simultaneous poems, and remind the old God that there are still people who are very well aware of the complete idiocy of the world.

Dada achieved the greatest successes in Germany. We Dadaists formed a company which soon became the terror of the population—to it belonged, in addition to myself, Raoul Haussmann, Georg Grosz, John Heartfield, Wieland Herzfelde, Walter Mehring and a certain Baader. In 1919 we put on several big evening shows; at the beginning of December, through no fault of our own, we gave two Sunday afternoon performances in the institute for socialist hypocrisy, the "Tribune," which achieved the success of good box-office receipts and a word of melancholy-reluctant praise in the form of an article in the *Berliner Tageblatt* by Alfred Kerr, a critic well known and appreciated a century ago, but now quite crippled and arterio-sclerotic. With Haussman, the "Dadasoph," to whom I became greatly attached because of his selfless shrewdness, and the above-mentioned Baader, I undertook in February 1920 a Dada tour, which began in Leipzig on February 24 with a performance in the Zentraltheater attended by a tremendous ruckus ("bruit") which gave our decayed old globe quite a shaking up; this affair was attended by 2,000 people. We began in Leipzig, on the basis of the sound idea that all Germans are Saxons, a truth, it seems to me which speaks for itself. We then went to Bohemia, and on February 26 we appeared in Teplitz-Schönau before an audience of fools and curiosity-seekers. That same night we drank ourselves into a stupor, after, with our last sober breath, we had appointed Hugo Dux, the most intelligent inhabitant of Teplitz, chief of all Dadaists in Czechoslovakia. Baader, who is almost fifty years of age and, as far as I know, is already a grandfather, then repaired to the Bawdy House of the Bumblebee, where he wallowed in wine, women and roast pork and devised a criminal plan which, he calculated, would cost Hausmann and myself our lives in Prague on March 1. On March 1 the three of us were planning to put on a show in the Prague produce exchange, which seats nearly 2,500 persons. And conditions in Prague are rather peculiar. We had been threatened with violence from all sides. The Czechs wanted to beat us up because we were unfortunately Germans; the Germans had taken it into their heads that we were Bolsheviks; and the Socialists threatened us with death and annihilation because they regarded us as reactionary voluptuaries. Weeks before our arrival the newspapers had started a monster Dada publicity campaign and expectations could not have been screwed to a higher pitch. Apparently the good people of Prague expected the living cows to fall from the heavens—in the streets

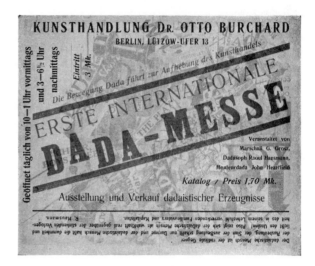

First International Dada Fair. (Catalogue, first page). Berlin, June 1920.

crowds formed behind us with rhythmic roars of "Dada," in the newspaper offices the editors obligingly showed us the revolvers with which, under certain circumstances, they were planning to shoot us down on March 1. All this had smitten Baader's brain with a powerful impact. The poor pietist had conceived such a very different picture of our Dada tour. He had hoped to return to his wife and children with money in his pocket, to draw a comfortable income from Dada and, after performance of his conjugal duty, retire with a pipeful of Germania ersatz tobacco to dream in all tranquillity of his heroic feats.

But now he was to take leave of his precious life, now there was a chance that he would end his poetic career in a Prague morgue. In his terror he was willing to promise anything, to bear any disgrace if his cousin, the old God of the Jews, with whom he had so often allied himself, would only preserve him this last time from the dissolution of his individuality as a pseudo-bard. *Dum vita superest, bene est.* The performance in the produce exchange was to begin at 8 o'clock. At 7:30 I ask Hausmann about Baader's whereabouts. "He left me a note saying he had to go over to the post-office." And so he left us up to the very last moment in the belief that he would still turn up; this he did in order to prevent us from changing the program, thus exposing us with all the more certainty to the fury of the public. The whole city was in an uproar. Thousands crowded around the entrances of the produce exchange. By dozens they were sitting on the window-ledges and pianos, raging and roaring. Hausmann and I, in great agitation, sat in the little vestibule which had been rigged up as a green room. The windowpanes were already beginning to rattle. It was 8:20. No sign of Baader. Only now did we see what was up. Hausmann remembered that he had seen a letter "to Hausmann and Huelsenbeck" stuck in his underclothes. We realized that Baader had deserted us, we would have to go through with the hocus pocus by ourselves as best we could. The situation could not have been worse—the platform (an improvised board

structure) could be reached only through the massed audience—and Baader had fled with half the manuscript. Now was the time to do or die. Hic Rhodus! My honored readers, with the help of God and our routine, a great victory was won for Dada in Prague on March 1. On March 2 Hausmann and I appeared before a smaller audience in the Mozarteum, again with great success. On March 5 we were in Karlsbad, where to our great satisfaction we were able to ascertain that Dada is eternal and destined to achieve undying fame.

Richard Huelsenbeck (left) and Raoul Hausmann. Prague, 1920.

DADA

Was ist **dada**?

Eine Kunst? Eine Philosophie? eine Politik? **Eine Feuerversicherung?** Oder: *Staatsreligion?* ist **dada** wirkliche ENERGIE? oder ist es ⚑ **Garnichts**, d. h. **alles?**

Die Geister einer unbedeutenden Epoche sind vor eine große und schwere Aufgabe gestellt. Wo die Wirklichkeit, zu der alles Geistige in engster Beziehung steht und von der es den stärksten Teil seiner Antriebe erhält, in höchsten Taumel gerissen ist, wo ein Tag verneint, was der vorhergehende heiligte, wo die Ereignisse sich überstürzen wie

ZNERSCHLÄGE

ist es schwerer als in ruhiger Zeit, das Maß der Persönlichkeit auszubalanzieren und den Kreis zu formieren, aus dem man als gesammelte Erscheinung aufwächst. Es fehlt das, was man die Schule der Geistigkeit nennen kann. Derjenige, der im Ausdruck seiner Gedanken seine Lebensarbeit sieht, bleibt am Anfang der Entwicklung auf das Wort und die Tat der Vorhergehenden angewiesen. Unwillkürlich richten sich die Augen des jungen Dichters auf die ältere Generation; je weniger sicher er sich fühlt, umsomehr ist er bestrebt, aus dem Leben der Väter ein Ziel zu suchen, das ihm für ein gemeinsames Streben verbindlich zu sein scheint. Die Tradition ist ein mächtiges Agens, das in den bedeutendsten Kulturen immer wieder gesucht und hervorgehoben wird. Die französische Geistigkeit ist ohne die Tradition nicht denkbar und immer wieder steht jemand auf, der das Genie latin preist, wie es sich von Rabelais bis Anatol France, bestimmt von klimatischen und völkischen Verhältnissen geäußert hat. Immer wieder hat es dort eine Renaissance française gegeben und mit dem Eigentümlichen des französischen Geistes wie es von Vätern und Großvätern gehandhabt worden ist, wäre die Kultur des Landes dahin. Dies Gemeinsame, dies Abstrakte hinter der Fülle der einzelnen Erscheinungen hat die Jugend von jeher gesucht, um sich eine Schule daraus zu machen. Es ist der Sinn für Verehrung und Begeisterung, eine Eigenschaft der Zwanzigjährigen, die sie dazu befähigt, sie sucht Gemeinschaft, Freundschaftsbunde, Klubs, in denen man Alles diskutieren kann, um das Neue daraus wachsen zu lassen. Dies natürliche Bedürfnis bildete die Handwerks- und Malschulen, aus der die große Kunst des Mittelalters hervorging. Die Jugend allein hat das Recht und das Vorrecht, sich unter zu ordnen, weil sie allein aus einem Abhängigkeitsverhältnis gestärkt hervorgehen, kann, weil sie allein eine Bildung des Charakters findet, wo andere in Knechtschaft und Infamie herabsinken. Aber wo findet die Jugend einer Epoche wie die unsere, die Möglichkeit sich Lehrer zu suchen, von deren Lippen sie Klugheit und Weltweisheit kennen lernen kann, in deren Büchern sie den

Tretet Dada bei

sINN DER wELT

Küße
DIW
sizzen
auff den
TELE
grap hen
sTangen

suchen und finden könnte?

Dadaco (trial sheets for unpublished anthology.) Munich, 1920. Page.

III. *Dada Fragments*

By Hugo Ball. 1916–17. Translated from the German by Eugene
Jolas. These fragments, first translated in *Transition,*
Paris, no. 25, Fall, 1936, are from Ball's *Flucht aus der
Zeit,* Munich-Leipzig, Duncker and Humblot, 1927.
By permission of Eugene Jolas.

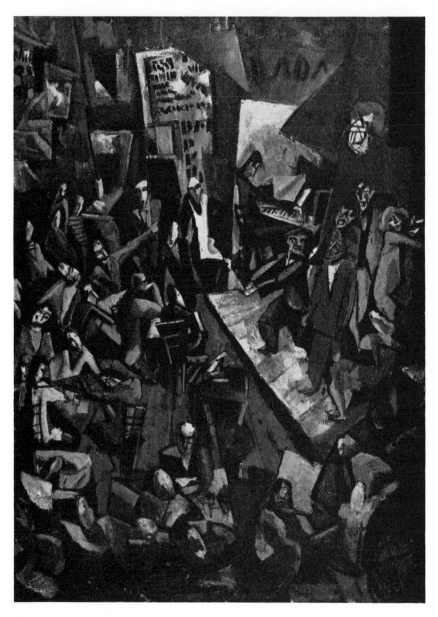

Marcel Janco. *Cabaret Voltaire*. Oil. 1917.

Hugo Ball: *Dada Fragments (1916-1917)*

March 3, 1916—Introduce symmetries and rhythms instead of principles. Contradict the existing world orders . . .

What we are celebrating is at once a buffoonery and a requiem mass . . .

June 12, 1916—What we call Dada is a harlequinade made of nothingness in which all higher questions are involved, a gladiator's gesture, a play with shabby debris, an execution of postured morality and plenitude . . .

The Dadaist loves the extraordinary, the absurd, even. He knows that life asserts itself in contradictions, and that his age, more than any preceding it, aims at the destruction of all generous impulses. Every kind of mask is therefore welcome to him, every play at hide and seek in which there is an inherent power of deception. The direct and the primitive appear to him in the midst of this huge anti-nature, as being the supernatural itself . . .

The bankruptcy of ideas having destroyed the concept of humanity to its very innermost strata, the instincts and hereditary backgrounds are now emerging pathologically. Since no art, politics or religious faith seems adequate to dam this torrent, there remain only the *blague* and the bleeding pose . . .

The Dadaist trusts more in the sincerity of events than in the wit of persons. To him persons may be had cheaply, his own person not excepted. He no longer believes in the comprehension of things from *one* point of departure, but is nevertheless convinced of the union of all things, of totality, to such an extent that he suffers from dissonances to the point of self-dissolution . . .

The Dadaist fights against the death-throes and death-drunkenness of his time. Averse to every clever reticence, he cultivates the curiosity of one who experiences delight even in the most questionable forms of insubordination. He knows that this world of systems has gone to pieces, and that the age which demanded cash has organized a bargain sale of godless philosophies. Where bad conscience begins for the market-booth owners, mild laughter and mild kindliness begin for the Dadaist . . .

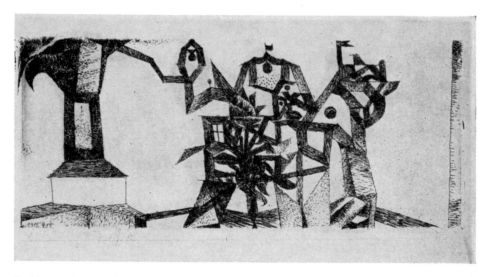

Paul Klee. *Luftschloesschen*. 1915. (Courtesy Curt Valentin, N.Y.).

The image differentiates us. Through the image we comprehend. Whatever it may be—it is night—we hold the print of it in our hands . . .

The word and the image are one. Painting and composing poetry belong together. Christ is image and word. The word and the image are crucified . . .

June 18, 1916—We have developed the plasticity of the word to a point which can hardly be surpassed. This result was achieved at the price of the logically constructed, rational sentence, and therefore, also, by renouncing the document (which is only possible by means of a time-robbing grouping of sentences in a logically ordered syntax). We were assisted in our efforts by the special circumstances of our age, which does not allow a real talent either to rest or ripen, forcing it to a premature test of its capacities, as well as by the emphatic élan of our group, whose members sought to surpass each other by an even greater intensification and accentuation of their platform. People may smile, if they want to; language will thank us for our zeal, even if there should not be any directly visible results. We have charged the word with forces and energies which made it possible for us to rediscover the evangelical concept of the "word" (logos) as a magical complex of images . . .

August 5, 1916—Childhood as a new world, and everything childlike and phantastic, everything childlike and direct, everything childlike and symbolical in opposition to the senilities of the world of grown-ups. The child will be the accuser on Judgment Day, the Crucified One will judge, the Resurrected One will pardon. The distrust of children, their shut-in quality, their escape from our recognition —their recognition that they won't be understood anyway . . .

Childhood is not at all as obvious as is generally assumed. It is a world to which hardly any attention is paid, with its own laws, without whose application there

is no art, and without whose religious and philosophic recognition art cannot exist or be apprehended . . .

The credulous imagination of children, however, is also exposed to corruption and deformation. To surpass oneself in naiveté and childishness—that is still the best antidote . . .

November 21, 1916—Note about a criticism of individualism: The accentuated "I" has constant interests, whether they be greedy, dictatorial, vain or lazy. It always follows appetites, so long as it does not become absorbed in society. Whoever renounces his interests, renounces his "I." The "I" and the interests are identical. Therefore, the individualistic-egoistic ideal of the Renaissance ripened to the general union of the mechanized appetites which we now see before us, bleeding and disintegrating.

January 9, 1917—We should burn all libraries and allow to remain only that which every one knows by heart. A beautiful age of the legend would then begin . . .

The middle ages praised not only foolishness, but even idiocy. The barons sent their children to board with idiotic families so that they might learn humility . . .

March 30, 1917—The new art is sympathetic because in an age of total disruption it has conserved the will-to-the-image; because it is inclined to force the image, even though the means and parts be antagonistic. Convention triumphs in the moralistic evaluation of the parts and details; art cannot be concerned with

CATALOGUE DE L'EXPOSITION CABARET VOLTAIRE
KATALOG DER AUSSTELLUNG CABARET VOLTAIRE

Hans Arp:	Zeichnung I (1914)	L. Modegliani:	Portrait Hans Arp II (Dessin)
	Zeichnung II (1914)	Eli Nadelmann:	Dessins I — IV
	Papierbild I (1916)	Max Oppenheimer:	Remboursement (Oel)
	Papierbild II (1916)	Pablo Picasso:	Eau-forte I
	Papierbild III (1916)		„ II
Paolo Buzzi:	L'Ellipse (Parole in libertà)		„ III
Francesco Canguillo:	Parole in libertà		„ IV
Corrado Govoni:	Parole in libertà	O. van Rees:	Landschaft I (Oel. 1913
Marcel Janco:	Dessins I — V		Landschaft II (Oel. 1913
	Décorative		Landschaft III (Tempera. 1913
	Enterrement et voiture		Stilleben (Papierbild. 1916
	Matrapazlâc	M. Slodki:	Affiche Cabaret Voltaire
	Mouvement (Peinture)		Dostojewski Holzschnitt
	Caracterul arhanghelilor		Tolstoi „
V. Kissling:	Paysage I		Interieur I „
	„ II.		Interieur II „
August Macke:	Landschaft (Aquarell)	Artur Segall:	Composite.
F. T. Marinetti:	Dune (Parole in libertà)		Holzschnitte I - III
L. Modegliani:	Portrait Hans Arp I (Dessin)	Henry Wabel:	Landschaft (Oel)

Catalogue of Cabaret Voltaire Exhibition (from the review, edited by Hugo Ball). Zurich, 1916.

this. It drives toward the in-dwelling, all-connecting life nerve; it is indifferent to external resistance. One might also say: morals are withdrawn from convention, and utilized for the sole purpose of sharpening the senses of measure and weight . . .

March 7, 1917—One might also speak of Klee as follows: He always presents himself as quite small and playful. In an age of the colossal he falls in love with a green leaf, a little star, a butterfly wing; and since heaven and infinity are reflected in them, he paints them in. The point of his pencil, his brush, tempt him to minutiae. He always remains quite near first beginnings and the smallest format. The beginning possesses him and will not let him go. When he reaches the end, he does not start a new leaf at once, but begins to paint over the first one. The little formats are filled with intensity, become magic letters and colored palimpsests . . .

What irony, approaching sarcasm even, must this artist feel for our hollow, empty epoch. Perhaps there is no man today who is so master of himself as Klee. He scarcely detaches himself from his inspiration. He knows the shortest path from his inspiration to the page. The wide, distracting, stretching-out of the hand and body which Kandinsky needs to fill the great formats of his canvases, necessarily brings waste and fatigue; it demands an exhaustive exposition, and explanation. Painting, when it seeks to retain unity and soul, becomes a sermon, or music.

April 18, 1917—Perhaps the art which we are seeking is the key to every former art: a salomonic key that will open all mysteries.

Dadaism—a mask play, a burst of laughter? And behind it, a synthesis of the romantic, dandyistic and—daemonistic theories of the 19th century.

Hugo Ball. c. 1920.

54

IV. *Merz*

By Kurt Schwitters. 1920. Translated complete
from the German by Ralph Manheim. First appeared
in *Der Ararat,* Munich, 1921.
By permission of Ernst Schwitters.

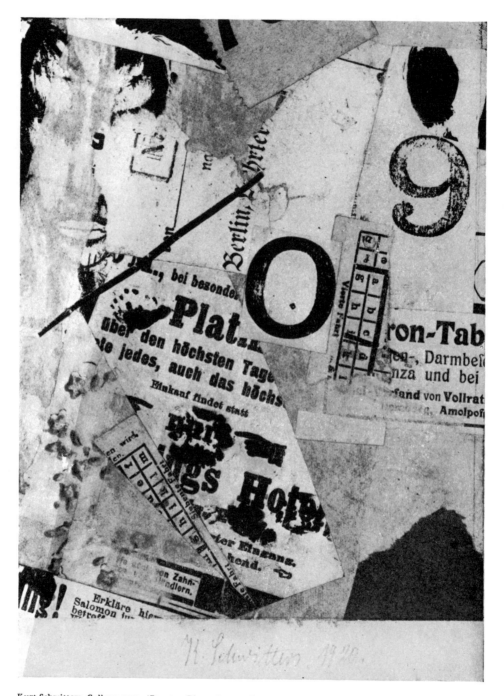

Kurt Schwitters. *Collage.* 1920. (Courtesy Pinacotheca gallery, N.Y.; photograph by J. D. Schiff).

Kurt Schwitters: *Merz (1920)*

I was born on June 20, 1887 in Hanover. As a child I had a little garden with roses and strawberries in it. After I had graduated from the *Realgymnasium* [scientific high school] in Hanover, I studied the technique of painting in Dresden with Bantzer, Kühl and Hegenbarth. It was in Bantzer's studio that I painted my Still Life with Chalice. The selection of my works now [1920] on exhibit at the Hans Goltz Gallery, Briennerstrasse 8, Munich, is intended to show how I progressed from the closest possible imitation of nature with oil paint, brush and canvas, to the conscious elaboration of purely artistic components in the Merz object, and how an unbroken line of development leads from the naturalistic studies to the Merz abstractions.

To paint after nature is to transfer three-dimensional corporeality to a two-dimensional surface. This you can learn if you are in good health and not color blind. Oil paint, canvas and brush are material and tools. It is possible by expedient distribution of oil paint on canvas to copy natural impressions; under favorable conditions you can do it so accurately that the picture cannot be distinguished from the model. You start, let us say, with a white canvas primed for oil painting and sketch in with charcoal the most discernible lines of the natural form you have chosen. Only the first line may be drawn more or less arbitrarily, all the others must form with the first the angle prescribed by the natural model. By constant comparison of the sketch with the model, the lines can be so adjusted that the lines of the sketch will correspond to those of the model. Lines are now drawn by feeling, the accuracy of the feeling is checked and measured by comparison of the estimated angle of the line with the perpendicular in nature and in the sketch. Then, according to the apparent proportions between the parts of the model, you sketch in the proportions between parts on the canvas, preferably by means of broken lines delimiting these parts. The size of the first part is arbitrary, unless your plan is to represent a part, such as the head, in "life size." In that case you measure with a compass an imaginary line running parallel to a

plane on the natural object conceived as a plane on the picture, and use this measurement in representing the first part. You adjust all the remaining parts to the first through feeling, according to the corresponding parts of the model, and check your feeling by measurement; to do this, you place the picture so far away from you that the first part appears as large in the painting as in the model, and then you compare. In order to check a given proportion, you hold out the handle of your paint brush at arm's length towards this proportion in such a way that the end of the handle appears to coincide with one end of the proportion; then you place your thumb on the brush handle so that the position of the thumbnail on the handle coincides with the other end of the proportion. If then you hold the paint-brush out towards the picture, again at arm's length, you can, by the measurement thus obtained, determine with photographic accuracy whether your feeling has deceived you. If the sketch is correct, you fill in the parts of the picture with color, according to nature. The most expedient method is to begin with a clearly recognizable color of large area, perhaps with a somewhat broken blue. You estimate the degree of matness and break the luminosity with a complementary color, ultramarine, for example, with light ochre. By addition of white you can make the color light, by addition of black dark. All this can be learned. The best way of checking for accuracy is to place the picture directly beside the projected picture surface in nature, return to your old place and compare the color in your picture with the natural color. By breaking those tones that are too bright and adding those that are still lacking, you will achieve a color tonality as close as possible to that in nature. If one tone is correct, you can put the picture back in its place and adjust the other colors to the first by feeling. You can check your feeling by comparing every tone directly with nature, after setting the picture back beside the model. If you have patience and adjust all large and small lines, all forms and color tones according to nature, you will have an exact reproduction of nature. This can be learned. This can be taught. And in addition, you can avoid making too many mistakes in "feeling" by studying nature itself through anatomy and perspective and your medium through color theory. That is academy.

I beg the reader's pardon for having discussed photographic painting at such length. I had to do this in order to show that it is a labor of patience, that it can be learned, that it rests essentially on measurement and adjustment and provides no food for artistic creation. For me it was essential to learn adjustment, and I gradually learned that the adjustment of the elements in painting is the aim of art, not a means to an end, such as checking for accuracy. It was not a short road. In order to achieve insight, you must work. And your insight extends only for a small space, then mist covers the horizon. And it is only from that point that you can go on and achieve further insight. And I believe that there is no end. Here the academy can no longer help you. There is no means of checking your insight.

First I succeeded in freeing myself from the literal reproduction of all details. I contented myself with the intensive treatment of light effects through sketch-like painting (impressionism).

With passionate love of nature (love is subjective) I emphasized the main lines

by exaggeration, the forms by limiting myself to what was most essential and by outlining, and the color tones by breaking them down into complementary colors.

The personal grasp of nature now seemed to me the most important thing. The picture became an intermediary between myself and the spectator. I had impressions, painted a picture in accordance with them; the picture had expression.

One might write a catechism of the media of expression if it were not useless, as useless as the desire to achieve expression in a work of art. Every line, color, form has a definite expression. Every combination of lines, colors, forms has a definite expression. Expression can be given only to a particular structure, it cannot be translated. The expression of a picture cannot be put into words, any more than the expression of a word, such as the word "and" for example, can be painted.

Nevertheless, the expression of a picture is so essential that it is worth while to strive for it consistently. Any desire to reproduce natural forms limits one's force and consistency in working out an expression. I abandoned all reproduction of natural elements and painted only with pictorial elements. These are my abstractions. I adjusted the elements of the picture to one another, just as I had formerly done at the academy, yet not for the purpose of reproducing nature but with a view to expression.

Today the striving for expression in a work of art also seems to me injurious to art. Art is a primordial concept, exalted as the godhead, inexplicable as life, indefinable and without purpose. The work of art comes into being through artistic evaluation of its elements. I know only how I make it, I know only my medium, of which I partake, to what end I know not.

The medium is as unimportant as I myself. Essential is only the forming. Because the medium is unimportant, I take any material whatsoever if the picture demands it. When I adjust materials of different kinds to one another, I have taken a step in advance of mere oil painting, for in addition to playing off color against color, line against line, form against form, etc., I play off material against material, for example, wood against sackcloth. I call the *weltanschauung* from which this mode of artistic creation arose "Merz."

The word "Merz" had no meaning when I formed it. Now it has the meaning which I gave it. The meaning of the concept "Merz" changes with the change in the insight of those who continue to work with it.

Merz stands for freedom from all fetters, for the sake of artistic creation. Freedom is not lack of restraint, but the product of strict artistic discipline. Merz also means tolerance towards any artistically motivated limitation. Every artist must be allowed to mold a picture out of nothing but blotting paper for example, provided he is capable of molding a picture.

The reproduction of natural elements is not essential to a work of art. But representations of nature, inartistic in themselves, can be elements in a picture, if they are played off against other elements in the picture.

At first I concerned myself with other art forms, poetry for example. Elements of poetry are letters, syllables, words, sentences. Poetry arises from the interaction of these elements. Meaning is important only if it is employed as one such factor.

I play off sense against nonsense. I prefer nonsense but that is a purely personal matter. I feel sorry for nonsense, because up to now it has so seldom been artistically molded, that is why I love nonsense.

Here I must mention Dadaism, which like myself cultivates nonsense. There are two groups of Dadaists, the kernel Dadas and the husk Dadas. Originally there were only kernel Dadaists, the husk Dadaists peeled off from this original kernel under their leader Huelsenbeck [Huelse is German for husk, Tr.] and in so doing took part of the kernel with them. The peeling process took place amid loud howls, singing of the *Marseillaise,* and distribution of kicks with the elbows, a tactic which Huelsenbeck still employs. . . . In the history of Dadaism Huelsenbeck writes: "All in all art should get a sound thrashing." In his introduction to the recent *Dada Almanach,* Huelsenbeck writes: "Dada is carrying on a kind of propaganda against culture." Thus Huelsendadaism is oriented towards politics and against art and against culture. I am tolerant and allow every man his own opinions, but I am compelled to state that such an outlook is alien to Merz. As a matter of principle, Merz aims only at art, because no man can serve two masters.

But "the Dadaists' conception of Dadaism varies greatly," as Huelsenbeck himself admits. Tristan Tzara, leader of the kernel Dadaists, writes in his *Dada manifesto 1918:* "Everyone makes his art in his own way," and further "Dada is the watchword of abstraction." I wish to state that Merz maintains a close artistic friendship with kernel Dadaism as thus conceived and with the kernel Dadaists Hans Arp, of whom I am particularly fond, Picabia, Ribemont-Dessaignes and Archipenko. In Huelsenbeck's own words, Huelsendada has made itself into "God's clown," while kernel Dadaism holds to the good old traditions of abstract art. Huelsendada "foresees its end and laughs about it," while kernel Dadaism will live as long as art lives. Merz also strives towards art and is an enemy of *kitsch,* even if it calls itself Dadaism under the leadership of Huelsenbeck. Every man who lacks artistic judgment is not entitled to write about art: "quod licet jovi non licet bovi." Merz energetically and as a matter of principle rejects Herr Richard Huelsenbeck's inconsequential and dilettantish views on art, while it officially recognizes the above-mentioned views of Tristan Tzara.

Here I must clear up a misunderstanding that might arise through my friendship with certain kernel Dadaists. It might be thought that I call myself a Dadaist, especially as the word "dada" is written on the jacket of my collection of poems, *Anna Blume,* published by Paul Steegemann.

On the same jacket is a windmill, a head, a locomotive running backwards and a man hanging in the air. This only means that in the world in which Anna Blume lives, in which people walk on their heads, windmills turn and locomotives run backwards, Dada also exists. In order to avoid misunderstandings, I have inscribed "Antidada" on the outside of my Cathedral. This does not mean that I am against Dada, but that there also exists in this world a current opposed to Dadaism. Locomotives run in both directions. Why shouldn't a locomotive run backwards now and then?

As long as I paint, I also model. Now I am doing Merz plastics: Pleasure Gal-

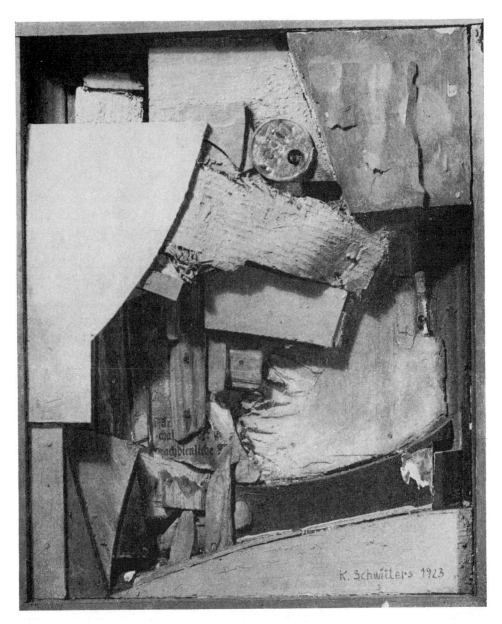

Kurt Schwitters. *Construction*. 1923. (Courtesy Pinacotheca gallery, N.Y.; photograph by J. D. Schiff).

lows and Cult-pump. Like Merz pictures, the Merz plastics are composed of various materials. They are conceived as round plastics and present any desired number of aspects.

Merz House was my first piece of Merz architecture. Spengemann writes in *Zweeman*, No. 8–12: "In Merz House I see the cathedral: *the* cathedral. Not as a church, no, this is art as a truly spiritual expression of the force that raises us up to the unthinkable: absolute art. This cathedral cannot be used. Its interior is so filled with wheels that there is no room for people . . . that is absolute architec-

ture, it has an artistic meaning and no other."

To busy myself with various branches of art was for me an artistic need. The reason for this was not any urge to broaden the scope of my activity, it was my desire not to be a specialist in one branch of art, but an artist. My aim is the Merz composite art work, that embraces all branches of art in an artistic unit. First I combined individual categories of art. I pasted words and sentences into poems in such a way as to produce a rhythmic design. Reversing the process, I pasted up pictures and drawings so that sentences could be read in them. I drove nails into pictures in such a way as to produce a plastic relief aside from the pictorial quality of the painting. I did this in order to efface the boundaries between the arts. The composite Merz work of art, par excellence, however, is the Merz stage which so far I have only been able to work out theoretically. The first published statement about it appeared in *Sturmbühne,* No. 8: "The Merz stage serves for the performance of the Merz drama. The Merz drama is an abstract work of art. The drama and the opera grow, as a rule, out of the form of the written text, which is a well-rounded work in itself, without the stage. Stage-set, music and performance serve only to illustrate this text, which is itself an illustration of the action. In contrast to the drama or the opera, all parts of the Merz stage-work are inseparably bound up together; it cannot be written, read or listened to, it can only be produced in the theatre. Up until now, a distinction was made between stage-set, text, and score in theatrical performances. Each factor was separately prepared and could also be separately enjoyed. The Merz stage knows only the fusing of all factors into a composite work. Materials for the stage-set are all solid, liquid and gaseous bodies, such as white wall, man, barbed wire entanglement, blue distance, light cone. Use is made of compressible surfaces, or surfaces capable of dissolving into meshes; surfaces that fold like curtains, expand or shrink. Objects will be allowed to move and revolve, and lines will be allowed to broaden into surfaces. Parts will be inserted into the set and parts will be taken out. Materials for the score are all tones and noises capable of being produced by violin, drum, trombone, sewing machine, grandfather clock, stream of water, etc. Materials for the text are all experiences that provoke the intelligence and emotions. The materials are not to be used logically in their objective relationships, but only within the logic of the work of art. The more intensively the work of art destroys rational objective logic, the greater become the possibilities of artistic building. As in poetry word is played off against word, here factor is played against factor, material against material. The stage-set can be conceived in approximately the same terms as a Merz picture. The parts of the set move and change, and the set lives its life. The movement of the set takes place silently or accompanied by noises or music. I want the Merz stage. Where is the experimental stage?

"Take gigantic surfaces, conceived as infinite, cloak them in color, shift them menacingly and vault their smooth pudency. Shatter and embroil finite parts and bend drilling parts of the void infinitely together. Paste smoothing surfaces over one another. Wire lines movement, real movement rises real tow-rope of a wire mesh. Flaming lines, creeping lines, surfacing lines. Make lines fight together and

caress one another in generous tenderness. Let points burst like stars among them, dance a whirling round, and realize each other to form a line. Bend the lines, crack and smash angles, choking revolving around a point. In waves of whirling storm let a line rush by, tangible in wire. Roll globes whirling air they touch one another. Interpermeating surfaces seep away. Crates corners up, straight and crooked and painted. Collapsible top hats fall strangled crates boxes. Make lines pulling sketch a net ultramarining. Nets embrace compress Antony's torment. Make nets firewave and run off into lines, thicken into surfaces. Net the nets. Make veils blow, soft folds fall, make cotton drip and water gush. Hurl up air soft and white through thousand candle power arc lamps. Then take wheels and axles, hurl them up and make them sing (mighty erections of aquatic giants). Axles dance mid-wheel roll globes barrel. Cogs flair teeth, find a sewing machine that yawns. Turning upward or bowed down the sewing machine beheads itself, feet up. Take a dentist's drill, a meat grinder, a car-track scraper, take buses and pleasure cars, bicycles, tandems and their tires, also war-time ersatz tires and deform them. Take lights and deform them as brutally as you can. Make locomotives crash into one another, curtains and portières make threads of spider webs dance with window frames and break whimpering glass. Explode steam boilers to make railroad mist. Take petticoats and other kindred articles, shoes and false hair, also ice skates and throw them into place where they belong, and always at the right time. For all I care, take man-traps, automatic pistols, infernal machines, the tinfish and the funnel, all of course in an artistically deformed condition. Inner tubes are highly recommended. Take in short everything from the hairnet of the high class lady to the propeller of the S.S. *Leviathan,* always bearing in mind the dimensions required by the work.

"Even people can be used.

"People can even be tied to backdrops.

"People can even appear actively, even in their everyday position, they can speak on two legs, even in sensible sentences.

"Now begin to wed your materials to one another. For example, you marry the oilcloth table cover to the home owners' loan association, you bring the lamp cleaner into a relationship with the marriage between Anna Blume and A-natural, concert pitch. You give the globe to the surface to gobble up and you cause a cracked angle to be destroyed by the beam of a 22-thousand candle power arc lamp. You make a human walk on his (her) hands and wear a hat on his (her) feet, like Anna Blume. (Cataracts.) A splashing of foam.

"And now begins the fire of musical saturation. Organs backstage sing and say: 'Futt, futt.' The sewing machine rattles along in the lead. A man in the wings says: 'Bah.' Another suddenly enters and says: 'I am stupid.' (All rights reserved.) Between them a clergyman kneels upside down and cries out and prays in a loud voice: 'Oh mercy seethe and swarm disintegration of amazement Halleluia boy, boy marry drop of water.' A water pipe drips with uninhibited monotony. Eight.

"Drums and flutes flash death and a streetcar conductor's whistle gleams bright. A stream of ice cold water runs down the back of the man in one wing and into a

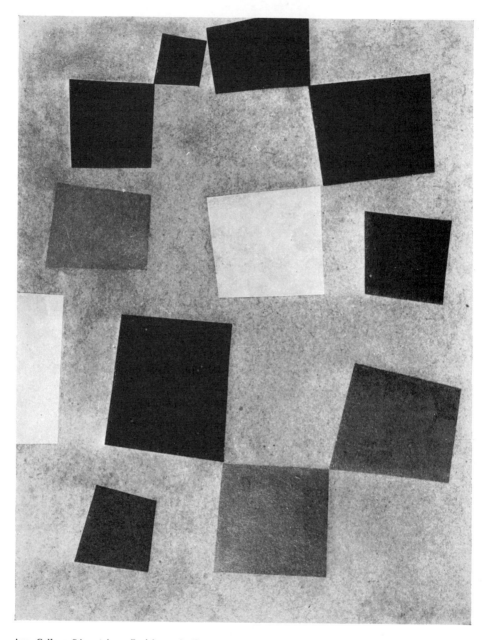

Arp. Collage *Géometrique*. Zurich, 1916. (Courtesy Museum of Modern Art, N.Y.).

pot. In accompaniment he sings c-sharp d, d-sharp e-flat, the whole proletarian song. Under the pot a gas flame has been lit to boil the water and a melody of violins shimmers pure and virgin-tender. A veil spreads breadths. The center cooks up a deep dark-red flame. A soft rustling. Long sighs violins swell and expire. Light darkens stage, even the sewing machine is dark."

Meanwhile this publication aroused the interest of the actor and theatrical director Franz Rolan who had related ideas, that is, he thought of making the theatre independent and of making the productions grow out of the material available in the modern theatre: stage, backdrops, color, light, actors, director, stage designer, and audience, and assume artistic form. We proceeded to work out in detail the idea of the Merz stage in relation to its practical possibilities, theoretically for the present. The result was a voluminous manuscript which was soon ready for the printer. At some future date perhaps we shall witness the birth of the Merz composite work of art. We can not create it, for we ourselves would only be parts of it, in fact we would be mere material.

P.S. I should now like to print a couple of unpublished poems:

Herbst (1909)

Es schweigt der Wald in Weh.
Er muss geduldig leiden,
Dass nun sein lieber Bräutigam,
Der Sommer, wird scheiden.

Noch hält er zärtlich ihn im Arm
Und quälet sich mit Schmerzen.
Du klagtest, Liebchen, wenn ich schied,
Ruht ich noch dir am Herzen.

Autumn (1909)

The forest is silent in grief.
She must patiently suffer
Her dear betrothed,
The summer, to depart.

In grief and anguish still
She holds him in her arms.
You, my love, wept when I departed.
Could I now but rest on your heart!

Gedicht No. 48 (1920 ?)

Wanken.
Regenwurm.
Fische.
Uhren.
Die Kuh.
Der Wald blättert die Blätter.
Ein Tropfen Asphalt in den Schnee.
Cry, cry, cry, cry, cry.
Ein weiser Mann platzt ohne Gage.

Poem No. 48 (1920?)

Staggering.
Earthworm.
Fishes.
Clocks.
The cow.
The forest leafs the leaves.
A drop of asphalt in the snow.
Cry, cry, cry, cry, cry.
A wise man bursts without wages.

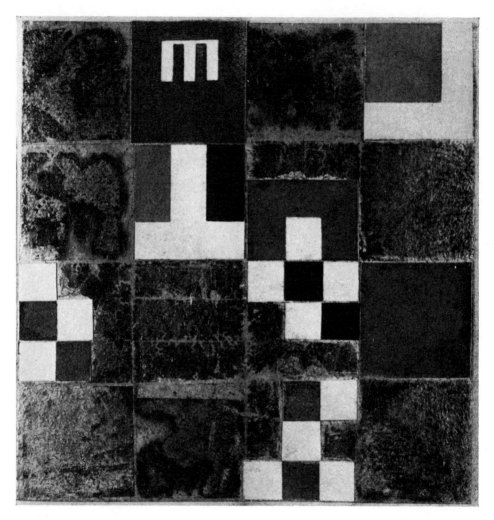

Sophie Taeuber-Arp. *Vertical Horizontal à Elements d'Objets*. Zurich, 1919. (Courtesy Museum of Modern Art, N.Y.)

V. *A Dada Personage*

Two letters (1917–18) by Jacques Vaché (to André Breton). Translated from the French by Clara Cohen. Originals published in Vaché's *Lettres de Guerre,* Paris, Au Sans Pareil, 1919. Translation appeared in *New Directions,* 1940. By permission of James Laughlin.

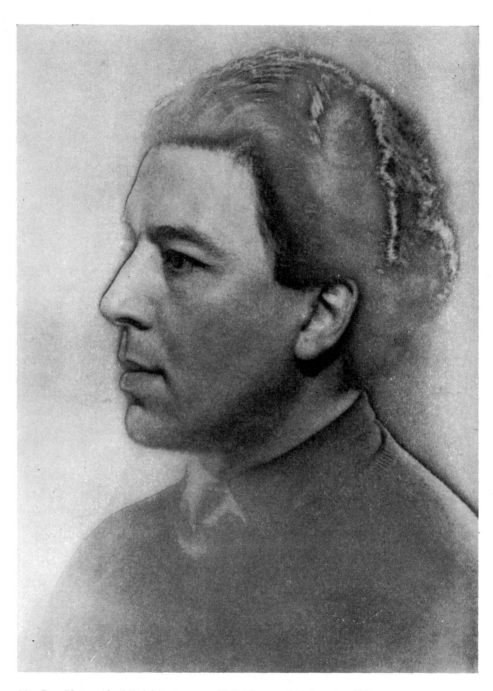

Man Ray. *Photograph of André Breton.* 1931. (Coll. Museum of Modern Art, N.Y.)

Jacques Vaché: *Two Letters (to André Breton)*

1.

Dear Friend: *18/8/17*

I've thought a lot of writing you since your letter of July 23rd—but I didn't manage to find an adequate form of expression—and still haven't. I think after all it's much better to write you on immediate improvisation—on a text I nearly know, and have even mulled over. We'll see what will come out of it when the surprises of our conversation have led us to a series of axioms agreed upon in a mutual umore (pronounce: umoree) because, after all, "Humoristic!" Your dramatic thesis pleases me; don't you perhaps think it a good idea to introduce (I'm not too keen on it, at the moment) a type, intermediary between the customs inspector and your "modern" no. 1—a sort of antebellum tapir, charmless, avid with egotism, really—a sort of avaricious and slightly baffled barbarian—All the same . . . and then the whole tone of our action has yet to be decided. I'd like it to be dry, without literature and above all not in the sense of "ART."

Besides, ART of course doesn't exist—so it's futile to go into a song and dance about it,—yet: we make art—because it's thusly and not otherwise—Well, what do you want to do about it?

So we neither like Art nor artists (down with Apollinaire and HOW RIGHT TOGRATH IS TO ASSASSINATE THE POET). All the same, since it's necessary to disgorge a little acid or old lyricism, let it be done abruptly, rapidly, for locomotives go fast. So Modernity, too—continually and killed every night—we ignore Mallarmé without hatred, but he's dead—we don't know Apollinaire any more—FOR—we suspect him of too conscious artistry, of patching up romanticism with telephone wire—and of not knowing dynamos.

The STARS unhooked again! It's boring,—and then sometimes how seriously they talk! A man who believes is a curiosity. BUT SINCE SOME AREN'T BORN HAMMY. . . . Oh well—I see two ways of letting this run—to form personal sensation with the aid of a flamboyant smashup of rare words—not often used—or else to draw angles, or

69

neat squares of feelings—those of the moment, naturally,—we'll leave logical honesty—in charge of refuting us—like everybody else.

O ABSURD GOD for everything is contradiction—isn't it? and will always be umore he who never gives in to hidden, sour life—shifty with everything—O my alarm clock, eyes and hypocrites, who detest me so! and will be umore he who feels the lamentable sleight-of-hand of simili universal symbols—It is in their nature to be symbolic.

Umore should not produce—but what can we do about it? I assign a bit of umore to LAFCADIO,[1] for he doesn't read or produce except in amusing experiences, like the Assassination—and that without satanic lyricism—my old rotted Baudelaire! The air we breathe had to turn dry—; machinery, rotaries with stinking oils,— zzzmmmm, zzzmmmmm, zzzmmmmmm,—Whistle! Amusing, the pohet, and prosily boring Max Jacob, my old cheat,—DOLLS DOLLS DOLLS do you want lovely dolls in painted wood? Two eyes—dead—flame—and also the crystal round of a monocle— with a pouple typewriter—I like this better. All this galls you a lot sometimes—but answer me—I'll be back in Paris in the beginning of October,—perhaps we might arrange an introductory lecture—what a grand noise! Anyhow I very much hope to see you. Best wishes, *J. T. H.*

2.

My dear André, *10/12/18*

I too will be glad to see you again—the number of pithy, if decidedly infinitesimal —How I envy you to be in Paris and able to mystify people who are worth the trouble! Here I am in Brussels, once more in my dear atmosphere of tango around 3 in the morning, of marvelous goings-on in front of a few monstrous cocktails with double straw and some kind of lipstick smile—I draw funny pictures with color pencils on heavy grained paper—and make notes for something or other—I'm not too sure just what. Do you know that I've forgotten what it's all about? You speak to me of a scenic action (characters—you remember—you specified them)—has it been given up for the time being? Excuse me for not guessing the meaning of your last sybilline letter; what do you expect of me, my dear friend? UMOR—my dear André, it's no small thing. It's not just a kind of neo-naturalism—Would you please, when you've time, explain to me a bit more what it's all about? I think I remember that, mutually, we had agreed to leave SOCIETY in an amazed half-ignorance till the psychological moment for some satisfactory and perhaps scandalous manifestation. As a matter of course and naturally I leave it to you to pave the way for this unsatisfactory God, rather sneering and terrible God—How funny it'll be, don't you see, if this real New Spirit breaks loose!

I've got your letter made out of cuts stuck together which made me feel very happy—it's very fine, but it wants a piece of a railroad timetable, don't you think? Apollinaire has done a lot for us, and is certainly not dead; he has besides done a good job of stopping himself in time—it's already been said but it's got to be re-

[1] cf. "Lafcadio's Adventures" ["Les caves du Vatican"] by André Gide.

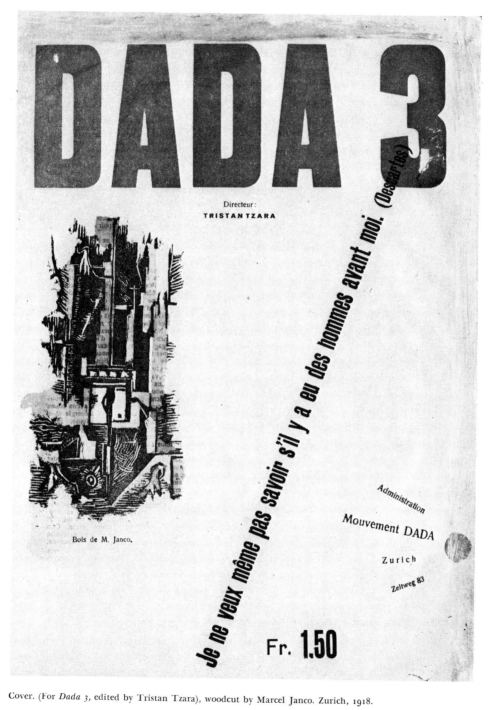

Cover. (For *Dada 3*, edited by Tristan Tzara), woodcut by Marcel Janco. Zurich, 1918.

peated: HE MARKS AN EPOCH. The beautiful things we can do, NOW! I enclose an extract from my present notes—perhaps you'd like to put them beside your poem, some place in what T. F. calls "the gazettes of ill repute"—what's becoming of this people?[1] Tell me all about this. Look how it's won us this war! Are you in Paris for some time? I expect to be there in about a month's time and look forward to seeing you at all costs.

<div align="right">Your friend, Harry James</div>

[1] Refers to Jarry's Ubu Roi: Le peuple polonais meaning the fools.

VI. *Seven Dada Manifestoes*

By Tristan Tzara. 1916–20. Complete translation from
the French by Ralph Manheim. Originally published in book
form in Paris, Editions Jean Budry, 1924. By permission
of the author.

Man Ray. *Photograph of Tristan Tzara.* 1931. (Coll. Museum of Modern Art, N.Y.)

Tristan Tzara: *Seven Dada Manifestoes*

1. Manifesto of Mr. Antipyrine

Dada is our intensity: it sets up inconsequential bayonets the sumatran head of the german baby; Dada is life without carpet-slippers or parallels; it is for and against unity and definitely against the future; we are wise enough to know that our brains will become downy pillows that our anti-dogmatism is as exclusivist as a bureaucrat that we are not free yet shout freedom—

A harsh necessity without discipline or morality and we spit on humanity. Dada remains within the European frame of weaknesses it's shit after all but from now on we mean to shit in assorted colors and bedeck the artistic zoo with the flags of every consulate

We are circus directors whistling amid the winds of carnivals convents bawdy houses theatres realities sentiments restaurants HoHiHoHo Bang

We declare that the auto is a sentiment which has coddled us long enough in its slow abstractions in ocean liners and noises and ideas. Nevertheless we externalize facility we seek the central essence and we are happy when we can hide it; we do not want to count the windows of the marvelous élite for Dada exists for no one and we want everybody to understand this because it is the balcony of Dada, I assure you. From which you can hear the military marches and descend slicing the air like a seraph in a public bath to piss and comprehend the parable

Dada is not madness—or wisdom—or irony take a good look at me kind bourgeois

Art was a game of trinkets children collected words with a tinkling on the end then they went and shouted stanzas and they put little doll's shoes on the stanza and the stanza turned into a queen to die a little and the queen turned into a wolverine and the children ran till they all turned green

Then came the great Ambassadors of sentiment and exclaimed historically in chorus

psychology psychology heehee

Science Science Science

vive la France
we are not naive
we are successive
we are exclusive
we are not simple
and we are all quite able to discuss the intelligence.
But we Dada are not of their opinion for art is not serious I assure you and if in exhibiting crime we learnedly say ventilator, it is to give you pleasure kind reader I love you so I swear I do adore you

2. Dada Manifesto 1918

The magic of a word—Dada—which has brought journalists to the gates of a world unforeseen, is of no importance to us.

To put out a manifesto you must want: ABC
to fulminate against 1, 2, 3,
to fly into a rage and sharpen your wings to conquer and disseminate little abcs and big abcs, to sign, shout, swear, to organize prose into a form of absolute and irrefutable evidence, to prove your non plus ultra and maintain that novelty resembles life just as the latest appearance of some whore proves the essence of God. His existence was previously proved by the accordion, the landscape, the wheedling word. To impose your ABC is a natural thing—hence deplorable. Everybody does it in the form of crystalbluffmadonna, monetary system, pharmaceutical product, or a bare leg advertising the ardent sterile spring. The love of novelty is the cross of sympathy, demonstrates a naive je m'enfoutisme, it is a transitory, positive sign without a cause.
But this need itself is obsolete. In documenting art on the basis of the supreme simplicity: novelty, we are human and true for the sake of amusement, impulsive, vibrant to crucify boredom. At the crossroads of the lights, alert, attentively awaiting the years, in the forest. I write a manifesto and I want nothing, yet I say certain things, and in principle I am against manifestoes, as I am also against principles (half-pints to measure the moral value of every phrase too too convenient; approximation was invented by the impressionists). I write this manifesto to show that people can perform contrary actions together while taking one fresh gulp of air; I am against action; for continuous contradiction, for affirmation too, I am neither for nor against and I do not explain because I hate common sense.
Dada—there you have a word that leads ideas to the hunt: every bourgeois is a little dramatist, he invents all sorts of speeches instead of putting the characters suitable to the quality of his intelligence, chrysalises, on chairs, seeks causes or aims (according to the psychoanalytic method he practices) to cement his plot, a story that speaks and defines itself. Every spectator is a plotter if he tries to explain a word: (to know!) Safe in the cottony refuge of serpentine complications he manipulates his instincts. Hence the mishaps of conjugal life.
To explain: the amusement of redbellies in the mills of empty skulls.

If you find it futile and don't want to waste your time on a word that means nothing. . . . The first thought that comes to these people is bacteriological in character: to find its etymological, or at least its historical or psychological origin. We see by the papers that the Kru Negroes call the tail of a holy cow Dada. The cube and the mother in a certain district of Italy are called: Dada. A hobby horse, a nurse both in Russian and Rumanian: Dada. Some learned journalists regard it as an art for babies, other holy jesusescallingthelittlechildren of our day, as a relapse into a dry and noisy, noisy and monotonous primitivism. Sensibility is not constructed on the basis of a word; all constructions converge on perfection which is boring, the stagnant idea of a gilded swamp, a relative human product. A work of art should not be beauty in itself, for beauty is dead; it should be neither gay nor sad, neither light nor dark to rejoice or torture the individual by serving him the cakes of sacred aureoles or the sweets of a vaulted race through the atmospheres. A work of art is never beautiful by decree, objectively and for all. Hence criticism is useless, it exists only subjectively, for each man separately, without the slightest character of universality. Does anyone think he has found a psychic base common to all mankind? The attempt of Jesus and the Bible covers with their broad benevolent wings: shit, animals, days. How can one expect to put order into the chaos that constitutes that infinite and shapeless variation: man? The principle: "love thy neighbor" is a hypocrisy. "Know thyself" is utopian but more acceptable, for it embraces wickedness. No pity. After the carnage we still retain the hope of a purified mankind. I speak only of myself since I do not wish to convince, I have no right to drag others into my river, I oblige no one to follow me and everybody practices his art in his own way, if he knows the joy that rises like arrows to the astral layers, or that other joy that goes down into the mines of corpse-flowers and fertile spasms. Stalactites: seek them everywhere, in mangers magnified by pain, eyes white as the hares of the angels.

And so Dada[1] was born of a need for independence, of a distrust toward unity. Those who are with us preserve their freedom. We recognize no theory. We have enough cubist and futurist academies: laboratories of formal ideas. Is the aim of art to make money and cajole the nice nice bourgeois? Rhymes ring with the assonance of the currencies and the inflexion slips along the line of the belly in profile. All groups of artists have arrived at this trust company after riding their steeds on various comets. While the door remains open to the possibility of wallowing in cushions and good things to eat.

Here we cast anchor in rich ground. Here we have a right to do some proclaiming, for we have known cold shudders and awakenings. Ghosts drunk on energy, we dig the trident into unsuspecting flesh. We are a downpour of maledictions as tropically abundant as vertiginous vegetation, resin and rain are our sweat, we bleed and burn with thirst, our blood is vigor.

Cubism was born out of the simple way of looking at an object: Cézanne painted a

[1] in 1916 in the Cabaret Voltaire, in Zurich.

cup 20 centimeters below his eyes, the cubists look at it from above, others complicate appearance by making a perpendicular section and arranging it conscientiously on the side. (I do not forget the creative artists and the profound laws of matter which they established once and for all.) The futurist sees the same cup in movement, a succession of objects one beside the other, and maliciously adds a few force lines. This does not prevent the canvas from being a good or bad painting suitable for the investment of intellectual capital.

The new painter creates a world, the elements of which are also its implements, a sober, definite work without argument. The new artist protests: he no longer paints (symbolic and illusionist reproduction) but creates—directly in stone, wood, iron, tin, boulders—locomotive organisms capable of being turned in all directions by the limpid wind of momentary sensation. All pictorial or plastic work is useless: let it then be a monstrosity that frightens servile minds, and not sweetening to decorate the refectories of animals in human costume, illustrating the sad fable of mankind.—

Painting is the art of making two lines geometrically established as parallel meet on a canvas before our eyes in a reality which transposes other conditions and possibilities into a world. This world is not specified or defined in the work, it belongs in its innumerable variations to the spectator. For its creator it is without cause and without theory. *Order=disorder; ego=non-ego; affirmation=negation:* the supreme radiations of an absolute art. Absolute in the purity of a cosmic, ordered chaos, eternal in the globule of a second without duration, without breath without control. I love an ancient work for its novelty. It is only contrast that connects us with the past. The writers who teach morality and discuss or improve psychological foundations have, aside from a hidden desire to make money, an absurd view of life, which they have classified, cut into sections, channelized: they insist on waving the baton as the categories dance. Their readers snicker and go on: what for?

There is a literature that does not reach the voracious mass. It is the work of creators, issued from a real necessity in the author, produced for himself. It expresses the knowledge of a supreme egoism, in which laws wither away. Every page must explode, either by profound heavy seriousness, the whirlwind, poetic frenzy, the new, the eternal, the crushing joke, enthusiasm for principles, or by the way in which it is printed. On the one hand a tottering world in flight, betrothed to the glockenspiel of hell, on the other hand: new men. Rough, bouncing, riding on hiccups. Behind them a crippled world and literary quacks with a mania for improvement.

I say unto you: there is no beginning and we do not tremble, we are not sentimental. We are a furious wind, tearing the dirty linen of clouds and prayers, preparing the great spectacle of disaster, fire, decomposition. We will put an end to mourning and replace tears by sirens screeching from one continent to another. Pavilions of intense joy and widowers with the sadness of poison. Dada is the signboard of abstraction; advertising and business are also elements of poetry.

I destroy the drawers of the brain and of social organization: spread demoralization

wherever I go and cast my hand from heaven to hell, my eyes from hell to heaven, restore the fecund wheel of a universal circus to objective forces and the imagination of every individual.

Philosophy is the question: from which side shall we look at life, God, the idea or other phenomena. Everything one looks at is false. I do not consider the relative result more important than the choice between cake and cherries after dinner. The system of quickly looking at the other side of a thing in order to impose your opinion indirectly is called dialectics, in other words, haggling over the spirit of fried potatoes while dancing method around it.

If I cry out:

Ideal, ideal, ideal,

Knowledge, knowledge, knowledge,

Boomboom, boomboom, boomboom,

I have given a pretty faithful version of progress, law, morality and all other fine qualities that various highly intelligent men have discussed in so many books, only to conclude that after all everyone dances to his own personal boomboom, and that the writer is entitled to his boomboom: the satisfaction of pathological curiosity; a private bell for inexplicable needs; a bath; pecuniary difficulties; a stomach with repercussions in life; the authority of the mystic wand formulated as the bouquet of a phantom orchestra made up of silent fiddle bows greased with philtres made of chicken manure. With the blue eye-glasses of an angel they have excavated the inner life for a dime's worth of unanimous gratitude. If all of them are right and if all pills are Pink Pills, let us try for once not to be right. Some people think they can explain rationally, by thought, what they think. But that is extremely relative. Psychoanalysis is a dangerous disease, it puts to sleep the anti-objective impulses of man and systematizes the bourgeoisie. There is no ultimate Truth. The dialectic is an amusing mechanism which guides us / in a banal kind of way / to the opinions we had in the first place. Does anyone think that, by a minute refinement of logic, he has demonstrated the truth and established the correctness of these opinions? Logic imprisoned by the senses is an organic disease. To this element philosophers always like to add: the power of observation. But actually this magnificent quality of the mind is the proof of its impotence. We observe, we regard from one or more points of view, we choose them among the millions that exist. Experience is also a product of chance and individual faculties. Science disgusts me as soon as it becomes a speculative system, loses its character of utility—that is so useless but is at least individual. I detest greasy objectivity, and harmony, the science that finds everything in order. Carry on, my children, humanity . . . Science says we are the servants of nature: everything is in order, make love and bash your brains in. Carry on, my children, humanity, kind bourgeois and journalist virgins . . . I am against systems, the most acceptable system is on principle to have none. To complete oneself, to perfect oneself in one's own littleness, to fill the vessel with one's individuality, to have the courage to fight for and against thought, the mystery of bread, the sudden burst of an infernal propeller into economic lilies:

DADAIST SPONTANEITY

I call *je m'enfoutisme* the kind of like in which everyone retains his own conditions, though respecting other individualisms, except when the need arises to defend oneself, in which the two-step becomes national anthem, curiosity shop, a radio transmitting Bach fugues, electric signs and posters for whorehouses, an organ broadcasting carnations for God, all this together physically replacing photography and the universal catechism.

ACTIVE SIMPLICITY.

Inability to distinguish between degrees of clarity: to lick the penumbra and float in the big mouth filled with honey and excrement. Measured by the scale of eternity, all activity is vain—(if we allow thought to engage in an adventure the result of which would be infinitely grotesque and add significantly to our knowledge of human impotence). But supposing life to be a poor farce, without aim or initial parturition, and because we think it our duty to extricate ourselves as fresh and clean as washed chrysanthemums, we have proclaimed as the sole basis for agreement: art. It is not as important as we, mercenaries of the spirit, have been proclaiming for centuries. Art afflicts no one and those who manage to take an interest in it will harvest caresses and a fine opportunity to populate the country with their conversation. Art is a private affair, the artist produces it for himself; an intelligible work is the product of a journalist, and because at this moment it strikes my fancy to combine this monstrosity with oil paints: a paper tube simulating the metal that is automatically pressed and poured hatred cowardice villainy. The artist, the poet rejoice at the venom of the masses condensed into a section chief of this industry, he is happy to be insulted: it is a proof of his immutability. When a writer or artist is praised by the newspapers, it is proof of the intelligibility of his work: wretched lining of a coat for public use; tatters covering brutality, piss contributing to the warmth of an animal brooding vile instincts. Flabby, insipid flesh reproducing with the help of typographical microbes.
We have thrown out the cry-baby in us. Any infiltration of this kind is candied diarrhea. To encourage this act is to digest it. What we need is works that are strong straight precise and forever beyond understanding. Logic is a complication. Logic is always wrong. It draws the threads of notions, words, in their formal exterior, toward illusory ends and centers. Its chains kill, it is an enormous centipede stifling independence. Married to logic, art would live in incest, swallowing, engulfing its own tail, still part of its own body, fornicating within itself, and passion would become a nightmare tarred with protestantism, a monument, a heap of ponderous gray entrails. But the suppleness, enthusiasm, even the joy of injustice, this little truth which we practise innocently and which makes us beautiful: we are subtle and our fingers are malleable and slippery as the branches of that sinuous, almost liquid plant; it defines our soul, say the cynics. That too is a point of view; but all flowers are not sacred, fortunately, and the divine thing in us is our call to anti-human action. I am speaking of a paper flower for the button-holes of the gentlemen who frequent the ball of masked life, the kitchen of grace,

80

white cousins lithe or fat. They traffic with whatever we have selected. The contradiction and unity of poles in a single toss can be the truth. If one absolutely insists on uttering this platitude, the appendix of a libidinous, malodorous morality. Morality creates atrophy like every plague produced by intelligence. The control of morality and logic has inflicted us with impassivity in the presence of policemen—who are the cause of slavery, putrid rats infecting the bowels of the bourgeoisie which have infected the only luminous clean corridors of glass that remained open to artists.

Let each man proclaim: there is a great negative work of destruction to be accomplished. We must sweep and clean. Affirm the cleanliness of the individual after the state of madness, aggressive complete madness of a world abandoned to the hands of bandits, who rend one another and destroy the centuries. Without aim or design, without organization: indomitable madness, decomposition. Those who are strong in words or force will survive, for they are quick in defense, the agility of limbs and sentiments flames on their faceted flanks.

Morality has determined charity and pity, two balls of fat that have grown like elephants, like planets, and are called good. There is nothing good about them. Goodness is lucid, clear and decided, pitiless toward compromise and politics. Morality is an injection of chocolate into the veins of all men. This task is not ordered by a supernatural force but by the trust of idea brokers and grasping academicians. Sentimentality: at the sight of a group of men quarreling and bored, they invented the calendar and the medicament wisdom. With a sticking of labels the battle of the philosophers was set off (mercantilism, scales, meticulous and petty measures) and for the second time it was understood that pity is a sentiment like diarrhea in relation to the disgust that destroys health, a foul attempt by carrion corpses to compromise the sun. I proclaim the opposition of all cosmic faculties to this gonorrhea of a putrid sun issued from the factories of philosophical thought, I proclaim bitter struggle with all the weapons of

DADAIST DISGUST

Every product of disgust capable of becoming a negation of the family is Dada; a protest with the fists of its whole being engaged in destructive action: *Dada; knowledge of all the means rejected up until now by the shamefaced sex of comfortable compromise and good manners: Dada; abolition of logic, which is the dance of those impotent to create: Dada; of every social hierarchy and equation set up for the sake of values by our valets: Dada; every object, all objects, sentiments, obscurities, apparitions and the precise clash of parallel lines are weapons for the fight: Dada; abolition of memory: Dada; abolition of archaeology: Dada: abolition of prophets: Dada; abolition of the future: Dada; absolute and unquestionable faith in every god that is the immediate product of spontaneity:* Dada; elegant and unprejudiced leap from a harmony to the other sphere; trajectory of a word tossed like a screeching phonograph record; to respect all individuals in their folly of the moment: whether it be serious, fearful, timid, ardent, vigorous, determined, enthusiastic; to divest one's church of every useless cumbersome accessory;

to spit out disagreeable or amorous ideas like a luminous waterfall, or coddle them
—with the extreme satisfaction that it doesn't matter in the least—with the same
intensity in the thicket of one's soul—pure of insects for blood well-born, and gilded
with bodies of archangels. Freedom: Dada Dada Dada, a roaring of tense colors,
and interlacing of opposites and of all contradictions, grotesques, inconsistencies:
LIFE

3. Proclamation without Pretension

Art is going to sleep for a new world to be born
"ART"—parrot word—replaced by DADA,
PLESIOSAURUS, or handkerchief

The talent THAT CAN BE LEARNED makes the
poet a druggist TODAY the criticism
of balances no longer challenges with resemblances

Hypertrophic painters hyperaes-
theticized and hypnotized by the hyacinths
of the hypocritical-looking muezzins

CONSOLIDATE THE HARVEST OF EX-
ACT CALCULATIONS

Hypodrome of immortal guarantees: there is
no such thing as importance there is no transparence
or appearance

MUSICIANS SMASH YOUR INSTRUMENTS
BLIND MEN take the stage

THE SYRINGE is only for my understanding. I write because it is
natural exactly the way I piss the way I'm sick

ART NEEDS AN OPERATION

Art is a PRETENSION warmed by the
TIMIDITY of the urinary basin, the *hysteria* born
in *THE STUDIO*

We are in search of
the force that is direct pure sober
UNIQUE we are in search of NOTHING
we affirm the VITALITY of every IN-
STANT

the anti-philosophy of *spontaneous* acrobatics

At this moment I hate the man who whispers
before the intermission—eau de cologne—

sour theatre. THE JOYOUS WIND

If each man says the opposite it is because he is
right

Get ready for the action of the geyser of our blood
—submarine formation of transchromatic aero-
planes, cellular metals numbered in
the flight of images

above the rules of the
and its control

BEAUTIFUL

It is not for the sawed-off imps
who still worship their navel

4. Manifesto of mr. aa the anti-philosopher

without searching for I adore you
who is a french boxer
or irregular maritime values like the depression of Dada in the blood of the
bicephalous
I slip between death and the vague phosphates
which scratch a little the common brain of the dadaist poets
luckily
for
gold
undermines
prices and the high cost of living have decided me to give up D's
it is not true that the fake dadas have snatched them away from me for
repayment will begin on
that is something to cry about the nothing that calls itself nothing
and i have swept away sickness in the customs house
i tortoise shell and umbrella of the brain rented out from noon to 2 p.m.
superstitious individual releasing the wheels
of the spermatozoidal ballet that you will encounter in dress rehearsal in the
hearts of all suspicious characters
I'll nibble your fingers a little
I'll buy you a re-subscription to love made of celluloid that squeaks like metal doors
and you are idiots
I shall return some day like your urine reviving you to the joy of living the mid-
wife wind
and i'll set up a boarding school for pimps and poets
and i'll come back again to begin all over
and you are all idiots

83

and the self-kleptomaniac's key works only with twilight oil
on every knot of every machine there is the noise of a newborn babe
and we are all idiots
and highly suspicious with a new form of intelligence and a new logic of our **own**
which is not Dada at all
and you are letting yourself be carried away by Aaism
and you are all idiots
cataplasms
made of the alcohol of purified sleep
bandages
and idiot
virgins
tristan tzara
Take a good look at me!
I am an idiot, I am a clown, I am a faker.
Take a good look at me!
I am ugly, my face has no expression, I am little.
I am like all of you![1]

But ask yourselves, before looking at me, if the iris by which you send out arrows of liquid sentiment, is not fly shit, if the eyes of your belly are not sections of tumors that will some day peer from some part of your body in the form of a gonorrheal discharge.

You see with your navel—why do you hide from it the absurd spectacle that we present? And farther down, sex organs of women, with teeth, all-swallowing—the poetry of eternity, love, pure love of course—rare steaks and oil painting. All those who look and understand, easily fit in between poetry and love, between the beefsteak and the painting. They will be digested. They will be digested.

I was recently accused of stealing some furs. Probably because I was still thought to be among the poets. Among those poets who satisfy their legitimate need for cold onanism with warm furs: *H o h o,* I know other pleasures, equally platonic. Call your family on the telephone and piss in the hole reserved for musical gastronomic and sacred stupidities.

DADA proposes 2 solutions:
NO MORE LOOKS!
NO MORE WORDS![2]
Stop looking!
Stop talking!

For I, chameleon transformation infiltration with convenient attitudes—multi-colored opinions for every occasion dimension and price—I do the opposite of what I suggest to others.[3]

[1] I wanted to give myself a little publicity.
[2] No more manifestoes.
[3] Sometimes.

I've forgotten something:
where? why? how?
in other words:
ventilator of cold examples will serve as a cavalcade to the fragile snake and i never had the pleasure of seeing you my dear rigid the ear will emerge of its own accord from the envelope like all marine confections and the products of the firm of Aa & Co. chewing gum for instance and dogs have blue eyes, I drink camomile tea, they drink wind, Dada introduces new points of view, nowadays people sit at the corners of tables, in attitudes sliding a little to left and right, that's why I'm angry with Dada, wherever you go insist on the abolition of D's, eat Aa, rub yourself down with Aa toothpaste, buy your clothes from Aa. Aa is a handkerchief and a sex organ wiping its nose, a rapid noiseless—rubber-tired—collapse, needs no manifestoes, or address books, gives a 25% discount buy your clothes from Aa he has blue eyes.

mr. aa the anti-philosopher sends us this manifesto

Hurrah for the undertakers of combination!
Every act is a cerebral revolver shot—the insignificant gesture the decisive movement are attacks—(I open the fan of knock-outs to distill the air that separates us) —and with words set down on paper I enter, solemnly, into myself.
I plant my sixty fingers in the hair of notions and brutally shake the drapery, the teeth, the bolts of the joints.
I close, I open, I spit. Take care! This is the time to tell you that I lied. If there is a system in the lack of system—that of my proportions—I never apply it.
In other words I lie. I lie when I apply it, I lie when I don't apply it, I lie when I write that I'm lying, for I am not lying for I have seen my father's mirror—chosen among the advantages of vaccara—from city to city—for myself has never been myself—for the saxophone wears the murder of the visceral chauffeur like a rose—it is made of sexual copper and tip sheets. Thus drummed the corn, the fire alarm and the pellagra down where the matches grow.

Extermination. Yes, of course.
But it doesn't exist. Myself: mixture kitchen theatre.
Hurrah for the stretcher bearers armed with ecstatic convocations! The lie is ecstasy—what transcends the duration of a second—there is nothing that transcends it. Idiots brood the century—idiots start some centuries all over again—idiots belong to the same club for ten years—idiots play see-saw on the clockface for the space of a year—I (idiot) leave after five minutes.
The pretension of the blood to pour through my body and my factitiousness the random color of the first woman I touched with my eyes in these tentacular times. The bitterest banditry is to complete a sentence of thought. Gramophone banditry little anti-human mirage that I like in myself because I think it absurd and insulting. But the bankers of language will always get their little percentage on the discussion. The presence of one boxer (at least) is indispensable for the bout—the

members of a gang of dadaist assassins have signed a contract covering self-protection for operations of this order. Their number was very small—since the presence of one singer (for the duet), of one signatory (at least) for the receipt, of one eye (at least) for sight—was absolutely indispensable.

Put the photographic plate of the face into the acid bath.
The disturbances that sensitized it will become visible and will amaze you.

Give yourself a poke in the nose and drop dead.
dada

5. manifesto on feeble love and bitter love

I
preamble = sardanapalus
one = valise
woman = women
pants = water
if = mustache
2 = three
cane = perhaps
after = decipher
irritating = emerald
vice = vise
october = periscope
nerve = ☞

or all this together in any arrangement at all whether savorous soapy brusque or definitive—picked at random—is alive.
So it is that above the vigilant mind of the clergyman set up at every animal vegetable imaginable or organic street corner, everything is equal to everything is without equal. Even if I didn't believe it, it is the truth just because I have set it down on paper—
because it is a lie that I have PINNED DOWN as you pin a butterfly to your hat. The lie moves about greeting Mr. Opportune and Mr. Convenient: I stop it, it becomes truth.
As a result Dada undertakes police duty with pedals and muted morality. Everybody (at some time or other) was complete in mind and body. Repeat this 30 times.
I consider myself very charming

Tristan Tzara

II

A manifesto is a communication addressed to the whole world, in which there is no other pretension than the discovery of a means of curing instantly political, astronomical, artistic, parliamentary agronomic and literary syphilis. It can be gentle, good-natured, it is always right, it is strong, vigorous and logical.
A propos logic, I consider myself very charming.

Tristan Tzara

Pride is the star that yawns and penetrates by way of the eyes and the mouth, it presses and digs on its breast is written: you will croak. That is its only remedy. Who still believes in doctors? I prefer the poet who is a fart in a steam engine—he is gentle but weep not—he is polite and semi-pederast, and swims. The both of them are no skin off my ass, none at all. It is an accident (which is not necessary) that the first is German, the second Spanish. Far be it from us, positively, to think of discovering the theory of probability of the races and the perfected epistolary of bitterness.

III

Mistakes have always been made but the greatest mistakes are the poems that have been written. There is but one justification for chatter: rejuvenation and the maintenance of biblical traditions. Chatter is encouraged by the postal administration which, alas! is becoming perfected, encouraged by the tobacco monopoly, the railroad companies, the hospitals, the undertaking establishments, the textile factories. Chatter is encouraged by family culture. Chatter is encouraged by the pope's pence. Every drop of saliva that escapes from conversation is converted into gold. Since peoples have always needed divinities to maintain the 3 essential laws which are the laws of God: to eat, make love and shit, since the kings are out of town and the laws are too hard, today it is only chatter that counts. The form in which it most frequently turns up is Dada.
There are people (journalists, lawyers, dilettantes, philosophers) who even regard the other forms—business, marriages, visits, wars, various congresses, joint stock companies, politics, accidents, dance halls, economic crises, emotional crises—as variations of dada. Since I am not an imperialist, I do not share their opinion—I prefer to believe that dada is only a divinity of a secondary order, which must simply be placed beside the other forms of the new mechanism for interregnum religions. Is simplicity simple or dada?
I consider myself rather charming.

<div align="right">Tristan Tzara</div>

IV

Is poetry necessary? I know that those who write most violently against it unconsciously desire to endow it with a comfortable perfection, and are working on this project right now;—they call this hygienic future. They contemplate the annihilation (always imminent) of art. At this point they desire more artistic art. Hygiene becomes purity oGod oGod.
Must we cease to believe in words? Since when have they expressed the opposite of what the organ emitting them thinks and wants?[1]
Here is the great secret:
The thought is made in the mouth.
I still consider myself very charming.

<div align="right">Tristan Tzara</div>

[1] Thinks wants and desires to think.

87

Obermusikdada Preiss ÷ in seiner Scene: „dadaistischer Holzpuppentanz".

Ewig lebt der Sport bei Potsdam

ÉDITIONS LIBRAIRIE
AU SANS PAREIL
37 Avenue Kléber
PARIS (XVIe)

monsieur Paul Eluard

First International Dada Fair. Burchard Gallery, Berlin, 1920 Catalogue. Last page (center portion obscured by mailing label).

39 Raoul Hausmann: ... Die ... mannes (Dr. Anselm Ruest)
40 George Grosz: ... Gesellschaft
41 George Grosz: ... ner Männerschönheit, Preisfrage „Wer ist der Schönste?
42 (siehe 3)
43 Otto Dix, Dresden ... erwerbsfä ...
44 dadamax Ernst (K ... n): sch ... afel für Gummifrucht (relief)
45 George Grosz: ...
46 George Grosz: ... auf Feri ... (*)
47 Francis Picabia, ... IL RON ... Buschmannzeichnung (Original)
48 Francis Picabia, ... hibalisme ...
49 Francis Picabia, ... scles Bri ...
50 George Grosz: Da ... ter stinkt ... us 20. Jahrhundert
51 George Grosz: M ... eines Meis ... werkes von Botticelli
52 George Grosz: „Da ... es her pe ... stic automaton „George' in May 1920, John ... is very g ... of it. (Meta-Mech. constr. nach Prof. R. Ha ...
53 George Grosz: Weg ... lten Mist! ...
54 George Grosz: Singe ... glaube an ... heiligen Goethe
55 Langlais Beckett Bat ... n Goorthy ...
56 George Grosz: Tatlinis ... Plan
57 George Grosz: Entwick ...)
58 Hans Arp, Zürich: Der ... da! (relief) ...
59 Die Dadaisten boxen! (... Wieland Herz ... e, links ... Trainer Beck ... rechts)
60 George Grosz: Tatlinis ... lanriß „Schu ... enkammer".
61 George Grosz: Tatl ... Planriß: ... lamenschieber im Café Kaiserhof
62 George Grosz: ... Jo ... Heartfie ... Nach Franz Jungs Versuch ... he ... sslen. 1920 ...
63 George G ... ettgewinnung nach de ... erfahren von Rittme ... r Hellriegel. (Erinnerung an eine Kriegs ... rung ... schaft.) (*)
64 George Grosz: Porträt des Dichters vo ... Kur ... stendamm Wieland Herzfelde. 1920 Aus „Tragigroteske ... icht. Träume von W. Herzfelde". (Berlin, Der Malik-Ve ...
65 Boxbild
66 Max Schlichter (dadameisterkoch), Berlin: Kochkunst-Preisarbeit
67 Otto Schmalhausen, Antwerpen (Ozdada-Works): High School Course in Dada (verkauft) (*)
68 Otto Schmalhausen, Antwerpen (Ozdada-Works): Dada's Darling
69 George Grosz: Das Geheimnisvollste und Unerklärlichste was ... ge ...

Otto Burchard
71 George Grosz: T ... Reichstagsabge ...
72 George Grosz: O ...
73 Grosz-Heartfield m ...
74 Grosz-Heartfield ... (Dr. Carl E ...
75 dada-Oz. Otto ... Zuidersee"
76 baargeld und dad ... dadaisten und ... sich in Blume ...

103 Francis Picabia ...
104 Otto Dix, Dresde ...
105 dadamax E ...
106 Aloi ... st ...
107 Aloi ...
108 Johan ... Eh ...
109 W. St ...
110 W. Stuckenschmid ...
111 W. Stuckenschmid ...
112 W. Stuckenschmid ...
113 Grosz-Heartfield ...
114 Grosz-Heartfield ...
115 dadamax Ernst: ... bei hoch und ...
116 Rudolf Schlichter, ... Heiland der W ...
117 Rudolf Schlichter, ...
118 Rudolf Schlichter, ...
119 Rudolf Schlichter, ...
120 Rudolf Schlichter, ...
121 Rudolf Schlichter, ...
122 baargeld (Köln a. ...
123 Hans Citroen (14 ... der Vogelpersp ...
124 Hans Citroen: W ...
125 Hans Citroen: L ...
126 Hans Citroen: D ...
127 Wieland Herzfelde ...
128 Ben Hecht (Chica ...
129 Grosz-Heartfield ...
130 Grosz-Heartfield ...
131 Grosz-Heartfield ...
132 George Grosz: ... seines Vaters ...
133 W. Stuckenschmid ...
134 baargeld, Köln ...
135 baargeld, Köln ...
136 Otto Else Lasker- ... Krone, was ni ...
137 Carl Boesner, dad ... Heartfield
138 John Heartfield ...
139 John Heartfield ...

Konstruktion. Den sozialistischen
ken Krieg gestimmt haben, gewidmet
sen), Antwerpen.) Warum???
au, ... aus ... vierte
sso, ... Neue ... ter-
... er!
ern ... in der ... er am

Rhein): simultan psychon: die
Aisen . . . (namen) . . . verwandeln

brik geklebtes Wahlplakat ‚Deutsche

ntisches (*)
reklameblatt (*)
hes Figurenbild (*)
irich
nd Marseillaise des dada Arp (*)
rud non (*)
od der Anna Blume

chard

ustrata (Plastik)
vordene Spießer Heartfield. (Elektro-

her Erzengel (Deckenplastik)
unstwerk vollkommen zu begreifen,
nden mit vollgepacktem Affen und
dem Tempelhoferfeld.

: Hindenburgsülze. Ein duftendes
eldmarschall Hindenburg
Bauernbild

(bei Kurt Wolff-Verlag, München)

-Südende: Hans Arp
es Dadabild aus der Zeit um 1850
rpen: „Beethoven" (Plastik)
I)) (*)
„Deutschland muß untergehen" von
k-Verlag, Berlin 1920)
Festival dada Mercredi 26. Mai 1920
von „391")
Vent (aus „391")
(*)
hrsatz vom Genuß
üße dada (dadaisten in der Werk-

ht nach dada (*)
etier Helmhacke auf dem Felde der

sikdada II: Dieses Bild ist kein Bild
e Impotenz des Herrn Dr. Pfitzner
ie Produktionskrise (verkauft) (*)
kennen mich nicht?
ka (*)
„Schall und Rauch, Berlin" (*)
Wirkungsradien des dadamaxernst

Handlungsgehilfen zum

lo aus Pompeji
s von Milo 1 (*)
s von Milo 2 (*)
ngsfigur von Tenea (*)
he verleumdung des dada baargeld
ppe Dada): Die Angel, Plastik aus

1914
merika an George Grosz
ada Richard Huelsenbeck (*)
zum Sport auf (*)
Land (*)
Kronprinzen über die Fahnenflucht
gewidmet (*)
Magdeburg: Mein Dackel Waldi
Expressionisten

n: Was nützt denn dem Kaiser die
mann sein Geld
r Monteurdada und sein Sohn Tom

eist die Welt (*)
siegt" von R. Huelsenbeck. Der

(vertical text) Sieg, Triumph, Tabak mit Bohnen

(vertical text) Verbesserte Bildwerke der Antike

141 George Grosz: Photoporträt von Otto Else Lasker-Dix, Dresden
142 George Grosz: Photoporträt des Musikdada I
143 Grosz-Heartfield mont.: Der deutsche Dummkopf in der Welt voran. Reklameplastik
144 Raoul Hausmann: Abgründe der Toilette
145 Georg Kobbe: Umschlag zu „didadische Korruption" von W. Petry. Leon Hirschfeld, Charlottenburg
146 Georg Kobbe: Schall und Rauch-Fantasie
147 max ernst, Cöln: nationalcodex und delicateß-index des dada baargeld
150 John Heartfield: Neue Jugend, Wochenausgabe No. 1
151 (siehe Saal I No. 13)
152 John Heartfield: „Leben und Treiben in Universal-City, 12 Uhr 5 mittags". Besitzer Lämmle, Kalifornien (*)
153 Ehrenporträt von Charlie Chaplin
154 Georg Koch (gen: Der Maskenkoch): Transformation
155 Maud E. Grosz: Das Waisenkind (Kissen) (*) } Die ersten dadaistischen
156 Maud E. Grosz: Mr. Curtis reist (Kissen) (*) } Kissen der Welt
157 John Heartfield: Umschlag für „Phantastische Gebete" von R. Huelsenbeck. (Der Malik-Verlag, Berlin)
158 A. Baader, Oberdada, Präsident des Erd- und Weltballs, Leiter des Weltsgerichts, Wirklicher Geheimer Vorsitzender des intertellurischen oberdadaistischen Völkerbunds, Repräsentant von Lehrer Hagendorfs Lesepult, ehemals Architekt und Schriftsteller: Reiseausstattung des Oberdadas bei seiner ersten Flucht aus dem Irrenhaus, am 17. September 1899. (Dada-Reliquie. Historisch)
159–166 B. Baader, Oberdada: Acht Seiten aus dem Buch des Weltsgerichts
 C. (*) (HADO = Handbuch des Oberdadaismus). Erste Ausgabe vom
 D. 26. Juni 1, 3 Uhr nachmittags. Das Buch ist am 10. Juli 1 in
 E. (*) Weimar vom Oberdada selbst der Nationalversammlung zum
 F. Geschenk geboten worden. Der Abgeordnete Friedrich
 G. Naumann, der das Geschenk übermitteln sollte, hat sich ge-
 H. weigert und ist deshalb gestorben.
 I. Das Material der Seiten besteht aus historischen Zeitungsblättern. Seite B ist das äußere, Seite C das innere Titelblatt.

Die zweite Ausgabe des HADO ist am 28. Juni 2 erschienen.
Sie liegt nicht öffentlich aus, kann aber beim Generaldada
Dr. Otto Burchard, Exzellenz, eingesehen werden.

167 M. Baader, Oberdada: Meine Visitkarte.
168 N. Baader, Oberdada: Geschäftskarte der Correspondenz Hähne.
169 O. Baader, Oberdada: Warum verdreht Carnegie seine Augen?
170 P. Baader am Galgen.
171 Q. Entwurf zu einem Tierparadies im Jardin d'Acclimation, Paris. (Enthält die Gelasse für alle französischen und deutschen Dadaisten, im Stil Hagenbeck, ohne Gitter.)
172 R. Der Club Dada in der Blauen Milchstraße. Begründung der neuen Zeitrechnung durch die Vorsitzenden des Anationalen Rats der unbezahlten Arbeiter (ARDUA) Baader und Hausmann. Beschluß: korporativ Reklame zu machen für Lehrer Hagendorfs Lesepult (Kein Mensch liest; kein Kind geht in die Schule ohne Lehrer Hagendorfs Lesepult). Käuflich an der Kasse der Dada-Ausstellung zum Preis von M. 7.75.
173 W. Bekanntmachungen des Oberdada. Man nehme das ausgelegte Buch, klappe es auf und stecke die Rückendeckel in die zwei eisernen Halten. Das Lesepult ist gebrauchsfertig. (Das ausgelegte Buch ist das Handbuch des Islam mit dem Bildnis des Oberdada (Allah ist groß aber der Oberdada ist noch größer). (Sie sich aus den Wolken gefallen im Café Josty, Berlin, Potsdamer Platz am 17. Mai 1). Bildnis aufgenommen am 29. Oktober 1914 bei A. Wertheim. Eintritt der Türkei in den Weltkrieg. Bestellungen auf Lehrer Hagendorfs Lesepult beliebe man, wenn an der Kasse kein Vorrat ist, in den goldenen Teller zu legen.
174 Z. Das große Plasto-Dio-Dada-Drama:

DEUTSCHLANDS GROESSE UND UNTERGANG
· durch Lehrer Hagendorf
oder
Die phantastische Lebensgeschichte
des Oberdada

Verlegt bei PAUL STEEGEMANN, ERNST ROWOHLT und KURT WOLLFF (Hannover, Berlin und München)

Dadaistische Monumentalarchitektur in fünf Stockwerken, 3 Anlagen, einem Tunnel, 2 Aufzügen und einem Cylinderabschluß.

Beschreibung der Stockwerke:
 Das Erdgeschoß oder der Fußboden ist die prädestinierte Bestimmung vor der Geburt und gehört nicht zur Sache.
 I. Stockwerk: Die Vorbereitung des Oberdada.
 II. Stockwerk: Die metaphysische Prüfung.
 III. Stockwerk: Die Einweihung.
 IV. Stockwerk: Der Weltkrieg.
 V. Stockwerk: Weltrevolution.
 Ueberstock: Der Cylinder schraubt sich in den Himmel und verkündet die Wiederauferstehung Deutschlands durch Lehrer Hagendorf und sein Lesepult. Ewig.

Die im Katalog mit einem Sternchen (*) versehenen Arbeiten werden nach Schluß der Ausstellung in der Société Anonyme, Inc., open its First Exhibition of Modern Art, 19 East 47th Street, New York ausgestellt. Es sind

Francis Picabia. Exhibition catalogue, text by Tristan Tzara. Galerie au sans pareil, Paris, 16–30 April, 1920.

A great Canadian philosopher has said: *Le pensée* (thought) and *la passé* (the **past**) are also very charming.[1]

V

A friend, who is too good a friend of mine not to be very intelligent said to me the other day:
the abrupt start
the chiromancer IS ONLY THE
　　　　　　　　　　　　good morning
WAY IN WHICH ONE SAYS good afternoon WHICH
DEPENDS ON THE FORM ONE HAS GIVEN
TO one's forget-me-nots
　　　one's hair
I answered him:
YOU ARE RIGHT idiot BECAUSE
　　　　　　　prince
　　　　　　　　　　opposite
I AM CONVINCED OF THE tartar
naturally WE ARE NOT
we hesitate
right. My name is THE OTHER
desirous of understanding
Since diversity is diverting, this game of golf gives the illusion of a "certain" depth. I maintain all the conventions—to do away with them would be to create new ones, which would complicate life in a really disgusting way.

We wouldn't know what was chic any more: to love the children of the first or second marriage. The "pistil of the pistol" has often put us into strange and upsetting situations. Scramble the meanings—scramble the ideas and all the little tropical rains of *demoralization, disorganization, destruction,* and *ruckus* will be safeguarded against lightning and recognized to be a public utility. One thing is certain: today you will find dadaists nowhere but in the Académie Française. Even so I consider myself very charming.

<div align="right">Tristan TZARA</div>

VI

It seems there is such a thing as: more logical, very logical, too logical, less logical, not very logical, really logical, logical enough. Very well, then, draw the consequences.
—Done:
Now recall to your memory the creatures you love best.
—Done?
Tell me the number and I'll tell you the lottery.

[1] The genders of la pensée and le passé are reversed. This is a standard way of making comic Americans speak French. Perhaps Tzara has in mind an English Canadian, perhaps not (*Translator*).

VII

A priori, that is with eyes closed, Dada places before action and above all: *Doubt.*
Dada doubts all. Dada's an awl. All is Dada. Watch out for Dada.
Anti-Dadaism is a disease: self-kleptomania, the normal state of man is Dada.
But the true dadas are against Dada.
The self-kleptomaniac
The man who steals—without thinking of his interest of his will—elements of his
individuality, is a kleptomaniac. He robs himself. He spirits away the characteristics
that remove him from the community. The bourgeois resemble one another—they
are all alike. They didn't used to be alike. They were taught to steal—theft became
a function—the most convenient and least dangerous is to rob oneself. They are
all very poor. The poor are against DADA. They are very busy with their brains.
They will never get done. They work. They work themselves—they deceive them-
selves—they rob themselves—they are very poor. So poor. The poor work. The poor
are against DADA. Anyone who is against DADA is with me, said a famous man,
but he died instantly. He was buried like a real dadaist. Anno domini Dada. Take
care. And remember this example.

VIII

To make a dadaist poem
Take a newspaper.
Take a pair of scissors.
Choose an article as long as you are planning to make your poem.
Cut out the article.
Then cut out each of the words that make up this article and put them in a bag.
Shake it gently.
Then take out the scraps one after the other in the order in which they left the bag.
Copy conscientiously.
The poem will be like you.
And here you are a writer, infinitely original and endowed with a sensibility that
is charming though beyond the understanding of the vulgar.

Example:

when the dogs cross the air in a diamond like the ideas and the appendix of the
meninges shows the hour of awakening program (the title is my own)
price they are yesterday agreeing afterwards paintings / appreciate the dream
epoch of the eyes / pompously than recite the gospel mode darkens / group the
apotheosis imagine he said fatality power of colors / cut arches flabbergasted the
reality a magic spell / spectator all to efforts from the it is no longer 10 to 12 /
during digression volt right diminishes pressure / render of madmen topsy-turvy
flesh on a monstrous crushing scene / celebrate but their 160 adepts in not to the
put in my mother-of-pearl / sumptuous of land bananas upheld illumine / joy ask
reunited almost / of has the one so much that the invoked visions / of the sing
this one laughs / destiny situation disappears describes this one 25 dances salva-

Max Ernst. *Third Gasometric Painting*. 1920. (Courtesy Cahiers d'Art, Paris).

tion / dissimulated the whole of it is not was / magnificent the ascent to the gang better light of which sumptuousness scene me music-hall / reappears following instant shakes to live / business that there is not loaned / manner words come these people

IX

There are people who explain because there are no others who learn. Do away with them and nothing but dada will be left.

Dip your pen in a black liquid with manifest intentions—it is only your autobiography you are brooding beneath the belly of the flowering cerebellum.

Biography is the equipage of the famous man. Great or strong. And there you are, a simple man like the others, after dipping your pen in the ink, full of

PRETENSIONS

manifested in forms as diverse as they are unforeseen, applying themselves to every form of activity, state of mind and mimicry; There you are, full of

AMBITIONS

to maintain yourself on the dial of life, in the spot which you have reached this

93

very instant, to progress by an illusory and absurd ascent toward an apotheosis that exists only in your neurasthenia;
there you are, full of
PRIDE
greater, stronger, more profound than any other.
My dear colleagues: a great man, a little strong, weak, profound, superficial man, *that is why you will all croak.*
There are men who have antedated their manifestoes in order to make people think that they had the idea of their own greatness a little ahead of time. My dear colleagues: before after, past future, now yesterday,
that is why you will all croak.
There are men who have said: dada is good because it isn't bad, dada is bad, dada is a religion, dada is a type of poetry, dada is a spirit, dada is sceptical, dada is magic, I know dada.
My dear colleagues: good bad, religion poetry, spirit scepticism, definition, definition
that is why you will all croak.
and croak you will I swear it.
The great mystery is a secret, but it is known to a few persons. They will never say what dada is. To distract you once more I will tell you something such as:
dada is the dictatorship of the spirit, or
dada is the dictatorship of language,
or if you like
dada is the death of the spirit,
which will please a good many of my friends.
friends.

X

It is certain that since Gambetta, the war, Panama and the Steinheil case, intelligence is to be found in the steets. The intelligent man has become a perfectly normal type. What we need, what offers some interest, what is rare because it presents the anomalies of a precious being, the freshness and the freedom of the great anti-men is
THE IDIOT
Dada is working with all its might to introduce the idiot everywhere. But consciously. And it is itself tending to become more and more idiotic.
Dada is terrible: it feels no pity for the defeats of the intelligence. Dada is more cowardly than otherwise, but cowardly like a mad dog, it recognizes neither method nor persuasive excesses.
The lack of garters that makes it stoop down systematically reminds us of the famous lack of system which actually never existed. The false rumor was started by a laundress at the bottom of her page, the page was carried to the barbarous country where the hummingbirds are the sandwichmen of soothing nature.
This was told me by a clockmaker holding in his hand a supple syringe which, in characteristic memory of the hot countries, he called phlegmatic and insinuating.

94

XI

Dada is a dog—a compass—the abdominal clay—neither new nor a Japanese nude—a gas meter of sentiments rolled into pellets—Dada is brutal and puts out no propaganda—Dada is a quantity of life undergoing a transparent transformation both effortless and giratory

XII

ladies and gentlemen buy come in and buy and do not read you will see the man who holds in his hands the keys of niagara the man who limps in a blimp with the hemisphere in a suitcase and his nose shut up in a japanese lantern and you will see you will see you will see the stomach dance in the massachusetts saloon the man who drives in a nail and the tire goes flat the silk stockings of miss atlantis the trunk that circumnavigates the globe 6 times to reach the addressee monsieur and his fiancée and his sister-in-law you will find the address of the carpenter the frog-watch the nerve shaped like a papercutter you will learn the address of the minor pin for the feminine sex and the address of the man who furnishes the king of greece with filthy photographs and the address of the *action française.*

XIII

Dada is a virgin microbe
Dada is against the high cost of living
Dada
a joint stock company for the exploitation of ideas
Dada has 391 different attitudes and colors depending on the sex of the chairman
It transforms itself—affirms—simultaneously says the opposite—it doesn't matter—screams—goes fishing
Dada is the chameleon of rapid, interested change
Dada is against the future. Dada is dead.
Dada is idiotic. Hurrah for Dada. Dada is not a literary school roar

Tristan TZARA

XIV

To paint the face of life in the pince-nez—blanket of caresses—panoply of butter-flies—*behold the life of the chambermaids of life.*
To lie down on a razor and on fleas in heat—to travel like a barometer—to piss like a cartridge—to make blunders, to be idiotic, to shower with holy minutes—to be beaten, to be always last—to shout the opposite of what the other says—to be the editorial office and bathroom of God who every day takes a bath in us in the company of the privy emptier—*that is the life of dadaists.*
To be intelligent—to respect everybody—to die on the field of honor—to subscribe to the government loan—to vote for Soandso—to respect nature and painting—to boo at dada demonstrations,—*that is the life of men.*
Dada is not a doctrine to be put into practise: Dada—if it's a lie you want—is a prosperous business venture.—Dada runs up debts and will not stick to its mattress. God has created a universal language, that is why no one takes him seriously. A language is a utopia. God can afford to be unsuccessful: so can Dada. That is why

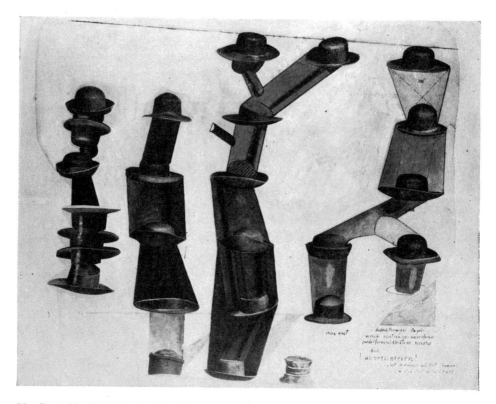

Max Ernst. *The Hat Makes the Man.* Cologne, 1920. (Coll. Museum of Modern Art, N.Y.)

the critics say: Dada is a luxury article or Dada is in heat. God is a luxury article or God is in heat. Who is right: God, Dada or the critic?

"You digress," says a charming reader.

"No, not at all! I simply wanted to arrive at this conclusion: subscribe to Dada, the only loan that brings in nothing.

XVI

roar roar roar roar roar roar roar
roar roar roar roar roar roar roar
roar roar roar roar roar roar roar
roar roar roar roar roar roar roar
roar roar roar roar roar roar roar
roar roar roar roar roar roar roar
roar roar roar roar roar roar roar
roar roar roar roar roar roar roar
roar roar roar roar roar roar roar
roar roar roar roar roar roar roar
roar roar roar roar roar roar roar
roar roar roar roar roar roar roar

roar roar roar roar roar roar roar
roar roar roar roar roar roar roar
roar roar roar roar roar roar roar
roar 1oar roar roar roar roar roar
roar roar roar roar roar roar roar
roar roar roar roar roar roar roar
roar roar roar roar roar roar roar
roar roar roar roar roar roar roar
roar roar roar roar roar roar roar
Who still considers himself very charming.

<div align="right">Tristan Tzara</div>

Supplement:

How I became
charming delightful
and delicious

I sleep very late. I commit suicide 65%. My life is very cheap, for me it is only 30% of life. My life contains 30% of life. It lacks arms strings and a few buttons. 5% is consecrated to a state of semi-lucid stupor accompanied by anemic râles. This 5% is called Dada. So you see that life is cheap. Death is a little more expensive. But life is charming and death is charming too.

A few days ago I attended a gathering of imbeciles. There were lots of people. Everybody was charming. Tristan Tzara, a small, idiotic and insignificant individual, delivered a lecture on the art of becoming charming. And incidentally, he was charming. And witty. Isn't that delicious? Incidentally, everybody is delicious. 9 below zero. Isn't that charming? No, it's not charming. God can't make the grade. He isn't even in the phone book. But he's charming just the same.

Ambassadors, poets, counts, princes, musicians, journalists, actors, writers, diplomats, directors, dressmakers, socialists, princesses and baronesses—all charming. All of you are charming, utterly subtle, witty, and delicious.

Tristan Tzara says to you: he would be quite willing to do something else, but he prefers to remain an idiot, a clown and a faker.

Be sincere for an instant: Is what I have just told you charming or idiotic?

There are people (journalists, lawyers, dilettantes, philosophers) who even regard the other forms—business, marriages, visits, wars, various congresses, joint stock companies, politics, accidents, dance halls, economic crises, emotional crises—as variations of dada. Since I am not an imperialist, I do not share in their opinion--I prefer to believe that dada is only a divinity of a secondary order, which must simply be placed beside the other forms of the new mechanism for interregnum religions.

Is simplicity simple or dada?

I consider myself quite charming

<div align="right">Tristan Tzara</div>

Colonial syllogism
No one can escape from destiny

No one can escape from DADA

Only DADA can enable you to escape from destiny.

You owe me: 943.50 francs.

No more drunkards!
No more aeroplanes!
No more vigor!
No more urinary passages!
No more enigmas!

Photographer Unknown. *Tristan Tzara* 1919. Courtesy Hans Richter.

VII. *History of Dada*

By Georges Ribemont-Dessaignes. 1931. Translated complete
from the French by Ralph Manheim. Published in *La Nouvelle
Revue Française,* Paris: no. 36, June, 1931; no. 37, July,
1931. By permission of the author and of Librairie Gallimard.

Man Ray. *Gift.* 1921. (Reconstruction by the artist of the original).

Georges Ribemont-Dessaignes: *History of Dada*

There are undertakings of the human mind which, at the moment of bursting, make such a noise that no one can tell whether it is God's thunder or a string of firecrackers set off by village children. Then time passes, everybody goes off shrugging his shoulders, and the undertaking in question loses interest. God's most authentic thunder has ceased to be anything more than a child's firecracker.

And yet it is only at a later time that we recognize the principles of an undertaking in a man's blood, and, if we are discerning, his virtues may take on their proper grandeur. It is too late. At this distance, all that appears is a corpse, dragged off into the past.

What has been called the Dada movement was really a movement of the mind, with its point of departure, its apogee and its fall, and not merely a new artistic school.

This movement was first spoken of in Zurich in 1916, and those who did the speaking were a Rumanian, Tristan Tzara, an Alsatian, Hans Arp, and two Germans, Hugo Ball and Richard Huelsenbeck. It had its high tide in Paris, in 1919, thanks to Tristan Tzara, Francis Picabia, André Breton, Louis Aragon, Philippe Soupault, G. Ribemont-Dessaignes and several others, such as Theodore Fraenkel, Jacques Rigaut, Paul Dermée, Benjamin Péret, etc. It died in Paris in 1921, after convulsions that dispersed the various members of the group.

But why the name of "Dada"? It means nothing, aims to mean nothing, and was adopted precisely because of its absence of meaning. How was it adopted, and why was it chosen in preference to any other name?

Here is what the poet and painter Hans Arp wrote in a number of *Dada*, entitled "Dada-au-grand-air" (Dada in the Open Air), which appeared in 1921 at Tarenz-bei-Imst (Tirol):

"I hereby declare that Tristan Tzara found the word Dada on February 8, 1916, at six o'clock in the afternoon; I was present with my twelve children when Tzara

for the first time uttered this word which filled us with justified enthusiasm. This occurred at the Café de la Terrasse *in Zurich and I was wearing a brioche in my left nostril. I am convinced that this word is of no importance and that only imbeciles and Spanish professors can take an interest in dates. What interests us is the Dada spirit and we were all Dada before Dada came into existence. . . ."*

This statement adulterates facts with fantasies calculated to tone down anything that might be too compromising from the Dada point of view. It confirms an interview with Tristan Tzara published in *Nouvelles Littéraires:*

"I found the word Dada by accident in the Larousse dictionary. We all liked it. . . ."

We add a detail which we learned from some of those involved: A paper-knife slipped at random between the pages of the dictionary acted as the necessary intermediary.

The activity of Dada was a permanent revolt of the individual against art, against morality, against society. The means were manifestoes, poems, writings of various kinds, paintings, sculptures, exhibitions, and a few public demonstrations of a clearly subversive character.

However, the implications of the movement went beyond literature and art. It aimed at the liberation of the individual from dogmas, formulas and laws, at the affirmation of the individual on the plane of the spiritual; it may even be said that the movement liberated the individual from the mind itself, placing the genius in the same rank as the idiot.

The young men who came to believe in the necessity of revolt were primarily poets and writers, in league with several painters. Consequently the media of art bore the brunt of their attack. Language and form fell beneath their blows like so many houses of cards. And it goes without saying that it was the media that had been most useful to them which they first destroyed. Nothing is made out of nothing; in other words, replacing the cubism, futurism and simultaneism that had nourished them, they smashed the forms of cubist, futurist and simultaneist thought with means closely resembling the objects destroyed. The real question was the destruction of values. A building that is being torn down includes beams, masonry, planks; that is to say, in addition to dust and noise, there are elements of the building itself. It is not surprising that in the beginning Dada should often have presented a futurist or cubist face, to the extent that Dada itself was often deceived by it.

Man is unable to destroy without constructing something other than what he is destroying. Consequently, though Dada had the will and the need to destroy every form of art subject to dogma, it felt a parallel need of expressing itself. It was necessary to replace submission to reality by the creation of a *superior reality* (a preoccupation which recurred later in surrealism, Dada's sawed-off son); to pursue the work of God without taking it seriously. The *superiority* of this creation does not aim at greatness through Law and Order, but at a new abstract universe made up of elements borrowed from the concrete, quite aside from any

Cover. (For *Sic no.23*, edited by Pierre Albert-Birot). Paris, November, 1917.

formal increase in value. One is no longer concerned with knowing whether a thing is beautiful or ugly; whether it is logical, probable or fanciful—we pursue the ugly, Apollinaire had already said—whether it is well done; whether it corresponds to the most elementary rules of composition. We no longer call on superior powers to intervene as guardians of order. There are no longer privileged zones in human aspirations; the lowest values are as much favored as the highest. And for the sake of strategy, since we must always be on the alert to avoid backsliding into habits which had become natural in the course of a long tradition—to prevent the beautiful, the noble, the exalted, the charming, the well-ordered, the perfect from catching the beast by the tail—we even show a weakness for the fantastic, the absurd, the vulgar, the coarse, the unbalanced, the unforeseen or the shapeless.

Two magazines then appearing in Paris, *Sic* and *Nord-Sud* (1916 and 1917–18), were impregnated with futurism and cubism. Founded in January 1916 by Pierre Albert-Birot, *Sic* was particularly futurist, with a tendency to escape from formal laws, invoking movement, speed, simultaneity, dynamism; as a sub-title it carried the programmatic formula:

<div align="center">SOUNDS—IDEAS—COLORS—FORMS</div>

Apollinaire, Paul Dermée and Gino Severini soon began to contribute.

Nord-Sud, more confused in its tendencies, quickly found numerous contribu-

tors; future Dadaists like André Breton (who at that time was writing poems in the style of Mallarmé), Philippe Soupault and Louis Aragon appeared side by side with Apollinaire, Pierre Reverdy, Max Jacob and Roch Grey.

Such confusion was propitious to the flowering of the Dadaist revolution. Even so, *Sic* and *Nord-Sud* would have been insufficient without the support of Francis Picabia with his reviews *291* and *391*, and of Marcel Duchamp, with his two little magazines, *Wrong-Wrong* and *The Blind Man*, of which only two issues appeared. It was in *The Blind Man* that he reproduced his "Sculpture," rejected by the New York Independents Salon, under the title of "Fountain" by R. Mutt, which was in fact a men's urinal.

291 published writing but stressed drawings and reproductions of paintings; its general tendency was already that which appeared at the birth of Dada: destructive, but with a view to a superior reality. Picabia's drawings are "mechanical."

The first number of *391* appeared on January 25, 1917, with a cover by Picabia entitled "Novia" and representing some of the internal organs of an automobile. Inside, there was a drawing by Marie Laurencin, representing heads of children and birds. There were some poems on the opposite page. One, signed "M.L." (did the initials stand for Marie Laurencin?) is charming, rather in the style of Apollinaire:

Roi d'Espagne	King of Spain
Prenez votre manteau	Take your cloak
Et un couteau . . .	And a knife . . .
Au jardin zoologique	at the zoo
Il y a un tigre paralytique	There is a paralytic
Mais royal	But royal tiger
Et le regarder fait mal.	And it hurts to look at him.

At the same date, the first Dada exhibition was put on in Zurich. This juxtaposition suggests that, though Picabia's efforts were moving in a direction similar to that which Dada was to follow, he was at this time still far from the concentration of explosive power which the new movement was to develop. But it should be added that Dada in its early stages only half suspected its own road: in reality it only became itself when the endeavors of the young poets in Zurich were combined with those of Picabia and with the more confused, more secret, and at that time extremely uncertain efforts which some young men in Paris were attempting to realize in the magazine, *Littérature,* soon known for its inquiry: "Pourquoi écrivez-vous?" (Why do you write?) What were the aspirations of these young men, André Breton, Philippe Soupault, Louis Aragon, Paul Eluard? They had made a terrible enigma of life, and to this enigma they sought a solution, or expected one from various writers in whom they successively placed confidence, although an obscure intuition impelled them to scoff at their own hope. The very title of the periodical is a sort of mockery and may be considered the equivalent of "Anti-littérature." Just as Picabia expressed his contempt for what was sensory and "pictorial" in painting, so they succeeded in destroying the usual effect of language and giving it an effect more certain, but also more perfidious, that

of dissolving thought. Could the obscure depths of the mind be brought to the surface of consciousness by this means? At the time they merely raised the question. Yet all this had already gone beyond literature. To liberate man seemed to them far more desirable than to know how one ought to write. The case of Rimbaud was on the order of the day, and for a long time did not cease to preoccupy them, to the point where each of the group struggled to find a means of adapting Rimbaud's experiments to his own needs. It was not enough to kill art, which is always like itself, even when one intended to compromise everything in order to avoid becoming attached. Perpetual freedom from attachments and the destruction of their own idols when they began to be cumbersome, were principles dear to all these men. They were haunted by the uselessness of life itself. To revolt against life! But there is only one wonderful remedy: suicide. And in 1918, shortly after the birth of Dada, which however was unknown to him, one of their friends committed suicide at Nantes. This was Jacques Vaché. Dandy, anglomaniac and opium addict, a young man who rejected life, he exerted a great influence on André Breton.

Though Dada may be said to have lived in Paris and in America, we must not forget that it first saw light in Zurich, ready-equipped with name and civil status, and that there it uttered its first cries.

Switzerland was at that time a center of intellectual ferment, a gathering-place for everyone in Central Europe who wanted to get away from the war. German pacifists, Russian, Hungarian, Rumanian revolutionaries, lived side by side, but forming separate groups. Lenin was there and could be seen playing chess in the cafés. Of course the pacifists and Bolsheviks were not concerned with questions of art, but with politics, social or international upheavals. Nevertheless, they shared with artists the impulse, characteristic of the period in question, to destroy values. Yet the politicals aimed only at destroying bourgeois social values, while the other intellectuals proposed to encompass the ruin of all human values.

At the end of 1919 there was a young Rumanian in Zurich who had studied philosophy but was carried away by a strong poetic impulse: this was Tristan Tzara. It is he who, from the beginning to the end of Dada, remained its most ardent spirit. He cannot be reproached for not having discerned from the very first exactly what Dada was to become: his chief distinction lies in having little by little unraveled the road it was to take, and in never having relaxed his will.

Hans Arp, an Alsatian who had done astonishing reliefs in wood, had arrived in Paris in 1914, and then had managed to evade the war, which lay in wait for him in both France and Germany; he took refuge in Zurich in October 1915. Around December, he received a letter from a young German of his acquaintance, Hugo Ball, a poet and a strange, tormented mind, asking Arp to take part in an exhibition he was organizing. Hugo Ball was a conscientious objector and had also taken refuge in Zurich. In search of an occupation, he was planning to start a cabaret where he could earn a living by putting on various kinds of shows and exhibitions.

In February 1916 Ball carried out this plan and opened the *Cabaret Voltaire* in the Spiegelgasse. His resources were limited, so at first he asked friends and acquaintances for paintings, drawing and engravings to sell. Music and recitations were offered, all with a rather confused expressionist-futurist-pacifist character.

On February 26, a German poet, Richard Huelsenbeck, arrived from Berlin. He too was animated by destructive tendencies and a desire for the new. "On March 30th," says Hugo Ball, "we put on a magnificent performance of Negro music on the initiative of M. Tristan Tzara. Tzara, Huelsenbeck and Janco for the first time recited simultaneous poems."

In June 1916 an issue of a magazine was published, with the title *Cabaret Voltaire*. In the table of contents we find among other things: "L'Amiral cherche une maison à louer" (The Admiral in Search of a House to Rent), a simultaneous poem by Huelsenbeck, Janko and Tzara; "Das Karousselpferd Johann" (Johann, the Merry-go-round Horse) by Hugo Ball; "Arbre" by Apollinaire; "Deux Poèmes" by Emmy Hennings, and "Der Idiot" by R. Huelsenbeck. The main feature of this issue was "La Revue Dada II." Indeed, as has been mentioned, the name Dada had been discovered on February 8, 1916.

But it was not until July 1917 that the first number of the magazine, so eagerly awaited, appeared under the title: *Dada I, recueil d'art et de littérature* (Dada, No. 1, Miscellany of Art and Literature).

This number is confused: the table of contents brings together the names of Arp, Tzara, Janco, A. Savinio, H. Guilbeaux; reflecting random influences, poetic works alternate with scandalous appeals. And soon it becomes evident that scandal is an element highly propitious to the desired ferment.

After the publication of *Dada*, No. 2 (December 1917) and his book, *25 Poèmes*, Tzara staged an evening performance during which a new Dadaist manifesto brought on a riot. This was the *Manifeste Dada 1918*, which was published in *Dada*, No. 3 (December). It gave the magazine for the first time an essentially Dada character, and in a tempestuous style proclaimed the equality of values, the identity of *yes* and *no*:

" . . . *There is literature that does not reach the voracious masses. The work of creators, issue of a true need on the part of the author, produced for its own sake. Containing the knowledge of a supreme egotism, in which laws wither away. Each page must explode, either through a profound and heavy seriousness, through a whirlwind, through intoxication, the new, the eternal, through the crushing gag, an enthusiasm for principles, or through the manner in which it is printed. On one side we have a staggering, fleeing world, betrothed to the Glockenspiel of hell, on the other hand: new men. Rough, resilient, riding on hiccups. Behind us, a maimed world and literary quacks afflicted with a mania for improvement.*

"*I say unto you: there are no beginnings, and we do not tremble: we are not sentimental. We are a furious wind, ripping the wet wash of clouds and prayers, preparing the great spectacle of disaster, fire, decomposition . . .*

MoUvEmEnT
DADA

BERLIN, GENÈVE, MADRID, NEW-YORK, ZURICH

PARIS,

CONSULTATIONS : 10 frs

S'adresser au Secrétaire

G RIBEMONT-DESSAIGNES
18, Rue Fourcroy, Paris (17·)

DADA
Directeur TRISTAN TZARA

D₄O⁴H²
DIRECTEUR
G RIBEMONT DESSAIGNES

LITTÉRATURE
DIRECTEURS
LOUIS ARAGON, ANDRÉ BRETON
PHILIPPE SOUPAULT

M'AMENEZ'Y
DIRECTEUR CÉLINE ARNAUD

PROVERBE
DIRECTEUR : PAUL ELUARD

391
DIRECTEUR : FRANCIS PICABIA

'Z'
DIRECTEUR PAUL DERMEE

Dépositaire
de toutes les Revues Dada
à Paris Au SANS PAREIL
37, Av. Kléber Tél : PASSY 25-22

Letter paper. (For the international dada movement). Paris, 1920.

"Dada *is the knowledge of all the methods rejected up to now by the shamefaced sex of comfortable compromise and good manners;* Dada: *the abolition of logic, the dance of the impotents of creation;* Dada: *abolition of all the social*

hierarchies and equations set up by our valets to preserve values; Dada: *every object, all objects, sentiments and obscurities, phantoms and the precise shock of parallel lines, are weapons in the fight;* Dada: *abolition of memory;* Dada: *abolition of archaeology;* Dada: *abolition of prophets;* Dada: *abolition of the future;* Dada: *absolute and unquestionable faith in every god that is the product of spontaneity.*

The *Littérature* group was asked to contribute to *Dada*, No. 3, but hesitated; at length Philippe Soupault alone contributed this brief poem:

FLAMME (FLAME)

Une enveloppe dechirée agrandit ma chambre
Je bouscule mes souvenirs
On part

J'avais oublié ma valise.

A torn envelope enlarged my room
I give my memories a shove
We are leaving

I had forgot my suitcase.

Francis Picabia who had arrived from Barcelona and New York and had already published several little books of poems in Switzerland, such as *Poèmes et Dessins de la Fille Née sans Mère* (Poems and Sketches of the Girl Born Without a Mother); *L'Athlète des Pompes Funèbres* (The Athlete of the Funeral Parlor), *Rateliers Platoniques* (Platonic False Teeth), now became aware of the tie between himself and the new movement: he made the acquaintance of Tzara and his friends, joined Dada and was saluted as the anti-painter.

It is at this moment that Dada can be said to have really been born.

In April 1919 there was another sensational show. And May *Dada*, No. 4-5 appeared under the title *Anthologie-Dada*. This time the whole Paris group contributed; but we also find Reverdy and Jean Cocteau.

It goes without saying that the reactions to this issue were not as violent as those produced by the show, which included a performance of *Noir Cacadou*, a dance of five persons concealed in weird-looking pipes. Instead of his poems, Serner placed a bunch of flowers at the foot of a dressmaker's dummy; a delirious audience prevented Tzara from reading a Dada proclamation, etc. Nevertheless, those able to attend the first demonstration now had something to judge Dada by, and the movement was on the march.

It was not long before Dada appeared in Paris; this occurred at the end of 1919, in the person of Tzara, who had left Switzerland. Welcomed with enthusiasm by André Breton and his circle, on terms of personal friendship with Francis Picabia and soon with the writer of these lines, Tristan Tzara was the guiding spirit of a movement that he regarded as his child, whom it was his duty to raise to maturity.

An approach was soon made to the Parisian public, hitherto acquainted only with the utterances of futurism and Apollinaire. *Littérature* organized a matinée which took place at the *Palais des Fêtes* in the Rue Saint-Martin. Since André Breton and Louis Aragon preserved a weakness for Reverdy, several of his poems were read. Jean Cocteau read some Max Jacob, and the public was delighted. This, after all, was being "modern"—Parisians love that. Then Breton presented a picture by Picabia, done in chalk on a blackboard, and rubbed out bit by bit after it appeared.

But when Tzara, after announcing a manifesto, merely read a vulgar article taken out of some newspaper, while the poet Paul Eluard and Theodore Fraenkel, a friend of Breton, hammered on bells, the public began to grow indignant and the matinée ended in an uproar. For the Dadaists themselves this was an extremely fruitful experiment. The destructive aspect of Dada appeared to them more clearly; the resultant indignation of the public which had come to beg for an artistic pittance, no matter what, as long as it was art, the effect produced by the presentation of the pictures and particularly of the manifesto, showed them how useless it was, by comparison, to have Max Jacob's poems read by Jean Cocteau.

It did not take many articles in the papers to make people talk about Dada. A sagacious advertisement stating that Charlie Chaplin would appear brought a large audience to a demonstration at the *Indépendents* early in 1920, which consisted chiefly in a reading of individual or collective manifestoes, in the course of which the Dadaists hurled insults and obscenities, which proved excellent reagents, at the audience, who, still expecting art, tried in good faith to "understand" what it was really being asked to undergo.

In order to give an idea of the tone used by the Dadaists, we reproduce one of the manifestoes read by seven persons and signed by Ribemont-Dessaignes:

TO THE PUBLIC:

Before going down among you to pull out your decaying teeth, your running ears, your tongues full of sores,

Before breaking your putrid bones,

Before opening your cholera-infested belly and taking out for use as fertilizer your too fatted liver, your ignoble spleen and your diabetic kidneys,

Before tearing out your ugly sexual organ, incontinent and slimy,

Before extinguishing your appetite for beauty, ecstasy, sugar, philosophy, mathematical and poetic metaphysical pepper and cucumbers,

Before disinfecting you with vitriol, cleansing you and shellacking you with passion,

Before all that,

We shall take a big antiseptic bath,

And we warn you:

We are murderers.

The success of these demonstrations, the shocked curiosity and appetite for novelty on the part of the public were so great that the Dadaists were immediately

invited to present Dada at the *Club du Faubourg,* directed by Leo Poldès.

The performance at the *Faubourg* was an enlarged edition of that at the *Indépendents.* People eager to become educated obtained a kind of satisfaction which, I hasten to add, set off a tumult. Persons of importance such as Henri-Marx, Georges Pioch, Raymond Duncan, Isadora's brother, spoke up, some in favor of Dada and some against it.

Another performance at the People's University in the Faubourg Saint-Antoine, known for its advanced social attitudes, had pretty much the same effect: a strange mixture of willing sympathy and profound indignation. These two clubs, which at that time represented the height of revolutionary activity in France, were opposed to a revolution of the mind. The anarchy of Dada appealed to any revolution of the mind. The anarchy of Dada appealed to them as being destructive of the established order, but it disappointed them in that they saw no new value arising from the ashes of past values. This connection was, however, instructive for Dada: the crowd is willing to accept anything in an art which is translated into works. But it does not tolerate attacks on reasons for living.

To repeat similar experiments, Dada would have had to risk turning to propaganda and consequently becoming codified. It preferred to prove its vitality by staging a big demonstration in another locale, before a different public. Was this right or wrong? An inner force impelled Dada to act in this way, failing to perceive that it was cheapening its merchandise, just as the futurists had done.

The demonstration took place in the *Salle Berlioz* of the *Maison de l'Oeuvre* (run by Lugné-Poé), on the evening of March 27, 1920. Arranged in a mood of collective enthusiasm, it was a complete success. The attitude of the public was one of amazing and unprecedented violence. The uproar which had met Marinetti's futurist demonstrations or Mme. Lara's performance of Guillaume Apollinaire's *Mamèlles de Tiresias* (Dugs of Tiresias), would have seemed mild beside this. The public seemed to have found a motive for abandoning itself to the joys of explosion, and, whatever took place on the stage, the audience reacted tumultuously.

No collective enthusiasm can last for long; and this enthusiasm was brief. Individual inclinations gained the upper hand. Moreover, on such a subject, there are two possible solutions to the curve described by the mind: either the mind must consent to die by belying the aim it had set itself, or it must kill itself in advance. That is to say, either Dada would have had to become crystallized in an activity perpetually the same, through creation of a Dadaist art, a Dadaist form of expression—or else, the better to negate, it would have to negate Dada; the better to destroy, it would have to destroy itself. A tragic fate. But it is the tragedy inherent in every undertaking of the mind, since the mind inevitably becomes bankrupt if it departs from the disinterested character of play.

The Dadaists met regularly at that time at the *Certà,* a bar now defunct, situated in the Passage de l'Opéra, or at its annex, the *Petit Grillon.* There were newcomers like Benjamin Perét, whose poems filled the Dadaists themselves with disgust or enthusiasm, depending on their mood of the moment, or Jacques Rigaut,

then secretary to Jacques-Emile Blanche. Rigaut, a particularly disorganizing intelligence, proved to be a Dada among the Dadas, that is, he demoralized whatever came into contact with him, and had not a little to do with the ruin of Dada; in short, he did wonders.

And it is he who was right. He was irreconcilable with any need for doing, producing, thinking. The unity of opposites, which had been so much discussed, and of those two opposites which epitomize everything, life and death, possessed him entirely. He showed how close he had been to death throughout his life—which ought to be written—by committing suicide in 1929, after having' exhausted all the reasons for living a man can offer himself.

We also met at Picabia's place, where we worked on issues of *391*, Picabia's personal weapon, which kept on appearing but contributed nothing new after the famous No. 12, of March 1920, which, under the inspiration of Marcel Duchamp, then briefly in Paris, carried on its front page a reproduction of Da Vinci's "Mona Lisa," adorned with a superb moustache, and on another page a regal ink spot entitled "Blessed Virgin."

It was also at Picabia's, between the *Maison de l'Oeuvre* Dada demonstration and the next, that we experienced the repercussions of a strange event known in the Dada archives as the "affair of the Anonymous Letter." Tristan Tzara had received a highly insulting unsigned letter, and its terminology led one to suspect that it had been written by either one of the Dadaists or one of their close enemies. Through application of the Hegelian-Dadaist dialectic, we came successively to the conclusion that the letter had been written by one of the members of the *Littérature* group, by Breton or Aragon, or possibly even by Philippe Soupault, Theodore Fraenkel or Francis Picabia, or, finally, by Tristan Tzara, who perhaps had written the letter to himself in order to foster demoralizing suspicion amid his own group. Yet we gave greater credence to another hypothesis: that Pierre Reverdy was guilty; a Dada delegation called on the cubist poet at his home and demanded an explanation. Reverdy took everyone to a café and defended himself with a sincerity that almost convinced the delegates.

It goes without saying that this letter was not the only one of its kind, and, as often happens in such cases, an epidemic broke out, and the situation became more and more involved, up to the time when the game lost interest for the underground demoralizers. As for finding out who had written the letters, no progress was ever made, and all suspicions remained fully justified.

It was in this shady, disorderly atmosphere that preparations were made for the second demonstration of the era of festivals. The program was painstakingly worked out, amid alternating enthusiasm and crisis. Sometimes the whole thing was on the point of being abandoned. It took place, however, at the *Salle Gaveau*, on May 26, 1920, and was known as the *Dada Festival*.

The *Festival* was a series of rather good numbers: one of the best was that by Philippe Soupault, entitled "Le célèbre illusioniste" (The Famous Magician), which consisted in letting loose multi-colored balloons, bearing the names of

Dada "Festival" in Gaveau Hall, Paris, 26 May, 1920. (See accompanying text).

famous men. Yet, while the first demonstration had been entirely spontaneous, it was apparent that this time an effort had been made, that the Dadaists had gone to no end of trouble, that they had obtained an *artistic* result without any renewal. A certain sense of the malicious was conveyed, but the whole thing was so successful that obviously Dada was acquiring the assurance of age, becoming an important though noisy person, and, as far as liberation and disorganization were concerned, merely organizing and chaining itself. Finally, there was a lack of courage in the Dadaists' recklessness. For example, the program stated that the Dadas would have their heads shorn on the stage. But none of them dared to make this experiment.

The program also included the following numbers: "Le sexe de dada" by Paul Dermée; "Manière forte" by Paul Eluard; "Festival manifeste presbyte" (Far-sighted Festival Manifesto) by Francis Picabia; "Le rastaquouère André Breton" (The Foreign Fly-by-night André Breton) and "La deuxième aventure de Monsieur Aa, l'antipyrine" (Second Adventure of Mr. Aa, the Fire-Extinguisher) by Tristan Tzara; "La nourrice américaine," music by Francis Picabia; "Danse frontière," by G. Ribemont-Dessaignes; "Système DD," by Louis Aragon; "Vaseline symphonique," by Tristan Tzara, played by 20 persons.

For lack of rehearsals, the presentation left something to be desired. The performers, who were the Dadaists in person, sometimes showed little ardor in the execution. Moreover, unexpected considerations of personal vanity made themselves felt. For instance, Tristan Tzara, though so expert at breathing life into these affairs, had all the trouble in the world getting his "Vaseline symphonique" played; though scarcely very musical, it encountered the open hostility of André Breton, who had a horror of music and suffered from being reduced to the role of an interpreter.

However, the public's horror was a pride to behold. The Gaveau family, which attended the festival, turned deathly pale at hearing the great organs, accustomed to Bach, resound to the rhythm of *Le Pélican,* a popular fox-trot. During an intermission some young people in the audience went to a butcher shop and bought some veal cutlets which they later hurled at the actors. Tomatoes splashed down on a big cardboard funnel in which the author of these lines, executing a "Danse frontière" of his own invention, was hidden. But they also fell elsewhere and one hit the post of a loge, splashing Mme Gaveau herself. This frenzy left more than one member of the public undecided: was this art, or was it real sacrilege at the expense of a heap of things that were really sacred? The various tones adopted by the press could hardly have enlightened anyone. It was Dada that undertook the task, in the course of its evolution. In the end it became nothing but an art of sacrilege, an art that may be accessible to all and for which anyone at all is bound to develop a taste. There is nothing easier to play with than fire.

The *Festival* at the *Salle Gaveau* left the Dadaists with an unpleasant impression, from which they were slow to recover, not because of the public furore, but because they were dimly aware of the end toward which they were fatally moving. They consoled themselves by an underground, shady activity, which developed at the *Certà* and in Picabia's drawing-room.

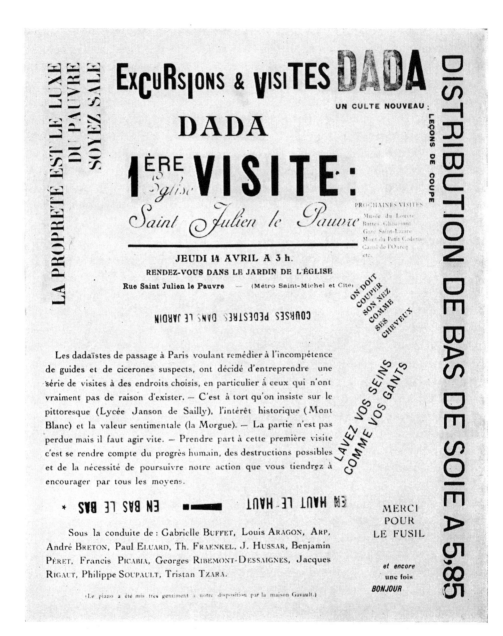

Invitation to dada visits and excursions, Paris, 1920. (Translation on opposite page).

It was at the *Certà,* or at least at the *Petit Grillon,* the annex, in the Passage Jouffroy, that a sensational adventure in the annals of Dadaism occurred. A waiter left his pocketbook on one of the benches after making change, and the Dadaists appropriated it. A lively discussion began. Would they keep the pocketbook and the money? The revolt against morality demanded that they keep it. But this was the property of a poor waiter. Was such an act not reprehensible in the Dadaist sense? Now if it were the fortune of a millionaire. . . . But on the

contrary, in returning it, would we not show that we made distinctions and that we condemned theft out of an absurd and threadbare sense of pity? Was it not much more significant to rob a poor man than a rich man? We kept the money. But what were we to do with it? The discussion continued on the second floor of a café in a street not far from the boulevards. One wanted to use the stolen money to put out an issue of a magazine; another preferred to drink it up; another . . . violent arguments ensued, with no result. Finally Paul Eluard appointed himself guardian of the pocketbook.

The very next day, the pocketbook was anonymously returned to the waiter. Eluard was the butt of cruel reproaches when his gesture became known; Breton expressed himself in harsh terms. This solution, however, put an end to a sterile discussion, which showed the complete inability of Dada to enter on the practical plane. As Richard Huelsenbeck was subsequently to write in No. 4 of the new *Littérature* series, Dada had ceased to be anything more than a "temple of the abstract myth."

But the Dadas had not lost all hope of renewing their activity. They organized a demonstration on the square outside the church of Saint-Julien-le-Pauvre. It introduced no novelty, but exacerbated the internal crisis, particularly the conflict between Francis Picabia and André Breton.

The program printed for this demonstration is instructive. In Dadaist typography it bears the title: *DADA excursions and visits, 1st visit, Church of Saint-Julien-le-Pauvre,* followed by this text:

The Dadaists passing through Paris, wishing to remedy the incompetence of suspect guides and cicerones, have decided to organize a series of visits to selected spots, particularly those which really have no reason for existing. . . . It is a mistake to insist on the picturesque (Lycée Janson de Sailly), on historical interest (Mont-Blanc) and on sentimental value (the Morgue). . . . The game is not yet lost but we must act quickly. . . . To participate in this first visit is to become aware of human progress in possible works of destruction and of the need to pursue our action, which you will want to encourage by every means.

Here and there, scattered about the page, are phrases such as:

Cleanliness is the luxury of the poor, be dirty.

Dada, a new cult.

Cut your nose as you cut your hair.

Wash your breasts like your gloves.

Upside up and downside down.

Other visits were announced: the Louvre, Buttes-Chaumont, Saint-Lazare Station, Mont du Petit Cadenas, Canal de l'Ourcq.

In itself this demonstration, which took place at three o'clock on April 14, almost exclusively under the influence of André Breton, who was keenly sensitive to the outward effect of monuments and localities, proved, more than anything, demoralizing. It consisted of only a few individual, almost improvised acts; one of the "numbers," perhaps the most successful (which does not mean much), was a tour conducted by Ribemont-Dessaignes, who acted as guide through the church-

yard, stopping here and there to read definitions taken at random from a big dictionary.

The result was what followed every Dada demonstration: collective nervous depression. It goes without saying that any thought of a further visit was abandoned. But the depression did not last long. A new impulse led André Breton to maintain his influence on Dada by arranging a demonstration of an entirely new character. We have seen that André Breton was singularly attached to the disorganizing virtue of Dada, that he several times boasted of his intention to transform it into a secret society with mysterious ramifications, the function of which would be to make life untenable for a certain number of well-known and important persons. It was in a similar spirit that he suggested putting on trial the writer, Maurice Barrès, whose former destructive activity (see, for example, *Un ennemi des lois* (An Enemy of the Law) however contained in germ his future constructive activity. After some hesitation and a certain repugnance on the part of Tristan Tzara, the demonstration was decided on and entitled: *Trial and Sentencing of M. Maurice Barrès, by DADA*. It took place in the *Salle des Sociétés Savantes* (Hall of Learned Societies), in the Rue Danton, on the evening of Friday, May 13, 1921.

The audience was numerous and tumultuous, for by then it was understood that every Dada demonstration involved a certain amount of obligatory uproar. But a good deal of water had flowed under the bridge since the *Festival* at the *Salle Gaveau*. Scenes had become an amusement; to make a noise had become a method of being a Dadaist oneself. Serious and benevolent citizens defended "these young people" who were offering an inimitable spectacle of intellectual justice. Mme Rachilde, who for a long time had boasted of her weakness for the Dadaists, spoke in their favor and also in favor of Maurice Barrès.

Barrès appeared on the platform in the form of a dummy. André Breton was the presiding judge, a role which doubtless made him feel like the "leader of men" that his temperament more and more impelled him to play. The duties of the public prosecutor were assigned to Ribemont-Dessaignes; the lawyers were represented by Aragon and Soupault. And, of course, numerous witnesses were called to the bar, including Tristan Tzara, Jacques Rigaut, Pierre Drieu la Rochelle, Renée Dunan, Louis de Gonzague-Frick, Marcel Sauvage and the poet Ungaretti, sympathetic to Dada, who found an opportunity to demonstrate his cruel and caustic wit. But the witness who made the greatest sensation was the *Unknown Soldier,* who testified in German.

Picabia had appeared in the hall; but he did not wait for the end to make a dramatic exit, bearing witness to his disgust for what Dada had become and, mingled with this judgment, his personal animosity toward Breton, Aragon and Soupault.

In order to make perfectly clear how he felt toward the movement, of which he had nevertheless been one of the chief ornaments, Francis Picabia cut all his bridges by publishing in *Comoedia* a series of articles insulting not only Dada but

also those who had been his most devoted friends. He boasted of having made use of them and of casting them aside when they were no longer useful to him. Even today, when questioned as to the motives of his rupture with Dada, he declares: "I was sick of living in the midst of a gang of people who, having no ideas of their own, spent their time asking me for ideas."

This arrogant attitude decided Andrè Breton to give equally striking proof of his own *hauteur*. The first effect of the schism was to provoke Dada to demonstrate how much life it still possessed.

Those who remained faithful—Philippe Soupault, Tristan Tzara, Ribemont-Dessaignes, Louis Aragon, Paul Eluard, Benjamin Péret—arranged as a new demonstration a *Dada Salon,* an international art exhibition held at the *Galérie Montaigne* in the Avenue Montaigne, beginning on June 6, 1922. In the course of this exhibition, a soirée and two matinées were to be given: the soirée on June 10, with complete success. Philippe Soupault, disguised as a Negro, was a magnificent President of Liberia, visiting the exhibition. Violent harangues won the support and applause of the audience. Tristan Tzara's play, *Le Coeur à Gaz* (The Gas Heart) enjoyed a big success.

But in the course of a performance at the *Théâtre des Champs-Elysées,* a scene occurred which stopped the Dada Salon. The Italian *bruitistes,*[1] led by Marinetti, were giving a performance of works written for their new instruments. These works were pale, insipid and melodious in spite of Russolo's noise-music, and the Dadaists who attended did not fail to express their feelings—and very loudly. Marinetti asked indulgence for Russolo, who had been wounded in the war and had undergone a serious operation on his skull. This moved the Dadaists to demonstrate violently how little impressed they were by a reference to the war.

The following day, Jacques Hebertot closed the gallery doors, and, when Tristan Tzara and Ribemont-Dessaignes came to protest, he threw them ignominiously out of his office.

Though André Breton had broken with Dada, he remained on good terms with his friends of the *Littérature* group and with Tristan Tzara. Nevertheless, personal relationships became more and more tense.

Breton's personal reactions led him to conceive of a grandiose undertaking in which he would have played the leading role. This was to be a super-congress of all intellectuals wielding influence on the state of the modern mind, in order to determine what was modern and what was not, in short, a grand congress of the mind.

Breton offered Dada a sort of reconciliation, with a view to getting this enterprise under way. But the Dadas were not in agreement. Tristan Tzara, in particular, supported by Ribemont-Dessaignes, raised numerous objections because of the dogmatic aspect such an undertaking would assume; it would be possible only if some destructive turn were envisaged at a desired moment, that is to say, if an exalted edifice of the modern mind were constructed, with the participation of

[1] Literally, "noisists."

291

No. 2 10 cents April, 1915

MOTHERHOOD A CRIME:

In the New York Sun of March 6th the following notice appeared concerning a sensational suicide in New York.

New Haven, March 6 — "The motive that drove Lillian May Cook to end her life with a bullet was to escape shame. Had she lived she would have become a mother."

This is but one of a thousand such incidents which occur every week. Should one think dramatically condensed report of the tragedy of a girl's life receive more than passing attention? We go to see Brieux's Maternity at the theatre. We applaud and subourn to a the dansant. When it comes to the test what do we DO?

DO NOT DO UNTO OTHERS:

The United States are very indignant at the restrictions placed upon their over-sea commerce by the Nations at War.

Do they realize how other nations feel about the restrictions imposed upon foreign importations in TIME OF PEACE by the many objectionable features of the administrative parts of our tariff laws?

THE ACADEMY:

John W. Alexander states as his reason for resigning the presidency of the New York Academy of Design that he is tired of the fruitless campaign to obtain larger quarters in which to display the productions of New York artists.

The spring exhibition of the Academy does not convince us that we miss much by not seeing more canvases of the standard of those shown.

We might parody the answer of Socrates to those who wondered at the small size of the house he had built for himself. "Would that the present SMALL quarters of the Academy (four large rooms) were filled with works of Art."

Must we have quantity instead of quality? What we really want is more art and less paint.

VALUES IN ART:

There was a great turmoil and indignation when the art collectors learned that a dealer had included a number of pieces from his own stock in the Arthur I. Hoe Collection when it was offered for sale at auction at the American Art Galleries.

We do not think this dealer's method should be encouraged . . .

But . . .

We would like to know how much artistic merit an old oriental specimen loses when it is discovered that it was formerly owned by Mr. X instead of Mr. H.

NEW MUSIC:

The musical composition written by Albert Savinio, published in this number of 291, should be called New Music rather than Modern Music. Savinio has devoted himself to finding the place of music among the modern arts. He does not try to express in music either a state of consciousness or an image. His music is not harmonious or even harmonized, but DISHARMONIOUS. Its structure is based on drawing. His musical drawings are, most of them, very rapid and DANSANTS, and belong to the most discordant styles, for this composer thinks that a sincere and truthful musical work must have in its formation the greatest variety of music. ALL THAT WHICH ONE HEARS— all that which the ear imagines or remembers.

He does not invent, he discovers the significance of all sorts of sounds and uses them to create an emotive source.

"La Passion des Rotules" is No. 12 in a series of "Chants Étranges" which has for its title "BELLOVEES FATALES."

"LES SOIRÉES DE PARIS:"

We forgot to state that the "Idéogramme" by Guillaume Apollinaire, published in the first number of "291," was originally printed in the French publication "Les Soirées de Paris."

MODERN MUSIC:

Mr. Leo Ornstein displays in his music the mentality of an artist toy-maker. He has preserved from his career as a child, wonder, the child, element. His musical compositions are toy imitations. Although they are intricate in their structure, the spirit has the naïve charm of a child imitating what strikes his attention. Nevertheless he has brought us a breath of the intentions of modern thought as applied to music.

COLOR MUSIC:

Nothing was proved on the question of the relationship of color to music in the concert given by the Russian Symphony Orchestra at Carnegie Hall on March 20th. The experiment as it was performed was absolutely unsuccessful. The idea that two sensations of such different character as those produced by the organs of sight and by the organs of hearing could be

mingled to form one sensation that would be either the addition or the conjugation of the two, still remains a theory. What has been demonstrated up to the present is, that of two simultaneous sensations one always predominates to the detriment of the other.

Probably, with the appropriate apparatus, and with a sufficient brain education the problem can be solved. The POTES is not denied even by theologians. But until now, all the experiments on this subject have left it a hypothesis.

THE FLOWER SHOW—FLORISTS:

The flower show in Paris is an event in the world of art as well as horticulture. The show in New York demonstrates that we are at least five years behind Europe from the horticultural standpoint and from the other standpoint. Tra-la, what a mess!

Why? We have imported excellent craftsmen, gardeners, and the show was one of magnificent specimens of grower's skill. Would you expect a master-plumber to be very strong on a Louis Quinze Salon? That good gardener of yours is trying the artistic. Now for the honor and glory of his craft discourage him. His model is the New York florist. There are no florists in New York. A florist is an artist. We have flower dealers. Watch their windows: Crockery and bric-a-brac . . . the latest. Help!

AN OPPORTUNITY MISSED:

The Carroll Galleries are to be congratulated on having shown a small number of Picasso paintings which were truly representative of the artist's early work. These paintings have now passed into private hands. There is cause for regret in the fact that the Metropolitan Museum of Art did not avail itself of this opportunity to acquire worthy examples of Picasso's paintings at a reasonable figure.

The policy of the Museum seems to be to close the door to the examples of paintings until they have so risen in value as to become scarce and difficult to acquire. The Museum

PUBLIC SPIRIT:

The daily papers have had much to say about George Grey Barnard's disinterested action in offering to replace at his own expense the two groups "Art" and "History" in front of the New York Public Library.

He puts the cost at from $15,000 to $20,000. Incidentally he is bringing suit against the firm who spoiled his work, for $50,000.

"I am bringing this suit for $50,000 simply to secure publicity," says Mr. Barnard.

Let us hope that when all accounts are settled and new orders booked, Mr. Barnard will not be "out of pocket."

THUMBS DOWN:

On March 15th, Beachy fell to death with his aeroplane in San Francisco Bay while accomplishing a spectacular flight for the entertainment of thousands of spectators.

On March 17th, Frank Stites fell 150 feet to his death while performing a feat in his aeroplane for a film company.

The American public is very indignant at the loss of innocent lives on the battlefields of Europe.

Bull fights are prohibited on U. S. territory. Our kind hearts rebel at the idea of cruelty to animals.

But the Public must be amused.

ECONOMIC LAWS AND ART:

There are many things in the Montross Show of American Moderns which tempt the critic to lay about him and slay commercially, but as a unit the Exhibition is unquestionably both interesting and significant. The mere fact that such an exhibition can take place on Fifth Avenue

then complains that it cannot afford to purchase them.

Is it impossible for the Museum to obtain advice from men with the eye and understanding that discerns artistic merit as distinct from monetary value?

where rents must be paid, is an important indication of the change of the public attitude, and the added fact that the gallery was usually crowded at twenty-five cents per head, shows that the interest is not spotty but widespread. In short, it is safe to announce that cubism or futurism, or whatever else these men call their work, is not only beginning to pay its way, but is underselling the trying ordeal of being the fashion.

The obvious question is: "Who took the lead the artists or the public?" In other words, is American cubism, or futurism, as sincere an expression that the speedy conversion of the public to its serious consideration was inevitable, or did the public interest, aroused by 291 and the big Armory Exhibition of French Moderns, create a demand which our men are trying consciously or unconsciously to supply? Judging from results in the Montross exhibition, both kinds of influence are present, thus leaving to the buying public an interesting opportunity of furthering modern thought by weeding out the true from the false, and to those who have reached a conclusion as to the critical faculties of the public, an opportunity of prophesying some of the future developments of modern art in America.

291

PUBLISHED TWELVE TIMES A YEAR.— *Twelve numbers ONE DOLLAR.— Special edition limited to one hundred copies on special paper.— Twelve numbers FIVE DOLLARS.— Single copies ONE DOLLAR.* Published by "291", 291 Fifth Avenue, New York, N.Y.— MAKE ALL REMITTANCES TO PAUL B. HAVILAND. Sample copy sent FREE on request to you or your friends. *Requests for copies of PARTICULAR NUMBERS should be accompanied by TEN CENTS IN POSTAGE STAMPS.*

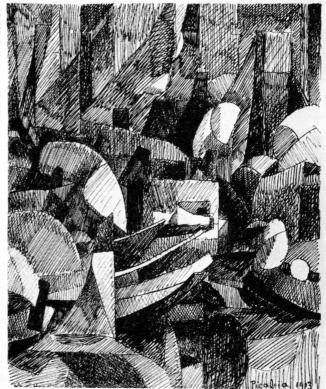

Picabia 1915

Magazine page. (From *291*, No. 2, edited by Alfred Stieglitz). Drawing by Francis Picabia. New York, April, 1915.

the most prominent personalities in all the arts; it would be absolutely indispensable to conclude with an even more magnificent débâcle, provoked by some perfidious means which remained to be devised.

Far from subscribing to this, André Breton clung to his great idea of distilling and unifying the essential principle of modernism. Manifestoes, radio appeals and news releases were to recruit the regulars and reserves of futurism, cubism, expressionism and all the "isms," anyone at all, in short, who had some appearance of modernism. The congress, entitled "Congress of Paris," would hold sessions in a theatre, under strict parliamentary procedure. The police were to intervene in case of open disorder. Stenographers were to take down the speeches, which would be published subsequently in a volume embodying the conclusions of the Congress.

This magnificent structure (grotesque however from the Dadaist point of view) could not gain the support of Tzara, who made a clean break. With him Paul Eluard, Theodore Fraenkel, Ribemont-Dessaignes and Eric Satie withdrew.

But the publicity which the Congress of Paris had received prevented Breton from retreating. So he persisted and, despite the defection of the greater part of Dada—it is true that he had the support of Picabia who had become anti-Dada—he continued his work as director of the Congress. But new difficulties arose, and certain members of the committee resigned. To add to all this the poet Roger Vitrac, head of *Aventure* magazine, on which Breton counted heavily, fell ill. This finally discouraged Breton: he abandoned the undertaking on which he had so set his heart.

The bitterness Breton felt led him to cast the main responsibility for the failure on Tristan Tzara and to indulge in open vengeance. He published in *Comoedia* several articles in which, scorning Dada amorality, he adopted a bourgeois point of view toward Tzara's conduct. He specifically accused Tzara of not being the father of Dada and of having defrauded Serner by claiming authorship of the *Dadaist Manifesto* of 1918, the real author of which was allegedly Serner. In writing of Tzara, he used pejoratively such terms as "arrived from Zurich," just as Picabia had called him a "Jew"; he also claimed that certain letters written by the Germans Schad and Huelsenbeck had denounced the intellectual larcenies of Tzara. Finally, he called Tzara a publicity-mad impostor, and concluded with a pathetic appeal in favor of himself who "proposed to consecrate his life to ideas."

Private polemics were soon added to the public discussions. Picabia played an active role. Obscure negotiations with Jean Cocteau served to create complete confusion, and Tzara found himself accused of "running with the hare and hunting with the hounds." In short, the situation became so strained that it was decided to liquidate. A meeting took place at the *Closerie des Lilas,* the old café on the Place de l'Observatoire. Breton was summoned to explain his "un-Dadalike" conduct, and Tzara denied having carried on secret transactions with Cocteau. Far from pacifying tempers, this effort merely brought about a final break, and officially marked the death of Dada.

But at the same time it was the final and irremediable collapse of the grand Congress of Paris.

After this meeting, Tristan Tzara published an issue of a magazine entitled *Le Coeur à barbe* (The Bearded Heart), full of violent attacks on various ex-Dadaists. Picabia replied by another, *La Pomme de Pin* (The Pine-cone) in which, associating himself with Marius de Zayas and Pierre de Massot (a young man who had been little spoken of until then), he expressed himself freely at Dada's expense.

Picabia was at St. Raphael. He had been there when, at André Breton's invitation, he had come out in support of the Congress of Paris. From there, too, he sent an astonishing letter to Breton, announcing the formation of a secret society, even giving its *high sign*. The idea of a secret society had always been dear to André Breton; he naturally accepted Picabia's suggestion. Releases were sent to the newspapers . . . but the undertaking ended there.

Dada was finished.

Born of an impulse toward liberation and life, conscious of the strength and weakness of the human mind, it had understood that it could work only toward its own ruin. It was aware of its bankruptcy and did not fight it.

For bankruptcy was its sign. Nevertheless, it did constitute a liberation—though temporary—for a few individuals. So much the worse for those who returned to servitude, as the dog of the Scriptures to his vomit.

DADA

☞ Société Anonyme pour

l'exploitation du vocabulaire.

Directeur : *TRISTAN TZARA.*

Dada, Corporation for the Improvement of the Vocabulary.

PRODUITS DENTIFRICE

PRODUITS A RASER

PRODUITS DE BEAUTÉ

SAVON DE TOILETTE

Cadum

CADUM S. A. COURBEVOIE - SEINE

Artist Unknown. *Cadum Baby.*

VIII. *The Dada Spirit in Painting*

By Georges Hugnet. 1932–34. Translated complete from the
French by Ralph Manheim. First published in Paris in
Cahiers d'Art: vol. 7, no. 1–2, no. 6–7, no. 8–10,
1932; vol. 9, no. 1–4, 1934. By permission of the author and
of Christian Zervos.

L'ESPRIT DADA DANS LA PEINTURE

I. — ZURICH & NEW YORK

Dada n'a pas d'âge. S'il a un visage, il le perd secrètement et le retrouve sans métamorphose. Il n'a pas de parents de pauvres, il est seul, il ne fait aucune distinction entre ce qui est et ce qui n'est pas. Il marche avec ce contre quoi il lutte. Il approuve en niant, il se nie et reprend sa force dans sa négation niée. Il vous attaque de face, en traître. Il ne parle pas. Il est toujours là et sous chaque parole. Il mine les institutions. Dada tout à coup parle abondamment et c'est un silence qui dure, qui dure tant que soudain et progressivement, les sons ne sont plus des mots et qu'il y a dans le matin une nouvelle pensée sans confusion et qui n'attend rien. Une pensée de caverne, un signe qui se déroule, un symbole où l'expérience n'a pas de passé. Dada se révolte contre lui-même, il se détruit à plaisir, il voit rouge et son désespoir est sans génie. Il n'y a pas d'espoir, tout s'identifie, il n'y a plus de degré dans le bien et dans le mal, il y a une conscience.

Dada est un état d'esprit.

Dada est une constatation et comme une constatation il est aussi irrémédiable que ridicule. Il n'a d'autre notion que de lui-même.

Dada n'a une histoire que parce qu'on veut bien y croire, parce qu'il a mis un chapeau sur un col en celluloïd et qu'il s'est assis à côté de nous, inconnu, méconnu, à qui nous disions bonjour depuis le commencement du monde comme à un inséparable.

NUL N'EST CENSÉ IGNORER **DADA**

Comme si, un jour, un lundi par exemple, le Bébé Cadum était descendu dans la rue pour vous bousculer dans l'autobus, Tristan Tzara a donné un nom à ce malaise délicieux : Dada.

Dada est né de ce qu'il haïssait. Il a eu du mal à s'éclaircir la voix. Sur le moment, la plupart ont cru que c'était un mouvement artistico-littéraire ou un mal du siècle.

Dada n'est pas un mal du siècle, mais le mal du monde. Dada se moque de l'art et de la littérature, et vous croyez qu'il plaisante.

A Zurich, en 1916, Hugo Ball fonde un cabaret littéraire : Le Cabaret Voltaire, où Dada se manifeste dans une confusion telle qu'il a du mal à se distinguer de qui est son ennemi héréditaire : l'Art, et qu'il évolue sur le plan du cubisme et du futurisme. Mais Dada profite de la confusion, il profite aussi de ce qui fermente dans Zurich qui abrite des déserteurs, des anarchistes et des révolutionnaires. Tous ceux qui se sont réfugiés à Zurich n'ont pas très bien conscience de ce qui se passe en eux, de cette force qui chez certains prend de la consistance et va éclater. Tout pourrit et tout n'a plus qu'une apparence, qui devient sordide. Sous les portes filtre une odeur de latrines.

Arp, Van Rees et Mme Van Rees, qui avaient exposé ensemble, en 1915, accrochent leurs œuvres aux murs du Cabaret Voltaire, à côté de celles de Picasso, Eggeling, Segal, Janco, Marinetti... Le 8 février 1916, par l'intermédiaire d'un coupe papier, le nouvel esprit trouve au hasard d'un dictionnaire le nom de ce qui se passe en lui : Dada. Et une soirée Dada est organisée avec un allemand, Richard Huelsenbeck, qui arrive de Berlin.

En vue de tenir nos abonnés au courant de toutes les tendances qui se sont partagées la peinture depuis Cézanne jusqu'à nos jours, comme nous l'avons déjà fait pour le fauvisme, nous publions une série d'articles sur le Mouvement Dada qui a joué depuis 1917 un rôle important.

COUVERTURE DES NUMÉROS 4 ET 5 DE LA REVUE DADA, COLLAGE DE ARP, 1919.

Dada ne cherche alors qu'à être subversif et en 1916 le subversif c'est le modernisme : cubisme, futurisme, musique nègre, tout ce qui exaspère le monde. Or Dada n'est pas moderne, et encore moins moderniste. Dada est actuel, de là son activité posthume.

La première publication Dada, ou plutôt dans laquelle apparaît ce nom : Dada, sort de l'imprimerie Heuberger et prend pour titre le nom du cabaret. Le Cabaret Voltaire réunit Apollinaire, Picasso, Modigliani, Arp, Tzara, van Hoddis, Huelsenbeck, Kandinsky, Marinetti, Cangiullo, van Rees, Slodky, Ball, Hennings, Janco, Cendrars. Le Cabaret Voltaire adopte le sous-titre de Recueil artistique et littéraire et Dada est contre l'art.

Pendant un an ont lieu plusieurs soirées au cours desquelles Dada se précise : les récitations d'Apollinaire, Max Jacob, Salmon, Laforgue, Jarry et Rimbaud sont remplacées par des manifestes, par des poèmes faits avec des sons, par des poèmes simultanéistes, qui sont des prétextes pour dégager des fanfreluches artistiques, Dada. Les expositions groupent toujours sous le signe de Dada des peintres qui n'ont rien à voir avec ce qu'est Dada déjà pour certains comme Richard Huelsenbeck et surtout Arp et Tzara.

La collection Dada est fondée et publie deux livres : la première aventure céleste de m. antipyrine, de Tristan Tzara, illustré par Janco, et phantastische gebete, de Richard Huelsenbeck, illustré par Arp.

Dans son premier livre, paru le 28 juillet 1916, Tzara écrit :

« Dada est notre intensité... Dada est l'art sans pantoufles ni parallèles ; qui est contre et pour l'unité et décidément contre le futur ; nous savons sagement que nos cerveaux deviendront des coussins douillets, que notre antidogmatisme est aussi exclusiviste que le fonctionnaire, que nous ne sommes pas libres et que nous crions liberté Nécessité sévère sans discipline ni morale et crachons sur l'humanité. Dada reste dans le cadre européen des faiblesses... »

First page of the original publication of *The Dada Spirit in Painting* by Georges Hugnet (which ran as a serial in Cahiers d'Art, Paris, 1932 and 1934). (Courtesy Cahiers d'Art, Paris).

Georges Hugnet: *The Dada Spirit in Painting*

1. Zurich and New York

Dada is ageless. If it has a face, it secretly loses it and recovers it unmetamorphosed. It has no poor relations; it is all alone; it makes no distinction between what is and what isn't. It sides with what it combats. It affirms as it negates; it negates itself and replenishes its strength from its negated negation. It attacks you head-on and insidiously. It doesn't speak. It is always present—behind every word. It undermines established institutions. Suddenly Dada speaks abundantly and there is an enduring silence, so enduring that suddenly and progressively sounds cease to be words, and in the morning there is new thought without confusion or expectation. A cave thought, an unfolding omen, a symbol in which experience has no past. Dada rebels against itself, it destroys itself at will, it sees red, and its despair is without genius. It has no hope, everything is identified with everything else, there are no degrees of good and evil, there is only consciousness.

Dada is a state of mind.

Dada is a statement and as such it is irremediable and ridiculous. It has no idea but itself.

Dada has a history only because we are willing to believe it has, because it put a hat on a celluloid collar and sat down, unnoticed and unknown, beside each one of us, and since the beginning of the world we greeted it with "good morning" like an inseparable friend.

None is supposed to be ignorant of Dada

As though one day, a Monday for example, the Cadum baby[1] had come down off his billboard to jostle you in the bus, Tristan Tzara gave a name to this delicious malaise: "Dada."

Dada was born of what it hated. It had a hard time clearing its throat. At the time nearly everyone thought it was an artistic and literary movement or a *mal de siècle.*

[1] See illustration, p. 122 (ed.).

125

Dada is not a *mal de siècle,* but a *mal du monde.* Dada is indifferent to art and literature, and you think it is joking.

At Zurich in 1916, Hugo Ball opened a literary cabaret called "Cabaret Voltaire"; here Dada came into being amidst such confusion that it had a hard time distinguishing itself from Art, its hereditary enemy, and proceeded to evolve on the plane of cubism and futurism. But Dada profited from the confusion; it also profited from the ferment going on in Zurich, a haven for deserters, anarchists and revolutionaries. Those who had taken refuge in Zurich were not themselves fully conscious of what was going on within them, of that force that in some of them was acquiring substance and becoming explosive. Everything was rotting, everything was reduced to appearances, and the appearances had become sordid. A smell of latrines was seeping beneath the doors.

Arp, van Rees and Mme van Rees, who had exhibited together in 1915, now began to hang their work on the walls of the Cabaret Voltaire, side by side with Picasso, Eggeling, Segal, Janco and Marinetti. . . . On February 8, 1916, a paper-knife was pointed at a page in a French dictionary opened at random, and a name

Francis Picabia. *Funny Guy* (handbill). Paris, 1921.

Performance of *Vous M'Oublierez* at Gaveau Hall, Paris, 26 May, 1920. Paul Eluard (standing), Soupault (kneeling), André Breton (seated), Fraenkel (with apron, right).

was found for the manifestation of the new spirit—Dada. And a Dada celebration was arranged for Richard Huelsenbeck, a German writer who had just come from Berlin.

In those days Dada was intent on being subversive, and in 1916 the subversive was the modern: cubism, futurism, hot jazz, everything that exasperated society. But Dada is not modern and even less modernistic; Dada is always a thing of the present, hence its posthumous activity.

The first Dada publication, or rather the one on which the word Dada first appeared, was *Cabaret Voltaire,* printed by Heuberger; it published many writers and artists: Apollinaire, Picasso, Modigliani, Arp, Tzara, van Hoddis, Huelsenbeck, Kandinsky, Marinetti, Gangiullo, van Rees, Slodky, Ball, Hennings, Janco, and Cendrars. It adopted the subtitle, "Literary and Artistic Miscellany," even though Dada was against art.

In the following year many meetings took place and Dada became less vague; recitations of poetry by Apollinaire, Max Jacob, Salmon, Laforgue, Alfred Jarry and Rimbaud were soon replaced by manifestoes, poems made of sounds, and simultaneist poems, all of which were devices for breaking Dada off from art. Painters who had little in common with what Dada was already becoming for such men as Richard Huelsenbeck, and especially Arp and Tzara, were still exhibiting in the name of Dada.

Cover. (For *Dada 2*, edited by Tristan Tzara). Zurich, December, 1917.

The "Dada Library" was established and brought out two volumes, *la première aventure céleste de m. antipyrine* (The First Celestial Adventure of Mr. Fire-Extinguisher) by Tristan Tzara, with illustrations by Janco, and *phantastische gebete* (Fantastic Prayers) by Richard Huelsenbeck, with illustrations by Arp.

In this first book, which appeared in July 1916, Tzara wrote: *"Dada is our intensity. . . . Dada is art without carpet-slippers or parallels; it is both for and against unity and absolutely against the future; we know that our brains will become soft cushions, that our anti-dogmatism is more exclusivist than the bureaucrat, that we are not free and that we proclaim freedom. Strict necessity with neither discipline nor morality, and we spit on humanity. Dada remains within the European framework of weaknesses. . . .*

"While we manifest facility, we seek the essential and we are glad when we can hide it; we don't wish to count the windows of the wonderful élite, because Dada

exists for no one, and we want everyone to understand this, because it is Dada's platform. . . . Art was a game, children assembled words that ended with the sound of a bell, then they shouted and wept their verses and put doll's shoes on them. . . . "

It is easy to see what separated Tzara from certain "artists" received into the Dada movement for the sake of increasing its numbers. Though Dada, comprehensibly enough, was later to take pride in having been first to publish work by Chirico and Klee, the names of Kisling, Marinetti and others seem strangely out of place.

Dada, No. 1, and *Dada,* No. 2, appeared in 1917. Though this review edited by Tzara did move toward clarity, it still reflected a state of confusion beneath which the Dada mind was slowly achieving consciousness of itself through the universal relativity of feeling and veracity. Dada turned to its own account everything done before, and at the same time turned threateningly against this. The strength of the Dada mind was that, though concerned only with the present, it would be made real only later, and not completely until after its disappearance as a movement endowed with a name, if not with a face.

Dada began to move toward what Tzara attempted to define by formulating the dichotomy, poetry-as-a-means-of-expression and poetry-as-an-activity-of-the-mind, and by declaring that the latter would definitely replace the former, relegating it to a category of literature, the function and value of which was exhausted, even if we suppose that by its technique of translation, whether competent or incompetent, whether in good or bad taste, it could ever have satisfied vital extra-literary aspirations.

Despite the systematic lack of punctuation and capital letters in some of the pieces published in *Cabaret Voltaire* and *Dada,* No. 1, and *Dada,* No. 2, despite Arp's remarkable cover designs and other work, Dada had not yet found the outward form that gives poetry a profound force aside from the text, the written word. It is in *Dada,* No. 3 that we find for the first time this concern, this searching unrestricted by the laws of taste and of art. In the *Anthologie Dada,* No. 4–5 there is a systematic use of distorted, disordered and heterogeneous typography, letters of different sizes, slanting print, collages and varicolored paper.

In *Essai sur la situation de la poésie,* written years later (in 1931), Tzara, in support of his definition of "poetry-as-an-activity-of-the-mind," cites the extra-literary preoccupations of some nineteenth-century French writers who have always been clumsily classified as belonging to the French romantic movement and thus relegated to "literature." He quotes lines from Charles Lassailly and Pétrus Borel (one might just as well quote from Eugène Sue, Eusèbe de Salle and even Victor Hugo, although their technique is quite different) who, by their use of *sound,* showed that they recognized *the inadequacy of words as a vehicle for the logic of feelings, for "the ineffable, the inexpressible," as they put it, and for specifically poetical activity as we shall see further on.* Tzara cites still other instances to show that various poets, from Baudelaire and Gérard de Nerval to Huysmans and Apollinaire unconsciously sensed the existence of a spiritual activity exclusive

Title page. (For *Dada 4–5*, edited by Tristan Tzara). Drawing by Francis Picabia. Zurich, 15 May, 1919.

of logic and the type of thought which, as Tzara wrote in one of the *7 manifestes dada "is manufactured in the mouth."* The Dada spirit, which surrealism continued on another plane (with as much difference as exists between anarchism and communism), achieved for the first time a complete awareness of the inherent aims of poetry—which is a force within man and not a means of pumping oneself dry. Like the poems made out of sounds by Ball and Tzara and like Tzara's jumbling

of words in a hat, the typography used by the Dadaists, the outward form of their written products, certain anecdotes (that will be told presently), their use of insults and their deliberately and continuously subversive attitude, their construction of paintings and objects out of elements entirely foreign to art, borrowed from everyday life and from nature, were the culmination of something that had been dimly felt, envisioned and half discovered during the nineteenth century by a few minds driven by a force of which they were no more conscious than they were of the cogent poetical meaning of their dreams.

Through a series of scandals by which it regained all the strength that had been scattered for centuries as well as turbulent timeliness, Dada began to look for direct means of entering into everyday life. Cognizant of its sphere, Dada increased its activity in the realm of the human and enlarged its techniques. It sent fictitious news items to newspapers. It shocked and repelled the onlooker and battled the police. It aroused violent protests. It was in publicity and the production of proclamations, posters and programs—all new weapons—that Dada was to manifest itself in its most intense form, and its intensity gave rise to the poetry which it stabbed and starved. Time and again, mistaken ideas about Dada were fostered by its indifference. Some time later in Cologne, visitors thought that a show by Arp, Baargeld and Max Ernst was a homosexual exhibition, because the entrance was through a public lavatory, and the show was closed by the police on grounds of obscenity. In those war days, Dada's internationalism was an element in its subversiveness, and in France it was believed to be a German movement in which French writers had compromised themselves!

During the time in Zurich when Dada was releasing false news items, the activities organized by the Dada poets were much more typical and effective than those of the painters, who had a strong tendency towards abstract art (and for a time in Arp's case toward absolute constructive purity), and were busy fighting against cubism, futurism and even expressionism. Eggeling wished to make use of the cinema, but the film he projected was to be abstract. It was only later, after the arrival of Picabia and acquaintance with the ideas of Marcel Duchamp, after the exhibitions by Arp, Baargeld, Max Ernst and Kurt Schwitters in Cologne and Hanover, that Dada painting, freed at last, was able to help in Tzara's systematic work of destruction and demoralization.

But from 1916 to 1918 in Zurich, Dada activities originated with writers and constituted a direct attack on the staid morality and sentiments of the public, which raged and swooned at such candor. These activities accelerated the decomposition of what was already rotten. Opposites were brought together: the art-lover that lies hidden in every man was either outraged or forced to submit to so much imbecility, so much genius. A trusting and hopeful audience, gathered together for an art exhibit or a poetry recital, was insulted beyond endurance. On the stage of the cabaret tin cans and keys were jangled as music until the enraged audience protested. Instead of reciting his poems, Serner placed a bunch of flowers at the feet of a dressmaker's dummy. Arp's poems, were recited by a voice hidden in an enormous hat shaped like a sugar-loaf. Huelsenbeck roared his poems in a mighty

crescendo, while Tzara beat time on a large packing case. Huelsenbeck and Tzara danced, yapping like bear cubs, or, in an exercise called "noir cacadou," they waddled about in a sack with their heads thrust in a pipe.

Tzara invented static and chemical poems. A static poem consisted of chairs on which placards were placed with a word written on each, and the sequence was altered each time the curtain was lowered. For these acts, Janco designed costumes of paper, cardboard and rags of every color, and the costumes were held together with pins, so that anybody might "do as well"; not only were the costumes without artistry, they battled against all semblance of any established art and all the formal rules it implied. Perishable, deliberately ugly and absurd, these materials, chosen at the whim of eye and mind, provided magnificent tatters, symbolizing perpetual revolt, despair that refuses to descend to despair.

Dada, No. 3 violated all the conventions of good taste in typography and layout and undermined the roots of good taste beneath the laurels of reason and logic. It introduced new names: Picabia, Reverdy, Birot, Dermée, Soupault, Huidobro and Savinio. Dada was spreading like a spot of oil. For the *Anthologie Dada* (which was a double number, 4–5), Arp made a remarkable and important cover, despite its tendency towards abstract art (obviously in opposition to Picasso whose work until then had been based on nature). This first break between Dada and modernism was to be carried further by Picabia and completed in 1920 by the Dadaists of Berlin, Cologne and Hanover: Baargeld, Max Ernst, Heartfield, George Grosz and Schwitters, to whom we may add Arp. Despite the desire for order that characterizes it, the cover of *Dada,* No. 4–5 might be said to be to cubism what Tzara's words jumbled in a hat were to the poetry of the early nineteenth century, which has also, absurdly enough, been called cubist. Picasso's collages, his cardboard sculpture-objects and the various materials that he used in his oil paintings beginning in 1913 (some examples of which have been reproduced in "Soirée de Paris"), such as pieces of newspaper, imitation wood and marble, contain lyrical elements not yet entirely out of touch with reality; but Arp and more especially Max Ernst used pieces of newspaper, wallpaper, photographs and vignettes at random and insisted on their *ready-made* qualities, which they distorted, transposed and displaced, and by their facile treatment of the imponderable, they integrated these borrowed elements into a recreation of the object, giving it a reality within a superior reality which for almost a century had had a name. This name, slightly changed, was to assume prime importance, for it came to designate the sole form of a new poetry. In 1920, in Cologne, Max Ernst's collages and those of Arp and Ernst in collaboration, reached their furthest development under a general name first applied to a little series of these collages and objects, "Fatagaga" *(fabrication de tableaux garantis gazométriques)* (Manufacture of Pictures Guaranteed to be Gasometric).

Apart from his collages, such as those reproduced in *Cabaret Voltaire* and on the cover of *Anthologie Dada,* the latter consisting of a piece of newspaper and a drawing followed by the word Dada, Arp's most important work, in the sense of stimulating the destructive urge that was entering into the Dada spirit, were his

ANTHOLOGIE
DADA

ARP

Paraît sous la direction de TRISTAN TZARA
MOUVEMENT DADA

Cover. (For *Dada 4–5*, edited by Tristan Tzara). Woodcut by Arp. Zurich, 15 May, 1919.

illustrations for two books by Tzara, 25 *poèmes* and *cinéma-calendrier du coeur abstrait* (The Abstract Heart Movie-Calendar); these were much freer than the illustrations done for Richard Huelsenbeck's book, which were rigidly formal and aspired to purity of form. Arp's preoccupation with abstract art, which for him reduced itself to a continuous refusal to record nature, separated him a little from Huelsenbeck and Tzara, who aimed to destroy the arts by systematic disorder and confusion. Nevertheless, it seems fitting to mention some of Arp's experiments, which were of far-reaching importance because they were in line with activities that were later to play a large part in the theory of prospecting in the land of the unconscious. Each morning, whether inspired or not, Arp repeated the same drawing, and so obtained a series showing variations which indicated the curves of automatism. He also experimented with chance, putting on a piece of cardboard pieces of paper that he had cut out at random and then colored: he placed the scraps colored side down and then shook the cardboard; finally he would paste them to the cardboard just as they had fallen.

Hans Richter came from *Die Aktion,* a German expressionist group which, during the war, had pursued the principle that artists must take an active part in politics, working against war and for the revolution. At his instigation painters of various directions formed an "Association of Revolutionary Artists" in Zurich in 1919. Fearing that the revolution would ignore the artists, the association aimed to bring aesthetically revolutionary artists into the political revolution that had just broken out in Munich and Budapest. Some of the future Dada painters were sympathetic and joined the association, but its existence was ephemeral, lasting no more than a few weeks. (Slightly later some Russian artists, Gabo, Lissitzky, Malevich, Pevsner and Tatlin, adopted the trend, under the name "contructionism," a movement which produced a second-rate, decorative art.) Besides Richter, the association included Arp, Baumeister, Eggeling, Alberto Giacometti, Helbig, Janco and Segal. They doubtless quickly saw that the radical methods of Dada, as represented by Tzara and Serner, were far more effective than their own, even from a revolutionary point of view, because after the mild stir provoked by the fake news items sent to newspapers by the two Dadaists, the association disintegrated, and the magazine which they had prepared for the press (proofs had been sent to Tzara, who returned them to the printer crossed out from top to bottom) never materialized. Abstract art, one of the doors opening onto the new art, proved to be ineffectual and one of the weak spots in Dada's beginnings.

Eager to spread, to gain ground, intent above all on action rather than selection, Dada utilized any people or methods available, feeling free to spew them out later. Dada was a lowdown skunk, but it had an aim, and men retained their value only in relation to this aim. Consequently, the arrival in Zurich of Picabia, who brought with him the Duchamp-Picabia spirit, is a noteworthy date in the history of Dada; on this date the useless begins to drop away and the essential narrows down to that human force, unconscious and willful, destructive and clean, that truly constitutes what Breton was to call "l'état d'esprit Dada" (the Dada state of mind), then expressed by a handful of individuals.

Cover. (For *291* no. 1, edited by Alfred Stieglitz). Drawing by de Zayas. New York, March, 1915.

Beginning with the third number of *Dada,* to which Picabia contributed for the first time, Dada understood and was able to gauge the distance between itself and certain vanguard magazines in Paris, such as *Sic* and *Nord-Sud,* which were literary and, despite a certain courage, full of heartbreaking good will and constructive aspirations. Picabia discovered Dada, and let Dada discover him. He brought with him a past, akin to Dada, over which hovered the spirit of Marcel Duchamp.

Duchamp, a painter who had been influenced first by Cézanne and then by cubism, had by 1913 become bored with a new aesthetic that had been widely adopted almost as soon as it was invented and was on its way to becoming a new academicism. In 1911 Duchamp had painted his "Nude Descending a Staircase" and "Sad Young Man on a Train," and already we can discern something other than cubism, that stylization of immobilized nature, fixed in the beauty of form.

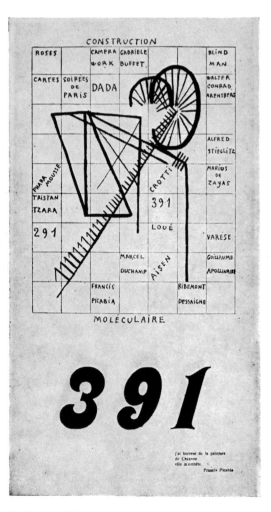

Cover. (For *391,* No. 8.) Drawing by Francis Picabia. Zurich, February 1919.

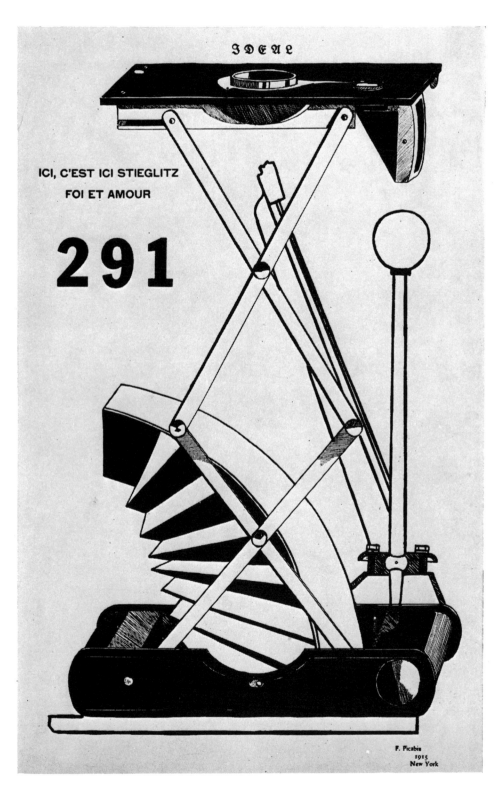

Cover. (For *291*, edited by Alfred Stieglitz). Montage by Francis Picabia, New York, 1915.

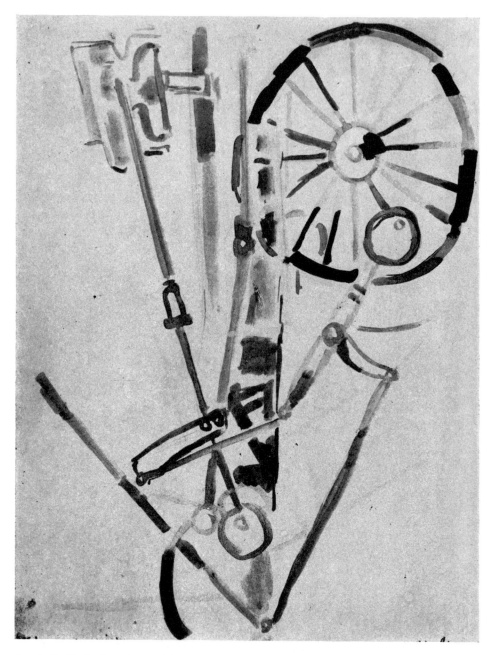

Francis Picabia. *La Novia* (watercolor). 1917(?). (Courtesy Robert Motherwell, N.Y.).

The "Bride," "The King and Queen Traversed by Quick Nudes" and the "Chocolate Grinder" were painted in Munich and Paris during 1912–13; in them synchronized movement opposes the static, and the "machine style," instead of clothing itself in the futurist aesthetic, serves as a means of translating the nude and the

figures. Doubtless exasperated by art, whether new or not, Duchamp undertook in 1912 something that made a great impression on the destructive mind of the period, a series of signed "Ready-Mades," beginning with a bottle-carrier (1912) and a bicycle wheel (1913) and culminating (1917) in a men's urinal which, under the title, "Fountain" by R. Mutt, he submitted to the first Independents Exhibition in New York, and in a snow shovel, typewriter cover and clothes-hanger submitted to the Bourgeois Gallery, also in New York, which was then showing Matisse and Picasso. To test the impartiality of the jury for the Independents, Duchamp submitted the urinal, symbol of his disgust with art and his spontaneous admiration for ready-made things, under an assumed name, and when they sent it back a few hours after the opening of the exhibition, he resigned. He made sumptuous playthings of painted glass, with star-shaped cracks (one of them rotated by a motor nearly decapitated Man Ray) and an immense painted glass, which Man Ray photographed in poetic perspective, entitled "The Domain of Rrose Sélavy" (an imaginary character invented by Duchamp); the glass painting, finally entitled "The Bride Stripped Bare by her Bachelors, Even" sums up Duchamp's short but immense life work, permanently abandoned around 1923 in favor of chess. In these works, he invented an attitude that distorted and transposed the "mechanical style" and then assumed a subversive aspect which his disgust changed into a definite destructiveness toward art and its precepts of mass and medium. The "ready-made" becomes consecrated, raised to the same footing as ancient and modern masterpieces tossed into the same sack; gagged and bound, reduced to impotence, art had to accept the fact.

Francis Picabia, though about to leave New York, where he had brought out *291* and contributed to *Camera Work*, tingeing both these publications with a brand of humor full of destructiveness, submitted work to two magazines founded by Marcel Duchamp in 1917. Picabia recognized the importance of these publications. One, *The Blind Man*, had two issues to which Bob Brown, Mina Loy, Alfred Stieglitz and others contributed; in honor of the first Independents' Exhibition, the magazine ran a reproduction of Duchamp's now famous urinal. The second, *Wrongwrong*, had only one issue. Its cover showed the photograph of a matchbox with a vignette of two dogs sniffing each others' ass.

Before following Picabia to Barcelona, then to Lausanne and finally to Zurich (where he went as a result of an exchange of letters with Tzara), we must mention the work of Man Ray in New York; Man Ray was to become active in the Dada movement and later in surrealism. Since then he has almost entirely given up painting for photography, but during 1916–17 he made object-paintings in which he introduced foreign elements, such as "ready-mades" in their most "vulgar," that is to say, least "artistic" form, doorbells, reflectors, lamps—a world of reflections and conjunctions in which the known creates the unknown and art retreats while the common object comes into its own—a world which his current photographs illumine with solid transparencies and filigrees resembling the concrete script of poetry and the marvelous newness of our time.

With Duchamp and Man Ray (to whom one might add Adon Lacroix), the me-

chanical, the everyday object, the abandoned and the scorned enter into painting-sculpture with the honors due their rank. Both of them made monstrous playthings, sometimes amusing, sometimes deadly, not for hanging on the wall but for use in everyday life. If you were bored or desperate while at Duchamp's place, you could whirl a bicycle wheel, putting into motion the elytrons of an object whose spiral movement was amusing to the eye; you could also catch your foot, and maybe kill yourself, on a clothes-hanger nailed to the floor. Duchamp opened the era of poetic experience in which chance and the concrete thing constitute a poetry that you can pick up in your hand or repulse with a kick. He painted three pictures entitled "Three Standard Needle Weavings" (Paris. 1913), which were an effort to give the meter a new face. This was the experiment: Duchamp took three threads, each a meter long, and these he let drop successively, from a height of one meter, on three virgin canvases. He then scrupulously preserved the contour of the fallen threads, fixing them with a little varnish; the result was a *dessin du hasard,* a chance design or drawing.

Again and again we encounter in Duchamp, both in Paris and New York, and in Picabia and Man Ray, this obsession, in various forms, with the laws of chance, which, at about the same time, preoccupied other men in Switzerland (neither group being aware of the existence of the others), who gave a name to this spirit, which made a place for itself, grew and grew, took hold of the world, gave it a new foundation and forced it to adopt a new consciousness. And Dada pushed society to its last entrenchments.

In 1917, Picabia, who was then in Barcelona, brought out several numbers of a magazine called *391* in memory of his New York venture, *291*. It is of no importance that the texts did not amount to much; the illustrations by Picabia suffice. One of the covers (No. 1, Barcelona) consists of a drawing by Picabia representing parts of a motor; the machinery is entitled "Novia." Picabia was to publish in *Dada* a design made entirely by dipping the wheels of a clock into ink and applying them to paper; in this way he was to discover by a different path, and by analogous means, the negation of art; the glorification of the "ready-made," which is borrowed and recreated outside its original use and its primitive function; and the domination of chance. Picabia was just as sick of cubist stylization and the brand of impressionism that the cult of the machine called futurism turned out to be, as Duchamp (who had undertaken, and successfully, never to make a work of art), and left on the period the magnificent mark of his disinterestedness. And so Picabia, from 1913 on, rejected the new forms that art was assuming, and tried to free himself, witness his pictures of the so-called Orphic period, among others, "Udnie, the Young American Girl," conceived according to an anti-static pictorial law, by which time and memory attempt to transpose their progress into color. His was a sort of anarchic humor, not at all paradoxical, as was perhaps believed when he left France for New York where he was to accomplish his work of demoralization. It was by a reversal of values that, in withdrawing from Paris, the center of the latest artistic novelties, Picabia—even if he never went so far as Duchamp—began to attack and undermine art in what

was most firmly established, most in good taste, most accessible to the advanced bourgeois, most sanctified and most hateful.

It is a fact that Picabia, in Zurich, in a milieu where he felt at home, contributed enormously to the moral drive of the Dada movement, to its outward manifestations, and likewise to its will and its dictatorship. He contributed with his painting and his writings. In *391* (Zurich), which was resumed in New York, and in the *Anthologie Dada* (4 and 5), to which Louis Aragon and André Breton contributed we are astonished to find other names (writers and artists utilizing Dada so as to pass as innovators and draw base profit, exploiting its destructive urge to gain reputations as modernists). The departure of Tzara and Picabia marks the end of Dada-Zurich. While in Germany Dada asserted itself through its revolutionary side, and adopted a communistic attitude, Dada was to find in Paris its poetic climax and, through its death, its transformation and fullness. In Paris, Tzara became acquainted with the group around *Littérature,* a periodical founded in March, 1919, and edited by Aragon, Breton and Soupault, with whom he had been in correspondence. He contributed to it from No. 2 on.

2. Berlin (1918–1922)

If Dada and its manifestations assumed, in Berlin, a new and characteristic form, quite different from the poetic disgust, revolt and subversiveness of Zurich, we need not search far for the reasons. Even though the two movements resulted from the same state of mind, it is impossible to confound them, for their attitudes did not produce the same momentary reactions. For Dada to arrive at a political will in France required an evolution brought about by several years of crisis and anxiety. And from this point of view, the Berlin Dada movement, because it quickly fulfilled its possibilities and impetuously entered into the new state of mind aware of social life, retains in our eyes an interest which has nothing to do with retrospective curiosity. The presentness of Dada is self-perpetuating.

The political situation, the revolutionary effervescence and social distress of Berlin amid the decline of a rotting imperialism, the filthy lesson taught by the leaders of society and by the great disillusionment of the war, automatically set spontaneously revolutionary Dada on a positive, realistic plane. A concrete and immediate task was open to those who, through outward and inner experience, had developed an instinctive revolt and come to recognize the need for political intervention and planning. The Dada mind, which had always been precise, became more violent and intense, while at the same time its realism showed the way to a social activity that was strictly revolutionary: the revolt of the mind on a poetic plane, and political revolt on a human plane. Dada—and sufficient stress has never been laid on this aspect, which, incidentally justifies certain of its aesthetic aversions—has always been human in its revolt against any institution encroaching on the freedom of man. In Berlin, Dada took on a particularly tragic cast, because, face to face with the events of the day, it found an opportunity to act efficaciously, to prove its mettle, to subdue its anarchic force, to establish its dictatorship while

voluntarily choosing a master. Here, even more patently than elsewhere, literary and artistic concerns became subordinate to the lyric but human force which it proposed to release by assigning it to a battle-position. Dada was determined to pay with its heart's blood. Its destructive urge was no longer gratuitous, and we are no longer dealing with an inventive anarchy wreaking, in the realms of poetry and the mind, total devastation in which no system can yet be foreseen, but with actions intelligible to everyone. Dada spontaneously offered its services to the proletariat and went down into the streets. It became a force of aggression and consolation at once. In the beginning it acted at random, as though for the pleasure of being a force. In order to act without restricting all its activities to its guiding principle, it incited to revolt by means of good-humored or cruel allusions; it became a lyrical, satirical, tendentious orator: subversive through caricature, it was insulting in public, and most usually its activity was double, since its attitude toward art scarcely veiled a secret evolution and process, poetically and plastically transposed. Intrinsically popular, it gained an immense popular success, although it sometimes shocked even those whom it had moved to be less indifferent toward the futures that were at stake, and to a more efficacious passion against the state of affairs that was slowly developing around them. Still, its success upset both the newspapers and the police.

When Richard Huelsenbeck returned from Zurich to Berlin, he left behind him a well-being favorable to poetic speculation, and found complete famine, misery and the complete failure of established institutions. We know what the situation in Germany was in 1917, we know it too well; conquerors, whoever they may be (and conquerors of what?), always like to point with patriotic jibes and songs to the misery of the people against whom they have been incited, because this misery stimulates their own courage. The difference between life in Switzerland and in Germany, between the tranquillity of the one and the dramatic turmoil, in which it was impossible to be inactive, of the other, enables us to foresee the new, but not surprising attitude of Dada, and the possibilities latent in its spirit.

Die Neue Jugend, a magazine to which expressionists and various modernist writers of diverse tendencies contributed, published an article by Huelsenbeck (the first to appear after his return to Berlin) in May 1917, entitled "The New Man." Though in this article Huelsenbeck makes no mention of Dada, he was preparing for its eruption. He appears to have met some young men impelled by an anxiety similar to his own, and desirous of a united repercussion, because he delivered a lecture in February 1918, in the New Secession Hall in Berlin, and that same year he was able to start publishing the first Dada organ, which already had a small following. Huelsenbeck's lecture, incidentally, was more historic than significant in itself, and much less combative than the German Dada activities were to become. The political situation determined the ultimate unleashing of Dada. Huelsenbeck's momentary isolation had probably forced him to explain before agitating and attacking, and he had related the story of the origin of the Dada movement in Zurich, the moral crisis from which it issued, and had tried to define the wishes of his group, then

Dadaco (trial sheets for unpublished anthology.) Munich, 1920. Montage with photograph of Heartfield.

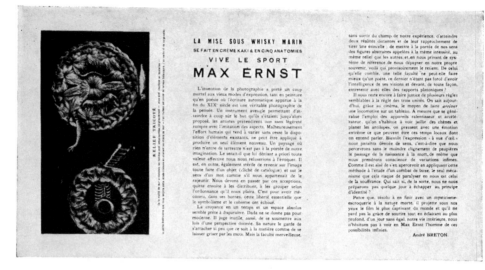

Max Ernst. *Exhibition Catalogue.* Text by André Breton. Paris, May, 1920.

uncertain because of the inevitable confusion brought to it by modern art and the devaluated interests it entailed. In April 1918, he organized another meeting, where he read a Dada manifesto signed, in the following order, by Tristan Tzara, Franz Jung, George Grosz, Marcel Janco, Richard Huelsenbeck, Gerhard Preiss, Raoul Hausmann and Walter Mehring. Further on, after an interval apparently intended to separate them from the above, a number of heterogeneous signatures are to be found, including some which ought to appear in the first group: O. Lüthy, Friedrich Glauser, Hugo Ball, P. A. Birot, Maria d'Arezzo, Gino Cantarelli, Prampolini, Van Rees and his wife, Arp, Täuber, G. Morosini and F. Mombello-Pasquati. In Berlin there were the same confusions and contradictions as in Zurich. To increase its numbers, Dada took in—though very briefly, it must be admitted—names both startling and discordant. In both cities there was a curious mixture of true and false Dadaists, if we may use these terms to distinguish between the moral consciousness of one group and the modernist theories of the other; and false Dadaists made use of the true ones. But, whether or not a reaction occurred, a selection was quickly made, and the first Dada publication, *Dada Club,* made no mistakes.

As soon as it discovered its reason for existing and acting in Germany, Dada eliminated its dead weight. *Dada Club* was edited by Huelsenbeck, assisted by F. Jung and R. Hausmann. Hausmann contributed two wood-cuts without the least concern for art; in their disorder they opposed all cubist, futurist and abstractionist laws, and this is the chief charm, from the Dada point of view. (This is a good place to say that the disdain in which Dada held all forms of modernism was indispensable to its own vitality; but it is necessary to add that experience has taught us to distinguish from futurism and abstract art—which, despite their relative riches, brought us nothing—cubism, the singularly poetic and poetry-inspiring grandeur of which had a powerful influence on our times, and even on Dada's

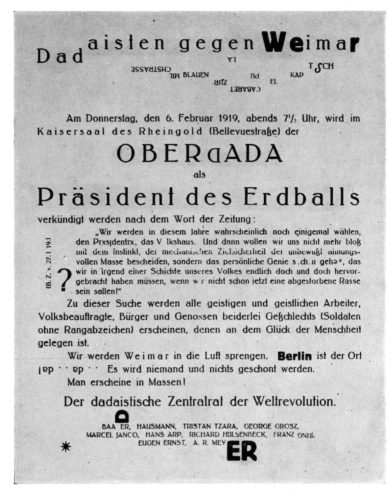

Manifesto. *"Dadaists against Weimar . . ."* (the text threatens to dynamite Weimar). Berlin, 1919.

most moving plastic realizations.) Franz Jung, physician, idealist philosopher, former expressionist, sympathized with, rather than belonged to the group; to the same category belonged Friedländer, author of an interesting book, *Creative Indifference,* which appeared during the war, and Carl Einstein, who edited a Dada magazine with an individualistic trend. No sooner was it born than the new movement found a formula for destruction, certainly owing to the Zurich experiment which served as a model. George Grosz did not contribute to *Dada Club,* but his name is mentioned in it from time to time. The text and illustrations (if not the quality), the make-up and typography, clearly stem from the Dada spirit of Zurich. The back cover announced a propaganda meeting for the end of May, with "simultaneous poems, noise music, and cubist dances (10 ladies)," very similar to the meetings organized in Switzerland by Arp, Huelsenbeck and Tzara. But it must be noted that in Berlin Dada had already taken on a significant attitude very dif-

ferent from that of the Swiss group, and the difference had become more and more accentuated: *Dada Club* attacked the republican bourgeois revolution as not being radical enough, and behind its trimmings of typographical disorder, gratuitous foolery and subversiveness, we discern, in big red letters, this statement among others: "The disappointed hopes of the German Revolution."

1918, the year of communist organizations, social upheavals and the armistice, saw the appearance of *Der Dada,* the organ of the Berlin movement, with only three issues. At first Hausmann alone was editor. The first number, which included Baader, Hausmann, Huelsenbeck and Tzara, is characteristic of Dada's intentional disorder. Letters of all types and sizes, Hebrew characters, printed in every direction and according to a personal design, are mingled with sentences in French and vignettes borrowed from the illustrations of dictionaries. A woodcut by Hausmann embellishes the issue with black and white spots, while sound poems and others composed of numbers or proof-reader's marks stand side by side with the statement: "He who eats of Dada dies if he is not Dada." The contents of Nos. 2 and 3 included Baader, Grosz, Hausmann, Heartfield, Herzfelde, Huelsenbeck, Mehring and Picabia. Charlie Chaplin, Erik Satie and Duchamp were mentioned. Hausmann had now been joined by other painters, Grosz and Heartfield. Collages made with strips of newspaper, photographs devised by Hausmann and Heartfield, composed at random and not very seriously, served as illustrations, along with faked photographs, a few caricatures by Grosz and some drawings with foreign matter, fastened or glued on. There were also absurd and stupefying photographs and vignettes partaking of the "ready-made," the advertisement and incidents bordering on the dream world. The plastic domain did not belong to painters alone; hand-made poetry was just as much the property of poets. The confusion of genres and media put painting within reach of everyone; and poetry as well. Personality no longer existed. Heartfield worked according to the instructions of Grosz. Dada was no manifestation of an individual brain, but an activity in common. *Der Dada* ran ads for books by Arp, Grosz, Hausmann, Heartfield and Herzfelde; for the Dada reviews, *Dada* and *Der Zeltweg* in Zurich, *Die Schammade* in Cologne and *DADAphone, Proverbe, 391,* and *Cannibal* in Paris. It also advertised a series of Grosz' political lithographs in the very personal style of caricature with which we are familiar; here are some of the eloquent titles: "The *boches* have been conquered, bochism is the conqueror," "God is with us," "The triumph of the exact sciences," "The pimps of death," "Rub out famine. . . ."

Its preoccupation with current struggle, with instantaneous revolutionary expression by whatever means regardless (by the negation of art as the symbol of an era at its end, or by the use of caricature as a weapon more popular and more general), invested the plastic manifestations of the Berlin movement with an appearance of sterility, which makes them interesting but appreciably less moving than those of Zurich, Cologne or Paris, produced under the marvelous sign of Dada's poetic effulgence. Poetry, with which the Berlin Dadaists were not concerned, had no place in their monuments of pure revolutionary propaganda which, intention-

(left) Cover. (For *Der Dada*, edited by Hausmann). Berlin, 1919. (center) Cover. (For *Dada Almanach* edited by Huelsenbeck). Berlin, 1920. (right) Cover. (For *Der Dada 2*, edited by Hausmann). Berlin, end of 1919. (Courtesy Cahiers d'Art, Paris).

ally ephemeral, resolutely anti-individualistic, have come down to us as documents relating to one episode of action and struggle, and nothing more. They are arms abandoned on the field of battle. What is important is now hidden elsewhere, and other symbols have come to the rescue of our anguish and its image, though we have not ceased to preserve an attitude which, though not one of revolt, is distinctly revolutionary. As for Grosz, he abandoned Dada just as he abandoned all political extremism. Of all this Dadaist group, some of whom carried on as strict Communists, he is the only one to have kept up his career as a painter. He has continued on the artistic plane to which he rose through caricature, and he has acquired fame. Consequently, his work readily invites every kind of criticism, but this does not interest us, especially in this account. Grosz' work leaves us indifferent, and bears no relation to the force that has taken hold of us.

After various activities carried out individually or in groups, ranging from a publicity prospectus to the establishment of a Dada night club, 1920 marks the apogee of Dada in Germany, and at the same time its decadence and downfall. In January and February, Hausmann and Huelsenbeck arranged a lecture tour through Germany (Dresden, Hamburg and Leipzig), and in April, through Central Europe, beginning with Prague. The lectures were frankly revolutionary, not to say communistic in tendency, which is not surprising if we consider the position that Dada had consistently taken. During the week of revolution in Berlin, in November 1917, which coincided with the first Dadaist impulses, Huelsenbeck had been named Commissar of Fine Arts. It was therefore impossible to make any mistake about Huelsenbeck; the public was forewarned, and the newspapers were not unaware of the character of the Dadaist enterprise. If the lectures were not official Communist meetings, it was common knowledge that they militantly favored the total revolution which Lenin and Marxism had brought to old Russia.

They drew a large audience, aroused great interest and sympathy, and invariably enjoyed a *succès de scandale;* the papers ran long stories treating Dada with a seriousness far different from the artistic and patriotic frenzy of the Swiss and French newspapers. In Germany, Dada was not crushed by irony; the representatives of the bourgeois order feared it and defended themselves desperately against it.

The great plastic demonstration in Berlin took place on June 5, 1920 in an exhibition which brought together 174 items. The programme emphasized the position of Dada by its numerous prefaces and declarations, and definitely confirmed the struggle that had been undertaken. Some apothegms of an aesthetic and anti-aesthetic nature formed a part of the exhibition which they defined. Grosz and Heartfield proclaimed: "Art is dead, long live Tatlin's machine art." It is important not to misunderstand this phrase: it was not dictated by any futurist tendency, and it is to be explained less by constructivist theories than by a desire to edify the masses—one more confirmation of the popular and proletarian spirit in Dada. Among other placards, the insults and advice of which are negative and gratuitously subversive, we find one more sincere which, by a simple statement, proclaims the new hope of Dada: "Dada is political." These words show how active and contemporary were its intent and goal, and to how small an extent artistic and literary. Here the history of Dada is closely bound up with political history; more than at any other time or place, Dada was a moral force, it was a state of mind and not a literary development. The break between it and what preceded it appeared more irremediable than ever. Added to the indifference of the Dadaists to art and above all to lasting art, the allusions contained in the written and plastic works which remain in our hands, like time bombs whose movement has stopped, make these works seem to us today not only clumsy but above all inanimate, because everything fugitive has left them and escapes us.

The Berlin Dadaists invited to their own exhibition all who participated in the Dada movement, whether on the same level or not, in Germany, Holland, Switzerland and France: Baargeld and Max Ernst (Cologne), Rudolph Schlichter (Karlsruhe), W. Stuckenschmidt (Magdeburg), Hans Citroën (Amsterdam), Otto Schmalhausen (Antwerp), Hans Arp and Francis Picabia. . . . Max Ernst called himself Dadamax Ernst and exhibited *Dadafex maximus* and "National Codex and Index of the Refinements of Dada Baargeld"; Otto Schmalhausen who called himself Dada-oz, exhibited a head of Beethoven with a mustache and cross-eyes, strangely reminiscent of the "Mona Lisa" which Duchamp, that same year, had adorned with a graceful moustache; and Arp exhibited reliefs and drawings. These names are lost in a mass of others, some obvious fakes added to present an appearance of numbers, or perhaps to justify works of daring and violence. Though exhibits were usually pretexts for the Berlin Dadaists to pursue their own interests, Hausmann (nicknamed Dadasoph), exhibited a "Self-portrait of Dadasoph" and Hanna Höch, "The Dictatorship of the Dadaists," and both of them showed collages, objects and drawings rather similar in spirit to the work of Arp or Picabia. Grosz, Heartfield and Baader, for example, were particularly tendentious, although Baader's was a special case of coming to the revolution through individualism and madness.

While the majority of the Dadaist painters were to some extent a product of German expressionism, Grosz derived by way of caricature, which he harnessed to the activity in which he was interested, and which he distorted until satire and humor passed over into provocation. The talent which Grosz may or may not have had—and the same is true of Heartfield—is secondary to the moral intent implicit in his work. All German plastic production must be considered in this light. Grosz exhibited drawings and photographic montages which were almost purely political and propagandistic. As we have already said, Heartfield constructed, under the direction of Grosz, "Field-Marshal Dada," in addition to a group of collages showing little respect for art and morality, and some mannequins with an almost entirely political content: from the ceiling of the exhibition room hung a German officer whose visor partly revealed a pig's head.

Johannes Baader, who was not a painter, exhibited among other manuscripts and objects, his visiting-card, *"the luggage of Superdada* (a nickname he had adopted) *at the time of his first escape from the insane asylum, 18 September, 1899. A Dada relic. Historic"; "Why Andrew Carnegie rolls his eyes"; "A project for an animals' paradise in the Paris zoo, containing compartments for all the French and German Dadaists in the Hagenbeck style without bars."* . . . Baader represents still another aspect of German Dadaism. He represents folly without restraint, an anarchic force that describes a trajectory and then vanishes. The events of his life, and his life itself, denote an unbalanced mind, and above all, a lack of control in his approach to the task defined by his friends; but at the same time they are characteristic of man's striving for power through will. Dadaism accepted this frantic individualism and made use of it in action, although it was hardly in keeping with its political trend. When Baader joined the Dada movement, he was no longer a young man. As by some of the titles under which he liked to masquerade, he had formerly been an architect and a writer. (Here are the titles which he had chosen for himself and constantly used, subject to frequent additions and inversions: *"Superdada, president of world justice, secret president of the League of Superdadaist Intertelluric Nations, representative of the desks of schoolmaster Hagendorff, formally architect and writer."*) His great wish had been to raise a monument to humanity in a form approximating a pyramid. He had written a book containing a series of letters addressed to the Kaiser and to Jesus Christ. In November, 1918, during services in the Berlin Cathedral, he mounted the pulpit unnoticed and, taking advantage of the resulting amazement, he delivered a sermon declaring that Dadaism would save the world. At the constituent assembly in Weimar, he distributed a tract professedly published by the *Green Cadaver,* a newspaper which probably never appeared and of which he claimed to be the editor. This supplement to a non-existent newspaper exists and is a significant document of an extraordinary period. The tract was lyrical and contained such sentences as these, certainly more astonishing than effective: *"The president of the terrestrial globe is in the saddle of Dada," "The Dadaists against Weimar."* The tract was signed by "The Central Dada Council of the World Revolution" consisting of Baader, Hausmann, Tzara, Grosz, Janco, Arp, Huelsenbeck, Jung, Eugen Ernst, and

Dadaco (trial sheets for unpublished anthology.) Munich, 1920. Four pages. Illustrations by Grosz.

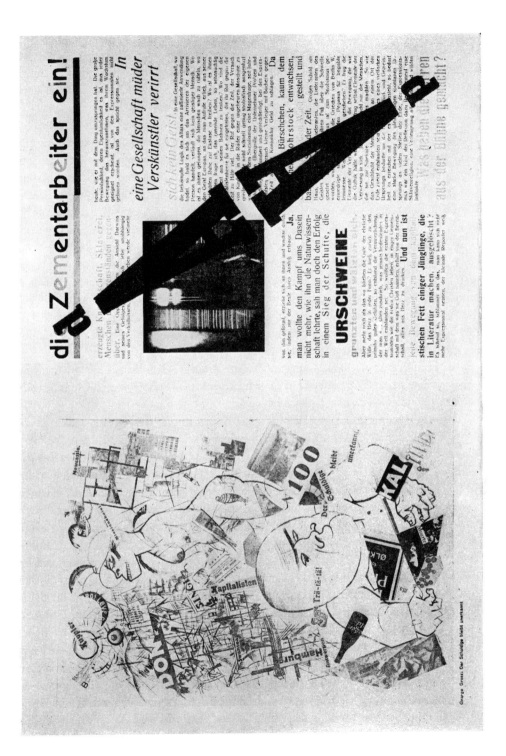

George Grosz: Der Schuldige bleibt unerkannt.

A. R. Meyer. To finish off the convention day, Baader arranged processions of children with dances and songs around statues of Goethe and Schiller. All these activities bear the mark of Baader's personal and lyrical madness. Dada was expansive and felt a need to act in the open; it was profound and absurd, solemn and baroque, always and with the utmost directness, human.

The Dada Almanac appeared in 1920 at about the same time as the exhibition and is the last of the important Dada publications. This work shows little emphasis on Dada's communistic attitude and is more poetical than social; its contributors were: Richard Huelsenbeck, Tristan Tzara, Walter Mehring, Francis Picabia, Georges Ribemont-Dessaignes, Adon Lacroix, Hugo Ball, Philippe Soupault, Citroën-Dada, Hans Arp, Paul Dermée, Raoul Hausmann, and Vincente Huidobro. . . . The cover carried the Schmalhausen head of Beethoven that had figured in the exhibition. There were photographs of the leading German Dadaists or their works. Of the reproductions of the great exhibition, the most subversive were those calling attention to certain declarations and objects, as, for instance, the German officer suspended from the ceiling. Otherwise, the contents were poetical or critical. Tzara, Ball and Adon Lacroix published sound poems recalling Dada's first outcries; Tzara traced the history of the movement in Zurich; Hausmann attacked abstract painting, while Alexander Partens (probably a pseudonym) defended it in just praise of Arp's work. Given Dada's attitude in Germany, its complete preoccupation with politics, this kind of recapitulation foretells the end of a frantic activity that was still being carried on.

Dada came to politics through poetic revolt, and politics absorbed Dada. Dada died of its transposition into reality, for it may be said that after 1920 Dada no longer existed. What was to take place in France some years later when, after the death of Dada, surrealism subdued and utilized its anarchic drive, occurred much sooner in Germany where Dada was only a flash in the pan, by the light of which a world was revealed. Dada's end was hastened by political events and the resulting transformation of its originally individualistic sense of rebellion and separation. An end worthy of Dada's grandeur and isolation, a normal end, inevitably brought about by the metamorphosis of its idealism and by its active intervention in society. It was Dada and its disorder versus all the unworthy forces that lay in wait to destroy it: the *embourgeiosement* of its combativeness and the distortion of its liberating energy; an aestheticism emerging from Dada through its annulment, of which abstract art is the most disastrous example. Dada and its refusal to establish an aestheticism of any kind, because aestheticism is always an absence of any attitude toward life and an end in itself, were defenseless. Dada had never been artistic, but it had always been a state of mind, and it had always been human: what happened in Germany clearly proves this. And the Communists, powerful in Germany owing to their organization, showed that they understood this fact by accepting representatives of Dada into their ranks—which on their part was no mistake.

Beginning in 1922, Grosz, Heartfield and his brother, Herzfelde, definitely branched off toward Communism, to which they committed themselves com-

pletely, while Huelsenbeck, for personal reasons, went out of circulation and began to travel. Since the Dada movement was not primarily pictorial, especially not in Germany, if we are to deal with it thoroughly we must not confine our attention to the painters. For example, the fact that Huelsenbeck had been named Commissar of Fine Arts during the German revolution of 1917, gives him great importance. Among those whose activity and personality demand our attention is the writer Herzfelde. Although he produced less outward evidence of himself than the painters, and consequently his name occurs here less frequently than theirs, he is one of the most significant and representative figures in the history of Dada and its development of a revolutionary attitude. At the end of the war, when Grosz and Heartfield were both soldiers, Herzfelde could be seen in the streets wearing his uniform as an active protest against war: in order to "dishonor the uniform," he wore a particularly disgusting one, and, on pretext of a skin disease, he shaved only one cheek. During the revolutionary disturbances after the war, he was so active in the strikes and the civil war that he was regarded as dangerous and jailed by the police on the basis of the glorious allegation that his attitude toward the masses endangered his life. With his brother and Grosz, he entered into relations with *Die Aktion,* a Communist paper with expressionist inclinations. Then, while Dada was demonstrating in one way or another, he acquired a printing press which, in addition to his own works and the magazine, *Der Dada,* secretly put out Communist pamphlets; closed by the police, the printing plant was replaced by a publishing house, "Malik Verlag." "Malik" published several books by Herzfelde and Grosz, and *Germany Must Die, Notes of an Old Dadaist Revolutionary,* by Huelsenbeck. . . .

3. Cologne and Hanover

Hans Arp and Max Ernst, who after 1910 had exhibited from time to time with painters of various attitudes, met in Cologne in 1913 and became friends. Contradictory as it may seem, Arp was then under the influence of both cubism and the beginnings of abstract art, or to be more exact, he was under the influence of Kandinsky. Impressionism,[1] a mixture of cubism and futurism, set its imprint on Arp, as on German art in general, and he contributed to *Der Blaue Reiter* (The Blue Rider), an art magazine edited by Kandinsky. We find the same expressionist trend in another extremely advanced group. "Moderner Bund" (Modern Group), to which Arp also belonged. Arp was on friendly terms with Paul Klee, was also a guide. Max Ernst, who belonged to the expressionist group around "Der Sturm" (The Storm), a magazine edited by Herwarth Walden, was painting without any clear course; the painter he most admired was Picasso in whom—particularly in collages, paintings connected with objects, and sculptures made from paper folded and unfolded—Ernst must have sensed some possibility of liberation, foreseeing that a game was on for the spiritual stake in a potential world. Later, in 1919—during

[1] Apparently an oversight for expressionism. (Tr.)

the full tide of the Dada period in Cologne—other influences affected Ernst: one, somewhat remote it is true, was that of Archipenko, in his "Sculpto-paintings," another, more definite, was that of Chirico, discernible, for example, in "Fiat Modes," an album of eight lithographs by Max Ernst, which appeared in Cologne in 1920.

Just before the war, Arp had written some poems which Ernst was among the first to appreciate. If it is true that these poems (never published) contained the germ of those which finally appeared in *Dada* (No. 4–5) (and later in book form in Hanover), I have no doubt that in that period such poems seemed utterly dazzling. The poems Arp wrote in 1918,[1] considered along with those of Hugo Ball and Tristan Tzara, have great importance in the history of poetry. Already, through Dada, the battle of poetry against its phantom was half won. Dada's contribution, which was more to the spirit of poetry than to the verse of any particular country or language, was highly valuable; and it may be presumed that, if not for language, which limits thought and was therefore attacked by Dada, these early poems would occupy a place commensurate with the unprecedented grandeur with which they flashed upon the world.

Dada did not propose a technical renewal nor a poetical fad, but imposed a force, quickly channelized, leading up to primordial intuitions, to consciousness of man's debasement and the discovery of his true motivations. Throughout the centuries, throughout errors due to falsity of data and deplorable literary obscurantism, a few isolated men have brushed against the truth and trembled at a dim perception of poetry. Whatever the label of their literary school, these men have done more for poetry—and by poetry I mean life itself and not the pleasure of carving out words— than any of the revolutions in taste brought about by agitated movements whose entire effort may be reduced to a simple change in inflexion, even if they did perfect poetic form or place a Phrygian cap on their dictionary, as was the case with the French romantic movement, full of talent but devoid of essential poetic spirit, if we except Nerval, Borel and Baudelaire for what they fleetingly perceived. In this connection, it seems to me worth while to quote here a few lines taken from an interview with Tzara published in *Merz*, a Dada magazine in Hanover: "*Dada was the materialization of my disgust. Before Dada, all modern writers had held fast to a discipline, to a rule, to a unity. After Dada, active indifference, spontaneity and relativity entered into life. . . . If it is this INTELLECTUAL DRIVE which has always existed and which Apollinaire called the NEW SPIRIT, you wish to speak to me about, I must say that modernism interests me NOT AT ALL. And I believe it is a mistake to say that DADAISM, CUBISM and FUTURISM have a common base. The two latter tendencies were based primarily on a principle of intellectual and technical perfectibility while Dada never rested on any theory and has never been anything but a protest. . . . Poetry is a means of communi-*

[1] Some of these poems have been published with English translations in the vol. by Arp. *On My Way* (d. m. a. b.), N.Y., 1949.

Arp. *Relief.* 1918. (Courtesy Cahiers d'Art, Paris).

cating a certain amount of humanity, of vital elements that the poet has within
himself."

If we remember the period of their origin, these statements, reprinted in 1923,
take on, by virtue of their clairvoyance and the comparisons they invite with cer-
tain passages by André Breton, a striking significance and validity. However
vague, they light up the terrain, as regards both the theories they condemn and
those they accept. The poetry to come has found its spark. The "protest" that con-
stituted Dada implies surrealism, which was perhaps already germinating else-
where, and in part opened the road to surrealism. Dada, by committing itself to
the spirit and its freedom, and not to the straitjacket implied in a reform of
the poet's arsenal, showed poetry in its true light and liberated it from its imi-
tation. From this point on we can conceive the question which Breton put to him-
self in a moment of solitude when all outside contact was broken and, as he tells
us, surrealism was being decided within him: Would the world end with a beautiful
book or with a poster advertising Hell?

Hans Arp's poems, like those of Tzara and in principle of many Dadaists,
brought about a complete reversal in the battle—a limited battle perhaps—of
literature, and it is this that gives them historic importance. It is not merely a
question of talent or of a facility in speech, music or the bizarre. Here we are dealing

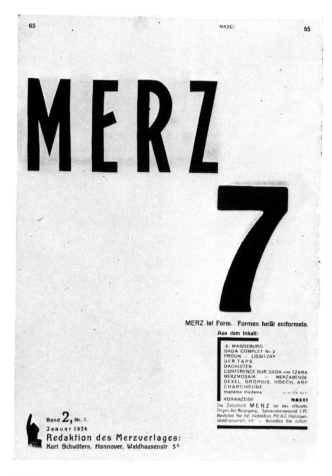

Cover. (For *Merz*, vol. 2, no. 7, edited by Kurt Schwitters). Hanover, January, 1924.

with a forthright statement using all available means, an attempt to bring together man and, if you will, his instincts, by intuition. This is more than a conception of lyricism, it is an actual contact with human exaltation and a recognition of poetry through an intermediary other than a stage setting, an atmosphere, or the enthusiasm of characters in fiction. Here madness and dreams come into play, and though it was too soon to draw any valid inferences from them, they had become a force to reckon him. Their searchlights rekindled dead fires.

The history of Dada in Cologne can be summed up in the names of Ernst, Baargeld and Arp. Immediately after the war, Max Ernst met Baargeld, a painter and poet, who was also living in Cologne. A periodical, *Der Ventilator* (The Ventilator), was founded by Baargeld, and for it Ernst wrote articles and poems. *Der Ventilator*, Dada in spirit, extremely subversive and rather threatening, clearly political and communistic, had enormous success. Sold in the streets and at the factory gates, it reached a circulation of twenty thousand copies. It was short lived only because it was suspended by the British army of occupation in the Rhineland.

Baargeld soon found himself riding both Dadaism and Communism. He founded

the Communist Party in the Rhineland, and brought it into the German C.P. Still, both he and Max Ernst energetically fought against the utilization of Dada for political ends and criticized the Berlin movement for limiting itself to propaganda. From the outset, Baargeld and Max Ernst refused to suppress their own poetic illumination in favor of propaganda. They believed that the poetic and political attitudes were not incompatible, and that the two attitudes could go along side by side without mutual interference; or else they felt that poetic exploration is not opposed *a priori* to a revolutionary attitude to society, and that a poetically revolutionary action corresponds in essence to such a social attitude. They wanted to hasten through their writings the decomposition of bourgeois art and thought, systematically and shamelessly; and like the Berlin Dadaists, they did not hesitate to express their political opinions publicly. I do not believe that at that time anyone thought of imposing this or that poetical formula, or of creating a proletarian literature. The problem and the alternative did not bother anyone very much: there were other fish to fry. The Dada spirit had made a clean sweep, and had raised all sorts of questions. It would be not uninteresting now to compare the attitude of Baargeld and Ernst with Louis Aragon's recent statements at the Kharkov Congress and with Breton's pamphlet, *Misère de la Poésie* (The Poverty of Poetry). Since then social and philosophical factors have changed the actual situation, but Dada had its say: the German Communist movement, and I venture to believe not only for reasons of proselytism, did not hesitate to take in the Berlin Dadaists, who were after all the pictorial and poetical representatives of the Dada spirit which the Communists did not neglect as a means of expression.

Their attitude once defined, Ernst and Baargeld brought out in 1919 *Bulletin D*, an exhibition catalogue, and in February 1920, *Die Schammade* [a neologism]. *Die Schammade* had as a subtitle, "Wake Up Dilettantes"; in its two numbers are to be found, besides Arp, Baargeld, Ernst, Picabia and Tzara, some new names, Aragon, Breton, Eluard, Ribemont-Dessaignes and Soupault, contributors to *Littérature*. What is striking in the two Cologne publications is their unity, rare enough in the Dada reviews, and the editor's ability to choose among so many possible contributors. The influence of the Paris Dada movement, already at high tide, was obvious. Dada in Cologne produced at the same time another movement, called "Stupid," which included several painters, H. Hoerle, Angelina Hoerle, A. Raderscheidt and a sculptor, F. W. Seiwert, about whom there is little to be said.

Beginning in 1919, Baargeld and Ernst, who were painting spontaneously, without premeditation, joined Arp in a work in a profoundly Dada spirit, the importance of which they did not realize. Here it was less the result that counted than the intent inherent in the act of creation. Dada destroyed the individual personality: Baargeld and Ernst worked together on paintings, each unaware of what the other was doing. Once, after Arp had expressed regret at not having done certain collages by Ernst, Ernst proposed that they both sign them. From this Dadaist pact was born a whole series of collages in collaboration called "Fatagaga," an abbreviation for "Fabrication de tableaux guarantis gazométriques."

Cover. (For *Bulletin D,* edited by Max Ernst and Baargeld). Cologne, 1919.

The Cologne collages brought to Dada painting a new factor and a typical inspiration. They were not arranged according to a plastic rhythm or a lyricism of materials or pieces of paper like Picasso's collages and even those reproduced in the Zurich magazine *Dada.* Marcel Duchamp had already discovered and applied to painting a certain automatism and anonymity, closely corresponding to Tzara's words jumbled in a hat. Baargeld and Ernst began to discover in one drawing another drawing, the contours of which slowly emerged from the knotted lines like a ghost, like a prophecy, like the voice of a ouija board, like the desperate cry of a reality imprisoned in its own form, dividing itself in the end without end, under the attentive eye of him who in seeing becomes seer. It was not exactly the aesthetic exploitation of a spot on the wall in the manner of Leonardo; nor was it

exactly the mere gift of alienating an object. It was the discovery of accident and surprise in their obscurest aspects, the discovery of a spiritual double view, analogous in part to Salvador Dali's theory of the paranoiac image. Arp, and especially Baargeld and Ernst, selected stenciled designs which they cut, modified, pasted or rubbed according to the image that had first been perceived, or that had gradually risen from the limbo of reality. More particularly, Ernst made use of vignettes, parts of which were covered by cuttings from other vignettes.

The pre-existing image took on an unprecedented power, and the ready-made became a magical instrument. Engraved on the philosopher's stone, the madman's design paid homage to the sublimity of the concrete. The dream discovered reality, which is no more than a sensory and visual interpretation. This gave rise to the extraordinary series of vignette-collages that Max Ernst set on the scent of poetry: I am thinking of the illustrations to Eluard's *Répétitions,* and of those marvelous stories, *La femme 100 têtes* (The Hundred-headed Woman) and *Rêve d'une petite fille qui voulut entrer au Carmel* (Dream of Young Girl Who Wanted to Join the Carmelites). He made other drawings by tracing and combining fragments of machinery, and in 1920 sent one to *"Section d'Or,"* an exhibition held by the dissident cubists in Paris, which refused it because it was not drawn by hand.

Following the trail of the marvelous, Baargeld and Ernst suspected a domain of encounters and escapes, and prepared to explore it. Starting from the restlessness of Zurich, they travelled other roads which led to the ends we know: the subconscious, and psychic automatism. . . . No theory guided them and one fact led them quite naturally to another. Their states of mind concurred, and constructed a great bridge of revelations. Counting on results of which they were by no means certain, they planned an exhibition to make their state of mind clearer to everyone, including themselves. Only Arp, Baargeld and Ernst took part in this show, which was held in April 1920. In the entire history of Dada, I know of nothing stronger or more convincing. The Cologne adventure is a comet in Dada's heroic period.

The site of the exhibition was picked deliberately. The center of Cologne was chosen as accessible to the public and its slander. Dada planned to insult, and to this end rented a little glassed-in court behind a café, which was reached through a public urinal: a wise precaution, with a certain number of visitors assured from the first—visitors or victims, it is hard to say. A young girl dressed for her first communion opened the exhibition. Did the blue posters, designed by Ernst, showing simple doves and adorable cows cut out of primers, give a hint of what this exhibition, this demonstration, by young painters would be? I can just see the gullible visitors in search of an aesthetic experience. The prettiness of art is measured by the admission fee. And this exhibition was not free. The public, expecting art, is treated to outrages against tradition. And suddenly the little girl dressed for her first communion begins to recite obscene poems. This picture represented a superposition of two post cards, "Saint Thérèse de l'Enfant Jesus" over a pin-up girl, "Petit Choc," with black stockings under her lace petticoat.

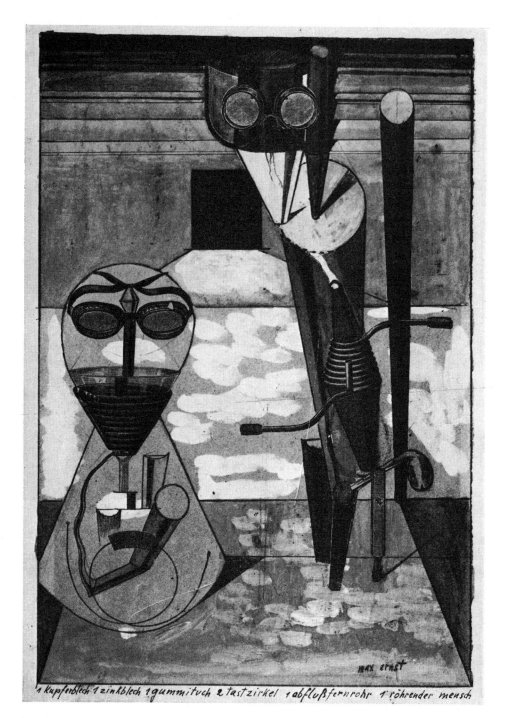

1 kupferblech 1 zinkblech 1 gummituch 2 tastzirkel 1 abflußfernrohr 1 röhrender mensch

Max Ernst. *Two Ambiguous Figures.* 1919. (Courtesy Arp, Meudon, France).

Max Ernst. *The Horse, He's Sick.* 1920. (Coll. Museum of Modern Art, New York).

On the walls hung the drawings we know; on the floor were strewn objects by Arp and Ernst. In a corner was Baargeld's "Fluidoskeptrik," an aquarium filled with red-tinted water; with an alarm clock at the bottom; on the surface a magnificent head of woman's hair floated as casually as the Milky Way, and an elegant arm of polished wood, such as glove-makers use, protruded from the water. Beside it stood an object by Ernst in very hard wood, to which a hatchet was chained; any visitor who felt inclined was allowed right to destroy the object, as one cuts down a tree. The object, useful enough for inactive people, anticipates Arp's "Planche à oeufs (Egg Board)," with directions for use, in five movements: first, chop several eggs; second, split some wood; third, ring the bells; fourth, masturbate; and last, throw the egg in the navel—movements of development and growth leading to a movement of precision. Such objects, first conceived by Marcel Duchamp, were a slow step toward the object with a symbolic function, the flowers of surrealism.

Naturally when a beer-drinker, having downed the drop which causes the vessel to overflow, went to the urinal and saw what was going on, the exhibition received some rough treatment: the objects were broken and the aquarium smashed . . . the red water flowed over the floor to complete the triumph of Dada. A complaint against obscenity was lodged with the police. When the police arrived they discovered that what had aroused the most indignation was an etching by Albrecht Dürer, and the exhibition was re-opened.

The same year an album of lithographs by Max Ernst appeared. *Fiat Modes* was somewhat influenced by the charm of Chirico, but in it there may be detected a

161

mystery and a sense of the dream peculiar to Max Ernst.

In the course of its faltering progress through the corridors of haunted houses and the great deserted buildings of the mind, Dada stepped on fire alarms: far in the distance could be heard the call to unnamed forces, awakened in untouched youth. Already Dada had committed itself to feeling rather than writing, to the identification of opposites with one another, to despised forces, to a revision of current values, to a human attitude resembling a barometer, to a kind of moral completion. We find examples of this not only in art, though it is in art that the destructiveness struck mankind most deeply. The Dadaist act now appeared in poetry, the poetic act *par excellence*. Dada restored to poetry an extra-literary power, the power of expansion.

All this gave rare brilliance to the Dada movement in Cologne. In 1919, the Zurich Dadaists had amused themselves by sending false news items to the daily papers. They had announced a duel between Tzara and Arp; great efforts were made to prevent it. From the beginning they bragged that Charlie Chaplin belonged to the movement. The newspapers really believed that an "International Dada Congress" would take place in Geneva, and reporters were sent. In Berlin all activity was political. The Cologne exhibition represented the lyrical aspect of Dada. I need not repeat facts that need no comment, but it is well to note in passing that Dada made clear beyond a shadow of doubt its anti-religious drive, and it sanctified the insult.

Dada died in Cologne and Berlin in the same year. Everyone abandoned the deathbed to carry Dada elsewhere. In 1922 Max Ernst left for Paris, where he began to agitate with the group gathered around the magazine *Littérature*. Arp had been no more than a transient in Cologne. As for Baargeld, he gave up painting and withdrew from any further public activity. He was killed in 1927, buried under a snowslide.

It was then that Dada rose again in Germany—in Hanover. A publisher, Paul Steegeman, brought out a Dada almanac, *Der Marstall* (The Royal Stables), and books by Arp, Serner, Vagts (a Czechoslovakian Dadaist), and Kurt Schwitters. It was Schwitters who gave Dada its final impetus.

A poet and painter, Schwitters occupies a special place in the history of Dada. The Berlin group, concerned only with revolutionary effectiveness, had disapproved of his hesitant attitude and kept him at a distance. Schwitters found himself isolated in Hanover and received little support in his activities. Holding steadfastly to the poetic sphere, he remained prudently bourgeois in politics. Not only was he not invited to the Berlin exhibition of June 1920, which through its size assemble the most disparate elements, but on several occasions Huelsenbeck and Haussmann came out openly against him. In speaking of Schwitters, they declared that only those who had gone through an initiation could be Dadaists, thus making something magical of Dada. Schwitters does not seem to have been very close to the Cologne group, despite his friendship with Arp. On the other hand, he always remained on good terms with the Zurich group, and this seems natural when we

remember the Zurich lack of a political position. His vagueness concerning the revolution, whether arising from indifference to political reality, or to simple prudence, was not the only reason for his isolation in Germany. As we know, Dada, toward which at all events he was moving spontaneously, categorically rejected modernism as harmful in all its forms to Dadaist activity. Dada had no wish whatever to set itself up as a consoler, and especially not by means of aesthetic programs and rules to be followed by those who thirsted for a new art. Even in its revolutionary aspect, we have proof that it had little interest in creating an art befitting a future society, even if that society were to emerge from Dada itself. And Schwitters did not dissimulate his sympathy, if not his express taste, for abstract art as represented by the "Sturm" group, the Russian constructivists, and Dutch neo-plasticism. These tendencies had been a point of departure for Dada. Just as Duchamp and Picabia had used futurism, Arp, Baargeld and Ernst had used abstract art, but this could lead to nothing.

Perhaps Schwitters was also criticized for having in him something of the traditional German poet. Uncertain even as to how he should regard Dada and react toward it, he adopted it and rejected it, confirmed it and denied it. Morally he was not in entire agreement, and up to a certain point regarded himself as a dissident. Did he see clearly what separated him from Dada's true aims, or was it the opposition around him that suggested the choice that he felt obliged to make? The truth is that his conception of Dada was often unclear. At all events he searched for a name to represent his transposition of Dada, and invented "Merz," which he adopted for his own use. He labeled everything he painted or constructed, most of his manifestoes and some of his books with the title "Merz," a term without meaning, a fragment of a word withdrawn from circulation and become a sacred symbol. "Merz" could not dethrone Dada, which was an impersonal monster hurled like a meteor, an effective and lyrical power, and the word remained, though implicitly embracing Dada, a purely individual designation, inseparable from the name Schwitters. In 1923 *Merz* was officially launched as a magazine giving the impression of attempting to resurrect Dada.

Schwitters arranged a series of lectures for Tristan Tzara in Jena, Weimar and Hanover. After the lecture held in a Hanover gallery, there was dancing around a dressmaker's dummy. In imitation of Tzara and Hugo Ball, Schwitters wrote long poems consisting only of sounds, and recited them in a rather surprising fashion, singing and whistling. The poems were difficult to read but his voice gave them an extraordinary poignance. The real Schwitters, the exciting side of his diffuse but remarkable personality, lies more in his life and work than in the literary role he attempted. He was able to create around himself an atmosphere into which he escaped, and it is in this that he was truly Dada. His house is said to have been very strange, and he apparently succeeded in evoking the impossible. Walking along the street, he would pick up a piece of string, a fragment of glass, the scattered princes of the waste land, the elements of these infinitely inspiring landscapes. At home, heaps of wooden junk, tufts of horsehair, old rags, broken and unrecognizable objects, provided him with clippings from life and poetry, and constituted

his reserves. With these witnesses taken from the earth, he constructed sculptures and objects which are among the most disturbing products of his time. To the principle of the object, he added a respect for life in the form of dirt and putrefaction. Under his influence, Arp composed some objects of pieces of old wood. To Arp's mechanical, meticulous neatness (which by the way is quite disconcerting), and to the quality of the marvelous evinced by Ernst in his objects, Schwitters suggested the irrational tastes that we know from our dreams: spontaneity and the acceptance of chance without choice. He made a model of a project for a monument to humanity, in which all sorts of materials were to be used helter-skelter: wood, plaster, a corset, musical toys, and life-size houses in the Swiss style. Parts of the monument were to move and emit sounds. His collages were made from pieces of paper picked up in the muddy streets, tramway tickets, postage stamps and obsolete banknotes.

This same quality, which might be called popular, is also apparent in certain of his poems, whose paranoiac aspect seems to be derived partly from the poems of Arp and Tzara. Nevertheless, Schwitters' personal accent predominates; it is a force that sweeps up the ready-made phrase, vulgarity and bad taste. His most important work was "Anna Blume" (1919), a written transcription of all that is eccentric in his sculpture. "Anna Blume" personifies the sentimental German girl with all her absurdities. His description of her is a grab-bag of clichés, newspaper clippings and popular songs, advertising copy and expressions of innocence. The grain of lunacy contained in this work, which includes all the elements of life tossed in just as they are, is still another face of Dada. (An actual Anna Blume sent a letter of protest to the papers, but more than likely this was a gag devised by Schwitters himself.)

Schwitters' spirit, despite his powerful individualism, derives directly from Dada. His work partakes of its apparent disorder and its poetical feeling for every human manifestation. And consequently it is hard to understand the attitude of Schwitters' magazine, or to understand what connection he could establish between his sympathies and himself. Everything in his character was in direct contradiction to the work he engaged in. For after several issues, *Merz*, which published Tzara's lecture and the statements quoted above, changed abruptly. *Merz* had never had much unity, and was very uneven. But after a certain point, *Merz* was only remotely a Dada review: only the reflection of Dada remained. Other interests opposed Dada and usurped its place. The double number, 8–9, entitled *Nasci* is an example. The typography and layout were done by Lissitzky in collaboration with Schwitters. *Nasci* came out for a new order, abstract in tendency, i.e., the discovery of form. It ran reproductions of Schwitters, Arp, Léger, Tatlin ("The Tower"), Braque and Man Ray, as well as Mondrian and Malevich. It was in this issue that Schwitters invented *"i,"* which was Dada in spirit: *"The only thing that the artist has to do in 'i' is to transform an already existing complex by delimiting a part of it which is rhythmic in itself."* "i" is a kind of alienation. But too many declarations in favor of harmony and form encumber this number, in which Dada is betrayed and banished.

Dada cannot be pacified. It prefers to leave the field. Through its clumsiness, its anxiety and disorganization, through its spiritual force—a force made fabulous by idiocy—through its mortal certitude and tenacious timeliness, through the divagations of public opinion, through the nationalistic and insulting remarks of the newspapers Dada takes on grandeur. It is all clairvoyance and presentiment, a force that provokes. The surface disorder of Dada concealed an order, but this order had nothing to do with abstraction, the narrowness of which demonstrates a resignation not at all commensurate with Dada. There is no proportion between the departure and the arrival. Dada was ending in a blind alley. Dada is poetry itself, and poetry is stifled by harmony. And what now? Would everything that had been aroused fall back into a leaden sleep?

4. Dada in Paris

> **DADA**, noun. Denomination deliberately devoid of sense, adopted by a school of art and literature appearing around 1917, whose program, purely negative, tends to render extremely arbitrary, if not to suppress completely, any relation between thought and expression. The word DADAISM is also used. Adjective: The DADA school. The principal representatives of the dada school were Tristan Tzara, Phillippe Soupault ("Rose des Rents"), Picabia, Ribemont-Dessaignes ("l'Empereur de la Chine"), Eluard ("Répétitions"), Breton ("Champs Magnétiques," in collaboration with Ph. Soupault), Aragon ("Feu de Joie," "Anicet"). Aside from humor and mystification, which had a large part in it, we may consider dadaism as the extreme limit of the possible divorce between words and meaning. "Sense," one of them has said, "is not a property of words that is assured." Extract from Larousse du XXᵉ Siècle, vol. 2, p. 619.

Louis Aragon, André Breton and Philippe Soupault were contributors to various advance guard magazines, among others *Sic,* in which we find Soupault's group of poems: "Aquarium," some subjective critical articles by Aragon and Breton, and, by the same authors, a piece of synthetic criticism which gives an impression of the authors appraised by a transposition or *collage* of formulas. In 1919 they founded *Littérature;* the ironical title proposed to add the editors' pioneer work to that of writers connected with the spirit of the time. These men, whom we shall call the *"Littérature* group," represented a poetic and critical position between Rimbaud and Lautréamont on the one hand and Jarry and Apollinaire on the other; they supported the effort to liberate the mind in progress since the second half of the nineteenth century; they were, therefore, resolutely modern in the sense of rising against and condemning contemporary thought, which had been compromised, and of approaching the solution of pending problems. Partisans of escape and revolt at any price, they were immediately attracted to the activity proposed by Dada.

Jacques Vaché, had already accustomed the group, by his personal and dangerous brand of humor, disintegrating and lucid, to a sort of disorganization of thought,

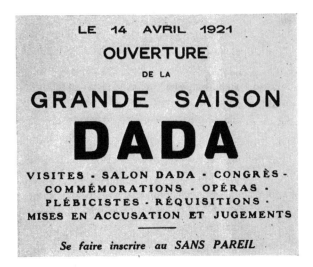

Announcement. *"Opening of the grand dada season."* Galerie au sans pareil, Paris, 14 April, 1921.

logic and life. Arthur Cravan in *Maintenant* (1913–15), Marcel Duchamp and Francis Picabia had attacked the seriousness and aestheticism of modern art: this attitude could not fail to fit in with their profound views concerning the negation of reality, and could not fail to influence them. On the other hand, the precise revolutionary spirit of Lautréamont or Rimbaud drove them to a systemization, less anarchistic and less flippant, of a definite struggle to be undertaken, just as certain poetic movements in advance of their times inspired them to work in an uncertain field where, for example, alongside Mallarmé and Charles Cros, they found Paul Valéry, fallen very nearly into oblivion. Actually, their poetic temper led them rather toward the marvelous, toward the unfathomed depths of the

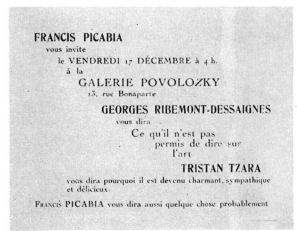

Invitation. *"Francis Picabia invites you . . ."* Paris, 1920(?).

"Some presidents and presidentettes" (of the dada movement). (From *Dada 6*, edited by Tristan Tzara). **Paris, February, 1920.**

unconscious recently revealed by Freud and hitherto completely neglected, than toward total disorder. Since they needed a means for suppressing disturbing elements, an absurd conformism and a body of thought bordering on nullity, they saluted in Dada, a phenomenon bursting forth in the midst of the post-war economic and moral crisis, a saviour, a monster, which would lay waste everything in its path. They felt that it would be an offensive weapon of the first order. Thus, though the word *surréalisme*, borrowed from Apollinaire and already full of meaning, was regularly used by the *Littérature* group and their friends, their magazine, for want of an alternative course at the moment, gave itself to Dada, a scarecrow erected at the crossroads of the epoch. For various reasons, the very different works of Eluard (*Le devoir et l'inquiétude*, 1917), Soupault (*Aquarium*, 1917), Breton (*Mont-de-piété*, 1920), Breton and Soupault in collaboration (*Les Champs magnétiques*, 1920) are not Dadaist, any more than works by the same authors published between 1921 and 1924, which stand in sharp contrast to pure Dada works. Dada made a clean sweep of the past, and the *Littérature* group appears to have been concerned more than anything with the revision and rehabilitation of certain values, and the transformation of thought. It appears more and more clear that, for them, the *state of mind* represented by Dada was only a state of mind, an astonishing halting-place, an escape, a liberating, shocking force. And its relatively

167

quick death or, as I prefer to call it, its dialectical transformation, is the proof. In this light, those who were to become the active members of the movement, found the devastating anarchy of Dada incomparably useful; to them it came as a sensation.

Tristan Tzara, who contributed to *Littérature* beginning with the second number (April 1919), arrived in Paris at the end of the year and settled there for good. He became friendly with the regular contributors to the review, which for some months had openly defended Dada and published poems derived from chance (experiments with sentences cut from newspapers, automatic writing, dada pinwheels (*papillons dadas*), (*Dada Corporation for the Improvement of the Vocabulary—Another: Quiet! Language is Not a Stenosteno nor What Dogs Lack*), without, however, neglecting different work such as Lautréamont's *Poésies,* Jacques Vaché's *Lettres de guerre,* both with introductions by Breton, unpublished works by Mallarmé, Cros, Rimbaud, articles on Raymond Roussel and Synge, texts by Valéry and Gide, whose "gratuitous act" as elaborated in *Les Caves du Vatican* ("Lafcadio's Adventures") was then of some importance, and a penetrating inquiry: "Why Do You Write?" . . . *Littérature* also asked Jules Mary for some recollections of Rimbaud, with deliberate derision. Tzara's arrival launched the era of public demonstrations, of group delirium, of Dada warfare and insults in which, because of previous success, the movement was thoroughly experienced. Picabia, who in 1918 had published *Rateliers platoniques, L'Athlète des pompes funèbres,*

Advertisement of *Au sans pareil* in reviews. Paris, c. 1921.

Cover. (From *Littérature* new series, no. 1, edited by André Breton). Design by Man Ray. Paris, March, 1922.

Poèmes et dessins de la fille née sans mère, and, in 1919, *Pensées sans langage,* found his place in organizing the Dada offensive on Paris.

The December 1919 issue of *Littérature* carried a *Lettre ouverte à Jacques Rivière* by Tzara, in response to a note on Dada by Rivière in the *Nouvelle Revue Française,* analyzing the aims of Dada; *Littérature* took the initiative and the responsibility for the first public demonstration. This "Premier Vendredi de *Littérature*" (First Friday Meeting of *Littérature*") was a confused and ill-managed meeting, but nevertheless somewhat important. It attracted a large audience to the Palais des Fêtes on Friday, January 23, 1920: the public flocked to see Dada at large. André Salmon was first on the program. Some poems were recited; the audience was happy because, there was a certain art in these, but its pleasure was soon spoiled. People in masks next began to recite a disjointed poem by Breton. Tzara read a newspaper story, which he called a poem, accompanied by an inferno of bells and rattles. Naturally the audience was exasperated and began to whistle. As a finale, some paintings were displayed, among them one by Picabia, that was exceedingly provocative from a plastic point of view, bearing, like several of his pictures and manifestoes of this epoch, the title "LHOOQ." After this meeting, which was simply an experiment, an effort to come in touch with life, the demonstrations, tracts and periodicals multiplied, always in a direction more and more outrageous. It was necessary to teach bourgeois common sense a lesson.

Cover. (For *Dada* no. 7, edited by Tristan Tzara). Drawing by Francis Picabia. Paris, March, **1920**.

Announcement. (Of the first *"Friday of Littérature"* at the Palais des Fêtes). Paris, **23** January, **1920**.

In February appeared the *Bulletin Dada* (sixth issue of Dada, which **was to re-** main in Paris), with work by those whose poems had been recited **at the first**

Cover. (For *Dada* no. 6, edited by Tristan Tzara). Paris, 1920.

demonstration: Picabia, Tzara, Aragon, Breton, Ribemont-Dessaignes and Eluard, in addition to Duchamp, Dermée and Cravan. The *Bulletin Dada* declared itself anti-pictorial and anti-literary. We find, superimposed on drawings by Picabia, declarations, definitions, poems that are bewildering, gratuitous, insane, intentionally nonsensical. A list of Dada presidents is given; large characters proclaimed: *True dadaists are against Dada. . . . Everyone is a leader of the Dada movement.* . . . This number also provides a program of the second demonstration, of the 5th of February, in the Salon des Indépendants. Thirty-eight lecturers were provided for the reading of manifestoes. The newspapers announced, in all seriousness, that Charlie Chaplin would be present at this meeting. Here is the program: mani-

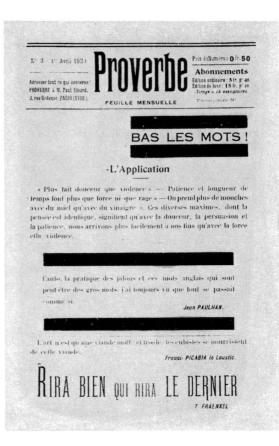

Cover. (For *Proverbe* no. 3, edited by Paul Eluard). Paris, 1 April, 1920.

festo by Picabia, read by six persons; by Ribemont-Dessaignes, read by nine persons; by Breton, by eight persons; by Dermée, by seven persons; by Eluard, by six persons; by Aragon, by five persons; by Tzara, by five persons and a journalist. The manifestoes were chanted in the midst of incredible confusion; the public began to throw coins at the readers, and the lights had to be turned out in order to end the meeting. A little later appeared *Proverbe,* a monthly edited by Paul Eluard, in which we find the same names; though Picabia had just contributed for the first time to *Littérature.* Among Dada publications, *Proverbe* sounded a very special note and took a definite position with regard to the others. Its first issue printed the following words by the Marquis de Sade: *"Good, I forgive you, and I must respect the principles which lead to mistakes,"* and carried an article by Paulhan on Breton and Reverdy. *Proverbe* devoted itself to a revision of language. It was at this time that Dada was expelled from the "Section d'or," a group of painters represented by Archipenko, Survage and Gleizes, at a meeting held at the Closerie des Lilas. The "Section d'or" had already refused a drawing by Max Ernst executed mechanically with stencils, and was intent on breaking with Dada, whose subversive spirit was becoming too embarrassing. This incident marks the rupture of Dada with artistic elements.

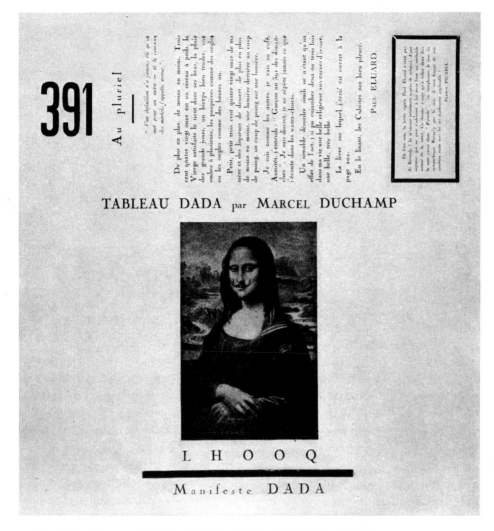

391. Mona Lisa with moustache by Francis Picabia after the original by Marcel Duchamp.

CANNIBALE

Cover. (For *Cannibale* no. 2, edited by Francis Picabia). Paris, May, 1920.

In 1918 a newspaper had stated: *"We were right to be suspicious. The Swiss review Dada which tried to bring about a Franco-German intellectual rapprochement, has thrown off its mask. The Dadaists are now a German school and are making a big stir. . . ."* (*L'Intransigéant,"* August 1918). Other articles had openly called Dada *Boche* (sic). Now the press was wondering whither Dada was headed: for some it was a symbol of the abyss, a dangerous madness, for others a delirious frolic. But all were alarmed. Not a day passed without some mention of Dada. There were editorials, news stories, gossip items, personal ads, for the most part insulting, caricatures; even music-hall reviews made reference to Dada. André Gide, Henry Bidou, Jacques-Emile Blanche, J.-H. Rosny, Sr., and Renée Dunan more or less took the side of Dada, or at least tried to understand it. The last-named wrote, referring to Tzara and Dada in general: *"Hence it must be admitted that it is the work which counts, that the work alone must be judged. The author can be what he likes, mad, two-headed, notary public, fourfooted, a Bolshevik, chimney-sweep or paralytic, a fortune-teller or a paranoiac. The work is capable of stirring up our mental menagerie. . . . Dada is not a mystification; it is the entire human mystery."* (*Journal du peuple,* March 1920). While some people tried to understand what was going on, others became enraged when they heard Dada connecting itself with Hegel, Fichte, Kant or Apollinaire, and by and large, people regarded it as a symptom of Bolshevism. Indeed every time Dada confronted an epithet like *boche,* it exaggerated its subversiveness: after a remark of this sort from Rachilde, all the Dadaists wrote her insulting letters with a faked return address from Berlin.

A Dada grand ball was organized by Serner, in Geneva, in the course of which music for the xylophone with slide, stringed drums, and grand or upright piano without keys, was played. There was a duet on the loves of the ornithorhynchus and the government gazette, a ballet of three feathered sardines, a "Reverie of the Forsaken Brontosaurus," and a gay monologue by Tzara. At the same time an exhibition of works by Picabia, Ribemont-Dessaignes and Arp took place, also in

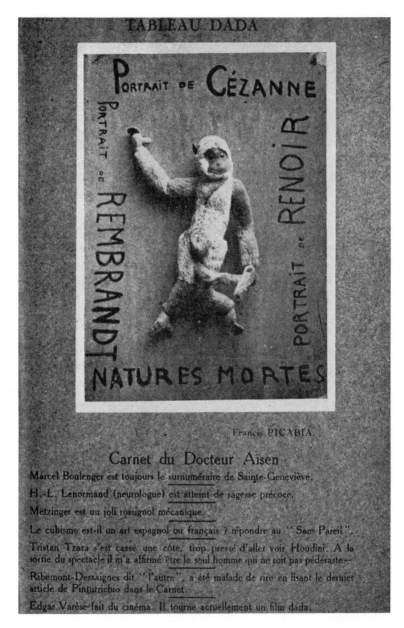

Francis Picabia. *Portrait of Cézanne.* 1920. (Courtesy Cannibale, Paris).

Geneva. In Paris Dada appeared before the Club du Faubourg, with the newspapers carrying the following announcement:

"The 291 presidents of the Dada movement have asked Messrs Breton, Aragon, Dermée, Eluard, Fraenkel, Picabia, Ribemont-Dessaignes, Soupault and Tzara to rule on the following questions: locomotion, life, Dadaist skating: pastry, architecture, Dada ethics: chemistry, tattooing, finance, and Dada typewriters: next Thursday, 8:30 p.m., at the Université Populaire du Faubourg-Saint-Antoine."

The meeting consisted in the reading of manifestoes and in discussions by Aragon and Ribemont-Dessaignes. Some time afterward appeared the first and sole number of *Z*, edited by Paul Dermée, with the usual contributors. A few epigrams by Picabia, such as, *"If you read André Gide aloud for ten minutes, your breath will stink,"* show how Dada had upset values in Paris. The last number of *Dada*, "Dadaphone," illustrated by Picabia and Schad (the latter with a photomontage showing Arp and Serner in the Royal Crocodarium in London) came out in March 1920; at the same time appeared a sensational number of *391*, containing the famous "Mona Lisa" with moustache by Duchamp, and the no less famous "Holy Virgin" by Picabia, which received newspaper comment all over the world. On March 27, at the Théâtre de l'oeuvre, one of the most significant Dada demonstrations took place. It consisted of plays ("le serin muet" by Ribemont-Dessaignes, "la première aventure céleste de M. antipyrine" by Tzara, and "s'il vous plaît" by Breton and Soupault), written in the Dada manner, pursuing every gratuitous fancy, every absurdity of thought, and all eminently demoralizing. Breton read, in complete darkness, a "manifeste cannibale," by Picabia. Some poems by Eluard ("Examples") were read. Ribemont's "Le pas de la chicorée frisée" (Dance of Curled Chicory) was played on the piano; likewise, as a joke, some melodies by Duparc. A transparent set, in front of the actors, consisted of a bicycle wheel and some signs hanging from clothes-lines. These melodies, in such a setting, completely exasperated the audience which began to whistle even at Duparc's band music, which normally they liked. Delighted with this contradiction, the actors, themselves Dadaists, began to insult the audience, welcoming catcalls with a smile; at this moment an anti-Dada paper, *Non,* edited by René Edme and André du Bief, was handed around. The program of this performance arranged, as usual by Picabia, revealed a resuscitated remark of Tzara as: "Dada Corporation for the

Max Ernst. *Exhibition catalogue.* Paris, 3 May—3 June, 1920.

176

Francis Picabia. *Exhibition catalogue.* Paris, 1920.

Improvement of Ideas." Picabia's picture, "Portrait of Cézanne," was shown at this demonstration; having searched in vain for a live monkey for the "still-life," the artist finally showed the picture, as illustrated. The Théâtre de l'Oeuvre had not witnessed such goings-on since the riot caused by the presentation of Alfred Jarry's play, "Ubu Roi."

Cannibale, Picabia's new periodical, came out on the first of April. Like the other Dada publications, *Dada, Z, Littérature,* and *391 (Dd 04 H2,* edited by Ribemont-Dessaignes, and *M'amenez-y,* by Céline Arnauld, never appeared), *Cannibale* showed a negative or humorous spirit, depending on the individual contributor. We must, however, make special mention of Picabia's picture about Cézanne, and quote the end of Soupault's "Litanies" which by their association of ideas departed to some extent from the somewhat stereotyped manner now customary with Dada:

"*Breton sees best without spectacles—Francis Picabia is not syphilitic—Fraenkel does not wear glasses—Soupault does not wear glasses—Aragon (Louis) does not wear glasses—Fraenkel does not wear glasses (ter)—Tristan (Tzara) does not need a doctor—Breton forgets his purse—and so, and so—shit.*" At the Sans Pareil gallery, Picabia exhibited his new work, introduced by Tzara: mechanical drawings and some paintings with objects of a more specifically Dadaist character. This exhibition led to another, in the following month, of Max Ernst's work, with a preface by Breton. Invitations were addressed to "little boys and girls" (*le petit et la petite*), and announced: "*at 22 o'clock the kangaroo—at 22:30 high frequency—at 23 o'clock, distribution of surprises—after 23:30, intimacies.*" The works of Max Ernst, collages or imaginary paintings, based on technical inventions that are a pictorial application of automatic techniques similar to those used by Breton and Soupault in their book, *Les Champs magnétiques,* bring to Dada painting a new and very personal vision which foreshadows surrealism. From the point of view of staging, the Max Ernst exhibition was a success. I quote d'Esparbès, a newspaper man of

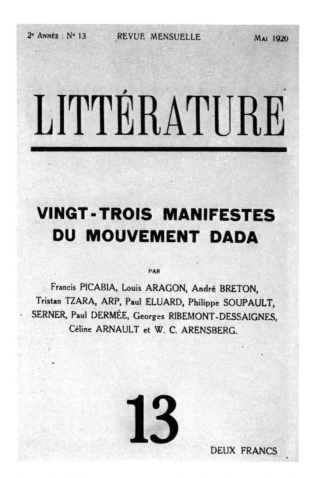

Cover. (For *Littérature* vol. 2 no. 13, ed. by Louis Aragon, André Breton, Philippe Soupault). Paris, 1920.

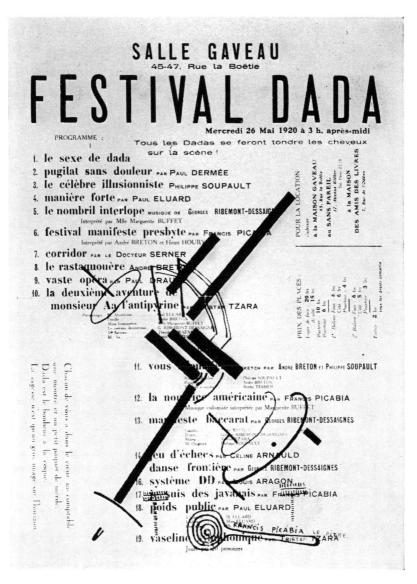

Program. (For the dada *"Festival"* at Gaveau Hall). Paris, 26 May, 1920.

the period: *"With the bad taste that characterizes them, the Dadaists have this time had recourse to horror. The scene was laid in a cellar, all the lights were extinguished in the store, groans arose through a trap door. . . . Another joker, hidden in a closet, insulted everyone present. . . . The Dadaists, without ties, but wearing white gloves, paced back and forth. . . . André Breton munched matches. G. Ribemont-Dessaignes kept shouting: 'It is raining on a skull.' Aragon miaowed. P. Soupault played hide-and-seek with Tzara, while Benjamin Péret and Charchoune shook hands every second. In the doorway, Jacques Rigaut in a loud voice counted the automobiles that drew up and the pearls of the ladies who*

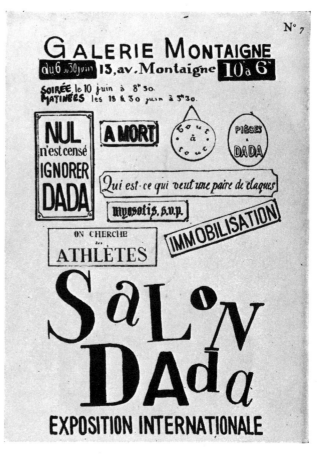

Invitation. (For the dada international exhibition, Galerie Montaigne). Paris, 6–30 June, 1922.

entered. . . ." I quote this fragment of the article as a document, because it is known that many articles, and the most disagreeable ones, were written by the Dadaists themselves under false names; Breton, for instance, signing as Decharme, and Eluard as Paul Draule. The following week brought Ribemont-Dessaignes' exhibition, "Course in Electric Alpinism and the Breeding of Microcardiac Cigarettes," with a preface by Tzara. Ribemont-Dessaignes, whose name I find for the first time in a number of *391* published in Barcelona in 1917, had written "le serin muet," produced at the demonstration at the Théâtre de l'Oeuvre, and "l'empereur de chine" (1916), both of which appeared in a volume the following year. Both these plays were quite astonishing and showed him to be a Dadaist of extreme purity. As for his drawings, they were inclined to be mechanical in quality and somewhat influenced by Picabia.

After three months of silence, the May issue of *Littérature* was devoted entirely to Dada. It published "Twenty-three Manifestoes of the Dada Movement" by Picabia, Aragon, Breton, Tzara, Arp, Eluard, Soupault, Serner, Dermée, Ribemont-Dessaignes, Céline Arnauld and Walter C. Arensberg: *"Pierre is a man. But*

dada escargot du ciel ARP

Joseph STELLA

BAARGELD Marcel DUCHAMP

Un ami de SAINT-BRICE Paul ELUARD

Man RAY venez voir GALA

J. EVOLA

Serge CHARCHOUNE

Louis ARAGON

Max ERNST du 6 au 30 Juin

SALON Philippe SOUPAULT

Tristan TZARA DADA

Jacques RIGAUT Benjamin PÉRET

Gino CANTARELLI

W. MEHRING

INVITATION A. FIOZZI

G. RIBEMONT-DESSAIGNES

de 10 h. à 6 h. Jacques VACHÉ

Th. FRAENKEL 1ʳᵉ soirée le 10 juin à 9 h.

GALERIE MONTAIGNE
13, AVENUE MONTAIGNE, 13

Last page of invitation (see opposite page).

there is no Dada truth. One need only pronounce a sentence for the contrary sentence to become DADA. I have seen Tristan Tzara without the voice to ask for a package of cigarettes in a tobacco shop. I do not know what was wrong. I can still hear Philippe Soupault insistently demanding live birds in paint shops. Perhaps, at this very moment, I am dreaming . . . DADA attacks you through your own reasoning. If we can reduce you to maintaining that it is more advantageous to believe or not to believe what all religions of beauty, love, truth and justice teach, then you are not afraid to put yourself at the mercy of DADA by accepting an encounter with us on the ground that we have chosen, which is doubt" (André Breton). The manifesto by Tzara is that "la première aventure céleste de M. antipyrine" already quoted in my first chapter, "Dada in Zurich and New York." At about this time, Breton contributed a manifesto entitled "For Dada" to the *Nouvelle Revue Française.*

On the 26th of the same month, the Salle Gaveau was rented for one of the last performances, "The Dada Festival," which seems to have surpassed all others in brilliance. A great effort was made to achieve a subversive success. We think

181

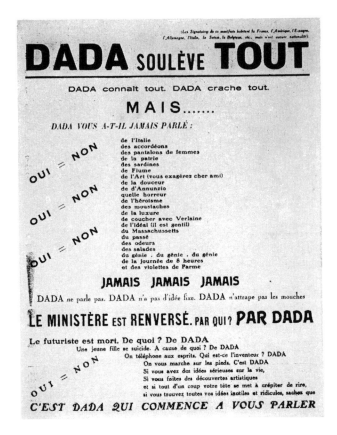

Manifesto. *"Dada soulève tout . . ."* Paris, January 12, 1921. See also p. 190.

here of the program and two photographs taken at the performance, one showing "vous m'oublierez," a sketch by Breton and Soupault, performed by Soupault, the other showing "la deuxième aventure de M. l'antipyrine," by Tzara. At the end of Tzara's play, the two grand pianos on the right and left of the stage were splattered with eggs thrown by the audience; the actors were also covered with eggs, and it is said that Ribemont, the only actor wearing a large reversed funnel as a hat, received some direct hits on the skull. Dada had given of its utmost. Before a hall jammed with people who had come to see "all the Dadaists having their hair cut on the stage," Dada had put itself in the right and the wrong; once again it had monstrously pulled the public's leg; once again, it had shown its delirious vitality.

Other names now appear in *Littérature:* Benjamin Péret (whose arrival in Paris is described in André Breton's book, *Nadja,* 1928), who from then on took part in all the demonstrations, and Clément Pansaers, a Belgian Dadaist, who that year in Brussels published *Le Pan Pan au cul du nu nègre* (Bang-bang at the Ass of the Negro Nude). In June, to close the Dada season, demonstrations as well as a permanent exhibition were organized at the Montaigne gallery; works by the painters and poets of the movement were shown. A magnificent catalogue of this demonstration was published, containing reproductions of Arp, Duchamp, Max Ernst,

Ribemont-Dessaignes, and poems by Eluard, Tzara, Péret, Arp and Aragon. Among the most striking works sent by the poets should be mentioned a mirror, "Portrait of an Unknown," and a piece of asphalt entitled "Cité du Retiro," both by Soupault. But already there were dissidents in the ranks of Dada: Breton, opposed to demonstrations of this type, emanating from an anti-artistic and anti-literary group, had refused to participate; nor does the name of Picabia appear in the catalogue, though it includes, among others, Arp, Aragon, Baargeld, Eluard, Ernst, Fraenkel, Péret, Man Ray, Ribemont-Dessaignes, Tzara, Rigaut, Soupault, Vaché, etc. Paintings by Duchamp, which had been expected, were replaced by slips of paper bearing the numbers. Duchamp had replied to a request by a cable from New York: *Peau de balle.*

A little before the various activities at the Montaigne gallery—its exhibitions of paintings and objects, and production of plays by Aragon, Eluard, Péret, Soupault and Tzara (whose *Le Coeur à Gaz* (The Gas Heart) was given for the first time)—there appeared a manifesto signed by the entire Dada group, *DADA soulève tout* (Dada Stirs up Everything). It contained the following sentences which, heartrending and blustering by turns, uphold the integrity of the Dada mind: *"Dada knows everything. Dada spits on everything. Dada says nothing. Dada has no fixed idea. Dada does not catch flies. The cabinet has been overthrown. By whom? By Dada. Futurism has died. Of what? Of Dada. Dada runs everything through a new sieve. Dada is bitterness laughing at everything that has been accomplished, sanctified, forgotten in our language, in our brain, in our habits. Dada says to you: Here is Humanity and the beautiful absurdities that have made it happy up to its present advanced age. Dada is never right. The imitators of Dada are trying to present Dada to you in a pornographic form, in a deformed and vulgar spirit which is not the pure idiocy which Dada demands but dogmatism and pretentious imbecility!"*

During this same month of January 1921 (while Paul Eluard was giving a series of Dada lectures in North Africa), the signers of *DADA soulève tout* once more attacked all art formulas by breaking up a lecture by the futurist Marinetti, on a new, now forgotten aesthetic, called "tactilism."

To the confusion natural to Dada, natural as the air it breathed, a new confusion was added, perhaps due to concern over the future. Francis Picabia, whose humor as time went on became more and more dangerous to Dada, was not free from a certain *malaise* already making itself felt and soon to be the death of Dada. Picabia wrote for a newspaper: *"The Dada spirit really existed only between 1913 and 1918, the period in which it never stopped evolving and transforming itself; after that it became as uninteresting as the output of the Ecole des Beaux-Arts, or the static elucubrations of the* Nouvelle Revue Française *and certain members of the Academy. In its desire to prolong its life, Dada has shut itself up within itself. . . ."* The article was entitled, "M. Picabia quits the Dadaists." It is true that these contradictions were always an integral part of Dada. The spirit of destruction in Dada, which had impressed such writers as Andre Gidé and Jacques Rivière, continued

to function among the ruins of the classified monuments that it had destroyed. But its weapons were not renewed, and they operated in the same domain: **art,** art in the sense most stifling for the disinterestedness at which Dada aimed, **art** realized and exhibited. Dada felt an immediate need to enter a new sphere, **to** return to life.

At Breton's instigation, the Dadaists therefore decided to give up exhibitions and plays and arrange "excursions and visits" through Paris. Invitations were sent out to meet Dada in the street. Leaflets gave the public a rendezvous for April 14 in the garden of the church of St. Julien-le-Pauvre. Other visits were planned: to the Louvre, the Buttes-Chaumont, the St. Lazare station, the Mont du Petit Cadenas and the Canal de l'Ourcq, and so on, but only the first "visit," at which Breton and Tzara spoke, actually took place. It is easy to imagine the effect of these walks, chosen at random and thus just as demoralizing as the disjointedness of Dadaist thought. But this opportunity for subversive activity came to nothing. Picabia wrote: *"Having been ill for the last six weeks, I had nothing to do with arranging this activity. All that I hope is that it will not become political, clerical or anti-clerical, because I will never take part in an activity of that kind, since I regard Dada as a personage having nothing to do with beliefs, whatever they may be."* And indeed, Dada attempted nothing further along these lines and began again to hold pictorial and poetic demonstrations like those at the Montaigne gallery, which provoked a temporary break with André Breton.

Champion of scandal for scandal's sake, Dada no longer surprised anyone. It had to find something else to arouse Dada from comfortable slumbers. Its vitality was at stake.

The *Littérature* group put on the most subversive meeting, from the moral point of view, in which Dada had ever been involved. The "Barrès trial" forced Dada to take a position on several concrete questions. On Friday, May 13, in the Hall of Learned Societies, Maurice Barrès was "indicted and tried by Dada." André Breton, president of the tribunal, had drawn up a stern and scathing indictment. Dressed in white smocks and clerical caps (red for the defense and black for the prosecution), Fraenkel and Deval were associate judges, Ribemont-Dessaignes public prosecutor, Aragon and Soupault counsel for the accused, represented by a

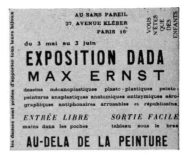

Invitation. To Max Ernst exhibition, *"Beyond painting . . ."* Paris, 3 May–3 June, 1920.

ridiculous mannequin from a novelty shop. The witnesses ran the gamut from Tzara to Ungaretti, via Rachilde (no doubt a witness for the defense) and Romov, the Russian critic. Péret, called to testify, appeared as the Unknown Soldier, dressed in a German uniform. Finally, Louis Aragon, as counsel for the defense, asked for the death of his client. In announcing the verdict, Breton declared: *"Dada, judging that the time has come to endow its negative spirit with executive powers, and determined above all to exercise these powers against those who threaten its dictatorship, is beginning, as of this date, to take appropriate measures. Believing that a given man, who, in a given period, is capable of solving certain problems, is guilty if, whether from a desire for tranquility, or from a need for outward action, or from self-kleptomania, or for moral reasons, he renounces that which is unique in him; if he agrees with those who maintain that without experience of life and awareness of responsibilities, there can be no human assertion, that without them there can be no true possession of oneself; and if he interferes with whatever revolutionary power may reside in the activity of those who might be tempted to learn from his first lesson; Dada accuses Maurice Barrès of offense against the security of the spirit."* In attacking this essentially French writer, Barrès, a respected author whose stylistic sleight-of-hand had befuddled a public already misled by nationalistic critics, in trying to unmask the dangerous clowning of this intellectual mountebank, this cowardly traitor, Dada created a new problem, by proposing a new line of action that could not be undertaken on the vacillating basis of perpetual contradiction. In the name of its revolutionary spirit, Dada rose against spiritual compromises and attempted to crystallize its rebellion on the plane of thought, rather than on a social plane, as in Berlin, which was still in the throes of revolution. The "Barrès trial," though disapproved of by Picabia and Tzara, surpassed any preceding demonstrations by Dada in Paris, and foreshadowed future activities induced by the threat of an unsolved problem. The tone of the verdict is somewhat different from that of the usual Dada writing. Only certain parts of the testimony gave to the trial a Dadaist, anarchist, contradictory and humorous tinge. One has only to read the issue of *Littérature* devoted to the "Barrès trial" to confirm this. Practically speaking, the result of the new extravaganza was general dismay, expressed, as far as the critics were concerned, in a threat never again to mention Dada in their columns. Once again Dada had been unable to reply categorically: the role of judge did not suit it at all.

In 1921, Dada's activities were confined to various publications. In April, Marcel Duchamp in New York brought out *New York dada* in English, with Duchamp's famous object-collage, "Belle Haleine, Eau de Violette," on the cover. Eccentric in appearance, the single number carried, among other illustrations, a faked photograph by Man Ray and the portrait of a Dadaist whimsy, a woman whose whole life was Dada, the delirious spectre of Dada mingling with the crowd in one of its monstrous transformations. Baroness Elsa von Loringhoven, who made objects in the manner of Schwitters, became famous in New York for her transposition of Dada into her daily life. Dressed in rags picked up here and there,

decked out with impossible objects suspended from chains, swishing long trains, like an empress from another planet, her head ornamented with sardine tins, indifferent to the legitimate curiosity of passers-by, the baroness promenaded down the avenues like a wild apparition, liberated from all constraint. Man Ray was at this time inventing his "rayographs," photos obtained by the direct application of objects to a sensitive plate; and, as a distraction from his precious painting, he was making his first attempts at movies based on poetic images. Marcel Duchamp pursued his rare work, the relaxation of a brilliant dandy whose sole pleasure lay in carrying creations to the extreme limits of poetry and humor, united in the form of mechanisms subtle, implacable and above reality. In his apartment, the floor was strewn with clothes-pegs like a forest of wolf traps, on the walls glass spirals revolved beside a shovel inscribed with the words: "Ahead of the broken arm." Duchamp wisely filled a bird-cage with bits of marble carved to resemble lump sugar: "Deceive the mind, deceive the muscle." He made motion pictures of his spirals and entitled them "Anaemic cinema," adding these phrases, which with extreme insolence borrowed their dangerous force from the principles of double-talk: *Un mot de reine, des maux de reins* (A queen's words, backaches), *Rrose Selavy et moi nous esquivons les ecchymoses des Esquimaux aux mots exquis* (Rrose Selavy and I dodge the ecchymoses of the eloquent Eskimos), *Il faut mettre la moelle de l'epée dans le poil de l'aimée* (Put the marroy of the sword into the hairy place of the beloved) . . . Duchamp contributed to *391*, to *Littérature,* and later, in 1924, to *The Wonderful Book, reflections on Rrose Selavy,* a book without text by Pierre de Massot. In this same period, *Le Pilhaou-Thibaou,* illustrated supplement of *391,* by Francis Picabia, appeared in Paris. In this number, preeminently confusionist, the decadence of Dada reaches us through a film of personal dissensions and squabbles. Any attempt to maintain Dada within Dada hastens its end; to take it out of itself brings the same result. *Le Pilhaou-Thibaou,* appearing at a moment when Dada might have profited from numerous past experiences, produced utter muddle, flirted with Cocteau, and invited highly suspicious contributors. "The Dadaists are ripe for Paul Poiret [the dressmaker]" declared Picabia who had quarreled with Tzara and therefore welcomed Serner, who had become Tzara's enemy. Intrigues were spun against Dada. Its origins were under discussion. Another bad sign. . . . The whereabouts of Dada were being investigated, and apparently the key to the enigma had been lost. Exploiting to the end the contradictory weapons of Dada, Picabia, in particular, was pleased to shut it up in a labyrinth of mirrors. His mind, which had found in the freedom of Dada its most sparkling flame and had made him, as a poet and an artist, perhaps the most sensational representative of the Dada spirit, assassinated Dada with the same assurance Picabia had shown in exalting its destructive existence. The last publication for the year 1921 was *Dada Tyrol-Dada en plein air* which appeared in September, apparently an appeasement-and-optimism issue, a vacation issue. Both in contents and presentation, which were purely poetical, we find again the aspect of Dada's happy days, the mingled influences of the publications in two languages brought out by Arp and Tzara in Zurich, by Max Ernst and

Baargeld in collaboration with Eluard, Ribemont-Dessaignes and Soupault in Cologne. *Dada Tyrol* may be considered the final number of *Dada*. Poetry and typography run riot in this last free and spontaneous expression of Dada on the brink of the abyss, Dada on the point of becoming legend. Dada needed a birth certificate. In order to reassure Tzara, who was worried by the rumors about his part in Dada's beginnings, Arp declared that it was indeed Tristan Tzara who . . . etc. And Huelsenbeck claimed the paternity of Dada.

The *enfant terrible* hidden in Dada had raised so many tragic and knotty questions that someone was bound to turn up who would be determined to furnish, by no matter what means, a solution to the problems that the nihilistic, confusionistic Dada raised only to abandon them forthwith. Dada had upset the rules of art and brought liberation to those desirous of escaping at last from the intellectual prison of bourgeoisism. Dada had behaved with great enthusiasm and straightforwardness. But where was it headed for? The obscure forces which, suddenly liberated, expanded with the exuberance of a full heart—whither were they leading? Undergoing a moral crisis indicated by certain incidents at this time (such as the affair of the pocketbook, which brought up the question of theft, authorized or not, depending on the situation), and on the other hand, feeling itself hemmed in by its own contradictions and by its multiple injunctions against modern art, which only too often had been nullified, Dada owed to itself to be its own judge. Did it not find life embarrassing? Was Dada, which wished to destroy all aestheticism, not accused of, for example, complaisance toward abstract art? Did not the Dada group gather together too many incongruous tendencies that tore it apart? Dada was staggering beneath the number and the quality of its representatives. It was no longer in keeping with the present. Its heedlessness had culminated in vain bravado and corruption. It was about to come up for trial. An incident hastened the course of events and set the spark to the powder.

A committee embracing names as disparate as Léger, Ozenfant, Delaunay, Breton, Auric, Paulhan and Vitrac, set out to prepare an "International Congress to establish directives for the modern spirit and defend it"—the Congress of Paris. It is easy to conceive that an undertaking of this sort would appear reactionary[1] to Dada and to foresee how each individual Dadaist would interpret it. For Dada the adjective "modern" was pejorative. Dada had always fought against the modern spirit. And, as a matter of principle, what confidence could be placed in the members of this committee, so disparate and for the most part so unfriendly to Dada? As for Breton, of course, his intention was clear. Amid the mounting tide of obscurity, he wished to create light. He wished to investigate the manoeuvres of Dada. Dada was at the end of its evolution. It had foundered like a ship in distress. A reorientation was necessary. Breton was preoccupied with too many things

[1] Note added by the author in 1935. This judgment has been historically contradicted by the realization of what this congress has already accomplished; the collective protest of the surrealists and divers intellectual groups against the war in Morocco (1925); founding of an association of revolutionary artists and writers (A.E.A.R., 1930); fusion with A.E.A.R. (1932) participation in the international congress of writers for the defense of culture (1935), etc.

despised by Dada; it was inevitable that he should try to clear away the vapors in order to see himself more clearly. Every endeavor to obtain a response from Dada, other than in the domain of poetic liberation, had failed. Dada sniffed the trap. It foresaw the weariness that its unchanging behavior, its stereotyped gestures, would inevitably induce in those who regarded Dada as a means to end all that. Its lack of rigor revealed its power of derision and its profound scepticism.

Tzara, when invited to join the committee, refused categorically: *"I am very sorry to have to inform you,"* he wrote to Breton, *"that the objections I expressed to the very idea of the congress are unchanged by my membership in it, and that to my regret I must refuse your offer. Please believe me,* cher ami, *that this is no act of a personal nature, either against you or the other members of the committee, and that I appreciate your desire to satisfy every tendency as well as the honor you have shown me. . . . But I consider that the present apathy resulting from the jumble of tendencies, the confusion of styles, and the substitution of groups for personalities . . . is more dangerous than reaction. . . . I therefore prefer to do nothing rather than to encourage an action that in my opinion is injurious to the search for the new, which I prize so highly, even if it takes the form of indifference."* Indifference, said Tzara; complacency, Breton must have thought. In reality, Dada, unconsciously no doubt, was retreating. It refused to take the lead. After this sabotaging of the congress, an unfortunate remark which Breton made about Tzara embittered their relations for good. This put Dada in the right, and on this occasion it was supported by writers and artists of all tendencies. At that time Breton's intentions were bound to remain incomprehensible. This desire for orientation, this fear of losing the freedom that had been gained, this desire to continue an activity beyond the powers of Dada, which had given everything it had to give, invited criticism from all sides. The "Congress of Paris" did not take place and Breton withdrew definitely from Dada as though impatient to be rid of it—soon revealing for what he had renounced its dictatorship—not like Picabia, whose departures were never final and who was always to remain a pure Dadaist.

Letters in the advertising columns of newspapers, personal disputes over who had invented Dada and who hadn't; flank attacks; continuous squabbles, introduced the period of confusion in which Dada lay dying, and which came to an end only with the revised *Littérature* group. At this point Picabia put out a paper, *Pomme de Pins* (Pine Cone), full of obscure intentions and violent abuse of Ribemont-Dessaignes and Tzara. *"The Congress of Paris"* writes Picabia, *"is fucked because Picabia belongs to it."* Elsewhere we read: *"Cubism is a cathedral of shit."* Farther on, *"Picasso is the only painter I love."* This is typically Picabia, whose desperate optimism seems to take delight in rending Dada to pieces. *Le coeur à barbe* (The Bearded Heart) is a pamphlet attacking the Congress of Paris and Breton.

In the second and following issues of the new series of *Littérature* Breton replies to the attacks of *Lâchez Tout;* and in the name of another undertaking he condemns Dada. *"We are subject to a sort of mental mimicry that forbids us to go deeply into anything and makes us consider with hostility what has been dearest to us. To give one's life for an idea, whether it be Dada or the one I am developing*

DANS LES CARTES

Aux bras levés parrallèles — pique
une tête hirsute est promise
Passion de Charles magnanime en voyage
Barque sabordée par Hogier

 jeune homme méchant

le filin casse — les castagnettes
Argine le soupir bleuet de caste agnelle
Jeune homme bon Lancelot t'est fidèle
Neuf — prison lente — les fers — sincérié
Concorde accord s'il est en sceau aux quatre plis
Désigne le jour ô huit de cœur
sept larmes de sang font midi

 Paul Dermée

DERNIÈRE HEURE

Dublin. — Tous les dadaïstes sont sinn-feiners

 London. — Tous les policemen sont dadaïstes — les voleurs aussi ! All's well ! Bonjour à Roger All Art (signé Baroness Orczi)

 Hyde Park. —

 Dadas couchent sur tous les bancs
 Dadas séduisent les pucelles
 Dadas sont fiers comme Artabans
 Dadas se moquent de Vauxcelles

 Rome. — Que faites-vous donc à Paris Venons de recevoir la *Guitoune Engourdie.* Sommes tous malades. Ipéca. Et la Section d'Art ou l'Action dort ? Vite, nouvelles. Aéroplane est prêt pour vous porter secours. Pilote : Prampolini !

 New-York. — Les jeunes gens des Universités de Minnesota, Connectitut et Massachusets réunis à l'occasion du Grand Match de foot-ball printanier envoient leur hommage enthousiaste et respectueux au Socrate du Dadaïsme : Jacques-Emile Blanche !

 T. S. F.

Brevet N° 406,225 — *Machine à décrotter les cervelles*
 SYSTÈME DADA

Le Gérant : *Paul Dermée*
 Imprimerie Littéraire 4, Rue Tardieu. Paris

Mars 1920

DIRECTEUR :
PAUL DERMÉE

Z_1

Abonnements : Le Numéro :
10 numéros : 5 fr. 1 fr.

Dépositaire *Au Sans Pareil* 37, Avenue Kléber, Paris

Qu'est-ce que Dada !

Tout est dada.

Chacun a ses dadas.

Vous vénérez vos dadas dont vous avez fait des dieux.

Les dadaïstes connaissent leurs dadas et s'en moquent. C'est la grande supériorité qu'ils ont sur vous.

Dada n'est pas une école littéraire ni une doctrine esthétique.

Dada est une attitude foncièrement areligieuse, analogue à celle du savant l'œil collé au microscope.

Dada est irrité de ceux qui écrivent "l'Art" " la Beauté ", " la Vérité " avec des majuscules et qui en font des entités supérieures à l'homme. Dada bafoue atrocement les majusculaires.

Dada ruinant l'autorité des contraintes tend à libérer le jeu naturel de nos activités. Dada mène donc à l'amoralisme et au lyrisme le plus spontané, par conséquent le moins logique. Ce lyrisme s'exprime de mille façons dans la vie.

Dada nous décape de l'épaisse couche de crasse qui s'est déposée sur nous depuis quelques siècles.

Dada détruit et se borne à cela.

Que Dada nous aide à faire la table rase, puis chacun de nous reconstruire une maison moderne avec chauffage central et tout à l'égout, dadas de 1920.

 PAUL DERMÉE
 DADAÏSTE CARTÉSIEN

Back and front pages of Z1, edited by Paul Dermée. Paris, March, 1920.

le cubisme construit une cathédrale en pâté de foie artistique
Que fait DADA ?

l'expressionnisme empoisonne les sardines artistiques
Que fait DADA ?

le simultanéisme en est encore à sa première communion artistique
Que fait DADA ?

le futurisme veut monter dans un lyrisme + ascenseur artistique
Que fait DADA ?

l'unanimisme embrasse le toutisme et pêche à la ligne artistique
Que fait DADA ?

le néo-classicisme découvre les bienfaits de l'art artistique
Que fait DADA ?

le paroxysme fait le trust de tous les fromages artistiques
Que fait DADA ?

l'ultraïsme recommande le mélange de ces 7 choses artistiques
Que fait DADA ?

le créacionisme le vorticisme l'imagisme proposent aussi quelques recettes artistiques
Que fait DADA ?

Que fait DADA ?

50 francs de récompense à celui qui trouve le moyen de nous expliquer

DADA

Dada passe tout par un nouveau filet.

Dada est l'amertume qui ouvre son rire sur tout ce qui a été fait consacré oublié dans notre langage dans notre cerveau dans nos habitudes. Il vous dit : Voilà l'Humanité et les belles sottises qui l'ont rendue heureuse jusqu'à cet âge avancé

☛ *DADA EXISTE DEPUIS TOUJOURS*

☛ *LA SAINTE VIERGE DÉJÀ FUT DADAÏSTE*

DADA N'A JAMAIS RAISON

Citoyens, camarades, mesdames, messieurs.

Méfiez-vous des contrefaçons !

Les imitateurs de DADA veulent vous présenter DADA sous une forme artistique qu'il n'a jamais eue

CITOYENS.

On vous présente aujourd'hui sous une forme pornographique, un esprit vulgaire et baroque qui n'est pas l'IDIOTIE PURE réclamée par DADA

MAIS LE DOGMATISME ET L'IMBÉCILITÉ PRÉTENTIEUSE !

Paris 12 Janvier 1921.

Pour toute information

S'adresser " AU SANS PAREIL "

37, Avenue Kléber. Tél. PASSY 25-22

E. Varèse, Tr. Tzara, Ph. Soupault, Soubeyran, J. Rigaut, G. Ribemont-Dessaignes, M. Ray, F. Picabia, B. Péret, C. Pansaers, R. Huelsenbeck, J. Evola, M. Ernst, P. Eluard, Suz. Duchamp, M. Duchamp, Crotti, G. Cantarelli, Marg. Buffet, Gab. Buffet, A. Breton, Baargeld, Arp, W. C. Arensberg, L. Aragon.

Manifesto. Reverse of *"Dada soulève tout . . ."* Paris, January 12, 1921. See also p. 182.

at present, would only tend to prove a great intellectual poverty." A few months later, Breton added, *Dadaism cannot be said to have served any other purpose than to keep us in the perfect state of availability in which we are at present, and from which we shall now in all lucidity depart toward that which calls us."* André Breton, who historically occupied the foremost place in the picture after this crisis from which Dada was not to recover, proceeded systematically to discredit everything that might have been alluring in what Dada still represented as freedom. After the suicide of Vaché, whose immense detachment had filled Breton with wonder, Breton had transferred all his hopes for Dada to Tzara. It is true that Breton's preoccupations did not exactly spring from Dada, but for him Dada was the terminal from which all trains left for all destinations. I have already explained how a book such as *Les Champs magnétiques,* devoted entirely to automatism considered as a means of exploring the unconscious, differed from Dada works. In March 1922, Breton satisfied his desire to meet Freud, in whose theories he had always been deeply interested, while Dada had expressly ignored them. According to Breton, every product of the mind strove toward a conclusion. Dada never concluded. In diverse articles such as "Pour Dada" appearing in 1920 in the *Nouvelle Revue Française,* Breton had attempted to assimilate to Dada his personal

ideas about poetry, based on the word "surrealism" used by Apollinaire and derived from the German Romantics and Gérard de Nerval, and on the role and destiny of this poetry which to him was closely related to psychoanalysis. Freed from the influence of Dada, Breton, in the new series of *Littérature*, engaged in experiments which were to give rise to surrealism as a movement.

A short time after the "Congress of Paris," the artists who had drawn away from Breton returned to *Littérature* to which they had been the first contributors. *Littérature* continued to seek among those who in the recent past had given poetry its new orientation for the baffling vein of gold that Dada continued to lay bare. While the attacks redoubled against Tzara, Dada's only remaining representative, whom Huelsenbeck went so far as to attack in Dada terms, *Littérature* published questionnaires which seem to be a crude form of the future surrealist inquiries and games. "L'entrée des mediums" by Breton, which serves as a preface to an account of hypnotic seances, marked a new phase of automatism considered as the sole means of achieving knowledge.

New names appeared: René Crevel, Robert Desnos, Jacques Baron. . . . Francis Picabia, who had remained on good terms with *Littérature*, contributed and, beginning with No. 4, designed the cover which in the preceding three numbers had carried a top hat by Man Ray whose album of photographs, *Champs delicieux*, came out at this time (1922). In a brilliant foreword, Tzara attacked painting and, indirectly, Picabia. It is evident that Picabia, highly esteemed by Breton, who wrote a preface for an exhibition of his work at Barcelona in November 1922, did not share his enthusiasm for surrealism, which was beginning to be mentioned more and more frequently, taking on definite shape with the result, less than two years later, of the "First Surrealist Manifesto." Early in 1924, several issues of *391* appeared, in which Picabia, the anti-Dada Dadaist, attacked surrealism and Rimbaud, and attempted to cut the ground from under Breton. In the "Mercure" con-

Program for the Dada Demonstration, Paris, March 27, 1920.

191

troversy the surrealists sided with Picasso, whose work was becoming more and more mature, and Picabia replied with "Relâche" in collaboration with Erik Satie, who had written the music (disdained by Picasso's admirers) for "Mercure." We can understand the emotion of the future surrealist group in beholding Picasso's admirable sets. But in justice to Picabia it must be said that "Relâche," when performed, showed magnificent freedom. The performance included "Entracte," one of the finest films I know, hardly surpassed by those which Dali and Man Ray were to make later on.

Tzara had quarreled with Breton, Aragon and Picabia, but had remained on good terms with many of the *Littérature* group. In July 1923, a "Soirée of the bearded heart" was arranged at the Théâtre Michel. Music by Satie, Auric, Stravinsky, Milhaud was to be played. Two films by Hans Richter and Man Ray were to be shown. The chief attraction was the performance of Tzara's "Coeur à gaz" performed by Jacques Baron, René Crevel, Pierre de Massot. . . . A text by Ribemont-Dessaignes was to be read, and there was to be a recitation of poems by Iliazde, whose real name was Zdanevitch. In Russia, Zdanevitch, in collaboration with Khlebnikov, had invented the "Zaoume" language, an extra-rational tongue

Moi, Pierre de Massot, jeune homme idiot, provincial, sentimental, arriviste, opportuniste et sans avenir, j'affirme que vous seuls, charmants artistes, êtes encore persuadés que FRANCIS PICABIA SE FOUT DU MONDE. Le public, beaucoup plus intelligent, a déjà évolué ; les créations perpétuelles de cet artiste le retiennent alors que vos cochonneries lui donnent envie de vomir sur les pieds trop sympathiques de Monsieur Frantz-Jourdain.

J'attends avec impatience les habituelles et stupides critiques de : Waldemar Georges, Louis Vauxcelles, Roger Allard, Jacques-Emile Blanche, attachés à des journaux imbéciles comme la merde au cul d'un chien.

1° L'AMOUR ESPAGNOL est un piège à revolver !

2° LA FEUILLE DE VIGNE cache vos selles !

Ayant un revolver à deux coups, je ne me cache pas derrière ma Légion d'Honneur.

Pierre DE MASSOT

(Littérateur de Littérature.)

Manifesto. "*I, Pierre de Massot, young man, idiot, provincial, sentimental, arriviste, opportunist, and without future . . .*" Paris, 1920.

Cover. (For *Littérature* new series, no. 7., edited by André Breton). Design by Francis Picabia. Paris, 1922.

not unrelated to the Dadaist poem. Paul Eluard refused to appear on this program because along with poems by Soupault, Tzara and himself, some of Cocteau's verses were to be recited. The performance was characterized by indescribable disorder. Aragon, Breton and Péret demonstrated against Tzara and climbed on the stage. Massot's arm was struck by a cane and broken. Péret's clothes were torn to shreds, and both he and Breton were thrown out. Calm had barely been restored when Eluard mounted the stage and assaulted the actors who were weighed down by their cardboard costumes done by Sonia Delaunay. At length, Eluard was overwhelmed by their numbers and fell violently against the footlights, a few of which were shattered. Some of the audience sprang to Eluard's defense, while others called for the police to restore order. At all events, Eluard received the next day an official-looking paper ordering him to pay 8,000 francs damages for offense against public morals. That is what Dada had come to.

"What is 'beautiful?' What is 'ugly?' What are 'big,' 'strong,' 'weak?' What are Carpentier, Renan, Foch? Don't know. What is myself? Don't know, don't know, don't know." So wrote Ribemont-Dessaignes. Dada had extolled incoherence and the absence of choice. It had claimed the right to complete idiocy. Exalting contradiction and successive negations, it should have been perpetual movement. It bore within it health as well as death. But it was doomed to bankruptcy and death. It

193

COW-BOY

à Jacques Lipschitz

Sur le Far West
 où il y a une seule lune
Le Cok Boy chante
 à rompre la nuit
Et son cigare est une étoile
 filante
SON POULAIN FERRÉ D'AILES
 N'A JAMAIS EU DE PANNE
Et lui
 la tête contre les genoux
 danse un Cake Walk
 New York
 à quelques kilomtères

Dans les gratte-ciels
Les ascenseurs montent comme des thermomètres
Et près du Niagara
 qui a éteint ma pipe
Je regarde les étoiles éclaboussées

Le Cow Boy
 sur une corde à violon
Traverse l'Ohio

Vincente HUIDOBRO

M. JANCO

DADA 1
Sommaire : H Arp — Broderie, bois 1 et 2. Tzara — Note sur l'art,
Poèmes nègres, Vers. O Lüthi. Madonna, I Meriano Walk.
N Moscardelli. Piante. M Janco — Relief, Construction, Bois.
A Savinio — Un vomissement musical. Notes Laban, La poésie
simultanée, H Guilbeaux, etc. Édition ordinaire épuisée
Édition de luxe, numérotée et contenant un bois de Janco . 8 Frs

DADA 2
Sommaire : O van Rees — Intérieur. Tzara — Note sur l'art, 2 poèmes
nègres, Vers. M d'Arezzo Strade. R. Delaunay — La fenêtre sur la
ville. P. A Birot — Rasoir mécanique, Pour Dada. F Prampolini — Bois
G Cantarelli — Costellazione. W Kandinsky — Aquarelle. S de Vaulchier
— Sentiments dans les palaces. W. Helbig — Peinture. M Janco Relief.
B San Miniatelli — Congime. G. de Chirico Le mauvais génie d'un roi.
Notes : Apollinaire, Pierre Reverdy, P. A Birot, Expositions, livres, revues etc.
Prix 2 Fr.

Édition de luxe, numérotée, et contenant un bois de Arp 8 Fr

DADA 3
(Décembre 1918) Prix Fr 1.50
*Édition de luxe tirée à part numérotée de 1 à 30, cartonnée, et contenant
2 gravures originales par M Janco et un bois gravé par H Arp . Fr 30*

RÉDACTION :
Tr. Tzara
Zurich, Seehof, Schifflande 23

ADMINISTRATION
Mouvement Dada
Zurich, Zelt

Imprimerie Jul. Heuberger, Zurich

Vincente Huidobro. *Cowboy*. (In Dada no. 3, edited by Tzara). Woodcuts by Arp and Janco. Zurich, 1918.

Le goût est fatiguant
comme a bonne compagnie

SALIVE AMÉRICAINE

L'estomac domino mécanique
des bedaines brouillard
bavarde au pas de course poussière
et subit la sécheresse du sherry en ballon.
Un radis fantastique se cabre
en tesson de bouteille
auprès de la truite téléphone.
Sur un carnet de poche Zanzibar
le nu vient sans moyens de transport.
Cela me rappelle les nœuds de cravates
seuls en wagon.
L'escalier tousse avec le bec de gaz
mes frères !

FRANCIS PICABIA

Bois de E. PRAMPOLINI

LA JOIE DES SEPT COULEURS
(Fragment)

PIERRE ALBERT-BIROT

„SIC"
(Sons idées couleurs)
Revue d'art et de littérature
Directeur : P. A. Birot
Paris, 37 rue de la Tombe-Issoire

Dada, No. 3, edited by Tristan Tzara. Zurich, 1918, Page with graphic work by Prampolini and Picabia.

was purity. *"Let us try, though it is difficult, to remain absolutely pure. Then we shall perceive everything that binds us."* Eluard had found this purity, but not in Dada which could hold on to nothing. Its development was sterility. It had opened the road that led to purity, just as it had opened the road to action, and all other roads.

What remains of Dada? Above all its works. Admirable books, sources of true poetry, magnificent enthusiasms between the covers of books like any other books; yet books of the rare category that one wants to own. I am thinking of a varied selection of titles published under the aegis of Dada, for example: *La première aventure céleste de M. Antipyrine* (1916), *Vingt-cinq poèmes* (1918),

Cinéma calendrier du coeur abstrait (1920), by Tzara; *Cinquante-deux miroirs* (1918), *Râteliers Platoniques* (1918), *La Pompe à nuages* (1920), *La toilette de la Pyramide* (1924), by Arp; *L'Empéreur de Chine* (1921), by Ribemont-Dessaignes; *Le Passager du Transatlantique* (1921), by Péret; *Les Champs magnétiques* (1922), by Breton and Soupault; *Les nécessités de la vie ou les conséquences des rêves* (1921), *Répétions* (1922) by Eluard; *Les Malheurs des immortels* (1922), by Eluard and Ernst.

What remains of Dada? The paintings of Duchamp and Picabia, whose role in Dada's beginnings cannot be sufficiently emphasized. The paintings of Arp, Max Ernst and Man Ray, which are poetry itself and which revolutionized painting from the twofold standpoint of spirit and technique. What remains of Dada? Failures who will never belong to the Academy, who will never dance in the Folies Bergère like Soupault whom Dada with its *je-m'en-foutisme* brought to the worst state of indifference; men who rose to the very summits of Dada, like Picabia, who, though he has since received the Legion of Honor, wrote in 1920: *"The sign of dada, which is as pleasant to wear as the Legion of Honor, does not cost 50,000 francs."* And again in 1932: *"The artists of our time are dishonoured by the Legion of Honor; what a bore it is, and how vulgar!"* Dada, the opposite of predilection, Dada, the mainstay of the "original deadlock" (*ballotage*[1] *original*) as Breton called it. Dada upset and demolished everything to make possible a new start in any direction. Almost Hegelian without knowing it, it did away with everything, making affirmation equivalent to negation. It aided in the rise of forces which, since the end of the last century, had been striving to burst out of the traditional channels of artistic expression. It made itself subversive. At times it achieved a political position. By its negative efforts it enabled surrealism to affirm itself and to gain time.

What is left of Dada? Marvelous poets, brilliant minds such as Picabia and Tzara who wrote manifestoes and edited *391* and *Dada;* the deadly anti-literary dandyism of Jacques Rigaut, concerning whom I confess that I should have said more; and above all the remarkable personality of Marcel Duchamp, whose spirit, whose moral austerity and haughty detachment, whose experiments and profound thought surpassed the limits of Dada.

What remains of Dada? Everything and nothing, just as it was, an adventure in implacable necessity, an adventure without its equal.

1 The electoral deadlock, so common in France, in which no candidate obtains a clear majority on the first ballot. (Tr)

IX. *Three Dada Manifestoes*

By André Breton. Before 1924. Translated complete from
the French by Ralph Manheim. First published in book form
in Breton's *Les Pas Perdus*, Paris, Librairie Gallimard,
1924. By permission of the author and of Librairie Gallimard.

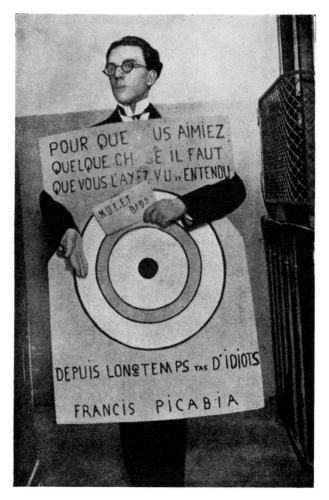

André Breton carrying placard by Picabia at "Dada Festival" in Gaveau Hall, Paris, 1920. Courtesy Cahiers d'Art, Paris.

André Breton: *For Dada, etc.*

1. For Dada

It is impossible for me to conceive of a joy of the spirit otherwise than as a breath of air. How can it be at its ease within the limits imposed on it by almost all books, almost all events? I doubt if there is a single man who has not been tempted, at least once in his life, to deny the existence of the outward world. Then he perceives that nothing is so important, so definitive. He proceeds to a revision of moral values, which does not prevent him from returning afterward to the common law. Those who have paid with a permanent unrest for this marvelous minute of lucidity continue to be called poets: Lautréamont, Rimbaud, but to tell the truth, literary childishness ended with them.

When will the arbitrary be granted the place it deserves in the formation of works and ideas? What touches us is generally less intentional than we believe. A happy formula, a sensational discovery make their appearance in the most miserable form. Almost nothing attains its goal, although here and there something over-shoots it. And the history of these gropings, psychological literature, is not in the least instructive. In spite of its pretensions, a novel has never proved anything. The most famous examples are not even worth looking at. The utmost indifference is in order. Incapable of embracing at one time the whole extent of a painting, or of a misfortune, where do we derive the right to judge?

If youth attacks conventions, we should not ridicule it: who knows whether reflection is a good counselor? Everywhere I hear innocence praised and I observe that it is tolerated only in its passive form. This contradiction would suffice to make me skeptical. To condemn the subversive is to condemn everything that is not absolutely resigned. In this I find no valor. Revolts exhaust themselves; these old liturgical sayings are not needed to dispel the storm.

Such considerations strike me as superfluous. I speak for the pleasure of compromising myself. Appeals to the questionable modes of discourse should be forbidden. The most convinced authoritarian is not the one you think. I still hesitate to speak of what I know best.

Dimanche[1]
L'avion tisse les fils télégraphiques
et la source chante la même chanson
Au rendez-vous des cochers l'apéritif est orangé
mais les mécaniciens des locomotives ont les yeux blancs
La dame a perdu son sourire dans les bois

Sunday
The airplane weaves telegraph wires
and the well sings the same song
At the coachmen's bar the apéritif is tinged with orange
but the engine drivers have white eyes
The lady has lost her smile in the woods

The sentimentality of the poets of today is a subject on which we should come to an agreement. From the concert of imprecations so pleasurable to them rises from time to time to their delight a voice proclaiming that they have no heart. A young man who at twenty-three had swept the universe with the most beautiful look I know of, has rather mysteriously taken leave of us. It is easy for the critics to claim that he was bored: Jacques Vaché was not the man to leave a testament! I can still see him smile as he uttered these words: last will. We are not pessimists. The man who was painted stretched out in a deck chair, so very *fin de siècle* lest he disturb the collections of the psychologists, was the least weary, the most subtle of us all. Sometimes I see him; in the streetcar a passenger points out to provincial relatives "boulevard Saint-Michel: the school quarter"; the windowpane winks complicity.

We are reproached for not constantly confessing. Jacques Vaché's good fortune is to have produced nothing. He always kicked aside the work of art, that ball and chain that hold back the soul after death. At the very moment when Tristan Tzara was sending out a decisive proclamation from Zurich, Jacques Vaché without knowing it, verified its principal articles. "Philosophy is the question: from what side shall we begin to regard life, God, the idea, or other appearances. Everything we look at is false. I don't think the relative result is any more important than the choice between cake and cherries after dinner." Given a spiritual phenomenon, we are in a hurry to see it reproduced in the domain of manners. "Give us gestures," people shout at us. But, as André Gide will agree, "measured by the scale of Eternity, all action is vain,"[2] and we regard the effort required as a puerile sacrifice. I do not place myself only in time. The red waistcoat of an epoch instead of its profound thought, there unfortunately is what everyone understands.

The obscurity of our utterances is constant. The riddle of meaning should remain in the hands of children. To read a book in order to know denotes a certain simplicity. The little that the most reputed works teach us about their author and their reader ought very quickly to decide us against this experiment. It is the thesis and not the expression that disappoints us. I resent passing through these ill-lighted sentences, receiving these confidences without object, suffering at every moment, through the fault of a chatterbox, a sensation of "I knew that before." The poets who have recognized this lose hope and run away from the intelligible, they know

[1] Philippe Soupault.

[2] Tristan Tzara.

that their work can gain nothing by it. One can love a mad woman more than any other.

> The dawn fallen like a showerbath. The corners of the room are distant and solid. White background. Round trip without mixture in the shade. Outside an alley with dirty children and empty sacks that tells the whole story, Paris by Paris, I discover. Money, the road, the journey with red eyes and luminous forehead. The day exists that I may learn to live, time. Forms of error. Big to act will become naked sick honey, badly game already syrup, drowned head, lassitude.
> Thought of little happiness, old flower of mourning, without scent, I hold you in my two hands. My head has the shape of a thought.[1]

It is a mistake to assimilate Dada to a subjectivism. None of those who accept this label today is aiming at hermeticism. "There is nothing incomprehensible," said Lautréamont. If I accept the opinion of Paul Valéry: "The human spirit seems to me so constituted that it can be incoherent only for itself," I further believe that it cannot be incoherent for others. I do not for this reason believe in the extraordinary encounter of two individuals, nor of one individual with the one he has ceased to be, but only in a series of acceptable misunderstandings in addition to a small number of commonplaces.

There has been talk of a systematic exploration of the unconscious. It is no novelty for poets to abandon themselves to the inclination of their spirit. The word inspiration, fallen I don't know why into disuse, was quite acceptable a short time ago. Almost all images, for example, strike me as spontaneous creations. Guillaume Apollinaire rightly believed that clichés such as "coral lips" whose success may pass for a criterion of value, were the product of this activity which he qualified as *surrealist*. Words themselves have doubtless no other origin. He went so far as to make this principle, that one must never abandon a former invention, the prerequisite for scientific development, for "progress," so to speak. The idea of the human leg, lost in the wheel, reappeared only by chance in the connecting rod of the locomotive. Likewise in poetry, the Biblical tone is beginning to reappear. I should be tempted to explain this last phenomenon by the minimum intervention or nonintervention of the personality of choice in the new writing techniques.

What threatens to injure Dada most effectively in the general estimation is the interpretation of it by two or three pseudo-scientists. Up until now, it has been regarded most of all as the application of a system that is enjoying a great vogue in psychiatry, the "psycho-analysis" of Freud, an application planned incidentally by the present author. One very confused and particularly malignant writer even seems to allege that we would profit by the psychoanalytic treatment if we could be subjected to it. It goes without saying that the analogy between cubist or dadaist works and the elucubrations of madmen is entirely superficial, but it is not yet recognized that our supposed "lack of logic" dispenses us with accepting a unique choice, that "clear" language has the disadvantage of being elliptical, finally that only the works in question can reveal the methods of their authors and consequently give criticism the raison d'être it has always lacked.

1 Paul Eluard.

Au lycée des pensées infinies
Du monde le plus beau
Architectures hyménoptères
J'écrirais des livres d'une tendresse folle
Si tu étais encore
Dans ce roman composé
En haut des marches[1]

At the school of infinite thoughts
Of the most beautiful world
Hymenopterous buildings
I should write books full of mad tenderness
If you were still in that novel
Composed at the head of the stairs

Anyway, all this is so relative that for every ten persons who accuse us of lacking logic there is one who reproaches us with the opposite excess. M. J.-H. Rosny, commenting on the declaration of Tristan Tzara: "In the course of campaigns against all dogmatism and out of irony toward the creation of literary schools, Dada became the Dada movement," remarks: "Thus the foundation of Dadaism is represented not as the foundation of a new school but as the repudiation of all schools. There is nothing absurd about such a point of view; quite on the contrary, it is logical, it is even too logical."

No effort has yet been made to give Dada credit for its desire not to pass for a school. Everyone continues to insist on such words as group, squad leader, discipline. They go so far as to claim that under color of exalting the individuality, Dada constitutes a danger to it, without pausing to note that it is most of all our differences that bind us together. Our common exception to the artistic or moral rule gives us only an ephemeral satisfaction. We are well aware that over and above this, an irrepressible personal imagination, more "dada" than the movement, will have free reign. M. J.-E. Blanche made this clear when he wrote: "Dada will survive only by ceasing to be."

Tirerons-nous au sort le nom de la victime
L'agression noeud coulant

Celui qui parlait trépasse
Le meurtrier se relève et dit
 Suicide
 Fin du monde
Enroulement des drapeaux coquillages.[2]

Shall we draw the victim's name out of a hat
Aggression slip knot

The one who was talking perishes
The murderer rises and says
 Suicide
 End of the world
Rolling of shell-fish flags.

The Dadaists have from the start taken care to state that they want nothing. In other words. There's nothing to worry about, the instinct of self-preservation always wins out. When, after the reading of the manifesto: "No more painters, no

[1] Francis Picabia.

[2] Louis Aragon.

more writers, no more religions, no more royalists, no more anarchists, no more socialists, no more police, etc.," someone naively asked us if we "allowed the continued existence" of man, we smiled, by no means resolved to do God's work. Are we not the last to forget that there are limits to understanding? If I am so pleased by these words of Georges Ribemont-Dessaignes, it is because essentially they constitute an act of extreme humility: "What is 'beautiful'? What is 'ugly'? What are 'big,' 'strong,' 'weak'? What are Carpentier, Renan, Foch? Don't know. What is myself? Don't know. Don't know, don't know, don't know."

2. Two Dada Manifestoes

I

The historical anecdote is of secondary importance. It is impossible to know where and when DADA was born. This name which one of us was pleased to give it has the advantage of being perfectly equivocal.

Cubism was a school of painting, futurism a political movement: DADA is a state of mind. To oppose one to the other reveals ignorance or bad faith.

Free-thinking in religion has no resemblance to a church. DADA is artistic free-thinking.

As long as the schools go in for prayers in the form of explanation of texts and walks in museums, we shall cry despotism and try to disrupt the ceremony.

DADA gives itself to nothing, neither to love nor to work. It is inadmissible that a man should leave any trace of his passage on earth.

DADA, recognizing only instinct, condemns explanation *a priori*. According to DADA, we must retain no control over ourselves. We must cease to consider these dogmas: morality and taste.

II

We read the newspapers like other mortals. Without wishing to make anyone unhappy, we feel entitled to say that the word DADA lends itself readily to puns. To tell the truth, that is in part why we have adopted it. We are incapable of treating seriously any subject whatsoever, let alone this subject: ourselves. Everything we write about DADA is therefore for our pleasure. There is no petty news item for which we would not give the whole of art criticism. Finally, the wartime press did not prevent us from regarding Marshal Foch as a faker and President Wilson as an idiot.

We ask nothing better than to be judged by appearances. It is rumored everywhere that I wear spectacles. If I told you why, you'd never believe me. It is in remembrance of a grammar example: "Noses were made to hold up spectacles; accordingly, I have spectacles." What's that you say? Ah, yes! That doesn't make us any younger.

Pierre is a man. But there is no DADA truth. One need only utter a statement for the opposite statement to become DADA. I have seen Tristan Tzara without words to ask for a box of cigarettes in a tobacco store. I don't know what was the matter with him. I can still hear Philippe Soupault asking insistently for live birds in

paint stores. Perhaps I myself am at this instant dreaming.

A red host is after all as good as a white host. DADA doesn't promise to make you go to heaven. It would be absurd, *a priori*, to expect a DADA masterpiece in the fields of literature and painting. Nor, of course, do we believe in the possibility of any social betterment, even though we hate conservatism above all things and declare ourselves the partisans of any revolution whatsoever. "Peace at any price" is the slogan of DADA in time of war, while in time of peace the slogan of DADA is: "War at any price."

The contradiction is still only an appearance, and doubtless of the most flattering sort. I speak and I have nothing to say. I find not the slightest ambition in myself: and yet it seems to you that I am animated: how is it possible that the idea that my right flank is the shadow of my left flank does not make me utterly incapable of moving? In the most general sense of the word we pass for poets because we attack language which is the worst of conventions. One may very well know the word Hello and say Goodby to the woman one meets after a year's absence.

In conclusion, I wish only to take into account the objections of a pragmatic order. DADA attacks you with your own idea. If we reduce you to maintaining that it is more advantageous to believe than not to believe what is taught by all religions of beauty, love, truth and justice, it is because you are not afraid to put yourself at the mercy of DADA by accepting an encounter with us on the terrain that we have chosen, which is doubt.

3. After Dada

My friends Philippe Soupault and Paul Eluard will not contradict me if I say that we have never regarded "Dada" as anything but a rough image of a state of mind that it by no means helped to create. If, like me, they come to reject its label and to note the abuse of which they are the victims, perhaps this initial principle will be saved. Meanwhile they will pardon me if, in order to avoid any misunderstanding, I inform the readers of *Commoedia* that M. Tzara had nothing to do with the invention of the word "Dada," as is shown by the letters of Schad and Huelsenbeck, his companions in Zurich during the war, which I am prepared to publish, and that he probably had very little to do with the writing of the *Dada Manifesto 1918* which was the basis of the reception and credit we accorded him.

The paternity of this manifesto is in any case, formally claimed, by Max Serner (sic), doctor of philosophy, who lives in Geneva and whose manifestos written in German before 1918 have not been translated into French. Moreover it is known that the conclusions formulated by Francis Picabia and Marcel Duchamp, even before the war, plus those formulated by Jacques Vaché in 1917, would have been sufficient to guide us without the manifesto. Up to now, it has seemed distasteful to me to denounce the bad faith of M. Tzara and I have allowed him to go on using with impunity the papers of those whom he robbed. But now that he has decided to exploit this last opportunity to be talked about, by wrongfully attacking one of the

most disinterested undertakings ever put under way,[1] I am not reluctant to silence him.

Dada, very fortunately, is no longer an issue and its funeral, about May 1921, caused no rioting. The cortège, not very numerous, took the same road as the followers of cubism and futurism, drowned in effigy in the Seine by the students of the Beaux-Arts. Although Dada had, as they say, its hour of fame, it left few regrets: in the long run its omnipotence and its tyranny had made it intolerable.

Nevertheless I noted at that time not without bitterness that several of those who had given to it, of those in general who had given the least, were reduced to misery. The others were not long in rallying to the powerful words of Francis Picabia, inspired, as we know, solely by his love of life and horror of all corruption. I do not mean to say that Picabia was thinking of reconstituting our unity around himself:

> It is hard to imagine
> How stupid and tranquil people are made by success

and he is more inclined than anyone I can think of to dispense with it. But, although there is no question of again substituting a group for individuals (M. Tzara has such lovely ideas!), Louis Aragon, Pierre de Massot, Jacques Rigaut, Roger Vitrac and myself can no longer remain insensitive to this marvelous detachment from all things, of which Picabia has set us an example and which we are glad to attest here.

For my part, I note that this attitude is not new. If I abstained last year from taking part in the demonstrations organized by Dada at the Galerie Montaigne, it is because already this type of activity had ceased to appeal to me, that I saw in it a means of attaining my twenty-sixth, my thirtieth birthday without striking a blow and therefore decided to shun everything that wears the mask of comfort. In an article of that period, which was not published and is known to few persons, I deplored the stereotyped character our gestures were assuming, and wrote as follows: "After all there is more at stake than our carefree existence and our good humor of the moment. For my part, I never aspire to amuse myself. It seems to me that the sanction of a series of utterly futile 'dada' acts is in danger of gravely compromising an attempt at liberation to which I remain strongly attached. Ideas which may be counted among the best, are at the mercy of their too hasty vulgarization."

Even though our epoch has not achieved a high degree of concentration, shall we always consent to pursue mere whims? "The spirit," we have been told, "is not so independent as not to be upset by the slightest hubbub that occurs around it." What future shall we predict for the spirit, if it maintains this hubbub itself?

Far be it from me, even today, to set myself up as a judge. "The essence and the formula" will perhaps always evade me, but, and this cannot be repeated too often, it is the search for them that matters and nothing else. Hence this great void that we are obliged to create within ourselves. Without evincing an extreme taste for the pathetic, I am willing to do without almost everything. I do not wish to slip on

[1] The Congress of Paris (for the determination of the directives and defense of the modern spirit), April 1922.

Entr'acte, directed by René Clair, written by Picabia, music by Erik Satie. 1924. Still (Courtesy Filmgegner, edited by Hans Richter).

the floor of sentimentality. There is, strictly speaking, no such thing as error: at the most one might speak of a bad bet; and those who read me are free to think that the game isn't worth the candle. For my part, I shall try, once again, to join the fight, as far forward as possible, although I do not, like Francis Picabia: "One must be a nomad, pass through ideas as one passes through countries and cities," make a rule of hygiene or a duty out of it. Even should all ideas be of a nature to disappoint us, I propose none the less to devote my life to them.

X. *Marcel Duchamp*

By André Breton. Translated complete from
the French by Ralph Manheim. From *Littérature,* October 1922;
first published in book form in Breton's *Les Pas Perdus,* Paris,
Librairie Gallimard, 1924. By permission of the author and
of Librairie Gallimard.

New York Dada. April, 1921. Single issue of magazine
edited by Marcel Duchamp with assistance of Man Ray.
Complete facsimile. By permission of Marcel Duchamp.

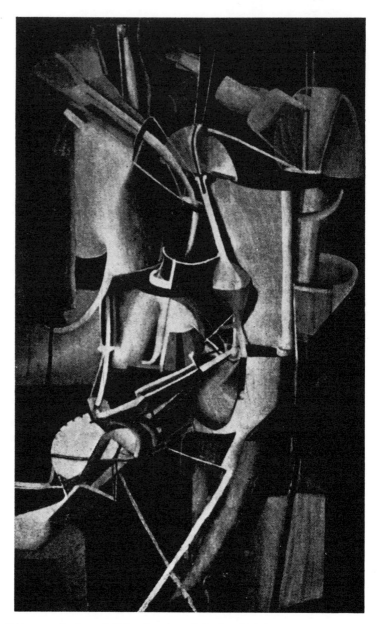

Marcel Duchamp. *The Bride*. 1912. Louise and Walter Arensberg Collection, Philadelphia Museum of Art.

André Breton: *Marcel Duchamp*

It is by rallying around this name, a veritable oasis for those who are still *seeking,* that we might most acutely carry on the struggle to liberate the modern consciousness from that terrible fixation mania which we never cease to denounce. The famous intellectual crab-apple tree which in half a century has borne the fruits called symbolism, impressionism, cubism, futurism, dadaism, demands only to be felled. The case of Marcel Duchamp offers us a precious line of demarcation between the two spirits that will tend to oppose one another more and more in the very heart of the "modern spirit," depending on whether or not this spirit lays claim to the possession of the truth that is rightly represented as an ideal nude woman, who emerges from the well only to turn around and drown herself in her mirror.

The admirable beauty of the face imposes itself through no striking detail, and likewise, anything one can say to the man is shattered against a polished plaque that discloses nothing of what takes place in the depths; and those laughing eyes, without irony, without indulgence, that dispel the slightest shadow of concentration and reveal the solicitude of the man to preserve a perfectly amiable exterior; elegance in its most fatal quality, that goes beyond elegance, a truly supreme *ease:* thus Marcel Duchamp appeared to me in the course of his last stay in Paris; I had not seen him before, and, because of certain strokes of his intelligence that had reached me, I had expected something marvelous.

First of all let us observe that the situation of Marcel Duchamp in relation to the contemporary movement is unique in that the most recent groupings invoke the authority of his name, although it is impossible to say up to what point he has ever given them his consent, and although we see him turning with perfect freedom away from the complex of ideas whose originality was in large part due to him, before it took the systematic turn that alienates certain others as well. Can it be that Marcel Duchamp arrives more quickly than anyone else at the *critical point* of an idea? It seems, in any case, if we consider his subsequent production, that his early allegiance to cubism was tempered by a sort of advance to futurism (1912: *The King and Queen surrounded by quick nudes*), that his contribution to both

movements was soon accompanied by reservations of a Dadaist nature (1915: *The Chocolate Grinder*), and Dada will succeed no better in relieving such scruples: the proof of this is that in 1920, at a time when nothing more was to be expected and when Tzara, who was organizing the Dada Salon, considered himself authorized to count Marcel Duchamp among the exhibitors, Duchamp cabled from America these simple words: "Balls to you," which obliged Tzara to fill in the gaps with enormous signs bearing the catalogue numbers of the missing paintings, thus only half saving his face.

Make no mistake, we have no desire to codify the modern spirit and, for the pleasure of the enigma, to turn our back on those who pretend to resolve it. May the day come when the sphinx, its riddle guessed, will hurl itself into the sea. But so far there have been nothing but phantom solutions. We have banded together and we will again, in the hope of witnessing a conclusive experiment. Let us, if you will, be as ridiculous and as touching as the spiritualists, but let us, my friends, be suspicious of all materializations whatsoever. Cubism is a materialization in corrugated paper, futurism in rubber, dadaism in blotting paper. For the rest, I ask you, is there anything that can do us more harm than a *materialization?*

It's useless for you to say that belief in immateriality is not a materialization. Let us leave certain among our friends to fight over these grotesque tautologies and return to Marcel Duchamp who is the opposite of St. Thomas. I have seen Duchamp do an extraordinary thing, toss a coin up in the air and say: "Tails I leave for America tonight, heads I stay in Paris." *No* indifference about it, it is certain that he infinitely preferred to go or to stay. But is not the personality of choice, the independence of which Duchamp, for example, by signing a manufactured object was one of the first to proclaim, the most tyrannical of all, and is it not fitting to put it to this test, provided that it is not to substitute for it a mysticism of chance?

Ah! if the coin could take a month or a year to fall, how well everyone would understand us! Fortunately it is in the interval of a breath that the thing is decided —naturally the breath must be taken—and one mustn't run short of oxygen to resume at once. (It goes without saying that to understand the above will remain the privilege of the few to whom, alas! it is given to appreciate, for their greater pleasure, the sentence issued from the pen of a man who remains, actually, quite foreign to these speculations, Guillaume Apollinaire, a sentence that gives the measure of that prophetic faculty to which he attached so much importance: "It is perhaps reserved for an artist so detached from esthetic preoccupations, so preoccupied with energy as Marcel Duchamp, to reconcile Art and the People.")

In writing these lines, despite the extremely ambitious title under which I thought fit to gather them, I have not undertaken to exhaust the subject: Marcel Duchamp. My desire was only to avoid, in connection with Duchamp, a return to errors akin to those of Apollinaire or of Dada, and even more to ruin any future systematization of Duchamp's *attitude* as it cannot fail to appear to simple people with a "love of novelty." I know that Duchamp does hardly anything now but play chess, and that he would be content if one day he might prove himself insuperable at that game. Thus it will be said that he has declared his attitude toward the in-

tellectual dilemma: he consents, if you will, to pass for an artist, in the sense of a man who has produced little because *he could not do otherwise.* Thus he, who has delivered us from the conception of blackmail-lyricism with ready-made expression, to which we shall have occasion to return, would for most people resolve himself into a symbol. I refuse to see in this anything more than a trap on his part. As for me, and I have said this before, the thing that constitutes the strength of Marcel Duchamp, the thing to which he owes his escape alive from several perilous situations, is above all his *disdain for the thesis,* which will always astonish less favored men.

In conclusion, I think it will be a good idea to concentrate our attention on this disdain and to this end it may suffice for us to evoke that glass painting to which Duchamp will soon have given ten years of his life, which is not the unknown masterpiece, and concerning which, even before its completion, the most beautiful legends are current; or to recall one or another of those strange plays on words which their author signs: Rrose Selavy, and which demand a special examination:

> *Conseil d'hygiène intime:*
> *Il faut mettre la moelle de l'epée dans le poil de l'aimée.*
> Advice for intimate hygiene:
> Put the marrow of the sword into the hairy place of the beloved.

For Marcel Duchamp the question of art and life, as well as any other question capable of dividing us at the present moment, does not arise.

Man Ray. *Photograph of Marcel Duchamp.* 1931. Coll. Museum of Modern Art, New York.

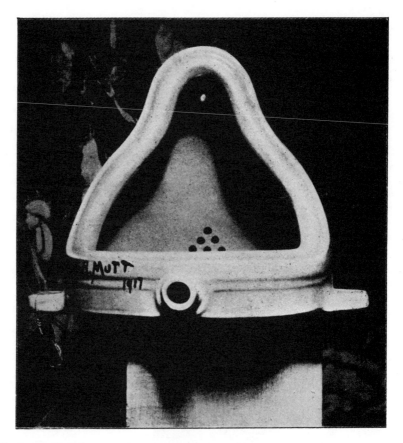

R. Mutt (Marcel Duchamp). Fountain. 1917. (Courtesy *The Blind Man*, New York, edited by Marcel Duchamp and Man Ray; photograph by Stieglitz).

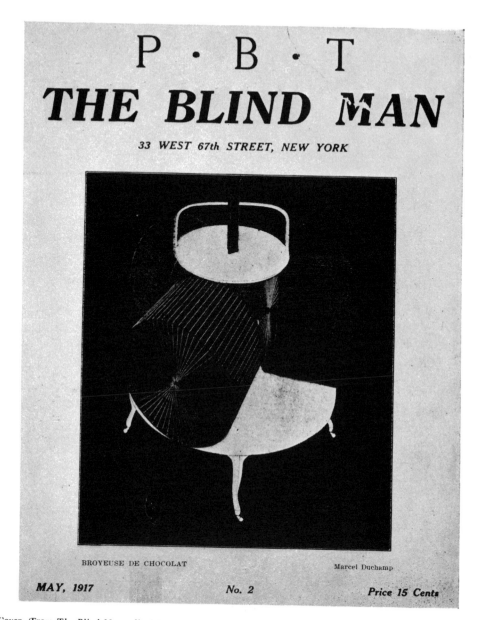

THE BLIND MAN

33 WEST 67th STREET, NEW YORK

BROYEUSE DE CHOCOLAT

Marcel Duchamp

MAY, 1917

No. 2

Price 15 Cents

Cover. (From *The Blind Man*, edited by Marcel Duchamp and Man Ray.) New York, May, 1917.

Cover. (For *New York Dada*, edited by Marcel Duchamp and Man Ray). New York, April, 1921.

New York Dada. First page. New York, April, 1921. (Photo by Alfred Stieglitz).

EYE-COVER ART-COVER CORSET-COVER
AUTHORIZATION

NEW YORK-DADA:

You ask for authorization to name your periodical Dada. But Dada belongs to everybody. I know excellent people who have the name Dada. Mr. Jean Dada; Mr. Gaston de Dada; Fr. Picabia's dog is called Zizi de Dada; in G. Ribemont-Dessaigne's play, the pope is likewise named Zizi de Dada. I could cite dozens of examples. Dada belongs to everybody. Like the idea of God or of the tooth-brush. There are people who are very dada, more dada; there are dadas everywere all over and in every individual. Like God and the tooth1brush (an excellent invention, by the way).

Dada is a new type; a mixture of man, naphthaline, sponge, animal made of ebonite and beefsteak, prepared with soap for cleansing the brain. Good teeth are the making of the stomach and beautiful teeth are the making of a charming smile. Halleluiah of ancient oil and injection of rubber.

There is nothing abnormal about my choice of Dada for the name of my review. In Switzerland I was in the company of friends and was hunting the dictionary for a word appropriate to the sonorities of all languages. Night was upon us when a green hand placed its ugliness on the page of Larousse—pointing very precisely to Dada—my choice was made. I lit a cigarette and drank a demitasse.

For Dada was to say nothing and to lead to no explanation of this off-shoot of relationship which is not a dogma nor a school, but rather a constellation of individuals and of free facets.

Dada existed before us (the Holy Virgin) but one cannot deny its magical power to add to this already existing spirit and impulses of penetration and diversity that characterizes its present form.

There is nothing more incomprehensible than Dada.

Nothing more indefinable,

With the best will in the world I cannot tell you what I think of it.

The journalists who say that Dada is a pretext are right, but it is a pretext for something I do not know.

Dada has penetrated into every hamlet; Dada is the best paying concern of the day.

Therefore, Madam, be on your guard and realize that a really dada product is a different thing from a glossy label.

Dada abolishes "nuances." Nuances do not exist in words but only in some atrophied brains whose cells are too jammed. Dada is an anti "nuance" cream. The simple motions that serve as signs for deaf-mutes are quite adequate to express the four or five mysteries we have discovered within 7 or 8,000 years. Dada offers all kinds of advantages. Dada will soon be able to boast of having shown people that to say "right" instead of "left" is neither less nor too logical, that red and valise are the same thing; that $2765 = 34$; that "fool" is a merit; that yes $=$ no. Strong influences are making themselves felt in politics, in commerce, in language. The whole world and what's in it has slid to the left along with us. Dada has inserted its syringe into hot bread, to speak allegorically into language. Little by little (large by large) it destroys it. Everything collapses with logic. And we shall see certain liberties we constantly take in the sphere of sentiment, social life, morals, once more become normal standards. These liberties no longer will be looked upon as crime, but as itches.

I will close with a little international song: Order from the publishing house "La Sirène" 7, rue Pasquier, Paris, DADAGLOBE, the work of dadas from all over the world. Tell your bookseller that this book will soon be out of print. You will have many agreeable surprises.

Read Dadaglobe if you have troubles. Dadaglobe is in press. Here are some of its colloborators:

Paul Citroen (Amsterdam); Baader Daimonides; R. Hausmann; W. Heartfield; H. Hoech; R. Huelsenbeck; G. Grosz; Fried Hardy Worm (Berlin); Clement Pansaers (Bruxelles); Mac Robber (Calcutta); Jacques Edwards (Chili); Baargeld, Armada v. Dulgedalzen, Max Ernst, F. Haubrich (Cologne); K. Schwitters (Hannovre); J. K. Bonset (Leyde); Guillermo de Torre (Madrid); Gino Cantarelli; E. Bacchi, A. Fiozzi (Mantoue); Krusenitch (Moscou); A. Vagts (Munich); W. C. Arensberg, Gabrielle Buffet, Marcel Duchamp; Adon Lacroix; Baroness v. Loringhoven; Man Ray; Joseph Stella; E. Varese; A. Stieglitz; M. Hartley; C. Kahler (New York); Louis Aragon; C. Brancusi; André Breton; M. Buffet; S. Charchoune; J. Crotti; Suzanne Duchamp; Paul Eluard; Benjamin Peret; Francis Picabia; G. Ribemont-Dessaignes; J. Rigaut, Soubeyran; Ph. Soupault, Tristan Tzara (Paris); Melchior Vischer (Prague); J. Evola (Rome); Arp; S. Taeuber (Zurich).

The incalculable number of pages of reproductions and of text is a guaranty of the success of the book. Articles of luxury, of prime necessity, articles indispensable to hygiene and to the heart, toilet articles of an intimate nature.

Such, Madame, do we prepare for Dadaglobe; for you need look no further than to the use of articles prepared without Dada to account for the fact that the skin of your heart is chapped; that the so precious enamel of your intelligence is cracking; also for the presence of those tiny wrinkles still imperceptible but nevertheless disquieting.

All this and much else in Dadaglobe.

TRISTAN TZARA

New York Dada. Second page. New York, April, 1921.

216

PUG DEBS MAKE SOCIETY BOW

R. Goldberg

Marsden Hartley May Make a Couple—Coming Out Party Next Friday

A beautiful pair of rough-eared debutantes will lead the grand socking cotillion in Madison Square Garden when Mina Loy gives a coming-out party for her Queensberry proteges. Mina will introduce the Marsden Hartleys and the Joseph Stellas to society next week, and everybody who is who will be who-er than ever that night.

Master Marsden will be attired in a neat but not gaudy set of tight-fiting gloves and will have a V-back in front and on both sides. He will wear very short skirts gathered at the waist with a nickel's worth of live leather belting. His slippers will be heavily jewelled with brass eyelets, and a luxurious pair of dime laces will be woven in and out of the hooks. He may or may not wear socks. He has always been known as a daring dresser.

Attire of Debutantes.

Master Joseph will wear a flesh-colored complexion, with the exception of his full-dress tights. He has created a furore in society by appearing at informal morning battles with coattails on his tights. The usual procedure at matinee massacres is for the guest of honor to wear tuxedo trunks with Bull Durham trimmings. He will affect the six-ounce suede glove with hard bandages and a little concrete in em if possible. His tights will be silk and he wears them very short.

Before the pug-debs are introduced, Miss Loy will turn a gold spigot and flocks of butterflies will be released from their cages. They will flitter through the magnificent Garden, which has been especially decorated with extra dust for the occasion. Each butterfly will flit around and then light on some particular head. If you get two oleofleas on your dome, try and keep it a secret.

Description of Ring

The ring will be from the Renaissance period with natural wood splinters. The gong will sound curfew chimes at the end of each round. It will be played by a specially imported pack of Swiss gong ringers. The ropes will be velvet and hung like portieres. Edgar Varese, the violinist, has donated a piece of concert resin to be used on the canvas flooring, which will be made in Persia. Incidentally, the tights worn by the fighters will be made by Tweebleham, of London, purveyor to the Queen, by highest award.

Master Marsden will give his first dance to his brother pug-deb Joseph, which will probably fill Marsden's card for the evening. Visiting diplomats in the gallery de luxe will please refrain from asking for waltzes.

—*With apologies to "Bugs" Baer.*

VENTILATION

On the question of proper ventilation opinions radically differ. It seems impossible to please all. It is our aim, however, to cater to the wishes of the majority. The conductor of this vehicle will gladly be governed accordingly. Your cooperation will be appreciated.

DADATAXI, Limited.

New York Dada. Third page. New York, April, 1921.

217

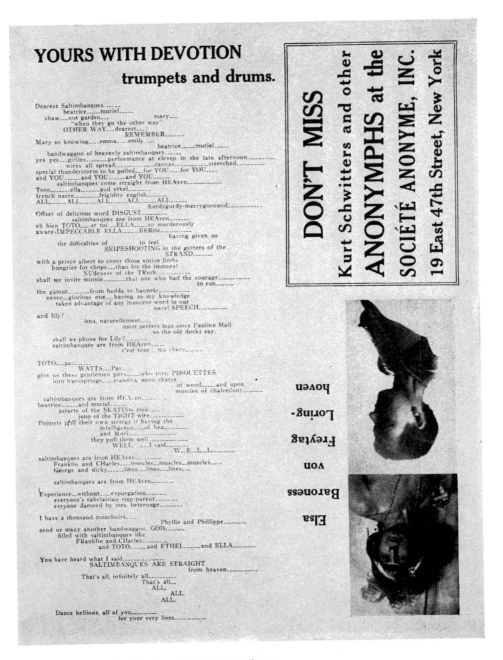

YOURS WITH DEVOTION
trumpets and drums.

Dearest Saltimbanques......
 beatrice......muriel......
 shaw...not garden...... mary...
 "when they go the other way"
 OTHER WAY...dearest......
 REMEMBER......
Mary so knowing....emma....emily.....
 beatrice......muriel......
 bandwaggon of heavenly saltimbanques......
yes yes...girlies......performance at eleven in the late afternoon......
 wires all spread......canvas......stretched..........
special thunderstorm to be pulled...for YOU......for YOU....
and YOU......and YOU......and YOU......
 saltimbanques come straight from HEAven......
Toto......ella......and ethel......
french nacre......frigidity english......
ALL......ALL......ALL......ALL......
 hurdygurdy-merrygoround..........
Offset of delicious word DISGUST......
 saltimbanques are from HEAven......
eh bien TOTO....et toi...ELLA......so murderously
aware-IMPECCABLE ELLA......EERtie......
 having given us
 the difficulties of to feel
 SNIPESHOOTING in the gutters of the
 STRAND......
with a prince albert to cover those votive limbs
 hungrier for chops...than for the immoral
 NUdeness of the TRuth..........
shall we invite minnie......that one who had the courage..........
 to run......
the gamut......from hedda to hannele..........
 never...glorious one...having to my knowledge
 taken advantage of any innocent word in our
 novel SPEECH..........

and lily?
 lena, naturellement....
 most perfect legs since Pauline Hall
 so the old ducks say.
 shall we phone for Lily?......
 saltimbanques are from HEAven......
 c'est tont...ma chere......

TOTO...pav......
 WATTS...Pav......
give us these gentlemen pavs......who turn PIROUETTES
 into handsprings....standing upon skates
 of wood...and upon
 muscles of chalcedony..........
saltimbanques are from HEAven......
beatrice......and muriel.
 astarte of the SKATING rink......
 juno of the TIGHT wire..........
Puppets pull their own strings if having the
 intelligence....of bea..........
 and Mari......
 they pull them well..........
 WELL......I said..........
 W...E...L...L..........
saltimbanques are from HEAven..........
 Franklin and CHarles....muscles...muscles...muscles....
 George and dicky......lines...lines...lines....

saltimbanques are from HEAven..........

Experience...without...expurgation......
 everyone's rabelaisian step-parent..........
 evryone damned by mrs. beterouge..........

I have a thousand mouchoirs....
 Phyllis and Phillippe..........
send us many another bandwaggon, GOD........
 filled with saltimbanques like
 FRanklin and CHarles..........
 and TOTO......and ETHEL......and ELLA........

You have heard what I said..........
 SALTIMBANQUES ARE STRAIGHT
 from heaven..........
 That's all, infinitely all..........
 That's all...
 ALL...
 ALL.
 ALL.

Dance hellions, all of you..........
 for your very lives..........

hoven

Loring-

Freytag

von

Baroness

Elsa

New York Dada. Fourth and final page. New York, April, 1921.

XI. Dada Fragments from Zurich

Notes from a Dada Diary. 1932. By Jean (Hans) Arp. Translated from the German by Eugene Jolas. First published in Paris in *Transition,* no. 21, March, 1932. By permission of the author and of Eugene Jolas.

End of the World. 1916. By Richard Huelsenbeck. Translated from the German by Ralph Manheim. Poem from Huelsenbeck's *Phantastische Gebete,* Zurich, Collection Dada, 1916. By permission of the author.

Arp. *Woodcut*. 1917. (From Dada no. 1). Zurich, 1917.

Hans Arp: *Notes from a Dada Diary*

monsieur duval

man is a beautiful dream. man lives in the sagalike country of utopia where the thing-in-itself tap-dances with the categorical imperative. today's representative of man is only a tiny button on a giant senseless machine. nothing in man is any longer substantial. the safe-deposit vault replaces the may night. how sweetly and plaintively the nightingale sings down there while man is studying the stock-market. what a heady scent the lilac gives forth down there. man's head and reason are gelded, and are trained only in a certain kind of trickery. man's goal is money and every means of getting money is alright with him. men hack at each other like fighting cocks without ever once looking into that bottomless pit into which one day they will dwindle along with their damned swindle. to run faster to step wider to jump higher to hit harder that is what man pays the highest price for. the little folk song of time and space has been wiped out by the cerebral sponge. was there ever a bigger swine than the man who invented the expression time is money. time and space no longer exist for modern man. with a can of gasoline under his behind man whizzes faster and faster around the earth so that soon he will be back again before he leaves. yesterday monsieur duval whizzed at three o'clock from paris to berlin and was back again at four. today monsieur duval whizzed at three o'clock from paris to berlin and was back again at half past three. tomorrow monsieur duval will whiz at three o'clock from paris to berlin and will be back again at three o'clock that is at the same time he leaves and day after tomorrow monsieur duval will be back before he leaves. nothing seems more ridiculous to present-day man than broad clear living.

vases with umbilical cords

spiders flee into the cracks in the earth in the face of man's ugliness and human thinking. from his eight curl-ringed holes he shoots off a lot of hot air. man wants what he can't do and despises what he can. the trick is his goal and its achievement. he feels himself a god when he roars up to heaven with a clockworks under his behind. when dada unveiled the deepest wisdom for man he smiled indulgently

and continued to jaw. when man thinks and jaws even the rats have to vomit. jawing is to him the most important thing of all. jawing is a healthy airing. after a beautiful speech we also have a huge appetite and a different point of view. man takes for red today what he thought was green yesterday and what in reality is black. every moment he emits final explanations about life man and art and knows no more than the stink-mushroom what life man and art are. he thinks that this blue fume this grey fog this black smoke which he gives forth is more important than the braying of a jackass. man thinks he is related to life. gladly this big-mouthed frog calls himself a son of light. but light dwells magnificently in the sky and chases man far from its path. only as a murderer is man creative. he covers with blood and mud everything within his reach. only the physically unfit among men compose poems pluck the lyre or swing the paintbrush.

in art too man loves a void. it is impossible for him to comprehend as art any-thing other than a landscape prepared with vinegar and oil or a lady's shanks cast in marble or bronze. every living transformation of art is as objectionable to him as the eternal transformation of life. straight lines and pure colors particularly excite his fury. man does not want to look at the origin of things. the purity of the world emphasizes too much his own degeneration. that is why man clings like a drowning creature to each graceful garland and out of sheer cowardice becomes a specialist in stocks and bonds.

man calls abstract that which is concrete. yet i find this a good deal in his favor since for the most part he mistakes with nose mouth and ears, in other words with six of his eight curl-framed holes the behind for the front. i understand that he should call a cubist picture abstract because parts have been abstracted from the object which served as a pretext for the picture. but a picture or a plastic for which no object was pretexted i find as concrete and as perceptible as a leaf or a stone.

art is a fruit growing out of man like the fruit out of a plant like the child out of the mother. while the fruit of the plant grows independent forms and never re-sembles a balloon or a president in a cutaway suit the artistic fruit of man shows for the most part a ridiculous resemblance to the appearance of other things. reason tells man to stand above nature and to be the measure of all things. thus man thinks he is able to live and to create against the laws of nature and he creates abortions. through reason man became a tragic and ugly figure. i dare say he would create even his children in the form of vases with umbilical cords if he could do so. reason has cut man off from nature.

i love nature but not its substitute. illusionistic art is a substitute for nature. in many points however i have to count myself among the ugly men who let reason tell them to put themselves above nature. gladly would I create children in the shape of vases with umbilical cords. we must smash the toys of these gentlemen said the dadaists in order that the lousy materialists can recognize on the ruins what is essential. dada wanted to destroy the rationalist swindle for man and incor-porate him again humbly in nature. dada wanted to change the perceptible world of man today into a pious senseless world without reason. that is why hugo ball furiously beat the dadaistic kettle-drum and trumpeted the praise of unreason.

dada washed out the venus of milo and made it possible for laocoon and sons after a struggle of a thousand years with the rattle snake to at last step out for a moment. their worn out tooth brushes were restituted to the great benefactors of the people and their vocabulary of wisdom was revealed as a hieroglyph for greed and murder. dada is a moral revolution. dada is for nonsense. which does not mean bunk. dada is as senseless as nature and life. dada is for nature and against art. dada is direct like nature and like nature wants to give its essential place to each thing. dada is moral the way nature is. dada represents an infinite sense and finite means.

sketch for a landscape

the earth is not a fresh-air resort and the idyllic prospectuses of the earth tell lies. nature does not run along the little thread on which reason would like to see it run. the light of day is beautiful but poisonous and rustic life even creates hexameters and madness. we can of course insure our house against fire our cash register against burglary or our daughter against devirgination but heaven looks nevertheless down into the bottomless pots of our home countries and extracts the sweat of fear from our foreheads. every moment we shuffle off this mortal coil by a hair's breadth. from out of every plank seat a black claw grabs us by the back sides. all bosom friendship and love is a lot of apple sauce. like water off the duck's back so love runs off the human bacon. in loneliness man rides down the styx on his chamber pot. in the neighborhood of karlsruhe he would like to get off because his name is karl and he would like to take a little rest. but chance would have it that here a thicket of laurel feet victory tripe and sabre rattling germanic spooning couples make it impossible for him to get off in that beautiful landscape and thus man damn it to hell continues riding lonelily down the styx on his chamber pot. shamelessly nude clouds without fig leaves or decorations ride past the blue german eyes and lay their eggs in heraldic nests. from the springs beer flows in streams. water fire earth air have been gnawed at by man. but also from man to man the mannikin does what he can. no ha-ha-hallelujah can help him. in carl einstein's poems the sketch for a landscape there is no further mention that man the measure of all things gets away with a black eye. of man in these poems there remains less than of his lares and penates. einstein gives man a good drubbing and sends him home. the white buttocks of an aged narcissus emerge once but it is quickly ignored as fata morganata. aside from this encounter and a few parts of the human anatomy that flow through the black belly of this landscape concepts are the most corporeal vestige of man. you speaks with i about flight and fear of death. human qualities migrate through light and shadow.

carl einstein's sketch for a landscape is an ice-cold pit. no rabbit can live and sleep in this pit for these pits are bottomless. In order that the third dot on the i be not missing i would say further that this pit is as tenebrous as night. no perfumed columns, no fluted rump weals, no schwepperman's eggs architecturally beautify its entrance. with teeth chattering the reader asks this insomnia in persona can you give ghost knocks but not even a violet answers him so much as cuckoo. with

staring eyes and mug hanging wide open this landscape roars through the void. only a handful of snuff remains of the sphinx the olympus and Louis XV. the golden rule and other valuable rules have vanished without leaving a trace. a chair leg clings sea-sick with madness to a torture stake. shreds of sneezing skies jump over ruminating coffins. each of these poems is served on ice. the breasts of this landscape are made of cold storage meat. but nevertheless in the coldest abstractions of einstein there is very distinctly the unmodern question why has this garden party been arranged. einstein is not satisfied with the art pour art of the world. he is for the delusional ideas of the good old days and against reason. he does not want to see illusion used as a scare crow nor the reservation of the ghosts eliminated. it seems to him that people have not yet succeeded in unveiling the world through reason. a great deal in the new doctrine for him does not fit together like a meander in patent leather shoes who goes walking on the arm of a somnambulist box of sardines through the sooty hortus deliciarum. einstein's poems have nothing to do with modern alarm clocks. before them reason takes its tail between its legs and goes philandering somewhere else. einstein does not want to cover up the asphodel meadows. his apollo is not yet the hen-pecked mate of a hundred horse power mrs rolls royce. here an unhygienic polonaise is being danced against all the prohibitions of the concrete top-hat of the glass neck-tie and the nickel cutaway to the tune of the old snowman still lives. whether today people planted antennae instead of narcissi doesn't matter one way or the other. the main thing is to have here and there a lucida intervalla in order to be able to take a gulp from the saving whiskey bottle of illusion. the darkness which einstein distills from the smiling meads of the earth goes beyond jack and the bean stalk beyond the corner grocer and beyond all human endurance. yes yes the earth is not a valley of tears in the vest pocket.

⊕

the seven head lengths of beauty have been cut off one after the other but nevertheless man acts as if he were a being that vegetates outside of nature. industriously he adds seven to black in order to get thereby another hundred pounds of chatter. gentlemen who always stood for the dream and life are now making a loathsomely industrious effort to reach the goal of class and to deform hegel's dialectics into a popular song. i am justified in my theory that man is a pot the handles of which fell out of his own holes. poetry and the five year plan are now being busily stirred together but the attempt to stand up while lying down will not succeed. man will not let himself be made into a happy hygienic number which brays ee-on enthusiastically like a jackass before a certain picture. man will not let himself be standardized. in this ridiculous circus which stands without relation to life itself the books of hugo ball epitomize a gigantic act. hugo ball leads man out of his silly corporeality towards his true content dream and death. art and the dream represent the preliminary step to the true collectivity of the redemption from all reason. hugo ball's language is also a magic treasure and connects him

with the language of light and darkness. through language too man can grow into real life.

Werner Graeff. *Hans Arp*. 1924.

Richard Huelsenbeck: *End of the World (1916)*

Dedicated to Elizabeth Huelsenbeck (1948).

This is what things have come to in this world
The cows sit on the telegraph poles and play chess
The cockatoo under the skirts of the Spanish dancer
Sings as sadly as a headquarters bugler and the cannon lament all day
That is the lavender landscape Herr Mayer was talking about
when he lost his eye
Only the fire department can drive the nightmare from the drawing-
room but all the hoses are broken
Ah yes Sonya they all take the celluloid doll for a changeling
and shout: God save the king
The whole Monist Club is gathered on the steamship Meyerbeer
But only the pilot has any conception of high C
I pull the anatomical atlas out of my toe
a serious study begins
Have you seen the fish that have been standing in front of the
opera in cutaways
for the last two days and nights . . .?
Ah ah ye great devils—ah ah ye keepers of the bees and commandants
With a bow wow wow with a boe woe woe who today does not know
what our Father Homer wrote
I hold peace and war in my toga but I'll take a cherry flip
Today nobody knows whether he was tomorrow
They beat time with a coffin lid
If only somebody had the nerve to rip the tail feathers
out of the trolley car it's a great age
The professors of zoology gather in the meadows
With the palms of their hands they turn back the rainbows
the great magician sets the tomatoes on his forehead
Again thou hauntest castle and grounds
The roebuck whistles the stallion bounds
(And this is how the world is this is all that's ahead of us)

XII. *Dada Fragments from Paris*

(Two poems.) 1921. By Paul Eluard. Translated from the
French by Clara Cohen. Published in book form in Paris
in Eluard's *Les Necessités de la Vie,* Paris, Au Sans Pareil, 1921.
Translations appeared in *New Directions,* 1940. By permission
of James Laughlin.

Project for a Contemporary Literary History. 1922. By
Louis Aragon. Appeared in Paris in *Littérature,* new series, no. 4,
September 1922. Complete facsimile.

White Gloves. 1920. By André Breton and Philippe Soupault.
Fragment of *Les Champs Magnetiques,* Paris, Au Sans Pareil,
1920. Translation appeared in *New Directions,* 1940.
By permission of James Laughlin.

Paul Eluard: *Les Fleurs*

I am fifteen years old, I take myself by the hand. Conviction of
being young with the advantages of being most affectionate.

I am not fifteen years old. From the past is born an incomparable
silence.

I dream of this fine, this splendid world of pearls and stolen
grasses.

You think I'm upset; I'm not. Don't take me,—let me be.

My eyes and fatigue must be the color of my hands. Faith, what
a grimace at the sun, for nothing but rain.
I assure you there are things as clear as this story of love; if I die,
I do not know you any more.

Paul Eluard: *Information Please*

To drink red wine in blue glasses and castor oil in
German brandy, distant horizon

A man alive rides a horse alive to meet a woman alive
leading on a leash a dog alive.

A black dress or a white? Big shoes or little ones?

Look. There, across there, he who works earns money.
I have read "Old shamefaced invalid," "coquettish fortune
in Paris," and "This fan with beautiful ribs."

Flame extinguished, your old age is extinguished smoke.

I do not like music, all this piano music robs me of all I love.

Louis Aragon. Project for a History of Contemporary Literature (facsimile). (Courtesy Littérature, Paris, 1922).

Avant-propos

Agadir. — Les vols du Louvre. — Le Futurisme. — Les ballets russes. — Nick Carter. — Les Duncans.

De 1913 à la guerre

Alcools. — Comment on parlait de Lautréamont. — Vers et Prose, la Closerie des Lilas. — Rimbaud aux mains de Paul Claudel. — La Phalange. — L'époque des Soirées de Paris. — Guillaume Apollinaire se rallie au futurisme un jour de Grand Prix. — Savinio en bras de chemise. — Les Indépendants. — Cravan. — La baronne. — Le Phalène. — Le Sacre. — Chirico. — Lettre d'Arthur Rimbaud contenant Rêve *(N. R. F. du 1ᵉʳ Août 1914).*

Du 1ᵉʳ août 1914 à la mort d'Apollinaire (10 novembre 1918)

Le Cinéma, Charlot et les Vampires. — Le Mot, l'Elan et les Solstices. — Montparnasse et Montmartre. — Guillaume Apollinaire et la guerre. — Mardis de Flore. — Sic. — Kisling, Abdul, Modigliani, etc. — Baptême de Max Jacob. — Manifestations de l'O. S. T. : Philippe Soupault, les Fuégiens. — Parade. — La rue Huyghens : où la musique s'en mêle. — Les Mamelles de Tirésias. — Jacques Vaché. — La révolution russe. - Paul Valéry fait paraître la Jeune Parque. — L'aventure Fraenkel-Cocteau : que penser de la poésie moderne ? — 291. — Nord-Sud. — Querelles montmartroises. — Le procès Satie. — Le Val-de-Grâce : André Breton. — Apollinaire censeur et Louis Delluc. — Je fais un sonnet en l'honneur du général Joffre. — L'influence de Jarry se fait sentir. — Guillaume Apollinaire et l'esprit nouveau, Roger Allard, le cubisme littéraire. — Philippe Soupault à l'hôpital. — Organisation commerciale de la Nouvelle Revue Française. — Les Trois Roses, L'Eventail, L'Instant, La belle Edition, Madame Aurel, Madame Lara, Art et Vie. — Soi-même et la Caravane. — 391. — Pierre Bertin, Pelléas à l'Odéon. — Madame Bathory au Vieux Colombier. — Paul Guillaume, les Rosenbergs. — Picabia en Espagne, en Suisse et en Amérique. — La Suisse pendant la guerre : Dada, Bolo, Casella, Guilbeaux, Romain Rolland. — L'Espagne : Marie Laurencin, Robert Delaunay. — L'Amérique : Marcel Duchamp, Man Ray, Cravan, W. C. Arensberg, etc. — L'Allemagne : Huelsenbeck, Baader, Max Ernst, Baargeld, etc. — Les Ecrits Nouveaux : admiration d'André Germain pour André Breton. — Soirées chez Valéry. — André Breton à Moret. — Le mirage américain. — Adrienne Monnier — Monsieur Dermée et les fous. — Mariage de Philippe Soupault. — Mort de Guillaume Apollinaire.

De l'armistice à Dada (novembre 1918 à janvier 1920)

Manifeste Dada 1918. — Codification du cubisme littéraire. — Aujourd'hui naît et meurt. — Valori Plastici. — Art et Vie devient Art et Action. — Cocteau prend figure. — Mort de Jacques Vaché. — L'époque des collages. — Le Dit des Jeux du Monde, les Cuirs de Bœuf. — Le Crapouillot, l'Europe nouvelle. — Les prolégomènes de Littérature (le jeune Cliquennois). — Gide se met au courant. — Littérature. — Le Sans-Pareil rue du Cherche-Midi. — Débuts de Paul Morand. — Isidore Ducasse. — Max Jacob et ses nains. — Matinée Reverdy : Raymond Radiguet. — La N. R. F. recommence. — Fraenkel sur le Rhin. — Je rentre à Paris. — Les Champs magnétiques. — Couleur du Temps : Paul Eluard croit reconnaître un mort. — Le Surréalisme. — Les prix littéraires. — Où l'on commence à en avoir assez du cubisme. — Conversations avec Zurich. — Le rétablissement des relations internationales (Ezra Pound, Ivan Goll, etc.). — Je rencontre Drieu la Rochelle. — Vlaminck, Derain, Picasso. — L'offensive réactionnaire en peinture et les premiers Indépendants; J. L. Vaudoyer, A. Lhôte. J. E. Blanche, Louis Vauxcelles un peu partout. —

ON LANCE FAVORY.— J. E. Blanche critique littéraire. — Georges Auric au Val-de-Grâce. — Maurice Raynal à la Renaissance. — Fernand Vandérem découvre la littérature moderne. — IL VA FALLOIR TOUT COMPROMETTRE. — Premiers craquements (Reverdy). — Francis Picabia rentre à Paris.

Dada (janvier 1920 à octobre 1921)

Picabia — Tzara. — Ribemont-Dessaignes. — Les ballets russes : un vol de fourrures. — Premier Vendredi de Littérature — La grande colère. — La Section d'Or — Ere des manifestations : Grand Palais, Faubourg, Université populaire. Œuvre, les lettres anonymes, la Salle Gaveau. — Rachilde et Dada. — Le Salon Gallimard. — Acte de vandalisme chez André Breton. — Dada et la N. R. F. — Le Salon de Madame Erlanger : Drieu, Eve Francis. — Max Jacob à Lariboisière : apparition de Benjamin Péret. — Public de Dada. — Dada court à la réussite philosophique. — Paul Valéry chez Miss Barney. — Salon Mühlfeld. — André Germain invite rue du Mont-Thabor.— Le silence — Expositions au Sans-Pareil. — Les livres Dada paraissent. — Cannibale. — Tzara fait son petit Chateaubriaud. — L'Anthologie Crès. — Madame de Noailles. — Clément Pansaers et la Belgique. — Succès de Picabia : vernissage chez Povolotzki. — Carco grand homme pour Cora et Mistinguett. — Le Bœuf sur le toit et les spectacles Cocteau. — Picabia s'écarte de nous. — Jacques Rigaut fait illusion. — Encore 391. — Où sont les peintres ? L. A. Moreau, Nam, Segonzac, etc. chez Madame Rappoport. — Le mirage allemand : Max Ernst, exposition et manifestation. — Marinetti à Paris : colère de Madame Gustave Kahn. — Vente Kahnweiler. — Saint-Julien-le-Pauvre. — Films de Louis Delluc. — L'Affaire Barrès. — L'excommunication majeure. — Petite entreprise de démolition : histoire d'un portefeuille. — Picabia directeur de Little Review en remplacement de Jules Romains. — Les Dissidences. — André Breton se sépare de Dada. — Le salon Dada, programme et manifestation. — Les bruiteurs futuristes. — Hébertot, fermeture du salon Dada. — Paul Eluard à Saint-Brice. — Les mariés de la Tour Eiffel : Robert Delaunay. — Nouvel éclat de Montparnasse. — Blanche à la campagne. — Le Tyrol pendant l'automne 21.

Après Dada (octobre 1921 à nos jours)

Soirées de Broussais. — Un coup de poing de Georges Braque. — Le torchon brûle. — Rapport de Fernand Divoire sur la poésie (instruction publique). — Aventure, Roger Vitrac, Jacques Baron (Henry Cliquennois reparaît). — Vernissage Man Ray et la Librairie Six. — Congrès de Paris (Max Morise). — Cocteau veut revoir André Breton. — Le salon de Madame Aurel existe encore ! — Comité du C. P. — André Breton revoit Francis Picabia . révélations. — Tzara démasqué. — La grande crise sentimentale et ce qui s'ensuit — La Closerie des Lilas. — Comment finit le Congrès. — Le Cœur à barbe qui devait s'appeler l'Œil à poil. — Voyage en Angleterre : Georges Limbour au Havre. — Dés : politique de Tzara. — Américains : Josephson, Brown, Cummings. — Secession à Vienne — Le Docteur Caligari — Salmon, auteur dramatique — Robert Desnos. — Le Petit Casino : projets de manifestations. — Benjamin Péret au Matin. — La manifestation interdite : beautés du passage du Caire. — Les milieux anarchistes. — Man Ray, grand photographe. — Les littérateurs s'organisent. — Procès Bessarabo. — Francis Picabia à la campagne. — Paul Eluard au Tyrol. — Philippe Soupault, homme d'affaires. — Drieu de retour à Paris. — Bal à Bullier. — Peintures de Crotti : André Lhôte. — Le grand prix du roman à Francis Carco. — Paul Souday s'en prend à Baudelaire : RIEN N'EST ENCORE ENTENDU.

Conclusion

Etat des esprits au début de l'été 1922. — Comment Dada n'a pas sauvé le monde. — Prodromes d'une nouvelle littérature de chemin de fer dont Chateaubriand et Max Jacob seront les prototypes. — Une vague de réaction. — Encore plusieurs qui ne se sont pas pendus. — Tout se classe. — Médiocrité universelle. — Comment on écrira l'histoire.

Louis ARAGON.

A. Breton & P. Soupault: *The Magnetic Fields (fragment). (1920)*

The corridors of the big hotels are empty and the cigar smoke is hiding. A man comes down the stairway and notices that it's raining; the windows are white. We sense the presence of a dog lying near him. All possible obstacles are present. There is a pink cup; an order is given and without haste the servants respond. The great curtains of the sky draw open. A buzzing protests this hasty departure. Who can run so softly? The names lose their faces. The street becomes a deserted track.

About four o'clock that same day a very tall man was crossing the bridge that joins the separate islands. The bells, or perhaps it was the trees, struck the hour. He thought he heard the voices of his friends speaking: "The office of lazy trips is to the right," they called to him, "and on Saturday the painter will write to you." The neighbors of solitude leaned forward and through the night was heard the whistling of streetlamps. The capricious house loses blood. Everybody loves a fire; when the color of the sky changes it's somebody dying. What can we hope for that would be better? Another man standing in front of a perfume shop was listening to the rolling of a distant drum. The night that was gliding over his head came to rest on his shoulders. Ordinary fans were for sale; they bore no more fruit. People were running without knowing why in the direction of the estuaries of the sea. Clocks, in despair, were fingering their rosaries. The cliques of the virtuous were being formed. No one went near the great avenues that are the strength of the city. A single storm was enough. From a distance or close at hand, the damp beauty of prisons was not recognized. The best refuges are stations because the travelers never know which way to go. You could read in the lines of the palm that the most fragrant vows of fidelity have no future. What can we do with muscle-bound children? The warm blood of bees is preserved in bottles of mineral water. We have never seen sincerities exposed. Famous men lose their lives in the carelessness of those beautiful houses that make the heart flutter. How small they seem, these rescued tides! Earthly happinesses run in floods. Each object is Paradise.

A great bronze boulevard is the shortest road. Magical squares do not make good stopping places. Walk slowly and carefully; after a few hours you can see the pretty nose-bleed bush. The panorama of consumptives lights up. You can hear every footfall of the underground travelers. And yet the most ordinary silence reigns in these narrow places. A traveler stops, changing expression. Wondering, he approaches the colored bush. Without doubt he wants to pick it but all he can do is shake hands with another traveler who is covered with stolen jewels. Their eyes exchange sulphurous sounds like the murmuring of a dry moon, but a glance disperses the most wonderful meetings. No one could recognize the pale-faced travelers.

XIII. *From the Annals of Dada*

Zurich Chronicle. 1915–19. By Tristan Tzara. Complete
translation from the French by Ralph Manheim. First published
in Berlin in the *Dada Almanach,* 1920. By permission
of the author.

Collective Dada Manifesto. 1920. By Richard Huelsenbeck.
Translation from the German by Ralph Manheim. See bibliography
#299. By permission of the author.

Lecture on Dada. 1922. By Tristan Tzara. Translated from
the French by Ralph Manheim. Original published in *Merz,*
vol. 2, no. 7, January, 1924. By permission of the author.

Hans Richter. *Prelude.* 1919.

1. Tristan Tzara: *Zurich Chronicle (1915–1919)*

1915. November—Exhibition of Arp van Rees Mme van Rees, at the Tanner Gallery—great uproar new men see in paper—and see only a world of crystalsimplicitymetal—neither art nor painting (Chorus of critics: *"What shall we do?"* Exclusive constipation) a world of transparencelineprecision turns somersaults for a certain foreseen brilliant wisdom.

1916. February—In the most obscure of streets in the shadow of architectural ribs, where you will find discreet detectives amid red street lamps—BIRTH—birth of the CABARET VOLTAIRE—poster by Slodky, wood, woman and Co., heart muscles CABARET VOLTAIRE and pains. Red lamps, overture piano Ball reads Tipperary piano "under the bridges of Paris" Tzara quickly translates a few poems aloud, Mme Hennings—silence, music—declaration—that's all. On the walls: van Rees and Arp, Picasso and Eggeling, Segal and Janco, Slodky, Nadelman, colored papers, ascendancy of the NEW ART, abstract art and geographic futurist map-poems: Marinetti, Cangiullo, Buzzi; *Cabaret Voltaire*, music, singing, recitation every night—the people—the new art the greatest art for the people—van Hoddis, Benn, Tress,—balalaika—Russian night French night—personages in one edition appear, recite or commit suicide, bustle and stir, the joy of the people, cries, the cosmopolitan mixture of god and brothel, the crystal and the *fattest* woman in the world: "Under the bridges of paris"

February 26—HUELSENBECK ARRIVES—bang! bang! bangbangbang
　Without opposition year perfume of the beginning.
　Gala night—simultaneous poem 3 languages, protest noise Negro music/ Hoosenlatz Ho osenlatz/ piano Typerrary Lanterna magica demonstration last proclamation!! *invention dialogue!!* DADA! latest novelty!!! bourgeois syncope, BRUITIST music, latest rage, song Tzara dance protests—the big drum—red light, policemen—songs cubist paintings post cards song Cabaret Voltaire—patented *simultaneous poem* Tzara Ho osenlatz and van Hoddis Hü ülsenbeck Hoosenlatz whirlwind Arp-two-step demands liquor smoke towards the bells / a whispering of:

235

arrogance / silence Mme Hennings, Janco declaration, transatlantic art = the people rejoice star hurled upon the cubist tinkle dance.

1916. June—Publication of "CABARET VOLTAIRE" Price 2 francs. Printed by J. Heuberger

Contributors: Apollinaire, Picasso, Modigliani, Arp, Tzara, van Hoddis, Huelsenbeck, Kandinsky, Marinetti, Cangiullo, van Rees, Slodky, Ball, Hennings, Janco, Cendrars, etc. DaDada d a d a dadadadadada dialogue the new life—contains a simultaneous poem; the carnivorous critics placed us platonically in the giddy house of overripe geniuses. Avoid appendicitis sponge your intestines. "I found that the attacks became less and less frequent and if you wish to remain young avoid rheumatism."

<div align="right">Thermal golf mystery</div>

The Cabaret lasted 6 months, every night we thrust the triton of the grotesque of the god of the beautiful into each and every spectator, and the wind was not gentle—the consciousness of so many was shaken—tumult and solar avalanche—vitality and the silent corner close to wisdom or folly—who can define its frontiers? —slowly the young girls departed and bitterness laid its nest in the belly of the family-man. A word was born no one knows how DADADADA *we took an oath of friendship* on the new transmutation that signifies nothing, and was the most formidable protest, the most intense armed affirmation of salvation liberty blasphemy mass combat speed prayer tranquillity private guerilla negation and chocolate of the desperate.

1916. July 14—For the first time anywhere. Waag Hall

1. Dada Night
(Music, dances, theories, manifestoes, poems, paintings, costumes, masks)
In the presence of a compact crowd Tzara demonstrates, we demand we demand the right to piss in different colors, Huelsenbeck demonstrates, Ball demonstrates, Arp "Erklärung" (Statement), Janco "meine Bilder" (my pictures), Heusser "eigene Kompositionen" (original compositions) the dogs bay and the dissection of Panama on the piano on the piano and dock—shouted Poem—shouting and fighting in the hall, first row approves second row declares itself incompetent the rest shout, who is the strongest, the big drum is brought in, Huelsenbeck against 200, Ho osenlatz accentuated by the very big drum and little bells on his left foot—the people protest shout smash windowpanes kill each other demolish fight here come the police interruption.

Boxing resumed: Cubist dance, costumes by Janco, each man his own big drum on his head, noise, Negro music / trabatgea bonoooooo oo ooooo / 5 literary experiments: Tzara in tails stands before the curtain, stone sober for the animals, and explains the new aesthetic: gymnastic poem, concert of vowels, bruitist poem, static poem chemical arrangement of ideas, "Biriboom biriboom" saust der Ochs im Kreis herum (the ox dashes round in a ring) (Huelsenbeck), vowel poem a a ò, i e o, a i ï, new interpretation the subjective folly of the arteries the dance of the heart on burning buildings and acrobatics in the audience. More outcries, the big drum,

piano and impotent cannon, cardboard costumes torn off the audience hurls itself into puerperal fever interrupt. The newspapers dissatisfied simultaneous poem for 4 voices + simultaneous work for 300 hopeless idiots.

1916. July. for the first time: DADA COLLECTION (patented cocktail)
 Just appeared:
Tristan Tzara: "The First Celestial Adventure of Mr. Fire-extinguisher." With colored woodcuts by M. Janco. Price: 2 francs. Impotence cured prepaid on request.

1916. September.
 "Phantastische Gebete" (Fantastic prayers) Verses by RICHARD HUELSENBECK with 7 woodcuts by Arp, DADA COLLECTION
"indigo indigo streetcar sleeping bag bedbug and flee indigo indigai unbaliska bumm DADAI" "brrs pffi commencer Abrr rpppi commence beginning beginning"

1916. October.
 "SCHALABEN SCHALOMAI SCHALAMEZO MAI" by Richard Huelsenbeck, with drawings by Arp, Dada collection. Incomparable for your baby's toilet! Illustrated

1917. January–February—Corray Gallery, Bahnhofstrasse, Zurich.
 I. Dada Exhibition.
Van Rees, Arp, Janco, Tscharner, Mme van Rees, Lüthy, Richter, Helbig, Negro art, brilliant success: the new art. Tzara delivers 3 lectures: 1. cubism, 2. the old and the new art, 3. the art of the present. Large poster by Richter, poster by Janco. Several elderly Englishwomen take careful notes.

1917. March 17—DADA GALLERY Directors: Tzara, Ball. March 17, introductory address.
 I. Exhibition of: Campendonk, Kandinsky, Klee, Mense, etc.

1917. March 23—Grand Opening Dada Gallery Zurich, Bahnhofstrasse 19.
 Red lamps mattresses social sensation Piano: Heusser, Perrottet, Recitations: Hennings, A. Ehrenstein, Tzara, Ball, Dances: Mlle Taeuber / costumes by Arp /, C. Walter, etc. etc. great enchanted gyratory movement of 400 persons celebrating.

March 21, March 28, April 4, and every Wednesday—Tour of the gallery guided by L. H. Neitzel, Arp, Tristan Tzara.
 LECTURES: March 24, Tzara: Expressionism and abstract art; March 31, Dr. W. Jollos: Paul Klee; April 7, Ball: Kandinsky; March 28, Tzara: on the new art

April 14—2nd Performance of the Dada Gallery: Jarry, Marinetti, Apollinaire, van Hoddis, Cendrars, Kandinsky

ASSAULT NIGHT
 Heusser, Ball, Glauser, Tzara, Sulzberger, A. Ehrenstein, Hennings, etc. Negro Music and Dancing with the support of the Misses Jeanne Rigaud and Maya Chrusecz, Masks by Janco.
Premiere: "Sphynx and Straw Man" by O. Kokoschka. Firdusi, Rubberman, Anima, Death

This performance decided the role of our theatre, which will entrust the stage direction to the subtle invention of the explosive wind, scenario in the audience, visible direction, grotesque props: the DADAIST theatre. Above all masks and revolver effects, the effigy of the director. Bravo! & Boom boom!

April 9–30—2nd Exhibition of the dada Gallery: Bloch, Baumann, Max Ernst, Feininger, Kandinsky, Paul Klee, Kokoschka, etc. etc.

April 28—NEW ART NIGHT Tzara: cold Light, simultaneous poem by 7 persons. Glauser: poems, Negro music and dances Janco: paintings Mme Perrottet: Music by Laban, Schönberg etc. Ball, Hennings, etc. F. Hardekopf reads from his works.

The audience makes itself comfortable and rarefies the explosions of elective imbecility, each member withdraws his own inclinations and sets his hope in the new spirit in process of formation: "Dada."

May 2–29—3d Exhibition of the Dada Gallery: Arp, Baumann, G. de Chirico, Helbig, Janco, P. Klee, O. Lüthy, A. Macke, I. Modigliani, E. Prampolini, van Rees, Mme van Rees, von Rebay, H. Richter, A. Segal, Slodky, J. von Tscharner etc. CHILDREN'S DRAWINGS—NEGRO SCULPTURES Embroidery Relief

1917. May 12.—Dada Gallery OLD AND NEW DADA ART NIGHT
A. Spa: from Jacopone da Todi to francesco Meriano and Maria d'Arezzo; music by Heusser, performed by composer; Arp: Verses, Böhme—of cold and calcification.
NEGRO POEMS
Translated and read by Tzara / Aranda, Ewe, Bassoutos, Kinga, Loritja, Baronga / Hennings, Janco, Ball etc. Aegidius Albertinus, Narrenhatz' Song of the Frogs.
The public appetite for the mixture of instinctive recreation and ferocious bamboula which we succeeded in presenting forced us to give on May 19, a
REPETITION OF THE OLD AND NEW ART NIGHT
May 25. H. HEUSSER. PERFORMANCE OF OWN COMPOSITIONS. PIANO. SONG. HARMONIUM. RECITATION: Miss K. Wulff.
June 1. Dada Gallery goes on unlimited vacation.

1917. July.—Mysterious creation! magic revolver! The DADA MOVEMENT is launched.

1917. July—Appearance of DADA No. 1 a review of art and literature[1]
Arp, Lüthy, Moscardelli, Savinio, Janco, Tzara, Meriano. Wisdom repose in therapeutic art, after long persecutions: neurasthenia of pages, thermometres of those painters named The Subtle Ones.

1917. December—DADA No. 2 price: 2 francs.[1] Contributors: van Rees, Arp, Delaunay, Kandinsky, Maria d'Arezzo, Chirico, P. A. Birot, G. Cantarelli etc. etc.

[1] Regular edition out of print; de luxe edition, 8 francs. Dada Movement, Zurich, Seehof, Schifflande 28.

238

1918. July—just appeared:
 tristan tzara: 25 poems
 arp: 10 woodcuts
 dada collection

1918. July 23—Meise Hall Tristan Tzara Night
 Manifesto, antithesis thesis antiphilosophy, DadADADA DADA daDA dadaist spontaneity dadaist disgust LAUGHTER poem tranquillity sadness diarrhea is also a sentiment war business poetic element infernal propeller economic spirit jemenfoutisme national anthem posters for whorehouses draymen tossed on stage, savage outbursts against the rarefaction of the academic intelligence etc.

September 1918. Wolfsberg Gallery. Exhibition of Arp, Richter, Mc Couch, Baumann, Janco etc.

1918. December—DADA No. 3. Price 1.50 francs; de luxe edition: 20 francs.
 Liberated order at liberty search for a continuous rotary movement "I do not even wish to know if there were men before me" Long live Descartes long live Picabia, the antipainter just arrived from New York the big sentiment machine check long live dada Dschouang-Dsi the first dadaist down with melody down with the future (Reverdy, Raimondi, Hardekopf, Huelsenbeck, Picabia, Prampolini, Birot, Soupault, Arp, Segal, Sbarbaro, Janco, Richter, Dermée, Huidobro, Savinio, Tzara were contributors). Let us destroy let us be good let us create a new force of gravity NO = YES Dada means nothing life Who? catalogue of insects / Arp's woodcuts / each page a resurrection each eye a salto mortale down with cubism and futurism each phrase an automobile horn let us mix let us mix friends and colleagues the bourgeois salad in the eternal basin is insipid and I hate good sense.
 At this point intervenes / hats off! / Novissima danzatrice. Dr. W SERNER Attraction! who has seen with his own eyes and squashed the bedbugs between the meninges of the counts of goodness.
But the mechanism turns
turn turn Baedeker nocturnes of history
brush the teeth of the hours
keep moving gentlemen
noise breaks pharmaceutical riddles

1918. December 31—Arp: the columns of reclining legs the cardboard phenomenon dance crater gramophone succession of lights in the darkness cocktail surprises for lovers and progression fox-trot house Flake, Wigmann, Chrusecz, Taeuber, madness in centimetres problematic and visual exasperation / first free exercise of / dadaist spontaneity / in color / and / each man his own battle horse

1919. January—Exhibition of Picabia, Arp, Giacometti, Baumann, Ricklin etc. at the Kunsthaus.

1919. January 16—Kunsthaus. Lecture by Tzara "On Abstract Art" with slides in which professors are seen arranging the ineffable in drawers full of squares cooked

in oil of assassin applause on the part of Good-will explanation from Boomboom, the genuine, by the lack of landscape hat fish in pictures escaping from their frames. Infusion of slow bacteria under shivering veins.

1919. February—Just appeared: / Dada Movement Editions / 391 / Price 2 francs / Traveling magazine / New York—Barcelona / Gabrielle Dada Manifesto Buffet Alice Bailly, Arp the eternal will exhibit tree roots from Venice, Picabia, PICABIA. The Blind Man, Ribemont-Dessaignes, Tzara, Duchamp, etc.

1919. April 9—Kaufleuten Hall NON PLUS ULTRA

9. Dada Night. Producer: W. Serner.

Tamer of Acrobats, Tzara, signs crucifix of impatience mist of suspicions sparks of anxiety showed their canine teeth 2 weeks before the show and publicity acute disease spread through the countryside.

1500 persons filled the hall already boiling in the bubbles of bamboulas.

Here is Eggeling connecting the wall with the ocean and telling us the line proper to a painting of the future; and Suzanne Perrotet plays Erik Satie (+ recitations), musical irony non-music of the jemenfoutiste goofy child on the miracle ladder of the DADA MOVEMENT. But now Miss Wulff appears / superhuman mask ½ o/o § ? / to accentuate the presence of Huelsenbeck and Laughter (beginning) the candy makes an impression a single thread passes through the brains of the 1500 spectators. And when the shaded stage is revealed with 20 persons reciting Tr. Tzara's simultaneous poem: "THE FEVER OF THE MALE?" the scandal assumes menacing proportions islands spontaneously form in the hall, accompanying, multiplying underlining the mighty roaring gesture and the simultaneous orchestration. Signal of the blood. Revolt of the past, of education. "Feverish fiction and 4 acrid macabre cracks in the barrack." Under the bridges of Paris. In the ammoniac storm a scarf is brought to the author by Alice Bailly and Auguste Giacometti.

Richter elegant and malicious. FOR against and without DADA, from the Dada point of view dada telegraphy and mentality etc. dada. dada dada. Arp hurls the cloud pump under the enormous oval, burns the rubber, the pyramid stove for proverbs bright or swampy in leather pockets. Serner takes the floor to illuminate his dadaist MANIFESTO and now, when "a queen is an armchair a dog is a hammock" the tumult is unchained hurricane frenzy siren whistles bombardment song the battle starts out sharply, half the audience applaud the protestors hold the hall in the lungs of those present nerves are liquefied muscles jump Serner makes mocking gestures, sticks the scandal in his buttonhole / ferocity that wrings the neck / Interruption.

Chairs pulled out by roots projectiles crash bang expected effect atrocious and instinctive.

NOIR CACADOU, Dance (5 persons) with Miss Wulff, the pipes dance the renovation of the headless pythecantropes stifles the public rage. The balance of intensity inclines towards the stage. Serner in the place of his poems lays a bunch of flowers at the feet of a dressmaker's dummy. Tzara prevented from reading the DADA PROC-

Opposite: *Simultaneous poem* (with a note for the middle class by Tzara) by Richard Huelsenbeck, Marcel Janco, and Tristan Tzara. (Courtesy Cabaret Voltaire, Zurich).

L'amiral cherche une maison à louer

Poème simultan par R. Huelsenbeck, M. Janko, Tr. Tzara



HUELSENBECK, JANKO, chant, TZARA

HUELSENBECK, chant	Ahoi ahoi Des Admirals gwirktes Beinkleid schnell zerfällt	Teerpappe macht Rawagen in der Nacht
JANKO, chant	Boum Boum boum Where the honny suckle wine twines itself around the door a swetheart	is waiting patiently for my great room in der me
TZARA	Ahoi Boum boum boum Il déshabilla sa chair quand les grenouilles humides commencèrent	la door à brûler cheval l'ame du

HUELSENBECK, chant	und der Conciergenbäuche Klapperschlangengrün sind milde ach	verzerrt in der Natur chrza prrrza chrrza et
JANKO, chant	can hear à Bucarest the weopour on dépendra mes amis dorénavant	very trés intéressant les griffes des morsures chrza my great room prrrza is
TZARA	serpent Klapperschlangengrün will arround around	c'est très intéressant les griffes des morsures équatoriales

HUELSENBECK, chant	prrrza mine chrrza admirably Wer suchet Grandmother Dimanche:	Wer Schwan kein ist dem said deux eléphants wird
JANKO, chant	confortabily Wer Grandmother Dimanche:	braucht the ladies love télégraphiste Le Wer assassine find
TZARA	Der Ceylonöve ist kein Schwan au restaurant	aufgetan Journal de Genève Wasser love Wer Le

Intermède rythmique

HUELSENBECK	hihi Yabomm hihi hihi hihi hihiiii	*ff crrec ff fff*
TZARA	rouge bleu rouge bleu rouge bleu rouge bleu rouge bleu	*p crrec f ff fff*
SIFFLET (Janko)	*p crrec f ff fff*	
CLIQUETTE (TZ)	rrrrrrrrr rrrrrrrrr rrrrrrrrr rrrrrrrrr rrrrrrrrr	*decrus uniform*
GROSSE CAISSE (Huels.)	O O O OO O OOOO OOOOO OOOOO OO OOOO OO	*p f fff p*

HUELSENBECK (chant)	im Kloset zumeistens was er nötig hatt ahoi iuché ahoi iuché der	Find was er nötig it's five
JANKO (chant)	I love the ladies I love to be among the girls	And when it's five
TZARA	la concierge qui m'a trompé elle a vendu l'appartement que j'avais loué	Dans l'église après la messe le pêcheur dit à la comtesse : Adieu Mathilde

HUELSENBECK (chant)	hatt' O süss gequolines Stelldichein des Admirals im Abendschein uru uru uru	uri uro is
JANKO (chant)	o'clock and tea is set I like to have my tea with some brunet shai shai shai	uri Every body is
TZARA	Le train traîne la fumée comme la fuite de l'animal blessé aux uro shai shai intestins écrasés	uro shai Every body is doing it

HUELSENBECK (chant)	Der Affe brüllt die Seekuh bellt im Lindenbaum der Schrag zerschellt taratata	oh mon
JANKO (chant)	doing it see that ragtime couple over there tarasce	knallt mit schnellen tombent Oh!
TZARA	Autour du phare tourne l'auréole des oiseaux bleuilis en mottifs de lumière vis- throw there shoulders in the air She said the raising her heart und dwelling oiseaux	In Joschiwara dröhnt der Brand Tandis que les archanges chient et les

HUELSENBECK (chant)	Peitschen um die Lenden Im Schlafsack grünht der	Tastatur L'Amiral n'a rien trouvé
JANKO (chant)	oh yes yes yes yes yes yes yes yes yes yes	volle sir L'Amiral n'a rien trouvé
TZARA	cher c'est si difficile La rue s'enfuit avec mon bagage à travers la ville Un métro mêle	Oberpriester und zeigt der Schenkel son cinéma la prore de je vous adore était au casino du sycomore L'Amiral n'a rien trouvé

Eh même temps Mr Apollinaire essayait un nouveau genre de poème visuel, qui est plus intéressant encore par son manque de système et par sa fantaisie tourmentée. Il accentue les images centrales, typographiquement, et donne la possibilité de commancer à puremement formels. Ils cherchent un effort musical, qu'on peut imaginer en faisant les mêmes abstractions que sur une partiture d'orchestre.

Je voulais réaliser un poème basé sur d'autres principes. Qui consistent dans la possibilité que je donne à chaque écoutant de lier les associations convenables. Il retient les éléments caractéristiques pour sa personalité, les entremèle, les fragmente etc, restant tout-de-même dans la direction que l'auteur a canalisé.

Le poème que j'ai arrangé (avec Huelsenbeck et Janko) ne donne pas une description musicale mais tente à individualiser l'impression du poème simultan auquel nous donnons par la une nouvelle portée.

La lecture parallèle que nous avons fait le 31 mars 1916, Huelsenbeck, Janko et moi, était la première réalisation scénique de cette esthétique moderne.

TRISTAN TZARA

NOTE POUR LES BOURGEOIS

Les essays sur la transmutation des objets et des couleurs des premiers peintres cubistes (1907) Picasso, Braque, Picabia, Duchamp-Villon, Delaunay, suscitaient l'envie d'appliquer en poésie les mêmes principes simultans.

Villiers de l'Isle Adam eût des intentions pareilles dans le théâtre, où l'on remarque les tendances vers un simultanéisme schématique; Mallarmé essaya une reforme typographique dans son poème: Un coup de dés n'abolira jamais le hazard; Marinetti qui popularisa cette subordination par ses "Paroles en liberté"; les intentions de Blaise Cendrars et de Jules Romains, dernièrement, amenèrent Mr Apollinaire aux idées qu'il developpa en 1912 au "Sturm" dans une conférence.

Mais l'idée première, en son essence, fut extériorisée par Mr H Barzun dans un livre théorique Voix, rythmes et chants Simultanés où il cherchait une relation plus étroite entre la symphonie polyrythmique et le poème. Il opposait aux principes successifs de la poesie lyrique une idée vaste et parallèle. Mais les intentions de compliquer en profondeur cette technique (avec le Drame Universel) en exagérant sa valeur au point de lui donner une idéologie nouvelle et de la cloîtrer dans l'exclusivisme d'une école, échouèrent.

LAMATION delirium in the hall, voice in tatters drags across the candelabras, progressive savage madness twists laughter and audacity. Previous spectacle repeated. New dance in 6 enormous dazzling masks. End. Dada has succeeded in establishing the circuit of absolute unconsciousness in the audience which forgot the frontiers of education of prejudices, experienced the commotion of the NEW.

Final victory of Dada.

1919. May—Latest novelty DADA ANTHOLOGY Dada, Nos. 4–5. Price: 4 francs; de luxe edition: 20 francs.

Alarm clock firecrackers Picabia, electric battery Picabia Tzara ringing calendar 3 easy plays Cocteau note on midwife poetry Globe Giacometti Reverdy 199 Globe Tohu-bohu Radiguet triangle catastrophe p.a. Birot, Hausmann latest magic TNT Arp Aa 24 arp in sections asphodel foreskin owl taxi driver G. Ribemont-Dessaignes words at random in function of priest Gabrielle Buffet MAM vivier dada receiver of contributions André Breton the dragoon Chirico rolls the Dada statue out full length Louis Aragon invents streets Ph. Soupault Eggeling Richter the pretty bird drum Huelsenbeck, the splendors Hadekopf and Serner-SERNER-ser serves the cablegram Art is dead etc.

Inaugurate different colors for the joy of transchromatic disequilibrium and the portable circus velodrome of camouflaged sensations knitting anti-art the piss of integral courage diverting diversities under the latest cosmopolitan vibration.

1919. June—Mock duel Arp + Tzara on the Rehalp with cannons but aimed in the same direction audience invited to celebrate a private bluish victory.

1919. October—Just appeared: DER ZELTWEG / Dadaists in the spotlight! Price 2 Francs. Contributors: O. Flake, Huelsenbeck, Christian Schad, Serner, Arp, Tzara, Giacometti, Baumann, Helbig, Eggeling, Richter, Vagts, Taeuber, Wigmann, Schwitters, etc. Dadaists in the spotlight!! Neo-Dadaism Attention aux pick-pockets very much E pericoloso. Tr. Tzara.

Up to October 15, 8590 articles on dadaism have appeared in the newspapers and magazines of: Barcelona, St. Gall, New York, Rapperswill, Berlin, Warsaw, Mannheim, Prague, Rorschach, Vienna, Bordeaux, Hamburg, Bologna, Nuremberg, Chaux-de-fonds, Colmar, Jassy, Bari, Copenhagen, Bukarest, Geneva, Boston, Frankfurt, Budapest, Madrid, Zurich, Lyon, Basel, Christiania, Bern, Naples, Cologne, Seville, Munich, Rome, Horgen, Paris, Effretikon, Bern, London, Innsbruck, Amsterdam, Santa-Cruz, Leipzig, Lausanne, Chemnitz, Rotterdam, Brussels, Dresden, Santiago, Stockholm, Hanover, Florence, Venice, Washington, etc. etc.

2. Richard Huelsenbeck: *Collective Dada Manifesto*. (1920)

Art in its execution and direction is dependent on the time in which it lives, and artists are creatures of their epoch. The highest art will be that which in its conscious content presents the thousandfold problems of the day, the art which has

d^{ad}aⁱ_tⁿ_i_sCHes 三^a_nⁱF_e_s^t

Die Kunst ist in ihrer Ausführung und Richtung von der Zeit abhängig, in der sie lebt, und die Künstler sind Kreaturen ihrer Epoche Die höchste Kunst wird diejenige sein, die in ihren Bewußtseinsinhalten die tausendfachen Probleme der Zeit präsentiert, der man anmerkt, daß sie sich von den Explosionen der letzten Woche werfen ließ, die ihre Glieder immer wieder unter dem Stoß des letzten Tages zusammensucht. Die besten und unerhörtesten Künstler werden diejenigen sein, die stündlich die Fetzen ihres Leibes aus dem Wirrsal der Lebenskatarakte zusammenreißen, verbissen in den Intellekt der Zeit, blutend an Händen und Herzen

Hat der Expressionismus unsere Erwartungen auf eine solche Kunst erfüllt, die eine Ballotage unserer vitalsten Angelegenheiten ist?

Nein! Nein! Nein!

Haben die Expressionisten unsere Erwartungen auf eine Kunst erfüllt, die uns die Essenz des Lebens ins Fleisch brennt?

Nein! Nein! Nein!

Unter dem Vorwand der Verinnerlichung haben sich die Expressionisten in der Literatur und in der Malerei zu einer Generation zusammengeschlossen, die heute schon sehnsüchtig ihre literatur- und kunsthistorische Würdigung erwartet und für eine ehrenvolle Bürger-Anerkennung kandidiert. Unter dem Vorwand, die Seele zu propagieren, haben sie sich im Kampfe gegen den Naturalismus zu den abstrakt-pathetischen Gesten zurückgefunden, die ein inhaltloses, bequemes und unbewegtes Leben zur Voraussetzung haben. Die Bühnen füllen sich mit Königen, Dichtern und faustischen Naturen jeder Art, die Theorie einer melioristischen Weltauffassung, deren kindliche, psychologisch-naivste Manier für eine kritische Ergänzung des Expressionismus signifikant bleiben muß, durchgeistert die tatenlosen Köpfe Der Haß gegen die Presse, der Haß gegen die Reklame, der Haß gegen die Sensation spricht für Menschen, denen ihr Sessel wichtiger ist als der Lärm der Straße und die sich einen Vorzug daraus machen, von jedem Winkelschieber übertölpelt zu werden Jener sentimentale Widerstand gegen die Zeit, die nicht besser und nicht schlechter, nicht reaktionärer und nicht revolutionärer als alle anderen Zeiten ist, jene matte Opposition, die nach Gebeten und Weihrauch schielt, wenn sie es nicht vorzieht, aus attischen Jamben

Richard Huelsenbeck. *Collective Dada Manifesto,* 1920. From Dada Almanach. See also p. 245.

been visibly shattered by the explosions of last week, which is forever trying to collect its limbs after yesterday's crash. The best and most extraordinary artists will be those who every hour snatch the tatters of their bodies out of the frenzied cataract of life, who, with bleeding hands and hearts, hold fast to the intelligence of their time. Has expressionism fulfilled our expectations of such an art, which should be an expression of our most vital concerns?

No! No! No!

Have the expressionists fulfilled our expectations of an art that burns the essence of life into our flesh?

No!　No!　No!

Under the pretext of turning inward, the expressionists in literature and painting have banded together into a generation which is already looking forward to honorable mention in the histories of literature and art and aspiring to the most respectable civic distinctions. On pretext of carrying on propaganda for the soul, they have, in their struggle with naturalism, found their way back to the abstract, pathetic gestures which presuppose a comfortable life free from content or strife. The stages are filling up with kings, poets and Faustian characters of all sorts; the theory of a melioristic philosophy, the psychological naiveté of which is highly significant for a critical understanding of expressionism, runs ghostlike through the minds of men who never act. Hatred of the press, hatred of advertising, hatred of sensations are typical of people who prefer their armchair to the noise of the street, and who even make it a point of pride to be swindled by every smalltime profiteer. That sentimental resistance to the times, which are neither better nor worse, neither more reactionary nor more revolutionary than other times, that weak-kneed resistance, flirting with prayers and incense when it does not prefer to load its cardboard cannon with Attic iambics—is the quality of a youth which never knew how to be young. Expressionism, discovered abroad, and in Germany, true to style, transformed into an opulent idyll and the expectation of a good pension, has nothing in common with the efforts of active men. The signers of this manifesto have, under the battle cry:

Dada!　!　!　!

gathered together to put forward a new art, from which they expect the realization of new ideals. What then is DADAISM?

The word Dada symbolizes the most primitive relation to the reality of the environment; with Dadaism a new reality comes into its own. Life appears as a simultaneous muddle of noises, colors and spiritual rhythms, which is taken unmodified into Dadaist art, with all the sensational screams and fevers of its reckless everyday psyche and with all its brutal reality. This is the sharp dividing line separating Dadaism from all artistic directions up until now and particularly from FUTURISM which not long ago some puddingheads took to be a new version of impressionist realization. Dadaism for the first time has ceased to take an aesthetic attitude toward life, and this it accomplishes by tearing all the slogans of ethics, culture and inwardness, which are merely cloaks for weak muscles, into their components.

The Bruitist poem

represents a streetcar as it is, the essence of the streetcar with the yawning of Schulze the coupon clipper and the screeching of the brakes.

The Simultaneist poem

teaches a sense of the merrygoround of all things; while Herr Schulze reads his paper, the Balkan Express crosses the bridge at Nish, a pig squeals in Butcher Nuttke's cellar.

The Static poem

makes words into individuals, out of the letters spelling woods, steps the woods

ihre Pappgeschosse zu machen — sie sind Eigenschaften einer Jugend, die es nie-
mals verstanden hat, jung zu sein. Der Expressionismus, der im Ausland gefunden,
in Deutschland nach beliebter Manier eine fette Idylle und Erwartung guter Pension
geworden ist, hat mit dem Streben tätiger Menschen nichts mehr zu tun. Die Unter-
zeichner dieses Manifests haben sich unter dem Streitruf

DADA!!!!

zur Propaganda einer Kunst gesammelt, von der sie die Verwirklichung neuer Ideale
erwarten. Was ist nun der **DADAISMUS?**

 Das Wort Dada symbolisiert das primitivste Verhältnis zur umgebenden Wirk-
lichkeit, mit dem Dadaismus tritt eine neue Realität in ihre Rechte. Das Leben erscheint
als ein simultanes Gewirr von Geräuschen, Farben und geistigen Rhytmen, das in
die dadaistische Kunst unbeirrt mit allen sensationellen Schreien und Fiebern seiner
verwegenen Alltagspsyche und in seiner gesamten brutalen Realität übernommen wird. Hier
ist der scharf markierte Scheideweg, der den Dadaismus von allen bisherigen Kunst-
richtungen und vor allem von dem **FUTURISMUS** trennt, den kürzlich Schwach-
köpfe als eine neue Auflage impressionistischer Realisierung aufgefaßt haben. Der
Dadaismus steht zum erstenmal dem Leben nicht mehr ästhetisch gegenüber, indem
er alle Schlagworte von Ethik, Kultur und Innerlichkeit, die nur Mäntel für schwache
Muskeln sind, in seine Bestandteile zerfetzt.

Das
BRUITISTISCHE Gedicht

schildert eine Trambahn wie sie ist, die Essenz der Trambahn mit dem Gähnen
des Rentiers Schulze und dem Schrei der Bremsen.

Das
SIMULTANISTISCHE Gedicht

lehrt den Sinn des Durcheinanderjagens aller Dinge, während Herr Schulze liest,
fährt der Balkanzug über die Brücke bei Nisch, ein Schwein jammert im Keller des
Schlächters Nuttke.

Das
STATISCHE Gedicht

macht die Worte zu Individuen, aus den drei Buchstaben Wald, tritt der Wald mit
seinen Baumkronen, Försterlivreen und Wildsauen, vielleicht tritt auch eine Pension
heraus, vielleicht Bellevue oder Bella vista. Der Dadaismus führt zu unerhörten neuen
Möglichkeiten und Ausdrucksformen aller Künste. Er hat den Kubismus zum Tanz
auf der Bühne gemacht, er hat die **BRUITISTISCHE** Musik der Futuristen (deren rein
italienische Angelegenheit er nicht verallgemeinern will) in allen Ländern Europas
propagiert. Das Wort Dada weist zugleich auf die Internationalität der Bewegung,

Richard Huelsenbeck. *Collective Dada Manifesto*, 1920. From Dada Almanach. See also p. 243.

with its treetops, liveried foresters and wild sows, maybe a boarding house steps out
too, and maybe it's called Bellevue or Bella Vista. Dadaism leads to amazing new
possibilities and forms of expression in all the arts. It made cubism a dance on the
stage, it disseminated the BRUITIST music of the futurists (whose purely Italian
concerns it has no desire to generalize) in every country in Europe. The word Dada
in itself indicates the internationalism of the movement which is bound to no
frontiers, religions or professions. Dada is the international expression of our
times, the great rebellion of artistic movements, the artistic reflex of all these
offensives, peace congresses, riots in the vegetable market, midnight suppers at the

Esplanade, etc., etc. Dada champions the use of the
new medium in painting.

Dada is a CLUB, founded in Berlin, which you can join without commitments. In this club every man is chairman and every man can have his say in artistic matters. Dada is not a pretext for the ambition of a few literary men (as our enemies would have you believe), Dada is a state of mind that can be revealed in any conversation whatever, so that you are compelled to say: this man is a DADAIST—that man is not; the Dada Club consequently has members all over the world, in Honolulu as well as New Orleans and Meseritz. Under certain circumstances to be a Dadaist may mean to be more a businessman, more a political partisan than an artist—to be an artist only by accident—to be a Dadaist means to let oneself be thrown by things, to oppose all sedimentation; to sit in a chair for a single moment is to risk one's life (Mr. Wengs pulled his revolver out of his pants pocket). A fabric tears under your hand, you say yes to a life that strives upward by negation. Affirmation—negation: the gigantic hocuspocus of existence fires the nerves of the true Dadaist—and there he is, reclining, hunting, cycling—half Pantagruel, half St. Francis, laughing and laughing. Blast the aesthetic-ethical attitude! Blast the bloodless abstraction of expressionism! Blast the literary hollowheads and their theories for improving the world! For Dadaism in word and image, for all the Dada things that go on in the world! To be against this manifesto is to be a Dadaist!

Tristan Tzara. Franz Jung. George Grosz. Marcel Janco.
Richard Huelsenbeck. Gerhard Preiss. Raoul Hausmann.
O. Luthy. Frederic Glauser. Hugo Ball. Pierre Albert-Birot.
Maria d'Arezzo Gino Cantarelli. Prampolini.
R. van Reese. Madame van Reese. Hans Arp. G. Thäuber.
Andrée Morosini. François Mombello-Pasquati.

3. Tristan Tzara: *Lecture on Dada.* (1922)

Ladies and Gentlemen:

I don't have to tell you that for the general public and for you, the refined public, a Dadaist is the equivalent of a leper. But that is only a manner of speaking. When these same people get close to us, they treat us with that remnant of elegance that comes from their old habit of belief in progress. At ten yards distance, hatred begins again. If you ask me why, I won't be able to tell you.

Another characteristic of Dada is the continuous breaking off of our friends. They are always breaking off and resigning. The first to tender his resignation from the Dada movement *was myself.* Everybody knows that Dada is nothing. I broke away from Dada and from myself as soon as I understood the implications of *nothing.*

If I continue to do something, it is because it amuses me, or rather because I have a need for activity which I use up and satisfy wherever I can. Basically, the true Dadas have always been separate from Dada. Those who acted as if Dada were

important enough to resign from with a big noise have been motivated by a desire for personal publicity, proving that counterfeiters have always wriggled like unclean worms in and out of the purest and most radiant religions.

I know that you have come here today to hear explanations. Well, don't expect to hear any explanations about Dada. You explain to me why you exist. You haven't the faintest idea. You will say: I exist to make my children happy. But in your hearts you know that isn't so. You will say: I exist to guard my country against barbarian invasions. That's a fine reason. You will say: I exist because God wills. That's a fairy tale for children. You will never be able to tell me why you exist but you will always be ready to maintain a serious attitude about life. You will never understand that life is a pun, for you will never be alone enough to reject hatred, judgments, all these things that require such an effort, in favor of a calm and level state of mind that makes everything equal and without importance.

Dada is not at all modern. It is more in the nature of a return to an almost Buddhist religion of indifference. Dada covers things with an artificial gentleness, a snow of butterflies released from the head of a prestidigitator. Dada is immobility and does not comprehend the passions. You will call this a paradox, since Dada is manifested only in violent acts. Yes, the reactions of individuals contaminated by *destruction* are rather violent, but when these reactions are exhausted, annihilated by the Satanic insistence of a continuous and progressive "What for?" what remains, what dominates is *indifference*. But with the same note of conviction I might maintain the contrary.

I admit that my friends do not approve this point of view. But the *Nothing* can be uttered only as the reflection of an individual. And that is why it will be valid for everyone, since everyone is important only for the individual who is expressing himself.—I am speaking of myself. Even that is too much for me. How can I be expected to speak of all men at once, and satisfy them too?

Nothing is more delightful than to confuse and upset people. People one doesn't like. What's the use of giving them explanations that are merely food for curiosity? The truth is that people love nothing but themselves and their little possessions, their income, their dog. This state of affairs derives from a false conception of property. If one is poor in spirit, one possesses a sure and indomitable intelligence, a savage logic, a point of view that can not be shaken. Try to be empty and fill your brain cells with a petty happiness. Always destroy what you have in you. On random walks. Then you will be able to understand many things. You are not more intelligent than we, and we are not more intelligent than you.

Intelligence is an organization like any other, the organization of society, the organization of a bank, the organization of chit-chat. At a society tea. It serves to create order and clarity where there is none. It serves to create a state hierarchy. To set up classifications for rational work. To separate questions of a material order from those of a cerebral order, but to take the former very seriously. Intelligence is the triumph of sound education and pragmatism. Fortunately life is something else and its pleasures are innumerable. They are not paid for in the coin of liquid intelligence.

These observations of everyday conditions have led us to a realization which constitutes our minimum basis of agreement, aside from the sympathy which binds us and which is inexplicable. It would not have been possible for us to found our agreement on principles. For everything is relative. What are the Beautiful, the Good, Art, Freedom? Words that have a different meaning for every individual. Words with the pretension of creating agreement among all, and that is why they are written with capital letters. Words which have not the moral value and objective force that people have grown accustomed to finding in them. Their meaning changes from one individual, one epoch, one country to the next. Men are different. It is diversity that makes life interesting. There is no common basis in men's minds. The unconscious is inexhaustible and uncontrollable. Its force surpasses us. It is as mysterious as the last particle of a brain cell. Even if we knew it, we could not reconstruct it.

What good did the theories of the philosophers do us? Did they help us to take a single step forward or backward? What is forward, what is backward? Did they alter our forms of contentment? We are. We argue, we dispute, we get excited. The rest is sauce. Sometimes pleasant, sometimes mixed with a limitless boredom, a swamp dotted with tufts of dying shrubs.

We have had enough of the intelligent movements that have stretched beyond measure our credulity in the benefits of science. What we want now is spontaneity. Not because it is better or more beautiful than anything else. But because everything that issues freely from ourselves, without the intervention of speculative ideas, represents us. We must intensify this quantity of life that readily spends itself in every quarter. Art is not the most precious manifestation of life. Art has not the celestial and universal value that people like to attribute to it. Life is far more interesting. Dada knows the correct measure that should be given to art: with subtle, perfidious methods, Dada introduces it into daily life. And vice versa. In art, Dada reduces everything to an initial simplicity, growing always more relative. It mingles its caprices with the chaotic wind of creation and the barbaric dances of savage tribes. It wants logic reduced to a personal minimum, while literature in its view should be primarily intended for the individual who makes it. Words have a weight of their own and lend themselves to abstract construction. The absurd has no terrors for me, for from a more exalted point of view everything in life seems absurd to me. Only the elasticity of our conventions creates a bond between disparate acts. The Beautiful and the True in art do not exist; what interests me is the intensity of a personality transposed directly, clearly into the work; the man and his vitality; the angle from which he regards the elements and in what manner he knows how to gather sensation, emotion, into a lacework of words and sentiments.

Dada tries to find out what words mean before using them, from the point of view not of grammar but of representation. Objects and colors pass through the same filter. It is not the new technique that interests us, but the spirit. Why do you want us to be preoccupied with a pictorial, moral, poetic, literary, political or social renewal? We are well aware that these renewals of means are merely the successive

Portrait de TRISTAN TZARA
par
FRANCIS PICABIA

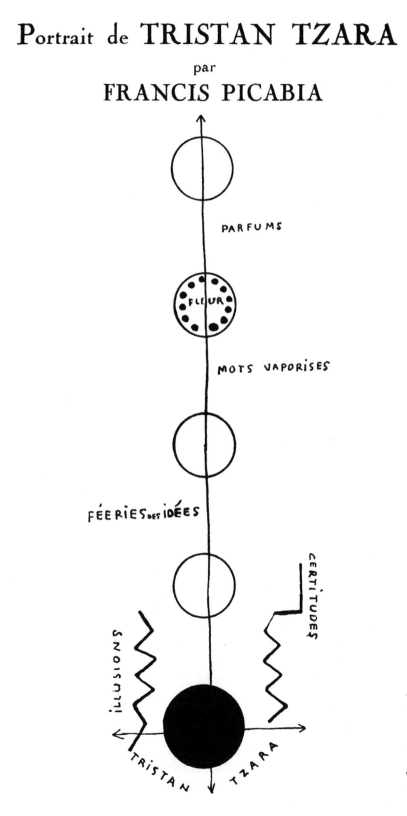

Francis Picabia. *Portrait of Tristan Tzara.* 1918.

cloaks of the various epochs of history, uninteresting questions of fashion and facade. We are well aware that people in the costumes of the Renaissance were pretty much the same as the people of today, and that Chouang-Dsi was just as Dada as we are. You are mistaken if you take Dada for a modern school, or even for a reaction against the schools of today. Several of my statements have struck you as old and natural, what better proof that you were Dadaists without knowing it, perhaps even before the birth of Dada.

You will often hear that Dada is a state of mind. You may be gay, sad, afflicted, joyous, melancholy or Dada. Without being literary, you can be romantic, you can be dreamy, weary, eccentric, a businessman, skinny, transfigured, vain, amiable or Dada. This will happen later on in the course of history when Dada has become a precise, habitual word, when popular repetition has given it the character of a word organic with its necessary content. Today no one thinks of the literature of the Romantic school in representing a lake, a landscape, a character. Slowly but surely, a Dada character is forming.

Dada is here, there and a little everywhere, such as it is, with its faults, with its personal differences and distinctions which it accepts and views with indifference.

We are often told that we are incoherent, but into this word people try to put an insult that it is rather hard for me to fathom. Everything is incoherent. The gentleman who decides to take a bath but goes to the movies instead. The one who wants to be quiet but says things that haven't even entered his head. Another who has a precise idea on some subject but succeeds only in expressing the opposite in words which for him are a poor translation. There is no logic. Only relative necessities discovered *a posteriori,* valid not in any exact sense but only as explanations.

The acts of life have no beginning or end. Everything happens in a completely idiotic way. That is why everything is alike. Simplicity is called Dada.

Any attempt to conciliate an inexplicable momentary state with logic strikes me as a boring kind of game. The convention of the spoken language is ample and adequate for us, but for our solitude, for our intimate games and our literature we no longer need it.

The beginnings of Dada were not the beginnings of an art, but of a disgust. Disgust with the magnificence of philosophers who for 3000 years have been explaining everything to us (what for?), disgust with the pretensions of these artists-God's-representatives-on-earth, disgust with passion and with real pathological wickedness where it was not worth the bother; disgust with a false form of domination and restriction *en masse,* that accentuates rather than appeases man's instinct of domination, disgust with all the catalogued categories, with the false prophets who are nothing but a front for the interests of money, pride disease, disgust with the lieutenants of a mercantile art made to order according to a few infantile laws, disgust with the divorce of good and evil, the beautiful and the ugly (for why is it more estimable to be red rather than green, to the left rather than the right, to be large or small?). Disgust finally with the Jesuitical dialectic which can explain everything and fill people's minds with oblique and obtuse ideas with-

out any physiological basis or ethnic roots, all this by means of blinding artifice and ignoble charlatan's promises.

As Dada marches it continuously destroys, not in extension but in itself. From all these disgusts, may I add, it draws no conclusion, no pride, no benefit. It has even stopped combating anything, in the realization that it's no use, that all this doesn't matter. What interests a Dadaist is his own mode of life. But here we approach the great secret.

Dada is a state of mind. That is why it transforms itself according to races and events. Dada applies itself to everything, and yet it is nothing, it is the point where the yes and the no and all the opposites meet, not solemnly in the castles of human philosophies, but very simply at street corners, like dogs and grasshoppers.

Like everything in life, Dada is useless.

Dada is without pretension, as life should be.

Perhaps you will understand me better when I tell you that Dada is a virgin microbe that penetrates with the insistence of air into all the spaces that reason has not been able to fill with words or conventions.

Viking Eggeling. *Basse générale de la peinture.* Extension. Lithograph. From *Dada*, No. 4-5, Zurich.

XIV. *Some Memories of Pre-Dada: Picabia and Duchamp.*

Written by Gabrielle Buffet-Picabia for the present volume. 1949. Translated from the French by Ralph Manheim.

La Pomme de Pins. 25 February 1922. Edited by Francis Picabia. Single issue of review edited and largely written by Picabia. Published in St. Raphael (France). Complete facsimile.

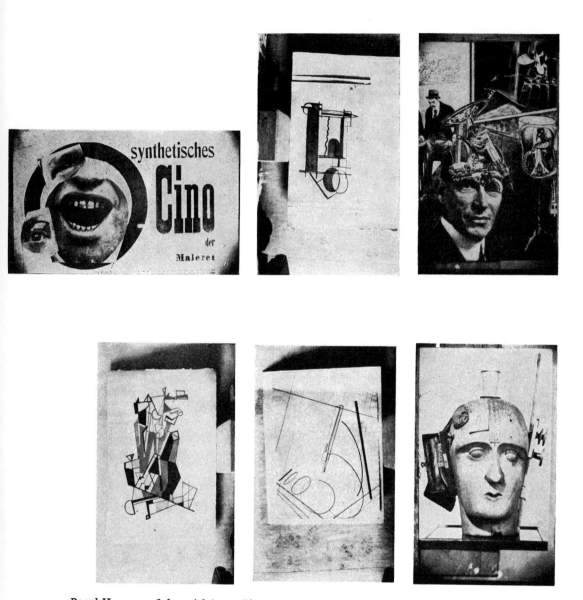

Raoul Hausmann (left to right). 1. *Photomontage*. 1918. 2. *Drawing*. 1919. 3. *Photomontage*. 1920. 4. *Drawing*. 1919. 5. *Drawing*. 1920. 6. *Dada-Plastic*. 1920. Courtesy the artist.

Gabrielle Buffet-Picabia: *Some Memories of Pre-Dada: Picabia and Duchamp (1949)*

I

If, since the beginning of the century, there had not been a certain irresistible undercurrent of thought preparing its rise to the surface and seeking formulation, Dada would never have attained the "historical" importance now given it.

After the self-satisfied rationalism of the nineteenth century, an ebullience of invention, of exploration beyond the realm of the visible and the rational in every domain of the mind—science, psychology, imagination—was gradually breaking down the human, social and intellectual values which up until then had seemed so solid. All of us, young intellectuals of that period, were filled with a violent disgust at the old, narrow security; we were all conscious of the progressive decline of reason and its experience, and alert to the call of another reason, another logic which demanded a different experience and different symbols.

We were convinced of the arbitrariness and falsity of our poor creation, the world. And yet, in our striving for a new gestation, we were none the less compelled to seek a new arbitrary principle, which we had to manufacture out of the whole cloth, with no other tools but trust—to chance or intuition. It was in this period of perplexity which seemed at first without issue—and such a period is characteristic of every inventive process—that the most gifted, most clear-sighted and audacious minds made their personal contribution, selecting and establishing new symbols.

The chance which, in 1908, led me to meet one of them (Francis Picabia) put me in contact with one of the most striking symptoms of the state of mind in question: abstract painting.

Since my childhood, an imperious taste had drawn me towards music; at first it represented merely an extraordinary pleasure, experienced without any outward suggestion or education, as directly as heat and cold; later, it became the object of a no less impassioned curiosity concerning this phenomenon within me: this impalpable but imperious inner reality of the world of sound, this almost visceral

255

predilection for such and such a harmony, such and such a rhythm. Finally, after I had been initiated into the organization of sounds into music, into the strict discipline of harmony and counterpoint, which make up its complex and artificial structure, the problems of musical composition became for me a constant source of amazement and reflection. Consequently, I was well prepared to hear Picabia speak of revolutionary transformations in pictorial vision, and to accept the hypothesis of a painting endowed with a life of its own, exploiting the visual field solely for the sake of an arbitrary and poetic organization of forms and colors, free from the contingent need to represent or transpose the forms of nature as we are accustomed to see them.

May I confess that the first supposedly abstract paintings that I saw left me in a state of perplexity? Such is the power of mental and sensory habits. However, though some of the studies, which Picabia showed to no one, already achieved a total break with pictorial traditions, others were still based upon an objective scheme, which, to be sure, became less and less precise, but in whose structure one could still recognize the impressionistic suggestion of a landscape. Some of these works, which then struck me as incomplete and uncertain, assume at present an extraordinary magnitude and precision; they speak eloquently of a will to abandon the obsolete formulas of imagination and expression, of a determination to reconstruct on a new plane, of an unremitting and painful quest in the domains both of thought and technique. It was a strange period of gestation and adaptation; new works brought nothing but doubt, dismay, anxiety, until minds could adjust themselves and corresponding new reflexes could be created.

It was in 1910, on the occasion of an exhibition at the Hedelberg Gallery, that Picabia's friend Dumont introduced us to Marcel Duchamp, then a very young man, but one whose ideas far surpassed the works he had so far accomplished, which were still subject to Cézannian and cubist influence. Though very much detached from the conventions of his epoch, he had not yet found his mode of expression, and this gave him a kind of disgust with work and an ineptitude for life. Under an appearance of almost romantic timidity, he possessed an exacting dialectical mind, in love with philosophical speculations and absolute conclusions. It has always seemed to me that the meeting of those two exceptional personalities, Picabia and Duchamp, was of capital importance for them both. In that period Picabia led a rather sumptuous, extravagant life, while Duchamp enclosed himself in the solitude of his studio at Neuilly, keeping in touch with only a few friends, among whom we were numbered. Sometimes he "took a trip" to his room and vanished for two weeks from the circle of his friends: this was a time of escape into himself, in the course of which the "sad young man in a train" was transmuted into a captivating, impressive incarnation of Lucifer. The very different temperaments and conceptions of the two men led them to the same extreme point of logical decomposition, to the same immediate, routine logic of the senses. They were as opposed in their reactions as in their methods; but their roads ran parallel, magnetized by the same pole. Picabia exceeded the limits of his creative field by an exasperation of his lyric vein, always under pressure; he abandoned himself to

chance and to his exceptional imaginative faculties. Duchamp on the contrary, by a discipline that was almost Jansenist and mystical, suppressed every impulse, every desire to create, suppressed all joy in creating, and to avert the danger of a routine reminiscence or reflex, forced himself to a rule of conduct directly counter to the natural. But they emulated one another in their extraordinary adherence to paradoxical, destructive principles, in their blasphemies and inhumanities which were directed not only against the old myths of art, but against all the foundations of life in general. Guillaume Apollinaire often took part in these forays of demoralization, which were also forays of witticism and clownery. Better than by any rational method, they thus pursued the disintegration of the concept of art, substituting a personal dynamism, individual forces of suggestion and projection, for the codified values of formal Beauty. These games of exploration in an inaccessible dimension and in unexplored regions of being, this climate of invention which has never since been retrieved, seem to have contained all the germs of what later became Dada, and even of later growths.

Thus they arrived at certain postulates which soon developed into the arcana of the new plasticity and poetics: such as the calligrammes and conversation poems of Apollinaire, or the "ready-mades" of Marcel Duchamp, and above all, the intrusion into the plastic field of the "machine," this newcomer issued from the mind of man, this veritable "daughter born without a mother," as Picabia called his book of poems which appeared in 1918.

It seems incomprehensible to the present generation that the machines which populate the visual world with surprising and spectacular forms, hitherto unknown, could for a long time have remained the victims of a frenzied ostracism in the official world of the arts, and that they could have been looked upon as essentially antiplastic, both in substance and in function. I remember a time when their rapid proliferation passed as a calamity, when every artist thought he owed it to himself to turn his back on the Eiffel tower, as a protest against the architectural blasphemy with which it filled the sky. The discovery and rehabilitation of these strange personages of iron and steel, which radically distinguished themselves from the familiar aspects of nature, both by their construction and by the dynamism inherent in the automatic movements they engendered, was in itself a bold, revolutionary act; but one which, if it had not gone beyond descriptive representation, would have remained very close to the landscape and the still life. Yet, first enthroned for their own sake, the machines soon generated propositions which evaded all tradition, above all a mobile, extra-human plasticity which was absolutely new (and which we encounter in the Futurist theories of the day). The multiple possibilities which this unexplored field offered to the imagination seem to have shown Duchamp his true mission. Or perhaps he created for his own personal use an imaginary mechanical world, which became the place, the climate, the substance of his works. When Picabia was likewise seduced by this theme, he made use of machines with very different intentions, in a humoristic or symbolic spirit. Thus in 1915 he published in Stieglitz's journal, *291*, a series of "object portraits." Stieglitz is represented by a camera; and an automobile horn symbolizes Picabia, who calls

himself *The Saint of Saints. The American Girl* is a sparkplug (*kindler of flame*). These objects are depicted with the precision and relief of a mail order catalogue, with no attempt at aesthetic expression. They are distinguished from catalogue representations only by their isolation and by the intentions with which they are charged. They mark the first symptoms of the crisis of the object (denatured objects, divested of their specific *raison d'être*) which raged in Dada and which, with certain psychological deviations, assumed its full scope in surrealism. And in 1913 Marcel Duchamp showed his first "ready-mades." The "ready-made" consisted of common manufactured objects which he declared to be "works of art" and exhibited as such. This implies that in spirit he divested them of their utilitarian existence and breathed a new identity into them. Still more symptomatic was the *Sugar Cage*, a normal bird cage which, instead of birds, contained lumps of sugar actually made out of white marble. Here there was no mystification, as one might have supposed, but an ironic conflict between the reality of things and the reality which he assigned to them; a kind of compensation entirely in his own manner, by which he escaped the absolute of appearances and sensory relations.

It would seem, moreover, that in every field, the principal direction of the 20th century was the attempt to capture the "nonperceptible." Which justifies and illuminates the poetic and plastic hermeticism of the arts which illustrate our age.

II

The declaration of war in 1914 put a brutal end to this period, characterized as much by its rupture with tradition as by fecund realizations whose effects are not yet exhausted.

The call to arms afflicted the whole world around us. The return to the values of the rubber stamp brought cruel disarray to our little group. Our world of abstraction and speculation vanished like a castle in the clouds. Rejected by the army, Marcel Duchamp prepared to leave for the United States; Guillaume Apollinaire went off to war; Picabia, who had never thought of invoking his Cuban nationality, was compelled in his turn to don uniform, to which no one could have been less suited, and served as a general's chauffeur up to the day when an influential and understanding friend managed to save him from the barracks by entrusting him with an important mission to Cuba. He was to go by way of New York, and set sail in April, 1915. Meeting Marcel Duchamp and a group of old-time friends in New York, he forgot his mission and pursued his voyage no further. This total incomprehension of the exigencies of war might have turned out very badly for him if, thanks to his dissipated life in New York, he had not fallen gravely ill. He profited by a temporary discharge which, from medical board to medical board, carried him to the end of the war.

We passed the years 1915 to 1918 in the United States, except for a few *intermezzi*, such as a trip to Panama, and a stay of several months in Spain. Despite the uncertainty of the times, they left me with the memory of a life rich in experience.

258

However, I cannot help associating the circumstances of these times, the world's anguish that everyone consciously or not bore within himself, with the development of the two men who are the principal subjects of these lines towards a nihilism carried almost to its ultimate limits. I was then in a position to follow step for step the development which for one of them, Duchamp, led to the cessation of all artistic creation, despite the protests of his friends, and which spurred the aggressive, humorous, often cruel imagination of Picabia towards a massacre of all man's reasons (or rather, excuses) for being.

No sooner had we arrived than we became part of a motley international band which turned night into day, conscientious objectors of all nationalities and walks of life living in an inconceivable orgy of sexuality, jazz and alcohol. Scarcely escaped from the vise of martial law, we believed at first that we had returned to the blessed times of complete freedom of thought and action. This illusion was quickly dissipated. The famous American neutrality was indeed nothing but seething slag from the furnace that raged beyond the ocean. It was a brutal life, from which crime was not excluded. We knew, for example, the hero-victim of a fatal drunkenness induced by companions with a view to stealing his identification papers. An enraged propaganda filled the air, both for internationalism and the European crusade. Shameless speculation was rife in every section of society. No sooner had I landed than, betrayed by my French accent, I was approached by a bootblack at the Hotel Brevoort, the hairdresser at Macy's, and my dentist, each of whom, while busying himself about my person, disclosed to me in profound secrecy that he had access to an inexhaustible stock of rifles and ammunition. And each one offered me an attractive share in his profits if only I would present him to the French purchasing commission at the Hotel Lafayette, whose members, it would seem, had also rather lost their heads between dollars and whiskey. Seen from Broadway, the massacres in France seemed like a colossal advertising stunt for the benefit of some giant corporation. New York was rife with espionage; we had been warned and told to be careful what we said in public places. Soon we had a curious experience with this aspect of the war. We were invited to a cocktail party at the house of a certain Mrs. X., who affected the role of a patron of modern art. One of the numerous guests was Count Bernstorff, then German ambassador to Washington. The lady of the house, with or without malicious intent, introduced me most amiably and in a manner most complimentary to myself, adding, "Mrs. Picabia speaks every language." "But what is your native language?" the count asked me politely. And when I replied that I was French, a fact my accent could scarcely have left in doubt, he said in impeccable French, "Then, Madame, you will permit me to speak your language." We conversed for some time in an elegant diplomatic tone, though it would have been evident to any listener that both of us were on guard. The next morning Picabia was called to the French Commission. It was already known that we had met Bernstorff at Mrs. X's. We learned that our hostess' husband was one of the principal manufacturers of arms and other war materials for France, while Mrs. X herself was generally held to be the mistress of the German ambassador—in short, a dubious situation. The French Commission asked Picabia to profit by

Mrs. X's friendliness towards him to learn more about her and clarify her role. Of course he rejected any proposal of this kind, and soon afterward we left for Panama.

In the midst of this international fair, however, there was a little isle of grace where the life of the arts and the spirit had been preserved and where, aloof from official circles and activities, it developed an exceptional revolutionary activity. A little group of artists, mostly European, whose uncontested lights were Duchamp and Picabia, gathered in the gallery of Alfred Stieglitz at 291 Fifth Avenue, or at the home of Walter and Lou Arensberg, generous and intelligent patrons of the arts, where at any hour of the night one was sure of finding sandwiches, first-class chess players, and an atmosphere free from conventional prejudice. The Arensbergs showed a sympathetic curiosity, not entirely free from alarm, towards the most extreme ideas and towards works which outraged every accepted notion of art in general and of painting in particular.

I have preserved the pleasantest memories of evenings passed at the New York studio of the Arensbergs, already filled with fine modern works. It was Walter Arensberg who put up the bail for Cravan and delivered him from the hands of the law after Cravan had taken it into his head to disrobe in public on the platform from which he was to initiate the ladies of Park Avenue into the mysteries of abstract painting.

We had found Marcel Duchamp perfectly adapted to the violent rhythm of New York. He was the hero of the artists and intellectuals, and of the young ladies who frequented these circles. Leaving his almost monastic isolation, he flung himself into orgies of drunkenness and every other excess. But in a life of license as of asceticism, he preserved his consciousness of purpose: extravagant as his gestures sometimes seemed, they were perfectly adequate to his experimental study of a personality disengaged from the normal contingencies of human life. He later recognized, in an interview with James Johnson Sweeney, that in this fabrication of his personality he was very much influenced by the manner of Jacques Vaché, whom he had met through Apollinaire. In art he was interested only in finding new formulas with which to assault the tradition of the picture and of painting; despite the pitiless pessimism of his mind, he was personally delightful with his gay ironies. The attitude of abdicating everything, even himself, which he charmingly displayed between two drinks, his elaborate puns, his contempt for all values, even the sentimental, were not the least reason for the curiosity he aroused, and the attraction he exerted on men and women alike. Utterly logical, he soon declared his intention of renouncing all artistic production. And if he continued to busy himself with his great work in glass, *The Bride Stripped Bare by Her Bachelors, Even,* to which for two years he had been devoting such meticulous care, it was because it had been purchased prior to completion. He was almost happy when it was cracked in moving. As to painting, he kept his word, he never again touched a brush. But at long intervals he did work on certain strange objects or machines, strictly useless and anti-aesthetic, which one of his historians very aptly named "wolf traps" (he should

260

have added: "for the mind."). He drugged himself on chess, playing night and day like a professional. And when asked to participate in artistic events, he consented only for the sake of the scandal that might be provoked. At the New York Independents exhibition, for example, he exhibited a urinal entitled *Fountain*, which was of course disqualified. Yet a kind of occult prescience of men and things gave him an extraordinary influence on all the innovating artists of his generation, particularly the Surrealist, for whom he became a kind of symbol. Although he has to his credit only a very limited number of painted works or invented objects, his contribution is considerable, and, because of his sure judgment, he later came to be consulted as an authority, even in official circles.

Picabia had resumed painting as soon as he arrived in New York, but after a year in the army his new works marked, both in inspiration and technique, a total break with those of the preceding years, among which *Udnie*, *Edtonils* and *Physical Culture* were impassioned and convincing expressions of the Orphic formula, as Apollinaire called it.[1] Now his researches moved farther and farther away from the visual element in painting. They drew inspiration from rudimentary, mechanical or geometric forms, and were executed with the dryness of blueprints. The colors are sober and few; he sometimes added to his paintings strange substances, wood which created relief, gold and silver powders, and particularly poetic quotations which are integrated in the composition and indicate the title of the work. These titles are exceedingly mysterious for anyone who hopes to find in them any key to reality. The whole develops in an imaginary realm, where the relations between words and forms have no objective, representational intent, but recreate among themselves their own intrinsic relations.

Far as they are from classical painting, these works nevertheless preserve an extraordinary plastic power, and are still true paintings. (Some of them were exhibited in 1915 at the Modern Gallery run by Marius de Zayas.)

Then, between 1916 and 1918, Picabia painted next to nothing. The conditions under which we lived, tossed from one neutral country to another, were not very conducive to painting. But his creative mechanism remained intact. Restricted in his thoughts and movements, he gave new form to the forces germinating within him, and from this impulse was born a new source of poetic inspiration, an anarchic but not hermetic language, in which words lose their immediate meaning and exchange the exigencies of syntax for those of rhythm and image, becoming plastic in themselves.

One of the most striking records of this period remains the journal *391*, which he himself supplied with all, or very nearly all, the texts and illustrations during the three years in which its nineteen issues appeared.

Here I quote an article about *391* which I wrote some ten years ago for the magazine *Plastique,* edited by Sophie Täuber-Arp.

"PEOPLE ASK: 'WHY 391? WHAT IS 391?'

"It is a story bound up with certain intermittent, international episodes, swinging and bouncing from New York to Barcelona, from Zurich to Paris: in a realm

[1] [Cf. Apollinaire's *The Cubist Painters*, d.m.a., vol. 1, 2nd ed., N.Y., 1949. ed.]

beyond the oceans, beyond years, events and figures. For before *391* there was *291*.

"At the very beginning, *291* was a small, modest suite (in the English usage, signifying apartment), situated on the fourth floor of a house on Fifth Avenue, New York.

"Here Alfred Stieglitz had his photographic laboratory and several rooms in which he showed, side by side with his own works, a few pictures by modern painters whom he numbered among his friends, and who shared his curiosity for every manifestation of art and thought. His photographs, remarkable specimens (especially if we take into account the remote date at which they were done — 1901) of what can be drawn from an object by a man adroit in controlling and directing its automatism, confronted the art of the painters with a new problem and a mysterious competition.

"Stieglitz published a truly sumptuous magazine named *Camera Work*, containing his own photographic work and that of his disciples (Steichen among others); reproduction of works exhibited in his gallery; and long, serious articles devoted to the themes upon which he himself, his white hair tossed back in splendid disorder, his somber, intense eyes peering through or over his glasses, often expatiated in his little gallery: articles highly anarchic for that time, attacking capitalism, easy success, and money which corrupts the wills of men. Surrounded by his disciples, he could discourse for hours, meting out truths to uncomprehending visitors, dismissing simple curiosity seekers, seducing the undecided. 291 Fifth Avenue became perhaps even more famous as a laboratory of ideas than of photography. So much so that soon the number 291 came to symbolize an avant-garde movement. In 1912 the name of the magazine *Camera Work* was changed to *291*. Such is the genesis, such the mystery—now unveiled—of this number which has intrigued so many readers.

"*391* was born some years later, in 1916, in Barcelona.

"It was the memory of that happy period rather than any logical filiation which led F. Picabia, who was responsible both for the magazine and its title, to invoke this remote parentage.

"Barcelona, an international refuge during the tempest of 1914–1918, then sheltered among other exiles, Marie Laurencin, Albert Gleizes and Juliette Roch, Cravan, Picabia, etc. Picabia, whose unused energies were forever involving him in some Utopian attempt to reconstitute a group and a trend, had thought of establishing a little magazine to celebrate the unforeseen reunion, in an atmosphere of boredom and inactivity, of a few specimens of prewar artistic life, who had been outlawed from the world by their military incompetence and the tragic circumstances of the era.

"This first issue resembled the sumptuous American magazine in no way: in appearance it was more than modest, but it was full of imagination. Marie Laurencin is represented by a charming (and thoroughly objective) portrait of Marie and Janine Picabia (my daughters). Picabia, like a safety valve releasing steam, published a number of strictly mechanical drawings, adorned with mottos that were

often subversive and sometimes poetic; the rest of the issue consisted of a few rather mediocre texts. But this number also inaugurated a section devoted to false news reports concerning the friends and enemies of the whole world. Starting out as a mere joke, this section quickly degenerated in subsequent issues into a highly aggressive system of assault, defining the militant attitude which became characteristic of *391*. The following issues appeared in New York in 1917. Though its intentions were not gentle, *391* nevertheless had great charm, sometimes it was positively hilarious, and in general it was remarkable for its verve and good humor. It remains a striking testimonial to the revolt of the spirit in defense of its rights, against and in spite of all the world's commonplaces."

To sum up this stormy, destructive activity, we may say that though born of the tragic conditions of the epoch, it also marks a culmination of the profound revolution which had been smouldering in the minds of men since the beginning of the century. It only remains to be asked (and a very crucial question this is!) in what form it would have crystallized if the oppression of men's bodies and minds in those cruel days had not provoked this explosion of protest, which was no longer a mere break with tradition but a voluntary break with reason, a kind of auto-inoculation of the absurd by the absurd, assuming the unforeseen dimensions of an immanent, inexorable force, born of circumstances.

It must be stressed in any case that this activity was utterly gratuitous and spontaneous, that it never had any program, method, or articles of faith.

Without other aim than to have no aim, it imposed itself by the force of its word, of its poetic and plastic inventions, and without premeditated intention it let loose, from one shore of the Atlantic to the other, a wave of negation and revolt which for several years would throw disorder into the minds, acts, works of men.

I insist on the perfect gratuitousness of the "demonstrations," which learned historians have represented as conscious and meaningful—in actual fact these demonstrations issued spontaneously from the most trivial circumstances and gestures.

The magazines *The Blind Man* and *Wrong-Rong* (note the involuntary spelling mistakes voluntarily preserved) which appeared under the aegis of M. Duchamp, were intended as nothing more than somewhat subversive amusements. They appeared in only a single issue each—de luxe issues, one might call them—for their circulation was restricted to close friends and contributors.

The cover of one of these magazines bore a vignette representing two dogs sniffing one another in the canine manner; it was a reproduction of an actual match box selected by one of the contributors.

Cravan's lecture, which the Surrealist chronicles report as a decisive Dada act, was the unforeseen outcome of a luncheon at which he had a few too many drinks.

Cravan himself, in a giant's body, harbored the soul of an English bourgeois Romantic in constant battle with the temperament of an adventurer prepared for every illegality. This man who, without money or papers, had secretly crossed ten frontiers in a Europe at war, actually felt very much abashed at his little luncheon

scandal, and it was due to the enthusiastic commentaries of his friends Duchamp and Picabia that the lecture became famous and that he acquired the halo of a Dada luminary.

III

A highly remarkable circumstance which raises many questions is the existence in Zurich of a group of painters and writers whose activities singularly resembled the New York group, although there was no possible contact which could have made known the one group to the other. The only difference between the two was that, duly organized and united under a name of their own choice, the Zurich Dadas seemed to have a better idea of what they wanted and solemnized in official, well-regulated ceremonies, the same cult of unreason which the New York contingent contented themselves with living. It should be noted that this happened in Zurich, Switzerland, another neutral country and, as such, a haven for all those who refused to submit to the exigencies of the war and had made good their escape.

This group consisted of Arp, who had come from Strassburg to escape the Germans, of Hugo Ball from Germany, Janco from Hungary, Tzara from Roumania, and others. In 1916 Janco[1] and his wife Emmy Hennings, opened a kind of literary cabaret in the Spiegelgasse, the street then inhabited by Lenin, who had likewise taken refuge in Switzerland. The walls were decorated with Futurist drawings, collages by Arp and works by Janco. In life and the arts alike, the little group was animated by the same revolutionary spirit, and protested against all intellectual and social prejudice.

Arp wrote at this time:

"At Zurich in 1915, disinterested as we were in the slaughter-houses of the world war, we gave ourselves to the fine arts. While the cannon rumbled in the distance, we pasted, recited, versified, we sang with all our soul. We sought an elementary art which, we thought, would save men from the curious madness of these times. We aspired to a new order which might restore the balance between heaven and hell."

Arp was above all preoccupied with art and the aesthetic problems of the moment. With no introductory stage, he went straight into abstract painting and after 1915 his works show no sign of classical technique. He created objects, poems, and true works of art. He himself has described some of these objects:

"*Egg board,* a game for the 200 families, to be played either in the drawingroom or open air. The participants leave the field, covered from head to foot with egg yolks. *Navel bottle,* a monstrous household article, combining bicycles, sea serpents, brassiere and Pernod spoon. *The glove,* which can be worn in place of the now obsolete head, was intended to make the bourgeois feel the unreality of his world, the futility of his effort and even the inanity of the patriotic real estate business. This of course was a naive effort on my part, for the bourgeois is less gifted with imagi-

1 [This is of course a slip for the husband of Emmy Hennings was Hugo Ball, who founded the Cabaret Voltaire. ed.]

nation than the earthworm and carries in place of a heart an enormous bunion which torments him in times of changing weather, i.e., times of crisis on the stock market.

"In this period Hugo Ball wrote his admirable book *Flight from the Times*, indicative of a development from nihilism towards a mystical spiritualism. Tzara was distinctly nihilistic but he was also a poet. He inspired the propaganda of the little group, to which his organizational talent soon made him invaluable. The early elements were now joined by important recruits: Sophie Täuber, a member of Mary Wigman's ballet; Laban and his dancing school; Huelsenbeck and Dr. Serner. The quarters in the Spiegelgasse proved too small and the group moved to the Cabaret Voltaire, where it was decided that a name should be given to this little association of rebels, united in their spirit of revolt and desire for escape. The Larousse dictionary was consulted for an international word free from any political or partisan color, and even from any exact meaning. Huelsenbeck came across the word "Dada," whose childishness seemed to meet all the requirements. It was unanimously adopted. The Dadas now organized a program of activities which have been described by Tzara in the book entitled *Dada Almanach*.[1] This program included exhibitions of painting or of what passed as such, in the old Spiegelgasse headquarters, renamed for the occasion Dada Galleries, publication of a magazine entitled *Cabaret Voltaire* until in 1917 it became *The Dada Review*, recitation evenings at which poems by Kandinsky, Apollinaire, Max Jacob, Arp and Tzara were read. These evenings soon degenerated into intentionally incoherent and blasphemous demonstrations. At the first of them, Huelsenbeck recited a poem with the endlessly recurring refrain, "And the pastor buttons his fly." Tzara paraded round the stage in a top hat crowned with a lighted candle. The protests of the public mingled with the uproar created by the actors; respectable members of the audience shouted with rage.

"Secretly, in his quiet little room Janco devoted himself to a naturalism in zigzag. I forgive him this secret vice because he evoked and perpetuated the Cabaret Voltaire in one of his paintings. In an overcrowded room, teeming with color, several fantastic personages are seated on a platform; they are supposed to represent Tzara, Janco, Ball, Mrs. Hennings and your humble servant. We are in the midst of an enormous tumult. The people about us are shouting, laughing, gesticulating. We reply with sighs of love, salvos of hiccups, poetry, Wa Was, and the miowings of mediaeval Bruitists. Janco plays an invisible violin and bows down to the ground. Mrs. Hennings, with the face of a madonna, tries to do the split. Huelsenbeck beats incessantly on his big drum while Ball, pale as a chalk dummy, accompanies him on the piano.

"During a visit of Picabia to Lausanne in 1918, the publication of a volume of poems, with illustrations, the *Girl Born Without a Mother* (in other words, the machine), brought him to the attention of the unknown comrades in Zurich, and in February, 1918, the two currents met. The Dadaists in Zurich were living in a fever of demonstrations, publications, exhibitions in many points resembling the

1 [The *Zurich Chronicle 1915–1919* by Tzara in this volume. ed.]

life led by the *391* group. However the Dadaists displayed an attitude less egotistical, more mystical and naive, a desire to appeal to automatic, collective, primitive forces, rather than individualistic exasperation.

"Dada wished to destroy the reasonable frauds of men and recover the natural, unreasonable order. Dada wished to replace the logical nonsense of the men of today with an illogical nonsense. That is why we beat the Dadaist bass drum with all our might and trumpeted the praises of unreason. . . Dada like nature is without meaning. Dada is for infinite meaning and finite means.

"The meeting of *391* and Dada was celebrated in new issues of *391* and of *The Dada Review. 391* appeared on bright pink paper. Arp, Tzara, Picabia and myself contributed to the two magazines, not only with individual work but by the execution in common of an illustration for Dada Nos. 3 and 4. Every detail of this illustration is still fresh in my mind. The medium was an old alarm clock which we bought for a few cents and took apart. The detached pieces were bathed in ink and then imprinted at random on paper. All of us watched over the execution of this automatic masterpiece. The magazine was printed in the awe-inspiring lair of a revolutionary Swiss printer who happened to be out of prison, and who at last restored my conception of the anarchist type, which had been quite upset by my experience of the anarchist club in New York.

"The fusion of *391* and Dada brought a brusque shift in the destinies of Dada and was the point of departure for the astonishing career of Tristan Tzara in Paris, where he established himself in 1920.

"*391* also continued its career of mystification and blasphemy . . . quite gratuitously, for the public, well trained if not educated, accepted everything with a smile; but the spirit which had blown so hard and ardently degenerated in the postwar climate of Paris into a battle of clans, or even of individuals. Picabia abandoned it in 1923 for other publications (*Cannibale* among others), which were no more than pale imitations."

The final period of Dada, the period of its apogee and decadence, occurred in Paris, in 1920. Picabia invited Tzara to France, where he received him, lodged him and introduced him to artistic circles. And soon the climate of Dada activities was restored, more intense than ever. The publications, demonstrations, exhibitions followed one another in an accelerated rhythm, now with a well defined technique of the scandalous and grotesque. In Paris the success of Dada was immense, doubtless because its nihilism corresponded to the general postwar discouragement, which it expressed in a new and brilliant form. And also, perhaps because it brought forth an exceptional expenditure of talent and wit. The fireworks were fed by Picabia and Tzara and other outstanding lights, who later rose to fame. Among these were Paul Eluard and André Breton, for whom Dada was a jumping-off place to a great new adventure, Surrealism.

The Parisian success of Dada definitely consecrated it as a revolutionary movement. But this label was soon to encompass its downfall. Dada acted on men's

minds like an ebullient, stimulating potion—it could not assume any fixed form without irremediably losing its ephemeral, mobile, imponderable virtues.

Through ambition or incomprehension some of its members tried to enlist it in political activity. The misunderstandings began. Picabia abandoned the movement.

(Quotation: "Dada is dead, why did I kill Dada?")

Dada vanished one fine day as a meteor disappears in the sky, leaving behind it the memory of its brilliant trajectory and the light of the numerous fires it kindled in passing.

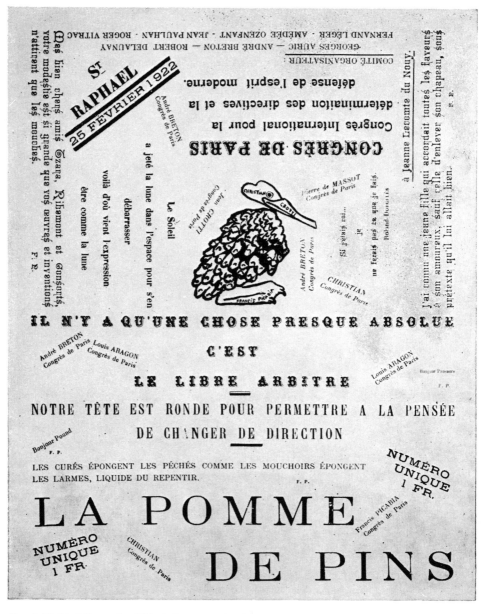

Francis Picabia (editor and publisher). *La Pomme de Pins*. St. Raphael, France, February 25, 1922. (Facsimile of the only issue published: English translation in editor's introduction, p. xxxi.)

L'Idéal

Lorsque vous avez en face de vous un Tableau de Velasquez et que lui tournant le dos, vous voyez un Picasso, pouvez-vous constater la distinction entre ces deux Tableaux ?

Vous cessez de voir le Velasquez quand vous tournez le dos. Mais vous conservez subjectivement l'image Velasquez et vous apercevez le Picasso objectivement, d'où s'en suit une critique qui est la racine de l'idéal.

FRANCIS PICABIA.

LUMIÈRE FROIDE
LUMIÈRE CHAUDE = LUMIÈRE

CHALEUR CHAUDE = BRÛLURE
CHALEUR FROIDE

Christian
Congrès de Paris.

André BRETON
Congrès de Paris.

= Energie = MOUVEMENT = MYSTÈRE

Louis Aragon
Congrès de Paris.

RANGE

Lieu
bit
fa

Jean Crotti

André BRETON
Congrès de Paris.

TOIT s'est que friction dans le monde. Simple question d'amour et de coiffeur. L'homme né coiffeur passe son temps à faire la tête des autres, comme on fait les poches. Elle le rare c'est qu'il y réussisse.

ROGER VITRAC, directeur d' "aventure"

Le pôle négatif est aussi nécessaire que le pôle actif et les deux extrémités de la ligne droite se touchent dans la circonférence.

Liquidation des Stocks.

1.000 RELIGIONS À VENDRE
Un Bréviel d'occasion sur commande. Très bons marchés de objets vieux pour vieux cultes modernes. Si leur valeur filtré un bas-âge AVOCATS le Chambres des Députés.

La Croyance vient de l'Education
Elle rencontre sa perte dans le raisonnement
Mais la foi ne se trouve que dans le Mystère.

CH.

J. CROTTI

ITINERAIRE

Pour aller à Fréjus : L'AUTOBUS
à Cannes : LA CORNICHE
en Vous : L'ASCENCEUR
au-delà : LA VIE.

BAZAR DE SAINT-RAPHAEL
Grand Solde d'Idées
Quelques Pensées DE l'in de saison

André BRETON
Congrès de Paris

RÉELLES OCCASIONS
PRIX SANS PRÉCÉDENTS

MA GLOIRE

D'OR Je rêve : *d'Or je lèse* : je parle d'or, je les endors. Il vit un cadre de stuc. ACCRO-FOL y voulut mettre un tableau. Il l'y mit vivant il - li - mi - té - ment.

CH

Les Cubistes qui veulent à toute force prolonger le cubisme ressemblent à Sarah Bernhardt.

F. P.

Tristan Tzara le perfide a quitté Paris pour la Connerie des Lilas, il est décidé à mettre son chapeau haut-de-forme sur une locomotive : C'est plus facile évidemment que de le mettre sur la victoire de Samothrace.

Ribemont Dessaigne un jour qu'il était à poils mit un chapeau haut-de-forme pour ressembler à une locomotive, le résultat fut piteux. Vauxcelles le prit pour un tuyau de poils — même pas, mes Chers Amis, il avait tout simplement l'air d'un Con ! ! !

Mon Amie n'avait qu'un œil de verre : elle *vit DA : aussitôt elle en eût deux de la même* *couleur. C'est depuis lors que la lune attique* *tique à l'une des lunes nettes de l'Opéra.*

MAX JACOB † ✠

PIERRE DE MASSOT
CONGRÈS DE PARIS

QUI
avale son parapluie
MARCHE
forcément droit.

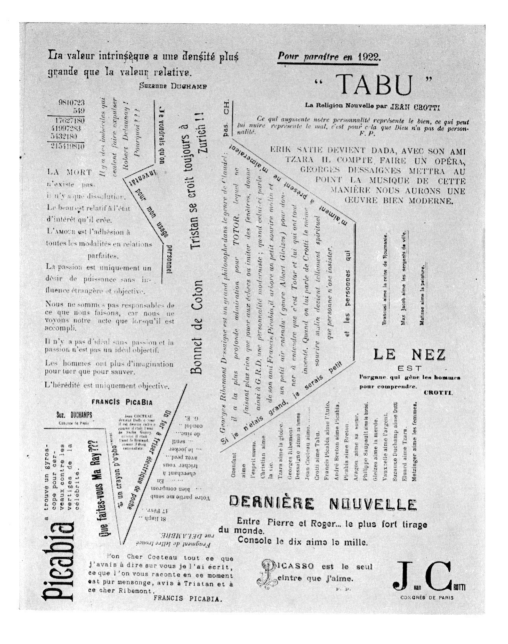

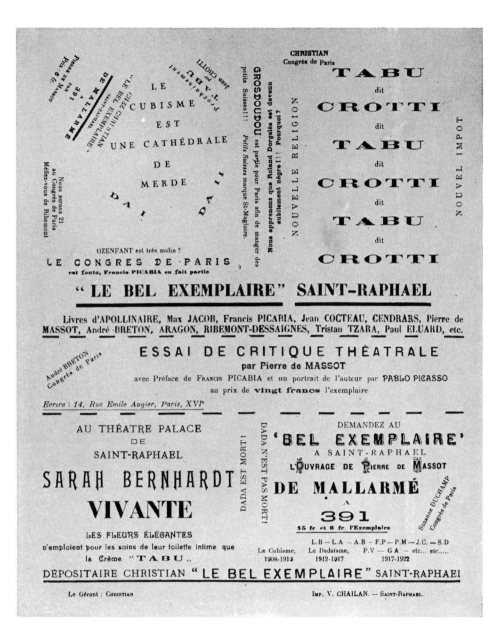

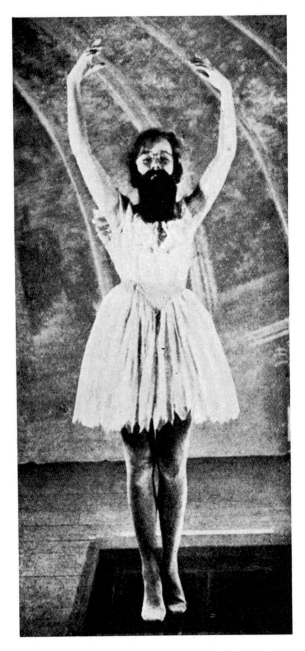

Entr'acte, directed by René Clair, written by Picabia, music by Satie. 1924. Still showing Picabia.

272

XV. *Theo van Doesburg and Dada*

By Kurt Schwitters. 1931. Translated from the German by
Ralph Manheim. Original appeared in the last number of

De Stijl, January, 1932. By permission of Ernst Schwitters.

SONATE

Grim glim gnim bimbim

grim glim gnim bimbim

grim glim gnim bimbim

grim glim gnim bimbim

grim glim gnim bimbim

grim glim gnim bimbim

grim glim gnim bimbim

grim glim gnim bimbim

bum bimbim bam bimbim

bum bimbim bam bimbim

bum bimbim bam bimbim

bum bimbim bam bimbim

grim glim gnim bimbim

grim glim gnim bimbim

grim glim gnim bimbim

grim glim gnim bimbim

bum bimbim bam bimbim

bum bimbim bam bimbim

bum bimbim bam bimbim

bum bimbim bam bimbim

Tila lola lula lola

tila lula lola lula

tila lola lula lola

tila lula lola lula

Grim glim gnim bimbim

grim glim gnim bimbim

grim glim gnim bimbim

grim glim gnim bimbim

bem bem

bem bem

bem bem

bem bem

Tata tata tui E tui E

tata tata tui E tui E

tata tata tui E tui E

tata tata tui E tui E

Tillalala tillalala

tillalala tillalala.

Tata tata tui E tui E

tata tata tui E tui E.

Tillalala tillalala

tillalala tillalala.

Tui tui tui tui tui tui tui tui

te te te te te te te te

tui tui tui tui tui tui tui tui

te te te te te te te te.

Tata tata tui E tui E

tata tata tui E tui E.

Tillalala Tilla lala

tillalala tilla lala

Tui tui tui tui tui tui tui tui

te te te te te te te te

tui tui tui tui tui tui tui tui

te te te te te te te te

O be o be o be o be

o be o be o be o be.

KURT SCHWITTERS

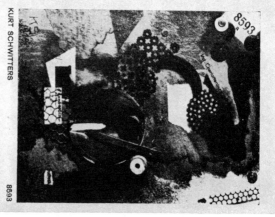

Sonata, by Kurt Schwitters. From Mécano, No. 4–5, Leiden, 1923. Collage by Schwitters.

Kurt Schwitters: *Theo van Doesburg and Dada (1931)*

Everyone knows the van Doesburg of the *Stijl magazine,* the artist of poise, consecutive development, and logical construction, but only a few know his importance for Dada. And yet he introduced Dadaism to Holland in 1923 with unparalleled success, and himself enacted a good bit of Dada in the process.

In his magazine *Mecano* he had already shown himself a great connoisseur of things Dada, and in every line one senses his genuine enthusiasm for Dada, whether he intended it or not.

At the end of 1922, Theo van Doesburg invited the leading Dadaists to a Congress in Holland, which was to take place the following year. Unfortunately we underestimated the receptivity of the Dutch, and so, aside from van Doesburg, I was the only Dadaist who appeared for the introductory evening at the Hague Kunstkring. Theo van Doesburg delivered an explanatory lecture about Dadaism and I was supposed to provide an example of Dadaism. But the truth is that van Doesburg, as he appeared on the platform in his dinner jacket, distinguished black shirtfront and white tie, and on top of that, bemonocled, powdered all white, his severe features imprinted with an eerie solemnity, produced an effect that was quite adequately Dada; to cite his own aphorism: "Life is a wonderful invention."

Since I didn't know a word of Dutch, we had agreed that I should demonstrate Dadaism as soon as he took a drink of water. Van Doesburg drank and I, sitting in the middle of the audience, to whom I was unknown, suddenly began to bark furiously. The barking netted us a second evening in Haarlem; as a matter of fact it was sold out, because everyone was curious to see van Doesburg take a drink of water and then hear me suddenly and unexpectedly bark. At van Doesburg's suggestion, I neglected to bark on this occasion. This brought us our third evening in Amsterdam; this time people were carried out of the hall in a faint, a woman was so convulsed with laughter that for fifteen minutes she held the public attention, and a fanatical gentleman in a homespun coat prophetically hurled the epithet "idiots" at the crowd. Van Doesburg's campaign for Dadaism had gained

a decisive victory. The consequence was innumerable evenings in all the cities of Holland, and everywhere van Doesburg managed to arouse the most violent hostility to himself and his forces. But again and again we all of us—Petro van Doesburg and Vilmos Huszar also belonged to our little group—ventured to beard the infuriated public, which we ourselves had taken care to infuriate, and despite his black shirt-front, Does always produced the effect of a red rag. The Dutch found this deep-black elegance and distinction atrociously provocative, and consequently he was able to plough his public round and round, to cultivate his soil with the greatest care, in order that important new things might grow from it.

It was for me the finest of experiences when suddenly, in Utrecht, as I was proclaiming the great and glorious revolution (van Doesburg was in the dressingroom), several unknown, masked men appeared on the stage, presented me with an extraordinary bouquet and proceeded to take over the demonstration. The bouquet was some three yards high, mounted on an immense wooden frame. It consisted of rotted flowers and bones, over which towered an unfortunately unpotted calla lily. In addition, an enormous putrid laurel wreath and a faded silk bow from the Utrecht cemetery were laid at the feet of the bourgeoisie. One of the gentlemen sat down at my table and read something out of an immense Bible he had brought with him. Since I understood very little of his Dutch, I considered it my duty to summon van Doesburg to exchange a few friendly words with the gentleman.

But this is not quite what happened. Van Doesburg came and saw and conquered. He took one look at the man and did not hesitate for long, but, without introducing himself, without any ceremony whatsoever he tipped the man with his Bible and gigantic bouquet over into the music pit. The success was unprecedented. The original invader was gone, to be sure, but the whole crowd stood up as one man. The police wept, the public fought furiously among themselves, everyone trying to save a little bit of the bouquet; on all sides the people felicitated us and each other with black eyes and bloody noses. It was an unparalleled Dadaist triumph.

I should very much have liked to appear more often with so gifted a Dadaist as van Doesburg. World Dadaism has lost in van Doesburg one its greatest thinkers and warriors.

XVI. *Dada Lives!*

By Richard Huelsenbeck. 1936. Translated from the German
no. 25, Fall, 1936. By permission of the author and of Eugene Jolas.

Snapshot. *Richard Huelsenbeck* (with two children in a park). c.1919.

Richard Huelsenbeck: *Dada Lives!* (*1936*)

In 1916 Hugo Ball founded the Cabaret Voltaire in Zurich, Switzerland. He had left Germany because of his pacifist convictions, and wanted to create, through this Cabaret, a platform for himself in Switzerland, since, at that time, shelter to political refugees was still granted there. With his wife, Emmy Hennings, he organized a center to express the aims of the creative man smothered by the World War. The name of Voltaire was not chosen accidentally, but out of veneration for a man who had fought all his life for the liberation of the creative forces from the tutelage of the advocates of power.

Dadaism was born in the Cabaret Voltaire in 1916. In order to understand why it still lives and why it created such a sensation throughout the world, one must know the special circumstances of its genesis. Among Hugo Ball's intimate collaborators, besides his wife, Emmy Hennings, and myself, were Hans Arp, and the Roumanians, Tristan Tzara and Marcel Janco. Our work in the Cabaret Voltaire had, from the very beginning, an anti-militaristic, revolutionary tendency. Friends came to visit us from the various belligerent countries—from Italy, the Futurists; from Paris, Picabia; from Germany, René Schickelé and Werfel. All of them, even the Futurists, loathed the senseless, systematic massacre of modern warfare.

We were not politicians, but artists searching for an expression that would correspond to our demands for a new art. All of us were enemies of the old rationalistic, bourgeois art which we regarded as symptomatic of a culture about to crumble with the war. We loathed every form of an art that merely imitated nature and we admired, instead, the Cubists and Picasso. We agreed with the Futurists that most public monuments should be smashed with a hammer, and we delighted in the non-representational experiments of Hans Arp, van Rees and Marcel Janco.

One day Hugo Ball was seated in his modest room in a Zurich tenement flat. Besides his wife, I was the only person present. We were discussing the question of a name for our idea, we needed a slogan which might epitomize for a larger public

the whole complex of our direction. This was all the more necessary since we were about to launch a publication in which all of us wanted to set forth our ideas about the new art.

We were conscious of the difficulty of our task. Our art had to be young, it had to be new, it had to integrate all the experimental tendencies of the Futurists and Cubists. Above everything, our art had to be international, for we believed in an Internationale of the Spirit and not in different national concepts.

Hugo Ball sat in an armchair holding a German-French dictionary on his knees. He was busy in those days with the preliminary work for a long book in which he wanted to show the deleterious changes German civilization had undergone as a result of Luther's influence. Consequently, he was studying countless German and French books on history.

I was standing behind Ball looking into the dictionary. Ball's finger pointed to the first letter of each word descending the page. Suddenly I cried halt. I was struck by a word I had never heard before, the word dada.

"Dada," Ball read, and added: "It is a children's word meaning hobby-horse." At that moment I understood what advantages the word held for us.

"Let's take the word dada," I said. "It's just made for our purpose. The child's first sound expresses the primitiveness, the beginning at zero, the new in our art. We could not find a better word."

Emmy Hennings, who in those days was already oriented towards Catholicism and who, at that very moment, was busy erecting an altar in another corner of the room, came over to us. She, too, thought that Dada was an excellent word. "Then we'll take Dada as the slogan for our new artistic direction," said Ball. That was the hour of the birth of Dadaism. The following day we told our friends, Tristan Tzara, Marcel Janco and Hans Arp what we had found and decided on. They were enthusiastic about the word Dada.

And so it happened that it was I who pronounced the word Dada for the first time. I was the first to point it out and to insist that we use it as a slogan for our efforts. I do not mean to over-estimate this service, for Dada has become the symbol of the totality of our artistic expressions. But it is perhaps important to re-state the authorship of Dada since today Dadaism assumes once more a very special importance. My idea of Dada was always different from that of Tristan Tzara who, after the dissolution of the Cabaret Voltaire, founded and became the leader of Dadaism in Paris.

Dada, in my opinion, is intimately connected with the events that are shaking the world today. Dada is regarded in present-day Germany as the symbol of destructive art. In this lies its immortal service. In the word Dada there is still such revolutionary force that the Chancellor of a great empire, himself, poured forth

his rage against it for a whole hour, threatening the Dadaists and their successors with arrest.[1]

Dada as an artistic direction in painting, the plastic arts and literature could never be accurately defined (in contra-distinction to Futurism and Cubism which were artistic creeds with definite programs). Tzara, in Paris, eliminated from Dadaism its revolutionary and creative element and attempted to compete with other artistic movements. That, of course, after a while, was bound to lead to failure, and I cannot feel any surprise that Dadaism should have been rejected in the classical land of rationalism.

Dada is a perpetual, revolutionary "pathos" aimed at rationalistic bourgeois art. In itself it is not an artistic movement. To quote the German Chancellor, the revolutionary element in Dada was always greater than its constructive element. Tzara did not invent Dadaism, nor did he really understand it. Under Tzara in Paris Dada was deformed for the private use of a few persons so that its action was almost a snobbish one. What Dada really is, and what it still means today, can be gauged from the hatred nurtured against it by people who would like to turn the history of the world backward and bring back the old, rationalistic, bourgeois art.

The eternal value of Dada can be deduced from the fact that in Germany an exhibition of "Dadaistic Works of Shame and Filth" was organized officially in order to frighten off the constructive burghers. Dada is forever the enemy of that comfortable Sunday Art which is supposed to uplift man by reminding him of agreeable moments. Dada hurts. Dada does not jest, for the reason that it was experienced by revolutionary men and not by philistines who demand that art be a decoration for the mendacity of their own emotions.

While Tzara transformed Dadaism into an artistic movement, I felt it to be a volcanic eruption. That I was right is proven by the present times and the evolution of the world. Everywhere, throughout the world, where forces are at work to turn back the wheel of history, Dada will be hated. Therefore it is not difficult to predict a great future for Dada. Dada will experience a golden age, but in another form than the one imagined by the Paris Dadaists.

I am firmly convinced that all art will become dadaistic in the course of time, because from Dada proceeds the perpetual urge for its renovation. I am glad to have contributed my share to this change.

[1] See: Hitler's Nuremberg speech of 1934 and also his *Mein Kampf.*

Photographer Unknown. *Johannes Baader.*
c. 1919. From Dada Almanach. 1920.

Johannes Baader. *Gruene Leiche* (handbill). Berlin, 1918(?).

XVII. *Dada* X Y Z ...

By Hans Richter. 1948. Written by Richter for the present volume.

Still. (From *Spook Before Breakfast*, directed by Hans Richter). Germany, 1927.

Photographer unknown. *Viking Eggeling*. 1925.

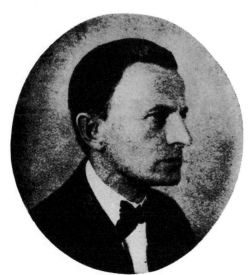

Hans Richter: *Dada X Y Z . . . (1948)*

I never understood Hugo Ball very well. He was rather tall and very thin; when I first met him he looked to me like a dangerous criminal. I took his soft speech for a technique to put one off guard. His dark, mostly black clothes and black, wide brimmed hat made him look abbé-like (another suspicious note).

When he recited his abstract poems in the enormously over-crowded DADA exhibition at the *Tiefenhoefe* in Zurich in 1917, towering over an exploding and applauding-laughing crowd of pretty girls and serious bourgeois, he was Savonarola, fanatical, unmoved, unsmiling.

He was human, nevertheless; he loved Emmy Hennings. When she could not make up her mind, whether a solid and handsome Spaniard or Ball was her favorite, he followed her with a revolver in his pocket (so she said) and searched my apartment, to learn whether the lovers were hidden there. Such problems concerned all of us, and Tzara and I had long conferences to make up the mind Emmy could not.

Of all the personalities in the DADA movement, Hugo Ball oscillated the most. By the end of 1917 he was deep in politics (in Berne, the capital) assisting the heroic Dr. Hermann Roesemeier in the editing of a democratic anti-Kaiser weekly (*Freie Zeitung*) which fought a hopeless battle against the past, present and future of All-German arrogance. He had become a hardworking, whispering diplomat . . . not really. In a city that was full of spies, intrigues and "pulls," he was clearly one of the few idealists, whose intelligence was obviously great enough to attract political figures.

The next time I heard from him, about 15 years later, he was buried near St. Abbondio in Southern Switzerland, where he had lived with his wife Emmy. I learned that Ball had become very religious. When he died in 1927 in St. Abbondio, people from all over the Ticino (the southern, Italian-speaking canton of Switzerland) had come to his funeral, as they had come to him for help and advice during his life among them. Emmy Hennings, a protestant, always had a strong leaning towards the mysticism of the church, but Ball had made faith, the Catho-

lic faith, finally the theme of his life. He had visited Rome, and the priests of the church respected him as one of their own. When I left Switzerland in 1941, fourteen years after his death, the people of the canton still spoke with admiration and love of his sincerity and goodness. He had become a kind of Saint. My first judgement had been very wrong, he was a good man.

Emmy Hennings, who had met and inspired some of the best German poets during her lifetime—who had always, as long as I can remember (1912), lived among artists and writers—had become a writer herself. Books about Hugo Ball, who still "occupies" part of her house in Agnuzzo, short stories and fine poems. She is now correspondent for the *Neue Züricher Zeitung* (the Swiss "Times"), the *National Zeitung* and writes for magazines. She does not live among the Bohême, but with the villagers of the romantic medieval little Swiss villages near the Italian border. She still walks around with the slightly uplifted look of the mystic.

Another mysterious person, of great capabilities, whom I would love to meet again, was Dr. Walter Serner. Nobody knows what happened to him. Whether he finally settled down on a hacienda with one (or several) rich, beautiful women in South America or became involved with illegal heroin traffic in Shanghai is unknown. He was highly prolific, even before DADA, when he published a little intellectual revolutionary magazine, *Sirius*. He was the great cynic of the movement, the complete anarchist, an Archimedes to unhinge the world . . . and to leave it unhinged.

He was as proud as he was poor. Always in an excellent tailored black jacket and striped trousers, the only ones he had, a pink round face accentuated only by a pair of rimless glasses over his lean elegant nose. He was from Vienna and was a wizard of economy, but even so he did not always succeed in having enough or even anything to eat. That he did not tell to anybody, he just disappeared. None of us knew where he lived. He stayed two or three days in bed, not eating, then he reappeared again, pink and fresh, immaculately dressed and managed life again, somehow. His point of view on women was very direct, a kind of caveman with high-class psychology. He did not look it, but he favored the violent approach. Marietta, his steady and extremely lively girlfriend, thought of him as one of the greatest characters living. (She was a great character herself.)

The audience of the "Greatest-Ever-DADA-Show" in Zurich at the *Kaufleuten* (1918) did not seem to look at him the same way. When Serner, sitting on the stage, elaborated his ideas to a headless dummy, to whom he had politely offered a bouquet of artificial flowers, the audience interrupted him abruptly. At the sentence, "Napoleon, also quite a tough bum," the students and younger people on the balcony jumped down on the stage with parts of the several-hundred-years-old balustrade in their fists. The Greatest-Ever-DADA-Show ended in a free for all. When exhausted, we finally got out and looked for *Tzara*, we discovered him unhurt and peaceful in the restaurant in front counting the cash. It was the biggest sum DADA had ever seen.

Tristan Tzara, besides being an inspired poet, always seemed to me the greatest realist of all of us. A vital young man who decided to get the most out of every

286

thing. He was the push behind the publicity, pushing and affronting the public opinion . . . as a matter of play. He represented the Latin side of DADA, coming from the little Paris of the Balkans: Bucharest. The mixture of the Germanic philosophical serious side of DADA (Huelsenbeck, Ball and Serner) with the spirited (Tzara) was a delightful aspect of this movement and its essential foundation.

Tzara was a good organizer and kept DADA going when the going was rough. Mr. Heuberger, our little printer, was more often in jail than out (for revolutionary leaflets) but Mrs. Heuberger, accustomed to such occurrences, ran her cellar business with tears in her eyes. We had to help her when her husband was "detained" to get the DADA numbers done well, by hook or by crook. It was like child birth every time.

Rather different from the versatile Tzara was his compatriot, the olive-skinned Marcel Janco, whose painted abstract plaster reliefs were in all our homes. Where Tzara was aggressive, he was soft and rather sweet. He lived as a kind of head of the family with two younger brothers and a pretty French wife in a bourgeois flat near a church. He was the one who had really a heart. Many years later he wrote me from Bucharest that he had become an architect and that he had such a great desire to go west again (France). But then came the Iron Guard to kill thousands of Rumanians and then the Nazis again killed thousands. I didn't hear from him again.

Also from Slodki, the small, dark, extremely shy painter (Ukrainian?) nothing was heard anymore. He wore the dirtiest suits in that clean city, Zurich. But his heart was very friendly. I didn't know very much about him, but who really knows anything about such unboisterous people in this boisterous world?

And then of course there was Jean Arp, at that time still Hans (as an Alsatian then under German rule). Psychologically he stood between the Tzara-Janco and the Huelsenbeck–Ball–Serner group. For his sovereign sense of humor a small accident might testify. He was called before a medical committee at the German Consulate General in Zurich, to be examined for his mental state (what else but mental defectiveness could have led him to DADA and abstract painting?) and asked how old he was. He took a piece of paper and wrote 16.9.87

16.9.87

16.9.87 all the way

down the page. Then he added the three columns together and presented the result to the physicians. They believed him.

I don't think that Arp ever had an enemy. Friendly, polite, unchanging and without any pretensions he always made good company. He gave DADA a slightly ironic, olympian touch. He took DADA immensely seriously, but laughed about it happily.

We met often, not only at the café Odeon, but at a much more attractive place, at von Laban's famous dance school. That's where Arp found his future wife (Sophie Taeuber) and where I found mine. Also Tzara and Serner were partly and temporarily entangled with the place and its inhabitants. Through this personal

contact the whole Laban school got finally involved with the DADA show at the *Kaufleuten* and danced in abstract settings by Arp with abstract masks by Janco and the choreography by Sophie Taueber. I don't know whether that was the first abstract dance performance ever done, but it was sensational anyhow. I know, though that the puppets Arp and Taeuber made shortly afterwards were the first abstract puppets ever used at puppet shows. They consisted mostly of thread spools joined together, decorated with feathers (to make a prince) or with pearls (to make a princess) or rags (to make the villain). They moved with a grace not of this earth and would have out-circused even Calder's circus in their purity. (They were lost later on.)

One day Tzara introduced me to a Swedish painter who had just come to Zurich from the Ticino, Viking Eggeling. He joined our group but he never was a Dadaist. He was too fanatical to be one. He was the persistent explorer of the counterpoint in painting, of a universal (abstract) language. That was exactly the direction in which I was moving too. We became friends for life in thirty seconds. Eggeling was for Tzara in a way ununderstandable, too "classical" ("Goethe and all that"). Eggeling came as we all did, from Cubism. The fact that he tried to integrate Giorgione and the Italian Renaissance with modern experience made him a little suspicious in Tzara's eyes, but as it is with every new movement, people were accepted also on account of their personality. Even the "classical" attitude could go with DADA when the guy who did it went for it in its own, great way. And that Eggeling certainly did.

Eggeling influenced me deeply as an artist as well as a personality. I had visualized since I was eighteen a world set in perfect "music" of forms and colors. I had taken steps in this direction and had found the first letters to an "alphabet" in the Pos.-Neg. relationship. Eggeling had most valuable new clues to realize such a world and was methodical where I was spontaneous. (I enjoyed life enormously and DADA was but a confirmation of this joy.) At the same time I contributed to Ludwig Rubiner's *Zeit Echo,* a magazine following the great humanitarian tradition of Tolstoi and Romain Rolland. In articles and drawings (*Volksblaetter*-broadsides) I attacked the war and the social irresponsibility of the artist. The obvious contradiction between DADA and Tolstoi intrigued me. The responsibility of the artist for his individual vision seemed to exclude the responsibility of the citizen for men and mankind (and vice versa). It is a contradiction for me still today, but I found that contradiction is one of the fundamental laws of existence, which we can integrate only occasionally, if we are lucky.

Richard Huelsenbeck, one of the "founding fathers," and I met only after the war was over in Germany (1919). He had left Switzerland just before I arrived in 1916. His learned and solid mind (he was an M.D.) was nearest to Ball, with whom he was connected by a sincere friendship. It was he who took the DADA bacillus to Germany where it was considerably colored by the revolution in 1918. He became the aggressive historian of the movement, interpreted its "meaning" and created some of its most characteristic works.

I met him again thirty years later, here in New York. We are now both elderly

gentlemen. We look at DADA with love. The *"épater le bourgeois,"* the *"je m'en-foutisme"* was more than just the eternal rebellion of youth; it was an action directed against the conventional routine with which the generation preceding us made war, rules, art, and us. It broke up what was past & dead, and opened the way to emotional experience from which all the arts profited and still profit.

Note:

Vormittags-Spuk Spook before Breakfast a short film produced for the International Music Festival at Baden-Baden, Germany, with an original score by Paul Hindemith, was produced at a time when DADA had been already integrated into Surrealism. But *Spook* . . . was in its essence still DADA, though it was shown as a Surrealist movie.

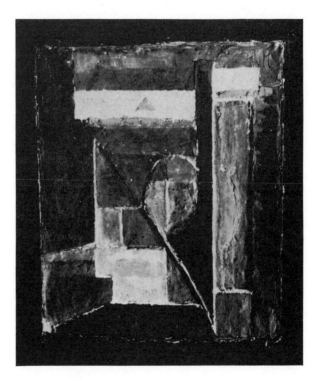

Marcel Janco. *Painted Relief.* Zurich, 1917. Oil. Coll. the artist.

Dear Motherwell:

I want to make a correction – a sad one – in my short essay about the Dada people. Emmy Hennings died in Magliaso (Tessin) in a small room above a grocery store in August 1949. In order to make a living (to survive) she had to work during the day in a factory. — We had not heard from her since years. — Arp told me that he saw her in Lugano 1½ year ago.

All my best

Yours

Hans Richter

13.4 East 60 Str.

Jan 26.49

Hans Richter. *Letter* (to Robert Motherwell). New York, Jan. 26, 1949. (The text obviously means **August 1948**, as the month of Ball's wife's death, not 1949.)

XVIII. *Dada Was Not A Farce*

By Jean (Hans) Arp. 1949. Translated from the German by
Ralph Manheim. Written by the author for the present volume.

Sophie. 1946. By Jean (Hans) Arp. Translated from the
German by Ralph Manheim. Poem written by Arp
at the time of the accidental death of his wife,
Sophie Taeuber-Arp. By permission of the author.

The Three Kerndadaists. Hans Arp, Hans Richter, Richard Huelsenbeck under Huelsenbeck's picture, "The Lion Hunt." 1950. Courtesy C. R. Hulbeck. Photograph by Paul Weller.

Arp: *Dada Was Not a Farce (1949)*

Madness and murder were rampant when Dada in the year 1916 rose out of the primordial depths in Zurich. The people who were not directly involved in the monstrous madness behaved as if they did not understand what was going on around them. Like stray lambs they looked out into the world with glassy eyes. Dada wanted to frighten mankind out of its pitiful impotence. Dada abominated resignation. To speak only of Dada's confusing unreality and fail to penetrate its transcendent reality, is to render only a worthless fragment of Dada. Dada was not a farce.

Die Flucht aus der Zeit (Flight from the Times) by Hugo Ball is a philosophical and religious diary full of lofty contemplation. In this book stand the most significant words that have thus far been written about Dada. *Die Flucht aus der Zeit* is a flight from the material world. In past centuries men yearned for spiritual bliss. They strove to liberate themselves from their bodies. Their life was a preparation for their death. Today people smile at this endeavor as at an obsolete superstition, and melt into meaninglessness and gray foam. Today nothing is sacred to man. He seizes upon everything with his coarse senses. Everything can be bought and sold. His tumult and shouting stifle every poem, every prayer. When in 1926 Sophie Taeuber and I went to visit Emmy Hennings and Hugo Ball on the Tyrrhenian Sea, we spent whole days speaking of Dada. Emmy Hennings read her poems, her profound, creative dreams. We forgot the cruel plaint of Empedocles; we forgot the earth: "that joyless land where are murder and wrath and other species of Fates, and wasting diseases, and putrefaction and fluxes, roaming in darkness over the meadow of Doom." And reverently we spoke of art, which can utter and conjure the ineffable. We spoke of Dada as of a crusade that would win back the promised land of the Creative.

When I met Richard Huelsenbeck, he had fled from a world of vain progress, a word of absurd arts. He had fled from discolored days and nights, in which aged harlots with grass-green hair lurked in wait for carrion lips and lascivious neighing, and on plains fenced round with bones leeches in helmets paraded before be-

medalled scarecrows. When the inventions began to rumble and thunder, when artificial, poisonous heavens began to burst, Huelsenbeck wrote his *Phantastische Gebete* (Fantastic prayers). In these poems Huelsenbeck revealed the diabolical spectre of earthly disorder on a scale which makes it possible to comprehend the incomprehensible madness of the inhuman. Each of his poems brings man into relation with the infinite. With the composure of Herodotus, Huelsenbeck sings of his observations. The human void is greeted with the appropriate froth and horn-blowing. *Phantastische Gebete* brought a new pathos to German poetry.

From 1915 to 1920 I wrote my *Wolkenpumpe* (Cloud Pump) poems. In these poems I tore apart sentences, words, syllables. I tried to break down the language into atoms, in order to approach the creative. At length I rejected art, because it distracts us from the depths and disturbs the pure dream. Out of the billowy breast of height and depth, I awaited the figures upon whose brows gleam tiaras of diamond kisses. Chance opened up perceptions to me, immediate spiritual insights. Intuition led me to revere the law of chance as the highest and deepest of laws, the law that rises from the fundament. An insignificant word might become a deadly thunderbolt. One little sound might destroy the earth. One little sound might create a new universe.

Nor were the painters and sculptors who belonged to the Dada group from 1916 to 1920, reconciled to the art and life of our planet. Among these were Janco, Eggeling, Sophie Taeuber and myself. We were all determined no longer to wrest pictures out of acts, still lifes, landscapes. But we also condemned futurism and cubism. We desired unlimited freedom. We wished to look unencumbered into the heights and depths. Futurism was the art of illusory movement and as such we placed it beyond the pale. For it Viking Eggeling and Hans Richter substituted the abstract film. Pure movement replaced simulated movement. Movement had now become real. But soon the unreality of the real became manifest. Greater and greater, more and more resplendent, spiritual beauty emanated from the films of Hans Richter and Viking Eggeling.

I met Sophie Taeuber in 1915 in Zürich. Like the leaves of a tree in a fairytale, her luminous works descended on my existence. Only a few days after our first meeting, we executed embroideries and collages together. Together we planned large montages. We had met in the beauty of the starry firmament and its mighty architecture had foreordained our work forever. The things and beings that would rise out of us would be free from sorrows, torments, spasms. Our work would radiate bliss like the rose windows of the old cathedrals. The sombre would be immersed in pure light. The arbitrary would dissolve in the essential. The wind of the ultimate depths blew mightily upon us and the earth seemed to us a beautiful goblet, overflowing with luminous life. We forgot the brooding, sultry world of war and ruins. Sophie Taeuber cultivated beauty like a wise gardener. She called each of the singing laughing blossoms of heaven by its name.

Some of us lived in gray cells and our lot of earthly joy was meager. But by way of recompense we were visited by the angels. Angels are no economists. Magnificently they squander their light. Janco never wearied of proclaiming the new art.

If I remember rightly, he spoke as follows, and exactly as I should have done:
"Spiritual reality bestows rich gifts on him who does not close himself to it. In the
depths, the abscesses of festering reason dissolve without trace. Apes and parrots
are the greatest enemies of art and dreams. Men with their reason seek the key that
will open the gate of mystery, the gate of life. Never in this way will they penetrate
to the infinite, peacock-colored halls, in which the golden flames dance and embrace
one another."

Photographer Unknown. *Sophie Taeuber-Arp.* 1942.
Courtesy Arp.

Arp: *Sophie [Taeuber-Arp] (1946)*

What was your dream
when you left this shore.
Did you dream of a raft of stars adrift,
did you dream of a golf of candor?

You pushed aside the intransigent spheres
to pick a flower.
You were resonent with a world of light.

Butterflies represent a scene of your life
in which the dawn awakens on your lips.
A star takes shape according to your design

The curtain of day falls on the dreams
You are a star changing into a flower
The light slips beneath your feet
Radient wings surround you like a hedge

The flower is cradled on your wings.
It wears a jewel of dew.
It dreams a tear of sensibility.
Its kisses are pearls.

It vanishes, it vanishes,
in its own light
It vanishes, it vanishes
in its purity and gentleness. ·

You dreamed upon the finger of the sky,
amid the last flakes of night.
The earth was covered with tears of joy.
The day awoke in a crystal hand.

Appendices

A. *The Dada Case.* 1920. By Albert Gleizes. Translated from the
French by Ralph Manheim. First published in *Action,* Paris,
no. 3, April 1920.

B. *Open Letter to Cahiers D'Art.* 1937. By Tristan Tzara.
Translated from the French by Ralph Manheim. Apropos
Hugnet's *The Dada Spirit in Painting.* First printed in
Cahiers d'Art, Paris, vol. 12, no. 1–3, 1937. Published
here at the request of Tzara.

C. *Marcel Duchamp: Anti-Artist.* 1945. By Harriet and
Sidney Janis. First appeared in *View,* New York, vol. 5,
no. 1, 21 March 1945; and in *Horizon,* London, vol. 12, no.
70, October 1945. By permission of Harriet and Sidney Janis.

D. *Sound-Rel,* 1919, and *Birdlike,* 1946. By Raoul Hausmann.
By permission of the author.

APPENDIX A
Albert Gleizes: *The Dada Case (1920)*

As long as those who were subsequently to instigate the Dada movement produced in isolation, taking individual responsibility for their work, they created very little stir in the so-called enlightened world. Public opinion, which is merely a collective neurosis, failed to crystallize around these scattered persons. But, from the day when the Dada label was affixed to their "productions," everything changed. What had been invisible became visible. What had been known to a few, became manifest to all. The press, which never devoted four lines to a Dada individual, opened its columns to the new association. The socio-diplomatic salons where the stars of our artistic fashion are created, anxiously followed the developments in the *affaire Dada*. The prophets of our so-called French society—that is to say, the authors of articles monopolizing the "French" spirit—trembled at their own uncertainty as to the destinies of this new aspirant to the avant-garde of modern ideas.

Most of the articles purporting to give information about the Dada case revealed the same blindness to its significance. The Dadaists are called fakers, ignoramuses, idiots; they are accused of producing a kind of *a priori* advertising. No attempt is made to see them in their proper place, to look behind appearances. Only Lenormand has written an article showing a certain penetration, avoiding the usual scepticism of the man-about-town, and actually seeking a logical key to the mystery. Lenormand's explanation is in part sound. But since he knew very little about the Dadaists personally, his arguments remained inconclusive. He saw the Dadaists from afar, communicating with them by mail. That is why it seems worthwhile to round out the picture by a special study of the dominant elements in Dada.

Let us proceed methodically, considering the Dada agitation in relation to the epoch. It cannot for one moment be denied that we are now at a great turning-point in the history of mankind. In every country a hierarchy, the hierarchy of bourgeois capitalism, is crumbling, powerless to recapture the reins of power. Events have proved stronger than men, and men are being tossed this way and that, with very little idea of what is happening. The political parties from the extreme right to the extreme left continue to accuse one another of every crime. They cannot get it into their heads that responsibility is an idle word when applied to man, and that superior forces which scientific investigations have not succeeded in fathoming act upon the species far more strongly than any supposed individual will. This bourgeois hierarchy which has organized the economic system on a material plane sees nothing but its threatened class interests. It has reached such a degree of impotence that it can no longer conceive of a system which might provide a safety valve for the ever-mounting pressure in the lower parts of its organism. On the contrary, it constantly increases the pressure, having lost all conception of a possible breaking-point.

On the material plane this bourgeois hierachy is already dead; what we see now

is the decomposition of its corpse. The movement with which it still seems to be endowed is merely the wriggling of the worms that are devouring it, and the glow which prevents the night from being complete is the phosphorescence that we know as the will-o'-the-wisp.

Here let it be understood that "bourgeois hierarchy" is not meant in any demagogic sense. The mania for classification has created certain distinctions whose reality is purely an appearance, and our demagogues use them as a basis for telling the lower classes that they have nothing in common with the upper classes. If they do this for reasons of strategy, it is understandable, but if they are simple-minded enough to believe what they say, it's too bad for them. The bourgeoisie is the expression of a human leaning towards the bestial enjoyment of material realities. And as the division of wealth—an economic conception—is based on money, it is to the power of money that the goods of this world belong. In the human struggle, those who have this power are on top, those who do not possess it but who have the same desire to possess it for the same ends, are on the bottom. Consequently the bourgeois spirit is not peculiar to any special class, but is common to the whole of society. The last scavenger of cigarette butts has the same impulses as the financier who makes peace or war, all that separates them is a simple matter of realization.

The collapse of the money-base and the increasing shortage of goods—these are the factors that are undermining the whole social organism. The cataclysm seems inevitable. There will be nothing ideological about it. From the point of view of the human consciousness, it will be quite simply a rebellion of the stomach and an exasperation of the desire to enjoy life. And indeed, every class of our decomposing society is characterized by an urge toward the satisfaction of every physical desire, and by a total lack of constructiveness or organization.

This engulfing materialism, which is so typical of our bourgeois society, quite naturally prevents us from paying serious attention to the disintegration on the spiritual plane, since spiritual values are what count least in a regime of this sort and the word spiritual has taken on an air of waggish insignificance, living on services rendered and on jokes.

However, it is by juxtaposing the rot on the material plane with the rot on the spiritual plane that we shall gain an accurate understanding of the Dada movement. I am even prepared to say that it is easier to follow the course of this movement than that of the material crisis. Its organism is simpler than the complex of material forces.

The decomposing material body of the bourgeois hierarchy has its counterpart in the decomposition of its spiritual values. The material body returns to dust, the spirit returns to the void. The Dada movement is not the voluntary work of individuals; it is the fatal product of a state of affairs.

Hence it is impossible to accuse the Dadaists of lacking sincerity. If we accept the current conception of what is intelligence, the Dada leaders are intelligent, some of them very much so. Moreover, they are not so very young, and this should be some reassurance as to their honorable intentions.

They are products of the wealthy upper bourgeoisie, and we know that wealth

confers possession of the goods of this world, with a view to sensual enjoyment. Even though the environment in which they have developed has stamped them irremediably, we cannot very well hold them responsible for the class into which they were born.

Being intelligent, they have desired to possess not only material goods, but spiritual goods as well. Gifted with a certain dexterity, even a very young man can convey an impression of spirituality. The upper bourgeoisie is quite flattered to discover among its own a man sufficiently intelligent to keep his mind occupied for a while. Between Edmund Rostand and the Dadaists, there is no insurmountable barrier. It is always the word, the spoken word, and the same mental undernourishment. The same devotees who swooned over Rostand already have their big toe on the step of the Dada car.

At the source of the Dada spirit, we find an adroit utilization of spiritual values once combatted, but now grown fashionable. Then various new impulses brought a sudden revelation. The need to be first became a dogmatic tenet, bringing with it further madness. And to these diverse psychological states correspond a series of pathological states. The abuse of pleasures of all sorts brings the search for artificial stimulation of the senses, to the lashing of the nervous system with liquor and drugs. Result: the total loss of control over the physical organism.

Prior to this stage, what does the individual offer? An intellectual suppleness, yes, but no extraordinary sensibility; a certain *savoir-faire* but nothing to suggest any latent constructive temperament. During this stage and after, he has the illusion of being liberated from the physical laws that govern us. This is a familiar adjunct of the hypnosis induced by drugs, but it is more serious when the illusion is prolonged past the crisis. It is at this moment that the domain of Dada opens. The impossibility of constructing, of organizing anything whatsoever, the absence of even the most confused notion of any such construction, has led Dada to decree that there is no such thing and that the only solution is to do anything, no matter what, under the guise of instinct.

But instinct would seem to be a psychological command which must be translated in order to be properly executed. In the vegetable kingdom or among the lower animals living in the wild state, command, translation, execution are simultaneous, the instinct is manifested free from all constraint. Among the domesticated animals and man, entangled as they are in the mesh of ideas, this simultaneity never occurs in what I would call the waking state. Certain exceptional circumstances are needed before instinct can free itself from its contingencies; these circumstances depend on events and automatically restore the savage state. Consequently disorganization of the practical human conventions is by no means a manifestation of instinct. Such a reversal of values cannot be attributed to instinct, except perhaps to what has improperly been called the *instinct of destruction,* which in truth is merely the consequence of an atrabilious condition.

The stages of human development cannot be based on instinct. In the course of their searchings, men often have intuitions, no doubt, but these take their significance solely from a constructive arrangement. Any calculated striving to re-

capture instinct inevitably reminds us of an aged man striving to recapture the first days of his life. When we say that a person has fallen back into infancy, we mean simply that he has lost all his faculties of control, all his powers of organization and construction. To seek an analogy between the wailing of the newborn babe and the mumbling of the dotard, to be deceived by a certain outward similarity, is to have lost all conception of values.

The leaders of Dada, I repeat, are intelligent. They have cultivated men among them, and in general they do not lack a certain cleverness; often, it must be said, they grossly abuse their cleverness, of which they are only too well aware. Similarly, they are gifted with a critical sense. This critical sense and intelligence has always brought them close to worthwhile trends, but their total lack of constructive faculty has kept them in a doubtful relation to these trends. Their works have always been the blurred image of a face whose architectural determinant they did not discern. Falling into the trap of avant-gardism, they inaugurated the era of subconcious manifestations.

In any case, this intelligence, this culture, this wit, this critical sense, cannot be regarded as an adequate basis for full responsibility. A bit of logic in their ideas and the execution of their ideas is not enough. We know of institutionalized madmen who apply equal logic to their madness, and who are not devoid of intelligence, culture, cleverness, and critical sense. On closer investigation, we find in their special heredity certain manias which are hypertrophied in out-and-out madness. From the pathological point of view, the case of the Dadaist leaders is easily understandable. It is their absolute lack of directing will which has doomed them to the spiritual anarchy in which they seek a justification for their individuality.

Their only certainties derive from an exasperation of the bourgeois conception of art, essentially individualistic and hence reserved for a few of the initiate. Carrying this principle to its absurd conclusion, they shut themselves up in themselves. The presentation of the Dada work is always full of taste, the paintings reveal charming colors, all very fashionable, the books and magazines are always delightfully made up and rather recall the catalogues of perfume manufacturers. There is nothing in the outward aspect of these productions to offend anyone at all; all is correctness, good form, delicate shading, etc. . . .

The forms in their art work are likewise inoffensive, the *grafitti* they draw are quite proper. The texts are so impenetrable that there can be no possible ground for indignation. Sometimes a choice of words creates a lively and felicitous image. What they call instinct is anything that passes through their heads, and from time to time something quite nice passes through their heads. This is no more surprising than to find a certain suggestion of organization in accidental cloud formations.

But very soon we become aware of the dominants, the *leit-motivs* which recur in their artistic and literary works. And then the pathological case becomes brutally evident. Their minds are forever haunted by a sexual delirium and a scatalogical frenzy. Their morbid fantasy runs riot around the genital apparatus of either sex. There is real joy in their discovery of their own sex and the feminine sex. Though they deny everything *a priori,* we must, in spite of that denial. which strikes me

as somewhat premature, recognize that they are full of conviction when it comes to those ornaments with which babies are made and which they so love to toy with. They are obsessed with the organs of reproduction to such a degree that those of their works which may possibly reveal genius are inevitably of a genital character. Moreover, by lingering in these domains, they have found, perhaps without seeking it, another source of instinctive inspiration. They have discovered the anus and the by-products of intestinal activity. And their joy, already great, was further augmented. Progressing from one discovery to another, they announce their triumph to all comers. They make marbles with fecal matter, they gallop over it, they run probing fingers through it. This is a phenomenon well known to psychiatrists. They confuse excrement with the products of the mind. They use the same word to designate two different things.

It is indeed confusion which most characterizes the leveling movement called Dada. With these substantial realities, soul-stirring philosophical aspirations are mingled. The thinkers of the group have acquired solid certainties. Nothing exists. All is appearance and convention. There is no difference between a beautiful work and an ugly work. Nothing is good and nothing is bad. There is no difference between a suit made to order and a ready-made suit from La Belle Jardinière, between a limousine and a jalopy. Cleverly, they hasten to anticipate the obvious argument that there is no logical relation between such ideas and modern life; and, they add, "we always contradict ourselves anyway." In their metaphysical system they visibly confuse the absolute with human relativity. But it is needless to dwell too long on discussions of this sort, since the Dadaists affirm that to affirm is a heresy, and that there is nothing, nothing, nothing.

However, it is delightful to follow them in the field of propaganda. Never has a group disposed of such equipment for saying nothing, never has a group gone to such lengths to reach the public and bring it nothing. We are confronted by the manifestation of sheer bourgeois mentality, in which theatrical vanity far outweighs the logic of the idea to be put forward. Here there is no shadow of a contradiction. A perfect logic directs the means of publicity. A smooth-running mechanism automatically enlists the magazines and the scenic sarabandes. Of all human beings it is the Dadaists who have the greatest appreciation for the discovery of printing. They distribute profusely their magazines and books. They do not sell them, they give them away, and this they do in the grand manner. It must be said that they go to all this effort for reasons of hygiene. For these men who say nothing, nothing, nothing, are mortally afraid of silence. They cannot live alone. They seek the crowd, in which they believe. They are flat on their bellies before it, or else they engage in all sorts of clownery in order to coax catcalls or invective from it. They invite it to their demonstrations and stranger still, the crowd comes and does their bidding. As they disperse after their meeting, the Dadaists rub their hands and say, "Big success!" This crowd is composed of curiosity seekers and of highly Parisian boulevardiers, the arbiters of artistic fashion for snobbish circles. These elements are in quest of the "modern direction." The fear of no longer being modern holds them in its grip, and they keep asking each other what to do. Let them be of good

cheer and take up Dada without further hesitation, for Dada is modern if by this we mean that it is the great attraction of the day, the "great event of the season."

It is only the founders of Dadaism who are consistent with themselves and whose case merits attention; the others who have flocked to their banners are the victims of bourgeois intellectual society. The fever of the epoch has unhinged anxious temperaments, who are often gifted but lack the means of control necessary for constructing what they would have wished to construct. Dada tells them that there's no need to knock themselves out, that they can write whatever they please, and this relieves all anxiety. How comfortable! And a swarm of nonentities who for years and years have been unable to extract anything from themselves, find themselves justified by the new trend. Today the whole world is confronted not only by a social crisis, but by a spiritual crisis as well. And the result is that from all quarters the perplexed and disoriented swarm into the Dada trap.

The Dadaists no longer organize ideas by arranging words according to an ordering syntax. They have not yet destroyed the word itself, but they will do so yet. I know of certain Dadaists in New York, bolder or more naive than the others, who have attained this summit. Our Parisians will taste this dish some day when one of them who has not gone to America serves it up to them, deliciously transposed and adapted to the French spirit. And when Dada will have found its formula, its genetic and scatalogical base will have collapsed and the cataclysm will be upon us.

Dada claims to discredit art by its agitation. But one can no more discredit art, which is the manifestation of an imperious impulsion of the instinct, than one can discredit human society, which also springs from an imperious impulsion of the instinct. One can no more discredit art by systematically destroying its values, than one can discredit society by a fraudulent international bankruptcy. What Dada destroys, without assuming responsibility for its acts, is certain notions of servitude which would vanish very nicely without its help; since what is destroying the bourgeois hierarchy on the material plane is its false conception of the distribution of social wealth. And that is why Dada, in the last analysis, represents merely the ultimate decomposition of the spiritual values of that decomposed bourgeois hierarchy.

Its case deserves careful study as part of a general process whereby, amid the putrefaction of the corpse, something solid is already beginning to take form, something which tomorrow will appear very much alive on a twofold, material and spiritual plane, something which is neither modern nor classical, but quite simply in the human tradition.

APPENDIX B

Tristan Tzara: *A Letter on Hugnet's "Dada Spirit in Painting"*

Paris, February 16, 1937

My dear Zervos:

Your article [the last chapter of Hugnet's *Dada Spirit in Painting*] in the latest issue of *Cahiers d'Art* calls for comment and I wish to thank you for giving me an

opportunity to express myself on the controversial questions relating to the Congress of Paris and the *Coeur à barbe* (*Bearded Heart*) performance.

Is it possible to abstract an incident, to detach it from the time in which it occurred, to make it impervious to the pressure of events? It must furthermore be remarked that it is by no means fortuitous if the publication of this peculiarly tendencious article coincides with the most anguished moments registered by history since the War. The profound grounds for disgust from which Dada gathered its strength are again becoming singularly timely. But today they relate to a no less subtle category of pen-pushers, bureaucratic moralists and righteous vultures, who are again trying to "divide and rule" for the benefit of the most sordid special interests.

With this in mind, despite my dislike for concerning myself with events that took place fifteen years ago, I shall pass over a number of other questionable statements that occur in the aforesaid article and limit myself to the following observations:

1) The Congress of Paris was an enterprise concerned only with aesthetic discussions and had no influence on certain subsequent collective demonstrations of a social character. Not only was the judgment that it was reactionary as compared to Dada not "historically contradicted" by the various actions that followed; on the contrary, the very fact that the Congress, for lack of valid grounds and supporters, did not take place, strikingly confirms its lack of content and timeliness.

2) The words so indulgently judged "unfortunate" that were addressed to me in a newspaper release were: "newcomer from Zurich" and "publicity hungry imposter"; this occurred only a few days after the official invitation to participate in the Committee of said Congress.

3) *Le coeur à barbe* (April, 1922), a "pamphlet attacking the Congress," was headed by a foreword signed by Éluard, Ribemont-Dessaignes and Tzara, and further included contributions by: Huidobro, Péret, Satie, Serner, Rrose Sélavy, Soupault, etc. If there was any sabotage of the Congress, it was far from being my private affair.

4) In *Les Feuilles Libres* for April–May, 1922, along with all the documents concerning the Congress of Paris, there appeared a resolution in which the signatories, after a certain number of expected remarks, withdrew their confidence from the Committee of the Congress of Paris "in its present form and in its capacity of organizing committee." These signatories included: Satie, Tzara, Ribemont-Dessaignes, Man Ray, Éluard, Zadkine, Huidobro, Metzinger, Charcoune, Radiguet, Emmanuel Fäy, M. Herrand, Férat, Roch Grey, Raval, Nicolas Bauduin, Zborowsky, van Doesburg, Zdanévitch, Voirol, Pansaers, Survage, Mondzain, Marcelle Meyer, Arp, Dermée, Céline, Romoff, Péret, Sauvage, Arland and . . . Jean Cocteau.

5) It rings false to speak today of a legal paper which I allegedly sent Éluard the day after the performance of *Coeur à Gaz* (*Gas-operated Heart*) 1923. No one, including the supposed recipient, has ever accused me of this before. Moreover, if he had found this missive as abominable as the author of the article in question

would have us believe, the addressee of this "legal" paper would surely not have kept up over a period of many years a friendship with me, the existence of which I have no need to prove.

6) Into what blind alley is the historian of Dada trying to shunt the controversy? Rather than indulge in idle gossip, would it not have been better to speak of that meeting called by one of our group approximately one month before the performance of *Coeur à barbe,* in the course of which, as revealed in the minutes (!), it was decided, and surely not on my instigation, to resume Dada activity? The following day an exceedingly lamentable demonstration at the *Salon des Independents* led me to make up my mind, this time for good, to have nothing to do with any further attempts at repatching. The historian of Dada passes over all this, and numerous other points as well, in silence.

Since I am obliged to revive the anecdotal history of these times, permit me to recall that this same *Coeur à Gaz* had been performed two years previous by Éluard, Péret, Aragon, Ribemont, etc. . . . Hence the question seems opportune: Is it not likely that this demonstration, the hostility of which was directed, not against *Coeur à barbe,* but against the second part of the program, the performance of my play *Le Coeur à Gaz,* was not the expression of a principle, but of a personal vengeance directed against myself? For, although I am not eager to qualify such personal vengeance with the severity it deserves—I shall be pardoned for not bearing grudges at this late date—, the "moral" sentiment of my comrades-in-arms often faltered when confronted by the stumbling block of private vindictiveness. How else can one explain the persistence with which certain instigators of the demonstration persecuted me on the basis of all sorts of mutually contradictory justifications? Curious justifications, incidentally, which drew their substance from the effects of an act, the true causes of which could never be presented. In a book which recently appeared in England under the title, *A Short Survey of Surrealism,* by Gascoyne, whose good faith seems to have been abused, the end of Dada has already been explained (and this under the patronage of three responsible Paris personalities who, as the preface indicates, furnished the material) by the sentence from *Nadja* in which (five years after the event) the author [André Breton] affects to believe that it is I who "peached" to the police on the *Coeur à Gaz* demonstrators. (Still the police, as you see!) The maneuver, in the English book, consisted in failing to mention the sequel to this ill-starred mystification. For this vulgar fabrication was subsequently to be denied by the pen of its own author (cf. *Second Surrealist Manifesto,* in *The Surrealist Revolution,* No. 12, 1929.)

, But when the levity of these weighty charges became apparent, the author of *Nadja* was himself forced to admit as much in the few sentences which he wrote in the margin of page 21 (in place of the discredited sentences which he crossed out) in the copy of the book which he sent me at the time of its appearance (1928). And since these sentences were not inserted in subsequent editions of the book, I take the liberty of quoting them here in their entirety: *"I wish I had not written that. Perhaps I was mistaken. In any case, Tristan Tzara can boast* [. . .] *my first great*

cause of despair. All the confidence of which I had ever been capable was at stake. This is my defense."

Here the readers of *Nadja* may enjoy the first appearance of an unpublished item, and at the same time learn from this document of tardy good faith and from the fog in which they were knowingly plunged, how history is written, even history on a very small scale.

Please, my dear Zervos, accept my sincerest greetings, TRISTAN TZARA

P.S. Here is one more document relating to that joyous *Coeur à Gaz* demonstration.

My dear Tzara,

Here are the facts on the *Coeur à barbe soirée* in so far as it is possible to reconstitute the story fifteen years later.

The *soirée* was organized by the group around the Russian *"Tcherez,"* of which I was an editor. Having obtained a certain success with an exhibition of stage designs at Paul Guillaume's and a recitation evening at the *Galerie La Licorne,* we wished to undertake something on a larger scale. We decided to rent the *Théâtre Michel* and to ask you to take part in this soiree with a presentation of your *Coeur à Gaz.*

I thought that this demonstration would pass off in the same way as the preceding ones. But the day before, I received a letter from Paul Éluard, protesting against the use of his name on the program beside that of Jean Cocteau; Marcel Herrand had indeed decided to recite some poems by Tzara, Soupault and Cocteau, while M. Bertin would render others by Apollinaire, Éluard and Baron. To stress his disapproval, Éluard informed me in the same letter that under these new conditions he refused to preface my book *Ledentu le Phare,* which was about to appear. But when I met Éluard at the door of the theatre, he warned me that he would not content himself with this move against me, but would particularly demonstrate against you, for it was you whom he considered responsible for the appearance of his name beside that of Cocteau on the program. . . . As for your strange battle with Éluard, it is obvious that no one else participated in this encounter, either on your side or Éluard's. Éluard and I were close friends and I preserved my feelings of friendship for him even after that evening.—Permit me even to remind you that when you wished to snatch from my hands the cane I was holding, I resisted, saying: "No, not with my cane."

Altogether, between you and Éluard, my attitude and that of *"Tcherez"* was one of "non-intervention."

You will readily understand why I use this tragically current word in reference to that simple incident.

February, 1936 *Ilya Zdanévitch*

APPENDIX C

Harriet and Sidney Janis: *Marcel Duchamp: Anti-Artist (1945)*

Counter-art-wise Duchamp, arch rebel of 20th century art, stopped painting more than twenty years ago. Nevertheless, new works continued to come into being,

appearing sometimes mysteriously, sometimes miraculously, out of the depths of the serenity that surrounds and the quiet that informs his life and his person. These works are scarcely recognizable as the products of creative activity: they are so unorthodox and so far removed from patterns, centuries-old, of the material and conceptual substance of painting and sculpture. A cataloguing of this fascinating miscellany of the last quarter century would include rotoreliefs, cover designs, montages, objects, near-objects, cinema, ready-mades, collapsible sculpture for traveling, and mobiles.

Perhaps more than any other living artist in this revolutionary period, Duchamp has departed from all existing norms. As an example, since his arrival in America in 1941, he installed the surrealist exhibit for the Coordinating Council of French Relief Societies, Inc. Spinning in front of the pictures a veritable maze of cobwebs made from three miles of string, he symbolized literally the difficulties to be circumvented by the uninitiate in order to see, to perceive and understand, the exhibits. He has also been engaged in completing his imaginatively conceived *Boîtes* which contain facsimile reproductions of his life work, in half-tone, in color and in miniature objects. The *Boîte* is a device which, when manipulated, retrospectively unfolds the work of Duchamp before the spectator in such a way that the presentation constitutes virtually a composite portrait of the artist's personality set forth in esthetic terms.

Despite the prevailing idea that Duchamp has abandoned art, the high spiritual plane on which all of his activity is conducted converts every product, whether a personally selected "ready-made" or his dada installation of a surrealist exhibit, into a work of art. It is such cumulative evidence that attests to a continuing creativity on the part of Duchamp from the time of his earliest paintings done in 1910–11 under the impact of Cèzanne to the varied works executed today.

Always an active dadaist, Duchamp's attitudes were articulated, however, in the years preceding dada, and although acclaimed by the surrealists, he retains these proto-data attitudes in their nascent state. Whether or not dada had been formulated into an organized program, Duchamp would undoubtedly have gone his way just as he has done. Anti-artisan and anti-artist, he is anarchic in the true sense, in revolt even against himself. He says, "I have forced myself to contradict myself in order to avoid conforming to my own taste." Like the German, Kurt Schwitters, he may be regarded as a natural dada personality.

Out of this native dada spirit emerges the invention of a series of new techniques so original and varied, at once so imbued with the spirit of play and of earnestness, of freedom, spontaneity and yet of reflectiveness, so marked with the character of the individual and with that of the period, that they constitute not only an absorbing chronicle of the creative life of a highly sensitive, intelligent and civilized person, but, as well, an imposing contribution to modern esthetics.

These techniques are bound up with Duchamp's philosophic concepts. They spring from the core of his ideology. They are the means to a modern imagery, to a contemporary mythology, to miracle-provoking mechanomorphic fetishes. They are achieved in as detached and impersonal a manner, as unsentimental, unro-

mantic and unemotional a manner as it is possible for a highly speculative and disciplined individual to employ. This asceticism on the part of Duchamp is akin to that of Mondrian, and here a comparison with a similar tendency in another artist merely serves to point up the difference in accomplishment to be found in different personalities. Mondrian's severity carried him to a finality of logic envisioned within the premise of the original canvas rectangle, of primary color, and of paint and brush. To Duchamp, the brush, the canvas and the artist's dexterity of hand are anathema. He thinks and works in terms of mechanics, natural forces, the ravages of time, the multiplex accidents of chance. He marshals these forces, so apparently inimical to art, and employs them consciously to produce forms and develop objects, and the results themselves he regards as secondary to the means used in making them. Under such circumstances, his works literally demand consideration in terms of the techniques employed, for these techniques carry the burden, in a new and significant way, of the structure of intellectual, esthetic and spiritual content in the objects which he has made. So organic, and so intimate is the connection between concept and technique in Duchamp's entire work, that it becomes necessary to discuss one in order to show through its reciprocal action upon the other, their joint reason for being.

Duchamp's work falls into categories of threes, intentionally or otherwise: movement, machine concept, and irony. Irony subdivides into three groups: selection, chance and the ravages of time. Chance configurations are designated by Marcel as obtainable by employing the following three methods: wind, gravity and the device termed *adresse*.

Concept of Movement and Resulting Techniques

The idea of movement intrigued Duchamp almost from the time of his first painting. It remains a recurring theme which appears constantly in varying ramifications. In 1911 he painted *Portrait*, a monochrome picture with five versions of the figure spreading from a common base across the top of the canvas. This is still partly the idea of *simultaneity* deriving from cubism, but goes further in that it suggests movement of the figure itself as well as movement of the spectator around the figure as in cubism. The *Coffee-grinder*, 1911, charts movement by showing the position of the handle at various intervals within the arc it describes while in motion. *Nude descending a staircase*, 1912, is a progression, giving the kinetic continuity—virtually futurist—of the figure as it moves through a designated area of space. Duchamp terms this "giving a blueprint of movement." In *King and Queen traversed by swift nudes*, 1912, Duchamp opposes figures in motion and static figures; *Passage of the virgin to the bride*, 1912, fuses the concrete idea of the figure in motion with the abstract idea of its transition from one state of being to another. In his chef-d'oeuvre, the large glass titled *La Mariée mise à nu par ses célibataires, même*, 1915–23, the concept of this picture, to speak in most general terms, deals with cause and effect—the changes resulting in matter from the play of forces upon it. Whatever movement is implied in these changes is not given kinetically, as in other pictures mentioned, but is effected pictorially alone, by virtue of plastic rhythms.

These pictorial rhythms interact between the various mechanical forms which are presented as being stationary rather than in motion.

An early mobile, 1916, a bicycle wheel mounted on a kitchen stool, tacitly invited the observer to spin it. Here is the object itself, one that incorporates actual motion, as contrasted with previous painted representations of motion. *Rotary glass plaques,* 1920, is the next step. Now the construction is entirely fabricated by Duchamp and is spun this time by a motor. This is an ingenious device consisting of a series of rectangular opaque glass plaques of graduating sizes, spaced a meter deep on an axis and decorated with black and white lines. In motion these lines create an illusion of circles on a flat surface. Thus the object when spun seems reduced to two dimensions.

A further step is *Rotary demisphere,* 1925. Here a series of eccentric circles is painted upon a hemisphere. When set in motion by the attached motor, these circles optically spiral, alternating away from and then toward the observer.

Rotary demisphere in turn served as the model, the principal actor, for the film, *Anémic Cinéma,* 1926. There is a further application of this idea in a series of optical discs titled *Rotoreliefs,* 1935, which might be called phonograph records for the eye. The discs, placed upon the revolving turntable of a phonograph, exploit through optical illusion many variations of movement in three-dimensional space.

The techniques used throughout the continuity on movement are, first, the conventional paint and brush unconventionally employed, then many original and brilliantly conceived techniques developed for the large glass. These will be discussed later. Subsequently, constructions to be manipulated by hand, motor-driven constructions, as well as cinema, established movement, completing the change from semi-abstract representations of naturalistic movement (*Nude descending a staircase*) to actual physical motion, including optically created presentations of abstract movement (*Rotaries* and *Rotorelief*).

Machine Concept and Techniques of Application

In 1911, Duchamp's brother, the sculptor, Duchamp-Villon, asked each of a group of artists to make a picture for his kitchen. Among the artists were Léger, Metzinger, La Fresnaye, Gleizes and Duchamp himself. Marcel's contribution was the *Coffee-grinder,* which he made casually and pleasurably, responding to the mood of the circumstances under which it was requested. However, it was destined to be more than a perfunctory kitchen decoration, for while working on it, his interest shifted from the outward aspect of the object to its mechanics, to the manner in which it worked and moved as a machine.

This incident served to release the inventive and fecund personality of Duchamp as it exists today, as if inadvertently he had exposed to light and air, to the necessary elements, a nucleus from which his own psyche could develop and grow. Duchamp regards the *Coffee-grinder* as the key picture to his complete work. Looking back through the structure of his achievement, the elements, constantly in one mutation or another, in one degree of complexity or another, are all present in simple form

in the *Coffee-grinder:* movement, already referred to; the magic of mechanics; and the inimitable flair for pointed irony.

From the time of the *Coffee-grinder,* physical, poetic, esthetic or ironic references to the machine are part of Duchamp's created world; the kinetics of the machine, its dynamics, energy and rhythms, machine-made products, machine forms, and the machine itself formulate its physics, fill its space. In this world, the human mechanism operates like a machine and resembles the machine, natural forces are synchronized with man-made power. Duchamp animates the machine, mechanizes the soul. Between these counter effects, motion becomes pure operation without objective or consciousness.

Fascination with the mechanics of the *Coffee-grinder* became diverted to those of the human form, in paintings, and especially in the drawings, sketches and paintings made as preliminaries to the large glass. *Passage of the virgin to the bride* is as complex in its mechanical aspect as in its movement, for changes in the form of the inner mechanism of the bride follow changes in her state of being. *The Bride,* 1912, is perhaps the most poetic version on canvas of a work in the mechanomorphic concept.

By 1913, Marcel is rejecting as well as accepting this interest in the internal structure and workings of the human mechanism, for simultaneously with these constructions, he drew a pattern, another "blueprint," called the *Cemetery of uniforms and liveries.* This is a plan for the group of malic forms or bachelors used in the large glass, and conceived, as it were, as empty hoods—"hoods without motors beneath." The large glass visualizes both the inner and external character of objects and persons. The inner is that of the bride's structure, highly mechanized and abstract, which has been transformed, as we have seen, through the series of changes in the various preliminary sketches and paintings made for it. The bride has been further transformed by the malic forms in the glass itself. These are depicted in their outer aspects as moulds, or uniforms, symbolic of their occupations identified by Duchamp as those of priest, delivery boy, cavalry man, cop, undertaker, servant in livery, bus-boy, station master, gendarme.

They are responsible for setting in motion the series of causes and effects transmitted by the Duchamp-invented machinery and experimental apparatus: the glider, the chocolate grinder, the large scissors and the cones; also by visualized mechanical processes as in the three circles, or "optical evidences" of change.

In 1914, a year before starting the large glass, Duchamp had arrived at a speculative point of view as a result of which he designated objects as ready-mades. Ready-mades are what the name implies, complete objects which are at hand, and which by reason of the artist's selectivity are considered by him as belonging in the realm of his own creative activity. The assumption is that the object, conveying properties which coincide with the artist's angle of approach, is endowed as a work of art by virtue of the insight and authority of the artist's selection. Selection is here no longer just a step in a process. It becomes a completed technique.

That these objects, which Duchamp signed, were most frequently machine-made, reflects the conditioning imposed by his interest in the machine esthetic. Examples

are the famous *Fountain,* 1917, rejected from the Independent Show in New York that year, the Underwood typewriter hood, 1917, a coat rack, an arm from a hat rack, later used for a shadow in the sensitively achieved mural entitled *Tu m',* 1918. Occasionally, as with the bottle rack, his first ready-made, he added an inscription, or as with the shovel suspended from the ceiling and entitled *In advance of the broken arm,* 1915, he gave a literary title to "create another form, as if using another color." There is also the ready-made-aided, in which details are added to stimulate various responses. In the object subtitled *à bruit secret,* 1916, a device to express the idea of compression, two pieces of metal fastened by bolts compress a ball of twine. The ready-mades may be unique as a concept, but they are not necessarily intended to be unique as examples. For instance, the bottle rack was lost and replaced by another. Although the original inscription was forgotten and no other substituted, the act of replacing the object itself grants to the product of mass production the same validity as nature grants to any star in the skies or grain of sand upon the earth.

The ready-made is the forerunner of the surrealist *objet trouvé,* objects generally found in nature and singled out for possessing, through the workings of the elements of nature, fantasy, esthetic configuration or paranoiac images.

Irony as Concept and Technique

"The distinguishing quality of irony is that the meaning intended is contrary to that seemingly expressed. Irony may be gentle or cutting."—N. Webster.

"Irony is a playful way of accepting something. Mine is the irony of indifference. It is a 'meta-irony' ".—M. Duchamp.

Duchamp's credo for working is based on a highly evolved logic outside of the esthetic considerations of "good" or "bad." The esthetic result is not only an objective, it is intentionally disregarded. That a high esthetic quality stamps all that he touches is the result, not of intention, but of Duchamp's high degree of sensibility. He identifies the means of working, the creative enterprise, with life itself, considers it to be as necessary to life as breathing, synonymous with the process of living.

There is implied here the attempt to animate art, to establish a vital and meaningful interpretation between life and art, to cause both to pulsate as one natural living process. Merging the impulse of procreation with that of artistic creation, there apparently accrues for Duchamp a sense of universal reality which interpenetrates the daily routine of living.

Just as a child often cancels out a picture he has made by running a brush across it, Duchamp negates the seriousness of his own inner motivation by running it through with skepticism. Possessing a revolutionary attitude of mind, Duchamp postulates his responsibility to himself and to society, but, under the influence of his own philosophic detachment, disclaims such a responsibility. Here is the core of the inner drama, the conflict between acceptance and rejection that is the basis of Duchamp's philosophic and esthetic rationale. He resolves it by accepting both sides as concomitant parts of reality. Total skepticism could have meant suicide, as it did subsequently for one or two of the early surrealist poets. Or it could have

meant complete inactivity resulting from a constant state of bewilderment or a persisting mood of indifference. (It has long been the general impression that Duchamp fell into this condition because he does not paint on canvas or make sculpture that is readily classifiable as such.) Irony, the "playful way of accepting something," has made it possible for Duchamp to attempt a synthesis. Instead of accepting the alternatives of annihilation or of living in a vacuum, he has worked out a system that has produced a new atmosphere in which irony functions like an activating element, causing a pendulum-like oscillation between acceptance and rejection, affirmation and negation, and rendering them both dynamic and productive.

The *Coffee-grinder* is Duchamp's earliest proto-dada work, his first gesture of turning against the practises as well as the symbols of the traditional artist. Here for the first time, he dissects the machine, and in exploring its parts, makes a new machine, showing in the process sardonic amusement with, and irreverence for, the power of the machine and the modern sanctities of efficiency and utility. Something of this general attitude is present in Rube Goldberg's humorous play on mechanization, where a complex and fantastic display of ingenuity is employed to obtain a disarmingly simple result; in Ed Wynn's delightfully preposterous and satirical invention, contrived on the principle of the typewriter, as an aid for eating corn on the cob; and in Charlie Chaplin's film *Modern Times,* especially where the efficiency of the system for feeding the worker seeks to destroy the last vestige of human will and to convert him into a robot or a cog in the machinery.

All of Marcel's human mechanism pictures are both playfully and seriously ironical in their implications, *Nude descending a staircase, The Bride,* and especially the large glass.

With Duchamp, irony transcends individual doubt and frustration to become a commentary on the universal predicament of man in his world. Knowingly or otherwise, the large glass appertains in concept to the Christian tradition in painting. It is essentially an Assumption of the Virgin composition, with the lower part given over to the secular world and its motivations, the upper, to the realm of the inner mechanism and inner spirit. The basic plan serves, not for spiritual elevation in the religious sense, but for man's exaltation of woman—a satire on the deification of woman under the prevailing culture. Thus, though it follows the pictorial form of a religious picture, it is opposed to contemporary mores directly traceable to religious influences.

This picture is only one of a series of comments on contemporary culture which Duchamp has made. Another is the picture, quite disrespectfully titled in French *L.H.O.O.Q.,* 1919, a print of the *Mona Lisa* to which he added a moustache and beard as a boy marks up a poster in the subway. This act was evidently intended to register contempt for Renaissance culture, for the glorified sentimentality of the *Mona Lisa,* for the mere virtuosity of brush and of hand. A commentary on the level of popular taste exists in the ready-made-aided, *Pharmacie,* 1914, a vapid and fuzzy autumn scene, an existing chromo, adorned by Duchamp with red and green pharmaceutical vases, perhaps as "stop" and "go" signals for would-be art lovers.

Definitely incisive is the irony that exists in *Unhappy ready-made,* 1922–23. This object was constructed from a text book—a treatise on geometry—opened face up, hanging in midair and rigged diagonally to the corners of a porch. It was left suspended there for a period of time, during which the wind could blow and tear its pages of geometric formulae, the rain drench them, and the sun bleach and fade them. Thus exposed to the weather, "the treatise seriously got the facts of life." ("What is the solution?" Duchamp proceeds to ask. "There is no solution because there is no problem. Problem is the invention of man—it is nonsensical.") This ready-made epitomizes the conflict between human knowledge and the eternal verities.

Duchamp accepts as inevitable the action of the forces of nature, the changes which time effects, its proclivity for corroding, destroying, reducing to rubbish all that man builds, its haste in covering all human traces with dust.

At one time the large glass lay under a coat of dust which had accumulated over a period of six months. In this condition, it was dramatically photographed by Man Ray, and, the photograph titled *Elévage de Poussière,* all but resembles the traces of a lost civilization spotted from an airplane. Duchamp dropped fixative on the glass where the dust covered the cones, using the mottled effect of discoloration, as a color externally imposed. Preserving this as a memento of a condition prevailing at a given moment, he cleared away the remainder of the dust and began to work again. Here he submits to, but is not dominated by, the inevitable. Sometimes, as in *Unhappy ready-made,* he goes out to meet the situation, establishing the conditions under which the elements may act. The ravages of time he accepts with philosophic detachment, as in the ready-made consisting of the rusted metal comb, a contemporary object primitive enough in its form and aged enough in its incrustations to conjure up in advance the image of its appearance if, in the remote future, it were to be dug out of ruins. As the shovel predicts "the broken arm," the comb is offered as a sample of the state of archeological findings to be unearthed hundreds of years hence.

The Element of Chance

Chance is a sub-category of irony in the work of Duchamp, its use springing from the ironic point of view and its application highly charged with mockery. The results of his experiments with chance are applied with the precision and detachment of mathematics. Selection enters before and after the fact. Anomalous as this may sound, Duchamp uses chance intentionally. Through its use he arrives at "a new unit of measure," finding forms independent of the hand. A rich variety of techniques has developed from its use. Three basic means are employed—"wind, gravity, and aim."

Duchamp supplies the following key to his first experiment with chance: "Draft is a force. If you capture it, you can make a piston move." Air currents blowing a piece of mesh gauze against a screen, imprinted a limpid rectangle upon it. The experiment repeated three times gave three chance images, variations on

the square, which were used in their precise configuration on the cloud formation in the large glass.

Choosing deliberately a thread a meter long, Duchamp held it "straight and horizontal" at a height of a meter from the floor. This preparation was a kind of mathematical ritual. Then, chance and gravity were allowed to play their parts. The thread was dropped on to a horizontal plane where it was fixed in the chance line that it formed. This experiment was repeated three times, giving three variations of the chance line which were used in several pictures. These lines, titled *3 stoppages etalon*, 1913–14, arranged into three different groupings for a total of nine, were projected on the large glass in relation to the nine malic forms. The lines fanned out like huge cracks, anticipating the direction the actual cracks took when the glass was eventually broken by accident. Here again, perhaps, is Duchamp's acceptance of the intervention of nature, or at least of "fate." In using glass, he surely knew, even though he ignored the fact, that the chances were it would be broken. All the more reason, it is astounding that by the use of chance, he was to anticipate the configuration when the breakage occurred.

The third device in allowing shapes to create themselves and thus void the responsibility of the hand, is termed by Duchamp *adresse,* that is, skill in aiming. Nine marks were made upon the glass by the impact of shots of matches dipped in paint, from a toy cannon ("If the instrument is bad, the skill is tested more.") Aiming nine shots at a given point, these formed a polygram as a result of variation in the aim-control and accompanying conditions. He then converted the flat polygram or floor plan into an elevation plan. Here the nine points became the locations for the nine malic forms in perspective.

The laws of chance were later exploited in dadaism by Arp and, in surrealism, Ernst's decalcomania of chance has been the means for releasing the springs of inspiration for many of the younger surrealist painters.

The various techniques already mentioned in connection with Duchamp's work are only a part of those implicit therein. There might also be mentioned as of particular interest, the "optical evidences" in the large glass, actual optical drawings for the correction of eyesight, transcribed in perspective and scraped out of quicksilver that had been applied, mirror-fashion, to the glass. There is also the use of lead wire and string to supplant the hand in drawing lines. The device of kinesthetic surprise is employed in the object sardonically titled *Why not sneeze?,* 1921. Here in lifting a wire cage filled with cubes of sugar, one is startled by its unexpected weight, for the cubes are marble, not sugar.

The mural *Tu m'* is rich in inventive techniques, and combines most of those so far discussed. Further, it contains many new ideas. *Trompe l'oeil* is introduced —Duchamp painted a simulated rent in the canvas "held together" with real safety pins. Shadows and the ghosts of shadows appear, forecasting the later *fumage* of Paalen, Matta and others. These shadows are thrown by the hat rack, bicycle wheel and a corkscrew. Set in the center of the canvas is a pointing hand, the sign painter's *cliché,* for the execution of which Duchamp brought in a local artisan;

and, projecting at right angles from the canvas, is a ready-made object consisting of a bristle brush.

As fascinating as are the many techniques and philosophic ideas in themselves, they serve the more important function of being aids to the reëxamination of esthetic concepts, of contemporary culture and its relation to culture in general. That Duchamp's esthetic sensibility enabled him to do this on a high spiritual plane adds immeasurably to the stature of his achievement. Perhaps more than any one of his contemporaries he has rediscovered the magic of the object and its esoteric relation to life, for centuries obscured in the Greek concept of sculpture. Contemporary points of view may be found in Duchamp's work, cubism, futurism, *collage,* dada, and surrealism. This is not eclecticism, but the varied activity of a creative nature too large to be confined in any one movement. So all-encompassing, so pulsating with contemporaneity and so fecund is his work that as various phases of vanguard art unfold and develop, they find in it their counterpart. Picasso's energy is so intense that he exploits every possibility implicit in his inventions. Klee's fantasy leaves more space for the investigations of the younger painters. But the treasure trove of subtleties in creative ideas and techniques in Duchamp's work is still essentially untouched. Tapping these resources will provide a rich yield for the new generation of painters, in whose awareness lies the future of twentieth-century painting; for here, deeply embedded with meaning, is one of the great, little explored veins in contemporary art.

```
            Beckoefkei 7 eckne Büe 7 P F f
     ds  Me F 7 aede  5 ucer n racun O 2 chase
     A    hea Oletché F Mistrei Edeie Vhj 6
     s         ihe H O chchra H -        VDchf
     s         5 bxegz F ucea            de S W
               d Pa Odw Ner              R V
               adiiiedtd

     d 3 ec
   z medec
 f H E hlte
  na § 16 fl
nm-se      S P de
  ugej     or R F A - nph
         M M ixunji
     a 5 c l accheilin        P ag C
      rwfdnz teufb               8 aéln
 r gtrzbu - teit rzo        M chffr           eat
Q R se Eu  Czenésn C                      L n
ir B Z B r  2 ilqu
  4 H H V nt                                   ff
  i7mekru            D                   E nchou
  B P & fuia      fed Qv   .....          ité Jled
  t H O V U 2 n    ch & qusr    V       nziichdb
     dtr'g        R Q ndm        as Cf      r, os Bsiu
                  Auét Ach       Dö ? iEston  x C B
                  Wm G t f       M C i a ? arana Uemi
                  u C E A P U    caUrUMOET öo I
                  chnsmenn  dr   rüeöuyüBzeszr
                                 yGr - rokeui 3 e
                  eod            oailen 2 Dpas X u
                                 u éF5 ew Ro Uau 6 gotuinuie
                                 geee Bnckeöliden 3 nis
```

R.Hausmann 1919

BIRDLIKE

```
Pitsu puit puittituttsu uttititi ittitaan
piét piét pieteit tenteit tuu uit
ti ti tinax troi troi toi to
Iti iti loi loi loioutkouto !
turulu tureli tur luititi
Gou-guiqu gou-guiqu
Psuit psouit psui uitti It
Loitiioito !
Prrn prrn qurr nttpruin
tiou-tiou-iou Oui o'
Oui-oui lii lii lo'
Psuiti tipsru !
Troi ti ti loinx
```

Raoul Hausmann 1946

Appendix D: Raoul Hausmann. *Sound-Rel.* 1919 and *Birdlike.* 1946. Facsimiles. Courtesy the author.

Bibliography

Did Dada Die? *A Critical Bibliography*

Compiled by Bernard Karpel *Librarian, Museum of Modern Art*

"The Word and the Image are One" *Hugo Ball*

DID DADA DIE?

In spite of the natal date of February 8, 1916, to which Bazin[139] and other writers make reference—relying upon the roguish and obviously dadaistic memoir of Arp[32] —Dada was destined to burst upon Europe at a moment of travail. Like other cultural phenomena, mechanical as well as mental, the dadaist mood arose "spontaneously" at widely separate points, and, almost simultaneously, in the consciousness of different nationalities.[316] Dada owes its immediate inception to the turbulence of its decade when Europe, rent by contradiction and tension, embarked upon the final stupidity of war. Not only was society cast loose from its accustomed moorings, but, as an aftermath of its internal storms, the artists as well. Without exception, the polyglot figures at Zurich were men bereft of homeland, adrift in a world that ignored and revolted them, a world which they sought to forget, to fight, and later to reform, by communal acts of bravado.[35] Small wonder that the Cabaret Voltaire,[61] itself a name of protest and humanity, gladly adopted the brawling infant and added its cacophony to their own.[201]

At the risk of oversimplification, the course of Dada can be projected through the seminal personalities of Tzara,[395-422] Huelsenbeck and Arp. Above all, the movement required a St. Paul. Many early texts were the work of Tzara, pre-eminently the littérateur. Whether one views these manifests as unique, or the systematization of the impulses that electrified the circle clustered about the prophetic Hugo Ball,[211-216] restless mystic who was to fix his vision in a more catholic sphere, it was Tzara who made Dada an ecstatic venture in journalism. To his incessant publicity ("the thought is made in the mouth") one can attribute the almost single-handed conversion of Paris to the cause. Such homage can be paid without discounting the radiating force of the French intellectuals, or the proto-dadas in distant lands who made ready the way.[87] To them, a sizable literature is dedicated, a literature which occasionally, and erroneously, sees Dada as a national episode.[100] The enigmatic Duchamp,[240-257] the ubiquitous Picabia,[315-337] the poet Eluard,[252-259] Breton the pamphleteer,[216a-225a] and that wider circle which included Ribemont-Dessaignes[345-357a] and others need no chauvinism to champion their distinctive contributions to Dada, which they propagated and made eloquent. Yet it is no grotesquery of time that Dada was a screeching bird of passage[10] to the generation of 1920. In flamboyant Paris it had to disgorge elements of the romanesque, pursuing a reality beyond the horizon.[96] The essence of the Dada insight as a French phenomenon is adequately defined in Robert Motherwell's introduction to these texts. While broadly conceived and equitable, he is concerned primarily with an artistic reality less indigenous to central Europe. Bibliographically speaking, the evidence indicates a contrapuntal mass, opposing to America and France forces emanating from Zurich and Berlin.[175]

Along with his gift as man of letters, Huelsenbeck[294-308a] brought an analytic mind, keenly attune to the metaphysics of Ball, yet solidly aware of social verities. Underneath the bitter sequence of the days before Zurich and after Berlin, during which "Dada lived its extreme despair," there must be evidences of a profound dis-

location which could be detected. However, the disease lay not in Dada but "in the inability of a rationalized epoch . . . to see the positive side of an irrational movement."[134] On the one hand, an abysmal sense of things out-of-joint, of violent contradictions between the professed and the actual, of an intolerable *malaise*, which, in retrospect, represents the adolescence of Dada. On the other, "born of what it hated,"[162] militant opposition to the status quo at every point of attack. Characteristically, in a German world, to be engaged meant to be politically engaged. If the area of events required substantial alteration, literature alone was not enough, nor was the act of verbalization, however clever and vociferous. Art, too, is propaganda; its manifestations are, to the extreme degree, both pictorial and political.[293] Profoundly aroused by the perversion of values in the "natural" society of its day, etched in vitriol in the Malik Verlag editions,[272a] Dada lustily wielded the weapons of obliteration. Snatched from the relative calm of the Cabaret Voltaire, the force of Dada became explosive.[300] Revolution is the consequence of a series of premises, inexorably translated from concept to reality. Pursued fervently, it dominates Dada in the heart of Europe, and can be traced as it acts upon or is supplemented, with an almost insane lucidity, by the individual talents of Baargeld,[206-210] Ernst,[260-271] Grosz,[272-280] Hausmann,[281-289] Heartfield[290-292] and the lyric Schwitters.[365-386] How right is Huelsenbeck to remark that "what Dada was in the beginning and how it developed is utterly unimportant in comparison with what it has come to mean."[295]

At the very beginnings, art was cradled in the house of Dada,[149] and Arp[188-205] was never far from its bosom. By no means was he alone in finding the pen equally adapted to text and picture; in this he can be grouped with Picabia and Schwitters among others. Yet, *par excellence,* the sense of the organic rings most resonantly in Arp. One cannot say that this is the gift of Dada to Arp, or of Arp to Dada, as one cannot divorce birth from pain. No detachment was possible for nerves rubbed raw by the horrors of the academies, with sensibilities nauseated by the entrails of history paraded in the public galleries. "Merde pour la peinture et ses salons."[357] To the prostitution of the cosmic, the dadas opposed the comic, proclaiming the non-art, the anti-art as the forms of liberation. Even with Duchamp, whose work in New York preceded the coming-of-age to Dada, the drive towards the non-conventional forms of art was compulsive. Obviously, dada art ranged widely, from the cancelled check of Duchamp and other notorious ready-mades[249] and improvisations,[86] to the haphazard accumulations of débris by Schwitters[373] who sanctified the mundane. In their efforts to find another locus the dadaists fumbled and babbled, like their poets and pamphleteers.[113] Dada art learned to spit in the eye; the new vision was to be clarified by violence. How extraordinarily direct was the instinct of the artist: "Dada wanted to destroy the rationalistic swindle for man and to incorporate him humbly in nature."[192] Dada was like a half-tamed beast stricken by the loathsome stereotype, dumbly aware of natural remedies that would enable it to vomit forth alien poisons. By exploiting these internally generated resources, the creative act becomes—simultaneously—an act of revulsion and a manifestation of revolution. Destruction is avowed and paramount. "With aims and purposes a

world can be destroyed. If you have knowledge of what is possible and conform to it, you can construct a new world with the débris of the old."[373a] True, the positive objective was never exactly in focus. Frequently, the forms of realization were experimental, paralleling the dissonances of dada poetics with its own type of incoherence. As the insights of Dada grew clearer, others were to remark that the contrast of the subjectively real with the conventional symbolized the assault upon society by indirection.[261] By indirection, too, Dada discovered the uninhibited well-springs of feeling, the biomorphic symbolism of the free flowing design which cast upon the face of its century the ineradicable mark of the organic.[170] Even the world of mechanics was humanized by the sense of hazard, the play of an Olympian caprice.[251] Puck had come to roost in Pandora's box of cogs and gears.

Dada, then, is a link in the chain reaction of impulses that swept over Europe in the early decades of the twentieth century. First fauvism, which revealed with chromatic splendor the force of the non-mimetic vision, accompanied or followed by cubism, expressionism, futurism, dada and surrealism. Each had its literary spokesmen; none can be divorced from its literature.[19] As Doesburg, dadaist cosmopolitan, observed: "Enfin le baudelaire-chimère devint . . . le ribemont-dessaignes."[234] But dada, Wotan-like, seems to have proclaimed its coming and foreseen its end,—not without having left a multitudinous progeny without rival. In 1922, Tzara stated that 12,000 items had already been printed on Dada. Even discounting what there was of the-tongue-in-the-cheek in that interview,[42] the bibliography below testifies in almost five hundred citations to the existence of innumerable documents. Unfortunately, owing to its ephemeral nature, Dada constitutes a literature sparsely represented in public collections. Important items, such as *Der Ventilator*[88] and other publications known to have been issued by the German dadaists,[307] are either non-existent or inaccessible; others, cited by Tiege,[125] have not, to this day, been presented in detail or seriously evaluated. Necessarily, some bibliographical entries have been based on citations in reliable sources,[1-5] or confirmed on the authority of dadaists now alive.[68]

In large measure, the following represents a survey rather than an exhaustive inventory. Enough has been retained, it is hoped, to convey an impression of the distinctive products of Dada and the characteristic contributions of the major dadaists, along with an enumeration of the basic references. Since it was not practicable, in the present instance, to compile an index to the available periodicals and bulletins, possibly the most typical works of this colorful era, only a reminiscent but representative fraction has been incorporated below. Supplemented by a detailed author index, the references have been assembled into the following categories:

Bibliography[1-5]—Surveys & Outlines[6-21]—Contemporary Documents [22-56]—Bulletins & Periodicals[57-93]—Dada as Literature[42-129a]—Dada as Psyche[130-136]—Dada as Art[137-187]—Some Dadaists: Arp[188-205]—Baargeld [206-210]—Ball[211-216]—Breton[216a-225a]—Cravan[226-229]—Doesburg[230-239]—Duchamp[240-251]—Eluard[252-259]—Ernst[260-271]—Grosz[272-280]—Hausmann[281-289]—Heartfield[290-293]—Huelsenbeck[294-308a]—Janco[309-314]—Picabia[315-337]

—Ray[333–344]—Ribemont-Dessaignes[345–357a]—Richter[358–364]—Schwitters
[365–386]—Serner[387–594]—Tzara[395–422]—Index (p. 379–382).

This imposition of apparent order can be criticized as an example of that kind of surgical analysis which robs the living organism of life while studying the blood stream. Admittedly, the dada document can be classified only under protest.[407] Like the movement itself and its multiple demonstrations, it divulges itself in protean shapes: an event becomes a revelation of high policy,[22] formalities an occasion for idiotic mockery,[45] an exhibition a declaration of international solidarity,[112,171] the vocal and subversive manifest becomes wholly visual,[273] and the lecture an act of social outrage.[302] Yet this elemental attempt to penetrate muddied disguises may serve to clarify an overall picture now made possible, at least for the English reader, by the publication of an anthology of dada poets and painters. In spite of certain omissions, not altogether attributable to the editor and publisher, these latest Documents of Modern Art constitute the most comprehensive display of the dada universe since the spectacular era of the 'twenties.

As the crisis of Dada recedes, the significance of its tumultuous career becomes apparent. From two points of view, Dada is very much alive. Of the founding fathers, Arp, Duchamp, Huelsenbeck, Picabia and Tzara are still actively at work; of the dadaists on record in the bibliography, Doesburg and Schwitters are only recently dead. Breton and Eluard, Ernst and Janco, to name a few others, are animated participants in the cultural affairs of today. Within and owing to this miscellany, Arp,[130] Huelsenbeck[134] and Tzara[136] collaborate in memoirs of reflection, which skim from the froth of Dada its superficial agitation. Practically, the violence with which Dada couched its words and stormed its enemies appears unassailable as a military tactic, considering its small numbers and the entrenched strength of the traditionalists. Secondly, and in retrospect, the essential success of the Dada onslaught resides in the spontaneous energies which it released half-knowingly and which remain to irradiate the imagination of our epoch.[320] Richter puts it succinctly: "It broke up what was past and dead, and opened the way to emotional experience from which all the arts profited and still profit."[21,293,344] By this exploit, the liberation of the psyche, Dada terminated what was transitory in Dada, and kindled a deathless flame.[114b]

Energies that activated the adherents of Dada, in spite of the passing of youth, have not diminished their passion for causes. Interpretation and conviction symbolize contradictory and irreconcilable positions.[297] Yet the unprejudiced observer is frequently obliged to view with irritation the occasional attempt to confine Dada within a national framework, or to establish individual priorities.[104] To some extent, this is an error in semantics, depending on one's concept of dada as an artistic insight or literary technique.[222a] Some figures, like Grosz and Ernst, seem intensely national during the dada era; however, even here, one hesitates to generalize about the Germans who also produced Schwitters,[365–386] poet who aimed "only at art, because no man can serve two masters." Regardless of absolute valuations, Dada is an historic event firmly rooted in middle Europe, and the painters first formally integrated into *Dada*[66] were Arp, Eggeling, Janco, Richter. Duchamp

and Picabia, like Doesburg,[230-239] can, with equal validity, find their milieu in the international scene within which they seem most comprehensible. "We believed in an internationale of the Spirit."[296] Basically, Dada is not a definition, and, even pictorially, lacks the visual coherence of such a movement as surrealism. Its core seems to consist in a sense of opposition rather than a statement of objectives. Since criticism finds it difficult to function with fluid concepts, or with the mercurial refusal of artists to remain within the rigid formula of "style," the writing of art history suffers from the easy intrusion of chauvinism. But history, whether of civilization or art, still survives as an exercise in the making of myths. Overwhelmingly, the need is for greater possession of the fact rather than an eloquent demonstration of personality. In the instance of contemporary art, multifaceted but lacking a single point of iridescence, the truth lies at least in this direction. Here is the lucidity of Dada: "To separate the ready made in quantity from the already found. The separating is an operation."[242]

NOTE: The bibliographer wishes to acknowledge the cooperation of the following, who, by the loan of rare material, have contributed to his understanding of an historic manifestation: Mr. Walter C. Arensberg, Miss Katherine Dreier, Dr. Charles R. Hulbeck, Mr. Hans Richter.

To the reader: The symbol † indicates a translation, in whole or part, or reproduction, either complete or partial, of the item mentioned. See table of contents, or general index, for exact pagination. Pictures are noted in general index.

BIBLIOGRAPHY

1. BAZIN, GERMAIN. *Notice historique sur dada et le surréalisme. I. Dada.* p.340–1 In Huyghe, René. *Histoire de l'art contemporain: la peinture.* Paris, Alcan, 1935.
 To be extensively supplemented by his "notices biographiques et bibliographiques" on Arp, Duchamp, Picabia, Ray, Ernst (p.342–44). Originally published in *L'Amour de l'Art* Mar.1934.

2. BERÈS, PIERRE, INC. *Cubism, futurism, dadaism, expressionism and the surrealist movement in literature and art.* 33p. New York, Pierre Berès, 1948.
 Catalog no.15, issued for a special exhibition, including numerous annotations by Dr. Lucien Goldschmidt.

2a. BOLLIGER, HANS. *Selected bibliography.* In *History of modern painting from Picasso to surrealism.* p.207–8 Geneva, Albert Skira, 1950.
 Vol.3 of Skira's *History.* To be supplemented by chronologies and data in *Biographical and bibliographical summaries* (p.191–205) on Arp, Doesburg, Duchamp, Ernst, and Picabia. Enlarged version published in German edition (1950).

3. FARNER, KONRAD. *Bibliographie.* In Lucerne. Kunstmuseum. *Thèse, antithèse, synthèse.* p.18–38. 1935.
 Part of catalog for exhibition held Feb.24–Mar.31. Pt.1. *Ideologische Situation der Gesellschaft.*—II. *Periodica.*—III. *Theorie.*—IV. *Mathematik.*—V. *Psychologie—Psychoanalyse.*—VI. *Monografie.* A selective bibliography on contemporary art in general, containing some references to dada, but of greater significance for its review of the intellectual and cultural patterns of the twentieth century of which dada itself is a manifestation.

4. MATARASSO, H. *Surréalisme: poésie et art contemporains. Catalogue à prix marqués.* [108]p. ills. Paris, H. Matarasso, Libraire, 1949.
 Extensive bibliography, with annotations, including dadaist as well as surrealist items.

5. [NEW YORK. MUSEUM OF MODERN ART. *Checklist of Eluard and Dausse surrealist collection.* n.p. 1935].
 Typescript list of dada and surrealist books, periodicals and ephemera donated to the Library by Walter P. Chrysler, Jr. in 1935. Material comprises the personal collections

of Paul Eluard and Dr. Camille Dausse. The unpaged checklist was probably prepared by the Jeanne Bucher bookshop of Paris.

SURVEYS & OUTLINES

6.　HUELSENBECK, RICHARD. *En avant Dada; eine Geschichte des Dadaismus.* 44p. Hannover, Leipzig, Wien, Zurich: Paul Steegemann, 1920 (Die Silbergäule, 50–51). †
　Translated portion titled *En avant* published in *Littérature* n.s., no.4, p.19–22, Sept. 1922. Somewhat similar section translated by Ralph Manheim for *Possibilities* no.1, p.41–43 Winter 1947–48 (New York, Wittenborn, Schultz).

7.　HUELSENBECK, RICHARD, ED. *Dada Almanach. Im Auftrag des Zentralamts der deutschen Dada-Bewegung, herausgegeben von Richard Huelsenbeck, mit Bildern.* 160p. Berlin, Eric Reiss, 1920. †
　Includes Tzara's *Chronique Zurichoise, 1915–1919* (p.10–29), a detailed chronology of of soirées, exhibitions, publications. Other contributions by Huelsenbeck, Tzara, Hans Baumann, Walter Mehring, Picabia, Ribemont-Dessaignes, Mario d'Arezzo, Adon Lacroix, Ball, Daimonides (Dr. Döehmann), Alexander Partens, Baader, Soupault, Citroën, Gabrielle d'Annunzio. Noted on p.157: "Dada-Reklame-Gesellschaft. Direktion: H. Ehrlich: Generalvertreter: Huelsenbeck, Hausmann, Grosz, Herzfeld". [Herzfeld, brother of the publisher, took the name of Heartfield]. Huelsenbeck was also involved in an ambitious but unrealized anthology planned by Wolff Verlag.[34]

8.　LITTÉRATURE (PARIS). *Vingt-trois manifestes du mouvement dada.* May 1920.
　Dada number, 2 no.13, p.1–23. Contains contributions by Picabia, Aragon, Breton, Tzara, Arp, Eluard, Soupault, Serner, Dermée, Ribemont-Dessaignes, Céline Arnauld and W. C. Arensberg. Manifestoes read at the Salon des Indépendants, at the Club du Faubourg, and at the Université Populaire du Faubourg Saint-Antoine, Feb. 5, 7, and 19, 1920.

9.　MASSOT, PIERRE DE. *Le Dadaïsme.* In his *De Mallarme à 391.* p.123–32 Paris, Au Bel Exemplaire, 1922.

10.　ARAGON, LOUIS. *Projet d'histoire littéraire contemporaine. Littérature* (nouv. sér.) no.4: 3–6 Sept. 1922. †
　Outline of outstanding personalities and events from 1913. See text, p. 230–1.

11.　TZARA, TRISTAN. *Sept manifestes dada. Quelques dessins de Francis Picabia.* 97p. Paris, Editions du Diorama, Jean Budry & co., [1924]. †

tristan tzara

sept
manifestes
dada

quelques dessins de francis picabia

éditions du diorama
jean budry & c°
3, rue du cherche-midi
paris

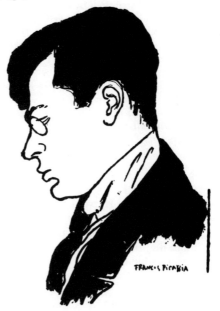

See bibl. 11

Texts dated 1916–1920; details of first publication or delivery noted in colophon. Edition not dated in imprint but issued 1924 in 300 copies, 50 on Chine, 250 on Lafuma. Tzara's major pronouncements of the dada era, to be supplemented by *Dada* (1917–1920),[66] *Chronique Zurichoise*,[7] and *Conference sur dada* (Weimar, 1922).[135] See text, p.75–98.

12. BRETON, ANDRÉ. *Les Pas perdus.* 222p. Paris, Gallimard, 1924 (Les documents bleus. 6). †

Partial contents: *Jacques Vaché*, p.67–72.—*Deux manifestes dada*, p.73–77.—*Pour dada*, p.85–94.—*Max Ernst*, p.101–3.—*Aprés dada*, p.123–7.—*Lachez tout*, p.129–32.—*Marcel Duchamp*, p.141–6.—*Francis Picabia*, p.159–65.—*Caractères de l'evolution moderne et ce qui en participe*, p.181–212. Essays sometimes reprinted, e.g., "Pour dada" La Nouvelle Revue Française Aug. 1920, etc. See texts, p.199–211.

13. RIBEMONT-DESSAIGNES, GEORGES. *Histoire de dada.* La Nouvelle Revue Française 36 no.213: 867–79 June 1931; 37 no.214: 39–52 July 1931. †

See text, p.101–20.

14. TZARA, TRISTAN. *Memoirs of dadaism.* In Wilson, Edmund. *Axel's castle, a study in the imaginative literature of 1870–1930.* p.304–12 New York & London, Scribner's, 1931. "A partial translation . . . appeared in *Vanity Fair*". Supplements his *Chronique*[7] with events in Paris from 1920.

15. HUGNET, GEORGES. *L'Esprit dada dans la peinture.* illus. Cahiers d'Art 7 no.1–2: 57–65, no.6–7: 281–5, no.8–10: 358–64, 1932; 9 no.1–4: 109–14, 1934. †

This series of essays, supplemented by the condensed version and modified text published on the occasion of the New York exhibition (1936)[17,162], is the most important study published in the 'thirties. Part I: Zurich & New York.—II. Berlin (1918–1922).—III. Cologne et Hanovre.—IV. Dada à Paris.

16. HUYGHE, RENÉ, ED. *Histoire de l'art contemporaine: la peinture.* p.316–18, 337–44. illus. Paris, Alcan, 1935.

Includes *La nouvelle subjectivité* by René Huyghe (p.316–18), *Le dadaïsme et le surréalisme* by Jean Cassou (p.337–40), *Notice historique sur dada et le surréalisme* by Germain Bazin (p.340–44). Additional "notices" on Arp, Duchamp, Ernst, Picabia, Ray. Originally published in *L'Amour de l'Art* Mar.1934.

17. NEW YORK. MUSEUM OF MODERN ART. *Fantastic art, dada, surrealism.* Edited by Alfred Barr, Jr.; essays by Georges Hugnet. 3.ed. 271p. illus. New York, Museum of Modern Art, distributed by Simon and Schuster, 1947 (cop.1936).

The most satisfactory American publication on the subject, now requiring supplementation by the 1951 edition of *Dada Painters and Poets* (Wittenborn). Originally a catalog and text prepared for an exhibition of the same title held Dec. 1936–Jan. 1937. Contents include essays by Hugnet "Dada," p.5–34; and "In the light of surrealism," p.35–52 (first published in the *Bulletin of the Museum of Modern Art* 4 no.2–3 Nov.–Dec. 1936). The essay on dada is a condensation, with minor revisions, of the original series published in *Cahiers d'Art*.[15] In addition to a short bibliography, there is a valuable outline by Elodie Courter and Alfred H. Barr, Jr. *Brief chronology, the dada and surrealist movements with certain pioneers and antecedents* (p.53–64).

18. ARP, HANS. *Tibiis canere* (Zurich, 1915–20). illus. XXe Siècle no.1: 41–44 Mar.1938. Reproduces "Cabaret Voltaire", the painting by Marcel Janco.

18a. KERN, WALTER. *Zürich, 1914–1918.* Werk no.5: 129–33 May 1943.

19. LEMAITRE, GEORGES. *From cubism to surrealism in French literature.* p.155–78 Cambridge, Mass., Harvard University press, 1947 (cop. 1941).

Includes bibliography, on individual writers as well as the movement in general.

20. NADEAU, MAURICE. *Histoire du surréalisme.* 2. rev. ed. p.44–57 et passim Paris, Éditions du Seuil, 1946.

Includes bibliography, p.347–58. The second volume, published 1948 is a collection of texts titled "Documents surréalistes".

20a. GLAUSER, F. *Dada.* Schweizer Spiegel 25 no.1: 78–86, 88–94 Oct.1949.

Originally published in issue of Oct.1931.

21. RICHTER, Hans. *Dada XYZ.* . . . New York, 1948. †
New text for this anthology, p.285–90. See also bibl. 361c.

21a. BUFFET-PICABIA, Gabrielle. *Some memories of pre-dada: Picabia and Duchamp.*
1949. †
Original text for this anthology, p.xxxx. To be supplemented by bibl.148.

21b. BOLLIGER, Hans. *The dada movement.* In *History of modern painting from
Picasso to surrealism.* p.111–14, 115b illus. Geneva, Albert Skira, 1950.
Additional data in biographical and bibliographical summaries, including Duchamp,
Picabia, Arp, Doesburg, Ernst. General bibliography, p.206–7.

21c. BAUR, John I. H. *Dada in America.* 1951. (See bibl. 423).

CONTEMPORARY DOCUMENTS

Nos.22–56 represent a *selection* of numerous articles and other writings culled from
the periodical literature, the surveys and anthologies, and can be supplemented, ob-
viously, by similar references under the individual dadaists. Here these serve, however,
to illustrate a cross-section of characteristic items and the contemporary reception of
dada. The reader is reminded of Cendrars' statement cited in the editor's preface: "And
what is a document? . . . A springboard . . . For jumping . . . Into reality . . ."

22. *L'Affaire Barrès.* Littérature 3 no.20: 1–24 Aug.1921.
"Dada se constituait en tribunal révolutionnaire".

23. ALBERT-BIROT, Pierre. *Poème à crier et à danser.* S I C no.23:[3] Nov.1917.
Translations of two poems from S I C noted in editor's preface, p. *xxxv–xxxvi.*

24. ARENSBERG, Walter Conrad. *Partie d'échecs entre Picabia et Roché.* 391 no.7:[3]
Aug.1917.
Not all texts published under his name were necessarily authorized or derived from
Arensberg.

25. ARLAND, Marcel. *Sur un nouveau mal du siècle.* La Nouvelle Revue Française
22:149–58 Feb. 1, 1924.

26. BAADER, Johannes. *8 Sätze von Johannes Baader.* Merz nr. 7: 68 Jan.1924.
An early leaflet "Sonderausgabe Grüne Leiche" is reproduced, with portrait, in this
anthology, p.262. Baader also participated in *Der Dada* no.1,2.[68]

27. BUFFET, Gabrielle. *Petit manifeste.* 391 no.8:[2] Feb.1919.
Essays also issued under name of Buffet-Picabia.

28. CHENEY, Sheldon. *Why dada?* Century Magazine 104:22–9 May 1922.

28a. CLAIR, René. *Entr'acte.* A film. Paris, 1924.
"Filmographie complète de René Clair. Production—Rolf de Maré (Ballets Suedois,
Paris). Scenario—Francis Picabia; Musique—Érik Satie. Interprétation—Francis Picabia,
Erik Satie, Marcel Duchamp, Man Ray, Jean Borlin, Inge Friess," etc. Program notes
issued by the Film Society (London) Jan. 17, 1927; a full length publication, with
numerous stills by Viazzi in bibl. 326a.

29. COCTEAU, Jean. *Chansonette sédebrol.* Cannibale no.1:10 Apr. 25, 1920.
"Le dadaïsme . . . malaise intolerable".

30. COENEN, Frans. *Dadaïsme.* Groot-Nederland (Amsterdam) 19 no.2:535–43 1921.

31. *Dada: the newest nihilism in the arts.* Current Opinion 68:685–7 May 1920.

32. *Dada Intirol Augrandair Der Sängerkrieg.* Tarrenz B. Imst 16 Septembre 1886–1921.
[4]p. illus. [Paris, Au Sans Pareil, 1921]. †
Sometimes cited as *Dada Au Grand Air.* Title partly inverted to read *Der Sänger Krieg
In Tirol.* Cuts by Arp and Ernst; contributions by Tzara including "Monsieur Aa
l'antiphilosophe"; by Ernst, including "Fatagagalied," "Der alte Vivisektor," "Die un-
geschlagene Fustanella"; by Arp, including a "Déclaration" on the finding of the word
"dada" by Tzara; and by Baargeld, Eluard, Ribemont-Dessaignes, Soupault, Th.
Fraenkel. Hugnet declares that this bulletin "may be considered the final number of
Dada".[66] Probably published Sept.1921.

33. *Dada soulève tout.* [2]p. Paris, Jan. 12, 1921. †
Broadside manifesto. Also reproduced in *The Little Review* 7 no.4: [62] Jan.–Mar.1921.

DADA
INTIROL (upside down/mirrored)
AUGRANDAIR
DER SÄNGERKRIEG (mirrored)

TARRENZ B. IMST 16 SEPTEMBRE 1886—1921 1 FR. 2 MK.
EN DEPOT AU SANS PAREIL 37 AVENUE KLÉBER PARIS

MAX ERNST: Die Leimbereitung aus Knochen
La préparation de la colle d' os

NET

Un ami de New-York nous dit qu'il connait un pickpocket littéraire ; son nom est Funiguy, célèbre moraliste, dit bouillabaisse musicale avec impressions de voyage.

Tzara envoie à Breton: une boîte de souvenirs conservés dans du lait d'autruche et une larme batavique munie d'indications pour sa transformation en poudre d'abeilles. Il est attendu à Tarrenz b. Imst par le rire morganatique des plaines et des cascades.

Le titre de ce journal appartient à Maya Chrusecz.

Wir kochen geneigte Herrschaften in Parafin und hobeln sie auf.

Arp visse S. G. H. Taeuber sur le tronc d'une fleur.

Dans le catalogue du salon Dada il se trouve une erreur que nous tenons à corriger. Le tableau mécanique de **Marcel Duchamp „Mariée"** n'est pas daté de 1914, comme on voulait nous faire croire, mais de **1912**. Ce **premier tableau mécanique** a été peint à Munich.

La baronne Armada de Duldgedalzen, connue dans l'histoire sous le nom La Cruelle, a organisé devant des invités, sur ses domaines à Tarrenz, un massacre parmi les paysans des environs.

Maintenant que nous sommes mariés, mon cher Cocteau, vous me trouverez moins sympathique. En Espagne on ne couche pas avec les membres de sa famille, dirait Marie Laurenein.

Tzara envoie à Soupault: 4 baleines en éponge molle, 2 agiuilles pour l'empoisonnement des arbres, un peigne perfectionné à 12 dents, un lama vivant et agité et une pomme cuite au jambon de cadavre. A Mic les salutations de son cœurouvert.

Arp envoie à Eluard: un turban d'entrailles et d'amour à 4 chambres. A Benjamin Péret: des minéraux bouillis des drapeaux de fourmillières et des postiches sur l'impériale couronnée par les putains des souris.

Funiguy a inventé le dadaïsme en 1899, le cubisme en 1870, le futurisme en 1867 et l'impressionisme en 1856. En 1867 il a rencontré Nietzsche, en 1902 il remarqua qu'il n'était que le pseudonyme de Confucius. En 1910 on lui érigea un monument sur la place de la Concorde tchéco-slovaque, car il croyait fermement dans l'existence des génies et dans les bienfaits du bonheur.

Tzara envoie à Marcel Duchamp: des bonbons d'amour trempés dans du whisky nègre et un nouveau divan turc muni de cuisses vivantes de pucelle.
A Man Ray: Une carte postale transparente avec les montagnes et le reste, et un frigorifère qui parle français à l'approche d'un magnéto.
A Marguerite Buffet: un paquet de chocolat à la boutonnière ainsi que 3 notes musicales d'une qualité tout-à-fait exceptionnelle.

Paris (16), 12 rue de Boulainvilliers.

TRISTAN TZARA

See bibl. 32: Dada Au Grand Air

**He, he, Sie junger Mann
Dada ist keine Kunstrichtung**

dadaco

Kurt Wolff

Verlag in
München

*Dadaistischer Handatlas
Erscheint im Januar 1920*

Grösstes
Standard-Werk
der Welt

Der Dadaco gibt den einzigen
authentischen Aufschluss über alle
Dadaisten der Gegenwart

M. Höch

Huelsenbeck
Hausmann-Baader
Mehring
Grosz-Heartfield

Centralamt der **dada** istischen Bewegung in
DEUTSCHLAND

Charlottenburg, Kantstr. 118. Richard Huelsenbeck. Fernsprecher: Steinplatz 8998.

See bibl. 34

329

34. *Dadaco; Dadaistischer Handatlas erscheint im Januar 1920.* [4]p. illus. München, Kurt Wolff Verlag, 1920. † (See bibl. 68).

Preliminary sheets for a projected international anthology edited by the German dadaists. Advertised in *Der Zeltweg,* Nov.1919, as "dadaistischer Weltatlas". Montage presumably by Heartfield, Hausmann and Grosz. Trial sheets, largely by Grosz, also exist. For further details, see reproductions. Presumably abandoned, when almost completed, owing to differences between the publisher and Heartfield over design and content.

35. *Dadaisten gegen Weimar.* [Berlin? Feb.] 1919. †

Single sheet, dated Feb. 6, referring to "Der dadaistische Zentralrat der Weltrevolution Baader, Hausmann, Tzara, Grosz, Janco, Arp, Hülsenbeck, Franz Jung, Eugen Ernst, A. R. Meyer".

36. DAIMONIDES. *Zur Theorie des Dadaismus.* In *Dada Almanach.* p.54–62 1920.[7]

Pseudonym of Dr. Carl Döehmann.

37. DERMÉE, PAUL. *Premier et dernier rapport de la Section d'Or: excommuniés.* 391 no.12:6 Mar.1920.

Dadaists expelled at Closerie des Lilas meeting.

38. FLAKE, OTTO. *Thesen.* Der Zeltweg [1:3–5] Nov.1919.

39. GIDE, ANDRÉ. *Dada.* La Nouvelle Revue Française n.s. 7 no.79:477–81 Apr. 1, 1920.

40. GLEIZES, ALBERT. *L'Affaire dada.* Action no.3:26–32 Apr.1920. †

See text, p.298–303.

40a. JARRY, ALFRED. *Gestes et opinions du Docteur Faustroll, pataphysicien. Roman néoscientifique, suivi de spéculations.* 323p. Paris, Eugène Fasquelle, 1911.

40b. JARRY, ALFRED & TERRASSE, CLAUDE. *Ubu roi. Texte et musique, fac-simile autographique.* 175p. Paris, Mercure de France, 1897.

Presented at the Théâtre de l'Oeuvre, Dec. 10, 1896.

40c. JARRY, ALFRED. *[Extracts].* New Directions [no.5]:432–5 1940.

Translations by C. Cohen from "Pataphysique et Catachimie" and "Ubu Roi".

41. KNOBLAUCH, ALFRED. *Dada.* 76p. Leipzig, Kurt Wolff, 1919 (Der Jüngste Tag, 73–74).

With woodcut by Lyonel Feininger.

42. KREYMBORG, ALFRED. *Dada and the dadas.* Shadowland 7 no.1:43,70 Sept.1922.

Quotes Tzara briefly.

43. *Manifest Proletkunst.* Merz no.2:24–5 Apr.1923.

"Signed" by Doesburg, Schwitters, Arp, Tzara, Chr. Spengemann.

43a. MASSOT, PIERRE DE. *"Moi, Pierre de Massot . . ."* [manifest]. [Paris, 1920?] †

See reproduction of single sheet, p.192.

44. PANSAERS, CLÉMENT. *Le Pan Pan au cul du nu nègre.* Brussels, 1922?

Copy not available to compiler. A poem "Pan-Pan" appears in Littérature 3 no.19:20–3 May 1921, and an additional contribution "Ici finit la sentimentalité" in 2 no.14:18–22 June 1920.

45. PARIS. SALLE GAVEAU. *Festival dada; programme: mercredi 26 mai.* 1920.

Single sheet, listing 19 events. Verso notes publications offered by Sans Pareil (bookshop and gallery). Same program listed on rear cover of *Projecteur* May 21, 1920 (prospectus issue).

46. RIGAUT, JACQUES. *Papiers posthumes.* Paris, Au Sans Pareil, 1934. †

Lord Patchogue published in bibl. 104 (p. 274–82) first appeared in La Nouvelle Revue Française Aug. 1930, accompanied by a memoir by Jacques-Émile Blanche "A young man of the century" (p.268–73) and a critical note by the editor (p.267–8).

47. RIGAUT, JACQUES. *[Untitled contribution].* Littérature 2 no.17:5–8 Dec. 1920. †

"Le suicide doit être une vocation." Also published in La Révolution Surréaliste 5 no.12:55–57 Dec. 5, 1929. A memoir by Blanche appears in bibl. 104, and is quoted partly in editor's Introduction, p. xxv.

48. RIVIÉRE, JACQUES. *Reconnaissance à dada.* La Nouvelle Revue Française 15:216–37 Aug.1920.

Extracts quoted in bibl. 104 (p.169–70).

49. SATIE, Érik. *Mémoires d'un amnésique*. In Myers, Rollo. *Erik Satie*. p.135–43 London, Dennis Dobson, 1948. †

Fragments dated 1912–1924. Early extracts published in the Journal of the Société Musicale Indépendent (Paris), Apr. 15, 1912, Feb. 15, 1913. Constant Lambert's comment on Satie from his "Music Ho!" (London, 1934, rev. ed. 1937) is quoted in the editor's Introduction, p. xvi. See text, p.17–19.

49a. SATIE, Érik. *Le Piège de Méduse. Comedie lyrique en un acte . . . avec musique de danse . . . Ornée de gravures sur bois de M. Georges Braque*. Paris, Galerie Simon, 1921.

Presented at the Théâtre Michel, May 24, 1921.

50. SCHINZ, Albert. *Dadaism*. The Bookman 55:63–65 1922.

50a. SOUPAULT, Philippe. *Le Profil de dada*. illus. Labyrinthe no.17:9 Feb. 15, 1946.

Reprinted from Montaigne catalog[171], with illustrations of dada publications.

51. *Thermomètre littéraire de " S I C "*. S I C 4 no.42–43:339 Mar.–Apr.1919. †

— 339 —

Thermomètre Littéraire de " SIC "

EXPLO	11	391 SION
Dada 3. --		
	10	
Les Jockeys camouflés (Pierre Reverdy)	9	
Valori plastici (n°ˢ 2 et 3)	8	Album de reproductions peintures et sculptures illustré de quelques poèmes.
L'Instant. - La Raccolta. - Noi.	7	- Valori plastici (n°1) - J'ai tué (Blaise Cendrars)
Les 3 roses. -	6	
Vell i nou. - La Revista. Données sur André Gide. (Christian). -	5	Mercure de France - L'Eventail. Les cahiers idéalistes.ˉ - Le Crapouillot.
La Caravane. - Le Carnet Critique. - Le Scarabée. Jeanneret). - L'Art. - Les Cahiers. - Le Faubourg.	4	L'Affranchi. - Après le Cubisme (Ozenfant et Atys. - Ariste. - Les Lettres parisiennes.
Les Humbles. - A l'ami mort (Lucien Jacques). - Les Pionniers de Normandie.	3	Le Néostiche et le Verbe intégral (E, Adam).
Quand ils auront passé de l'ombre à la lumière Grangé). - La chaîne aux anneaux brisés	2	(Louis Boumal). - La procession fleurie (Pierre (Garrigue Garonne).
La Mélée.	1	
	0	
La Revue Nationale. - La Jeunesse Française.		La Flamberge. - Lutétia.

See bibl. 51

52. TOPASS, JAN. *Essai sur les nouveau modes de l'expression plastique et littéraire: cubisme, futurisme, dadaïsme.* La Grand Revue 103:579–97 1920.

53. VACHÉ, JACQUES. *Lettres de guerre.* 32p. Paris, Au Sans Pareil, 1919 (Collection de Littérature). †
Drawings by the author; introduction by André Breton. Also published in *Littérature* nos.5,6,7 1919. Partly translated by C. Cohen: "Two letters to Andre Breton" *New Directions* p.544–7 1940 (Dated 18–8–17;10–12–18). See text, p.69–72.

54. VACHÉ, JACQUES. *Les lettres de guerre de Jacques Vaché, suivis d'une nouvelle. Précédées de quatre préfaces d'Andrè Breton.* [80]p. Paris, K éditeur. 1949.
The Breton essays appeared previously in bibl.12,53,99; "Trente ans après" is dated 1948.

55. ZAHN, L. *Dadaismus oder Klassizimus?* Der Ararat 1:50–2 1920.

56. ZURICH. SAAL ZUR KAUFLEUTEN. *8.dada soirée.* Apr. 19, 1919. †
Program, frequently noted in relation to the Salle Kaufleuten, which lists Eggeling, Richter, Arp, Serner, Suzanne Perrotet, Käthe Wulf, Hans Heusser. Described by Tzara in his *Chronique Zurichoise*[7].

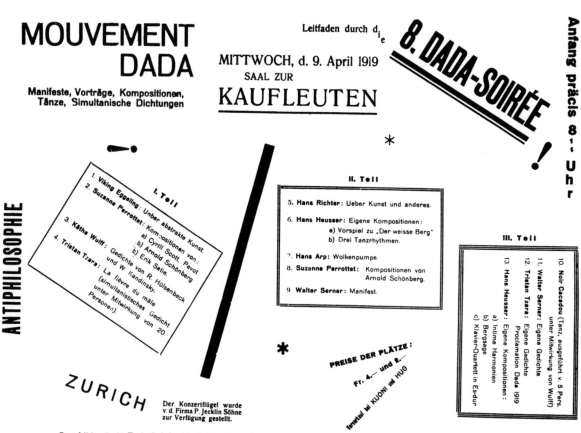

See bibl. 56: 8. Dada-Soirée (Salle Kaufleuten)

BULLETINS & PERIODICALS

The dust of history settles with deadly rapidity upon the more fragile documents of literature, in particular, the little magazine, the avant-garde periodical, the once-and-no-more bulletin hardly to be distinguished from the throwaway. In respect to Dada, obsessed with the momentary advantages of publicity at any price, and overwhelmed at all times by the necessity of printing on a limited or non-existent budget, the casualty rate was high. By no means pretending to be a definitive record, nos.57–93 are an assemblage of material known to the compiler partly by direct examination, partly by reliable hearsay. Among other contemporary and short-lived periodicals containing dada material, some of which are not even listed or recorded in entirety in the monumental Union List of Serials (H.W.Wilson Co.) are: *Ma* (Wein), *Nord-Sud* (Paris). *L'Oeuf Dur* (Paris), and similar items noted in Farner[3], Matarosso[4] and elsewhere. Tiege[125], for example, refers to obscure and inaccessible reviews titled *Ipéca* (France), *A 31* (France), *The Next Call* (Holland), *Dadajok* (Serbia), *Mavo* (Japan). The bibliographic study by Hoffman[110] is of very limited value. A brief list of periodicals is noted in Nadeau[20] and *Merz*[78], in no.7 for example, preserves, in its "eingesandte Zeitschriften," a record of these little magazines, regularly cited in the advertising and review sections of the major dada journals. Contemporary periodicals, which temporarily were directed by the dada current or momentarily reflect its force, are frequently helpful in this inventory, e.g. *De Stijl* 6 no.8: 113–15 1924.[239] The chronology in *Fantastic art*[17] includes brief notes tracing the appearance of these magazines, but the most useful list, in spite of its incompleteness, is the inventory of the Eluard and Dausse private libraries[5].

57. *Aventure.* Edited by R. Vitrac. (Paris, 1921).
Three numbers. (Not available to compiler).

58. *Bleu.* Edited by J. Evola, Cino Cantarelli, Aldo Fiozzi. (Mantova, 1921).
No. 3, Jan. 1921, is dada number, with contributions by Evola, Tzara, Serner and others. Refers to "Jazz-Band Dada Ball" organized by Evola and Schad, and similar events. (No other copies available to compiler).

59. *The Blind Man.* Edited by Marcel Duchamp. no.2 (New York, 1917).
No.2, May 1917, published by Beatrice Wood. Contributions by E. Satie, C. Demuth, W. C. Arensberg, L. Eilshemius, G. Buffet, A. Stieglitz, and others. (Duchamp acknowledges editorial participation by Man Ray). Apparently only number two issued.

60. *Bulletin D.* Edited by J. T. Baargeld and Max Ernst.·(Cologne, 1919).
Only one number. Contains exhibition catalog and reproductions. "Für den Inhalt verantwortlich Max Ernst."

61. *Cabaret Voltaire.* Edited by Hugo Ball. (Zurich, 1916). †
Only one number issued, in June. Partial contents: Introduction, dated May 15, by Hugo Ball, p.5. *L'amiral cherche une maison à louer*, R. Huelsenbeck, M. Janko, Tr. Tzara, p.6–7.—*Der Idiot*, Richard Huelsenbeck, p.18—*La revue dada 2*, Tristan Tzara, p.19.—*Blick und Blitz; Sehen*, Wassilij Kandinsky, p.21—F. T. Marinetti, p.22–3.— *Cabaret*, Hugo Ball, p.24— *Dada, dialogue entre un cocher et une alouette*, R. Huelsenbeck, Tr. Tzara, p.31.—*Katalog der Ausstellung Cabaret Voltaire* p.32. Illustrations by Arp, Janco, etc. Edition of 500 copies, also 50 de luxe issues with original print (no.1–10, Arp; no.11–20, M. Janco; no.21–30, Max Oppenheimer; no.31–40, M. Slodki; no.41–50, A. Segall). The first appearance of the term "dada" in print. While not the first official dada publication,[307,414] this is the first association of dada personalities. Introduction by Ball translated in editor's Introduction, p. xviii.

62. *Cannibale.* no.1,2. Edited by Francis Picabia. (Paris, 1920). †
No.1, Apr.25, contains Picabia's *Tableau dada* (*Portrait de Cézanne, etc.*); no.2 dated May 25. Sometimes cited as continuation of "391".[86]

63. *Club Dada.* Edited by R. Huelsenbeck, F. Jung, R. Hausmann. (Berlin, 1918). †
One issue. Also 50 special copies, signed by the editor, and 10 signed copies with manuscript poem by Huelsenbeck. (*Dada Almanach*[7] published "Eine Erklärung des Club Dada", p.132–3).

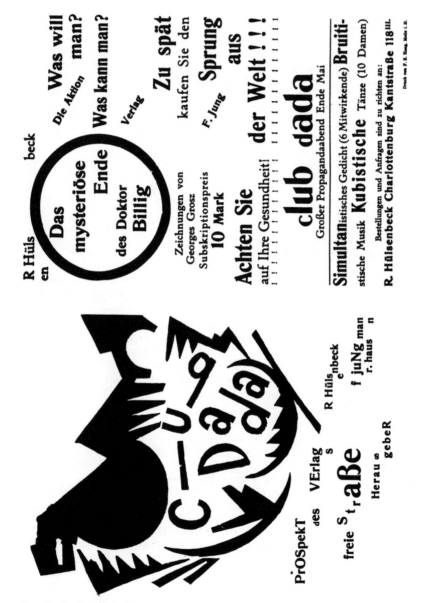

See bibl. 63: Club Dada (front and rear cover)

AVRIL 1922

LE CŒUR A BARBE

1 Fr.

JOURNAL TRANSPARENT

Administration: AU SANS PAREIL
37, Avenue Kléber - PARIS (XVIᵉ)

Ont Collaboré à ce 1ᵉʳ numéro:
Paul ELUARD, Th. FRAENKEL, Vincent HUIDOBRO, Mathew JOSEPH-SON, Benjamin PÉRET, Georges RIBEMONT-DESSAIGNES, Erik SATIE, SERNER, Rrose SÉLAVY, Philippe SOUPAULT, Tristan TZARA.

64. *Le Coeur à Barbe*. Edited by Tristan Tzara. (Paris, 1922).
One issue dated April. "Gérant Géorges Ribemont-Dessaignes." Contributions by Eluard and others. This publication, according to Gascoyne,[158] brought about *La Pomme de Pins*.[80]

65. *Dd O4 H2*. Edited by Ribemont-Dessaignes.
Publicized 1920, but never published; possibly an editorial failure, probably a dadaistic gesture.

66. *Dada*. Edited by Tristan Tzara. (Zurich, Paris, 1917–1920).
Dada 1: July 1917, correspondance, M. Janco, Zurich.—Dada 2: Dec. 1917, correspondance, F. Arp, Zurich.—Dada 3: Dec. 1918, directeur Tristan Tzara, Zurich.—Dada 4–5: cover-title, *Anthologie Dada* May 15 1919, redaction Tristan Tzara, Zurich.—Dada 6: cover-title, *Bulletin Dada*, Feb. 5 1920, Tristan Tzara, Paris.—Dada 7: cover-title, *Dadaphone*, Mar. 1920, Tristan Tzara, Paris. No.1–5 printed by J. Heuberger, Zurich. No.4–5 issued in variant German edition. Also published in "edition de luxe" with original prints by M. Janco, H. Arp, R. Hausmann. No.6 has lettered on cover: "Programme de la matinée du mouvement Dada le 5 février 1920." Sometimes *Dada Au Grand Air*[32] is cited as a final number of Dada. Lemaitre[19] chooses to say that *Dada* "changed its name and became the *Cannibale*."[62] The reference in no.1 to F. Arp, Hans Arp's brother, who was totally unaware of this forced association, is a typical dada gesture.

67. *Dada Au Grand Air*. See bibl. 32.
Both Ribemont-Dessaignes[13] and Hugnet[15] imply that this document "may be considered the final number of *Dada*".[66]

68. *Der Dada*. Edited by Raoul Hausmann. (Berlin, 1919–1920). See bibl. 289.
Advertised as "Zeitschrift der deutschen Dadaisten, einzig authentisches Organ der Dada-Bewegung in Deutschland." No.3 (1920) reads "Directeurs: Groszfield, Hearthaus, Georgemann." Probably three numbers issued, including participation by only Baader, Huelsenbeck. Published in *Dada Almanach*[7] p.135–41: "Ein Besuch im Cabaret Dada" von Alexis [aus dem Zeitschrift *Der Dada*]. *Dadaco*[34] inserted in no.2.

69. *Dada W/3*. Cologne, 1919.
"Co-founder with Baargeld and Arp of "Dada W/3" (i.e.Westupidia, divided by 3)." (No copy available to compiler).

70. *Dadameter*. See bibl. 84.

71. *Das Hirngeschwür*. Edited by Walter Serner. (Zurich, 1919).
Subscription for six issues of monthly publication advertised Apr.1919; for 10 copies, May 15, 1919. (No copy available to compiler).

72. *L'Invention et Proverbe*. See bibl. 82.
Includes extract from *La Pompe des nuages* by Arp, *Proverbe dada* by Tzara, *Yap à dada* by Ribemont-Dessaignes, etc.

73. *Litterature*. Edited by André Breton and others. (Paris, 1919–24).
First series, no.1–20, Mar.1919–Aug.1921, edited by Breton, Aragon and Soupault. Second series, no.1–13, Mar.1922–June1924, edited by Breton. Special dada number 13, May 1920.[8]

74. *Maintenant*. Edited by Arthur Cravan. 4 nos. (?) (Paris, 1913–1915).
"The forerunner of "391" and other aggressive post-war publications." (Buffet)[228] (No copies available to compiler).

75. *M'amenez-y*. Edited by Celine Arnauld.
Publicized 1920, but never published. A painting by Picabia dated 1918 and titled *M'AMENEZ-Y* was published in *Plastique* no.2:5 1937.

76. *Der Marstall*. [Heft 1–2.] (Hanover, 1920).
Advertised by Paul Steegemann Verlag in its *Silbergäule* editions. Sections included "Anna Blume"[366] †, "Dada-Kongresse", "Die Wolkenpumpe"[196], "Sekunde durch Hirn"[129a], "Aus der Geschichte des Dadaismus"[6]. Noted in currently received works in *Bleu* (no.3)[58] as "rivista bibliografica". (No copy available to compiler).

MÉCANO

LEIDEN. — PARIS: RUE DU MOULIN VERT 51 TER PARIS XIV.

ADMINISTRATIE EN VERTEGENWOORDIGING VOOR HOLLAND: "DE STIJL" UTR JAAGPAD 17

GÉRANT LITÉRAIRE: I. K. BONSET

No 4—5 en

No. { White, Blanc.
 { Wit, Weiß.
 1923

ADMINISTRATIE: UTR. JAAGPAD 17, LEIDEN (HOLLAND)

1923

N. B. Thuisbezorging
zonder prijsverhooging.

HOLLAND'S BANKROET DOOR DADA

Et je trouve qu'on a en tort de dire que le Dadaïsme, le Cubisme, le Futurisme, reposaient sur un fond commun. Le deux dernières tendances étaient surtout basées sur un principe de perfectionnement technique ou intellectuel tandis que le Dadaïsme n'a jamais reposé sur aucune théorie et n'a été qu'une

Protestation

(Tristan Tzara)

Dada est la force désintéressée, ce n'est pas une maladie, pas une énergie pas une vérité.

Evola

Waar het hart leeg van is loopt de neus van over.

Bonset

See bibl. 77: Mécano no. 4–5

77. *Mecano.* Edited by Theo van Doesburg. 4 nos. (Leiden, 1922–23).
Probably no.1 (*Bleu*) 1922, no.2 (*Jaune*) 1922, no.3 (*Rouge*) 1922, no.4–5 (*Blanc*) 1923, issued as inserts in *De Stijl,* and separately.

78. *Merz.* Edited by Kurt Schwitters. (Hanover, 1923–32). †
Jahrgang I (1923)—1: Holland-dada.—2: /i/.—3: Merz-Mappe, 6 Lithos von K. Schwitters. —4: Banalitäten.—5: Arpe-Mappe, 7 Arpaden von Hans Arp.—6: Imitatoren.—7: Tapsheft.—8–9: Nasci.—10: Bauhaus–Buch.—11: Ty-re.—12: "Der Hahnpeter," ein Märchen von K. Schwitters. No.8–9 issued jointly with El Lissitzky in new format; no.11 is TYpo-REklame issue; no.12 issued as hand-colored, numbered edition of 50 signed copies illustrated by Käte Steinitz. Merz 20 is Schwitters Katalog[370]; no.21 is *Erstes-Veilchen Heft*[376]; no.22 announced as *Entwicklung;* no.24 issued as *Ursonate*[375] (1932). Schwitters and Steinitz, in association with van Doesburg, also issued Die *Scheuche Märchen* (Hannover, Apossverlag, 1925).

79. *New York Dada.* Edited by Marcel Duchamp and Man Ray (New York, 1921). †
One issue dated April. Duchamp has referred verbally to editorial collaboration by Man Ray. The illustrations may contain a montage of Stieglitz photographs. See p.214–18.

79a. *Orbes.* Edited by Jacques-Henry Levesque and Olivier de Carne. (Paris, 1928–193?)
No.1, 1928; no.2, 1929; no.3 Printemps 1932 only issues available to compiler. No.1 included contribution by Picabia, no.2 *Picabia peintre* by George Isarlov. No.3 includes, in part: Erik Satie *Bonne éducation* (inédit); Georges Hugnet *Tristan Tzara;* Vivian Du Mas *L'Occultisme dans l'art de Francis Picabia;* Francis Picabia *Montres délicieux, Entr'acte.*

80. *La Pomme de Pins.* Edited by Francis Picabia. (St. Raphael, Feb. 25, 1922). †
Unique number, published in association with Marius de Zayas and Pierre de Massot, as answer to *Le Coeur à Barbe.*[64] Texts partially translated in editor's Introduction, p. xxx.
Reproduced, p.268–71.

81. *Projecteur.* Edited by Celine Arnauld. (Paris, 1920).
One issue, dated May 21. Writer occasionally printed as Arnault.

82. *Proverbe.* Edited by Paul Eluard. no.1–6 (Paris, 1920).
No.1, Feb.1–no.5, May 1. No.6, July 1, issued as *L'Invention et Proverbe no.1.*

See bibl. 83

83. *Rongwrong*. Edited by Marcel Duchamp. New York, 1917.
Only one number, usually but incorrectly cited as Wrong-Wrong. Contribution by "Marcel Douxami" is dated May 5, 1917. Items by Carl Van Vechten, Henry J. Vernot, and H.F. (Photostatic copy in Museum of Modern Art Library. Original in collection of Walter C. Arensberg, Cal.)

84. *Die Schammade*. Edited by Max Ernst. (Cologne, 1920). †
One number, issued Feb. by "Schloemilch Verlag." Cover by Arp. Lettered on cover: *Dadameter,* and on title: *(Dilettanten erhebt euch)*. In addition to illustrations, Ernst contributions are: "Worringer, profetor Dadaistikus"; "Antwort der Weltbürger an Kurt Pinthus-Genius, Adamismus"; "Lisbeth"; "Lukrative Geschichtsschreibung." Contributions by Aragon, Arp, Baargeld (bibl.208), Breton, Eluard, Hoerle, Huelsenbeck, Picabia, Ribemont-Dessaignes (bibl.351), Serner (bibl.393), Soupault, Tzara (bibl.414a).

85. *S I C*. Edited by Pierre Albert-Birot. no.1–54 (Paris, 1916–19).
No.1, Jan.1916–no.53–54, Dec.1919. Excepting the numerous literary items, "Dada" is only incidental material in no.21–22,23,25,28,32,47–48,49–50 (largely Tzara). Among other writings[23], the editor contributed a poem, "Pour Dada," to Dada no.2 1917.[66]

85a. *Sirius*. See bibl.393b.

85b. *De Stijl*. See bibl.239.

86. *391*. Edited by Francis Picabia. (Barcelona, New York, Zurich, Paris, 1917–24).
No.1 issued Jan. 25, 1917 in Barcelona. No.12, Mar.1920, contains "LHOOQ, tableau dada by Picabia (after work by Marcel Duchamp) and "La Sainte Vierge" by Francis Picabia. Issue of July 10 1921 titled "Annexe: *Le Pilhaou-Thibaou,* supplement illustré, directeur Funny Guy"; includes contributions by Serner and others. Note commentary in bibl. 148 on "291," "391," etc. Possibly published in New York in association with Walter C. Arensberg. Lausanne also noted as place of imprint. (Information varies; only occasional copies available to compiler).

87. *291*. Edited by Alfred Stieglitz. no.1–12. (New York, 1915–16).
"Stieglitz Gallery, 291 Fifth Ave., publishes a review illustrating proto-Dada work by Picabia" and others. Editorial assistance by M. De Zayas. Picabia material in no.4,5–6, 9,10–11,12. Sometimes "291" and "391" are cited as equivalent editorial works of Picabia, and Lemaitre[19] chooses to say that "291 later became 391."

88. *Der Ventilator*. Edited by J. T. Baargeld. (Cologne, 1919).
Dada radical newspaper. Also called "pamphlet." (No copies available to compiler).

89. *Vertical*. Edited by Guillermo de Torre and Jacques Edwards. (Madrid, 1920).
Noted in *Cannibale* Apr.1920. (No copies available to compiler).

90. *Wrong-Wrong*. See Rongwrong.[83]

91. *Z*. Edited by Paul Dermée. (Paris, 1920). †
Only one issue, dated Mar. Includes illustrations.

92. *Der Zeltweg*. Edited by Flake, Serner and Tzara. (Zurich, 1919).
One number, 32p. with illustrations, issued Nov. by Verlag Mouvement Dada. Contributions by Arp, Baumann, Eggeling, Flake, Giacometti, Helbig, Huelsenbeck, Janco, Richter, Schad, Schwitters, Serner, Taeuber, Tzara, Vagts, Wigman. Cover design by Arp. The phrase "Société Anonyme" appears here (see bibl.111), was also adopted as dada publicity in Paris, and, by way of Man Ray and Duchamp, may have been accepted as official title for the avant-guard collection of Katherine Dreier.[185a]

93. *Der Zweemann*. Edited by Hans Schiebelhuth and Christof Spengemann. (Hanover, 1919–2?).
Spengemann is frequently noted in dada documents, and published Huelsenbeck's manifesto.[133] "Die Erste Jahresfolge: November 1919 bis Oktober 1920." (No copy available).

See bibl. 84: Dadameter, cover-title for Die Schammade

DADAMETER

louis aragon

arp

| d |

d'adamax

| i |

baargeld

| œ |

andré breton

303 dadaisten

paul eluard

| s |

max ernst

| c |

angelika hoërle

| h |

heinz hoerle

| a |

richard huelsenbeck

| ∃ |

francis picabia

| ∃ |

qualitätsdada

| a |

ribemont-dessaignes

| d |

serner

| œ |

philipp soupault

tristan tzara

zentrodada

dadameter an-
timeter anti-
nommetrisches
dadascop

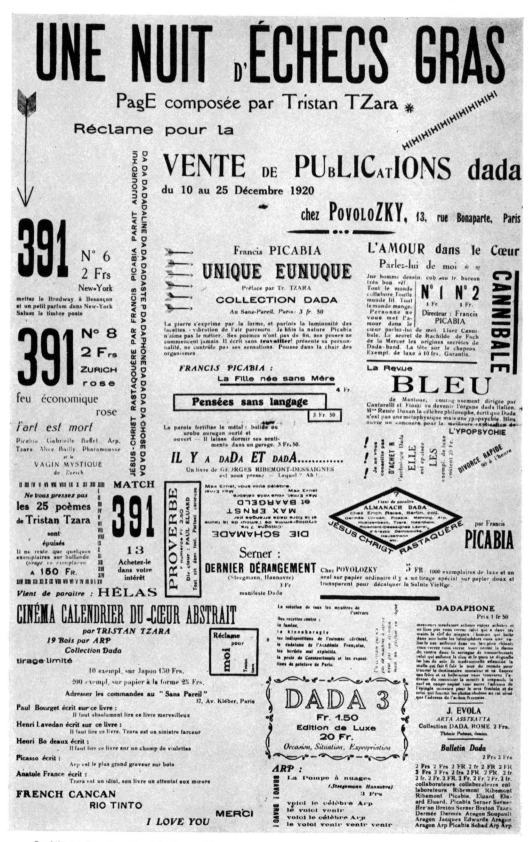

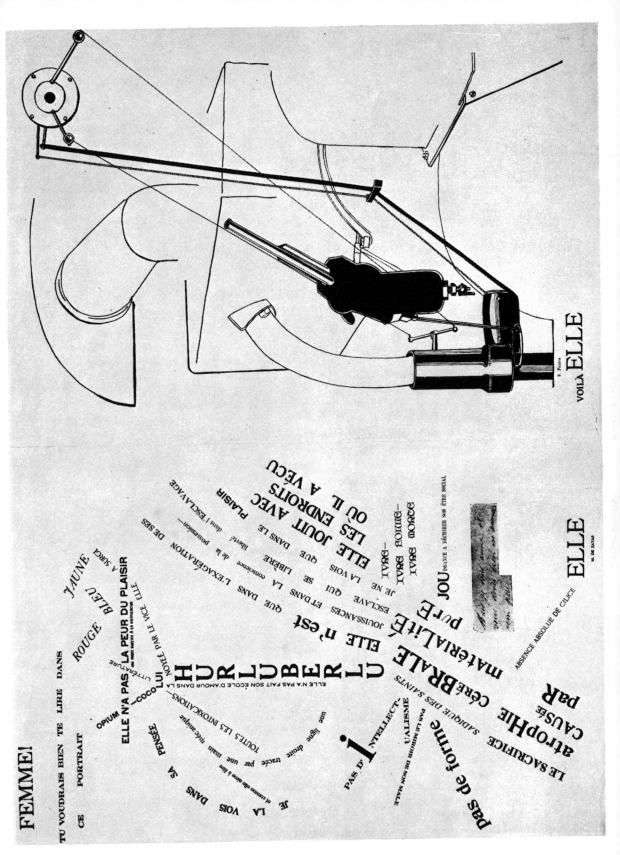

VOILA **ELLE**

F. Picabia

FEMME!

TU VOUDRAIS BIEN TE LIRE DANS

CE PORTRAIT

JAUNE

ROUGE BLEU

BLEU

À SURÇA

OPIUM

ELLE N'A PAS LA PEUR DU PLAISIR

LITTÉRATURE

COCO

LUI

NOYÉE PAR LE VICE ELLE

PENSÉE

SA

JE LA VOIS DANS

TOUTES LES INTOXICATIONS

une ligne droite tracée par une main méthodique

et comme elle aime à dire

PAS D'INTELLECT

HURLUBERLU

ELLE N'A PAS FAIT SON ÉCOLE D'AMOUR DANS LA

pas de forme

ELLE n'est

QUE DANS L'EXAGÉRATION ET DANS LA

JOUISSANCES

ESCLAVE QUI SE LIBÈRE

DE SES

de la possession

—

ELLE JOUIT AVEC

LES ENDROITS

OÙ IL A VÉCU

atrophie cérébrale matérialité

LE SACRIFICE SADIQUE DES SAINTS

PAS LE SOURIRE DE SON MALE

UALISME

ELLE JOUIT AVEC DANS LE PLAISIR

JE NE LA VOIS QUE LIBÉRÉ liberté dans l'ESCLAVAGE

IVRE MORTE

VRAI

JOU ISSANCE A DÉCHIRER SON ÊTRE SOCIAL

PURE

ABSENCE ABSOLUE DE CILICE

CAUSÉE PAR

ELLE

M. DE ZAYAS

See bibl. 87: Page from "291" no. 9, Nov. 1915

DADA AS LITERATURE

> "Language, for the Dadas, is no
> longer a means; it is an entity."
>
> Jacques Rivière[48]

94. AESCHIMANN, PAUL. *Le Dadaïsme.* In Montfort, Eugène, ed. *Vingt-cinq ans de littérature française.* tome 1:65–67 Paris, Librairie de France [1925–26?]

95. ARESSY, LUCIEN. *Du futurisme au dadaïsme.* In his *Verlaine et la dernière Bohème.* 9 ed. rev. p.250–61 Paris, Jouve, 1947.

96. BALAKIAN, ANNA. *Literary origins of surrealism: a new mysticism in French poetry.* p.127–47 New York, King's Crown press, 1947.
 "Chapter VI. The road to chaos." Ph.D. thesis (Columbia University).

97. BARTA, SÁNDOR. *Mese a trombitakezü diákrol, 1918–1922. Mések és novellak.* 56p. Wien, M/A, 1922.
 Dada fables and short stories titled: Fable of the student with the horn-shaped hand.

98. BARZUN, JACQUES. *Fragment de l'universal poème.* Transition 27:17–32 Apr.–May 1938.
 Simultaneous poem, begun 1907. Critical note, p.377, in which Ball mentions influence on Cabaret Voltaire. Huelsenbeck says (1950) that the dadaists were aware of Jarry and the Futurists (publicized by *Der Sturm*) but not of Barzun. Compare the varying accounts of Ball[61], Tzara[129], Jolas[113] and Moholy-Nagy[117].

99. BRETON, ANDRÉ, ED. *Anthologie de l'humour noir.* 262p. illus. (ports.) Paris. Editions du Sagittaire, 1940.
 Partial contents: *Francis Picabia,* p.189–91.—*Arthur Craven,* p.203–4 (por.).—*Marcel Duchamp,* p.221–25 (por.)—*Jacques Rigaud,* p.239–43.

99a. BOSQUET, ALAIN. *Surrealismus, 1924–1949.* p.10–15 Berlin, Karl H. Henssel, 1950.

99b. BOUVIER, ÉMILE. *Initiation à la littérature d'aujourd'hui.* Paris, Renaissance du Livre, 1927.
 Section on Vaché included in bibl. 104, and partly quoted in editor's Introduction, p. xxiv.

99c. CENDRARS, BLAISE. *John Paul Jones.* In *The European Caravan.* Edited by Samuel Putnam. p.200–4 1931.[104]

99d. CENDRARS, BLAISE. *La Fin du monde, filmée par l'Ange N.-D. Roman. Composition en couleurs par Fernand Léger.* Paris, La Sirène, 1919.

100. CLOUARD, HENRI. *Histoire de la littérature française.* tome 2:148–9 Paris, Albin Michel, 1949.
 "La subversion, 1.—Dada." Recent statement, brief and inadequate.

100a. *Collection Dada.* (Zurich, Paris, etc., 1917–2?)
 In 1919, the series was announced to include bibl. 66,414,416,305,307, Picabia's *L'Athèlete des pompes funèbres, Rateliers platoniques, Poésie ronron,* and "391" no.8. See also bibl.105 (Rome), and other French imprints, bibl. 317,323,350,etc. Similar to the imprints of Au San Pareil are those of Steegemann, e.g.129a,366,392,etc.

101. *Columbia dictionary of modern European literature.* 899p. New York, Columbia university press, 1947.
 Edited by Horatio E. Smith, with sections referring to some personalities of the dada era, usually French. Excellent overall view of the continental literary climate. (New edition in progress). Significantly supplemented by bibl.104.

102. COWLEY, MALCOLM. *The death of dada.* In his *Exile's return, a narrative of ideas.* p.146–80 New York, W. W. Norton, 1934.
 Part I. A brief history of dada.—2. Discourse over a grave.—3. Case record.—4. Significant gesture. Also published in the *New Republic* as "The religion of art; a discourse over the grave of dada" (77:246–49 Jan.10,1934) and as "The religion of art; the death of a religion" (77:272–5 Jan.17,1934).

102a. DOESBURG, THEO VAN. The literature of the advance guard in Holland. 1925. See bibl.234.

103. DRAKE, WILLIAM A. *The life and deeds of dada.* Poet Lore 33:497–506 Winter 1922.

344

104. *The European caravan: an anthology of the new spirit in European literature.* Compiled and edited by Samuel Putnam [and others]. Part I: France, Spain, England and Ireland. p.85–109 et passim New York, Brewer, Warren & Putnam, 1931.

> Partial contents: The birth of dada.—Dada and the revolt against "literature" (1919–1920).—The influence of dada on early after-war poetry.—The death of dada. Includes extracts from Tzara and Picabia, Vaché, Cendrars, Rigaut, etc. Introduction to the French section by André Berge, p.45–291. Extracts from Putnam and Bouvier[99a] quoted in editor's Introduction. An extraordinary anthology, unique in scope and insight.

105. EVOLA, J. *Arte astratta: teorica, composizioni, poemi.* Roma, P. Maglioni & G. Strini, 1920 (Collezione Dada).

> Reviewed in Reflector (Madrid) 1 no.1:19 Dec.1920.

106. FLAKE, OTTO. *Ja und Nein: Roman.* Berlin, S. Fischer, 1920.

107. GAUNT, WILLIAM. *The march of the moderns.* p.210,226–7,272–4 et passim London, Jonathan Cape, 1949.

107a. FOWLIE, WALLACE. *Age of surrealism.* 203p. The Swallow press and William Morrow co., 1950.

108. GIEDION-WELCKER, CAROLA. *Poètes à l'écart; Anthologie der Abseitigen.* 272p. illus. (ports.) Bern-Bümpliz, Verlag Benteli, 1946.

> Includes sections on Picabia, van Doesburg, Ball, Arp, Schwitters, Dermée and Tzara. Introductions and bibliographies by the editor.

109. GIEDION-WELCKER, CAROLA. *Die Funktion der Sprache in der heutigen Dichtung.* Transition no.22:90–100 Feb.1933.

110. HOFFMAN, FREDERICK J. *The little magazine, a history and a bibliography,* by Frederick J. Hoffmann, Charles Allen, Carolyn F. Ulrich. p.3,9,62–3,180,245,287,299,300. Princeton, N. J., Princeton university press, 1946.

> Confined to the vanguard journal in the United States, but within these limitations an excellent study upon which to model a European counterpart.

111. *Die Hyperbel vom Krokodilcoiffeur und dem Spazierstock.* Der Zeltweg p.[5–6] Nov.1919.

> At head of title: "Arp, Serner, Tzara (société anonyme pour l'exploitation du vocabulaire dadaïste)." Described by Arp as "a cycle of poems . . . later baptized *automatic poetry* by the Surrealists." This concept of the anonymous collective can be traced in such works as *L'Homme qui a perdu son squelette* (1939?), a novel in which Arp, Duchamp, Eluard, Ernst and others participated. The phrase "Société Anonyme" was employed in dada publicity in Paris and may have been suggestive to Man Ray, who named the pioneer Dreier collection of vanguard art.[185a]

112. HUGNET, GEORGES. *Introduction.* In *Petite anthologie poétique du surréalisme.* p.7–42 Paris, Jeanne Bucher, 1934.

113. JOLAS, EUGENE. *From jabberwocky to "lettrism."* Transition Forty-Eight no.1:104–20 Jan.1948.

114. JOLAS, EUGENE, ed. *Transition workshop.* 413p. New York, Vanguard press, 1949.

> Includes Arp "Notes from a diary" (p.333–8); Ball "Fragments from a dada diary" (p.338–40); Huelsenbeck "Dada lives" (p.341–4).

114a. LEMAITRE, GEORGES. *From cubism to surrealism in French literature.* 1947. See bibl.19.

> This superior study and the Balakian thesis[96], the European Caravan[104] and Raymond[120] are the ablest American titles. The English reader should consider, as a nucleus of references, bibl.113,117,104,120,19,96. Lacking English equivalents for bibl.124, the translations in this anthology of dada poets will be most convenient.

114b. LEVESQUE, JACQUES-HENRY. [*Letter on dada*]. Mar.30,1950. †

> The dada spirit, and "the post-war dada period." Quoted en toto in the editor's Introduction, p. xxxii.

115. MASSOT, PIERRE DE. *De Mallarmé à 391.* 132p. Paris, Au Bel Exemplaire, 1922.

> "Francis Picabia," p.95–122.—"Le Dadaïsme," p.123–9.—"Annexe à 391," p.131–2. Hugnet also refers to Massot's 1924 booklet on Rrose Sélavy, see text p.186.

115a. MAXIMOV, André. *Dadaism in French literature.* Sewanee Review 39:269–75 July–Sept.1931.

116. MEHRING, Walter. *The lost library; the autobiography of a culture.* New York, Bobbs-Merrill, 1951.

Includes a chapter on dada as literature.

116a. MICHAUD, Régis. Modern thought and literature in France. 326p. New York, Funk & Wagnall, 1934.

117. MOHOLY-NAGY, Laszlo. *Literature.* In his *Vision in motion.* p.292–352 Chicago, Paul Theobald, 1947.

Refers, in part, to Christian Morgenstern's sound poems *Galgenlieder* (1905) which apparently parallel the experiments of Barzun.[98] Quoted by Hausmann in editor's Introduction, p. xxxiv.

117a. PICABIA, Gabrielle. *Apollinaire.* Transition Fifty no.6:110–25 Oct.20,1950.

Anecdotes of Picabia and Duchamp as well, by Gabrielle Buffet-Picabia.

118. PUTNAM, Samuel. *Paris was our mistress; memoirs of a lost and found generation.* p.162 et passim New York, Viking press, 1947.

119. RAYMOND, Marcel. *De Baudelaire au surréalisme.* éd. nouv. p.240–46,252,267–80 Paris, José Corti, 1947.

First published 1933 by Corrêa. Translation issued 1950 in New York.[120]

120. RAYMOND, Marcel. *From Baudelaire to surrealism.* p.241–6,252,269–283 New York, Wittenborn, Schultz, inc., 1950 (Documents of modern art. 10).

Passages quoted in editor's Introduction, p. xxviii. Extensive bibliography prepared for this translation, p.366–412: "A reader's guide" by Bernard Karpel.

121. ROSENBERG, Harold. *New dada.* Instead (New York) no.2:[unpaged] Mar.1948.

122. SCHINZ, Albert. *Dadaïsme; poignée de documents sur un mouvement d'égarement de l'esprit humain après la grande guerre.* illus. Smith College Studies in Modern Languages 5 no.1:51–79 1923.

123. SENECHAL, Christian. *La Révolte: de dada au surréalisme.* In his *Les Grands courants de la littérature française contemporaine.* p.379–86 Paris, E. Malfère, 1933.

124. SOERGEL, Albert. *Satyrspiel nach der Tragödie—Dada!* In his *Dichtung und Dichter der Zeit.* p.623–34 illus. Leipzig, R. Voigtländers Verlag, 1925.

Commentary on Schwitters, p.620–3.

125. TIEGE, Karel. *Svét, který voni.* 239p. Prague, Odeon, 1930.

Kapitola I: Od romantismu k dadismu, p.7–68.—II: Dada, p.69–91.—IV: O dadaistech, 123–56. Vol.2 of "O humoru, clownech a dadaistech." Tiege also published an essay "Hyperdada" in ReD (Prague) no:1:35–8 Oct.1927, included in the first volume of this work, "Svét který se smeje" (1928).

126. TOPASS, Jan. *Quelques considérations sur le cubisme, le futurisme et le dadïsme.* In his *La Pensée au révolte.* p.9–32 Bruxelles, René Henriquez, 1935.

Similar essay published 1920.[52]

127. TZARA, Tristan. *An introduction to a dada anthology.* [1]p. New York, Wittenborn, Schultz, Inc., 1951.

Original text for this anthology, written 1948. Issued as separate and as insert. See editor's comment, p. xxx.

128. TZARA, Tristan. *L'Esprit dada dans la peinture.* Cahiers d'Art 12 no.1–3:101–3 1937. †

Corrective comment on Hugnet's survey of dada.[15] Republished here at Tzara's request.

129. TZARA, Tristan. *Note pour les bourgeois.* Cabaret Voltaire [no.1]:6–7 [June] 1916. †

Text refers to Barzun, Apollinaire and simultaneous poetry. See note, bibl.98.

129a. VISCHER, Melchior. *Sekunde durch Hirn, ein dada-Roman.* Hannover, Paul Steegemann, 1920? (Die Silbergäule, 59–61).

DADA AS PSYCHE

These representative readings illuminate a distinction of Dada which it was to confer

346

on Surrealism as well. Characterized by Breton,[12] Ribemont-Dessaignes[13] and Hugnet[15] as "a state of mind," the dadaist ideology is revealed in such essays, which, like others throughout the bibliography, individually illustrate a unique blend of destructive force and constructive insight.

130. ARP, HANS. *Dada was not a farce.* 1949. †
Text reproduced, p.283–5.

131. BALL, HUGO. *Fragments from a dada diary.* Transition no.25:73–6 Fall 1936.
Texts dated Mar.3,1916–Apr.18,1917. Translated by Eugene Jolas from *Die Flucht aus der Zeit* (1927).[213] Also published in bibl.114.

132. HARTLEY, MARSDEN. *The importance of being dada.* In his *Adventures in the arts.* p.247–54 New York, Boni and Liveright, 1921.
"Dadaism offers the first joyous dogma . . . for the release and true freedom of art." Also published in *International Studio* Nov.1921.

133. HUELSENBECK, RICHARD. *Dadaistisches Manifest.* In *Dada Almanach.* p.36–41. 1920.[7] †
"Erste Dada-Manifest in deutscher Sprache; verfasst von Richard Huelsenbeck, vorgetragen auf der grossen Berliner Dada-Soirée in April 1918." Also issued as collective manifesto, "signed" by Tzara and others, in various forms. Published also in *Der Zweemann* (Hanover).[93] Reproduction in part, and full translation, p.242–6. The manifest is supplemented in the *Dada Almanach* by an "Einleitung," p.3–9.

134. HUELSENBECK, RICHARD. *Dada manifesto 1949.* New York, Wittenborn, Schultz, inc., 1950. †
Original text prepared for this miscellany; issued as inserted pamphlet and as separate leaflet. See commentary in editor's Introduction, p. xxx.

135. TZARA, TRISTAN. *Conference sur dada.* Merz. 2 no.7:68–70 Jan.1924. †
"Vortrag Tzaras auf dem Dadakongress in Weimar 1922."

136. TZARA, TRISTAN. *An introduction to a dada anthology.* See bibl.127.

DADA AS ART

"The public history of modern art is the story of conventional people not knowing what they are dealing with."
Robert Motherwell (preface, p. xviii).

For a full chronology of artistic events, consult the outlines by Aragon,[10] Barr and Courter,[17] Bazin[139] and Tzara[182] which refer to occasions noted in detail in the extensive surveys by Ribemont-Dessaignes[13] and Hugnet.[15] Certain major documents have been recorded below, e.g. Cologne,[152] Berlin,[142] Paris,[171] New York,[17] Zurich,[187,66] and others will be found under individual listings, e.g. Ernst,[269] Picabia,[334] Ray,[344] Ribemont-Dessaignes,[357a] etc. Bolliger has compiled a recent chronology.[21b]

137. ARAGON, LOUIS. *La Peinture au défi.* 32p. plus 23 illus. Paris, Galerie Goemans, 1930.
"Exposition de collages: Arp, Braque, Dali, Duchamp, Ernst, Gris, Miro, Magritte, Man-Ray, Picabia, Picasso, Tanguy . . . mars 1930."

138. BARR, ALFRED H., JR. *Abstract dadaism.* In New York. Museum of Modern Art. *Cubism and abstract art.* p.172–8 incl.illus. New York, Museum of Modern Art, 1936.
Catalog issued for exhibition of the same title, containing essay and notes by A. H. Barr, jr., catalog by D. C. Miller and E. M. Fantl, bibliography by Beaumont Newhall.

139. BAZIN, GERMAIN. *Notice historique sur dada et le surréalisme.* In Huyghe, René. *Histoire de l'art contemporain: la peinture.* p.340–2 Paris, Alcan, 1935.
Biographical and bibliographical notes, p.342–4, on Arp, Duchamp, Ernst, Picabia, Ray. Originally published in *L'Amour de l'Art* Mar.1934. See bibl.16.

140. BELLI, CARLO. Kn. p.115–22 Milano, Edizioni del Milione, 1935.

141. BENET, RAFAEL. *El futurismo comparado; el moviemento dada.* p.19–28 illus. Barcelona, Ediciones Omega, 1949 (Coleccion Poliedro).

142. BURCHARD, OTTO, KUNSTHANDLUNG. *Erste internationale Dada-Messe . . . Katalog.* illus. [4]p. [Berlin, 1920]. †

"Veranstaltet von Marschall G. Grosz, Dadasoph Raoul Hausmann, Monteurdada John Heartfield . . . Ausstellung und Verkauf dadaistischer Erzeugnisse." International dada exhibition of 174 items held June 5, representing Cologne, Karlsruhe, Magdeburg, Amsterdam, Antwerp, Zurich and Paris. Montages by Grosz and Heartfield; contributions by Hausmann, W. Herzfelde; list of works by Heartfield, Hausmann, Grosz, Baargeld, Ernst, Baader and others. Installation view in *Dada Almanach* (p.128).[7]

143. BIEDERMAN, CHARLES. *Art as the evolution of visual knowledge.* p.500–2,507 Red Wing, Minn., Charles Biederman, 1948.

144. BRANCUSI, CONSTANTIN. [Statement]. De Stijl no.79–84:81–2 1927.

"When we are no longer children we are already dead."

145. BRETON, ANDRÉ. *Le Surréalisme et la peinture, suivi de Genèse et perspective artistique du surréalisme, et de Fragments inédits,* 203p. illus. New York, Brentano's, 1945.

"Genèse et perspectives artistiques du surréalisme," p.79–103, first published in English in *Art of This Century.*[160] "Fragments inédits" includes "Phare de la Mariée," p.107–24, published also in View, and "Vie legendaire de Max Ernst," p.159–68. Similar title for edition of 1928.[223]

146. BROOKLYN MUSEUM. *International exhibition of modern art, arranged by the Société Anonyme for the Brooklyn Museum.* 117p. illus. New York, Société Anonyme—Museum of Modern Art, 1926.

Cover-title of publication which supplements the exhibition checklist issued by the Brooklyn Museum. Title page reads: "Katherine Dreier. Modern art." Exhibit held November–December. Brief illustrated comment on Arp (p.21), Picabia (p.22), Duchamp (p.23), Schwitters (p.34), Ernst (p.35), Hoerle (p.37), Man Ray (p.96), and others. Definitive catalog of the collection and additional data published in 1950.[185a]

147. BRZEKOWSKI, JAN. *Kilométrage de la peinture contemporaine, 1908–1930.* Paris, Fischbacher, 1931.

Incorporates essay "Kilométrage 3" from *L'Art Contemporain* (Sztuka Wspólczesna) no.3:82–4 [193?]. Arp items include a letter, the cover and plates. "Le Dadaïsme—déplacement des valeurs plastiques de la déformation dans le domaine de l'intellectual et du psychique."

148. BUFFET-PICABIA, GABRIELLE. *On demand "Pourquoi 391? Qu'est-ce que 391?."* Plastique no.2:2–8 incl. 3 plates Summer 1937.

Partly quoted in bibl.21a.

148a. BUFFET-PICABIA, GABRIELLE. *Dada.* illus. Art d'Aujourd'hui no.7–8: [26–9] Mar. 1950.

Includes reproduction of Duchamp's original "L.H.O.O.Q." (1919), a Mona Lisa with moustache and goatee, published in *391* (no.12) in Picabia's version.

149. CABARET VOLTAIRE (Zurich). *Catalogue de l'exposition Cabaret Voltaire.* p.[32] See bibl.61.

150. CHENEY, SHELDON. *A primer of modern art.* p.139–45 New York, Boni and Liveright, 1924.

Also available in reprints and subsequent editions.

151. CHENEY, SHELDON. *The story of modern art.* p.478–80 New York, Viking press, 1941.

151a. CIRLOT, JUAN EDUARDO. *Diccionnario de los ismos.* p.78–81 Barcelona, Buenos Aires, Argos, 1949.

152. COLOGNE. DADA AUSSTELLUNG. *Dada-Vorfrühling: Gemalde, Skulpturen, Zeichnungen, Fluidoskeptrik, Vulgärdillettanismus.* [4]p. [1920].

Exhibit held April at Winter's Brauhaus, with only Arp, Baargeld, Ernst. Closed by police but reopened May. Catalog above lists these three, Picabia and "two dilettantes."

153. CREVEL, RENÉ. *L'Esprit contre la raison.* p.23–6,50 Marseille, Les Cahiers du Sud, 1928.

154. DORIVAL, BERNARD. *Les Étapes de la peinture française contemporaine; tome troisième: Depuis le cubisme 1911–1944.* p.208–15 Paris, Gallimard, 1946.

155. DREIER, Katherine S. *Western art and the new era.* p.118–20 New York, Brentano's, 1923.

155a. FERNANDEZ, Justino. *Dada.* In his *Prometeo, ensayo sobre pintura contemporáneo.* p.29–38 Mexico, D. F., Editorial Porrua, 1945.

156. FOCILLON, Henri. *The life of forms in art.* 94p. illus. New York, Wittenborn, Schultz, inc., 1948.
Quoted in editor's Introduction, p. xxxvi. "In praise of hands" (p.65–78) is new text for this second English edition, revised, of 1942 Yale press publication. Originally "Vie des formes" (Presses Universitaires de France).

157. FOIX, J. V. *Dada.* illus. D'Aci I D'Alla 22 no.179:[47] Dec.1934.

158. GASCOYNE, David. *The dadaist attitude.* In his *A short survey of surrealism.* p.23–44 London, Cobden-Sanderson, 1935.

158a. GIEDION-WELCKER, Carola. *Modern plastic art: elements of reality, volume and disintegration.* 166p. Zurich, H. Girsberger, 1937.
Includes commentary, illustrations and biographical data on dadaist sculptors. New edition planned for 1951 (New York, Wittenborn, Schultz, inc.).

158b. GINDERTAEL, R.-V. *Du coté de dada . . . et du surréalisme.* illus. Art d'Aujourd'ui sér.2, no.3:14–15 Jan.1951.

159. GOMEZ DE LA SERNA, Ramon. *Dadaismo.* In his *Ismos.* p.247–54 Buenos Aires, Editorial Poseidon, 1943.

160. GUGGENHEIM, Peggy, ed. *Art of this century.* 156p. illus. New York, Art of This Century [Gallery], 1942.
The editor's private collection comprising "an anthology of non-realistic art covering the period from 1910 to 1942." Includes essays by André Breton "Genesis and perspective of surrealism" (p.13–27); by Hans Arp "Abstract art, concrete art" (p.29–31). Biographical sections on Duchamp (p.56), Picabia (p.60), Arp (p.101), Ernst (p.103), Ray (p.106), Schwitters (p.108) include occasional quotations from the artists' writings. Breton's essay subsequently appeared in bibl. 145.

161. HILDEBRANDT, Hans. *Die Kunst des 19. und. 20. Jahrhunderts.* p.399–400,416–17,427–8,449 et passim Wildpark-Potsdam, Akademische Verlagsgesellschaft Athenaion, 1924.
Sections on Ernst, Grosz, Schwitters, photomontage, etc.

162. HUGNET, Georges. *Dada.* Bulletin of the Museum of Modern Art (New York) 4 no.2–3:3–17 Nov.–Dec.1936.
"This brief history of Dada has to do primarily with painting." Subsequently published in bibl. 17.

163. HUYGHE, René. *Le Dadaïsme.* In his *La Peinture française: Les contemporains.* p.52–3 Paris, Pierre Tisné, 1939.
New edition, 1949.

164. HUYGHE, René, ed. *Histoire de l'art contemporaine: la peinture.* See bibl. 16.

164a. KASSÁK, Ludwig & MOHOLY-NAGY, Ladislas, ed. *Buch neuer Künstler.* Wien, Zeitschrift "MA," 1922.
Brief text supplemented by extensive pictorial selections of vanguard art, including dada comment and reproductions. Preface dated May 31, imprint dated Sept.1922.

165. KLEIN, Jerome. *Dada for propaganda.* Art Front (New York) 1 no.3:7–8 Feb.1935.

166. LEVY, Julien, ed. *Surrealism.* p.10–11 New York, Black Sun press, 1936.

167. LISSITZKY, El & ARP, Hans. *Die Kunstismen.* 11p. plus 48 plates Erlenbach-Zürich, München und Leipzig, 1925.
Cover-title: Kunstism 1914–1924. Text also in French and English, with definitions of "dadaism" by Arp, of "Merz" by Schwitters, of "Verism" by Grosz.

167a. MYERS, Bernard S. *Modern art in the making.* p.357–62 illus. New York, Toronto, London, McGraw-Hill book co., 1950.
Ch.20: Escape into the mind.

168. MOHOLY-NAGY, Laszlo. *Vision in motion.* p.310–20, 330–41 et passim Chicago, Paul Theobald, 1947.
See also bibl. 383.

169. NEW YORK. MUSEUM OF MODERN ART. *Fantastic art, dada, surrealism.* 248p. illus. 1936. See bibl. 17.

170. NEW YORK. MUSEUM OF MODERN ART. *Modern art in your life, by Robert Goldwater* [&] René d'Harmoncourt. 48p. illus. New York, Museum of Modern Art, 1949.
An exhibit based on the application to everyday design of the twin concepts of the geometric pattern (Mondrian) and the free contour (Arp). Issued as *Bulletin* of the Museum v.17, no.1, 1949.

170a. PARIS. CINÉMATHEQUE FRANÇAISE. *250 films d'essai et d'avant-garde* [*programme*]. Juillet-Septembre 1949.
Series of nine films, July 10 and Aug. 20, title "Dada." Includes Eggeling (1918), Ruttmann (1921), Léger (1923), Man Ray (1923), Ruttmann (1924), Duchamp (1924), René Clair (1924), H. Richter (1926).

171. PARIS. GALERIE MONTAIGNE. *Salon dada, exposition internationale.* [16]p. illus. 1922. Exhibition held June 6–30, listing 81 works. Nos.28–31 by Duchamp are blank. Primarily a series of contributions in de luxe catalog: Soupault, Eluard, Margarine, Ray, Rigaut, Ribemont-Dessaignes, Tzara, Mehring, Péret, Aragon, Arp, Evola. Exhibitors included Arp, Aragon, Baargeld, Cantarelli, Charchoune, Eluard, Ernst, Evola, Fiozzi, Fraenkel, Franton & Brekel, Mehring, Péret, Ray, Ribemont-Dessaignes, Rigaut, Soupault, Stella, Tzara, Vaché, Gala & Paul Eluard, Un Ami de St. Brice.

172. PARTENS, Alexander. *Dada-Kunst.* In *Dada Almanach.* p.84–90 1920.[7]

173. RAYNAL, Maurice. *Anthologie de la peinture en France.* See note, bibl. 174.

174. RAYNAL, Maurice. *"Dada" and scepticism in painting.* In his *Modern French painters.* p.25–6 New York, Brentano's, 1928.
Additional material in essay "Francis Picabia" (p.134–6). Originally published as *Anthologie de la peinture en France.* Paris, Éditions Montaigne, 1927.

175. RAYNAL, Maurice [and others]. *History of modern painting, v.3* Geneva, Albert Skira, 1950.
See bibl. 21a. Originally announced as a series of essays by Raynal and others on Arp, Duchamp, Picabia, Ernst, Schwitters, etc.

176. RIBEMONT-DESSAIGNES, Georges. *Dada painting or the oil eye.* illus. The Little Review 9 no.4:11–12 Autumn and Winter 1923–24.
On Arp, Duchamp, Ernst, and Man Ray.

177. ROTHSCHILD, Edward F. *The meaning of unintelligibility in modern art.* p.68–74 Chicago, University of Chicago press, 1934.

178. SALMON, André. *Dada.* In his *L'Art vivant.* p.294–7 Paris, G. Crès, 1920.

179. SANDUSKY, L. *The Bauhaus tradition and the new typography.* P M (New York) 4 no.7:16–17 June–July 1938.
On typographical innovations, including dada examples, published in the little magazine later titled A D. Note also significant changes in dada periodicals, e.g. *Merz* no.8–9 (Nasci number). Compare commentary on vignette illustrations, montage, etc. (bibl. 274,293,383,etc.).

179a. SAN LAZZARO, G. Di. *Painting in France, 1895–1949.* p.100–2 New York, Philosophical library, 1949.
Translation by B. Gilliat-Smith and Bernard Wall.

180. SANTOS TORROELLA, R. *Genio y figura del surrealismo; anécdota y balance de una subversion.* illus. Cobalto 2:6–9 1948.
Lettered on title-page: Volumen II, cuaderno primero: Surrealismo. Special issue of *Cobalto* (Ediciones Cobalto, Barcelona).

181. SEUPHOR, Michel. *Dada.* In *L'Art abstrait.* p.60–62 et passim illus. Paris, Maeght, 1949.
Dada poster by Janco, in color, facing p.62. Arp (p.62–4); Van Doesburg (p.64–6), plus portraits and plates. Biographical and bibliographical notes on Arp (p.279–80),

Eggeling (p.292), Picabia (p.308), Richter (p.311), Schwitters (p.311–13,386), Van Does-burg (p.315–6). "Bibliographie," p.319–21.

182. TZARA, TRISTAN. *Chronique Zurichoise 1915–1919.* In *Dada Almanach.* p.10–29. 1920.[7] †
 Detailed chronology of soirées, exhibitions, publications, etc. Reproduced in translation, p.235–42.

182a. VENICE. BIENNALE. [Dada—international art exhibition]. 1952?
 Scheduled as part of the regular Biennale, which has already exhibited Cubism and Fauvism. Hans Richter will organize this section of the XXVIth international, and has prepared an introductory article for its magazine.[361c]

183. VIAZZI, GLAUCO. *Dadaismo e surrealismo.* Domus 202:378–82 illus. Oct.1944.

184. WEDDERKOP, H. von. *Dadaismus.* Jahrbuch der Jungen Kunst 2:216,218–9,222–4 1921.

185. WILENSKI, REGINALD HOWARD. *Modern French painters.* p.261–3,276–7,294,296–7, et passim New York, Reynal & Hitchcock [1940].
 Another edition, 1944.

185a. YALE UNIVERSITY ART GALLERY, NEW HAVEN. *Collection of the Société Anonyme: Museum of Modern Art 1920.* 223p. illus. New Haven, Conn., 1950.
 Pioneer collection donated by Katherine Dreier and Marcel Duchamp, trustees. Various texts, edited by G. H. Hamilton, curator, which include biographical and bibliographical notes for Picabia (p.4–5), Van Doesburg (p.66–7), Arp (p.69–70), Schwitters (p.89–90), Ernst (p.114–5), Duchamp (p.148–50), Man Ray (p.174), Ribemont-Dessaignes (p.187). The Société was so named by Man Ray (p.174) but the phrase "société anonyme" appeared earlier in print in *Der Zeltweg* (1919)[111] and was current in Paris on dada publicity about 1920.

185b. ZAYAS, MARIUS DE. [*L'Art moderne à New York*]. 2 v. (in progress?).
 Announced in Littérature, Oct. 1, 1922, as "pour paraître." Apparently extensive notes on which the author is still engaged (New York, 1951). In view of his close association with the American era of dada ("291," "391," etc.), these essays may eventually be helpful in clarifying some obscure events, and the relations between Paris and New York.

186. ZERVOS, CHRISTIAN. *Dada.* In his *Histoire de l'art contemporain.* p.407–14 illus. Paris, Cahiers d'Art, 1938.
 Plates: p.408–14.

187. ZURICH. GALERIE DADA. [*Exhibitions*]. See bibl. 66.
 Gallery events regularly listed in *Dada,* also noted in *Chronique Zurichoise.*[182]

SOME DADAISTS

ARP, HANS [JEAN]

> "Dada gave the Venus of Milo an enema . . . Dada is for nature and against art."[192]

188. ARP, HANS. *Dada was not a farce.* 1949. †
 Original text for this anthology. See p.293–5.

188a. ARP, HANS. *Dadaland, Zürcher Erinnerungen aus der Zeit des ersten Weltkrieges.* Atlantis (Zurich) Sonderheft 1948.
 Probably published in bibl. 193, modified from bibl. 194a.

189. ARP, HANS. *Gedichte: Weisst du schwarzt du. Fünf Klebebilder von Max Ernst.* [26]p. Zurich, Pra Verlag, 1930.
 Poems written 1922; illustrations in 1929. Parts also published in *Marie* no.2–3:5 July 8 1926, *De Stijl* no.73–74:5–10 1926 and elsewhere.

190. ARP, HANS. *Die Hyperbel von Krokodilcoiffeur und dem Spazierstock.* Der Zeltweg Nov.1919.
 See note for bibl. 111.

191. ARP. Hans. *Die Kunstismen (1914–1924)*. See bibl. 167.
Variant version of bibl. 192.

192. ARP, Hans. *Notes from a diary*. Transition no.21:190–4 Mar.1932. †
Variant of text published in *Transition*[192] and modified in *On My Way*.[193] See p.221–5.

193. ARP, Hans. *On my way: poetry and essays 1912 . . . 1947*. 147p. illus. New York, Wittenborn, Schultz, inc., 1948 (Documents on modern art. 6).
Edited by Robert Motherwell. Contributions by C. Giedion-Welcker, G. Buffet-Picabia. Includes essay "Dadaland" (p.39–47) and scattered commentary on dadaism. Extensive bibliography.

194. ARP, Hans. *Der Pyramidenrock*. [70]p. illus. Erlenbach-Zürich und München, Eugen Rentsch Verlag [1924].
Extracts published as "Einzahl, Mehrzahl, Rübezahl" in *G* no.3:48–9 June 1924, with comment by Hans Richter.

194a. ARP, Hans. *Tibiis canere (Zurich, 1915–20)*. illus. XX^e Siècle 1 no.1:41–44 Mar.1938.
With illustration of Janco's painting "Cabaret Voltaire." Subsequently published, in modified versions characteristic of Arp, as "Dadaland."[193,188a]

194b. ARP. Hans. *Sophie*. 1946. †
A poem on Sophie Taeuber-Arp.

195. ARP, Hans. *Der Vogel selbdritt*. [Berlin, Privately printed, 1920].
Imprint of Otto V. Holten. Most of the poems published as projections for and extracts from "Die Schwalbenhode" and "La Couille d'Hirondelle" appeared here. "Die Schwalbenhode. Gedichte mit 6 Originalholzschnitten des Verfassers" was announced but not published by Der Malik-Verlag (Berlin, 1920). Portions also appear in *Dada*[66], *Dada Almanach*[7], *391*[86], and elsewhere.

196. ARP, Hans. *Die Wolkenpumpe*. 22p. Hannover, Paul Steegemann, 1920 (Die Silbergäule, bd. 52–53).
Read at the 9. dada soirée, salle Kaufleuten, Apr. 9, 1919. First published extracts in *Dada* 4–5:[20] May 15 1919 (*Anthologie Dada*, German edition). Extracts also published in *Der Zeltweg*[92], *Die Schammade* (Dadameter) p.5–6 Feb. 1920, with cover and illustrations by Arp; with French translation by Breton and Tzara in *Littérature* 2 no.14: 23–4 June 1920, *Proverbe* no.6: 2 July 1 1921, and elsewhere.

196a. ARP, Hans. *7 Arpaden*. 7 prints in folio. Hannover, Merzverlag [1923].
Lithographs issued as *Merz* no.5, "Arp-Mappe, Zweite Mappe des Merzverlages" in 50 numbered copies. Illustrations also published (in miniature) in *G* no.3:48 June 1924. The most distinctive recognition of Arp in *Merz*, which also published texts, e.g. no.6 Oct.1923. A full record of Arp's graphic and illustrative work is noted in the bibliography for "On My Way."[193]

197. *Dada*. (Zurich, Paris, 1917–1920). See bibl. 66.
Numerous contributions by and on Arp, including graphic work.

198. *Dada W/3*. (Cologne, 1919). See bibl. 69.
Founded by Arp, Baargeld, Ernst. Probably short-lived.

199. ERDMANN-CZAPSKI, Veronika. *Hans Arp "Pyramidenrock": Zur Entwicklungspsychologie des Dadaismus*. Das Kunstblatt 10:218–21 June 1926.

200. ERNST, Max. *Arp*. Littérature no.19:10–12 May 1921.

201. GIEDION-WELCKER, Carola. *Jean Arp*. illus. Horizon 14 no.82:232–9 Oct.1946.
A survey of his artistic development, including the dada period, and a critique of the "Cabaret Voltaire." Republished, with minor changes, in "On My Way."[193] Essay on Arp also published in *Das Kunstblatt* 14:372–5 Dec.1930.

202. HUELSENBECK, Richard. *Die Arbeiten von Hans Arp*. Dada 3:7 Dec.1918.
An English translation, signed by the author, has been inserted in copy in the Museum of Modern Art Library, New York.

203. PARTENS, Alexander. *Dada-Kunst*. In *Dada Almanach* 1920.[7]
Partly quoted by the artist in "On My Way" (p.47).[193]

204. SCHWITTERS, Kurt. *An Arp*. Merz no.4:1 July 1923.

205. TZARA, Tristan. *Les Poésies de Arp*. Dada 4–5:[20] May 15 1919.
Introduction to first publication of extracts from "Die Wolkenpumpe" (text printed in German edition of "Anthologie Dada"). Essays on Arp also published in *Littérature* no.19 1921, *Merz* no.6 1923.

BAARGELD, JOHANNES THEODOR

206. *Bulletin D*. Edited by Baargeld and Ernst. 1919. See bibl. 60.
Includes list of 4 works, and article "Schlagt das warme Ei aus der Hand!"

207. *Dada W/3*. Cologne, 1919. See bibl. 69.
Founded by Arp, Baargeld, Ernst.

208. *Die Schammade*. Edited by Ernst. See bibl. 84.
In addition to illustrations, Baargeld contributions are: "Bimbamresonanz I, II (p.10,22); "Röhrensiedlung oder Gotik" (p.3); "26 doch simpel" (p.31.).

209. *Der Ventilator*. Edited by Baargeld. 1919. See bibl. 88.
Sometimes called "a pamphlet." Apparently a leftist newspaper.

210. COLOGNE. DADA AUSSTELLUNG. *Dada-Vorfrühling*. 1920. See bibl. 152.
Baargeld an important participant.

210a. HUGNET, George. *L'Esprit dada dans la peinture, III: Cologne et Hanovere*. illus. Cahiers d'Art no.8–10: 358–64 1932. †

BALL, HUGO

> "We should burn all libraries and allow to remain only that which every one knows by heart. A beautiful age of the legend would then begin."[214]

211. BALL, Hugo. *Cabaret*. Transition no.22:10 Feb.1933.
"Written in 1915 . . . never published before" (Eugene Jolas).

212. BALL, Hugo. *Clouds; Cats and peacocks*. Transition no.21:304–5 Mar.1932.
Translation of two poems, "Wolken"; "Katzen und Pfauen."

213. BALL, Hugo. *Die Flucht aus der Zeit*. Munich-Leipzig, Duncker & Humblot, 1927. †
Also edition of Verlag Josef Stocker (Luzern, 1946), with frontispiece. Includes material variously published, e.g. bibl. 214, etc. See p.51–4.

214. BALL, Hugo. *Fragments from a dada diary*. Transition no.25:73–6 Fall 1936. †
Translated by Eugene Jolas from "Die Flucht aus der Zeit"[213], with another passage "Sound poems (Zurich 1915)" on p.159–60.

214a. BALL, Hugo. *Gnostic magic*. Transition no.23:86–7 July 1935.
Portion quoted in editor's Introduction, p. xix.

215. BALL, Hugo. *Uber dada*. De Stijl 14 no.79–84:78–79 1927.
Dated 1916. Includes other fragments, of which "Uber Literatur" (p.79–80) is on Huelsenbeck.

216. *Cabaret Voltaire*. Edited by Hugo Ball. (Zurich, 1916). †
First dadaist publication. See bibl. 61. Introduction by Ball translated in editor's Introduction, p. xviii.

BRETON, ANDRÉ

> "Dada attacks you through your own reasoning."[222]

216a. BRETON, André, ed. *Anthologie de l'humour noir*. See bibl.99

217. BRETON, André & SOUPAULT, Philippe. *Les Champs magnétiques*. 11p. Paris, Au Sans Pareil, 1921. †
"Les Champs Magnétiques sont dédiés à la mémoire de Jacques Vaché." Two portraits by Picabia. See "fragment," p.232.

218. BRETON, André. *Les Contes du "Cannibale": Les reptiles cambrioleurs*. Cannibale no.2:14 May 25 1920.

219. BRETON, André. *Genesis and perspective of surrealism.* In Guggenheim, Peggy, **ed.** *Art of this century.* New York, 1942.
First publication of text subsequently issued in French.

220. BRETON, André. *Mont de piété.* Paris, Au Sans Pareil, 1919.
"Avec deux dessins d'André Derain."

221. BRETON, André. *Les Pas perdus.* Paris, Gallimard, 1924. †
For details, see bibl.12. Translated selections, p.199–211.

222. BRETON, André. *Patinage dada.* Littérature 2 no.13:9 May 1920.

222a. BRETON, André. *Surrealism: yesterday, today and tomorrow.* This Quarter 5 no.1: 7–44 1932.
Translation by the editor, E. Titus, in surrealist number supervised by Breton. Quoted partly in editor's Introduction, p. xxvi.

223. BRETON, André. *Le Surréalisme et la peinture.* 72p. illus. Paris, N R F, Gallimard, 1928.
Illustrations after Arp, Ernst, Picabia, Ray, and others. Also published in an enlarged edition of 1945.[145]

224. BRETON, André. *Vous m'oublierez. Sketch par André Breton et Philippe Soupault.* Cannibale no.1:3–4 Apr. 25 1920.
Also published in *Littérature* n.s. no.4:25–32 Sept. 1 1922.

225. BRETON, André & SOUPAULT, Philippe. *White gloves.* New Directions [no.5]:488–90 1940.
Translation, by J. Laughlin and C. Cohen, of fragment from "Les Champs magnétiques."[217]

225a. *Littérature.* Edited by André Breton and others. (Paris, 1919–24).
Special dada number 13, May 1920. Editorial details noted in bibl. 73.

CRAVAN, ARTHUR

"I do not want to be civilized."[226]

226. CRAVAN, Arthur. *Exhibition at the independents (1914).* From bibl. 74. †
See text, p.3–13.

226a. CRAVAN, Arthur. *Notes.* illus. V V V (New York) no.1:55–57 June 1942, no.2–3: 91–93 Mar.1943.
Brief introduction by Breton to unpublished texts in possession of Mina Loy.

227. BRETON, André. *Arthur Cravan.* In his *Anthologie de l'humour noir.* p.203–4 illus. (port.) Paris, Editions du Sagittaire, 1940.

228. BUFFET-PICABIA, Gabrielle. *Arthur Cravan and American dada.* Transition no.27:314–21 Apr.–May 1938. †
See text, p.13–17.

229. *Maintenant.* Edited by Arthur Cravan. (Paris, 1913–1915). See bibl.74.

229a. *La Terre n'Est pas une vallée des larmes.* p.8–16 illus. Bruxelles, "La Boétie", 1945.
Includes bibl. 226,227, a letter to Fénéon, and illustration from *Stadium* (6no.153, Apr. 29, 1916) showing Cravan in ring with Jack Johnson.

DOESBURG, THEO VAN

"For the sake of progress we must destroy Art."[233]

230. DOESBURG, Theo Van. *Antikunstenzuivererede-manifest.* Mécano Jaune no.[2]: unpaged 1922.
Signed: I. K. Bonset.

231. DOESBURG, Theo Van. *Dada.* De Nieuwe Amsterdammer no.279 1920.
Probably one of a series (bibl.232?), mentioned in Cannibale (no.2, May 1920).

232. DOESBURG, Theo Van. *Dadaïsme.* Merz no.1:16 Jan.1923, no.2:28–32 Apr.1923.
"1. Dada vormt zich.—2. De veelvormigheid von Dada."

233. DOESBURG, Theo Van. *The end of art.* De Stijl 7 no.73–74:29–30 1926.

See bibl. 235

234. DOESBURG, Theo Van. *The literature of the advance guard in Holland.* The Little Review 11 no.1:56–9 Spring 1925.

Includes "Manifesto II of De Stijl 1920" signed by Doesburg, Mondrian and Kok." The new conception of life is based upon *depth and intensity.*"

234a. DOESBURG, Theo Van. *Uit het "Journal d'ideés" van Theo van Doesburg.* De Stijl Dernier numéro [no.90]:24–30 Jan.1932.

Extracts dated 1930. "Le vrai principe spirituel . . . dans les arts était créé en France par les "décadents," les vrais poètes comme: mallarmé, verlaine, baudelaire, rimbaud . . . c'était là où la réaction contre le naturalisme commencait à se développer. L'animal se transformait en chimère."

235. DOESBURG, Theo Van. *Wat is dada?* [16]p. De Haag, Uitgave "De Stijl," 1923.

236. *Mécano.* Edited by Theo van Doesburg. (1922–23). See bibl.77.
Doesburg, whose name was C. E. M. Küpper, also contributed as Aldo Camini and I. K. Bonset. See note, bibl. 111.

237. *Die Scheuche Märchen.* [12]p. Hannover, Apossverlag, 1925.
"Typografisch gestaltet von Kurt Schwitters, Käte Steinitz, Th. van Doesburg." Probably a communal product of *Merz.*[78]

238. SCHWITTERS, Kurt. [*Theo van Doesburg and dada*]. De Stijl Dernier numéro [no.90]:24–30 Jan.1932. †
Untitled memoir on Doesburg as dadst supreme, Hanover, June 1931. See p.275–6.

239. DE STIJL (Leyden). *Van Doesburg, 1917–1931.* illus. Leiden. 1932.
Memorial issue: "Dernier numéro," Jan.1932. If numbered, this would have been issue 90 of the journal which was largely the voice of van Doesburg. Includes biography, bibliography, contributions by Arp, Schwitters[238], and others, as well as selections from the artist's writings. While *De Stijl* is not primarily a dada periodical, it fathered *Mécano*, and owing to Doesburg, publicized dada during its heyday.[235,348] Its cosmopolitan imprints—"Weimar, Haag, Antwerp, Parijs, Rome, Warschau, Leiden, Hannover, Brno, Weenen"—reflect the internationalism of *Dada*[66] and*391*.[86] Like other contemporaneous and post-war manifestations deriving from the partly-realized hopes of an international and collective expression, it flourished and died in the shadow of an intense individualism.

DUCHAMP, MARCEL

> "*To separate the* ready-made *in* quantity *from the* already-found. *The separating is an operation.*"[242]

240. DUCHAMP, Marcel. *Boîte-en-valise; contenant la reproduction des 69 principals oeuvres de Marcel Duchamp.* [New York, 1941?]
Leather box, with complete work in miniature. Probably completed 1941–42 (New York). Edition of 20 advertised by Art of This Century Gallery, 1943.

240a. DUCHAMP, Marcel. *A complete reversal of art opinions by Marcel Duchamp iconoclast.* illus. Arts and Decoration. v.5, no.11:427–28,442 Sept.1915.

240b. DUCHAMP, Marcel. *Marcel Duchamp* [*an informal interview*]. illus. (por.) Bulletin of the Museum of Modern Art (New York) 13 no.4–5:19–21,37 1946.
Personal statement in special number, "Eleven Europeans in America," compiled by J. J. Sweeney. Bibliography.

241. DUCHAMP, Marcel. *La Mariée mise à nu par ses célibataires même.* Paris, Éditions Rrose Sélavy [1934].
"300 numbered and signed copies of a collection of manuscript notes, drawings and paintings (1911 to 1918) which served as a basis for composing the *Glass*." (View)[251] Extracts of the notes published with brief comment by Breton in *Le Surréalisme au Service de la Révolution* no.5:1–2 May 15 1933. Extracts in bibl.242.

242. DUCHAMP, Marcel. *The bride stripped bare by her own bachelors.* This Quarter 5 no.1:189–92 Sept.1932. †
Extracts introduced by Breton. Quoted in editor's Introduction, p. xxvii.

243. DUCHAMP, Marcel. *Rrose Sélavy.* [16]p. Paris, G L M, 1939 (Biens nouveaux.4).
Subtitled: "Oculisme de précision. Rrose Sélavy, New York–Paris, poil et coups de pied en tous genre." Lemaitre refers to an edition of 1937.

244. *The Blind Man.* Edited by Marcel Duchamp. See bibl.59.
Cover reproduced here.

245. BRETON, André. *Marcel Duchamp.* Littérature n.s. 5:7–10 Oct. 1 1922. †
Includes verbal puns by Rrose Sélavy throughout issue similar to bibl.243, and Man Ray photo of the "Glass." Subsequently published in *Les Pas perdus.*[12] See p.209–11.

245a. BUFFET-PICABIA, Gabrielle. *Some memories of pre-dada: Picabia and Duchamp.* See bibl.21a. †
Similar notes in bibl.117a,148a. See text, p.255–67.

246. DESNOS, Robert. *Rrose Sélavy.* Littérature n.s.7:14–22 Dec. 1 1922.
Partly published in *View.*[251]

246a. DREIER, Katherine S. & MATTA ECHAURREN [Roberto]. *Duchamp's glass . . . an analytical reflection.* 17p. incl. illus. New York, Société Anonyme, 1944.
The Glass, titled "La Mariée mise à nu par ses célibataires, même."

247. JANIS, Harriet & JANIS, Sidney. *Marcel Duchamp, anti-artist.* illus. View 5 no.1: 18–19, 21 Mar.1945. †
Special Duchamp number[251]. Also published in *Horizon* 12 no.70:257–68 Oct.1945.

247a. KUH, Katherine. *Marcel Duchamp.* In Chicago. Art Institute. *20th century art from the Louise and Walter Arensberg collection.* p.11–18 Chicago, 1949.
The largest group of Duchamp works in a private, pioneer collection, now part of the Philadelphia Museum of Art. Additional article "Nude descending a staircase" published in *Magazine of Art* 42:264–5 1949.

247b. *Marcel Duchamp.* In Yale University Art Gallery. *Collection of the Société Anonyme.* p.148–50 illus. New Haven, Conn., 1950.
Biographical notes; essay by K. S. Dreier dated 1949; list of exhibitions, objects and publications; bibliography.

248. *New York Dada.* Edited by Marcel Duchamp. See bibl.79. †

249. NORTON, Louise. *"Buddha of the bathroom."* illus. The Blind Man 2:5–6 May 1917.

250. *Rongwrong.* Edited by Marcel Duchamp. See bibl.83.

251. VIEW (New York). *[Marcel Duchamp number].* 54p. illus. New York, 1945.
Special issue, series V, no.1, Mar.1945. Cover by Duchamp. Also issued as separate, in edition autographed by the participants. Contributions by C. F. Ford, Breton, J. T. Soby, Gabrielle Buffet, Desnos,[246] Harriet and Sidney Janis,[247] N. Calas, F. J. Kiesler, Ray, Mina Loy, Julien Levy, Henri Waste, R. A. Parker.

ELUARD, PAUL

"Pour nous, tout est une occasion de s'amuser."[254]

252. ELUARD, Paul. *Les Animaux et leurs hommes; les hommes et leurs animaux.* Paris, Au Sans Pareil, 1920.
"Avec cinq dessins d'André Lhote."

253. ELUARD, Paul. *Cinq moyens pénurie dada, ou deux mots d'explication.* Littérature 2 no.13:20 May1920.
Also published in *Die Schammade* (Dadameter) p.26 Feb.1920.[84]

254. ELUARD, Paul. *Développement dada.* Mécano Jaune no.[2]:[1] 1922.

255. ELUARD, Paul. *Les Malheurs des immortels; révélés par Paul Eluard et Max Ernst.* 43p. incl. illus. Paris, Librairie Six, 1922.
Also English translation by Hugh Chisholm: *Misfortunes of the immortals* (New York, Black Sun press, 1943).

256. ELUARD, Paul. *Les Nécessités de la vie et les consequences des rêves, précédé d'exemples.* Paris, Au Sans Pareil, 1921.
Poems translated in bibl.258.

257. ELUARD, Paul. *Répétitions.* Paris, Au Sans Pareil, 1922.
"Dessins de Max Ernst."

258. ELUARD, Paul. *Information please; Les Fleurs* [two poems]. New Directions [no.5]: 509,511 1940. †
From bibl.256. See text, p.228–9.

259. *Proverbe.* Edited by Paul Eluard. 1920. See bibl.82.

*"I prefer . . . the proposition of Rimbaud:
The poet becomes a seer by a long, immense
and conscious disorder of all the senses."*[260]

260. ERNST, MAX. *Au delà de la peinture.* illus. Cahiers d'Art 11 no.6–7:149–84 1936.
With many illustrations from his early work. Also published in Cahiers d'Art monograph on Ernst (nos.6–7), and in bibl.261.

261. ERNST, MAX. *Beyond painting, and other writings by the artist and his friends.* 204p. illus. New York, Wittenborn, Schultz, inc., 1948 (Documents of modern art.7).
Anthology edited by Robert Motherwell, with essays by Arp, Breton, N. Calas, J. Levy, Matta, Ribemont-Dessaignes, Tzara. Includes extensive bibliography.

262. ERNST, MAX. *Dada est mort, vive dada!* Der Querschnitt 1:22 Jan.1921.

263. ERNST, MAX. *Fiat modes. (Pereat ars). 8 originallithografien.* Köln, Verlag der ABK [1919?–20].
Advertised in *Die Schammade* of Feb. 1920. Edition examined by compiler has imprint of "Schlomilchverlag" and has been dated on stylistic grounds as later.

263a. ERNST, MAX. [*Letter on dada manifesto 1949*]. Paris, 1949. †
Quoted in editor's Introduction, p. xxxiv.

264. ERNST, MAX. *Misfortunes of the immortals, by Max Ernst and Paul Eluard.* 46p. incl. illus. New York, Black Sun press, 1943.
Reissue of Paris edition of 1922[255], with translation by Hugh Chisholm, and three additional drawings.

265. ERNST, MAX. *s'Fatagalied.* In *Dada Au Grand Air.* p.[2] 1921.[32]
One of several contributions, signed "Arp and Max Ernst, Fatagaga." [FAbrication des TAbleaux GArantis GAzométriques].

266. *Bulletin D.* Cologne, 1919. See bibl.60.
Illustrations by Ernst, including "Setzt ihm den Zylinder auf," written with H. Hoerle.

267. BRETON, ANDRÉ. Les Pas perdus. p.101–3,147,156–8,196 Paris, Gallimard, 1924 (Les Documents bleus. 6).
Main essay also published in bibl.261.

268. *Dada W/3.* Cologne, 1919. See bibl. 69.

269. SANS PAREIL, GALERIE (Paris). *Exposition dada, Max Ernst.* illus. 1920. †
First one-man collage show, held May 3–June 3 "au Sans Pareil," listing peintopeintures, dessins, fatagaga. Preface by André Breton.

270. *Die Schammade.* Cologne, 1920. See bibl.84.
Includes among several contributions by Ernst, "Worringer, profetor Dadaistikus."

271. VIEW (New York). [Max Ernst number]. illus. 1942.
Special double issue of Apr.1942, v.2, no.1 (Ernst-Tchelitchew). Includes catalog of Valentine Gallery exhibit, brief bibliography, and contributions by and on Ernst.

GROSZ, GEORGE

*"I drew and painted by opposition and by
my work tried to convince this world that
it is ugly, ill and hypocrite."*[167]

272. GROSZ, GEORGE. *Dadaism.* In his *A little yes and a big no: the autobiography of George Grosz.* p.181–7 New York, Dial press, 1946.
Includes account of Baader and Schwitters.

272a. GROSZ, GEORGE. *Ecce homo.* 84 plates Berlin, Der Malik-Verlag, 1923.
One of the most caustic collections of drawings, without text. Also issued in several de luxe editions, nos.1–50 including 16 watercolors and 84 lithographs, signed by the artist.

273. GROSZ, GEORGE. *Das Gesicht der herrschenden Klasse; 57 politische Zeichnungen.* 63p. incl. illus. Berlin, Der Malik-Verlag, 1921 (Kleine revolutionäre Bibliothek 4).
Originally issued as 60 drawings in 1919, based on published work from "Die Pleite,"

die schammade

(dilettanten erh'ebt euch)

schloemilch verlag köln

max ernst
 See bibl. 270: Title-page of Die Schammade (Dadameter)

+KLEINE
+
GROSZ
MAPPE
Nr. 77

20 Originallithographien

INHALT:

1. Fräulein und Liebhaber
2. Straße
3. Straßenbild
4. Kaffeehaus
5. Goldgräberbar
6. Krawall der Irren
7. Straße des Vergnügens
8. Werbung
9. Gesellschaft
10. Café
11. Spaziergang
12. Häuser am Kanal
13. Vorstadthäuser
14. Die Fabriken
15. Die Kirche
16. Das einzelne Haus
17. Der Dorfschullehrer
18. Jägerlatein
19. Mord
20. Hinrichtung

HUNDERT EXEMPLARE, NUMERIERT NR. 21—120, PREIS à FÜNFUNDDREISSIG MARK
FÜNFZEHN SONDER - EXEMPLARE, VOM KÜNSTLER SIGNIERT,
AUF KAISERLICH JAPAN, NUMERIERT NR. 6—20,
PREIS à FÜNFZIG MARK DES-
GLEICHEN NR. 1—5, à
SECHZIG MARK

✶

DER MALIK-VERLAG / BERLIN-HALENSEE / 1917

See bibl. 274

360

"Der blütige Ernst," and similar sources. One of a series of Malik editions partly listed in Benson.[277]

274. GROSZ, GEORGE. *Kleine Grosz Mappe; 20 Lithographien.* Berlin-Halensee, Der Malik-Verlag, 1917. †
100 numbered copies, 15 of which, on royal Japan, were signed by the artist. Includes introductory poem, "Aus den Gesängen," with vignette illustrations in protomontage style, a formula which can be traced in *Dadaco*[34], in the catalog of the Berlin exhibit of 1920[142], in the French *Le Coeur à Barbe*[64], etc.

275. GROSZ, GEORGE. *Die Kunst ist in Gefahr; drei Aufsätze.* 45p. illus. Berlin, Der Malik-Verlag, 1925.
At head of title: George Grosz und Wieland Herzfelde. Herzfelde, publisher of the Malik editions, was brother of Heartfield. Partial translation in bibl.276.

276. BALLO, FERDINANDO, ed. *Grosz.* 79p. plus 57 illus. Milano, Rosa e Ballo, 1946 (Documenti d'arte contemporaneo).
Includes texts, in Italian, by Grosz[275], Dorfles, Bulliet, Dos Passos, Landau, Marcel Ray, Schiff, Serouya, Tavolato, Waldman, Galtier-Boissière & Zimmer, Wolfradt[280], plus plates from various works.

277. BENSON, EMANUEL M. *George Grosz, social satirist.* illus. Creative Art 12 no.5:340–7 May 1933.
Biographical summary.—Selective bibliography.—Articles, portfolios, books illustrated by Grosz, p.347.

277a. *Dadaco.* [München, 1919]. See bibl.34. †
Extant trial sheets consist largely of montage layouts.

278. FELS, FLORENT. *Grosz.* In his *Propos d'artistes.* p.75–84 illus. Paris, La Renaissance du Livre, 1925.
Includes biographical and militant statement by Grosz on German dadaism, p.78–84.

279. SCHIFF, FRITZ. *La Peinture d'Allemagne inquiète.* In Huyghe, René, ed. *Histoire de l'art contemporain: la peinture.* p.441–5 illus. Paris, Alcan, 1935.
Originally published in *L'Amour de l'Art* Oct.1934. Also reprinted in bibl.276.

280. WOLFRADT, WILLI. *George Grosz.* illus. Jahrbuch der Jungen Kunst 2:97–112 1921.
Also published in *Cicerone* 13 no.4:103–18 Feb.1921. Subsequently issued in "Junge Kunst" series (Leipzig, Klinkhardt & Biermann, 1921), and reprinted in bibl.276.

HAUSMANN, RAOUL

> *"The new man should have the courage to be new."* (Presentism, Feb. 1921).

281. HAUSMANN, RAOUL. *Chaoplasma (Simultangedicht)* Merz no.4:38 July 1923.

282. HAUSMANN, RAOUL. *Dada in Europe.* Der Dada no.3:[3–5] 1920.

283. HAUSMANN, RAOUL. *Dada ist mehr als Dada.* De Stijl 4no.3:40–7 Mar.1921.

284. HAUSMANN, RAOUL. *Hurrah! Hurrah! Hurrah! Grotesken mit Einband und Illustrationen des Verfassers.* Berlin, Dèr Malik-Verlag [1920].

284a. HAUSMANN, RAOUL. [*Letter to Richter*]. Feb. 18, 1950.
Quoted in editor's Introduction, p. xxxiv, followed by notes from Moholy.[117]

285. HAUSMANN, RAOUL. *Letze Nachrichten aus Deutschland.* Dada 4–5:24 May 15 1919.
Text in German edition only of "Anthologie Dada."

285a. HAUSMANN, RAOUL. *Maikäfer flieg; Sieg, Triumph, Tabak und Bohnen* [Manifests]. Zenith (Zagreb) 1922.

286. HAUSMANN, RAOUL. *Opto-fonetische Konstruktion 1922.* illus. Plastique no.5:13 1939.

286a. HAUSMANN, RAOUL. *Pamphlet gegen die weimarische Lebensauffassung.* Der Einzige (Berlin) Apr.1919.

287. HAUSMANN, RAOUL. *Rückkehr zur Gegenständlichkeit in der Kunst.* In Dada Almanach. p.147–151. 1920.[7]

287a. HAUSMANN, RAOUL. *Sound-rel (1919).–Birdlike (1946)*.
See text, p.316.

287b. HAUSMANN, RAOUL. *Three little pinetrees*. Plastique no.4:8–13 1939.
"Re-wording: T. W. Schlichtkrull." Also published in *Arts Lettres* (Paris) no.6 1946 as "Trois petits sapins," described by Hausmann as "première lettre du courrier dada."

288. HAUSMANN, RAOUL. *Was die Kunstkritik nach Ansicht des Dadasophen zur Dadasophen Ausstellung sagen wird*. In Burchard Kunsthandlung. *Erste international Dada-Messe*. p.2. Berlin, 1920.[142]

288a. BERLIN. *Erste internationale Dada-Messe*. 1920. See bibl.142. †
Hausmann a leading organizer. Texts in catalog, and many items in the exhibit.

289. *Der Dada*. Edited by Raoul Hausmann. Berlin, 1919–20. See bibl.68.
No.1,2 edited solely by Hausmann in 1919, with many texts, cuts, photos and montages by him. No.3 issued under the imprint of Der Malik Verlag.

HEARTFIELD, JOHN

"Through the formal movement of Dadaism and its destruction of the traditional media and forms of art he finds a new medium and a new form."[293]

290. HEARTFIELD, JOHN. *Photomontagen zur Zeitgeschichte.I*. illus. Zürich, Kultur und Volk, 1945.
Contents: Alfred Durus *John Heartfield und die satirische Photomontage*, p.17–18.—Wolf Reiss *Als ich mit John Heartfield zusammen arbeitete*, p.31–6.—Louis Aragon *John Heartfield und die revolutionäre Schönheit*, p.83–95.—*Ammerkungen:Dada, Dadaismus*, p.99. Source of essays cited by Farner.[293]

290a. BURCHARD KUNSTHANDLUNG. *Erste internationale Dada-Messe*. Berlin, 1920. See bibl.142. †
Heartfield a leading organizer. Includes many items by him, or in association with Grosz.

291. *Der Dada*. Edited by Hausmann, Grosz and Heartfield. Berlin, 1919–20. See bibl.68.

292. *Dadaco*. [München, 1919]. See bibl.34. †
Montage planned by Heartfield, Hausmann and Grosz. Note commentary on montage techniques in bibl.293,274,179,etc.

293. FARNER, KONRAD. *John Heartfield's photomontages*. illus. Graphis 2 no.13:30–5, 121–4 Jan.–Feb.1946.
Quotes Grosz on early work with Heartfield, and mutual development of montage techniques (1915–16). Text in German and English. Bibliography, p.124.

HUELSENBECK, RICHARD

"From Dada proceeds the perpetual urge for . . . renovation."[296]

294. HUELSENBECK, RICHARD. *Ein Besuch im Cabaret Dada*. illus. Der Dada no.3:[6–8] 1920.

295. HUELSENBECK, RICHARD. *Dada*. Possibilities no.1:41–43 Winter 1947–48. †
"En avant dada: 1920," an extract from planned dada anthology (Wittenborn, Schultz, inc., 1951). French translation of most of text previously published in *Littérature*[303] and elsewhere[298].

296. HUELSENBECK, RICHARD. *Dada lives*. Transition no.25:77–80 Fall 1936. †
"Our art had to be international, for we believed in an Internationale of the Spirit." Translated from the German by Eugene Jolas. Also published in bibl.114.

297. HUELSENBECK, RICHARD. *Dada manifesto 1949*. New York, Wittenborn, Schultz, 1951. p.*xxx–xxxi*.
Text planned originally as a statement to be "signed" by Arp, Duchamp, Ernst, Hausmann, Richter and Tzara. Issued as a separate on the occasion of the publication of "Dada Painters and Poets," with special commentary in editor's Introduction, p. xxx.

Phantastische Gebete

VERSE VON
RICHARD HUELSENBECK

ZEICHNUNGEN VON
GEORGE GROSZ

DER MALIK~VERLAG/BERLIN, ABTEILUNG DADA

298. HUELSENBECK, RICHARD. *Dada siegt; eine Bilanz des Dadaismus.* 40p. Berlin, Der Malik-Verlag, 1920. †
 "Abteiling Dada, April 1920. Einbandentwurf von George Grosz." See text, p.23–47.

299. HUELSENBECK, RICHARD. *Dadaistisches Manifest.* [3]p. [1920?]. †
 "Signed" by Tzara, Jung, Grosz, Janco and others. Text identified in mss. as "written by Richard Huelsenbeck, 1920." Actually incorporated in *Dada Almanach*[7], also published by *Der Zweemann*[93] and as independent leaflet.

300. HUELSENBECK, RICHARD. *Deutschland muss untergehen! Erinnerungen eines alten dadaistischen Revolutionärs.* Berlin, Malik-Verlag, 1920.
 "Mit drei Ausschnitten aus dem Gemälde 'Deutschland, ein Wintemärchen' und einer Zeichnung von George Grosz."

301. HUELSENBECK, RICHARD. *Doctor Billig am Ende; ein Roman, mit acht Zeichnungen von George Grosz.* 129p. München, Kurt Wolff, 1921.
 "Fragment" published in *Club Dada*[63] (p.10,12–15) 1918. Reviewed by Doesburg in *De Stijl* 4 no.6:93–4 June 1921.

301a. HUELSENBECK, RICHARD. *End of the World* [*poem*]. 1916.[305] †
 See text, p.226. Also published in bibl. 34,68,306.

302. HUELSENBECK, RICHARD. *Erste Dadarede in Deutschland.* In *Dada Almanach* p.104–8 1920.[7]
 "Gehalten von R. Huelsenbeck in Februar 1918, Saal der Neuen Sezession, I. B. Neumann." Comment by J. B. Neumann, New York, 1950: "The gallery was completely wrecked by the audience."

303. HUELSENBECK, RICHARD. *En avant.* Littérature n.s. 4:19–22 Sept. 1 1922.
 Portion of similar text issued in *Possibilities*.[295]

304. HUELSENBECK, RICHARD. *Der neue Mensch.* Neue Jugend (Berlin) no.1:2–3 May 23 1917.
 Cited by Hugnet in this anthology (p.142). Photostat copy in Museum of Modern Art Library, New York.

305. HUELSENBECK, RICHARD. *Phantastische Gebete.* Zurich, Collection Dada, 1916.
 "Verse . . . mit 7 Holzschnitten von Arp . . . Sept.1916." Reviewed in *Anthologie Dada* (German edition).[66]

306. HUELSENBECK, RICHARD. *Phantastische Gebete. Zeichnungen von George Grosz.* 2. Aufl. 31). illus. Berlin, Der Malik-Verlag, 1920.

307. HUELSENBECK, RICHARD. *Schalaben, Schalomai, Schalamezomai.* Zurich, Collection Dada, 1916.
 Also noted as ". . . Schalabai . . ." "Verse, mit 4 Zeichnungen von H. Arp. Kollektion Dada, Okt. 1916."[298] If these dates are precise, nos. 305 and 307 may be the first dada imprints, unless the customary reference, no. 414, was published between the date of issue of the *Cabaret Voltaire*[61] in June, and Sept. 1916. No. 307 was issued as a leaflet edition of 25 copies, one of which exists in the library of Hans Arp. (No copy of bibl. 305,307,414 accessible to the compiler).

308. HUELSENBECK, RICHARD. *Verwandlungen; Novelle.* 54p. München, Roland-Verlag, Dr. Albert Mundt, 1918.

308a. HUELSENBECK, RICHARD. *Vorwort zur Geschichte der Zeit.* Club Dada [no.1]3–8 1918.

308b. HUELSENBECK, RICHARD. *Zürich 1916, wie es wirklich war.* Neuen Bücherschau (Berlin) Dec.1928.

308c. DEUX ILES, GALERIE (Paris). *Charles-Richard, Beate et Tom Hulbeck (Hulsenbeck); peintures—collages—dessins, du 12 octobre au 4 novembre 1950.* [16]p. illus. Paris, 1950.
 Preface by Jean Arp; statement by Michel Seuphor.

JANCO, MARCEL

> "*We demanded the* tabula rasa. *We knew then that the caveman was a great artist—and that we must start afresh.*"[312a]

309. JANCO, MARCEL. *M. Janco: album; 8 gravures sur bois, avec un poème par Tr. Tzara.* Zürich, Mouvement Dada, 1917.
 Possibly prints issued in *Cabaret Voltaire*[61], *Dada*,[66] *Tzara*[414] and elsewhere.

310. JANCO, MARCEL. *L'Amiral cherche une maison à louer. Poème simultan par R. Huelsenbeck, M. Janko, Tr. Tzara.* Cabaret Voltaire [no.1:6–7] 1916. †
 Poster by Janco on p.17.

310a. JANCO, MARCEL [*Letter to Hans Richter*]. Mar. 10 1950. †
 Partly quoted in editor's Introduction, p. xx.

311. ARP, HANS. *Dadaland.* In his *On my way.* p.39–47 New York, Wittenborn, Schultz, inc., 1948 (Documents of modern art. 6).
 Modified version of "Tibiis canere (Zurich, 1915–20)."[194a] Partly quoted in editor's preface, p.xx.

312. *Dada.* (Zurich, Paris, 1917–1920). See bibl.66.
 Noted in *Dada* no.1: "Prière d'adresser la correspondance à M. Janco." Commentary in S I C (Paris), no.21–22, 1917: "Dada; cahiers d'art d'une tenue et d'une sobriété sympathiques, publiés à Zurich par le poète roumain Tristan Tzara et le peintre Janco." No.1 issued in edition de luxe, with woodcut by Janco. No.2 issued in edition de luxe (30 copies) with two gravures by Janco. Reproductions and prints in other numbers.

312a. FEIGL GALLERY (NEW YORK). *Marcel Janco, October 17–November 4.* [8]p. illus. (port.) 1950.
 Exhibition catalog; biographical notes (1895–1949); letter dated Aug. 8, 1950 (translated excerpt); bibliography.

312b. HUELSENBECK, RICHARD. [*A note on Marcel Janco*]. 1950. †
 Quoted in editor's Introduction, p. xx.

313. TZARA, TRISTAN. *Marcel Janco.* Dada no.1:[14] July 1917.

314. TZARA, TRISTAN. *La Première aventure céleste de M. Antipyrine, avec des bois gravés et coloriés par M. Janco.* Zurich, Collection Dada, 1916.
 Possibly the first dada imprint; offered also in edition de luxe, hand-colored. Advertised 1917 under the imprint of "Mouvement Dada."

PICABIA, FRANCIS

"The picturesque is the opposite of art, art is the opposite of life."[160]

315. PICABIA, FRANCIS. *Aerophagie, o artériosclérose—Le refrain, de quoi (2 personnages hommes).* Cannibale no.1:7 Apr. 25 1920.

316. PICABIA, FRANCIS. *Francis Picabia et dada.* L'Esprit Nouveau 1 no.9:1059–60 1920.
 "L'Esprit Dada . . . fut exprimé par *Marcel Duchamp et moi* à la fin de 1912; Huelsenbeck, Tzara ou Ball en ont trouvé le "nom-ecrin" Dada en 1916."

317. PICABIA, FRANCIS. *Jésus Christ rastoquouere.* 66p. Paris, Collection Dada, 1920.
 Introduction by Gabrielle Buffet; drawings by Ribemont-Dessaignes.

318. PICABIA, FRANCIS. *Manifeste cannibale dada.* Dada (Dadaphone) no.7:2 Mar.1920.
 Translation by Alexis published in *Dada Almanach.*[7] Also published in *Der Dada* no.3.

319. PICABIA, FRANCIS. *Manifeste dada.* 391 no.12:1 Mar.1920.

320. PICABIA, FRANCIS. *Opinions et portraits.* 391 no.19 [Oct.?] 1924.
 "Les oeuvres de . . . Breton . . . sont une pauvre imitation de Dada . . . et . . . surréalisme est exactement du même ordre."

321. PICABIA, FRANCIS. *Pensées sans langage: poéme.* 119p. Paris, Eugène Figuière, 1919.
 Dedicated to Buffet, Ribemont-Dessaignes, Duchamp, Tzara.

322. PICABIA, FRANCIS. *Poèmes et dessins de la fille née sans mère.* Lausanne, Imprimeries Réunis S A, 1918.
 "18 dessins, 51 poèmes." Colored drawing titled "Fille née sans mére" dated "New York, 1915" was published in *291* no.4 (edition de luxe) June 1915. One poem translated in editor's Introduction, p. xxxi.

323. PICABIA, Francis. *Unique eunuque. Avec un portrait de l'auteur par lui-même et une préface par Tristan Tzara.* 38p. Paris, Au Sans Pareil, 1920 (Collection Dada).

324. ARP, Hans. *Francis Picabia.* [1]p. New York, Pinacotheca Gallery, 1950.
Gallery broadside, announcing exhibition at the Pinacotheca, Feb. 15. Text signed "Ascona, 1949."

325. BRETON, André. *Francis Picabia.* In his *Anthologie de l'humour noir.* p.189–91. Paris, Éditions du Sagittaire, 1940.
Breton also wrote the preface to Picabia's exhibit at Barcelona, Nov.1922.

325a. BUFFET-PICABIA, Gabrielle. *Some memories of pre-dada: Picabia and Duchamp.* See bibl.21a. †

326. *Cannibale.* Edited by Picabia (Paris, 1920). See bibl.62.

326a. CLAIR, René. *Entr'acte, a cura di Glauco Viazzi.* 65p. illus. Milano, Poligono, 1945 (Biblioteca cinematografica.1).
Scenario by Picabia; music by Satie; direction and cinematography by Clair. The film was released 1924.[28a] Largest portion of Poligono edition consists of pictorial sequences with running commentary. A contribution titled "Entr'acte" appeared in *Orbes* no.3 1932.[79a]

327. DUCHAMP, Marcel. *Catalogue des tableaux, aquarelles et dessins par Francis Picabia appartenant à M. Marcel Duchamp.* illus. Paris, Drouot Hotel, 1926.
Catalog of sale, dated Mar.7, with unpaged insert by Rrose Sélavy titled "80 Picabias."

328. *Francis Picabia in his latest words.* illus. This Quarter 1 no.3:296–304 1927.

329. LA HIRE, Marie De. *Francis Picabia.* 36p. illus. Paris, Galerie La Cible, 1920.
Includes detailed account of relations with the dadaists.

330. LITTLE REVIEW (New York). [*Picabia number*]. Spring 1922.
Largely pictures, an article by Picabia and some dada commentary.

331. MASSOT, Pierre De. *Francis Picabia.* In his *De Mallarmé à 391.* p.95–122 Paris, Au Bel Exemplaire, 1922.

332. *La Pomme de Pins.* Edited by Picabia (Paris, 1922). See bibl.80. †
Texts translated in editor's Introduction, p. xxx.

333. RAYNAL, Maurice. *Francis Picabia.* In his *Modern French painters.* p.134–6 1928.[174]

334. SANS PAREIL, GALERIE (Paris). *Exposition dada, Françis Picabia.* 1920. †
Illustrated catalog of exhibition held Apr. 16–30, with preface by Tristan Tzara, who also published brief comment in *Cannibale* no.1 Apr. 25 1920. Reviewed by Ribemont-Dessaignes in *L'Esprit Nouveau* 1:108–10 1920.

335. *291.* (New York). [*Picabia number*]. 1915. †
No.5–6, July–Aug.1915, with 5 plates and incidental note by de Zayas. See plate, no.9.

336. *391.* Edited by Picabia (Barcelona, New York, Zurich, Paris, 1917–24). See bibl.86.
Among the "big three" dada journals: *Dada* (Zurich, Paris)[66]; *Merz* (Hannover)[78], and *391.*

336a. *491.* [4]p. illus. Paris, René Drouin, 1949.
Catalog in newspaper format issued March 4, 1949 for Picabia exhibition of 136 works dated 1897–1949. Edited for the Drouin Gallery by Michel Tapié, with contributions by Breton, Buffet-Picabia, Roché, Tapié, and essay by the artist "50 ans de plaisir."

337. TZARA, Tristan. *Pic (3f 9P 1) bia, Paris 1919.* Der Zeltweg [no.1:29] Nov.1919.

RAY, MAN

> "Chance and hazard were the guiding sources of inspiration."[339]

338. RAY, Man. *Les Champs délicieux. Album de photographies, avec une préface de Tristan Tzara.* Paris, Man Ray, 1922.
"Rayographs," 12 mounted photos in folio. Edition of 40 copies; no.41 contained "les épreuves des cliches rayés."

339. RAY, MAN. *Dadaism*. In Beverly Hills, Cal. Modern Institute of Art. *Schools of twentieth century art*. p.[15] 1948.
Brief statement in catalog of exhibit held Apr. 22–May 30.

339a. RAY, MAN. *Photogenic reflections*. Berkeley (California) no.9:1 [Dec.1950].

340. RAY, MAN. *Revolving doors, 1916–1917*. 10 colorplates in folio Paris, Editions Surréalistes, 1926.
Edition of 105 copies in pouchoir process. This is dated "New York, 1916" in the Société Anonyme catalog.[185a]

341. DESNOS, ROBERT. *The work of Man Ray*. Transition no.15:264–6 Feb.1929.

341a. *New York Dada*. Apr.1921. See bibl. 79. †

342. PARIS. LIBRAIRIE SIX. *Exposition dada, Man Ray*. 1921.
Catalog of exhibit held Dec. 3–31, listing 35 works dated 1914–1921. Notes by Aragon, Arp, Eluard, Ernst, Ray, Ribemont-Dessaignes, Soupault and Tzara.

342a. PARIS. GALERIE MONTAIGNE. *Salon dada*. 1922. See bibl.171.

343. PASADENA ART INSTITUTE. *Retrospective exhibition 1913–1944: paintings, drawings, watercolors, photographs by Man Ray*. [8]p. Pasadena, Cal., 1944.
"The first complete retrospective" held Sept. 19–Oct. 29. Biographical sketch.

344. RIBEMONT-DESSAIGNES, GEORGES. *Man Ray*. 63p. incl. illus. Paris, Gallimard, 1924 (Peintres nouveaux,37).
"Sa principale tendance est de remplacer progressivement la peinture par les procédés employant la lumière." (notice).

344a. RIBEMONT-DESSAIGNES, GEORGES. *Man Ray*. illus. Les Feuilles Libres n.s. no.40:267–9 May–June 1925.

RIBEMONT-DESSAIGNES, GEORGES

> "Does one still remember Dadaism, except to laugh, to scorn, to spit?"[353]

345. RIBEMONT-DESSAIGNES, GEORGES. *Buffet*. Littérature 3 no.19:7–8 May 1921.
"Les dadaïstes sont contre l'art."

346. RIBEMONT-DESSAIGNES, GEORGES. *Dada painting or the oil eye*. illus. The Little Review 9 no.4:10–12 Autumn–Winter 1923–24.

347. RIBEMONT-DESSAIGNES, GEORGES. *Dadaland*. Cannibale no.2:6 May 25 1920.
Translation by Walter Mehring published in *Dada Almanach* (p.96–98).[7]

348. RIBEMONT-DESSAIGNES, GEORGES. *Dadaïsme*. De Stijl 6 no.2:28–30 Apr.1923, no.3–4:38–40 May–June 1923.

349. RIBEMONT-DESSAIGNES, GEORGES. *Dadaïsme et isthme de dada*. Mécano *Rouge* no.[3]:[1] 1922.
Also "Manifeste a l'hulle," no.2 (Jaune) 1922.

350. RIBEMONT-DESSAIGNES, GEORGES. *L'Empereur de Chine, suivi de Le Serin muet*. Paris, Au Sans Pareil, 1921 (Collection Dada).
"L'Empereur de Chine" (1916), p.11–127. "Le Serin muet" (1919), p.131–51, first performed at the Manifestation Dada, Mar. 27, 1920, Théatre de l'Oeuvre.

351. RIBEMONT-DESSAIGNES, GEORGES. *Fiche bavarde*. Die Schammade (Dadameter) [no.1:23] Feb.1920.

352. RIBEMONT-DESSAIGNES, GEORGES. *Histoire de dada*. La Nouvelle Revue Française no.213–4 1931. See bibl. 13. †

353. RIBEMONT-DESSAIGNES, GEORGES. *In praise of violence*. The Little Review 12 no.1:40–41 Spring–Summer 1926.

354. RIBEMONT-DESSAIGNES, GEORGES. *Manifeste selon Saint-Jean Clysopompe*. 391 no.13:2–3 July 1920.

355. RIBEMONT-DESSAIGNES, GEORGES. *Le Massacre des innocents, épître aux dadaïstes repentis*. Les Feuilles Libres no.31:21–25 Mar.–Apr.1923.

356. RIBEMONT-DESSAIGNES, GEORGES. *Non—seul plaisir*. 391 5 no.11:[2] Feb.1920.

357. RIBEMONT-DESSAIGNES, Georges. *Sur la vie, l'art, etc.* De Stijl 7 no.75–76:59–62 1926.

"Merde pour la peinture et ses salons."

357a. SANS PAREIL, GALERIE (Paris). *Exposition dada, Georges Ribemont-Dessaignes.* 1920.

Catalog of paintings and drawings exhibited May 28–June 10, with introduction by Tzara.

RICHTER, HANS

> "[Dada] broke up what was past and dead,
> and opened the way to emotional experience
> from which all the arts profited."[21]

358. RICHTER, Hans. *Avant-garde film in Germany.* In Manvell, Roger, ed. *Experiment in the film.* p.219–33 London, Grey Walls press, 1949.

"The style of [Vormittagsspuk] shows . . . my dadaistic past." This film is sometimes called *Ghosts Before Noon*, sometimes *Ghosts Before Breakfast.*

359. RICHTER, Hans. *Gegen ohne für dada.* Dada 4–5:25 May 15 1919.

Written on the occasion of the 8. dada soirée[56]; text printed only in German edition of *Anthologie Dada.*[66]

360. RICHTER, Hans. *A history of the avantgarde.* In *Art in cinema; edited by Frank Stauffacher.* p.6–21 San Francisco, San Francisco Museum of Art, 1947.

Part 1: Political and economic unrest.—2: The opposition against conventional film routine.—3: The artistic climate of Europe.—4: The influence of new technique and new art on the public.—Chronology and commentary.

360a. RICHTER, Hans. *[Letter on Eggeling].* Mar.23 1950. †

Quoted in editor's Introduction, p. xxxi.

361. RICHTER, Hans. *Origine de l'avant-garde allemande.* Cinématographe no.2:6 May 1937.

"L'avant-garde allemande dérive de la peinture."

361a. RICHTER, Hans. *Dada X Y Z.* New York, 1948. See bibl. 21. †

See text, p.285–90.

361b. RICHTER, Hans. *[Eggeling].* In Stockholm. National museum. *Viking Eggeling, 1880–1925* . . . p.9–10 illus. Stockholm, 1950.

Exhibit held Oct.27–Nov.19; catalog no.178; bibliography. Memoir on an association during the time of dada.

361c. RICHTER, Hans. *Sidelights on dada, 1916–1918.* La Biennale (Venice) Summer 1951?

Zurich memoirs, scheduled for publication in forthcoming issue of the Biennale magazine (no.4?). "Dada is not a fence but an open space—not a church either. Everyone is his own Pope." Article publicizes forthcoming international Dada exhibition at the 1952 Biennale, to be organized by Richter.[182a]

362. *Dada.* (Zurich, Paris, 1917–1920). See bibl.66.

Paintings or prints by Richter are reproduced in no.3,4–5. Exhibit at Galerie Wolfsberg reviewed in *Anthologie Dada.*[66]

363. DEUX ILES, GALERIE (Paris). *Hans Richter, du 10 au 28 février.* [8]p. 1950.

Notes by Arp, Duchamp, Michel Seuphor. Exhibition of recent works only, but reproduces one lino-cut from "Dada 1919."

364. TZARA, Tristan. *Chronique Zurichoise, 1915–1919.* See bibl.7. †

Includes references to early events in which Richter was a participant. See also program of the 8th dada soirée, reproduced p.332. Text on Zurich events, p.235–42.

SCHWITTERS, KURT

> "Merz aims only at art, because
> no man can serve two masters."[373]

365. SCHWITTERS, Kurt. *Art and the times.* illus. Ray no.1:4–8 [1927].

See bibl. 397

366. SCHWITTERS, Kurt. *Anna Blume, Dichtungen.* 37p. Hannover, Paul Steegemann, 1919. (Die Silbergäule, 39–40).

Lettered prominently in red on cover: "dada." Extracts also published in *Merz.*[18] Translation of "Anna Blossom," Merz poem no.1, included in editor's Introduction, p. xxi.

367. SCHWITTERS, Kurt. *Die Blume Anna.* 32p. Berlin, Der Sturm, no date.

Probably issued 1924. Title reads: "elementar. Die Blume Anna. Die neue Anna Blume. eine Gedichtsammlung aus den Jahren 1918–1922. Einbecker Politurausgabe von Kurt Merz Schwitters."

368. SCHWITTERS, Kurt. *C O E M.* Transition 24:91–3 June 1936.

Translation by Eugene Jolas of "Cathedral of Erotic Misery."

369. SCHWITTERS, Kurt. *Dada complet.* Merz no.1:4–11 1923, no.4:41 July 1923, no.7: 66–67 Jan.1924.

Article in no.1 preceded by "Dadaismus in Holland" (p.3), presumably by Doesburg.

370. SCHWITTERS, Kurt. *Katalog.* illus. Merz no.20:98–105 1927.

"Katalog" issue of Merz. with factual introduction by Schwitters (p.99–100) dated 4.3.1927. Catalog of 150 works from 1913 to 1926 (p.101–2). To be supplemented by catalog "Paintings and sculpture by Kurt Schwitters" issued by the Modern Art Gallery, London, Dec.1944.

371. SCHWITTERS, Kurt. *Die Kathedrale, 8 lithos von Kurt Schwitters.* Hannover, Paul Steegemann, no date (Die Silbergäule, 41–42).

7 stapled plates and decorated cover; advertised as "Merz-Antidada-Zeichnungen." Probably 1919 or 1920.

372. SCHWITTERS, Kurt. *Konsequente Dichtung.* G no.3:45–6 June 1924.

With portraits, and additional comment by Richter.

373. SCHWITTERS, Kurt. *Merz.* Der Ararat 2:3–11 1921. †

Translated in part by Dreier.[378]

373a. SCHWITTERS, Kurt. *Les Merztableaux.* Abstraction—Création—Art Non-Figuratif [no.1]:33 1932.

Fragment quoted in Guggenheim.[160] Additional commentary and two illustrations of "Merzbau" in no.2:41 1933, which are also illustrated in bibl.17.

374. SCHWITTERS, Kurt. *Revolution: causes and outbreak of the great and glorious revolution in Revon.* Transition no.8:60–76 Nov.1926.

"This work was written during my dada period." Translation and adaptation by Eugene Jolas.

375. SCHWITTERS, Kurt. *Ursonate.* [34]p. Hannover, Merzverlag, 1932. †

"Ursonata" of 1924 is mentioned by Moholy[117]. In 1927, *i 10* published "Meine Sonate in Urlauten" (1 no.11:392–401). The Hanover edition was issued as *Merz* no.24:153–86 1932. *Transition* published extracts, no.21:320 Mar.1932, no.22:38–39 Feb.1933.

376. SCHWITTERS, Kurt. *Veilchen; eine kleine Sammlung von Merz-Dichtungen aller art.* [12]p. Hannover, Merzverlag, 1931.

Issued as "Erstes Veilchen Heft," *Merz* no.21:106–17 1931. Part of series titled "Das Veilchen" issued about 1923.

377. ARP, Hans. *Kurt Schwitters.* In his *Onze peintres, vus par Arp.* p.[18–21] illus. Zurich, Girsberger, 1949.

378. DREIER, Katherine. *Kurt Schwitters, the dadas have come to town!* [3]p. [New York, Dec. 25 1947].

Mimeographed statement for exhibit at the Pinacotheca, Jan.19–Feb.1948. Gallery catalog, listing 26 works, contains excerpt from fuller mimeographed statement, and note by N. Gabo and Charmion Wiegand. Dreier includes partial translation of "Merz."[373]

379. GIEDION-WELCKER, Carola. *Schwitters: or the allusions of the imagination.* illus. Magazine of Art 41:218–21 Oct.1948.

380. VORDEMBERGE-GILDEWART, F. *Kurt Schwitters (1887–1948).* illus. Forum (Amsterdam) 3 no.12:356–62 1948.

einleitung:

Fümms bö wö tää zää Uu, **1**
 pögiff,
 kwii Ee.

Oooooooooooooooooooooooooooooooooo, **6**

 dll rrrrrr beeeee bö, **(A)** **5**
 dll rrrrrr beeeee bö fümms bö,
 rrrrrr beeeee bö fümms bö wö,
 beeeee bö fümms bö wö tää,
 bö fümms bö wö tää zää,
 fümms bö wö tää zää Uu:

erster teil:

thema 1:

Fümms bö wö tää zää Uu, **1**
 pögiff,
 kwii Ee.

thema 2:

Dedesnn nn rrrrrr, **2**
 Ii Ee,
 mpiff tillff too,
 tillll,
 Jüü Kaa?
 (gesungen)

thema 3:

Rinnzekete bee bee nnz krr müü? **3**
 ziiuu ennze, ziiuu rinnzkrrmüü,

 rakete bee bee. **3a**

thema 4:

Rrummpff tillff toooo? **4**

See bibl. 375

381. *Hommage à Kurt Schwitters.* illus. K (Revue de la Poésie) no.3 1949.

Special number, no.3:34–42 May 1949. Essays by Arp (p.34–6) and Carola Giedion (p.35–7), from "Die Weltwoche," Aug. 15, 1947. Texts and poems by Schwitters, (p.37–42).

382. *Merz.* Edited by Kurt Schwitters. (Hannover, 1923–32). See bibl.78.

"Merz 3 ist eine Mappe von 6 Lithos, mit der Hand auf den Stein gemerzt. 50 numerierte Examplare." Other special numbers, see bibl.370,375,376,etc.

383. MOHOLY-NAGY, SIBYL. *Moholy-Nagy, experiment in totality.* p.22–25,99–103 New York, Harper & bros., 1950.

"The name [Merz] was accidental and came from the four central letters of the word 'komMERZiel' which had appeared on a scrap of newspaper in one of the Merz collages." The meeting of Marinetti and Schwitters was published as "The dadaism we forgot" Berkeley (Calif.) no.8:1,3 [Mar.1950], supplemented on p.3–4 by Schwitters' "He, a dadaist parable."

384. NEBEL, OTTO. *Kurt Schwitters.* Einleitung von Otto Nebel. 32p. illus. Berlin, Verlag Der Sturm [1922?] (Sturm-Bilderbücher,IV).

"15 Stempelzeichnungen und 15 Gedichte." Additional material in *Der Sturm* (15 no.1,2,3 1924, 16 no.1–12 1925, etc.).

385. SPENGEMANN, CHRISTOF. *Die Wahrheit über Anna Blume; mit dem Bildnis Kurt Schwitters.* Hannover, Der Zweemann Verlag [1919?].

Advertised in bibl.366.

386. THOMAS, EDITH. *Kurt Schwitters.* In *L'Art abstrait.* p.311–13 illus. Paris, Maeght, 1949.

SERNER, WALTER

"J'ai un seul espoir, je crains de l'avoir."[86]

387. SERNER, WALTER. *Bestes Pflaster auch roter Segen.* Dada 4–5:7 May 15 1919.

Text in German edition only of *Anthologie Dada.* Additional contribution, p.[18]: *Riesenprogramm, Schlager auf Schlager, einzig in seiner Art.*

388. SERNER, WALTER. *Carnet du Docteur Serner.* 391 no.11:[4] Feb.1920.

"Signed": Docteur V. Serner.

389. SERNER, WALTER. *Le Corridor.* Littérature 2 no.13:14–15 May 1920.

390. SERNER, WALTER. *Dada-park.* Der Zeltweg [no.1:25–27] Nov.1919.

391. SERNER, WALTER. *Die Hyperbel von Krokodilcoiffeur.* See bibl.111.

392. SERNER, WALTER. *Letzte Lockerung, Manifest Dada.* 45p. Hannover, Leipzig, Wien, Zurich, Paul Steegemann, 1920 (Die Silbergäule, 62–64).

Dated "Lugano, im März 1918." Also published in German edition of *Anthologie Dada:* "Letzte Lockerung Manifest." Dada 4–5:15–17 May 15 1919. Advertised in *391* no.14 as "Dernier dérangement."

393. SERNER, WALTER. *Paneelparabole FK 37 . . . SZ 489 . . . GHZZZ 88 . . . IK 12.* Die Schammade (Dadameter) [no.1:14–15 Feb.] 1920.

393a. *Das Hirngeschwür.* Edited by Serner. See bibl.71.

393b. *Sirius.* Edited by Walter Serner. (Zurich, 1915–16).

Possibly issued in 10 or 12 numbers, under sub-title "Monatsschrift für Literatur und Kunst." No full set available; no.7 known to compiler. Contributions by the editor, T. Däubler, P. Altenberg, etc. Illustrations by Kubin, Picasso, Schad, Arp (figurative style).

394. *Der Zeltweg.* Edited by Serner, Flake, Tzara. (Zürich, 1919). See bibl.92.

TZARA, TRISTAN

"Dada is our intensity"[415]

395. TZARA, TRISTAN. *Bulletin à Francis Picabia.* Die Schammade (Dadameter) [no.1:12] Feb.1920.

DIE ORIGINAL DADAISTEN

GEBEN DAS COPYRIGHT IHRER WERKE DEM VERLEGER PAUL
STEEGEMANN IN HANNOVER DER IN LEIPZIG WIEN ZÜRICH
DADAFILIALEN HAT

HERR KURT SCHWITTERS

AUS HANNOVER WALDHAUSEN SETZTE ALS ERSTER DADAIST
AUF EINEN DOPPEL SILBERGAUL 39/40 DIE JETZT WELTBERÜHMTE

ANNA BLUME VIER MARK

10 000 EXEMPLARE SIND IN DREI MONATEN VERKAUFT
ANNA BLUME KANDIDIERT FÜR DEN ERSTEN DEUTSCHEN REICHS-
TAG NACH DER KLEINEN REVOLUTION UND HOFFT NOCH VIEL
GELD ZU VERDIENEN JA

DIE KATHEDRALE VIER MARK

IST DIE SEHNSUCHT ALLER ZEITEN HERR SCHWITTERS HAT
SIE AUF SILBERGAUL 40/41 AUFGEBAUT

DIE WOLKENPUMPE VIER MARK

HAT UNS SCHON LANGE GEFEHLT ALS CACADOU SUPERIEUR
KNALLT SIE AUF SILBERGAUL 52/53 ALLE BÖSEN GEWITTER AUS
DEN GEMÜTERN DER DEUTSCHEN MENSCHEN SIE SPENDET RAT
UND HILFE IN UNGLÜCKSFÄLLEN HERR ARP AUS ZÜRICH IST
DER NOBLE HERSTELLER

DIE LETZTE LOCKERUNG SECHS MARK

IST DAS ENDE ALLER FILOSOFIE DAMENSTRÜMPFE GAUGINS
UND DADA BALANZIEREN DIE KAFFEEMÜHLE WELT DER BE-
RÜCHTIGTE DR SERNER AUS GENÈVE HAT DIE LETZTE LOCKE-
RUNG GELOCKERT BAND 62/64

SEKUNDE DURCH HIRN SECHS MARK

DER PRACHTVOLLSTE SCHUNDROMAN ALLER ZEITEN
DAS LIEBLINGSBUCH DER LITTERARICH GEBILDETEN BAND 59/61
DIESES WERK DES HERRN VISCHER AUS PRAG STROTZT VON
GEMEINHEIT UND UNZUCHT SIE MÜSSEN ES LESEN

EN AVANT DADA VIER MARK IST
DIE GESCHICHTE DES DADAISMUS

BAND 50/51 VERFASST VON GEHEIMRAT RICHARD HUELSENBECK
DEM BESITZER DES ZENTRALAMTS DER DADABEWEGUNG IN
DEUTSCHLAND BERLIN HIER ERFAHREN SIE DAS GEHEIMNIS DES
DADA SENSATIONELLE ENTHÜLLUNGEN AUS DEM LIEBESLEBEN
DER DADAISTEN DIE PRAKTIKEN DER ENGELMACHERINNEN DIE
LUES DES HERRN PICABIA DIE SPEISUNG DER GEISTIGEN AUF
DEM POTSDAMER PLATZ KUBISMUS FUTURISMUS EXPRESSIONIS-
MUS REVOLVER UND LITTERATUR-DIE PRÜGELEI IN DRESDEN
DADA IN ALLER WELT BRUITISMUS JEDERMANN KANN DADAIST
WERDEN

FASST EINE HALBE MILLION SILBERGÄULE TRABEN AUF DER
ERDE HERUM

DER DIREKTOR PAUL STEEGEMANN HAT DAZU SOZUSAGEN ALS
VORBEREITUNG

DEN MARSTALL

DEN ANTIZWIEBELFISCH ÖFFENTLICH ERSCHEINEN LASSEN DA
WERDEN DIE SILBERGÄULE MIT POLEMIK UND ELAN VORGE-
RITTEN FÜR ZWEI MARK MARK DIE NUMMER

SERNER
LETZTE LOCKERUNG
manifest dada

See bibl. 392: Title page and rear page of *Letzte Lockerung.*

PAUL STEEGEMANN VERLAG HANNOVER
LEIPZIG / WIEN / ZÜBICH

tristan tzara
cinéma calendrier du cœur abstrait
maisons
bois par arp
collection dada
en dépôt au sans pareil
37 avenue kléber
paris

396. TZARA, TRISTAN. *Chronique Zurichoise, 1915–1919.* In *Dada Almanach.* 1920.[7] †
A detailed chronology, to be supplemented by other accounts, bibl.6–21, and similar memoirs, e.g. bibl. 194a. For events of 1920 and later, see bibl.14. A contribution titled "Chronique Zurich" first appeared in *Dada* 4–5:[2] May 15 1919. See text, p.235–42.

397. TZARA, TRISTAN. *Cinéma calendrier du coeur abstrait. Maisons. Bois de Arp.* Paris, Au Sans Pareil, 1920 (Collection Dada). †
"Calendrier 1–4" published in *Dada* no.3, other portions in *Dada* 4–5, *391* no.11, *Die Schammade* 1920, etc. Parts published under variant titles, including combinations of the above title. Also advertised as "Maisons."

398. TZARA, TRISTAN. *Le Coeur à gaz.* Der Sturm 13 no.3:33–8,40,42 Mar.1922.
Also published by Éditions G. L. M. in 1938, and in 1946 with frontispiece by Max Ernst.

399. TZARA, TRISTAN. *Conference sur dada.* 1922. See bibl.135. †
A major pronouncement on the occasion of the Weimar congress. See text, p.246–51.

400. TZARA, TRISTAN. *La Deuxième aventure céleste de Monsieur Antipyrine.* (fragment) *391* no.14:2 Nov.1920.
Also printed in *Littérature* no.14. Complete edition: Paris, Reverberes, 1938. On "Antipyrine," see note for bibl.414.

401. TZARA, TRISTAN. *Epilogue sur dada.* 1948. See bibl.127.
Originally planned as a statement in this miscellany, but issued as a separate on the occasion of its publication.

402. TZARA, TRISTAN. *Eye-cover, art-cover, corset-cover, authorization.* New York Dada [no.1:2] 1921. †
"You ask for authorization to name your periodical Dada."

403. TZARA, TRISTAN. *Inzwischen-Malerei (On s'approche du point de tangence).* Der Zeltweg p.[8–9] Nov.1919.
"Geschreiben 1916 zur 1. Dada-Ausstellung, Zürich. Deutsche Ubersetzung: W. Serner."

404. TZARA, TRISTAN. *Lettre ouverte à Jacques Rivière.* Littérature no.10:2–4 Dec.1919.
"En réponse à la note MOUVEMENT DADA parue dans La Nouvelle Revue Française du 1er septembre 1919."

405. TZARA, TRISTAN. *Manifest dada 1918.* Dada 3:1–3 Dec.1918. †
Also published in *Dada Almanach*[7] and *Sept manifestes dada.*[11]

406. TZARA, TRISTAN. *Memoirs of dadaism.* 1930. See bibl.14.
Comment in editor's Introduction, p. xxiv.

407. TZARA, TRISTAN. *Aa l'antiphilosophe: Arp.* Littérature no.6:22–23 Aug.1919.
Subsequently issued: *Monsieur Aa l'antiphilosophe* Création no.2:[4] 1921; *Monsieur Aa l'antiphilosophe: Arp* Littérature no.19:9 May 1921; *L'Antitête* Paris, Cahiers Libres, 1933; *L'Antitête, v.1: Monsieur Aa l'antiphilosophe.* Eaux-fortes par Max Ernst. Paris, Bordas, 1949.

408. TZARA, TRISTAN. *Morceaux choisis.* 310p. Paris, Bordas, 1947.
Preface by Jean Cassou first published in *Labyrinthe.*[420] Bibliography, p.297–301.

409. TZARA, TRISTAN. *Note 6 sur l'art nègre.* S I C no.21–22:[2] Sept.–Oct.1917.

410. TZARA, TRISTAN. *Note 14 sur la poésie.* Dada 4–5:[5] May 15 1919.
Dated 1917.

411. TZARA, TRISTAN. *Note pour les bourgeois.* Cabaret Voltaire June 1916. See bibl. 129. †

412. TZARA, TRISTAN. *Une Nuit d'echecs gras, page composée par Tristan Tzara.* 391 no.14:4 Nov.1920.

413. TZARA, TRISTAN. *Le Papier collé, ou le proverbe en peinture.* Cahiers d'Art 6 no.2: 61–74 1931.

414. TZARA, TRISTAN. *La Première aventure céleste de Monsieur Antipyrine.* Zurich, Collection Dada, 1916.
Woodcuts by Janco. Also issued in edition de luxe, and publicized under the imprint of "Mouvement Dada." Possibly first dada imprint, but see note bibl.307. Extract in *This*

Quarter 5 no.1:129–30 Sept.1932. Includes "Manifeste de M. Antipyrine"[11] which, as the editorial preface points out, is mis-translated as Mr. Fire-Extinguisher, "Anti-pyrine" being the trade name of a patent medicine for headaches in France."

414a. TZARA, TRISTAN. *Proclamation sans prétention, dada 1919.* Die Schammade (Dadameter) [no.1:25 Feb.] 1920. †
Also published in bibl.11,66.

415. TZARA, TRISTAN. *Sept manifestes dada.* Paris, Jean Budry [1924]. See bibl.11. †
See text, p.75–98.

416. TZARA, TRISTAN. *Vingt-cinq poèmes. H. Arp, dix gravures sur bois.* Zurich, J. Heuberger, 1916 (Collection Dada).
Also noted in editions of 1918. Reviewed in S I C no.40–41:314 Feb.–Mar.1919. "Vingt-cinq-et-un poemès" published by Editions de la Revue Fontaine (Paris, 1946).

417. *Le Coeur à Barbe.* Edited by Tzara. 1922. See bibl.64.

418. *Dada.* Edited by Tzara. (Zurich, Paris, 1917–1920). See bibl.66.

419. *Der Zeltweg.* Edited by Flake, Serner, Tzara. 1919. See bibl.92.

420. CASSOU, JEAN. *Tristan Tzara et l'humanisme poétique.* Labyrinthe 2 no.14:1–2 Nov. 15 1945.
Republished as preface to bibl.408.

420a. HUGNET, GEORGES. *Tristan Tzara.* Orbes no.3:43–56 Printemps 1932.
Text dated July 1931. Same issue includes Tzara poems.

421. LEIRIS, MICHEL. *Présentation de "La Fuite."* Labyrinthe 2 no.17 Feb. 15 1946.
Article captioned: "Il y a trente ans . . . le mouvement dada fut créé à Zurich nous déclare . . . Tzara." Illustrated by dada title-pages, supplemented by Soupault's "Le Profil de dada."

422. LEMAITRE, GEORGES. *From cubism to surrealism in French literature.* rev. ed. p.166–90,214,237–8 Cambridge, Mass., Harvard University; London, Oxford University, 1947.
Bibliography.

423. BAUR, JOHN I. H. *Dada in America: the machine and the subconscious.* illus. Magazine of Art 44 no.6 Oct.1951.
Chapter from his forthcoming book, "Revolution and Tradition in Modern American Art," which will be published by Harvard University Press, late in 1951.

INDEX TO BIBLIOGRAPHY

(Reference is to the numerals of the bibliography, not to pages)

ADDENDA: DADA ALIVE AND WELL

Buried in the previous introduction (p. 322) is the point of view that has guided the present, but more limited compilation. "The following represents a survey rather than an exhaustive inventory. Enough has been retained, it is hoped, to convey an impression of the distinctive products of Dada and the characteristic contributions of the major dadaists, along with an enumeration of the basic references." That pioneer bibliography encompassed a past era of over four decades in over 400 references while the documentation below is confined to 150 numbered entries for three contemporary decades. However, the explosive interest in this movement, surely sparked in some measure by the publication of Motherwell's anthology of 1951 (and a later edition) gave birth to activities that demonstrated the vitality of the participants and the significance of Dada. Is is altogether fitting that what began with the Cabaret Voltaire in Zurich should now culminate, but only temporarily, with a Dada Archive and Research Center in Iowa City. When Alfred H. Barr, Jr. originally titled his seminal study of 1936 "The Marvelous and the Fantastic" he must have foreseen this evolution in style and place. Although selective, the categories follow the Wittenborn precedent: *Bibliographies* (no. 424–436), *General Works* (no. 437–472), *Periodicals & Documents* (no. 473–475), *Exhibition Catalogs* (no. 476–491), *Artists & Writers: Arp to Tzara* (no. 492–573). Note that all selections suggest bibliographies for expanded research, in many instances authoritative and comprehensive guides.

BIBLIOGRAPHY

424. ADMUSSEN, Richard L. *Les Petites revues littéraires, 1914–1939. Répertoire descriptive.* St. Louis, Mo., Washington University Press; Paris, A. G. Nizet, 1970.
 Annotated bibliography. Complements Arbour below.

425. ARBOUR, Roméo. *Les Revues littéraires éphémeres paraissant à Paris entre 1900 et 1914. Répertoire descriptif.* Paris, José Corti, 1956.
 Supplemented by Admussen above.

426. CAWS, Mary Ann, ed. *Dada Surrealism.* No. 1, 2 (New York, 1971–72).
 No.2 (1972) includes bibliography on dada and surrealism in North America: 1969–1972. For exhibitions see no.439.

426a. DAVIS, Alexander, ed. *Art design photo.* Hemel Hempstead, Hertfordshire, England, 1969–1980. 10 vol.
 A classified bibliography and index on modern art. 1969–71 as *LOMA: Literature on modern art* (3 parts); 1972–80 (vol.1–7) as *Art design photo.* Numerous entries on dada, American and European.

427. EDWARDS, Hugh, comp. *Surrealism and its affinities, the Mary Reynolds collection: a bibliography.* Chicago, Art Institute of Chicago, 1973.
 First edition (1956) enlarged to 147p.; annotated; includes dada.

428. Ex Libris, New York. Catalogs, no.1– New York, 1974–.
 A specialized dealer's continuing series of classified and annotated lists on modern movements and artists, e.g. no.2: Dada and Duchamp (items 107–269). Documentation covers unusual titles.

429. GERSHMAN, Herbert S. *A Bibliography of the surrealist revolution in France.* Ann Arbor, University of Michigan Press, 1969. 57p.
 "From its origins in Dada to the recent past, 1916–68." Covers books and articles, periodicals, collective tracts, and manifestos. A supplement to his: *The Surrealist revolution in France.* 255p., chonology, notes.

430. KORNFELD & Klipstein. *Dokumentations–Bibliothek zur Kunst des 20. Jahrhunderts. Auktion.* Bern, June 5, 1957. 69p., illus.
 First major dada and other European movements auction organized by Hans Bollinger. Important later catalogs: *Dokumentations–Bibliothek zur Kunst und Literatur des 20. Jahrhunderts.* Illustrierte Bücher, 109p., illus. Bern, May 13–14, 1958.–*Dokumentations–Bibliothek III. Teile der Bibliotek und Sammlung Tristan Tzara, Paris. Auction.* June 12, 1968. 78p., illus., port. For details see no.570.

431. NEW YORK MUSEUM OF MODERN ART. *Catalog of the Library of the Museum of Modern Art.* Boston, Mass., G. K. Hall, 1976. 14 vol.
 Edited by Inga Forslund, Librarian of the Museum. Comprehensive references passim to Dada, its art and history, literary and artistic personalities, exhibitions, and periodicals. Together with associated materials, e.g. Surrealism, publications on modern art, etc., constitutes a major resource for research. Special collections assembled by Bernard Karpel, 1942–73.

432. NICAISE, LIBRAIRIE. *Catalogs.* Paris, 1960–.
 Several distinctive publications, detailed descriptions, often illustrated. Out-

standing items: Cubisme, futurisme, dada, surréalisme (1960).–Poésie-prose: peintres graveurs de notre temps, éditions rares, revues (1964); this includes a detailed inventory of Duchamp's "Boîte-en-valise".–Livres de notre temps, livres illustrés, livres objets, 1969–Littérature moderne, éditions originales, 1970, etc.

433. RAABE, Paul [and others]. *Expressionismus: Literatur und Kunst, 1910–1923. Eine Ausstellung des Deutschen Literatur–Archives in Schiller-National Museum.* Marbach A. N., May 8–Oct. 31, 1960.

Dada, p.231–42. While less conveniently arranged, further data in his *Die Zeitschriften und Sammlungen des literarischen Expressionismus . . . 1910–1921.* Stuttgart, Metzlersche Verlag, 1964.

434. *Revue de l'Association pour l'Étude du Mouvement Dada.* No.1, p.75–88 Oct. 1965.

I. Aperçu analytique des livres consacrés au Mouvement Dada jusqu'a 1962 (François Sullerot). II. . . . entre 1963 et 1965 (Poupard-Lieussou).–III. Importants catalogues d'expositions (Poupard-Lieussou).–IV. Travaux universitaires (André Tinel).

435. SCHWARZ, Arturo. *Almanaco Dada: antologia litteraria–artistica, cronologia, repertorio delle rivista.* Milan, Feltrinelli, 1976.

A primary work. Exhaustive documentation (743p.) of the movement in all phases and languages by the outstanding collector, author and publisher.

436. SHEPPARD, Richard. Bibliography in *Dada spectrum*, ed. by Stephen Foster and Rudolf Kuenzli. Madison, Wis., Coda Press; Iowa City, University of Iowa, 1979.

Abbreviated listings, p.260–289. A) Books and articles: 1. Books–2. Articles and parts of books. B) Works by Dadaists.–C) Works on individual Dadaists (books, articles, parts of books).–D) Periodicals. N.B. Includes reprints.

GENERAL WORKS

437. ADES, Dawn. *Dada and surrealism reviewed.* London, Arts Council of Britain, 1978. 475p., illus.

With an introduction by David Sylvester and a supplementary essay by Elizabeth Cowling. An outstanding study published on the occasion of the exhibition at the Hayward Gallery, Jan. 11–Mar. 27. Important critical and bibliographical data; emphasis on periodicals; list of exhibits.

438. BUFFET-PICABIA, Gabrielle. Aires abstraites. Geneva, Cailler, 1957. 183p., illus.

Preface: Jean Arp. Previously published articles, e.g. "L'époque 'pre-dada' à New York", on artists and writers associated with dada.

439. CAWS, Mary Ann, ed. *Le Siècle éclaté 1: dada, surréalisme et avantgarde.* Paris, Minard, 1974. 214p.

Essays by Breton, Eluard, Duchamp, Tzara, etc. Chronology of dada and surrealist exhibitions, 1969–1973, p.203–213. See also no.426.

440. COUTTS-SMITH, Kenneth. *Dada.* New York, Dutton; London, Studio Vista, 1970. 167p., illus.

Popular "pictureback" edition; bibliography.

441. DANESI, Silvia, ed. *Il Dadaismo.* Milan, Fabbri, 1977. 127p., illus.

An anthology, six contributors including M. Calvesi. Biographies, chronology, bibliography.

442. DE TORRE, Guillermo. *Historia de las literaturas de vanguardia.* Madrid, Guadarrama, 1965.

Includes chapters (p.317–460) on dada and surrealism.

443. FOSTER, STEPHEN C. and KUENZLI, RUDOLF E., eds. *Dada spectrum: the dialectics of revolt*. Madison, Wis., Coda Press; Iowa City, University of Iowa, 1979. 291p., illus.
> An anthology of 12 contributions (M. Sanouillet, A. Cohen, D. Tashjian, etc.) For bibliographical details see no.436.

444. GREENBERG, ALLAN CARL. *Artists and the Weimar Republic:Dada and the Bauhaus, 1917–1925*. Ann Arbor, Mich., University Research Press, 1979. 273p.
> Originally University of Illinois dissertation, 1967. Explores "the relationship between art and politics [showing] artist intellectuals in the role of social reformers." Extensive bibliography.

445. GROSSMAN, MANUEL L. *Dada: paradox, mystification and ambiguity in European literature*. New York, Pegasus, 1971.

446. HUELSENBECK, RICHARD, ed. *Dada, eine literarische Dokumentation*. Hamburg, Rowohlt, 1964. 299p.
> Contents: 1. Manifeste, Pamphlete, Proteste.–2. Prostexte.–3. Lyrische Texte.– 4. Porträts, Selbstportrats, Anti-Porträts.–5. Bibliography by Bernard Karpel, p. 261–89. Documents collected by Karpel; edited by Huelsenbeck. Note that the "Dada Almanach" (Berlin, Reiss, 1920) was reprinted (New York, Something Else Press, 1966) "through the kind permission of Dr. Charles R. Hulbeck."

447. HUGNET, GEORGES. *L'aventure Dada (1916–1922), augmenté d'un choix de textes. Introduction de Tristan Tzara*. Paris, Seghers, 1971, 238p. illus.
> On Zurich, New York, Berlin, Hanover, Paris. Enlarged from the first edition: Paris, Galerie de l'Institut, 1957.

448. JEAN, MARCEL, ed. *The autobiography of surrealism*. New York, Viking Press, 1980, 472p., illus.
> Documents of 20th-century art. Bibliography by Bernard Karpel. See index for references to Dada, Arp, Ball, Tzara, etc.

449. KRAMER, HILTON. *The age of the avant-garde: an art chronicle of 1956– 1972*. New York, Farrar, Straus and Giroux, 1973
> See index for Dada, p.554.

450. LAST, REX W. *German dadaist literature: Kurt Schwitters, Hugo Ball, Hans Arp*. New York, Twayne, 1973. 188p.
> Bibliography, p.179–183.

451. LIPPARD, LUCY R., ed. *Dades on art*. Englewood Cliffs, N.J., Prentice-Hall, 1971. 178p.
> A significant anthology of newly translated material. General introduction, biographical commentary.

452. MATTHEWS, J. H. *Theatre in Dada and Surrealism*. Syracuse University Press, 1974. 286p.
> Bibliographical footnotes. Additional bibliography in *Henri Behar, Étude sur le théâtre dada et surréaliste*. Paris, Gallimard, 1967.

452a. MELZER, ANNABELLE H. *Latest rage the big drum: Dada and surrealist performance*. Ann Arbor, Mich., Research Press, 1980? 275p., illus.
> Trade edition version of doctoral dissertation.

453. MEYER, REINHARDT [and others]. *Dada in Zurich and Berlin, 1916–1920. Literatur zwischen Revolution und Reaktion*. Kronberg Ts., Scriptor, 1973. 316p.
> Bibliography, p.295–316.

454. PIERRE, JEAN. *Le futurisme et le dadaïsme*. Paris Editions Rencontre Lausanne, 1967.

A survey. Chronology, bibliography.

455. POUPARD-LIEUSSOU, YVES and SANOUILLET, MICHEL. *Documents dada: réunis et présentés....* Geneva, Weber, 1974. 96p., illus.

Facsimiles (some in color); essays and individual commentaries: references.

456. RAYMOND, MARCEL. *De Baudelaire au surréalisme*. rev. ed. Paris, Corti, 1969. 366p.

First English translation of first edition: *From Baudelaire to surrealism*. New York, Wittenborn Schultz, 1950. Documents of modern art. Extensive bibliography by Bernard Karpel. Also Methuen edition (London, 1970) with bibliography by S.I. Lockerbie.

457. RIBEMONT-DESSAIGNES, GEORGES. *Dada manifestes, poèmes, articles, projects, 1915–1930*. Paris, Editions Champs Libres, 1974, 192p., illus.

Chronology. Bibliography (1915–34) by J. P. Begot, p.171–187.

458. RICHTER, HANS. *Dada: art and anti-art*. New York, Abrams; London, Thames & Hudson, 1965. 246p., illus.

Appendix: Tzara-Zurich chronicle, 1915–1919. Bibliography, p.229–237. Translation: *Dada-Kunst und Antikunst; Der Beitrag Dadas zur Kunst des 20. Jahrhunderts*. Cologne, DuMont Schauberg, 1964. 259p.

459. RICHTER, HANS. *Köpfe und Hinterköpfe*. Zurich, Die Arche, 1967. 208p., illus.

Memoirs from the artistic circles in Europe during the 20s; reminiscences about artists and film directors. Supplemented by: *Begegnungen von Dada bis heute—Briefe, Dokumente, Erinnerungen*. Cologne, DuMont Schauberg, 1973 220p., illus.

460. RIHA, KARL and BERGIUS, HANNE. *Dada Berlin: Texte, Manifeste, Aktionen*. Stuttgart, Reclam, 1977. 184p., illus.

Documentary anthology; notes on personalities.

461. RODRIQUEZ PRAMPOLINI, IDA. *Dadá documentos*. México, D. F., Universidad Nacional Autonoma de México, 1977. 324p., illus.

With essay by Rita Eder: Hugo Ball y la filosofia Dadá. Bibliography; mentions the following not accessible to the compiler: Raúl G. Aguirre, *Dadaismo*. Buenos Aires, Centro Editor de América Latina, 1963.

462. RONDOLINO, GIANNI, ed. *L'Occhio tagliato: documenti del cinema dadaista e surrealista*. Turin, Martano, 1972, 311p., illus.

Nadar, no.10. Anthology on film-making and theory. Essay and notes by editor in Italian, French, English. Main texts in French.

463. RUBIN, WILLIAM S. *Dada and surrealist art*. New York, Abrams; London, Thames and Hudson, 1969, 525p., illus.

A major history and evaluation with 851 reproductions, 60 in color. Chronology by Irene Gordon. Bibliography, p.492–512. Also see corresponding exhibition directed by Rubin (no.480).

464. SANOUILLET, MICHEL. *Dada à Paris*. Paris, Pauvert, 1965. 646p., illus.

A definitive exposition by the leading French scholar. Bibliography, p.605–627 (ca. 350 citations). Also see relevant works (no.455, 551).

465. SCHWARZ, ARTURO. *New York Dada: Duchamp, Man Ray, Picabia*. Munich, Prestel Verlag, 1973. 223p., illus.

Texts in German and English. Annotated general essay; interview with Man Ray. Chronology, anthology, bibliography. Catalog of works. Issued on occasion of exhibitions: Munich. Städtische Galerie, Dec. 15, 1973–Jan. 27,

1974; Tübnigen. Kunsthalle. Mar. 9–Apr. 26, 1974. A prolific author and authority; see also no.518, 557.

466. SCHIFFERLI, Peter, ed. *Dada: Dichtung und Chronik der Gründer.* Zurich, Verlag der Arche, 1957. 191p., illus.

Writings and personalities of the Zurich period. Bibliography. Also a variant: *Als Dada begann. Bildchronik und Erinnerungen der Gründer.* Zurich, Sansoucci Verlag [1961]. 92p., illus. For extended bibliography see: M. Prosenc. *Die Dadaisten in Zürich.* Bonn, 1967. p.127–138.

467. SEITZ, William C. *The art of assemblage.* New York, Museum of Modern Art, 1961. 176p., illus.

Published on the occasion of an exhibition (Oct. 2–Nov. 12, 1961). "Dada and neo-dada", p.32–39. Bibliography by Bernard Karpel, p.166–173.

468. SHORT, Robert. *Dada & surrealism.* London, Octopus Books; New York, Mayflower Books, 1980, 176p., illus.

A popular survey with 180 reproductions; brief bibliography.

469. TASHJIAN, Dickran. *Skyscraper primitives: Dada and the American avant-garde, 1910–1925.* Middletown, Conn., Wesleyan University Press, 1975. 283p., illus.

Chap.1) *Camera Work* and the anti-art of photography.–2) *291* and Francis Picabia.–3) Marcel Duchamp and Man Ray (p.15–70), etc. Bibliography.

470. VERKAUF, Willy, ed. *Dada: monograph of a movement.* New York, Wittenborn, 1957. 188p., illus.

Text in English, French and German. Co-editors: Marcel Janco, Hans Bolliger. Chronology, dictionary. Bibliography, p.176–183 (draws heavily on "The Dada Painters and Poets", Wittenborn, 1951). Also London, Academy Editions; New York, St. Martins Press, 1975. 109p., illus. First European edition: Dada: Monographie einer Bewegung. Teufen, Swiz., Niggli, 1965. 128p., illus.

471. WATTS, Harriet Ann. *Chance: a perspective on Dada.* Ann Arbor, Mich., University Research Press, 1979, 189p.

"Chance is a conscious and central aesthetic principle [concentrating] on the views and works of . . . Duchamp, Arp, Richter, Tzara and Ernst." Studies in Fine Arts (series of doctoral dissertations, now typeset, printed and bound).

472. WILLETT, John. *Art and politics in the Weimar period: the new sobriety, 1917–1933.* New York, Pantheon Books, 1978, 272p., illus.

See index (p.266) for Dada; also personalities: Grosz, Huelsenbeck, etc. Chronological table incorporates the arts. Bibliography. See also Greenberg (no.444), Lewis (no.532).

PERIODICALS & DOCUMENTS

It is not easy to fabricate a balanced cross-section from the mass of material reported in *ARTbibliographies Modern, The Art Index* and similar compilations over the last three decades. Previous citations, both general (no.424, 425, 431, 433, 436, 437) and special (no.474, 482) will have to serve as substitutes. Fortunately, Alexander Davis has underway "a list of 1,000 serial publications" documented in his index (no.426a) for future release.

Distinctive *reprints*, however, have added a new dimension to research in this area. Three examples below typify the range of superior efforts that have restored such exotic items to the marketplace with maximum effect. Others have ventured into recordings and tapes. To have survived in this fashion the ostracism of silence that society inflicts on the outsider, too long the lot

of Dada, is a remarkable demonstration of the sustained vitality of its artists and writers (no.499,509)

473. LACH, FRIEDHELM, ed. *Kurt Schwitters* Merzhefte *als Faksimile–Nackdruk.* Bern, Verlag Herbert Lang, 1974. 32p plus portfolio.

"Thirteen issues of *Merz* and three other related works are housed on a decorated cloth and board portfolio. . . . The sixteen works are printed on various papers in inks of different colors and bound to match the originals." Unfortunately, omits some numbers issued in sound.

474. SCHWARZ, ARTURO, ed. *Documenti e periodici dada.* Milan-Rome, Gabrielle Mazzotta, 1970. 15 parts in folio.

Archivi d'arte del XX secolo. Edition of 500, in folios grouped by nationality. An indispensable collection based on the Schwarz archive. Owing to tone and scale a technical tour-de-force. Contents: *Bleu* (no.1–3) 1920–21.–*The Blind Man* (no.1–2) Apr. 10–May 1917.*–Cannibale* (no.1–2) Apr. 25–May 25, 1920.–*Club Dada* (no.1) 1918–*Le Coeur à barbe* (no.1) Apr. 1922–*Der Dada* (no.1–3) 1919–20.–*Dada* (no.1–7) July 1917–Mar. 1920.–*Dadaco: dadaistischer Handatlas,* 1920.–*New York Dada* (no.1) Apr. 1921.–*La Pomme de Pins* (numéro unique) Feb. 25, 1922.–*Projecteur* (no.1) May 12, 1920.–*The Ridgefield Gazook* (unique issue) Mar. 21, 1915.–*Rongwrong* (no.1) May 1917.–*Die Schammade* (no.1) [Feb] 1920. Cover title: Dadameter–Z (no.1) Mar. 1920.–*Der Zeltweg* (no.1) Nov. 1919.

*N.B. Both members of *The Blind Man* supplied by B. Karpel. Although correction for entry 59 (p.333) requested, publisher passed it by in 1951 edition.

475. SANOUILLET, MICHEL, ed. *Dada . . . 1916 à 1922.* Nice, Centre du XXᵉ Siecle, 1976. 2 vol.

Vol. I: Réimpression integrale de la revue.–II. Dossier critique et documents. See also no.455.

EXHIBITION CATALOGS (Chronologically)

A selection; for further suggestions consult no.431, 434, 439. Additional references are noted throughout *Artists & Writers*, e.g. no.496, 521, 548, 556, and 559.

476. DUSSELDORF, KUNSTHALLE. KUNSTVEREIN FÜR DIE RHEINLANDE UND WESTFALEN. *Dada: Dokumente einer Bewegung.* Sept. 5–Oct. 19, 1958. [106] p., ill.

Catalog by K. H. Hering and E. Ratke. Texts, 539 exhibits. Data also constitutes important bibliography. Reprint: New York, Arno Press, 1968.

477. GENEVA, GALERIE KRUGIER. [*Exposition Dada*]. Feb. 1966. n.p., illus.

Suites no.10, issued to commemorate 50th anniversary of the foundation in Switzerland of the Dada movement. Essay: Werner Haftmann. 82 works and documents. Similar commemoratives: Stockholm. Moderna Museet. *Dada.* Feb.–Mar. 1966. 44p., illus. no 19 of Meddelande från Moderna Museet; texts, documentation.

478. MUNICH. GOETHE-INSTITUT. *Dada 1916–1966. Documents of the international Dada movement.* Selected and commentated by Hans Richter, Southbury, Conn. 1966. 104p., illus.

Plates, p.57–88; catalogue, p.89–102; 296 exhibits. Biographies, bibliography. Facsimile of program: First International Dada Fair, June 1920. Variant catalogs issued for tour in Europe, India, e.g. Rome. Galleria Nazionale d' Arte Moderna. Nov. 15–Dec. 15, 1966. 100p. incl. 115 illus.

479. BERLIN. DEUTSCHE AKADEMIE DER KÜNSTE. *Der Malik-Verlag, 1916–1947: Ausstellungkatalog.* 1967. 160p., illus.

Bibliography, p.73–157.

480. NEW YORK. MUSEUM OF MODERN ART. *Dada, surrealism and their heritage*. Mar. 27–June 9, 1968. 252p., illus.

Exhibition directed by and publication by William S. Rubin. Also shown at Los Angeles and Chicago. Chronology, bibliography. See also no.463.

481. ROTTERDAM. MUSEUM BOYMANS–VAN BEUNINGEN. *De metamorfose van het object. Kunst und Anti-Kunst, 1910–1970*. June 25–Aug. 25, 1971. 160p., illus.

J. Markert: Dada en het object, p.56–79. Also shown Brussels, Berlin, Milan, Basel, Paris.

482. MUNICH. STADTISCHE GALERIE IN LENBACHHAUS. New York Dada. Dec. 15, 1973–Jan. 27, 1974. See no.465.

483. COLOGNE. KOLNISCHER KUNSTVEREIN. *Von Dadamax zum Grüngurtel: Köln aus den 20er Jahren*. Mar. 15–May 11, 1975. 251p., illus.

Covers arts and culture. Reprints *Bulletin D* (1919), *Brauhaus Winter* (1920), *Stupid* (1920).

484. PARIS, MUSÉE NATIONAL D'ART MODERNE. *Paris-New York*. June 1–Sept. 19, 1971. 729 p., illus.

Monumental publication of the Centre Pompidou. Includes Robert Lébel, "Paris-New York et retour avec Marcel Duchamp, dada et le surréalisme," p.64–77; Hélène Seckel, "Dada New York," p.342–367. Biographies.

485. BERLIN. EUROPAISCHE KUNSTAUSSTELLUNG, 15. *Tendenzen der Zwanziger Jahre*. Aug. 14–Oct. 16, 1977. 278p., illus.

Shown via Europat; Städische Galerie, Frankfurt, Nov. 10, 1977–Jan. 8, 1978 in part. Part 3: Dada in Europe—Werke und Dokumente. Also data on American and Latin American Dada. Catalog published by Dietrich Reimer Verlag (Berlin, 1977) contains essays, chronology, bibliography.

486. LONDON. HAYWARD GALLERY. *Dada and surrealism reviewed*. Jan. 11–Mar. 27, 1978.

Exhibition conceived by David Sylvester. See no.437 for further data.

487. IOWA CITY. UNIVERSITY OF IOWA. MUSEUM OF ART. *Dada artifacts*. Mar. 31–May 7, 1978. 96p., illus.

Texts: S. C. Foster, R. E. Kuenzli. Chronology, bibliography. Also see no.436.

488. PARIS, CENTRE GEORGES POMPIDOU. *Paris-Berlin, 1900–1933: rapports et contrastes France-Allemagne....* July 12–Nov. 6, 1978. 576p., illus.

Monumental publication, with section on Dada in Paris, Berlin, Cologne, Schwitters and Hanover, p.118–181. Essays: M. Giroud, H. Bergius, W. Spies, E. Roters. Supplement: catalog, biographies, bibliography.

489. GARDEN CITY, NEW YORK. ADELPHI UNIVERSITY. *Dada—in Berlin*. Oct. 22–Dec. 22, 1978. 62p., illus.

Catalog: Erica Doctorow. Artistic, literary and political activities at the time of the Weimar Republic. Essay, chronology, bibliogaphy.

490. NEW YORK. WHITNEY MUSEUM OF AMERICAN ART. *Dada and New York*. May 31–July 6, 1979 [26]p.

Catalog of exhibit at Downtown branch: press release, checklist, text, chronology, bibliography.

491. HANOVER. KESTNERGESELLSCHAFT. *Dada: photography and photomontage*. June 6–Aug. 5, 1979. 340p., illus.

Texts on Man Ray, Max Ernst, New York Dada, etc. Biographies, bibliography.

ARTISTS & WRITERS: Arp to Tzara

The variation in references for each individual depends, in part, upon the

available material, which in some instances is sparse, in others excessive. For obvious reasons, artists of eminence have merited a larger representation. To compensate for the overall compression, bibliographies are noted frequently.

ARP

492. ARP, JEAN (HANS). *Arp: On my way, poetry and essays, 1912 . . . 1947.* New York, Wittenborn, Schultz, 1948. 147p., illus.

Documents of Modern Art, edited by Robert Motherwell. Texts by C. Giedion-Welcker. G. Buffet-Picabia. Bibliography by Bernard Karpel (expanded in no.493).

493. ARP, JEAN (HANS). *Arp on Arp: poems, essays, memories.* New York, Viking Press, 1972. 574p., illus.

Translation: *Jours effeuillés* (Paris, Gallimard, 1966). Edited by Marcel Jean. Bibliographical notes, p.525–547; bibliography by Bernard Karpel, p.546–560.

494. DÖHL, REINHARD. *Das literarische Werk Hans Arps, 1903–1930.* Stuttgart, Metzlersche, 1967.

Annotated bibliography, p.207–253.

495. GIEDION-WELCKER, CAROLA. *Jean Arp.* New York, Abrams, 1957. 122p., illus.

Also Stuttgart, Gerd Hatje, 1957. Documentation: Marguerite Hagenbach. Bibliography expanded by her in: Eduard Trier. *Jean Arp sculpture; his last ten years.* New York, Abrams, 1968. p.133–145.

496. NEW YORK. MUSEUM OF MODERN ART. *Arp.* Edited, with an introduction, by James Thrall Soby. New York, The Museum, 1958. 126p., illus.

Texts: Arp, R. Melville, C. Giedon Welcker. Also Huelsenbeck: Arp and the dada movement. Catalog of the exhibition (Oct. 8–Nov. 30, 1958). Bibliography.

497. READ, HERBERT. *The art of Jean Arp.* New York, Abrams, 1968. 216p., illus.

On his life, works and poetry. Bibliography.

BAADER

498. BAADER, JOHANNES. [Archival scrapbook of clippings]. [405p.] n.p., n.d. A miscellaneous, generally undated series of mounted newspaper and other clippings, in apparently haphazard sequence. Includes a page titled "Aus dem Tagebuch," dated 1.6.52. Forwarded to Bernard Karpel by Baader shortly before he passed away. Original: Collection Mr. and Mrs. Leonard Brown, Springfield, Mass.

BAARGELD (Alfred Grünwald)

499. VITT, WALTER. *Aug der Suche nach der Biographie des Kölner Dadaisten Johannes Theodor Baargeld.* Starnberg, Keller Verlag, 1977 [108]p., illus.

"Mit Zahlreichen Arbeiten und Texten Baargelds sowie einem Reprint der Wochenschrift 'Der Ventilator,' Köln, Februar–März 1919". A rare document: vol.1, no.1–2, 3, 4, 5, and 6; undated issues; reproduced p.[67–108]. Chronology, bibliographic notes.

BALL

500. BALL, HUGO. *Flametti; oder, Vom Dandyismus der Armen. Roman* [Frankfurt] Suhrkamp, 1975. 182p.

Reprint of original edition: Berlin, Reiss, 1918.

501. BALL, HUGO. *Flight out of time: a dada diary.* Edited with an introduction, notes and bibliography by John Elderfield. New York, Viking, 1974. 254p., illus.

Documents of twentieth-century art. Translation: *Die Flucht aus der Zeit.* Lucerne, Stocker, 1946. Preface by Emmy Ball-Hennings. Includes diaries, dada manifesto, documents.

502. BALL-HEMMINGS, EMMY. *Ruf und Echo: mein Leben mit Hugo Ball.* Einsiedeln, Bensiger Verlag, 1953. 291p., illus.

503. VALERIANI, LUISA, ed. *Dada Zurigo: Ball e il Cabaret Voltaire.* Turin, Martano, 1970. 102p., illus.

BRETON

504. EIGELDINGER, MARC, ed. *André Breton: essais et témoignages ... textes inédites.* ... Neuchâtel, A la Baconnière, 1950 [251]p., illus.

Bibliography by B. Gheerbrant, p.229–247.

505. BROWDER, CLIFFORD. *André Breton: arbiter of surrealism.* Geneva, Droz, 1967. 214p.

Extensive bibliography, p.180–214.

CRAVAN

506. CRAVAN, ARTHUR, ed. *Maintenant. Textes présentés par Bernard Delvaille.* Paris, Losfeld [195?] 108p. illus.

Selected articles reprinted from his 1913–15 magazine. Appendix: statements by Cravan.

507. CRAVAN, ARTHUR, ed. *J'étais cigare.* Maintenant *suivi de* Fragments *et d'une* Lettre. Préface–coupure de José Pierre. Paris, Le Terrain Vague, 1971.

Le Desordre, no.11. Reprint from the dada era.

DOESBURG

508. BALJEU, JOOST. *Theo van Doesburg.* New York, Macmillan, 1974. 232p., illus.

Comprehensive section on his writings, extensive bibliography. Also Studio Vista edition (London).

509. DOESBURG, THEO VAN, ed. *De Stijl: maanblad voor moderne beeldende vakken.* Delft, Leiden, 1917–1932; reprint 1968.

Originally vol.1–8, reprinted in 2 vol.: Amsterdam, Atheneum and Polak & Van Gennep [with] The Hague, Bert Bakker, 1968.

510. EINDHOVEN. STEDELIJK VAN ABBEMUSEUM. Theo van Doesburg. Dec. 13, 1968–Jan. 26, 1969. 106p., illus.

Also shown: The Hague Gemeentmuseum, Basel Kunsthalle (1969). Texts, documents, biography, bibliography.

511. HEDRICK, HANNAH. *Theo van Doesburg, propagandist and practitioner of the avant-garde: belletristic activity in Holland, Germany and France, 1909–1923.* Ann Arbor, Mich., University Research Press, 1979. 172p., illus.

Studies in Fine Arts series. Doctoral dissertation typeset, printed and bound. Bibliography.

DUCHAMP

512. CABANNE, PIERRE. *Dialogues with Marcel Duchamp.* New York, Viking, 1971. 136p., illus.

Documents of 20th-century art. Translation of 1967 French edition. Texts: Robert Motherwell, Salvador Dali, Jasper Johns; bibliography by Bernard Karpel.

513. DUCHAMP, MARCEL. *Salt seller. The writings of Marcel Duchamp (Marchand du sel).* Edited by Michel Sanouillet and Elmer Peterson. New York, Oxford, 1973. 196p., illus.

Also London, Thames and Hudson, 1973. Introduction by Sanouillet (dated

1958). Bibliographical note. Translation (with revisions) of *Marchand du sel*. Paris, Le Terrain Vague, 1958. Bibliography by Poupard-Lieussou. Another anthology: *Duchamp du signe*. Écrits réunis et présentés par Michel Sanouillet. Paris, Flammarion, 1975. With collaboration of Elmer Peterson. Bibliography, p.279–91.

514. D'HARNONCOURT, Anne and McSHINE, Kynaston, ed. Marcel Duchamp. New York, Museum of Modern Art; Philadelphia, Philadelphia Museum of Art, 1973. 345p., illus.

Fourteen contributions including a catalog. Bibliography (approx. 200 references) by Bernard Karpel. Also a separate catalog: Marcel Duchamp, a retrospective exhibition. Philadelphia, Sept. 22–Nov. 11, 1973, New York, Dec. 3, 1973–Feb. 10, 1974; Art Institute of Chicago, Mar. 9–Apr. 12, 1974. Checklist (292 exhibits).

515. HOPPS, Walter, ULF, Linde, ARTURO, Schwarz. *Marcel Duchamp ready-mades, etc. (1913–1964)*. Milan, Galleria Schwarz, 1964. 95p., illus.

Chronology, checklist (108 exhibits), documents.

516. MASHECK, Joseph, comp. *Marcel Duchamp in perspective*. Englewood Cliffs, N.J., Prentice-Hall, 1975. 184p., illus.

Twenty-four essays and critiques by twenty-four contributors. Chronology, brief bibliography.

517. PARIS. CENTRE NATIONAL D'ART ET DE CULTURE GEORGES POMPIDOU. *Marcel Duchamp*. Paris, Musée National d'Art Moderne, 1977. 4 vol. (boxed), illus.

A monumental and scholarly testament to erase the indifference of decades at home. Vol.I: Chronologie.–II.: Catalogue raisonné, sources et bibliographie.–III.: abécédaire, approaches critiques.–IV.: H. P. Roché. Victor-Marcel Duchamp.

518. SCHWARZ, Arturo. *The complete works of Marcel Duchamp*. New York. Abrams; London, Thames and Hudson, 1969. 630p., illus.

Catalogue raisonné, p.372–580; descriptive bibliography, p.583–606; bibliography on Duchamp, p.607–617. Second revised edition, 1970. Also a popular edition, 1975, 211p., illus.

519. STEEFEL, Lawrence D., Jr. *The position of* La mariée mise à nu par ses celibataires, même *(1915–1923) in the stylistic and iconographic development of the art of Marcel Duchamp*. Princeton University, Department of Art and Archeology, 1960. 423 leaves plus 64 plates.

Doctoral dissertation. Bibliographical notes, p.292–423. Also available in xerox facsimile or microfilm (Ann Arbor, Mich., University Microfilm).

ERNST

520. ERNST, Max. *Écritures*. Paris, Gallimard, 1970. 448p., illus.

"Notes pour une biographie," p.11–99. Articles, essays, interviews, statements (1919–1969).

521. FISCHER, Lothar. *Max Ernst in Selbstzeugnissen und Bildokumentem*. Hamburg, Rowohlt, 1969. 187p., illus.

Critical reviews, chronology, exhibitions, biographical notes. bibliography.

522. NEW YORK. MUSEUM OF MODERN ART, *Max Ernst*. Edited by William S. Lieberman. Mar. 1–May 7, 1961. 63p., illus.

"An informal life of M. E. (as told by himself to a young friend)", p.7–24. Bibliography by Bernard Karpel; expanded by Lucy Lippard in: Max Ernst. New York, Jewish Museum, Mar. 3–April 17, 1966.

523. PARIS. GALERIES NATIONALES DU GRAND PALAIS. Max Ernst. May 16–Aug. 18, 1975. 173p., illus.

In cooperation with the Guggenheim Museum retrospective (Feb. 13–Apr. 20, 1975) and the de Menil family collection. A substantial, well documented catalog. Texts: Ernst, Pontus Hulten, Werner Spies.

524. RUSSELL, JOHN. *Max Ernst: life and work.* New York, Abrams, 1967. 358p., illus.

Chronology of works, biographical notes, bibliography.

525. SPIES, WERNER. *Max Ernst—Collagen: Inventar und Widerspruch.* Cologne, DuMont Schauberg, 1974. 499p., illus.

Oeuvre catalog (607 reproductions, 60 in color). Texts by Ernst, Breton, etc. Bibliography. Supplemented by his: Max Ernst: das Graphische Werk. Cologne, DuMont Schauberg; Houston, Menil Foundation, 1975–in progress. Collaborators: H. R. Leppien, H. Bolliger, etc.

526. TOURS, BIBLIOTHEQUE MUNICIPALE. *Max Ernst: écrits & oeuvre gravé.* Nov. 30–Dec. 31, 1963. 83p., illus.

Catalogue (351 exhibits) by M. M. Hugues and Poupard-Liessou. Also shown at Le Point Cardinal (Paris), Jan.–Feb. 1964.

527. WALDBERG, PATRICK. *Max Ernst.* Paris. J.-J. Pauvert, 1958. 443p., illus. Layout supervised by Ernst. Partial contents: Entrée d'Arp—Dada Cologne.— Dada chez soi au grand air.

GROSZ

528. BITTNER, HERBERT, ed. George Grosz. New York, Arts, 1960 [51]p., illus. "The two worlds of George Grosz" by R. Berenson and M. Muhlen, p.11–28. "On my drawings" by George Grosz, p.29–32. Reproductions (114) and bibliography, p.34–48.

529. FISCHER, LOTHAR, ed. *George Grosz in Selbstzeugnissen und Bilddokumenten.* Hamburg, Rowohlt, 1976. 157p., illus.

530. GROSZ, GEORGE. *Ein kleiner Ja und ein grosses Nein. Sein Leben von ihm selbst erzählt.* Hamburg, Rowohlt, 1955. 298p., illus.

First published in English by the Dial Press (New York, 1946) but now "better written and containing some extra material."

531. HESS, HANS. *George Grosz.* New York, Macmillan, 1974, 272 p., illus. Chronology, reproductions (227 with 10 portraits), exhibitions, bibliography.

532. LEWIS, BETH ERWIN. *George Grosz: art and politics in the Weimar republic.* Madison, Milwaukee & London, University of Wisconsin Press, 1971. 328p., illus.

Revised doctoral dissertation. Extensive documentation, p.271–311.

HAUSMANN

533. HAUSMANN, RAOUL. *An Anfang war Dada.* Steinbach-Giessen, Anabas Verlag, 1972. 188p., illus.

Edited by Karl Riha, Jünter Kämpf. Bibliography, p.175–185.

534. HAUSMANN, RAOUL. *"Je ne suis pas un photographe." Textes et documents choises et présentés par Michel Giroud.* Paris, Éditions du Chêne, 1976 (c.1975). 158p., illus.

Collection "L'oeil absolu." Chronology, statements, bibliography.

535. HAUSMANN, RAOUL. *Courrier Dada suivi d'une bibliographie de l'auteur par Poupard Lieussou.* Paris, Le Terrain Vague, 1958. 157p., illus.

Partial contents: Deux personages Dada—Huelsenbeck et Baader; Antidada et Merz. Bibliography, p.152–157.

536. PARIS. MUSÉE NATIONAL D'ART MODERNE. *Raoul Hausmann:*

autour de l'Esprit de notre temps. Assemblages, collages, photomontages. Nov. 22, 1974–Jan. 20, 1975. 28p., illus.

> Texts by the artist, Dominique Bozo, and others. Biography, exhibits (77), bibliography.

537. STOCKHOLM. MODERNA MUSEET. *Raoul Hausmann.* Oct. 21–Nov. 19, 1967.

> Text by the artist and others also in French. Catalog (64 exhibits), chronology, bibliography (6p.)

HUELSENBECK

538. HUELSENBECK, Richard, ed. *Dada, eine literarische Dokumentation.* Hamburg, Rowohlt, 1964.

> Selected, in part, for relevance to Huelsenbeck (Dr. Hulbeck in the United States). To these should be added a final retrospective: Reflections on leaving America for good. *American Scholar* Winter 1969–70, p.80–85.

539. HUELSENBECK, Richard. *Memoirs of a Dada drummer.* Edited, with an introduction, notes and bibliography by Hans J. Kleinschmidt. New York, Viking, 1974. 202p., illus.

> Documents of 20th-century art. Largely a translation, with some added essays, of his "Mit Witz, Licht und Grütze" (Wiesbaden, Limes Verlag, 1957). Extensive commentary on Dada and Huelsenbeck.

540. NEW YORK. GOETHE HOUSE. *Richard Huelsenbeck and his friends.* Mar. 12–Apr. 4, 1975. 15p., illus.

> Works by Huelsenbeck, Beate Hulbeck (his wife, a painter), Grosz and Arp. Exhibition, text and bibliography on Huelsenbeck and the Dada movement by Phyllis Freeman.

JANCO

541. HAIFA. MUSÉE D'ART MODERNE. *Marcel Janco: exposition retrospective.* Spring-summer 1968. [36]p., illus.

> Text: Arp, Mendelsohn; 100 exhibits (no.1–7: Dada Zurich); chronology. Comment also in Hebrew.

542. MENDELSON, Marcel L. *MARCEL JANCO.* Tel Aviv, Massadah, 1962. 136p., illus.

> French text, chronology, bibliography.

543. PARIS. GALERIE DENISE RENE. *Marcel Janco.* Oct.–Nov. 1963 [28]p., illus.

> Texts: Arp, Seuphor. Checklist, chronology, bibliography.

544. SEUPHOR, Michel. *Marcel Janco.* Amriswil, Bodensee Verlag, 1963. 43p., plus 24 illus.

> Künstler unserer Zeit. Text and chronology (English, French, German): bibliography (in German).

545. TEL-AVIV. MUSEUM. *Marcel Janco: Dada documents et témoignages, 1916–1958.* Tel Aviv, Hashalem Press, 1959. [17]p., illus.

> Artist's retrospective with catalog (4p.). Texts: Janco, Arp, Tzara, Seuphor, Richter. Bibliography.

MAN RAY

> Now authoritative form but to correspond to prior convention see *RAY.*

PICABIA

546. CAMFIELD, William A. *Francis Picabia: his art, life and times.* Princeton, N.J., Princeton University Press, 1979. 366p., illus.

> Comprehensive reproductions (409); extensive bibliography, p.299–347.

547. LE BOT, MARC. *Francis Picabia et la crise des valeurs figuratives, 1900–1925.* Paris, Klincksieck, 1968, 205p., illus.
Illustrations: Dada, no.44–52. Chronology, bibliography.

548. NEW YORK. SOLOMON R. GUGGENHEIM MUSEUM. *Francis Picabia* by William A. Camfield. Sept. 18–Dec. 6, 1970. 161p., illus.
Statements by the artist; notes on each work. Bibliography and exhibitions, p.149–161. Additional Camfield documentation in: Milan. Galleria Schwarz. Francis Picabia. June 6–Sept. 16, 1972, and infra.

549. PARIS. MUSÉE NATIONAL D'ART MODERNE. *Francis Picabia.* Jan. 23–Mar. 29, 1976. 202p., illus.
Exhibited at the Grand Palais. Numerous reproductions (250), essays, extensive biography, bibliography by Camfield.

550. PICABIA, FRANCIS. *Écrits, 1913–1920.* Paris, Belfond, 1975. 285p.
"Textes reúnis et présentés par Olivier Revault d'Allunes."

551. SANOUILLET, MICHEL. *Picabia.* Paris, Éditions du Temps, 1964. 175p., illus.–Tome II: Francis Picabia et "391." Paris, Losfeld, 1966. 2 vol.
Vol. I: Chronology, p.145–148; bibliography by Poupard-Lieussou, p.149–175.—II: Comprehensive monograph, notes, bibliography.

RAY

552. LOS ANGELES. COUNTY MUSEUM OF ART. *Man Ray, an exhibition . . . under the direction of Jules Langsner.* Oct. 27–Dec. 25, 1966. 148p., illus.
Partial contents: "The film poetry of Man Ray," "Man Ray on Man Ray," bibliography by Man Ray, p.144–148.

553. PENROSE, ROLAND. *Man Ray.* Boston, Graphic Society, 1975. 208p., illus.
A biography by a close friend. Well illustrated, with checklist of exhibition: New York Cultural Center. Man Ray. Dec. 1974–Feb. 1975, later in London and Turin (237 works). Also a trade edition lacking checklist.

554. RAY, MAN. *Self portrait.* Boston, Little Brown, 1963. 398p., illus.
"Dada films and surrealism," p.259–288. French edition: *Autoportrait. Paris,* Laffont, 1964. Italian edition: *Autoritratto.* Milan, Mazzotta, 1975.

555. RAY, MAN. *Ogetti d'affezion* [Objects of my affection]. Turin, Einaudi, 1970. 302p., illus.
New York, 1917–20.—Parigi, 1921–29.—Hollywood, 1940–50.—Parigi, 1957–70. Nota da Paola Fossati.

556. ROME. PALAZZO DELL ESPOSIZIONE. *Man Ray: l'occhio e suo doppio.* July–Sept. 1975. 281p., illus.
A major document: over 200 exhibits (catalog by M. Fagiolo), numerous reproductions, chronology, bibliography. Also English texts.

557. SCHWARZ, ARTURO. *Man Ray: the rigours of imagination.* London, Thames and Hudson; New York, Rizzoli, 1978. 384p., illus.
Bibliography (general), p.338–350; Man Ray, p.351–358. See also his: *Man Ray, 60 years of liberties.* Paris, Losfeld, 1971. 155p., illus. An anthology of 16 contributions from Arp to Tzara. Published on the occasion of an exhibition at the Galleria Schwarz, Milan. Chronology, 195 illustrations (36 col.), bibliography.

RICHTER

558. GRAY, CLEVE, ed. *Hans Richter by Hans Richter.* New York, Holt Rinehart and Winston, 1971. 191p., illus.
Foreword by the editor.

559. PROVIDENCE. RHODE ISLAND SCHOOL OF DESIGN. *The world*

between the ox and the swine. Dada drawings by Hans Richter. Sept. 16–Oct. 24, 1971. 56p., illus.

Preface: Daniel Robbins. Text consists of conversations between Richter and Robbins on intimate recollections related to the drawings. Biography, bibliography. First printed in R. I. Bulletin, Aug. 1971.

560. RICHTER, HANS. *Dada Profile.* Zurich, Die Arche, 1961. 115p., illus.

Sketches dated 1916–1918, also photos and documents. Partly published as "Dada profiles" in Perspectives on the Arts, Yearbook 5. New York, Art Digest, 1961.

561. RICHTER, HANS. *Hans Richter.* Introduction by Herbert Read. Autobiographical text by the artist. Neuchâtel, Switz., Griffon, 1965. 131p. illus.

Chronology, 145 reproductions, film index, bibliography.

562. WEINBERG, HERMAN G. *An index to the creative work of Hans Richter.* British Film Institute Index Series (London), no.6, 1946; revised 1957. 8p.

Published by *Film Culture Magazine*, New York, 1957.

SCHWITTERS

563. LACH, FRIEDHELM. *Der Merzkünstler Kurt Schwitters.* Cologne, DuMont Schauberg, 1971. p., illus.

564. NEW YORK, MARLBOROUGH GALLERY. *Merz: Kurt Schwitters.* Feb.–Mar. 1973. 107p., illus.

Also shown London, Zurich (1972). A series (1963, 1965, 1972, 1973) of significant shows and documentation. New York. Marlborough-Gerson Gallery. Kurt Schwitters retrospective. May–June 1965. 80p., illus. Text. W. Schmalenbach, K. T. Steinitz, H. Bolliger -London.Marlborough Fine Arts Ltd. Schwitters Mar.–Apr. 1963. 105p., illus. Text: Ernst Schwitters, Kurt Schwitters, H. Bolliger.

565. SCHMALENBACH, WERNER. *Kurt Schwitters.* New York, Abrams, 1967. 401p., illus.

Translation from the German: Cologne, DuMont Schauberg, 1967. Writings by the artist, p.193–241. Chronology, exhibitions, bibliographical notes. Bibliography by Hans Bolliger, p.372–394.

566. SCHWITTERS, KURT. *Das literarische Werk.* Hrsg. von Friedhelm Lach. Cologne, DuMont Schauberg, 1973–.

Bd. I: Lyrik.–II. Prosa, 1918–1930.–III. Prosa, 1931–1948. Detailed notes.

567. STEINITZ, KATE T. *Kurt Schwittters: a portrait from life.* Berkeley, University of California Press, 1968. 221p., illus.

Includes writings by Schwitters. Introduction: John Coplans, Walter Hopps. Biographies. Revision of earlier work: Kurt Schwitters: Erinnerungen aus den Jahren 1918–30. Zurich, Verlag der Arche, 1963. 168p., illus.

TZARA

568. BERGGRUEN & CIE. *Bibliographie des oeuvres de Tristan Tzara, 1916–1950.* Paris, Berggruen, 1951. [13]p., illus.

Pamphlet issued for Tzara exhibition, Galerie Berggruen, Feb. 24–Mar. 17, 1951.

569. CAWS, MARY ANN. *Tristan Tzara: Approximate man and other writings.* Detroit, Wayne State University, 1973. 267p.

Translated with an introduction and notes. Bibliography.

570. LACOTE, RENÉ, ed. *Tristan Tzara ... choix de textes, bibliographie, dessins, portraits, fac-simile, poèmes inédits.* Paris, Seghers, 1952. 229p., illus.

Reproductions of works by Bellmer, Ernst, Picabia, etc., Bibliography, p.221–225.

571. TZARA, TRISTAN. *Oeuvres complètes ... Texte établi, présenté et annoté par Henri Béhar*. Paris, Flammarion, 1975–.

Vol.I: 1912–1924 (publ. 1975).—II.: 1925–1933 (publ. 1977).

572. TZARA, TRISTAN. *Seven Dada manifestos and lampisteries*. Translated by Barbara White. Illustrations by Picabia. London, J. Calder, 1977. 118p., illus.

French edition: Lampisteries, précedées du Sept manifests dada. Paris, Pauvert, 1963. 148p., illus.

573. [TZARA, TRISTAN, COLLECTION]. BIBLIOTHEK UND SAMMLUNG TRISTAN TZARA, PARIS. *Auktion, 12 Juni*. Bern. Kornfeld & Klipstein, 1968. 70p., illus.

Prefatory note by Jean Hugues, libraire á Paris. An extraordinary document constituting an inventory of a continental personality, intimately involved in literature and the arts, as well as bibliography on dada and surrealism. Annotated, illustrated; 333 lots, indexed. Estimates (bound in) exceeded substantially in actual sale owing to scope, scarcity and significance.

Richard Huelsenbeck: *Dada Manifesto, 1949*

The signers of this manifesto are well aware that the recent venomous attacks on modern art are no accident.

The violence of these attacks stands in direct proportion to the worldwide growth of the totalitarian idea, which makes no secret to its hostility to the spiritual in art or its desire to debase art to the level of slick illustration.

The signers of this manifesto are not political thinkers; but in the matter of art they believe they have something significant to say because of a particular experience that made a lasting impression on them. The experience—Dadaism—occurred many years ago, and it is still too soon to foresee all its possible reverberations.

Dadaism was founded in Zurich in 1916 (see the note at the end of this manifesto). As an active movement it has long since gone the way of all things. Its principles, however, are still alive, and have demonstrated their vitality, although many of the founders, charter members and original supporters are dead.

This strange, surprising vitality has convinced the signers of this manifesto that the experience of Dadaism and its innermost creative principle endowed them (and others) with a special insight into the situation of modern art.

And because the creative principle in Dadaism has survived, we are at last in a position to pass fair judgment on Dadaism itself.

The more we contemplate, the more evident it becomes that the creative principle developed in Dadaism is identical with the principle of modern art. Dadaism and modern art are one in their essential presuppositions; consequently the misunderstandings that arise in connection with modern art are identical with the misunderstandings that have pursued Dadaism since its founding in 1916.

The signers of this manifesto believe, therefore, that if we can dispel the widespread misapprehensions about Dadaism, we shall have rendered an appreciable service to modern art in its struggle against popularization and sentimentalization. It is difficult to sum up the innumerable expressions of hostility to Dadaism in a few words. Nevertheless, at the risk of one more misunderstanding, we shall attempt a brief formulation; the misunderstanding from which Dadaism suffered is a chronic disease that still poisons the world. In its essence it can be defined as the inability of a rationalized epoch and of rationalized men to see the positive side of an irrational movement.

Over and over again, the drumming, shouting and dancing, the striving to *épater le bourgeois,* have been represented as the chief characteristics of Dadaism. The riots provoked by Dadaism in Berlin and Paris, the revolutionary atmosphere surrounding the movement, its wholesale attacks on everything, led critics to believe that its sole aim was to destroy all art and all the blessings of culture. The early Dada manifestoes, in which nonsense was mixed with earnestness, seemed to justify this negative attitude.

In the considered opinion of the signers of this manifesto, Dada had both destructive and constructive sides. The destructive aspect is obvious and requires no further description; the constructive aspect is not so easily discernible. It lies hidden beneath the manifest destructivism and must be elucidated in some detail if it is to be understood.

To forestall any possible misunderstanding, the signers of this manifesto wish to state that this document is not the confession of a superannuated criminal who has espoused the principles of the YMCA. Nor should it be identified with the protestations of a lady of easy virtue who takes up the Victorian way of life at the end of her career. This manifesto is rather a free declaration of men who have recognized the need for a constructive movement and discovered to their joy that they have never been far removed from such a movement. The worst that could be said is that the world has indeed come to a sorry pass if even the Dadaists feel it necessary to stress the positive and constructive aspect of their nature and principles.

The positive element in Dadaism is not a mere accident deriving from the structure of the mind (the positive always turns up when the negative goes out the door) ; on the contrary, Dadaism was positive and pursued positive aims from the very beginning of its existence. If this positive element has always been disregarded, any innate nastiness in Dadaism is less to blame than the generally negative, critical and cynical attitude of our time, which drives people to project their own vileness into persons, things and opinions around them. In other words, we believe that the neurotic conflict of our time, that manifests itself in a generally negative, unspiritual, and brutal attitude, discovered a whipping boy in Dadaism.

But let us consider the credit side of Dadaism. In this credit column stands first of all the uncontested fact that Dadaism became the father and grandfather of many artistic and philosophical movements; we can go so far as to say that Dadaism provided us with a precept for life, by expressing the principle that you must attain to the Ultima Thule of self-renunciation before you can find the way back to yourself. The Surrealist movement, founded by André Breton (whose writings should be reread from this angle) , is a scion of Dadaism. Surrealism undertook to realize the spiritual aspiration of Dadaism through an artistic direction; it strove for the magical reality which we Dadaists first disclosed in our constructions, collages, writings, and in the dances at the Cabaret Voltaire. As the philosophical consequences of Dadaism represented a positive reaction to a long series of negativistic, neurotic and aggressive manifestations, Dada was and is the termination and rejection of everything that had been said by Rimbaud, Strindberg, Ibsen, Nietzsche and others.

Unconsciously or semi-consciously, Dadaism anticipated many formulations that are now current—Sartre's Existentialism for example. It is no accident that Sartre calls himself "the Nouveau Dada." But we believe that there is an essential difference between Dadaism and Existentialism. Existentialism is essentially negative, whereas Dada lived its extreme despair, expressed it in art, and in this "participation créatrice" found a therapy for itself.

The work of the Dadaists asks those men who have conquered the negative within themselves to band together for constructive deeds. The work of the Dadaists, we firmly believe, makes it clear that the goal of Dadaism was human development, towards spirituality and freedom. This is particularly expressed in the Dadaist rejection of totalitarian solutions to the present conflicts of mankind. The signers of this manifesto wish here to repeat that they dissociate themselves radically and permanently from all those who either seek such solutions or who support a party or society that stands for such solutions. For Dadaists, the State cannot be the ruler of man; it is man who must rule the State.

Adolf Hitler's rage against the Dadaists proves that they were on the right path. He mentions them in *Mein Kampf*. The fact that in Russia art is compelled to dedicate itself to patriotic illustration clearly shows on what side Dadaism stood and where modern art must stand. Consciously or unconsciously, the adversaries of modern art, no less than the enemies of Dadaism, are totalitarian types. On the positive side of Dadaism stands its courage; it is as famed for the baldness of its formulations as for the force of its convictions.

The force and integrity of the Dadaist position make it easy for the signers of this manifesto to say once again that they condemn the use of art as an instrument of propaganda. Art is spiritual and the first characteristic of the spiritual is freedom. Creative expression is an expression of man's most authentic personality, identical with the divine act of creation. It is therefore a blasphemy to make art dependent on the State or to debase it by compelling it to illustrate misunderstood political theories. Art is spirit and as such can accept no master, neither the aristocrat nor the proletarian. It can bow to one master alone, and that master is the great spirit of the universe.

Yet precisely because art is spirit, it has the mission to expose the unspiritual; this it does in its own symbolic language. In this symbolic language, in its close relationship to the archetypes of mankind, in the representation of the creative tension between forms and colors, in the restoration of the original feeling of space and direction in the aesthetic and ethical sense, Dadaists see the essence of all artistic activity.

For Dadaists, art has a lofty, solemn mission, and nothing must be allowed to divert it from its eternal and essential aims. The signers of this manifesto therefore repeat that the value-giving function of art is the purpose and end of all human activity, and that this mission must be subordinated neither to politics, to social considerations, to friendship, nor to death. Returning to the positive in Dadaism, it is perhaps most evident of all in the lives of the individual Dadaists since the closing of the Café Voltaire.

Hugo Ball and Emmy Hennings became mystics soon after their departure from Zurich. Ball wrote his famous book: *Die Flucht aus der Zeit* (*Flight from Time*) (1927). It was a work far in advance of its time, and even at that early date Ball rejected all totalitarian solutions. In *Das Byzantinische Christentum* (*Byzantine Christianity*), Ball demanded a return to a spiritual attitude, and attacked materialism, machine worship, and overestimation of mass organization. Ball came out for spiritual individualism; this alone he believed could lead to new values, restore peace, and create a new world. Emmy Hennings, who first influenced Ball in many ways, wrote magnificent poems and books, demonstrating her great love for the spiritual in man and art.

Hans Arp and Sophie Taeuber agreed from the very beginning of the Dada movement that art had to be freed from illustration and imitation and carried back to its spiritual sources. They worked on constructions, collages and reliefs which today bear witness to a brilliant anticipation of modern directions in art. Eggeling, van Doesburg and Richter—to mention only a few—revealed in their works not only their joy in Dadaism, but also an ability to say positive, constructive, direction-giving things. In his paintings and objects the legendary Marcel Duchamp, who loved and championed Dadaism from the first, showed more than anyone else in our time the influence of Dada's turn from the cynical to the positive.

The development of Max Ernst, who was one of the first Dadaists and who later, along with Breton and Tzara, founded Surrealism, clearly reveals the constructive side of Dadaism.

In his *Phantastische Gebete* (*Fantastic Prayers*), in his writings on Dadaism and in other verse and prose works, Richard Huelsenbeck (now Charles R. Hulbeck) fought for the spiritual concept and the establishment of a new world of values in opposition to the old chaos and disintegration. Like Ball, he found in certain psychoanalytical works an intimate *rapport* with his own ideas and with the requirements resulting from the demise of Dadaism. With Ball, Carl Jung and others, he stood for the restoration of man by the intellect, against the disintegration of friendship, human relations and society.

The signers of this *Dada Manifesto 1949* wish (in the firm belief that it is the last of all Dada manifestoes) to stress once more their belief that the problem of Dadaism is identical not only with the problem of modern art, but with the problem of mankind in our time and perhaps in all times. They further believe that the small group of Dadaists in the Cabaret Voltaire in Zurich in 1916 were, more than any other men of our day, seized with despair at the evil of the times and overcame this despair, theoretically as well as practically, by setting up certain principles relevant both to the situation of art and the situation of the human community. Previous Dada manifestoes have been documents of accusation. This last Dada manifesto is a document of transcendence.

⊕
⊕

401

Note

Note

For reasons of historical accuracy, the undersigned consider it necessary to state that Dadaism was not founded by Tristan Tzara at the Cabaret Voltaire in Zurich. It is self-evident that Dadaism could not be invented by one man, and that all assertions to this effect are therefore false. Dadaism was a child of chance. The undersigned hereby state that the "discovery" of Dadaism was truthfully and correctly described by Richard Huelsenbeck in his book *En avant Dada* (published by Steegemann, Hanover, Germany, in 1920) and published in English in volume 8 of "The Documents of Modern Art": The Dada Painters and Poets.

1. This manifesto was written by Huelsenbeck (Dr. Charles R. Hulbeck) in March, 1949.

Tristan Tzara: *An Introduction to Dada*

From the point of view of poetry, or of art in general, the influence of Dada on the modern sensibility consisted in the formulation of a *human constant* which it distilled and brought to light.

It was in the same way that Romanticism, by defining an existing *state of mind,* was enabled, not only to delimit a permanent aspect of the individual sensibility but to broaden this state of mind so as to constitute a source of intellectual values which in certain epochs was to play an important role in the interpretation of social phenomena. It is too soon to estimate the historic importance of Dada, but even now it can be stated that by supplying the germ of surrealism it created, in the realm of poetry and art, a new intellectual climate which in some measure still survives.

Two traditions, one ideologically (the French Revolution, the Commune, etc.) the other poetically revolutionary (Baudelaire, Nerval, Rimbaud, Lautréamont, etc.), reacted simultaneously on the dadaists and the surrealists. An inner conciliation of these two currents was a constant preoccupation with us, yet even today this endeavor cannot be said to have lost its meaning and urgency.

When I say "we," I have primarily in mind that generation which, during the war of 1914–1918, suffered in the very flesh of its pure adolescence suddenly exposed to life, at seeing the truth ridiculed, clothed in the cast-off garments of vanity or base class interest. This war was not our war; to us it was a war of false emotions and feeble justifications. Such was the state of mind among the youth when Dada was born in Switzerland thirty years ago. Dada was born of a moral need, of an implacable will to achieve a moral absolute, of a profound sentiment that man, at the center of all creations of the spirit, must affirm his primacy over notions emptied of all human substance, over dead objects and ill-gotten gains. Dada was born of a

revolt common to youth in all times and places, a revolt demanding complete de-volition of the individual to the profound needs of his nature, without concern for history or the prevailing logic or morality. Honor, Country, Morality, Family, Art, Religion, Liberty, Fraternity, etc.—all these notions had once answered to human needs, now nothing remained of them but a skeleton of conventions, they had been divested of their initial content. We took Descartes' phrase: "I don't even want to know that there were men before me," as a motto for one of our publications. This meant that we wished to regard the world with new eyes, to reconsider the very fundamentals and test the truth of the notions handed down to us by our elders. On a completely unsystematic plane, our ideas ran parallel to those of the men of science who, at about the same time, were reconsidering the most widely accepted theories of physics, finding its deficiencies and going on from there to build the monumental edifice that is modern physics. Our own modest attempts at renewal occurred in the moral field of poetic or artistic research in its close association with the social order and the conduct of everyday life. The Russian Revolution was saluted by some among us as a window opened upon the future, a breach in the fortifications of an outmoded civilization.

Our horror of the bourgeois and the forms in which he clothed his ideological security in a world which he wanted to be congealed, immutable and definitive, was not, literally speaking, an invention of Dada. Baudelaire, Lautréamont and Rimbaud had already expressed it; Gerard de Nerval, at the antipodes of the bour-geoisie, had constructed his special world in which he foundered after attaining to the limits of the most universal knowledge; Mallarmé, Verlaine, Jarry, St. Pol Roux and Apollinaire had shown us the way. But our impertinence went perhaps a little farther. We proclaimed our disgust, we made spontaneity our rule of life, we repudiated all distinctions between life and poetry, our poetry was a manner of living. Dada opposed everything that was literature, but in order to demolish its foundations we employed the most insidious weapons, the very elements of the literature and art we were attacking. Why, nurtured as we were on the work of cer-tain poets who were our masters, did we turn against literature? It seemed to us that the world was losing itself in idle babbling, that literature and art had be-come institutions located on the margin of life, that instead of serving man they had become the instruments of an outmoded society. They served the war and, all the while expressing fine sentiments, they lent their prestige to atrocious inequal-ity, sentimental misery, injustice and degradation of the instincts. Man stood naked in the presence of life. The ideologies, dogmas, systems, created by the in-telligence of man, could no longer reach him in the essential nakedness of his con-sciousness. It was no longer a question of resistance to an obsolete society: Dada took the offensive and attacked the social system in its entirety, for it regarded this system as inextricably bound up with human stupidity, the stupidity which culmi-nated in the destruction of man by man, and in the destruction of his material and spiritual possessions. But these ideas, which today seem natural and obvious, were at the time of which I am speaking the mark of so subversive a spirit that we were bound to scandalize society, to scandalize it so drastically that it could only regard

us as criminals or imbeciles. We did not preach our ideas, we lived them, somewhat in the manner of Heraclitus, whose dialectic implied that he himself should participate in his demonstrations at once as subject and object of his conception of the world. This conception was one of continuous movement, perpetual change, a headlong flight of time. This led us to direct our attacks against the very fundaments of society, language as the agent of communication between individuals, logic as the cement. Our conception of spontaneity and the principle according to which "thought is made in the mouth" led us in full awareness to repudiate the primacy of logic over living phenomena.

Everything connected with language was for Dada a constant problem and preoccupation. In all this tentacular activity that was Dada, poetry was harassed, insulted and despised,—I am referring of course to a certain brand of poetry, "art poetry" or "static beauty." When in 1919 Picabia, at a gathering sponsored by *Littérature,* exhibited a drawing which he executed on a blackboard and erased as he went along; when I myself, on some pretext which I no longer remember, read a newspaper article while an electric bell drowned out my voice; when, a little later, under the title of *Suicide,* Aragon published the alphabet in the form of a poem in *Cannibale;* when in the same magazine Breton published an extract from the telephone book under the title *Psst* (dozens of other examples might be cited)— must we not interpret these activities as a statement that the poetic work is without static value, that the poem is not the aim of poetry, since poetry can very well exist elsewhere? What better explanation can I offer of my instructions for the manufacture of a Dadaist poem (draw words at random out of a hat)? It is certain that this Dada objective of destroying poetry with its own weapons was inspired in part by our hatred of the poetry which had been unable to escape from its role as an "instrument of expression," which, despite everything, was still literature. At this point Dada sought an issue in action and more especially in poetic action, which is often confused with the gratuitous. I shall cite examples: the series of visits to more or less absurd places in Paris and the art exhibition organized by Max Ernst in a Cologne urinal.

Another current came into being with the publication of *La 1ère Aventure Celeste de M. Antipyrine* (First Celestial Adventure of Mr. Fire-Extinguisher) (1916) and it was not until after its appearance that we began to write series or words having no apparent consecutive sense. Usually devoid of any grammatical tie (elliptical style), these poems were a part of the general tendency which expressed itself in the form of an organized struggle against logic. This method presupposed that words could be stripped of their meaning yet still be effective in a poem by their simple evocative power,—a kind of magic as hard to understand as it is to formulate. The analogy between this use of words and the flight of images was known to us, as was the role of words in *non-directed* thought, although we never gave expression to these ideas. Explaining was repugnant to us, for Dada was a dictatorship of the spirit. Attempts were made to compose new words but only a few poems were written entirely in an invented language. If the experiment was justified from the point of view of consequences to be drawn from the use of words

without meaning, it became ineffectual as soon as the poem was reduced to a succession of sounds.

Apollinaire in *Les Soirées de Paris* and Reverdy in *Nord-Sud* had established a parallelism between cubist painting and poetry. Into the domain of poetry they introduced the "commonplace," a language pill based on a minimum of collective understanding, the popular wisdom which passes the findings of *directed thought* through the sieve of its intelligence. Both these men contributed to Dada magazines at the beginning of the movement. This new element of poetry was an important acquisition for Dada. It was the point of departure for Paul Eluard's researches in his magazine *Proverbe*.

Dada was opposed to cubism on the ground that cubism tended, in its finished work, to express an immutable and static beauty, while everything in Dada stresses its *occasional,* circumstantial nature, the real aim of art being integration with the present-day world. With Dada the work serves only as an identification. Poetry is defined as a reality which is not valid aside from its future.

I shall not take space here to describe in detail the scandalous aspect of Dada, which was itself envisaged as a poetic factor. But I remember a snapshot taken on the stage during the demonstration at the Salle Gaveau in 1921; it showed the public standing, shouting, waving their arms. The spectacle was in the hall, gathered on the stage, we observed an audience gone wild. A play by Paul Eluard figured in the program. Two characters meet on the stage. The first says: "The post-office is across the street." The second replies: "What's that to me?" Curtain. The play was ended. In another sketch, by Breton and Soupault, entitled *S'il vous plaît,* only the first act was played. In the second act, according to the text since published, the authors were supposed to come out on the stage and commit suicide. The program also announced that the Dadaists would have their hair cut on the stage. Ribemont-Dessaignes performed a dance in which the upper part of his body was covered by an immense cardboard funnel and—this was a memorable innovation—not only tomatoes were hurled at the stage to be caught in the funnel but, for the first time anywhere in the world, beefsteaks. Numerous were the inventions with the gift of exasperating the public. The public was divided into several clans. One believed that we were masters of mystification, another that we were real imbeciles; not very numerous in any case were those who gave us a little real credit. And among these last must be counted Valéry and Jacques Rivière. There was good cause for dismay, for, while we voluntarily made ourselves into objects of scorn and vilification, while we did not hesitate to offer ourselves up as a holocaust to every mockery and humiliation, while from all this we even drew a kind of glory,—the writings of Aragon, Breton, Eluard and others evinced a clarity and vigor calculated to disconcert the most convinced adversaries.

Was this movement, only the destructive side of which had been seen by most critics, really necessary? It is certain that the *tabula rasa* which we made into the guiding principle of our activity, was of value only in so far as *something else* would succeed it. A state of affairs considered noxious and infamous demanded to be changed. This necessary disorder, of which Rimbaud had spoken, implied nos-

talgia for an order that had been lost or a new order to come.

Arp, Aragon, Soupault, Eluard, Breton, Picabia, Ribemont-Dessaignes, Crevel, Rigaud, Péret, Max Ernst, Duchamp, Man Ray, myself and a few others were the Dadaists of the first hour in France. The magazine *Littérature* was the organ of Dada in Paris, side by side with *391, Cannibale, Proverbe,* etc. It was Valéry who gave the name *Littérature* to the magazine, as an antithesis in allusion to Verlaine's celebrated phrase. Dada, which had broken not only with the traditional succession of schools, but also with those values which were ostensibly most unassailable, actually prolonged the unbroken line of schools and poets; by this marvelous chain it was connected with Mallarmé, Rimbaud, Lautréamont, and going still farther, with Baudelaire and Victor Hugo, thus marking the continuity of the spirit of revolt in French poetry, that poetry which is based on concrete life and situated at the very center of the preoccupations which become all the more universal in proportion as they are localized.

Dada was a brief explosion in the history of literature, but it was powerful and had far-reaching repercussions. It lay in the very nature of Dada to put a term to its existence. Dada was one of those adventures of the spirit in the course of which everything is put in question. It undertook a serious revision of values and confronted all those who participated in it with their own responsibilities. From the violence and sacrilege of Dada was born, if I may so express myself, a new literary heroism and a sense of moral danger and courage unaccustomed in the field of literature; here, as in the field of physics, danger and courage were the elements making possible the fusion of a categorical principle: Life and poetry were henceforth a single indivisible expression of man in quest of a vital imperative. Dada taught us that the man of action and the poet must commit their whole being to their principles, uncompromisingly and with complete self-abnegation. For Dada, a literary school, was above all a moral movement. It was individualistic, anarchic in certain respects, and it expressed the turbulence of the youth of all times. A product of the disgust aroused by the war, Dada could not maintain itself on the dizzy heights it had chosen to inhabit, and in 1922 it put an end to its existence.

Surrealism rose from the ashes of Dada. With some intermittences, most of the Dadaists took part in it. But that is the beginning of another story.

GENERAL INDEX

Key: The symbol † after the page number indicates a reprint, in whole or part, of the item listed. Page numbers in italics indicate a photograph, reproduction or facsimile. The abbreviation "per" indicates that the item is a periodical.